Digital Storytelling

Martial

Digital Storytelling

A Creator's Guide to
Interactive Entertainment

Carolyn Handler Miller

ELSEVIER

AMSTERDAM • BOSTON • HEIDELBERG • LONDON • NEW YORK • OXFORD
PARIS • SAN DIEGO • SAN FRANCISCO • SINGAPORE • SYDNEY • TOKYO

Focal Press is an imprint of Elsevier

Focal Press

Focal Press is an imprint of Elsevier
200 Wheeler Road, Burlington, MA 01803, USA
Linacre House, Jordan Hill, Oxford OX2 8DP, UK

∞ Recognizing the importance of preserving what has been written,
Elsevier prints its books on acid-free paper whenever possible.

Library of Congress Cataloging-in-Publication Data:

Miller, Carolyn, Handler.
 Digital storytelling/Carolyn Handler Miller.
 p. cm.
 Includes index.
 ISBN-13: 978-0-240-80510-8 ISBN-10: 0-240-80510-0 (pbk. : alk. paper)
1. Interactive multimedia. 2. Storytelling—Data processing. I. Title.
QA76.76.I59M55 2004
006.7–dc22 2004010366

British Library Cataloguing-in-Publication Data:
A catalogue record for this book is available from the British Library.

ISBN-13: 978-0-240-80510-8
ISBN-10: 0-240-80510-0

For information on all Focal Press publications
visit our website at www.focalpress.com

05 06 07 08 09 10 9 8 7 6 5 4 3 2
Printed in the United States of America

I dedicate this book to my husband, Terry, who has taken
the meaning of the word "support" to a whole new level,
and who has encouraged me, kept me going, and even managed
to make me laugh, even in the most stressful of times.

Table of Contents

Foreword

By Ken Goldstein

Something Happened.

'Twas round about the mid '80s, just about the time we were all truly starting to grok the impact of Apple's once-run Super Bowl spot that sounded the war cry to dismantle Big Brother. Almost ancient history now, but in retrospect it seemed to have a lot to do with the PC world taking a lesson from the Mac, replacing the monochrome monitor with 8-bit color, and there you have it, we decided we were all making interactive movies.

My own journey started almost entirely by accident, as any writer tempered by honesty is likely to share, largely due to too much time on my hands. Still looking for a crack in the armor through which I might find an excuse to force my way into "The Club," I attended a conference at UCLA called "The Future of Television." Speakers on the keynote panel included one of the foremost executive producers of all time, and if He had something to say about the future of television, I needed to be His disciple. Besides, I knew if I could ask just one intelligent question, I could leverage that into a post-conference spec script reading, and within days, the calls from my student loan officer would no longer be troublesome. Still new to town and terrified that traffic would come between me and my soon-to-be-acquired nest egg, I arrived much too early at the conference, hours before the keynote (curious, since I had always understood keynotes as kickoffs for conferences, but back then L.A. was too hip for anything important to start too early in the day). As fate would have it, we were offered a warm-up panel, and given that it was in an air-conditioned auditorium and I couldn't afford the French toast special in the cafeteria, I parked myself in the mini-audience and started to learn about something called *interactivity*.

What I remember most about that panel was that no one had a single example of any work they could show. They tried to make us believe this was because their work was so secret it could not be revealed in public, but I soon learned it was because none of their musings had yet been created. What they were saying sure sounded interesting, though—getting the audience into the story as a participant, technology allowing responsiveness to audience choice, a future where stories had unending endings or no endings at all. It was a revolution still in the making; the theorists were theorizing before there was reality to evaluate. There were only two possible outcomes: Either this was reject material for *Saturday Night Live*, or this was opportunity. To this day I thank the Force that I guessed right.

One thing has remained constant in the business of interactivity; there has never been a shortage of conferences. For the next several years, as the dour '80s

became the tech-hot '90s, I remember arguing with people at the third, fourth, and umpteenth CD-ROM conferences about what the word *interactivity* actually meant. Already tests were being run for something called *interactive TV*, where interactivity was little more than rapid-clip pounding on a remote control, clicking on the cashmere sweater worn by a darling sitcom actress, and having it sent to you overnight with a quick ding to an on-file credit card (the concept of Privacy wouldn't be invented for another fifteen years). Other fascinating applications included pointing at dumbed-down iconography on a monitor so that one could order a pizza during Act I of *Hill Street Blues* and have it arrive before the end credits, without one's fuzzy slippers ever touching the carpet until the doorbell rang. I kid ye not; many visionaries in control of very large investment portfolios considered this about as much control as your average consumer would ever want. Others thought it was about letting the audience vote to pick the ending of the show (as long as it was A or B, the unused footage, of course, economically being saved for next week's choice). Still others thought it was about branching, about story trees that went wider and broader and created thousands (and with the power of exponents, someday *trillions*) of lines of dialogue that would still lead back to the same two endings!

As the early and mid '90s of CD-ROM lore tipped to the late '90s of Internet infamy, I remember yet another conference. I was extremely honored to sit on a panel at the first Writers Guild of America West's "Words into Pictures" affair. I believe there were some seven people in the audience and three of us on the panel still trying to define *interactivity*. The rest of the conference attendees were in another room listening to a collection of screenwriting luminaries with whom I got to drink excellent wine later that night. I also got a great gift bag with a sweatshirt I still keep around the house, mostly because I loved the name of the conference: "Words into Pictures."

That was our tie to the past and our link to the future. At its core, our heritage remains that of audiovisual media. And yes, *something happened*. While we were arguing at conference after conference about what was meant by Interactivity, revenue for the computer and video game industry eclipsed that of the motion picture box office for North America. A generation of media consumers came to decide that active was more seductive than passive. Storytelling got stood on its head, but interactive or not, it was still storytelling, and it still required storytellers—a new generation of storytellers, but storytellers nonetheless. To capture the power of the chip, writers learned to do something they had never particularly liked—give up control. The most difficult lesson the digital storyteller learned was that, in order to become proficient in this virtual theater, digital storytelling by definition meant the release of control to the audience.

Truth be told, this is antithetical to every single thing you have ever learned or been taught about storytelling. Isn't storytelling the art of creating suspension of disbelief? Isn't every great writer a master at sweeping people away to another place, taking a reader or an audience to worlds where they have never been? Yes, that is still your job—that, and helping people to get that sweater that looks so good on you-know-who, or perhaps "real time" helping to pick the next generation *American Idol*, or at last getting that pizza home piping hot before Jeff reveals the lone *Survivor*. Played any good games lately?

Needless to say, Revolution has come slowly. But graciously enough, it has come. Thus, you have Carolyn Miller to guide you through a comprehensive romp that illustrates her own journey. Throughout the madness, throughout the

many years of opinions, ideas, and conferences, there were experiments. Many, many experiments. Some noble, some outlandish, many embarrassing, and as is so often the case, a very few both critically and commercially acclaimed. As Carolyn has admirably documented, she has been both student and artist on this all-too-strange path into tomorrow. She has played and she has made, studied and learned, created and captured the continuum that is our brief academic investigation. Since most of you missed these many conferences (trust me, your time was much better spent playing *Asteroids, Tetris,* or *Doom*), you now have the unique opportunity to let Carolyn, as storyteller, take you through the forest of many paths and few real trails. *Digital Storytelling* takes you behind the notions, brainchildren, and engines that have fueled our growth to the very point of origin at which we remain. Indeed, we are still at the beginning, an excellent time to join "The Club."

Hello World!

Sierra Madre, California
March 2004

Ken Goldstein is Executive Vice President and Managing Director of Disney Online, where he has been a humble servant of the Internet since 1998. Previously, he was the founding Vice President and General Manager of Red Orb Entertainment, a division of Broderbund Software, Inc., and Executive Publisher of Entertainment and Education Products for Broderbund. A long time ago in a county called Marin he hired a clever writer named Carolyn Miller to help put words in the mouth of a certain Carmen Sandiego. An even longer time ago, he too made a living as a writer and interactive designer on now long-forgotten games played by kids who are now having their own kids, but he left all that fun behind to help hire smart people like Carolyn.

Preface

AN ANCIENT CRAFT

This book is about storytelling—a new form of storytelling, to be sure, but part of a tradition that stretches back to preliterate times. Storytelling is a magical and powerful craft. Not only can it transport the audience on a thrilling journey into an imaginary world, but it can also reveal dark secrets of human nature or inspire the audience with the desire to do noble deeds. Storytelling can also be pressed into service for more utilitarian goals: to teach, to promote, and to train.

The type of storytelling we will investigate in this book, digital storytelling, can do all the things that traditional storytelling can do, and a number of people would argue that it can even do many of these things better. The first storytellers had only a single simple tool at their disposal—the spoken word—while later storytellers had more sophisticated methods of spinning tales, using actors, music, sound effects, and ultimately, filmed images. But digital storytellers, the newcomers in this long line of narrative artists, have an additional tool in their toolkit, something even more potent: interactivity. In this book we will see how interactivity affects not only the craft of storytelling, but the experience of audience as well.

WHAT IS DIGITAL STORYTELLING?

Digital storytelling is narrative entertainment that reaches its audience via digital technology and media—microprocessors, wireless signals, the Web, DVDs, and so on. Interactivity is one of its hallmarks. Older media, which is supported by analog technology (film, video, LPs, audiotape), cannot support back-and-forth communications between the audience and the material—interactivity—and this is a radical difference between the older media and the new. While not every single work of digital entertainment is interactive, all the projects profiled in this book

do have interactive elements, allowing for varying degrees of choice and control on the part of the user. We will be studying how interactivity can be used in narrative entertainment, examining both its demanding challenges and its remarkable advantages. We will also be looking closely at games, examining the significant connection between games and digital storytelling. We will see that although interactivity has a profound effect on storytelling, it does not alter the essence of what a story is: a narrative that depicts characters in a series of dramatic events, following the action from the inception of the drama to the conclusion. Although people often think of a "story" as a work of fiction, something that is make-believe, this is not necessarily the case. Documentaries, for example, are stories, too. In this book, we are including works of nonfiction as well as fiction, using the term "story" in its broadest sense. All the works profiled in this book are entertaining—the consuming of them is designed to be pleasurable—but in many cases they have other objectives as well. We will be examining how digital storytelling can be an effective vehicle for educational, informational, and commercial purposes, as well as for pure entertainment.

PUTTING THE FOCUS ON CONTENT

Digital technology is quite a recent development, and so is entertainment that makes use of such technology. After all, the first modern computers were not introduced until the middle of the twentieth century, and the first successful commercial work of digital entertainment—the arcade game, *Pong*—did not debut until 1972. Because this is such a new field, a great deal of attention has been placed on the technology and not what the technology could be used to do. This book is an effort to change this equation and put the focus squarely on content.

Although this book touches on technology and design, its primary focus is on creative questions: How can these new digital resources be used to develop engaging entertainment experiences and to tell compelling stories?

Essentially, this book was written with three major goals in mind:

1. To introduce readers to the remarkable works that are being produced in this new arena of storytelling.
2. To examine a broad array of interactive entertainments, to see where they share common ground and what we can learn from them that may be universally applicable to digital storytelling in general.
3. To serve as a guide to digital storytellers, articulating ideas of character design, structure, and other development techniques that are specifically tailored to digital entertainment and that will help to propel forward this new way of presenting stories.

THE SCOPE OF DIGITAL STORYTELLING

Digital storytelling is used to provide an enormous array of entertainment experiences. It encompasses such things as online role playing games involving hundreds of thousands of players; talking dolls with artificial intelligence; virtual reality simulations involving sword fights with comic book characters; action games on

pocket-sized wireless devices; and interactive cinema on full scale theatrical movie screens. These forms of entertainment would seem, at first glance, to be completely unalike, yet a closer investigation will reveal significant similarities.

This book will examine all major forms of digital storytelling, examining how they are created; the unique development challenges each of them presents; and the special kinds of entertainment experiences they offer. It will look at what can be borrowed from each one and applied to other forms of digital storytelling. In addition, the book will study projects that combine multiple media and see how this cross media approach to production can be used to expand a story universe and deepen the audience's involvement with the narrative.

SOURCES AND PERSPECTIVE

The material in this book is drawn from a number of sources: interviews, conferences, information provided by industry groups, print and electronic publications, and material provided by software developers. It is also based on my own experiences working in interactive media. I have inevitably brought my own perspective to this subject, and it is that of a writer. My academic background is in English literature and journalism; my professional background includes screenwriting and work as a writer or writer-content designer on over three dozen interactive projects. These include entertainment, educational, informational, and training projects made for CD-ROMs, kiosks, the Web, smart toys, and integrated media productions. In addition, researching this book called for many hours spent playing games, studying interactive movies and iTV shows, visiting websites, and interacting with smart toys—hardly an onerous task, and one that deepened my understanding of interactive entertainment.

The companies that produced the work for the case studies in this book are based not just in North America, but all over the globe: in Europe, in Asia, and in Africa. In gathering material, I interviewed a total of sixty people, many face to face, some by telephone, some by email, and a number by all three methods. They represent a range of professional positions, including developers, producers, designers, graphic artists, inventors, and writers. The organizations they work for include major Hollywood studios, TV networks, toy manufacturers, design firms, academic institutions, and their own small companies. Some of them work on a single medium or create a single genre of project; others are platform agnostic, finding ways to tell various kinds of digital stories across many media and platforms. My interview subjects include people responsible for some of the most popular interactive media projects ever developed; others have done immensely innovative work known only to a small circle of people. But whether well-known or obscure, valuable lessons can be learned from all of them.

THE ORGANIZATION OF THE BOOK

This book is organized into four sections, each with a different function.

- PART ONE: NEW TECHNOLOGIES, NEW CREATIVE OPPORTUNITIES puts digital storytelling into a historic context, covers the development of digital media, and discusses the implications of convergence.

- PART TWO: CREATING ENTERTAINMENT-RICH PROJECTS investigates some of the major concepts and tools of digital storytelling, and discusses how to make interactive entertainment for children as well as projects designed to teach, train, inform, and promote. It also gives a step-by-step description of the development process of a new media project.
- PART THREE: MEDIA AND MODELS: UNDER THE HOOD is organized into chapters devoted to different interactive categories (video games, the Web, DVDs, and so on) and deconstructs a number of new media projects, many of them seminal works of digital storytelling.
- PART FOUR: CAREER CONSIDERATIONS examines the career issues of being a digital storyteller and discusses how to go about creating one's own showcase.

Each chapter in the first three parts ends with a feature called "Idea-Generating Exercises." These exercises are designed to put you, the reader, in the driver's seat, and give you the chance to work with the concepts laid out in the chapter you just read.

Some of these are modeled on exercises I've used successfully with my students. Others are self-imposed mental workouts I've employed to stimulate my own creative juices. Still others were suggested to me by the subject matter of the chapters in which they are found, as a tool to probe the material more deeply. At the end of the chapters in Part Four, the section on career issues, I have given some practical tips and suggestions instead of offering a set of idea-generating exercises.

THE ROLE OF THE READER

As you are reading this book, I hope you will regard these pages as a starting place, and continue to look around you for other good examples of digital storytelling. Amazing new projects are being introduced to the public on a continual basis, and I encourage you to search them out. When you find a project that intrigues you, analyze it and deconstruct it, referring to the concepts of interactive storytelling laid out in this book.

The visionary storytellers whose projects are described here unharnessed their imaginations and gave themselves the freedom to devise new kinds of narrative experiences. I hope you will find inspiration in their works, and that you will use the ideas and tools you find in the book to create wonderful digital stories of your own.

Acknowledgments

A great many people contributed in various ways to this book and helped it become a reality. First and foremost, I would like to thank the people I interviewed, all sixty of you, for giving me so much of your time and for putting up with my endless questions. Your insights were invaluable and getting to learn about your innovative projects made working on this book a joy. I would also like to thank all of you who gave me permission to use images and documents from your projects to use in the book, often going to a great deal of trouble to secure the necessary approvals. Thanks, too, to Sue Terry, who helped obtain a number of images for me.

I would like to thank my editors at Focal Press, Amy Jollymore, who patiently guided me through the complex process of book publishing and who supplied me with much good advice and good cheer, and Troy Lilly, who gracefully shepherded my book through production. My literary agent, Susan Crawford, also deserves special thanks for finding such a good home for this book, for having faith in it from its earliest days, and for offering such warm support.

It is impossible to imagine how I would have been able to write this book without the assistance and encouragement of my husband, Terry. He aided me in innumerable ways, pointing out examples of digital storytelling I might have missed; explaining technologies I was uncertain about; and reading every word of the manuscript. Most important of all, he understood what I was trying to do and cheered me on every step of the way.

I would also like to thank my professional colleagues and friends for their support—especially Dr. Linda Seger, Kathie Yoneda, Dr. Rachel Ballon, and Sunny Fader—all of whom buoyed me up whenever my spirits were flagging.

Finally, I would like to thank the members of the New Media Committee of the Writers Guild of America, West. Unusual as it may be to thank a committee, this little band of writers has made a significant contribution to furthering the interests of digital storytellers and to increasing my own knowledge of the field. Its members have generously shared information; engaged in lively debates about the role of the writer in new technologies; and sought and obtained Guild

recognition for new media writers. Of this group, I want to particularly thank Liz Mitchell, who teamed up with me on several endeavors, including our massive study of the Internet and the virtual focus group project, and who generally brought interesting items to my attention. I am also grateful to our chair, Bob Silberg, who kept things going during some extremely rough times.

New Technologies, New Creative Opportunities

Interactive Storytelling: A Brief History

Can the roots of interactive storytelling really be traced all the way back to prehistoric religious rituals? What could they possibly have in common?

How are games played on a computer similar to those played on a ball field or on a tabletop game board?

Do various forms of linear entertainment—novels, plays, and movies—have anything useful to show us about creating interactive entertainment?

EARLIEST FORMS OF INTERACTIVE STORIES AND ENTERTAINMENT

Long before video games, or experiments with interactive TV, or the explosive growth of the Internet—long, even, before computers had ever been imagined—human beings all over the world devised and participated in interactive storytelling experiences. These beginnings, in fact, date back to ancient times, thousands of years before relatively old forms of media and entertainment like printed books and theatre.

Some professionals in interactive media hypothesize that the earliest forms of interactive storytelling took place around the campfires of prehistoric peoples. I can remember this theory being enthusiastically promoted back in the early 1990s, when the creative community in Hollywood was first becoming excited about the potential of interactive media. At almost every conference I attended at the time, at least one speaker would allude to these long ago campfire scenes. The prehistoric storyteller, according to this theory, would have a general idea of the tale he planned to tell, but not a fixed plot. Instead, he would shape and mold the story according to the reactions of those gathered around him.

This model evokes an inviting image of a warm, crackling fire and comfortable conviviality. It was no doubt a reassuring scenario to attendees of these first interactive media conferences, many of whom were still intimidated by computers and the concept of interactive media. But to me, this model never sounded particularly convincing. For one thing, how could anyone really know what took place around those smoky old campfires? And even if it were true that ancient storytellers constructed their tales to fit the interests of their listeners, how much actual control or participation in the story could these campfire audiences have had? At best, it would have been an extremely weak form of interactivity.

But no matter what one thinks of this campfire model, it is unquestionably true that a form of interactive stories—a far more profound and participatory form—dates back to extremely ancient times. According to the renowned scholar Joseph Campbell (1904–1987), the earliest form of story was the myth, and storytellers did not merely recite these old tales. Instead, the entire community would reenact them, in the form of religious rituals.

DEATH AND REBIRTH IN RITUAL

Campbell and other scholars in the field have observed that these mythological stories generally contain deep psychological underpinnings, and that one of their most common themes is death and rebirth. Campbell noted that participants who took part in myth-based rituals often found the experience so intense that they would undergo a catharsis, a profound sense of emotional relief. (The word catharsis comes from the Greek, *katharsis*, and means purgation, or purification.)

Ritual ceremonies evoking myths frequently reflected major life passages, such as a coming of age. According to Campbell, the ceremonies held for boys typically required them to undergo a terrifying ordeal, during which they would "die" as a child and be reborn as an adult. Girls also went through coming of age ceremonies, he found, though they tended to be less traumatic.

Figure 1.1 The Greek god Dionysus, pictured on this ancient vase (ca. 500 B.C.), was honored in intense ritual ceremonies that were an early form of interactive storytelling. Note the grapevine and clusters of grapes in the decoration; Dionysus was closely associated with grape cultivation and wine. Photograph by Maria Daniels, courtesy of University Museums, University of Mississippi.

Campbell discovered that cultures all over the world and across all cultures told myths about this universal coming of age experience, and he wrote an entire book about such myths, *The Hero with a Thousand Faces*. This genre of myth is often referred to as "the hero's journey." Its core elements and recurring characters have been incorporated into many popular movies and it has also served as a model for innumerable computer games.

Other myth-based rituals, especially in agricultural communities, would commemorate the death of the earth (winter) and its joyous rebirth (spring). One such ritual, well known to scholars of Greek drama, was called the Festival of Dionysus. Celebrated twice annually throughout ancient Greece, these festivals were a ritual retelling of the myth of Dionysus, the Greek god of wine and fertility. (See Figure 1.1.) They not only depicted important events in the god's life, but were also closely connected to the cycle of seasons, particularly the death and rebirth of the grapevine, a plant closely associated with Dionysus.

While some details of the Dionysian rituals have been lost over time, a fair amount is still known about them. They involved singing and dancing and the playing of musical instruments. The male participants would dress as satyrs, drunken creatures who were half man and half goat (the goat being one of the animal forms associated with the god), while the women would play the part of maenads, the god's frenzied female attendants. In some Greek communities, the festival included a particularly bloodthirsty element—the participants would take a live bull (symbolizing another animal form of the god) and tear it apart with their teeth.

Ultimately, these festivals evolved into a more sedate ceremony, the performance of songs called *dithyrambs* that were dedicated to Dionysus. These choral performances in turn evolved into classic Greek drama, both tragedy and comedy, which continued to retain the influence of the early rites. The word "tragedy," in fact, comes from the Greek word *tragoidia*, which means "goat song."

Odd though it may seem, the ancient celebration of the Festival of Dionysus bears an interesting resemblance to today's enormously popular Massively

Multiplayer Online Games (MMOGs). After all, the participants in these contemporary games take on a different persona, interact with other "players," and work toward accomplishing a particular goal, often playing out scenes that have life and death consequences. To me, the ritual reenactment of myths is a far more intriguing model of interactivity than that of the old campfire stories, and one from which we might be able to gain some useful insights.

POWERFUL REENACTMENTS IN OTHER CULTURES

The Greeks were by no means the only ancient community to reenact its myths. Campbell asserts that this was a common element of all preliterate societies. Even today, in regions where old traditions have not been erased by modern influences, isolated societies continue to perform ceremonies rich in mythological symbolism.

One such group is the Dogon people of Mali, West Africa, who live in clay dwellings tucked into the steep cliffs of the Bandiagara Escarpment, not far from the scorching Sahara desert. Because this region is so remote and relatively inaccessible, the Dogon have managed to preserve their ancient traditions and spiritual practices to this day. Their complex mythological beliefs influence almost every aspect of their lives from birth to death, and determine each individual's place in society, including membership in certain clans.

Many of the Dogon's beliefs are reenacted in elaborate dance ceremonies, during which participants don masks and full body costumes. One of the most dramatic of these ceremonies is the Sigui dance, which takes place just once every sixty years. It contains many of the elements Joseph Campbell noted as being customary in important ritualistic ceremonies, such as a representation of death and a rebirth. In this case, the Sigui dance symbolizes the passing of the older generation and the rebirth of the Dogon people.

Although the actual ceremony is performed at such great intervals, every so often a version of it will be presented to visitors who make the difficult trek to the Dogon's cliff dwellings. Some years ago, I had the great privilege of witnessing the reenactment of the Sigui dance. It was an extraordinary sight to see the costumed dancers appear, as if from nowhere, and parade into the center of the village where we waited. Their magnificent masks and costumes represented important animals, ancestors, and spirits in their belief system. A number of them danced on stilts, making them as tall as giants, and all the more impressive. They made swirling motions with their heads, so low that the masks brushed the ground.

Unlike Western dance troupes, which are made up of a select few talented individuals, who perform for an audience of nonparticipants, all members of Dogon society take part in the dances which their clan traditionally presents. Each dancer plays a highly symbolic and specific role.

Again, like the Dionysian rites, we can find similarities between these ceremonies and interactive storytelling. Although these Dogon dance dramas are done by living people and take place in a physical location, they nevertheless share an important feature with many interactive computer games: the use of avatars. An avatar, after all, is an embodiment or incarnation of an entity who is not actually present. In a Dogon ceremony, the figure that the dancer portrays is an avatar for a mythological being or spiritual figure. (See Figure 1.2.) In a computer game, the figure that the player controls is an avatar for a fictional being,

Figure 1.2 This Dogon dancer on stilts represents a female *tingetange*, or waterbird. Dogon dancers don masks and costumes to portray mythological beings or spiritual figures in much the same way as game players control avatars to play character roles in digital dramas. Photograph courtesy of Stephenie Hollyman.

a character in a game. Thus, even in a place as far away as Mali, in a region without electricity or telephone service, we can find parallels with computer-based entertainment.

Closer to home, and to our own lives, we can examine our own traditional religious practices and discover other surprising similarities to interactive storytelling. In the Jewish faith, for example, we find the profoundly powerful holiday of Yom Kippur, or Day of Atonement, an observance that dates back thousands of years. It is a holiday I've observed all of my life, first in children's services and then with the adults in the congregation.

Jews who observe Yom Kippur fast for an entire day, from sundown on one day until sundown the next. Most waking hours are spent taking part in a series of religious services held in the synagogue. One important ritual is the communal confession of sins one has committed during the past year. During this public recitation, one lightly smites one's chest. The overarching drama of Yom Kippur is the hope that by going through this ritual of self-denial, confession, and repentance, God will forgive us and seal our names in the Book of Life.

Though it may seem like something of a stretch to compare such a solemn religious holiday to contemporary interactive entertainment, no disrespect is intended. If we plunge ahead and make the comparison anyway, we will find some surprising similarities. Both the religious service and works of interactive entertainment are highly participatory and immersive; both are also highly involving. The similarity is even more pronounced if we consider an online form like a MMOG, since the Internet is such a powerful medium for fostering community involvement. Furthermore, both types of experiences work toward a clear-cut outcome. By taking part in a Yom Kippur observance, one experiences a catharsis, or feeling of intense emotional relief. The same is true if one has worked through a challenging computer game, and in doing so, has overcome a series of difficult obstacles to reach a positive outcome.

INTERACTIVITY AND GAMES

While religious rituals may have an indirect, though interesting, relationship with computerized media, another predecessor to digital entertainment has a far more direct connection: the playing of games. Like religious rituals, games date back to ancient times and once served important functions. In fact, games played such an honored place in early societies that they were often embedded in religious ceremonies.

The earliest games were developed not for idle amusement but for serious purposes: to prepare young men for the hunt and for warfare. By taking part in games, the youths would strengthen their bodies and develop athletic skills like running and throwing. By playing with teammates, they would also learn how to coordinate maneuvers and how to strategize. Over time, these athletic games evolved into formal competitions. Undoubtedly, the best known of the ancient sporting events are the Greek Olympic games. We can trace the Olympic games back to 776 B.C., and we know they continued to be held for more than one thousand years.

Athletic competitions were also held in ancient Rome, India, and Egypt. In many old societies, these competitions served a religious function as well as being a form of popular entertainment. In Greece, for example, the games were dedicated to the god Zeus, and the athletic part of the program was preceded by sacred religious rites.

Religion and sporting games were even more intricately mixed in the part of the world that is now Mexico and Central America. The Olmecs, Mayans, and other Native American peoples throughout the region played a ball game that we now know had great spiritual and symbolic significance to them, and was a central ritual in their culture. Some scholars believe that the ball game served as a conduit to the gods they believed dwelt beneath the earth; it was a way of communicating with divine powers.

The game was played by two competing teams in an outdoor court marked by a set of high parallel walls. The players had to keep the ball in the air, and could use any part of their body to do this except for their hands. As in a modern ball game, the two teams vied to lob the ball to a goal, in this case a high stone ring. However, unlike modern ball games, once a goal was scored, the game ended, and so did the life of at least one of the players. Scholars still are debating whether this fate fell to the captain of the winning team or the losing team. They do agree, however, that the leader of one of the teams was ritually executed by decapitation, and that this action was meant as a religious sacrifice, to please their gods. Visitors to the excavated ball court at Chichén Itzá, in Mexico's Yucatan Peninsula, can still see a stone relief depicting the decapitation ceremony. (See Figure 1.3.)

The sporting competitions that have come down to us from ancient times contained many of the key elements that continue to be hallmarks of today's athletic games. Furthermore, they are also the distinguishing characteristics of the majority of computer games as well. Both types of games are

- intensely competitive;
- demanding of one's skills, either physical or mental;
- regulated by specific rules;
- clearly structured, with an established way of beginning and ending;
- and played to achieve a clear-cut goal; in other words, to succeed at winning, and to avoid losing.

Athletic sports are not the only type of game that has come to us from ancient times. Board games dating back to 2700 B.C. have been found in the temples of the Egyptian pharaohs; board games were also highly popular in ancient China, Japan, and Korea; and the people of India developed chess and card games thousands of years ago.

Figure 1.3 This carving at Chichén Itzá of a Mayan postgame decapitation ritual illustrates that games can play a deadly serious role in the spiritual life of a culture, and can carry a deep symbolic meaning. The circle in the carving represents the ball, and the figure inside the ball is the skull of the decapitated player. Photograph courtesy of E. Michael Whittington, Mint Museum of Art, Charlotte, North Carolina.

Despite the obvious differences between an athletic game like hockey and a parlor game played with cards or chess pieces, these various pursuits share the same characteristics: They are competitive, regulated by rules and a structure, require skill, and have an end goal. And modern computer games generally share these characteristics as well.

CHILDREN'S GAMES AND THE "FUN FACTOR"

In addition to the structured games played by adults, children in every era and every culture have played games of all sorts. Many of them are more free flowing and less formalized than adult games. Children's pastimes range from "quest" games like hide-and-seek, to games that are more social in nature, like jump rope, to games of skill, like jacks. Children also enjoy make-believe activities like fantasy role-play. One old favorite, for example, is cowboys and Indians. A more sophisticated form of role-playing games can also be found in adult games, played both with and without the computer.

When it comes to fantasy role-play, children tend to be fairly conservative in that they usually only pretend to be characters of their own gender. Little girls enjoy dressing up like their mothers or pretending to be ballerinas or fairy princesses. Boys like to imitate fire fighters, police officers, and action heroes. Sometimes, however, children of either gender will pretend to be animals or fantasy creatures like monsters or ghosts. These role-plays are sometimes solo activities, but are more often done in groups. They can involve elaborate scenarios with each child taking on the part of a different character. Sometimes dolls and other "props" are pressed into service, too. Even adults engage in fantasy role-playing activities, as evidenced by the popular Renaissance Faires, which are elaborate reconstructions of Elizabethan England, complete with jousting, a royal court, and someone playing the part of Queen Elizabeth I. Many attendees come to these faires dressed in period costumes and attempt to speak in Elizabethan English. We will be looking at other types of role-playing activities a little later in this chapter.

Fantasy role-play activities are not strictly games, because they are not competitive in nature. They also don't follow a fixed set of rules or have a clear-cut end goal. But though they differ from more formalized games, the two pursuits have an important element in common: Both activities are experienced as "play." In other words, people engage in these activities for pleasure, and they perceive them as fun.

The expectation of having fun is one of the primary reasons that both adults and children have traditionally engaged in games and other play activities. This continues to be true in contemporary society, even when the playing is done on computers instead of on a ball field or in a schoolyard or in a living room. The importance of this fun factor was underscored in a survey conducted in 2002 by the Interactive Digital Software Association, a professional organization for publishers of interactive games. In the survey, game players were asked to name their top reason for playing games. Over 85% said they played games because they were fun.

ROLE-PLAYING GAMES ON THE COMPUTER

One genre of computer game whose lineage can be traced directly back to games played in the "real world" is the Role-Playing Game (RPG). As noted previously,

Figure 1.4 War game simulations played with miniature soldiers like these were the precursors of today's MMOGs. Photograph courtesy of Lloyd Pentacost.

children have a long history of engaging in fantasy role-play. But computerized role play for adult gamers, though similar in some ways to childhood fantasy role play, is derived from a relatively new form of entertainment called the Live Action Role Playing game (LARP).

The earliest forms of such games were war game simulations developed in the 18th and 19th centuries. These games were used to train officers in strategy, and were typically played on tabletops with miniature soldiers made of metal. (See Figure 1.4.) In the latter part of the 20th century, games like these, married to elements of improvisational theatre, morphed into Dungeons and Dragons LARPs, and from there into today's MMOGs. (For more on MMOGs, please see Chapter 12.)

NONLINEAR FICTION IN LITERARY WORKS

Traditional entertainment, especially material that is story based, is almost always linear. In other words, one event follows another in a logical, fixed, and progressive sequence. The structural path is a single straight line. Interactive works, on the other hand, are always nonlinear. Even when interactive works include a central storyline, players or users can weave a varied path through the material, interacting with it in a highly fluid manner.

Nevertheless, a few innovative individuals working in long-established media—printed fiction, the theatre, and motion pictures—have attempted to break free of the restrictions of linearity and have experimented with other ways of presenting story-based material.

One of the first was Laurence Sterne, author of the novel *The Life and Opinions of Tristram Shandy, Gentleman*. The nine-volume work was published between 1759

and 1766, not long after the first English novels were introduced to the public. In *Tristram Shandy*, Sterne employs a variety of unconventional ways of presenting the narrative flow, starting down one story path only to suddenly switch over to an entirely different one, and then a short while later turning down still another path. He also played with the sequence of chapters, taking chapters that had allegedly been misplaced and inserting them seemingly at random into the text. Sterne asserted that such unexpected narrative digressions were the "sunshine" of a novel and gave a book life.

Several mid-twentieth century authors also experimented with nonlinear narrative. William Burroughs caused something of a sensation when he introduced his "cut up" works, in which he took text that he had cut into fragments and reassembled it in a different order. He believed that these rearrangements enabled new meanings to emerge. It was a technique he learned from his friend Brion Gysin, a painter and writer. The method they used was akin to the making of collages in the art world—works composed of bits of assorted materials.

As for the brilliant modern author James Joyce, many now consider his novels to be a precursor of digital hypertext. In computerized hypertext, words are linked to other related "assets," such as photographs, sounds, video, or other text. The user who takes advantage of these links is rewarded by a deeper experience than would have been possible by following a simple linear thread. Joyce, particularly in his sweeping novels *Ulysses* and *Finnegan's Wake*, used a similar technique of associations, allusions, word pictures, and auditory simulations, though all on paper and within the covers of his novels. Entire websites are now devoted to the topic of the hypertext quality of Joyce's work.

Joyce died in 1941, long before the development of modern computers, but contemporary writers are now using digital technology to compose short stories and novels utilizing hypertext. Their works are available online, and electronic books are published by several companies. Most prominent among them is Eastgate Systems, an evangelist for serious works of hypertext.

But dropping back for a moment to books that are printed the old-fashioned way, on paper, another example of interactive narrative should be mentioned: a series of books introduced in 1979. Going under the general heading of *Choose Your Own Adventure*, and primarily written for the children's market, these unusual books presented a form of interactive fiction. At various points in the novel, the narrative would pause and the reader would be offered a number of different ways to advance the story, along with the page number where each option could be found. Many of these books offered dozens of alternate endings. Do these novels sound a little like computer games with branching story lines? Well, not surprisingly, some of them actually were made into computer games.

NONLINEAR DRAMA IN THEATRE AND MOTION PICTURES

In theatre and in motion pictures, writers and directors have also experimented with nonlinear methods of telling stories. The Italian playwright Luigi Pirandello (1867–1936) wrote a number of plays that probed the line between reality and fiction. His plays deliberately broke the "fourth wall," the invisible boundary that separates the audience from the characters on stage, and divides reality (the audience side) from fiction (the characters' side). In his play *Six Characters in*

Search of an Author, Pirandello breached the wall by having actors in an uncompleted play talk and refer to themselves as if they were real people. They fretted about the need to find a playwright to "complete" their plot lines, or lives. Pirandello won the Nobel Prize in literature in 1934 for his groundbreaking work, and his dramas influenced a number of other playwrights, including Samuel Beckett and Edward Albee.

Pirandello's boldness at smashing the fourth wall is also echoed in Woody Allen's film, *The Purple Rose of Cairo.* In this picture, Mia Farrow plays the part of a woebegone filmgoer with a passionate crush on a character in a movie (played by Jeff Daniels). Much to her astonishment and delight, her film hero speaks to her as she sits in the audience watching the movie, and even steps out of the screen and into her life.

This breaking of the fourth wall, while relatively unusual in the theatre and in movies, is a common occurrence in interactive media. Video game characters address us directly and invite us into their cyberworlds; fictional characters in Web-based games like *Majestic* send us emails and faxes and even engage in instant messaging with us; smart toys joke with us and remember our birthdays. This tunneling through of the fourth wall intimately connects us with a fictional universe in a way that is far more personal than was ever possible in older media.

Another revolutionary technique that first appeared in theatre and films, and was then employed more fully in interactive entertainment, is the use of multiple pathways or points of view. The play *Tamara,* written by John Krizanc, utilized a multiple pathway structure, and it created quite a stir in Los Angeles in the 1990s. Instead of being performed in a theatre, *Tamara* was staged in a large mansion, and multiple scenes were performed simultaneously in various rooms. Members of the audience had to choose which scene to watch (which they did by chasing after a character whose storyline they were particularly interested in); it was impossible to view everything that was going on during a single performance.

Tamara had a direct influence on the producers of the CD-i mystery game *Voyeur.* Like the play, the game also made use of multiple pathways. It, too, was set in a mansion with many rooms, and simultaneous action occurred throughout the mansion. But as a player, you could look through only one window of the mansion at a time (much like a member of the *Tamara* audience, who could observe what was happening in only one room at a time). To successfully play the game, you had to select a sequence of windows to peer through that would give you sufficient clues to solve the mystery.

In feature films, writers and directors have also experimented with breaking new ground in terms of narrative perspective. One notable example is the Japanese film *Rashomon,* made in 1950 by the renowned director-screenwriter Akira Kurosawa. *Rashomon* is the story of a woman's rape and a man's murder, but what made the film so striking was not its core story but Kurosawa's use of multiple points of view. The story is told in flashback by four different characters, each of whom was a witness to the crimes, but each giving a different version of what really happened. In the end, we are not told which is the "correct" version; we are left to puzzle out which person's perspective is the most plausible.

The director Robert Altman often uses a form of multiple pathways in his films, particularly in works like *Nashville* and *Gosford Park.* These movies have an almost dizzying abundance of characters and storylines. A viewer watching

them has the impression of multiple events occurring simultaneously, and sometimes wishes for the freedom offered by interactive media to jump from one storyline to another.

CONCLUSION

Extremely old forms of social interaction—religious rituals and games—were the precursors of modern interactive entertainment. Despite the obvious differences between the activities that have come down to us from ancient times and today's digital experiences, they help define some of the critical components required to create satisfying interactivity.

Namely, they are participatory; something important is at stake; rules and a structure guide our path through the interactivity; and the experience involves overcoming obstacles and achieving a goal of some sort. Furthermore, the act of participating in an interactive experience arouses some sort of feeling within us. It either involves us emotionally (as in religious rituals) or is enjoyable as a form of play (as in games).

The experiments in narrative that were first tried in novels, theatre, and film have also helped point the way to creators of interactive media, particularly in new techniques of storytelling. These older works introduced the concept of hyperlinking; of unpredictability; of multiple pathways and multiple events occurring simultaneously within a fictional world; and of new ways to peer into the lives and perspectives of characters. Other narrative works have pioneered the breaking of the fourth wall that divides fiction from reality.

IDEA-GENERATING EXERCISES

1. What traditional ritual have you participated in, or are aware of, that reminds you in some way of an interactive narrative? What is it about this ritual that you think is like a computerized interactive experience?
2. What game or sport have you played that you think could be adapted to a work of interactive entertainment? What would remain the same, what would have to be changed, and in what way?
3. What work of traditional storytelling (a novel, a play, a movie, or even a comic book) have you read or seen that contains a narrative technique that could be applied to a work of digital entertainment? What is this technique, and how could it be used?
4. Describe some ways that hypertext could be used to deepen the characterization of a fictional character.
5. Can you think of any work of traditional entertainment (poem, short story, novel, play, movie, TV show, etc.) that breaks the "fourth wall"? Describe how the fourth wall is broken in this work. Could the fourth wall be broken in a similar way in an interactive work? Why or why not?

Backwater to Mainstream: The Growth of Digital Entertainment

How did an organization with as serious a mission as the United States Department of Defense inadvertently contribute to the birth of interactive entertainment?

What were the original objectives of developing computer technology and the Internet, and in what way did they radically diverge from the goals originally set for them?

Who was a more likely candidate to invent the first computer game, a physicist working with an oscilloscope or a teenage kid fooling around on a PC?

What was it like working in the early days of interactive media, before anyone had established how interactivity and content could be combined?

What effect, if any, is the rising popularity of interactive media having on traditional forms of entertainment like movies and TV?

A RECENT BEGINNING

Without the computer, interactive digital entertainment could not exist. We would not have video games, or Massively Multiplayer Online Games (MMOGs), or interactive TV—not to mention still more recent developments like wireless entertainment and sophisticated forms of immersive environments. Even the oldest forms of computerized interactive entertainment, like video games, are quite recent innovations, especially when compared to traditional entertainment media, like the theatre, movies, or even television.

It is important to keep in mind that interactive entertainment has had an extremely short period of time to develop, and that the first years of any new medium are apt to be a rocky time, marked by much trial and error. The initial experiments in a new field don't always succeed, and significant achievements are sometimes ignored or even ridiculed when first introduced. Moreover, initial successes often create false expectations, especially when overly hyped by the press, and sometimes lead to a frenzy of excitement—a modern-day version of gold rush fever. Often the initial enthusiasm is followed by disenchantment and setbacks, as in the Dot Com boom and bust of the late 1990s and early twenty-first century.

While today's children have never known a world without computers, the same is not true for middle-aged adults. Individuals who were born before the mid-1950s grew up, went to college, and got their first jobs before computers ever became widely available. As for today's senior citizens, a great number of them have never even used a computer and frankly aren't eager to try. Almost certainly, though, they have taken advantage of computerized technology embedded in familiar devices, from microwaves to ATM machines to home security systems.

Surrounded as we now are by computers and computerized technology, it can be difficult to realize how quickly all of this has proliferated. Not only have the numbers of computers increased, but so have the power and usefulness of these ubiquitous devices, while at the same time their size and price have diminished. Throughout this technological revolution, innovative individuals have taken hold of these new tools and used them to create brand-new forms of entertainment.

A BRIEF HISTORY OF THE COMPUTER

While computers are newcomers to our world, only having been introduced in the middle of the twentieth century, the conceptual roots of computer technology date back to antiquity. Historians of information technology often point to the use of the abacus, the world's oldest calculating tool, as being the computer's original starting place. Various forms of the abacus were used by the Chinese, the Babylonians, and the Egyptians, perhaps as long ago as 3000 B.C. At first just a crude way of making arithmetic notations with stones and lines drawn in the sand, the abacus evolved into a portable device made of beads and wire. (See Figure 2.1.) It was the first instrument in human history to be employed for mathematical computations.

It would be centuries before substantial advances were made along the road to the invention of the computer. In 1642, Blaise Pascal built a numerical calculating machine in Paris to help his tax-collector father do his job more efficiently, but

7 2 3 0 1 8 9
NUMBER REPRESENTED

Figure 2.1 The abacus was humankind's first computing device.

the machine was never put into widespread use. Almost two centuries later, in 1833, Charles Babbage, a British professor of mathematics, came up with the idea for a device he called the Analytic Engine. Envisioned as a general-purpose computer, it was to be fed by punched cards and operated by a steam engine. Sadly, his visionary device was never completed.

Many decades later, however, in 1890, another punch-card machine was successfully built and put into operation. The inventors were Herman Hollerith and James Powers, and they designed an automatic computing machine for the United States Census Bureau. Hollerith formed a business called the Tabulating Machine Company to utilize their punch-card technology. After merging with several other companies, the company was reborn in 1924 as IBM.

Punch-card machines were the computing workhorses of the business and scientific world for half a century. The outbreak of World War II, however, hastened the development of the modern computer. Because of the war, machines were urgently needed to do complex calculations, and to perform them swiftly. The first of the new wave of computing machines to be completed was the Colossus computer, built by Alan M. Turing of Great Britain in 1943. The machine made an important contribution to the war effort by decoding Nazi messages and is considered by a number of historians to be the world's first all electronic computer. The majority of historians, however, believe the trophy should be awarded to the ENIAC (Electronic Numeric Integrator and Computer), which was completed in 1946 at the University of Pennsylvania. The ENIAC could perform calculations about 1000 times faster than the previous generation of computers. It could do 360 multiplications per second and 5,000 additions.

Despite the ENIAC's great speed, however, it did have some drawbacks. It was a cumbersome and bulky machine, weighing thirty tons, taking up 1,800 square feet

Figure 2.2 The ENIAC, completed in 1946, is regarded as the world's first high-speed electronic computer, but was a hulking piece of equipment by today's standards. Photograph courtesy of IBM Corporate Archives.

of floor space and drawing upon 18,000 vacuum tubs to operate. (See Figure 2.2.) Furthermore, though efficient at performing the tasks it had been designed to do, it was a laborious process to reprogram the ENIAC to do other tasks.

Limitations aside, and despite the earlier construction of the Colossus, the ENIAC is now generally regarded as the world's first high-speed electronic digital computer. The fiftieth anniversary of its completion, in 1996, was widely celebrated throughout the technology field as being the birthday of the computer, and the ENIAC's debut in 1946 was hailed as the birth of the Information Age.

During the three decades following the building of the ENIAC, computer technology progressed in a series of steps, resulting in computers that were smaller and faster, had more memory, and were capable of performing more functions. Concepts such as computer-controlled robots and Artificial Intelligence (AI) were also being articulated and refined. In 1950, for example, Alan Turing, the designer of the Colossus, devised what is still considered the gold standard test of AI. In what is now known as the "Turing Test," both a human and a computer are asked a series of questions. If the computer's answers cannot be distinguished from the human's, the computer is regarded as having AI.

By the 1970s, computer technology developed to the point where the essential elements could be shrunk down in size to a tiny microchip, meaning that a great number of devices could be computer enhanced. And as computer hardware became smaller and less expensive, personal computers (PCs) became widely available to the general public, offered by such companies as Radio Shack and Apple Computer in the 1970s, and by IBM in 1981. The use of computers accelerated rapidly through the '70s and '80s. In 1978, one-half million computers were in operation in the United States. Just two years later, the number had already doubled.

In 1982, *Time* magazine named the computer "Man of the Year." The accompanying cover story on the computer, written by Otto Friedrich, explained why *Time* chose a machine for the "Man of the Year" honor instead of a human. Says Friedrich: "There are some occasions... when the most significant force in a year's news is not a single individual but a process, and a widespread recognition

by a whole society that this process is changing the course of all other processes." Though the *Time* article makes for quaint reading today, filled as it is with glowing predictions about how computer technology will change life as we know it, its essential point has proven to be true. The computer has indeed had an enormous impact on almost every aspect of contemporary life, including entertainment.

In just one year following the *Time* article, ten million computers were in use in the United States. Computer use was also growing rapidly across the globe, with one hundred million computers in operation worldwide by 1989. It wasn't long before computer technology permeated everything from children's toys to supermarket scanners to household telephones.

THE BIRTH OF THE INTERNET

Without the invention of the computer, and the subsequent evolution of computer technology, digital entertainment could not exist. But one other technological milestone has also played an extremely important role in the development of digital entertainment: the birth of the Internet.

The basic concept that underlies the Internet—that of connecting computers together to allow them to send information back and forth even though geographically distant from one another—was first sketched out by researchers in the 1960s. This was the time of the Cold War, and such a system, it was believed, would help facilitate the work of military personnel and scientists working on defense projects at widely scattered institutions. The idea took concrete shape in 1969 when the United States Department of Defense commissioned and launched the Advanced Research Project Association Net, generally known as ARPANET.

At the time of its launch, ARPANET connected supercomputers at four American universities: the University of California at Los Angeles; Stanford Research Institute; the University of California at Santa Barbara; and the University of Utah. During the next two years, the system expanded to include 23 universities and research institutions. In 1973, it jumped the Atlantic and went international by bringing into its network the Royal Radar Establishment in Norway and University College in London.

Although ARPANET was designed to transmit scientific and military data, researchers and students with access to the network quickly discovered something else they could do with it—send electronic mail, or email, back and forth to each other. This novel form of electronic communication, so speedy and effortless, grew quickly in popularity.

Within a decade of its launch, ARPANET users found still another activity they could perform with the system: play interactive games. The year 1978 marked an important moment in the history of digital entertainment, for that was when the world's first MUD was created. MUD stands for Multi-User Dungeon (or Multi-User Domain or Multi-User Dimension). The MUD, and its close cousin, the MOO (MUD, Object Oriented), are text-based adventure games in which multiple players assume fictional personas, explore fantasy environments, and interact with each other. Aside from being text based, they are much like today's MMOGs.

The first MUD (and *MUD* was indeed its name) was a team effort of Richard Bartle and Roy Trubshaw, both students at the University of Essex in Great Britain. The goal of the game was to get enough points to reach the rank of Wizard, or

Witch—to "make wiz"—though certainly some of the pleasure of playing was to explore a rich fantasy environment (all constructed with words) and to interact with other players. Trubshaw and Bartle's creation proved to be enormously popular, and served as the granddaddy of a great many role-playing fantasy games that were to follow, particularly online games known as Massively Multiplayer Online Role-Playing Games, or MMORPGs. (For more on MMOGs and MMORPGs, see Chapter 12.) In 1990, Richard Bartle recalled the early history of their MUD and the enormous enthusiasm with which it was received, jotting down his memories in a posting on the website message board of Lulea University of Technology in Sweden. He described how word about the game soon spread outside of the University of Essex campus and how students from other universities were so eager to join in that their numbers threatened to overwhelm the campus computer system. Bartle says that despite this, the University of Essex graciously agreed to permit outsiders to play, though only from 2 A.M. to 6 A.M. on weekdays. But even at these very uninviting early morning hours, Bartle recalled, the game was always full to capacity. Ultimately, the MUD was licensed to CompuServe under the name *British Legends*.

Meanwhile, a critically important development was occurring with ARPANET. The system was beginning its evolution into what would become the Internet, a vast network of computer networks spanning the globe. In 1982, Vint Cerf and Bob Kahn came out with a new protocol called TCP/IP, or Transmission Control Protocol/Internet Protocol. A protocol is a format for transmitting data between two devices, and the protocol that Cerf and Kahn created became the common language that would be used by computers on the Internet. Without such a protocol, the Internet could not have grown into the immense mass-communication system it has become.

As much as any other development, the creation of TCP/IP can be regarded as the birth of the Internet. In 1990, ARPANET was decommissioned by the Department of Defense, leaving the Internet in its place. And by now, the word "cyberspace" was frequently being sprinkled into sophisticated conversations. The word, used to refer to the nonphysical world created by computer communications, was first coined in 1984 by William Gibson in his sci-fi novel, *Neuromancer*. The rapid acceptance of the word "cyberspace" into popular vocabulary was just one indication of how thoroughly electronic communications had managed to permeate everyday life.

THE WORLD WIDE WEB

Just one year after ARPANET was decommissioned, the World Wide Web was born, created by Englishman Tim Berners-Lee. Berners-Lee was working at an institution called CERN, a physics lab in Geneva, Switzerland. Because of his position there, he was aware of how difficult it was for researchers at various organizations to send information back and forth over the Internet. The programming languages they used were often incompatible and the data had to be converted in order to be readable. He recognized the need for a simple and universal way of disseminating information over the Internet, and in his efforts to design such a system, he developed the critical ingredients of the Web, including URLs, HTML, and HTTP.

Just two years after the release of the Berners-Lee design for the World Wide Web, another event occurred that contributed to the rapid acceptance of the Internet

by the general population. Up until this time, it was difficult for those who were not computer specialists to use the Internet, because in order to navigate a Web page, you needed to employ a complicated set of keyboard instructions. Furthermore, Web pages had a drab, unattractive appearance. To address this problem, Marc Andreesen and fellow students at the University of Illinois came up with something called Mosaic, a graphical browser that facilitated a far more attractive and user-friendly approach to the Web. Not only did Mosaic permit content to be displayed in a livelier way, but its navigation system of icons and buttons was simple to use. It had the advantage of being visually familiar to people who worked on Mac and Windows systems, the majority of computer users.

Soon after the introduction of Mosaic in 1994, another graphical browser was released. Called Netscape, it built upon the concepts initiated by Mosaic. The introduction of these two browsers brought about a surge in Web traffic.

WEB ENTERTAINMENT

With so many people now online, it was only a matter of time before some of them began to perceive the Web as a potential medium for entertainment. The mid and late 1990s saw the introduction of a number of new kinds of Web entertainment programming. One of the first popular hits was a Web soap opera called *The Spot*. Coming online in 1995, *The Spot* was an interactive account of the romantic and professional adventures of a group of young people sharing a beach house in California. The late 1990s saw the debut of two enormously popular MMOGs, *Ultima Online* in 1997 and *EverQuest* in 1999. Websites like Icebox featured offbeat animation, while several other sites, most prominently IFILM and AtomFilms, specialized in short films, both live action and animation. (For more on Web-based entertainment projects, please see Chapter 13.)

The Internet's popularity continued to zoom upward, climbing to over 500 million users worldwide by 2003, according to Jupiter Media Research. Meanwhile, another development was going on behind the scenes—the creation and development of Internet2, which was begun in 1996. Designed to be an advanced, high performance, super-fast system, computer scientists anticipated that Internet2 would be able to carry out functions not possible on the "old" Internet. Like ARPANET before it, Internet2 is a partnership of academic, industrial, and government institutions, and, like ARPANET, it is a nonprofit entity. The technologies and capabilities that this new system develops will be deployed back to the Internet; it is not intended that Internet2 will ever replace the first Internet. But just as no one could have foreseen how the old ARPANET would catch fire and develop as it did, no one at this point can predict what the future will hold for Internet2. (For more on the Internet, please see Chapter 13.)

THE FIRST VIDEO GAMES

Just as online games first came into being long before the Internet was an established medium, the first computer games were created years before personal computers became commonplace. They emerged during the era when computer technology was still very much the domain of research scientists, professors, and a handful of graduate students.

Credit for devising the first video game goes to a physicist named Willy Higenbothem, who created his game in 1958 while working at the Brookhaven National Laboratory in Upton, New York. His creation, *Tennis for Two*, was, as its name suggests, an interactive ball game, and two opponents would square off to play it. In an account written over twenty years later and posted on a Department of Energy website (*www.osti.gov*), Higenbothem modestly explained he had invented the game to have something to put on display for his lab's annual visitor's day event. From prior experience, he knew static exhibits bored people, so he decided to come up with something more lively and hands-on than usual, and the world's first video game was born. Higenbothem recalled that *Tennis for Two* was "simple" to design and took only three weeks to build.

The game was controlled by knobs and buttons and ran on an analog computer. The graphics were displayed on a primitive looking oscilloscope, a device normally used for producing visual displays of electrical signals and hardly the sort of machine one would associate with computer games. Nonetheless, the game worked well. Higenbothem's achievement is a vivid illustration of human ingenuity when it comes to using the tools at hand. After a stint at a second visitor's day exhibit, the setup that operated *Tennis for Two* was dismantled and pressed into service for other tasks.

A very different kind of computerized interactive experience was devised in the mid 1960s at MIT by Joseph Weizenbaum, a professor of computer science. He created a "virtual psychiatrist" named *ELIZA*, basing his concept on the ideas of artificial intelligence developed by Alan Turing. *ELIZA* would ask the user probing questions much like a real psychiatrist, and she would comment on the user's responses in a surprisingly thoughtful and life-like way, often with questions of her own.

The program Weizenbaum developed was evidently so convincing that the people who used it were convinced that *ELIZA* truly understood them. They became quite attached to her and dependent on their sessions together, which greatly disturbed *ELIZA*'s creator, Prof. Weizenbaum. Considering how "real" *ELIZA* seemed to be, she certainly deserves to take a bow as being the first virtual character of the Information Age. Furthermore, she gave birth to an entire genre of electronic characters, called "chatterbots." A chatterbot is a bot (artificial character, short for robot) with whom you can chat.

The most direct antecedent of commercial video games, however, was a game called *Spacebar*, another project produced at MIT. The creator was a student named Steve Russell, and he and a team of fellow students designed the game in the early 1960s on a mainframe computer. *Spacebar* soon caught the attention of students at other universities, and was destined to be the inspiration of the world's first arcade game, though that was still some ten years off.

Before the arcade games would ever see the light of day, however, the first home console games hit the market. The idea for making a home console game belongs to Ralph Baer, who came up with the revolutionary idea of playing interactive games on a TV screen way back in 1951. At the time, he was employed by a television company called Loral, and nobody would take his idea seriously.

Undaunted, Baer continued to promote his idea. By 1966, he was working for Sanders Associates, an electronics firm doing subcontracting work for the United States Department of Defense. At this point, his timing was better. The military, recognizing the potential for turning his concept into a vehicle for war strategy games, was willing to support his endeavor. Baer came up with two

games for his console project—a ball and paddle game and a hockey game—and was eager to explore the console's commercial potential. But the Department of Defense, leery about revealing top secret classified information, was reluctant to allow him to try to market it, even though his work contained no military content whatsoever. Finally, however, Baer received permission to go forward, and in 1970 Magnavox agreed to license his games and the console he had developed. Called the Magnavox Odyssey, the console was programmed with a dozen games and released in 1972. It demonstrated the feasibility of home video games, and paved the way for further developments.

Meanwhile, Nolan Bushnell and Ted Dabney, the future founders of Atari, were working on an arcade version of *Spacebar*, the game that had been made at MIT. Bushnell had become aware of the game while an engineering student at Stanford University. Bushnell and Dabney called their arcade version *Computer Space* and introduced it to the public in 1971. But the game—the first arcade game ever—was a dud. Players found it way too hard to play.

Bushnell and Dabney were convinced they were on to a good thing and refused to be discouraged. In 1972, they founded an arcade game company called Atari. The first game to be produced under its banner was *Pong*, an interactive version of Ping-Pong, complete with a ponging sound when the ball hit the paddle. This game was a huge success. In 1975, the company released a home console version of the game, and it too was a hit.

Pong helped generate an enormous wave of excitement about video games. A flurry of arcade games followed on its heels, and video arcade parlors seemed to spring up on every corner. By 1981, less than ten years after *Pong* was released, over one and a half million coin-operated arcade games were in operation in the United States, generating millions of dollars.

During the 1980s and 1990s, home console games similarly took off. Competing brands of consoles, with ever more advanced features, waged war on each other. Games designed to take advantage of the new features came on the market in steady numbers. Of course, console games and arcade games were not the only form of interactive gaming in town. Video games for desktop computers, both for the PC and Mac, were also being produced. These games were snapped up by gamers eager for exciting new products. (For more on games, please see Chapter 11 for video games and Chapter 12 for MMOGs.)

INTERACTIVE TELEVISION

Interactive television (iTV) has had a far rockier road to consumer acceptance than either the computer or the Internet, and is still struggling toward the goal of widespread implementation. Yet, surprisingly enough, the first trials of iTV date way back to the time when personal computers were first being introduced and the Internet hadn't even been born, the 1970s. Unlike PCs, which took off in a massive way, as did the Internet, the progress of iTV has been unsteady and at times it has threatened to disappear from sight altogether.

The world's first public trial of iTV was initiated in 1977 in Columbus, Ohio. Called *Qube*, it was a joint project of Warner Communications and American Express. *Qube* was a multichannel cable television system, and ten of its thirty channels were dedicated to interactive programming. Viewers controlled the programming via a push button cable box. An extremely ambitious undertaking,

Qube's interactive offerings included quiz shows, home shopping, polling, music videos, and children's programming. Viewers watching talent shows could even boot their least-favorite contestants off the stage.

After the system's introduction in Columbus, *Qube* was brought to several other cities, and viewers in some of these locations were offered up to sixty channels. *Qube* was relatively popular with adult subscribers (reports differ as to how many actually took advantage of its interactive capabilities); but by all accounts, the children of Columbus took it up with great enthusiasm. In any case, the *Qube* system was enormously expensive to build and maintain. After some years of operation, American Express withdrew its financial support, and Warner Communications could not afford to keep it going on its own. *Qube* shut down in 1984.

After *Qube's* demise, ten years would pass before any fresh attempts were made to try out iTV in the United States. A new venture called the *Full Service Network* was introduced in 1994 in Orlando, Florida, by Time Warner. Limited to about 4,000 homes, the *Full Service Network* offered video on demand, games, shopping, and an electronic program guide. Though praised for its performance and excellent service, it was also criticized for offering programming that predated the desires of the audience. In other words, Time Warner did not establish what viewers wanted in terms of interactive programming before going ahead and producing content for its service. As in the *Qube* trial, the *Full Service Network* proved to be exceedingly costly, and it was discontinued in 1997.

Microsoft also ventured briefly into the iTV waters in the early 1990s with a system called *Cablesoft*. But the corporation backed away when the Internet unexpectedly boomed. It seemed as if Internet broadband services would soon be able to fulfill many of the functions that would have been the province of iTV, making the idea of investing in iTV less than appealing.

In the intervening years, iTV service has been periodically rolled out in selected regions of the United States. However, as a whole, iTV has slipped beneath the radar of most Americans. The lack of uniform technology for receiving iTV into viewers' homes has hampered development, and recent ventures in this arena have been offered on a relatively limited scale. That is not to say, however, that some interesting iTV projects have not been developed, or that enthusiasm for iTV has evaporated among the professionals in the field.

Even though iTV has been slow to progress in the United States, the same is not true internationally. For example, France began to offer iTV programming in 1997, the first country in Europe to do so. In Great Britain, the BBC currently produces a rich slate of interactive programs, and iTV services are available to approximately 50% of the homes there. Other European countries with a significant iTV presence include Denmark, Sweden, and Germany. Among Asian countries, Japan has the highest rate of household penetration and is expected to soon match the leading European countries. In other Asian countries, iTV systems were up and running in Hong Kong and Singapore by the late 1990s. And in South Africa, the satellite-TV producer MultiChoice Africa has begun to offer iTV service to most of its subscribers. (For more on iTV, please see Chapter 14.)

INTERACTIVE CINEMA

If anything, interactive cinema has had an even more difficult time achieving popular success than iTV. The interactive cinema developed thus far has

taken two quite different paths. One type, designed as a group experience, is projected on a large screen, much like a typical noninteractive movie. The other type is designed to be a more intimate experience, somewhat like television. The movie is usually viewed in one's home and played on a small screen—via a computer, a DVD player, or some other device with a screen and a control apparatus.

The first theatrical interactive movies were produced between 1992 and 1995. They were made by a company called Interfilm, and the four-picture undertaking was backed by Sony. But making the movies was only part of the challenge. Before they could be shown to the public, movie theatres had to be fitted out with special equipment. This included installing a three-button control system in armrests of the seats, and a special projection system consisting of four laser disc players, a digital video switcher, a computer to control the interactivity, and a CD-ROM with the installation program.

The Interfilm movies followed a set format. Each lasted twenty minutes and at various junctures in the story, the audience would have a chance to select which of three possible events would take place next in the narrative. In this way, the format was much like the old *Choose Your Own Adventure* books first printed in the late '70s. Majority vote determined the winning scene at each juncture point in the movie.

The first Interfilm project to be released was *I'm Your Man*. It offered only one decision point every 60 seconds—very limited interactivity for anyone accustomed to the speed of video games. Later Interfilm offerings built in more interactive opportunities, providing a decision point every 15 seconds. For the price of a ticket, audience members were entitled to watch each film twice, being assured that no two viewings would ever be exactly the same.

Nonetheless, the Interfilm movies failed to catch on. Though the hardware worked well, with the laser disc players smoothly handling the switches between scenes, the audiences found the experience unsatisfying, and more of a gimmick than an immersive entertainment. Most felt the storylines were weak and the production values inferior to the Hollywood movies they were used to seeing. Nor did these films provide the fast-paced excitement or rich interactivity of a video game. Though Interfilm made a sincere effort to create a new form of entertainment, it failed to come up with a compelling way to blend the passive experience of movie going with the active experience of a video game. One reviewer, James Bererdinth, writing for an online movie review site, quipped: " ...it's my opinion that interactive movies should die a quick death, going the way of 'smell-o-vision.'"

I managed to catch one of the Interfilm productions myself, and I have to say that I find it hard to be any more enthusiastic than Bererdinth. The storyline was so thin that most twelve year olds would have been impatient with it, the humor was even less sophisticated, and the interactive opportunities artificial and uninvolving. In short, nothing about it would make me want to repeat the experience. Looking back now, it is difficult to say whether using the same system of interactivity, but with more compelling story material and better design, could have made a difference.

The failure of the Interfilm projects left a dark mark on large screen interactive movies and discouraged forward progress in this area. No other attempts were made to produce large-screen interactive movies until the early twenty-first century. But more recent projects in this area, undertaken by Immersion Studios, have been far more promising. The company has devised a more engaging type of interactivity

for audience members and has come up with more compelling storylines than Interfilm was able to do. Their pictures combine entertainment with science education and are typically screened in natural history and science museums.

Meanwhile, innovative developers have continued to plow ahead in the arena of small-screen interactive movies, producing projects that are driven more by story considerations than by gaming models. (For more on interactive cinema, please see Chapter 18.)

LASER DISCS, CD-ROMs, CD-i's, AND DVDs

Not counting the great variety of video game consoles, four other significant technologies were introduced during the twenty years between the late 1970s and the late 1990s. All of these technologies—laser discs, CD-ROMs, CD-i's, and DVDs—were used as vehicles for interactive entertainment.

LASER DISCS

Laser discs, also called video discs, were invented by Philips Electronics and made available to the public in the late 1970s. The format offered outstandingly clear audio and video and was easy to use, but it had a couple of disadvantages as well. For one thing, each side of the disc could hold only one hour of content; for another, it was a playback-only system, so it was not possible to record new content on the disc.

In private homes, laser discs were primarily used for watching movies. The format's interactive capabilities were more thoroughly utilized in educational and professional settings. But its potential as a vehicle for pure interactive fun came into full bloom in the arcade game *Dragon's Lair*, which fully exploited the capabilities of laser disc technology. Released in 1983, the game was an entertainment phenomenon unlike anything seen to date. It contained 22 minutes of vivid animation and reputedly took six years to make. Lines of teenagers eager to try out *Dragon's Lair* spilled out to the sidewalks of video game parlors everywhere. When their turn finally came, they inserted their coins and "became" the hero, Dirk the Daring, whose mission it was to rescue Princess Daphne from a castle full of monsters.

With a far more developed storyline than the typical "point and shoot" arcade offerings, players debated whether it was a game, a movie, or both. But even when they disagreed on what to call it, they were virtually unanimous in finding *Dragon's Lair* an absorbing and exciting experience. The game pulled in $30 million in sales in the first forty days and was ultimately ported over to a number of other platforms. Updated versions of the game can still be played today on DVD and on the Xbox. It even became a television series on ABC.

CD-ROMs

CD-ROMs (for Compact Disc-Read Only Memory) were introduced to the public in 1985, a joint effort of Philips and Sony, with prototypes dating back to 1983.

These little discs could store a massive amount of digital data—text, audio, video, and animation—which could then be read by a personal computer. Prior to this, storage media for computer games—floppy discs and hard discs—were far more restrictive in terms of capacity and allowed for extremely limited use of moving graphics and audio.

It was not until the early 1990s, however, that the software industry began to perceive the value of the CD-ROM format for games and "edutainment" (a blend of education and entertainment). Suddenly, these discs became the hot platform of the day, a boom period that lasted about five years.

Myst and *The Seventh Guest* were two extremely popular games that were introduced on CD-ROMs, both debuting in the early '90s. It also proved to be an enormously successful format for children's educational games, including hits like the *Carmen Sandiego* and *PutPut* series, *Freddie Fish*, *MathBlaster*, *The Oregon Trail*, and the *JumpStart* line.

The success of CD-ROM games, and particularly the ability of this platform to combine story elements with audio and moving visuals (video and animation), attracted the attention of Hollywood professionals. By this time, a few people with television or film backgrounds were already working in interactive media, myself included. But suddenly countless other writers, directors, actors, and producers became aware of this new type of entertainment. Intrigued with its possibilities, they crowded into seminars and workshops on multimedia or new media—the two terms most often used at the time to describe interactive projects. And many pros from traditional entertainment began to attend events like the Game Developers Conference and E3 (Electronic Entertainment Expo), seeking knowledge and new contacts who could provide a way in.

Hollywood was waking up to the fact that many of the creative skills employed to make movies and TV shows might also be of value in interactive media... though people also sensed that unfamiliar skills would be required as well, a scary prospect. The sudden boom in interactive media, particularly CD-ROMs, promised to offer fresh professional and creative opportunities at a time when jobs in TV and motion pictures were at a premium, and competition for them was fierce.

Although no one was keeping score, it is certainly true that hundreds of writers alone did get writing assignments in this new field, as evidenced by Writers Guild members listed in the Guild's new directory of interactive writers. And numerous members of SAG (the Screen Actor's Guild) found jobs doing voice-over work for animated games and took parts in live-action video games. Similarly, producers and directors found assignments in interactive projects that utilized their skills. As another sign of Hollywood's interest, many of the movie studios opened interactive divisions.

Unfortunately, the CD-ROM field went through a bleak downturn in the second half of the 1990s, caused in part by the newest competitor on the block, the Internet. Financial shakeups, mergers, and downsizing within the software industry put the squeeze on the production of new titles. For many in Hollywood, the bloom was now off the rose. Disenchanted with new media, they tried to make their way back into the linear word of motion pictures and TV. Others, however, stuck it out and looked for a way to parlay their newly acquired expertise into other kinds of interactive media, particularly the Internet. And despite the shake-up, CD-ROMs have remained a viable format for games, education, and even corporate training.

CD-i's

The CD-i (Compact Disc-interactive) system was developed jointly by Philips and Sony and introduced by Philips in 1991. Termed a "multimedia" system, it was intended to handle all types of interactive genres, and was the first interactive technology geared for a mass audience. The CD-i discs were played on special units designed for the purpose, and connected to a TV set or color monitor. The system offered high quality audio and video and was extremely easy to use.

Although CD-ROMs were already out on the market at the time CD-i's came along, the new platform helped spur significant creative advances in interactive entertainment, in part because Philips was committed to developing attractive titles to play on its new system. Philips' POV Entertainment Group produced *Voyeur*, a widely heralded interactive movie-game hybrid, and its Sidewalk Studio software production group made many innovative titles for children. (For more on the work done by Sidewalk Studio, and the early days of working in interactive media, please see the section of this chapter titled "Pioneering Interactive Titles" which follows shortly.)

DVDs

DVD technology was introduced to the public in 1997, initially developed by a consortium of ten corporations and now overseen by an umbrella organization called the DVD Forum. The technology was the successful result of a cooperative effort of major electronics firms, computer companies, and entertainment studios. The group opted to pool their resources and work collaboratively, rather than to come out with competing products, a practice that had led to the demise of prior consumer electronics products. In the few short years of its existence, the DVD has become the most swiftly adopted consumer electronics platform of all time.

The initials DVD once stood for "Digital Video Disc," but because the format could do so much more than store video, the name was changed to Digital Versatile Disc. The second name never caught on, however. Now the initials don't stand for any particular words; the initials themselves are the name of the technology.

DVD technology is so robust and versatile that it is on the way to becoming the single most important workhorse of the digital world. The quality of the audio and video is excellent, and the format combines the assets of laser discs and CD-ROMs, but with a far greater storage capacity than either. For instance, at the time of its introduction, a DVD disc could comfortably hold a two-hour feature-length film, opposed to only sixty minutes on a laser disc, and a dual-layer, double-sided disc can hold up to eight hours of high-quality video or thirty hours of VHS-quality video. It could also contain eight separate audio tracks, offering a variety of narrations, music, or languages, each with an independent audio stream. The technology also offered easy navigation via a menu system, and allowed for other kinds of interactivity as well. Although consumers are most familiar with DVD-Video (usually just called DVD), several other DVD disc formats exist as well. They include DVD-ROM (for multimedia purposes or data storage; these are used on a computer); DVD-R (a record-once format used to develop DVD-ROMs and DVD-Video); DVD-RAM (a recordable format for storing data); and DVD-Audio (an audio-only format).

In the first years after its introduction, the public primarily used DVDs to play movies or compilations of television shows. Most of the films and TV shows ported over to DVD conveniently broke the material into chapters and offered various add-ons, like a narration track of the director's comments, a "making of" documentary, and background information on various aspects of the project. But as the creative community began to realize the interactive entertainment potential of DVDs, they started to develop original material for this new platform. (For more on DVDs, please see Chapter 20.)

OTHER FORMS OF INTERACTIVE ENTERTAINMENT

In some cases, developers have quickly discovered a technology's potential for entertainment purposes and consumers have swiftly taken to the new medium. Into this "rapid acceptance" category we can put the Internet, DVD players, and game consoles. Sometimes, however, it has taken much longer to figure out how a certain technology or type of product could be harnessed to provide an entertainment experience. Sometimes progress has been slowed by technical hurdles or by tough creative challenges, and sometimes because the technology's potential for entertainment was not recognized. Among these "late bloomers" are electronic kiosks, smart toys, wireless devices, and immersive environments, including virtual reality. Other methods of creating entertaining experiences with digital technologies, such as cross-media productions, are still in their formative years.

For more on the development and recent work in each of these arenas, please see the chapters devoted specifically to them: Chapter 15 for Cross-Media Productions; Chapter 16 for smart toys; Chapter 17 for wireless devices; Chapter 19 for virtual reality and immersive environments; and Chapter 21 for kiosks.

PIONEERING INTERACTIVE TITLES

What if you had to create a new type of interactive project from scratch, one that was entertaining but also offered educational or informational material—in other words, something other than a video game? And you had to do this without having any models to draw from, and with technology that had never been used for this purpose before? Such was the daunting task faced by the teams of individuals who tackled the first non-video game interactive titles.

For each new project, an intimidating array of head-banging questions had to be answered, such as:

- How would you make best use of the platform's technology?
- What type of content would be best suited to the technology?
- How would the content's presentation differ from a linear project?
- What types of interactivity would it offer?
- How would the user be made aware of the interactivity, and know how to use it?

A handful of companies served as trailblazers for these early forays into the world of interactivity. Among them were Voyager, Synapse Technologies, AND

Communications, and the various divisions of Philips Interactive Media, including Sidewalk Studio and its POV Entertainment Group. I worked as a freelancer at one of these companies, AND Communications, and had colleagues and friends who worked at all the others. Thus, I have a good sense of just how challenging these first projects were.

Voyager, founded in 1985 by Bob Stein, focused at first on taking a series of classic feature films and porting them over to laser disc. But within a few years, the company undertook a new type of project, an interactive CD-ROM called *Beethoven's Ninth Symphony*. This title is generally cited as the world's first consumer CD-ROM. It was a risky venture, because when the title was released, in 1988, CD-ROM drives were still quite uncommon. Although the first of its kind, *Beethoven's Ninth* made intelligent, if rudimentary, use of the medium's features. Described as an annotated companion to Beethoven's masterpiece, it included a sixty-eight-minute performance of the symphony with a running commentary of the work given by a professor of music, plus a biography of the composer and a glossary of musical terms. Music lovers, in particular, were impressed with the added dimension it gave to Beethoven's work, and people in the budding field of interactive media were excited by the possibilities this CD-ROM suggested.

Two years later, Synapse Technologies, headed by Bob Abel, embarked on an immense undertaking called *Columbus: Encounter, Discovery and Beyond*—usually referred to simply as the *Columbus* project. It was generously funded by IBM and was intended to serve as a showcase of what "multimedia" could do. Designed for school use, it was intended to be run on a specialized high-end IBM computer.

Bob Abel, who passed away in 2001, is often described as a legendary figure, a brilliant pioneer in a variety of media, and his willingness to break new ground was a useful asset for this enormous venture. The *Columbus* project was timed to coincide with the 500th anniversary of the explorer's journey to the New World. Not only would it cover the expedition, but it would also delve into all manner of topics related to it. The massive title consisted of both laser discs and CD-ROMs, and by utilizing its built-in interactive features and powerful search engine, users would be able to link apparently disparate pieces of information and cross-fertilize concepts. According to Jenny Cool, who worked on the project as a writer, editor, and producer, the completed title contained an astounding amount of content: 4400 scenes, five hours of video, and 900,000 links.

A high-visibility undertaking with an aura of glamour, the *Columbus* project drew to it a great number of talented professionals, many from the ranks of Hollywood, all eager to take part in something that promised to be so groundbreaking. I clearly remember the buzz about it. As with many others working in Hollywood at the time, the *Columbus* project helped spark my interest in becoming involved with interactive media.

However, according to various accounts given by people who worked on *Columbus*, the gargantuan nature of the project, plus the lack of a systemized approach to the preproduction and production processes, created major difficulties in terms of organization and production. Dale Herigstad was one of those who participated in the project and remembers what it was like. Herigstad, currently a partner and the creative director of Schematic LLC, an iTV design firm, served as the interface consultant on *Columbus*. "It was rather chaotic because of the size of the project," he recalled during a recent interview. "But Bob Abel was a visionary,

so sometimes his projects got out of control." Unfortunately, after all the work and money that was poured into *Columbus*, it was never released to the schools, and few people have ever had a chance to see it.

Nevertheless, Herigstad remains proud of what was accomplished and of his contribution to the pioneering venture, particularly of the way he helped "architect" it. His job called for figuring out an interface system to graphically connect multiple pieces of information. He describes his work as early meta tag development and the beginning of much work in hyperlinking that would follow (a meta tag is information used by search engines, and is important for constructing indexes). Copies of *Columbus* now reside in the Smithsonian Institution and in the Library of Congress, and many people who worked on the project, including Dale Herigstad, went on to do influential work in interactive media.

Another company in the forefront of creating high-quality nongaming interactive content was AND Communications. The letters in the company's name stood for the initials of the three founders—A for Bob Abel (who later left to form Synapse); N for Morgan Newman; and D for Allen Debevoise. One of its early projects was *Illuminated Books and Manuscripts,* a series of educational titles on works of literary and historic importance. Like the *Columbus* project, *Illuminated Books and Manuscripts* was funded by IBM and was also intended for classroom use. These titles, however, were actually released.

In 1991, the company began work on two new educational projects, *Amazonia* and *Virtual Biopark*, both offering sophisticated approaches to natural history. It was on *Virtual Biopark* that I first got my feet wet in interactive media. *Virtual Biopark* and its sister project, *Amazonia*, had a complicated, though distinguished, parentage. They were made in collaboration with the National Zoo in Washington, D.C., which is under the helm of the Smithsonian Institution. The software was developed by Computer Curriculum Corporation (CCC), a subsidiary of the Simon & Schuster division of Paramount Communications.

I was brought into *Virtual Biopark* as a freelance writer. The concept of the project was to take a close look at four quite different forms of wildlife, and to investigate how the four were connected to other living creatures, including human beings. We would probe their role in art, literature, fashion, science, ecology, and so on. As with a number of early interactive projects, the design was modeled on publishing, and each piece of text was referred to as an article.

The animal I drew was the cheetah (and I was enormously grateful I hadn't been stuck with the spider instead). My assignment was to write portions of the prototype and to do all the text and voice-over dialogue for the cheetah section, based on research that would be provided to me. I would also be responsible for suggesting all the links among the portions I wrote, as well as to other parts of the program. To this day, I can remember poring over the arcane books and scientific documents heaped on my dining room table, trying to trace a seemingly simple theme, and ending up in a maze that seemed to have no exit. One such path began, straightforwardly enough, with the physical appearance of the cheetah. This led to an article about the markings on the cheetah's coat, which in turn led to an article on camouflage (though not before first branching off to an article on the fluffy coat of the cheetah cub, which became part of a whole other path about cheetah cubs). Camouflage took me to military uniforms, to tents, to hunting gear...I feared the linking would continue on to infinity. I'm sure I compiled hundreds of files on the cheetah, and was grateful for the company's well-thought-out organizing system.

Submerged as I was in my soup-to-nuts work on the cheetah, it was not easy to grasp a vision of the project as a whole. Some holes in my understanding were filled in at the design meetings, held at irregular intervals, which would bring the entire team together. We'd crowd into the largest room at AND, many of us sitting on the floor. Here updates would be given by our producer, our programmer, our art director, and other key members of the group. The atmosphere was charged and exciting. We were inspired by the sense of doing innovative work, of being on the cutting edge of something entirely new.

DEVELOPING THE FIRST TITLES FOR CHILDREN

Meanwhile, as I was working on *Virtual Biopark*, some pioneering work was going on across town in the children's interactive entertainment area. Let's look at things from the perspective of two people who were in the thick of it, Gary Drucker and Rebecca Newman, and get their views of what it was like to create projects in those early days. Beginning in 1988, Drucker and Newman were in charge of Sidewalk Studio, a software production group operating under the banner of Philips Interactive Media. It was one the first companies to make special titles for children, and one of their projects, *Cartoon Jukebox*, is considered the world's first completed CD-i. (See Figure 2.3.)

Drucker served as VP and Creative Director and Newman as VP and General Manager, and under their direction, Sidewalk Studio, under its own brand name, produced fourteen children's titles, twelve of which were in the CD-i format and two CD-ROMs. Drucker and Newman shared a close collaborative working

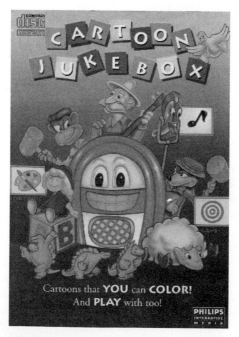

Figure 2.3 *Cartoon Jukebox*, developed by Sidewalk Studios, was the world's first completed CD-i and first children's title. Image courtesy of Atari Europe.

relationship, in part because they complemented each other's strengths, and in part because they were married. The challenges they faced in producing these first interactive titles were daunting. In a recent interview, they described what they had to deal with.

"Initially, we had to figure out what a title was, particularly given the limitations of CD-i," Gary recalled. "Specifically, we had giant pixels, slow disc speed, and a miniscule system memory." But Newman feels that CD-i also had its advantages, which she felt were too often disregarded but which they tried to utilize. "It was really the first interactive TV venture, and, as with TV, it had strong audiovisual capabilities," she said.

Sidewalk managed to make a series of successful titles at a time when other companies were not able to complete a single one. How was it able to accomplish this? For one thing, Drucker said, the Sidewalk team was able to figure out the CD-i technology to their advantage. He also believes his personal ability "to pursue doggedly how to create reliable production pathways" helped as we developed "the first low-res, relatively low cost, digital animation studio."

Furthermore, Drucker believes that the organizational strengths he and Newman brought to Sidewalk was a critical factor in its success. "I'm organized personally," he said, "and Rebecca's MBA is in information systems, so while titles that were begun before ours had trouble figuring out which file was which, we had developed a well-organized system to track our files. There were thousands of computer files in various states of completion, all labeled as to which were shots, games, sound effects, and so on."

Drucker feels that another important factor was his experience as a screenwriter, which helped him shape and clarify what each of their titles would be. "As a result of my screenwriting background, I had some sense of genre," he said, "even if some of the genres we were creating were 'interactive' and therefore new. Instead of our titles being vague, they were clearly crafted to be either this or that."

"*Cartoon Jukebox*," he explained, "was a collection of children's cartoons that one could color and, in some cases, play games with. A later title, *Surf City*, took an affectionate, *Grease*-like look at a beach town and the surf music that went with it. *The Berenstain Bears on Their Own* and *The Crayon Factory* each, though in different ways, annotated a story with games. *Sandy's Circus Adventure*, our second title, was a branching story. (See Figure 2.4.) In *Sandy*, the characters had to be consistent and clear. Perhaps people from a technology or documentary background didn't know what that meant in an entertainment, or edutainment, product."

But even after producing a number of titles, they remember each new project as being a significant challenge. "Designing a project was complex, each time out," Newman recalled. "There were so many pieces and aspects, much more than in a linear project, which has quite a few of its own. Therefore, there were many do-nots, often based on the limited CD-i technology. Some of these were production issues, software issues, organizational issues. But, in a way, few were creative issues. There is a certain freedom in doing something for the first, or near first, time. The anxiety of influence is less. Before some of our interactive titles, there were no interactive titles." And Drucker added another benefit of being one of the first in the field. "We existed in an era when financially successful edutainment was not identified," he said. "Therefore, we could—indeed, we had to—experiment."

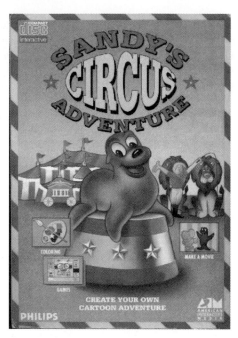

Figure 2.4 *Sandy's Circus Adventure* was one of the first interactive ventures to use a branching storyline. Image courtesy of Atari Europe.

THE RISING POPULARITY OF INTERACTIVE ENTERTAINMENT

From the debut of the world's first commercial video game, *Pong*, in the early 1970s, to the present day, the popularity of interactive entertainment has grown at a steady and impressive rate. It has increased both in terms of the numbers of people who are consumers of entertainment products and in terms of the revenues these products earn. We are now at the point where interactive entertainment has become a not-to-be-ignored rival of traditional entertainment.

This is especially true of video games, the most thoroughly established of all interactive media. According to figures released in 2002 by the Interactive Digital Software Association (IDSA), which conducts regular consumer surveys on gaming, about 145 million Americans—60% of the population aged six or older—play video games. And, since it is not possible for a full 60% of the entire population to be teenaged boys, it is obvious that a great many gamers defy the common stereotype of the people who play games. In fact, the survey found that the average age of gamers has risen to 28, and 43% of them are female. Nor is gaming just a passing fancy for these players. The majority of gamers have been playing for at least six years, and they expect to be playing at least ten years into the future.

It is interesting to note that people who enjoy interactive games tend to play them across a spectrum of platforms and devices. According to the 2003 IDSA survey, 39% of the people who play video games also play games on mobile devices like cell phones and PDAs, and a great number also play games online.

Although online gaming is less established than video games, it is growing rapidly in popularity. Jupiter Media Matrix reported that visitors to online gaming sites grew 50% within a single one-year period, ending in October 2001. The most immersive form of online games, MMOGs, are at present still considered

to be in their infancy in the United States, and a relatively small part of the online gaming scene, although enormously popular in Asia. Still, a recent report conducted by Executive Summary Consulting estimated that six million Americans participated in MMOGs in 2002 and spent half a billion dollars in the process, which isn't bad for a form of interactive entertainment that was not even introduced until 1997.

Experts believe that the popularity of online games will increase as broadband becomes more widely available, and broadband use is gaining at a rapid rate. In an article published late in 2002, the online news server *Digital Media Wire* reported that in the past two years, broadband use in the United States had tripled, and that 28% of American homes with Internet service were now connecting to the Internet via broadband. America's neighbor to the north, Canada, is far ahead of the United States, with about double the number of homes having high-speed Internet access. In some other parts of the globe, the use of broadband is also far ahead of the United States, with South Korea, Taiwan, Canada, and Sweden leading the pack, and the Netherlands, Japan, and Germany nipping at America's heels, according to a report in the online magazine *Business 2.0.*

THE IMPACT ON OLDER FORMS OF ENTERTAINMENT

As might be imagined, as interactive entertainment occupies more of people's leisure time, it cuts into the time once given over to older, more traditional forms of entertainment, particularly television and movies. For example, a report published late in 2001 by the UCLA Center for Communication Policy found that Internet users spent significantly less time watching TV, with an overall decline of 4.5 hours a week in front of the tube. According to this study, the average time spent online was 9.8 hours a week. People with a high-speed connection were online even longer, an additional 3.2 hours.

The growing use of the Internet has been particularly striking among the youngest members of our population. The online audience of children and teenagers has expanded swiftly, tripling in the years between 1997 and 2000, and increasing 40% in the final year alone. (See Figure 2.5.) By the year 2000, 25 million young people between two and seventeen years of age were Internet users. These figures were compiled by Grunwald Associations, a consulting firm that specializes in interactive technology, and published in a report called *Children, Families and the Internet 2000.* Peter Grunwald, whose company produced the report, termed this growth "explosive." The report noted that Internet usage rose with age, with a relatively modest 25% of kids six to eight spending time online, but zooming to a 70% usage by teens thirteen to seventeen. Interestingly, in the older age groups, the gender gap has not only been closed, but girls now actually outnumber boys by a small margin. The report predicts that the numbers of young people online will continue to climb steeply.

Grunwald's report, like the one conducted by UCLA, also noted that as Internet use goes up, TV viewing goes down, and found this decline in TV viewing to be substantial, particularly among teenagers. And, in a prediction that should send alarm bells clanging throughout the offices of TV networks, the UCLA report further suggested that TV viewing would continue to drop off as young people, accustomed to the interactive attractions of the Internet, moved into adulthood.

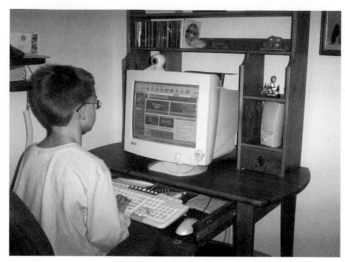

Figure 2.5 A rapidly growing number of children use the Internet, and their TV viewing is declining.

Just as the Internet is stealing people away from the TV set, movies are also starting to take a back seat to interactive entertainment. Video games are now seriously competing with movies in terms of where people are plunking down their leisure-time dollars. Back in 2001, the video game industry pulled in $9.4 billion dollars, a figure that included money spent on software, hardware, and accessories. During the same time period, Hollywood only ran up $8.35 billion dollars in box-office receipts. But although video gamers are the clear victor in this comparison, an oft-used one in the gaming industry, these figures do not include the money spent on the rental and purchase of videotapes and DVDs, among the movie industry's biggest profit centers. Nevertheless, the spending on video games continues to increase annually, to the point where Hollywood studios must be nervously eyeing gaming's hefty slice of the entertainment pie.

A GLOBAL PERSPECTIVE

Although these facts and figures primarily reflect trends in the United States, it is important to keep in mind that interactive entertainment is popular throughout the world, and that software production centers are scattered worldwide. The United States does not have the same stranglehold on interactive entertainment as it does on the television and motion picture industry. Countries from India to South Africa to Australia are creating innovative content for interactive devices, with especially strong production centers in Japan, South Korea, Germany, Great Britain, and Canada.

Furthermore, some forms of interactive entertainment are better established outside of the United States than within its borders. Wireless games are tremendously successful in Japan and Korea; iTV is well established in Great Britain and several other countries; cross-media productions do well in Scandinavian countries.

CONCLUSION

Clearly, interactive entertainment is no longer the niche activity it was in its earliest days. While once barely known outside of a few research labs and academic institutions, it can now boast of a worldwide presence and a consumer base numbering in the millions.

From the days when it was only available to the public at video game parlors, interactive entertainment can now be found on a great variety of media and platforms. It is also no longer just the domain of teenage boys. Its appeal has broadened to include a much wider spectrum of the population, in terms of age, gender, and interest groups. It can be enjoyed in homes, schools, offices, and, via wireless devices, virtually anywhere. It is powerful and universal enough to become a serious contender for the public's leisure-time dollars and leisure-time hours, and muscular enough to make Hollywood sit up and take notice.

A striking number of the breakthroughs that laid the groundwork for this new form of entertainment have come from unlikely places. Many were made at institutions usually associated with far more somber endeavors—organizations like the United States Department of Defense, the U.S. Census Bureau, and universities and scientific institutions. Thus, we should not be surprised if future breakthroughs also come from outside the ranks of the usual suppliers of entertainment.

As we can see by studying the history of interactive entertainment, the path to success has not necessarily been smooth or straight. Some new platforms or forms of entertainment have caught on quickly, while others still continue to struggle for popular acceptance. And sometimes, a new medium has created a tremendous flurry of interest, only to be followed by a chilly downturn. It can be difficult for those working in the field to avoid being snagged by these dramatic ups and downs, and to keep the big picture in mind—that, overall, interactive entertainment has grown steadily in popularity.

The early practitioners of interactive media employed skills that might seem old-fashioned in a high-tech environment—skills like being organized, being systematic, and using a collaborative approach. Nevertheless, such skills often made the difference between successfully completing a title and or never getting one done. Furthermore, these pioneers drew upon experience they'd acquired from work they'd performed prior to their involvement with interactive media. Rather than trying to reinvent the wheel, they applied whatever could be of value to their new line of work, and gave themselves the freedom to invent new approaches and techniques when nothing from the past would serve.

Various studies have documented the enthusiasm young people have for interactive media. This demographic group is somewhat akin to people who build snowmen. They have been pushing interactive entertainment forward much like makers of snowmen roll a ball of snow, causing it to swell in size. Almost inevitably, as members of this segment of the population grow older, they will continue to expect their entertainment to be interactive. But will the same kinds of interactive programming continue to appeal to them as they move through the various stages of life? And how can emerging technologies best be utilized to build new and engaging forms of interactive entertainment? These are some of the tough questions faced by creators in this field.

IDEA-GENERATING EXERCISES

1. Try to imagine yourself going through a normal day, but as if the calendar had been set back fifty years, before computers became commonplace. What familiar devices would no longer be available to you? What everyday tasks would you no longer be able to perform, or would have to be performed in a quite different way?

2. Suppose you had only a text-based computer system available to you, as Professor Weizenbaum did back in the 1960s when he created ELIZA. What kind of interactive character could you create?

3. Imagine for a moment that you had just been given the assignment of creating an interactive entertainment project for a brand new platform, one that had never been used for an entertainment purpose before. What kinds of questions would you want to get answers to before you would begin? What steps do you think would be helpful to take as you embarked on such a project?

4. With children and teenagers being major consumers of interactive entertainment, what kinds of interactive projects do you think could be developed that would continue to engage them as they moved into young adulthood? What new factors need to be considered, such as changing interests and the amount of leisure time typically available to young adults?

Moving Toward Convergence

Within the new media arena, we've heard a great deal of talk—some say hype—about convergence. But what do people actually mean by the term?

What can we realistically expect convergence to offer us in terms of the forward progress of interactive media?

What kinds of convergence have people been attempting in terms of interactive entertainment, and can we find any successes thus far?

AN ONGOING DEBATE

The topic of convergence has sparked many a debate within the world of interactive technology. For years, industry professionals have awaited the coming of convergence as eagerly as the people in ancient days awaited the Messiah. More recently, however, a backlash has grown against it, with a number of people dismissing convergence as an empty buzzword that has lost all useful meaning, having no more substance than a Halloween ghost. Still others contend that convergence is already here, right in our midst, an overlooked but significant reality, and assert that ever more exciting forms of convergence are on the way.

But why all this disagreement about a word that in essence means a coming together of different elements, a blending of two or more entities into one seamless whole? And why has its arrival or nonarrival been the subject of so much dispute? What does it matter whether convergence within interactive technologies ever takes place?

CONVERGENCE AND INTERACTIVE MEDIA

First of all, let's try to pinpoint what convergence means in the context of interactive technology. Unfortunately, this is no easy task—even experts in media have trouble pinning down a fixed definition of the concept.

If anyone should have a clear grasp of what convergence means, it should be Gary Arlen. Arlen is president of the research and consulting firm, Arlen Communications, and an acknowledged expert in the convergence of interactive media and telecommunications. Yet during two recent telephone interviews, he struggled to come up with a precise and universal description, saying there is no one "right" way to define the term. The reason for this, he explained, is that we are in the early stages of a business that is still defining itself as it goes, and furthermore, the term has been used in multiple technologies, where it is given different meanings.

"I've given up trying to define it," he admitted. "I think it's kind of like Scotch tape. It will define itself by the way it is used." Nevertheless, Arlen was able to lay out a lucid description of what the term means within the hardware and software worlds, the arenas most central to the interests of interactive entertainment. "The hardware and software people see convergence as the technology of voice, video and data delivery coming together through a single package," he said.

For many within these industries, the idea of convergence is built in large part on the widespread availability and consumer adaptation of broadband—high-speed access to images and other data via various delivery systems. Broadband is considered a critical element because it makes feasible such things as interactive TV, video on demand, and the receiving of moving images over wireless devices—not to mention a far faster way of accessing data on the Internet.

Thus, it is easy to see why convergence is such an attractive idea. It would make possible an exciting array of new electronic products and services, and offer potentially lucrative commercial opportunities to those in the business of making and selling hardware and software for consumer use. And, to creators of entertainment, it would mean a greatly expanded marketplace for interactive programming.

Convergence might be regarded as a four-part formula, a compound that requires four elements, or types of "ingredients," to work. They are

1. A communications delivery system (via satellite, cellular, dial-up, cable, Wi-Fi, Bluetooth, or some other means)
2. Hardware (such as a TV set, a game console, a wireless device, or a computer)
3. Digitized content (data such as text, audio, graphics, video, or animation)
4. Computerized technology (to access, manipulate, and interact with the content)

THE DIGITIZING OF CONTENT

As indicated above, in order for convergence to be possible, the content must be available in digital form. This is a significant requirement. Until fairly recently, critical visual and audio elements have been available only in analog form. But the digitizing of content is so important to the merging of technology and media that some people even refer to convergence as "digital media integration."

Digital information is made up of distinct, separate bits: the zeroes and ones that feed our computers. Analog information, on the other hand, is continuous and unbroken. The difference can easily be seen by comparing an analog clock to a digital clock. An analog clock displays time in a smooth sweep around the dial, while a digital clock displays time in specific numerical increments of hours, minutes, and seconds. Film, video, LPs, and audio tape are all analog; DVDs, CD-ROMs, CDs, and digital video are all digital. Digital information can be stored easily, accessed quickly, and can be transferred among a great variety of devices.

The digitizing of content is particularly critical when it comes to video. Analog video is a world champion hog that sucks up an enormous amount of memory. It is far too bulky to transmit conveniently through cyberspace. But when video is digitized, its audio and visual elements are compressed into tiny units of data— making it far more feasible to send and receive, and far more usable by computerized devices. It can be easily accessed and readily reassembled in an almost infinite number of ways, and thus becomes a viable form of content for interactivity.

THE CORPORATE MARRIAGE OF TECHNOLOGY AND ENTERTAINMENT

The dazzling promise of convergence has tempted a number of companies to impetuously plunge into the convergence waters, anticipating that this coming together of interactive media and technologies would result in significant strategic gains and profits. Unfortunately for some of these companies, their headfirst dive proved to be premature at best, and resulted in heavy losses, giving convergence a bad name. One of the most infamous of these corporate ventures was the merger of AOL and Time Warner. Entertainment mogul David Geffen might have had this unfortunate union in mind when he quipped that convergence "is the most expensive word in history," a quote captured by Gary Arlen in an article he wrote for *Multichannel News* (August 12, 2002).

When the merger was announced in January 2000, it seemed like a fairy-tale wedding of Internet technology and Hollywood entertainment. AOL, with twenty million subscribers, seemed like the ideal twenty-first century vehicle to promote and distribute Time Warner's vast library of movies, music, publications, and other products. Like many glamorous weddings, it was a pricey affair. AOL, the brash newcomer, was the purchaser, and acquired the media conglomerate for $163 billion worth of its stock. But the marriage went sour in less than two years. By July 2002, the newlyweds' stock had plummeted 78% from its postmerger high, and Roger Pittman, the Time Warner executive who had orchestrated the merger and who had been its most enthused champion, resigned under pressure. Pittman had been serving as the Co-Chief Operating Officer of the newly formed company.

With Pittman ousted, AOL Time Warner reorganized. The original postmerger goal had been to integrate the two entities with the expectation that this would maximize their potential. But after Pittman's exit, AOL Time Warner pulled back from this strategy and returned a great deal of autonomy to the various old departments within the original companies. It was much like a solution reached by an unhappy couple who cannot afford to divorce, but who agree to live in separate wings of the house.

In the *Los Angeles Times* coverage of the AOL Time Warner shake-up (July 19, 2002), staff writers Edmund Sanders and Jan Healey commented that the ambitious merger might have failed because it was too sweeping. "In the rush to maximize synergies," they wrote, "AOL Time Warner may have made a classic mistake: losing sight of what customers really want." The article also included a remark by Frank Catalon, head of an Internet marketing firm. "Convergence is a slow process," they quoted him as saying. "It shouldn't be a top-down effort. You start by taking small steps."

Interestingly, the failure of this merger to thrive was blamed on the same factors that were cited in the disappointing outcome of the first iTV ventures: that they offered services that customers did not want or were not ready for.

CONVERGENCE MADE REAL

The AOL Time Warner merger was a grandiose vision of convergence, and its lack of success received a flurry of negative publicity. However, other manifestations of convergence have fared much better, though they have received far less attention. They include a great variety of endeavors, from hardware devices, to software, to services.

Some, like the "smart fridge," admittedly sound like an idea culled from a science fiction novel. Manufactured by LG Electronics and officially dubbed the "Internet Refrigerator," this futuristic household appliance does quite a bit more than chill one's food. It is also a full service entertainment center, incorporating a TV, a radio, and a built-in digital camera. Furthermore, as its name suggests, it connects to the Internet, and, through its four hi-fi speakers, it can play music that it has downloaded from the Web. On the pragmatic side, it lists all the foods stored within, and can serve as a message center and date book for the entire family. As if all this were not enough, the titanium surface is smudge proof—something that could be its most winning feature in a household of sticky-fingered kids. This refrigerator was priced at $8500 in 2003, but no sales figures were available as

of this writing to learn how many had actually been snapped up. Whether or not the Internet Refrigerator proves to be a hit, however, experts in consumer electronics foresee an increasing number of smart appliances coming on the market, and some will certainly incorporate entertainment features.

GAME CONSOLES

More central to the interests of content creators is an entirely different category of convergent device: game consoles that hook up to the Internet. They include Microsoft's Xbox, Sony's PlayStation 2, and Nintendo's GameCube.

The Xbox was the first game console to come with the built-in capability to connect to the Internet. Its Etherport is designed specifically for a broadband connection (though users must already be subscribers to a broadband service in order to avail themselves of it). Owners of the other the two brands of game consoles can purchase adapters for dial-up or broadband connections.

The Microsoft Xbox also has its own online gaming service, called XboxLive. XboxLive launched in November 2002 with almost a dozen games and with plans to add many more. The XboxLive service also gives users the opportunity to download new material to freshen up their games—content like new missions, characters, and maps. Xbox users can not only play games against each other, but can also communicate by voice in real time via a feature called the Voice Communicator. It gives users the ability to disguise their voice through a variety of "voice masks." This is a wonderful feature if you'd rather sound like a tough Mafioso instead of the squeaky twelve-year-old kid you really happen to be. The Xbox opens up intriguing new turf for digital storytellers, a narrative landscape that not only offers multiplayer game play over the Internet but also includes live voice communications.

PlayStation 2 owners, once they have acquired an online adapter, can also use their console to play with other users on an online game network dedicated to their console. Called PlayStation Online, it includes a special PlayStation 2 version of Sony's hugely popular MMOG, *EverQuest*, as well as other games. Both the PlayStation 2 and the Xbox also play audio CDs and DVDs, and in fact many PlayStation owners use their console to watch movies. Nintendo has taken a more cautious approach with its GameCube, probably because typical users of this console are young children and are less likely to go online. At the time of its debut, it offered only one game, *Phantasy Star Online*, and no DVD component.

WIRELESS DEVICES

Like game consoles, many wireless devices such as cell phones, smart phones, and PDAs (Personal Digital Assistants) are also now capable of connecting to the Internet. While at first they could only display text, and sometimes simple graphics, the most recent wireless devices now display streaming video as well. Users of these little gadgets have the ability to play interactive games and enjoy other forms of online entertainment—another example of living, breathing convergence.

In 2003, Nokia announced a significant new piece of hardware designed for wireless online gaming, its Nokia N-Gage game deck. The N-Gage is a mobile phone as well as a hand-held game console and it wirelessly connects to the

Internet. The device facilitates the playing of multiplayer online games, and also functions as a digital music player and an FM radio. It will thus converge media and capabilities that have never before been available on a single device.

Even the most clever wireless gaming device is of no value, of course, unless people have games to play on them. When it comes to producing content for wireless devices, Japan and Finland (home of Nokia) are two nations that are in the forefront of such endeavors, and people in these nations are big fans of such entertainment. You can often see people in Japan and Finland whiling away free time with such games, playing them on commuter trains, in waiting rooms, and so on. Companies in the United States and many other countries are trying to catch up, however, and more sophisticated kinds of wireless entertainment projects are in the works.

Sometimes wireless devices let consumers take things a step further, and not only interact with the content, but actually provide some of the content themselves. With Sony's HandyCam, for example, you can shoot video and immediately post it online, all wirelessly. With a mobile device like the HandyCam, you could potentially contribute scenes to a collaboratively produced soap opera or perform a surveillance mission for a fictional espionage drama. You could even shoot material for a *Hidden Camera* type of show. (For more on wireless entertainment, please see Chapter 17.)

CONVERGENCE AND TELEVISION

Interactive television and video on demand are, of course, two of the most widely anticipated manifestations of convergence. As we saw in Chapter 2, iTV is already fairly well established in several countries. In the United States, single-screen interactivity is available only on a limited basis, via certain satellite and cable services, and an upgraded set-top box is needed to access it.

Dual-screen iTV, in which a television show and a website are synchronized, is available to anyone with a computer, online access, and a TV set. Only a small number of TV shows offer a synchronized online component, however, and at best this is a rickety, pasted-together form of convergence. It is anybody's guess when single-screen iTV will become more widely available. And nobody is betting on what kinds of interactive programming will catch on with consumers, either, although video on demand is already an extremely popular service wherever it is available. (For more on iTV, please see Chapter 14.)

OTHER FORMS OF CONVERGENT TELEVISION ENTERTAINMENT

But why must convergent television applications stop at iTV and video on demand? Why can't we have other forms of convergent television entertainment? The ever-adventurous BBC is breaking fresh new ground here. It has developed an entirely new kind of TV experience called *FightBox*, first aired in the fall of 2003. *FightBox* is a TV show that also utilizes the Web, game technology, and virtual characters, and will also be offered as a stand-alone multiplayer video game.

FightBox is a gladiator-style competition featuring virtual characters that have been digitally created by members of the general public. (See Figure 3.1.)

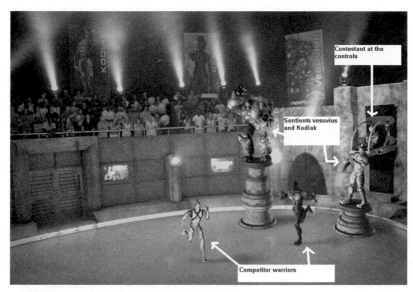

Figure 3.1 The arena for BBC's *FightBox*, a TV show that blends gaming, the Web, and TV in an entirely new way. Figures in the photo are labeled to show two *FightBox* Sentients (in-house fighters), the contestants, and the virtual warriors that the contestants are controlling. Image courtesy of the BBC.

These synthetic warriors battle ferociously with each other and are also pitted against a cast of digital "in-house" characters called *FightBox* Sentients—monster-like beings with awesome powers. The programs are shot live in front of a studio audience, and the human "masters" of the warriors are visible on the set as they control their fighters in the arena. The technology developed for *FightBox* allows virtual warriors and the show's human hosts to stand and sit side-by-side and even to chat. Members of the TV audience might even find themselves in the action, with one of the virtual warriors hurled from the arena right into their laps.

Anyone who is over eighteen and resides in the United Kingdom is eligible to enter the TV tournament. But first, aspiring competitors must create a warrior, which is done by downloading a software tool called FightKit. The tool is available at no charge on the *FightBox* website, *www.bbc.co.uk/fightbox*. Once players have designed and trained a warrior, they can compete in a series of qualifiers, which are tests of combat, agility, and ability. The sixty players with the best scores in the qualifiers get to move on to the TV show.

FightBox, in the spirit of the Web, offers ample opportunities for players to interact with each other online. For example, they can trade with each other for new or used body parts for their warriors, or form online "tribes" to pool information and resources. And, as with almost any other website, they can participate in online forums. Soon after the FightKit tool became available, in May 2003, multiple forums on the website were already fat with thousands of posts, and some forums were even spawning their own Web pages.

OTHER APPROACHES TO INTEGRATING MEDIA

Meanwhile, as players in the United Kingdom train their virtual warriors for ferocious combat on the BBC, another type of media integration is also moving

forward, a merging of a single entertainment property over multiple platforms or venues. Such ventures are sometimes called cross-media productions or integrated media—the concept is still so new that it doesn't yet have a formal name. Although primarily employed for story-based projects and games, a few examples of this approach have been produced for information-based projects as well, usually with a television documentary as the hub component.

In such endeavors, a project is designed from its very inception to span more than one medium, and at least one component is interactive. The project might incorporate such elements as a movie, a website, a DVD, a wireless game, a linear or interactive TV show, a novel, or even a live event. It might involve all of these media or just a few, and may well involve other platforms or methods of communication not mentioned here.

The objective of such projects is to expand the fictional (or informational) universe of the core material and to make it "live" across a variety of media. The subject matter for each of the components closely relates to the same core material, but the approach used for each medium or platform is designed to take advantage of its unique strengths and capabilities. For example, the material might be offered as a linear dramatic narrative for a TV show or a movie, but might be presented as an interactive timeline or community message board for a website and as a trivia game for a wireless device.

This approach enables the viewer/user/player to become involved in the material in an extremely deep way, and sometimes in a manner that eerily simulates a real-life experience. For instance, the user might receive phone calls or faxes from fictional characters in the story, or even engage in IM (instant message) sessions with them. By spanning a number of media, a project can become far richer, more detailed and multifaceted. Such projects also offer the audience a number of different ways to participate and gives them the opportunity to immerse themselves in the world as deeply as they choose, along with the freedom to select the amount of interactivity with which they feel comfortable. In an information-based project, such an approach offers people a variety of ways to learn more about the core topic, and to access the material that is of the greatest interest to them.

Probably the first cross-media production to catch the attention of the public was *The Blair Witch Project*, which consisted of just two components—a movie and website. The movie told the story of three young filmmakers who venture into the woods to make a documentary about a legendary witch, and then vanish under terrifying circumstances, leaving behind their videotapes. The movie is constructed solely of the footage that is allegedly discovered after their disappearance, and is presented as a factual documentary.

The website (*www. blairwitch.com*) focused on the same core story idea that was developed in the film. At the time of the movie's release in 1999, plenty of other websites had already been tied into movies. But what made *The Blair Witch Project* so remarkable, and what created such a sensation, was the way the website enhanced and magnified the "documentary" content of the film. It bore no resemblance to the typical promotion site for a movie, with the usual bios of the actors and director and behind-the-scenes photos taken on the set. In fact, it contained nothing to indicate that *The Blair Witch Project* was a horror movie, or that it was even a movie at all. Instead, the website treated the account of the filmmakers' trip into the woods as if were absolute fact.

Launched several months before the movie's release, the material presented on the website offered additional information about the events depicted in the movie,

including things that happened before and after the three filmmakers ventured into the woods. Visitors to the site could view video interviews with the filmmakers' relatives, townspeople, and law enforcement officers, or examine an abundance of "archival" material. The content of the website was so realistic than many fans were convinced that everything depicted in *The Blair Witch Project* actually took place. Of course, the website was, in fact, just an extremely clever and inexpensive way to promote the low-budget movie. It accomplished this goal supremely well, and created such intense interest and curiosity that *The Blair Witch Project* became an instant hit.

Cross-media projects made since *The Blair Witch Project* are not necessarily as motivated by promotional goals as this production was. In some cases, the creators are excited about the opportunity to expand their material to different media, and see this as a way of opening it up to more possibilities. In other cases, particularly in informational projects, the producers are looking to offer additional material in a way that is not limited by time constraints or other kinds of restrictions. But whatever the producers' motivations, all these projects have one thing in common: They utilize a convergent approach by presenting material over multiple media. (For more on this still relatively young area of cross-media productions, please see Chapter 15.)

ADAPTATION

A far older approach to story-based material, which sounds similar to cross-media productions, but is actually quite different, is the process of adaptation. Properties have been adapted from one medium and used in another ever since the days when we had at least one other medium to borrow (or steal) from. The ancient Greeks freely took stories from their myths and oral traditions and turned them into works for the theatre, just as many of today's movies are based on earlier source material, such as novels, plays, and comic books.

Unlike the cross-media approach, however, an adaptation is not a project that is developed simultaneously for several media, and is not intended to work as a storytelling approach in conjunction with other media. It does not spread various facets of a story across several media; instead it just retells the same story. An adaptation is primarily a way to get more mileage out of good material.

However, the examination of adapted works can be an informative way of gaining insights into popular culture. Producers and publishers like to bet on what they consider to be a sure thing and are most likely to adapt a work that they feel has mainstream appeal. Clearly, judging from the numbers of video games that have been turned into movies, film producers are looking at interactive media as a fertile area to plumb for source material.

The trend of turning games into movies began in 1993 with *Super Mario Brothers*. This first game-to-movie adaptation was not the box office sensation that was hoped for, and other such adaptations in the years that followed did not do well, either. However, the huge success of *Lara Croft: Tomb Raider* in 2001 proved that it was indeed possible to turn a popular game into a popular movie. *Lara Croft: Tomb Raider* spurred a great increase in such adaptations. The projects that have followed it, like the Lara Croft movie, have been done with more sensitivity about the special challenges of translating a game into a movie.

As with all adaptations, the process of turning a game into a movie is filled with pitfalls, and it is difficult to pull off well. Each type of adaptation has its own inherent problems. In adapting a novel into a movie, for instance, you must figure out how to translate passive descriptive material and internal monologues into a visual narrative told through dramatic action. You also have to pare down or eliminate an abundance of plot and characters.

In adapting a game into a movie, you need to figure out how to convey the sense of interactivity and choice that is so much part of a video game, but without making this seem repetitive or uninvolving. You also need to take what are typically one-dimensional characters in games and fill them out with more richly shaded personalities and backstories. Characters in movies usually need to be given a "character arc" so that they change and grow in the course of the story. This is something that movie audiences expect to see, but is rare in games. You almost inevitably need to condense what is often a huge game environment with many worlds and locations into a more contained film-like environment. These are a few of the issues that today's screenwriters are grappling with when they turn a game into a movie.

In the reverse sort of situation, turning a movie into a game, you are faced with an opposite set of problems. Most importantly, you need to work out how to convert a linear storyline with a single through-line into a multidimensional interactive experience. How will the user participate in the story world; what kinds of things will he or she do; and what will the overall goal or mission be? Characters usually need to be simplified, and their most important traits highlighted. More plot lines or layers of action will need to be provided than are usually found in a movie, and the story universe will generally need to be built out. Game designers have as many challenges in adapting a movie as film producers have in adapting a game, if not more.

In addition to video games, film producers have been eyeing other interactive media for prospective works to turn into movies. The first Internet-based material to make it to the big screen was Urban Entertainment's webisodic *Undercover Brother*, in 2002. The trend has gone the other way, too, with movies sometimes becoming material for the Web. For example, *Star Wars* has been turned into a MMOG. Sometimes TV shows become video games, too, as with the *X-Files*, *Law and Order*, *Buffy the Vampire Slayer*, *Sabrina the Teenage Witch*, and others. And sometimes video games become online games, as with *The Sims*, which lives on the Web as a MMOG called *The Sims Online*. This migration of a property from one medium to another is hardly a new phenomenon. What is relatively new, though, is that interactive media have joined the great pool of work that is regarded as attractive source material.

"SOFT" CONVERGENCE IN ENTERTAINMENT MEDIA

It is quite a straightforward business to point to examples of interactive projects that have been adapted for movies and other traditional media. However, it takes a little more work and thought to perceive a second, more subtle impact that the newer media are having on the older. If we look closely, though, we can see how interactive media are influencing traditional media in terms of structure, visual presentation, style, and a general approach to storytelling.

This is most clearly apparent in the way video games are influencing motion pictures. For instance, consider the British film *Sliding Doors*, about a young woman (Gwyneth Paltrow) whose life takes two separate paths when in one instance she rushes to catch a subway train and makes it, and in the other instance she just misses the train. From the subway incident on, the movie uses a branching plotline that is a very game-like type of structure. It also depicts two parallel universes that exist simultaneously in time, another game-like convention.

In the movie, we get to see Gwyneth Paltrow go down two different story paths, transferring back and forth from one to the other at various game-like "nodes" along the way. However, she does not consciously choose which path to follow the way a player would in a game. Also, in the movie, we get to see how each storyline is resolved, an opportunity we would not have in a game, unless we played it more than once. In a game, of course, the ultimate outcome would be based on the choices we made at each node or decision point. Nevertheless, for a linear piece of work, *Sliding Doors* does a remarkable job at reflecting a game-like experience.

As another example of the influence of games on movies, take the sci-fi film trilogy, *The Matrix*. Like *Sliding Doors*, they also present a structure with two parallel universes, but in these movies the characters can jump between worlds in a much more deliberate and conscious fashion than in *Sliding Doors*. The choreography of its dazzling fight scenes looks remarkably like what one might find in a video game, as does its dark, threatening ambience. These aspects of the movies were successfully transferred to the *Matrix* video game, *Enter the Matrix*.

Even more strikingly game-like is the German movie *Run, Lola, Run*. It is about a young woman who goes on a life and death mission to save her boyfriend. With its eclectic mix of animation and high-speed live action, it has a distinctly game-like look, feel, and pace. The movie is structured in three "rounds," each giving Lola twenty minutes to successfully achieve her goal. The first two rounds end badly, so the game (or story) is "reset" and Lola gets another chance. In each round she has to deal with many of the same obstacles, but it is not until round three that she manages to figure out how to deal with all of them, and is able to "win."

These are just three examples of recent movies that have been influenced by video games; many others could have been spotlighted as well. To a lesser extent, we can also find examples of the impact of the Internet on linear entertainment, particularly on television. Certainly the influence can be seen in the way material is presented visually on a TV screen. Instead of one single image, the frame is now often filled with multiple images like a Web page. Often the frame is divided into separate boxes, and we even find text scrolling at the bottom of the screen. Overall, television has adapted more of the visually dense style we have become familiar with from Web surfing. While particularly common in news programs, documentaries, and sports, we can also sometimes find this visual look in dramatic series. Two such examples are *CSI: Crime Scene Investigation* and *24*.

The Fox series *24*, one of the most innovative series of recent years, not only has a Web-like visual style, but also seems influenced by video games in terms of its story content and structure. The main character, Jack Baurer, played by Kiefer Sutherland, works for a government agency called CTU (Counter Terrorist Unit). Each sixty-minute episode covers sixty minutes of the story in real time. A twenty-four-hour period is played out in a sequence of twenty-four episodes, which works out to a full TV season. In each of these twenty-four hours, Jack

must prevent a catastrophe from occurring. In season one, it was the assassination of a presidential candidate; in season two it was the outbreak of a world war; in season three it was bioterrorism. As in a video game, the hero is given a perilous mission and has to contend with a relentlessly ticking clock. In fact, a digital clock can frequently be seen in the center of the screen, counting the hours and minutes of each hour. The clock is a visual motif that looms over every episode and heightens the tension.

In the series, Jack resolves one set of challenges only to be forced to deal with another set, much like advancing level by level in a game. In each of these "levels," he encounters a new group of bad guys and must overcome new obstacles or solve new puzzles, many of them quite game-like in nature (for example, locating where a nuclear bomb is hidden, or figuring out an escape route from a warehouse surrounded by assassins). In Jack's seemingly miraculous ability to narrowly escape bullets, fend off knife-wielding adversaries, and avert booby traps, he also shares some of the larger-than-life qualities of a video game action hero. And although we spend week after week watching him deal with one harrowing crisis after another, we never get to know much about the "inner" Jack. As with a video game hero, we become extremely knowledgeable about his physical and intellectual skills, but learn little about his thoughts or feelings.

Just as TV shows like *24* and movies like *Run, Lola, Run* contain elements influenced or directly borrowed from interactive media, the converse is also true. Interactive media borrow from established media, too. The cut scenes in video games are highly cinematic in content and style. Genres developed for radio and television, such as the soap opera or the quiz show, turn up on the Web (as in *The Spot* and *You Don't Know Jack*). Techniques of character development first devised for the theatre and for film are now employed in video games and smart toys. (For more about the inter-borrowing of tools between old and new media, please see Chapter 5.)

CONCLUSION

Although industry experts have not managed to reach a consensus about exactly what "convergence" is, its potential to open up new avenues of interactive entertainment is tantalizing, particularly in the arenas of iTV, wireless devices, and the Internet. Achieving convergence continues to be a much-sought-after goal in many fields connected with interactive technology.

In some regards, convergence is already a reality. We can purchase smart appliances, game consoles, and wireless devices that connect to the Internet and that offer two-way interactivity. Also, depending on where we live and what services are available to us, we can watch iTV. And our most popular forms of entertainment are converging in a variety of ways—through the use of multiple media to present a single property, through adaptation, and through the cross-fertilization of style and content.

As Gary Arlen noted about convergence in a recent interview: "Interest in it may fade in and out, but convergence is not going to go away." Though it might be a slippery task to hammer out a precise definition, a number of forms of convergence are already making an impact in interactive entertainment. It behooves creators of digital content to be aware of developments in this area and to be ready to take advantage of them.

IDEA-GENERATING EXERCISES

1. Think of two or more objects, devices, or forms of media that have not, to your knowledge, previously been linked together by computerized technology. What type of experience or service might result from merging them? Can you think of any way this convergence could be used to provide interactive entertainment, and, if so, what would such entertainment be like?

2. How could the use of voice communications among players, when employed during the playing of an online game, contribute to the overall entertainment experience?

3. What movie or TV show have you seen recently that seemed to be influenced by video games? In what way was this influence apparent?

4. What computer game have you played that might make a good movie? What about it would lend itself well to a cinematic adaptation? What about it would need to be changed in order to make it work as a movie?

5. What movie have you seen lately, or what novel or other material have you read, that might make a good video game or online game? What about it would lend itself well to such an adaptation? What about it would need to be changed in order to make it work as a game?

Creating Entertainment-Rich Projects

CHAPTER 4

Interactivity and Its Effects

How does the use of interactivity radically change the way an audience experiences a work of entertainment?

How does the use of interactivity radically change the material itself?

Why do interactive works so often incorporate some elements of gaming, and is it possible to construct an interactive story that has no game-like components?

WHAT IS INTERACTIVITY?

Without interactivity, digital entertainment would simply be a duplicate of traditional entertainment, except that the medium in which it is presented, such as video or audio, would be in a digital form rather than an analog form. To the audience member or listener, however, the difference would be minimal except perhaps in the quality of the picture or sound. Essentially, the experience of "consuming" the entertainment would be exactly the same.

It is interactivity that makes digital media such a completely different animal from traditional storytelling media, like movies, television, and novels. Traditional stories, no matter how they are told—whether recited orally by a shaman, printed in a book, or projected on a movie screen—have certain universal qualities. They are narrations that employ fictional characters and fictional events to depict a dramatic situation from its inception to its conclusion. Interactivity, however, profoundly changes the core material, and profoundly changes the experience of those who are the receivers of it.

We've all probably heard and used the word "interactivity" hundreds, even thousands, of times. Because of overuse, the word has lost its fresh edge, somewhat like a kitchen knife that has grown dull because it's been utilized so often. Let's take a moment to consider what interactivity means and what it does.

When you stop to think about it, interactivity is one of only two possible ways of relating to content; the other way is to relate to it passively. If you are passively enjoying a form of entertainment, you are doing nothing more than watching, listening, or reading. But if you are experiencing an interactive form of content, you are directly involved with the material; you are a participant. You can manipulate, explore, or influence it in one of a variety of ways. As the word "interactive" indicates, it is an active experience. You are doing something. And the prefix "inter" means "between," telling us that we are talking about an active relationship between the user and the content. It is a two-way exchange. You do something; the content reacts to what you've done. Or the content demands something from you, and you respond in some way.

INTERACTIVITY AS DIALOGUE

This dynamic of action-response is something like a conversation, a resemblance that interactive designer Greg Roach pointed out to me during a conversation about the nature of interactivity. Roach is CEO of HyperBole Studios, the company that made such award-winning games as *The X-Files Game* and *Quantum Gate*. He's considered a digital media pioneer, and has given a great deal of thought to the subject of interactivity. "Interactivity is fundamentally a dialogue between a user and the material," he noted. "The user provides the input; the input is responded to." He compared the act of designing interactivity to the act of writing a sentence in a language like English, which uses the grammatical structure of a subject, object, and verb. As an example, he used a simple interactive scene in which you give your character a gun. The interactive "sentence" would be: he (the subject) can shoot (the verb) another character (the object). Carrying Roach's grammatical analogy a step further, the sentences you construct in interactive media use the active voice, and are not weighed down by descriptive phrases.

("He watered his horse" rather than "he was seen leading his dusty old horse down to the rocky creek, where he encouraged it to drink.") These interactive sentences are short and to the point, far more like Hemingway than Faulkner.

Roach is not alone in using grammatical terms to talk about interactivity. Many game designers use the phrase "verb set" in referring to the actions that can be performed in an interactive work. The verb set of a game consists of all the things players can make their characters do. The most common verbs are walk, run, turn, jump, pick up, and shoot. A number of designers complain that the standard verb set is too limited, restricting their ability to create more diverse and robust works of interactive entertainment.

LEAN BACK VERSUS LEAN FORWARD

Passive entertainment and interactive entertainment are often referred to as "lean back" and "lean forward" experiences, respectively. With a passive form of entertainment like a movie or stage play, you are reclining back in your seat, letting the drama come to you. But with an interactive work—a video game or a MMOG, for instance—you are leaning forward toward the screen, controlling the action with your joystick or keypad.

What the audience does or does not do in terms of relating to the material is one of the most profound differences between interactive and passive entertainment. This relationship is so dissimilar, in fact, that we rarely even use the word "audience" when we are talking about those who are experiencing an interactive work. Instead, we may call upon one of several words to describe this person. If we're talking about someone playing a video game, we will probably refer to the person as a "player" or "gamer," while if a person is surfing the Net, we often use the term "visitor." For simulations and immersive environments, we often call the person a "participant." Some professionals also use the general term "interactor" or another all-purpose word, "user." More often than not, we talk about such people in the singular rather than in the plural. This is probably because each individual journeys through the interactive environment as a solo traveler, and each route through the material is unique to that person.

Because each user is in control of his or her own journey through the material, interactivity can never truly be a mass audience experience. This is the case even when thousands of people are simultaneously participating in an interactive work, as they may be doing with a MMOG or an iTV show. Think how different this is from how a movie or TV audience partakes of a particular narrative. Audience members watch the same unvarying story unfold simultaneously with hundreds—or even millions—of other viewers. Of course, each member of the audience is running the story through his or her own personal filter and is probably having a somewhat different emotional response to the material. Yet no matter how intensely people might be reacting, there is nothing any member of the audience can do to alter a single beat of the tale.

The users/players/visitors who participate in interactive entertainments are given two gifts that are never offered to audiences of passive entertainments: choice and control. They get to choose what to see and do within an interactive work, and the decisions they make control what happens. Less than fifty years ago, such freedom to manipulate a work of entertainment would have been unimaginable.

Unfortunately, liberty always comes with a price. In the case of interactive media, it is we, the members of the creative team, who must pay it. In traditional forms of entertainment, the creator—usually the writer—has God-like powers over the narrative. The writer gets to choose who the characters are, what they are like, and what they do. And the writer controls what happens to them. But in an interactive work, this kind of God-like control over the material must be relinquished and turned over to those individuals who, had this been a piece of traditional entertainment, would have been in your thrall: the audience. Of course, there are trade-offs. Even though we must give up the ability to devise a fixed narrative path and fixed characters, we now have the opportunity to work on a far vaster canvas than in previous media, and with materials never before available (For more about these new tools, please see Chapter 5.)

IMMERSION

One of the hallmarks of a successful interactive production is that it envelopes the user in a rich, fully-involving environment. The user interacts with the virtual world and the characters and objects within it in many ways and on many levels. Interactivity stimulates as many of the five senses as possible: hearing, seeing, touching—and, in some virtual reality environments, even smelling. (No one seems to have worked out a way yet to involve the fifth sense, tasting.) In other words, the experience is immersive. It catches you up in ways that passive forms of entertainment can never do.

This point was brought home to me by an experience I had during a Christmas season when I was temporarily living in Santa Fe, New Mexico. I'd heard about the city's traditional holiday procession called *Las Posadas*, and I wanted to see it for myself.

Las Posadas originated in medieval Spain as a nativity passion play and was brought to New Mexico about 400 years ago by the Spanish missionaries. They felt *Las Posadas* would be a simple and dramatic way to ignite the religious spirit of the local Pueblo Indians, and hopefully turn them into good Catholics.

Las Posadas, which is Spanish for "the inns," recreates the Biblical story of Mary and Joseph's search for a place to spend the night and where Mary can give birth. It is performed with different variations in towns all over the Southwest and Mexico, but the basic elements remain the same. In Santa Fe, the procession takes place around the historic town plaza. Mary and Joseph, accompanied by a group of musicians and carolers, go from building to building asking for admittance, but each time the devil appears and denies them entrance, until at last they find a place that will receive them.

On the evening of Santa Fe's *Las Posadas*, my husband and I waited in the crowd with the other spectators, all of us holding candles and shivering in the icy night air, waiting for the event to begin. Finally the first marchers appeared, accompanied by men holding torches to light the way. Mary and Joseph followed, with a group of carolers around them. The group paused in front of a building not far from us and all proceeded to sing the traditional song which pleads for lodging. The devil popped up from a hiding place on the roof and scornfully sang his song of refusal. It was very colorful, very different from anything I'd seen back home in southern California, and I was glad we had come.

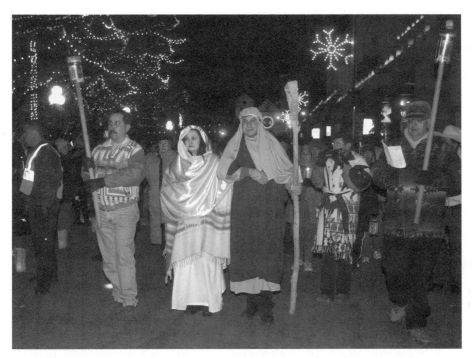

Figure 4.1 The *Las Posadas* procession in Santa Fe. By participating in a traditional event like this, one can experience the powerful nature of immersiveness. Photograph by Kathy De La Torre of the *Santa Fe New Mexican*, courtesy of the *Santa Fe New Mexican.*

But then I noticed that a number of people were breaking away from the throng of bystanders and joining in the procession. Spontaneously, I pulled my startled husband into the street after them. In a flash, we went from being observers to being participants, and began to experience *Las Posadas* in an entirely different way. Marching with the procession, we became part of the drama, too, and fully immersed in it. (See Figure 4.1.)

For the hour or so that it lasted, I became someone else. No longer was I a twenty-first century Jewish writer. I became a pious Catholic pilgrim transported back to a wintry medieval Spanish village. Some of this I experienced on a personal and physical level: I had to watch my step, taking care not to slip on a patch of ice or trip on a curb or get ahead of the Holy Family. I was aware of the scent of burning candles all around me, and the press of the crowd. Much of the experience was emotional and communal: My husband and I would do our best to sing along with the carolers and Holy Family when it came time to ask for a room at the inn. Whenever the devil would appear on a rooftop or balcony, we would join in the hearty boos and derisive shouts of the processioners. The best moment came when Mary and Joseph stopped in front of the heavy gates of the historic Palace of the Governors, the former seat of New Mexico's Colonial government. Once again we all sang the imploring song, but this time the gates swung open! A joyous cheer went up from the processioners, our voice among them, and we all surged into the courtyard. Welcoming bonfires and cups of hot cocoa awaited us Becoming part of *Las Posadas* instead of merely observing it transformed the experience for me. It was like the difference between watching a movie and suddenly becoming a character in it. To me, it vividly demonstrated the power of immersiveness—one of the most compelling and magical aspects of interactive media.

TYPES OF INTERACTIVITY

The player/user/visitor can interact with digital content in a variety of ways, and different types of interactive media lend themselves to different types of interactivity. For instance, the Internet is particularly good at providing opportunities to communicate with other users; smart toys excel at offering one-on-one play experiences; wireless devices do well at engaging users in short bursts of text or visuals. Each of the interactive media has its limitations, as well. In an immersive environment, a participant's ability to control objects may be limited. Game consoles, unless connected to the Internet, are restricted to just a few players at a time. Interactive TV, at least for now, does not lend itself to interactions with fictional characters or with participating in a narrative story. When it comes to the types of interactivity offered by the various digital media, no one size fits all.

That said, however, six basic types of interactivity can be found in almost every form of interactive entertainment. They are like the basic foodstuffs a good cook always keeps in the pantry, and can be used to make a wide variety of dishes. The basic types of interactivity are

1. The user inputs a stimulus; the program produces a response. The stimulus can be something as simple as clicking on an image and seeing a little animated sequence or hearing a funny sound. Or the user might click on a button and receive a few paragraphs of text information. The stimulus may involve successfully completing a series of steps or solving a puzzle, after which the user is rewarded by the occurrence of some sought-after event: The door to the safe swings open, or a character reveals a secret. The stimulus might also involve a physical act, such as putting a hat on a smart doll. The doll, recognizing the hat, responds with an appropriate comment ("Oh, I just love that pretty pink hat!"). The stimulus-response exchange is a universal component of all interactive programming.
2. The user can move through the program in a free manner; in other words, can choose what to do. Navigation may offer a vast, 3D world to explore, as in a video game or MMOG. Or it may be more limited, restricted to choosing options from a menu offered on a DVD or icons on a website. Navigation, like the stimulus-response exchange, is a universal component of every form of interactive programming.
3. The user can control virtual objects. This includes such things as shooting guns, opening drawers, and moving items from one place to another. While a fairly common form of interactivity, this one is not universal.
4. The user can communicate with other characters, including bots and other human players. Communication can be done via text that the user types in, or via choosing from a dialogue menu, by voice, or by actions (such as squeezing a smart doll's hand). Generally, communication goes both ways—characters or other players can communicate with the user, too. As with #3, it is a common, but not universal form of interactivity.
5. The user can send information. This often involves inputting data into a "community collection box." In turn, the data is generally assembled or tallied and fed back to the users. This form of interactivity is generally

found in devices that have a connection to the Internet or to an iTV service.

6. The user can receive or acquire things. The nature of the material can range from virtual to concrete, and the methods of acquiring it can range greatly as well. Users can collect information (such as news bulletins or medical facts); purchase physical objects (books or clothing); and receive video on demand. They can also collect virtual objects or assets in a game (a magic sword; the ability to fly). This type of interactivity is common in any medium that involves the Internet, wireless services, or iTV, as well as almost all video games.

Using these six basic "ingredients," digital creators can cook up a great diversity of experiences for people to participate in. They include:

1. Playing games. There is an almost infinite variety of games users can play: trivia games; adventure games; mysteries; ball games; role-playing games; and so on.
2. Participating in a fictional narrative.
3. Exploring a virtual environment.
4. Controlling a simulated vehicle or device: a fighter jet, a submarine, a space ship, a machine gun.
5. Creating a character, including its physical appearance, personality traits, and skills.
6. Manipulating virtual objects: changing the color, shape, or size of an object; changing the notes on a piece of music; changing the physical appearance of a room.
7. Constructing virtual objects such as houses, clothing, tools, towns, machines, and vehicles.
8. Taking part in polls, surveys, voting, tests, and contests.
9. Interacting with smart physical objects: dolls, robotic pets, wireless devices, household appliances.
10. Learning about something. Interactive learning experiences include edutainment games for children, training programs for employees, and online courses for students.
11. Playing a role in a simulation, either for educational purposes or for entertainment.
12. Setting a virtual clock or calendar to change, compress, or expand time.
13. Socializing with others and participating in a virtual community.
14. Searching for various types of information or for clues in a game.

This is by no means an exhaustive list, though it does illustrate the great variety of experiences that interactivity can offer, and the uses to which it can be put.

HOW INTERACTIVITY IMPACTS CONTENT

These various forms of interacting inevitably affect your content. Users expect to be offered a selection of choices, but by offering them, you give up your ability to tell a linear story or to provide information in a fixed order.

TAV. XV STANZA DELLA SEGNATURA Vaticano [n. 85 C]
Particolare della volta: *Adamo ed Eva* (cm. 170).

Figure 4.2 Rafael's Garden of Eden, showing Adam, Eve, and the serpent. An interactive version of this simple Bible tale can quickly spin out of control.

To see how this works, let's compare a linear and interactive version of a familiar story, the Garden of Eden episode from the Bible. The Garden of Eden episode is one of the best-known creation stories in the Western world, and thus seems an appropriate choice to illustrate what happens when you try to adapt a linear story and make it interactive. (See Figure 4.2.)

As it is handed down in Genesis, the story involves three characters: Adam, Eve, and the serpent. Each of them behaves in exactly the same way no matter how often one reads about them in the Old Testament. And the alluring tree that is the centerpiece of the story is always the Tree of the Knowledge of Good and Evil. God has warned Adam and Eve not to eat its fruit, though they are free to enjoy anything else in the garden. The serpent, however, convinces Eve to sample

the forbidden fruit, which she does. She gets Adam to try it, too, at which point they lose their innocence and are expelled from the Garden.

Now let's construct an interactive version of the same story. We'll use the same three characters and the same tree, but offer the player an array of choices. Let's say the tree now offers five kinds of fruit, each with the potential for a different outcome. If Eve picks the pomegranate, for instance, she might immediately become pregnant; if she eats too many cherries, she might get fat; only if she eats the forbidden fruit would the narrative progress toward the results depicted in the Bible.

As for the serpent, let's let the user decide what this character should be: malevolent or kindly, wise or silly. And we'll let the user decide how Eve responds to him, too. She might ignore him, or tell him to get lost, or try to turn him into a docile house pet... or, she might actually listen to him, as she does in the Bible. We'll give the user a chance to determine the nature of Adam and Eve's exchange, too. Adam might reject Eve's suggestion to try the fruit, or might come up with several suggestions of his own (open up a fruit stand, or make jam out of the tree's cherries). Or they may hotly disagree with each other, resulting in the Bible's first marital spat. Suddenly we have a vast multitude of permutations springing out of a simple story.

Note that all of this complexity comes from merely allowing the player one of several options at various nodes in the story. But what if you gave the players other types of interactive tools? You might allow them the opportunity to explore the entire Garden of Eden and interact with anything in it. They could investigate its rocky grottos, follow paths through the dense foliage, or even snoop around Adam and Eve's private glade. Or what if you turned this into a simulation, and let users design their own Garden of Eden? Or how would it be if you turned this into a role-playing game, and let the user play as Adam, as Eve, or even as the serpent? Or what if you designed this as a community experience, and gave users the chance to vote on whether Eve should be blamed for committing the original sin?

Our simple story is now fragmenting into dozens of pieces. What once progressed in an orderly manner, with a straightforward beginning, middle, and end, has now fallen into total anarchy. If adding interactivity to a simple story like the Garden of Eden can create such chaos, what does it do to a more complex work? Fortunately, however, it is possible to impose order on interactive material, as will be discussed in Chapters 5 and 7.

THE GREAT STORY AND GAME DEBATE

Within the community of interactive media professionals, a vexing question has been batted back and forth for years. The question goes something like this: Is it possible to have a successful work of interactive entertainment that is a pure story and not built on the mechanism of gaming? The question can also be reversed in this way: How much story can you tell in a game? Or even: Is it necessary to have any story components at all to make a good game?

If you examine most interactive works, they are constructed on a gaming model: They involve competition, obstacles, and a goal; achieving the goal is usually a work's driving force. While stories in traditional media use these same elements, they are less obvious, and great attention is placed on other things, such as character

development, motivation, the relationship between characters, and so on. Good linear stories also usually have an emotional impact on the audience.

Questions about story and game go to the heart of this book. As digital storytellers, we need to know what kinds of narrations we can construct using interactive tools. It is also important for us to know the similarities and differences between interactive stories and how stories are told in traditional media, such as movies, plays, and novels. And, when we go to create our own digital stories, we need to know which classic narrative tools will still be serviceable, which must be discarded, and what new ones need to be acquired.

THE DIFFERENCE BETWEEN STORIES AND GAMES

In order to participate in the raging game-story debate, it is helpful to first have a clear grasp of what makes the two forms unique and different from each other, and where they may be alike. Let's hear what a trio of experts has to say about this.

Game designer Greg Roach, introduced earlier in this chapter, has a vivid way of describing what he feels sets stories and games apart. He sees stories and games as two very different types of artifacts—artifacts being objects created by human beings. Roach says, "A story is an artifact you consume and a game is a process you enter into, and create the artifact." In other words, a story is a preconstructed chunk of material, while a game is something more malleable, something that one helps to construct.

Roach regards a linear work like a film as a single artifact, while an interactive work like a game, he says, has "immense granularity." Granularity is a term Roach uses to mean the quality of being composed of many extremely small pieces. "Film is monolithic, like a block of salt," he says, and for interactivity to be possible, the monolith must be busted up into fine pieces. "These granules of information can be character, atmosphere, or action. But if a work is too granular, if the user is inputting constantly, there are no opportunities for story." Roach stresses that in order to have an interactive story, "you must find a balance between granularity and solidarity. You need to find the 'sweet spot'—the best path through the narrative, the one with the optimum number of variables."

Despite the differences between stories and games, Roach believes a middle ground can be found, a place to facilitate story and character development in an interactive environment. As an example, he pointed out that adventure games contain both storytelling and granularity. Roach, like many other game designers and producers, believes that adventure games are the best example of a game genre that is rich in story. Many see adventure games as being on one end of a story/game continuum, with first-person shooters being on the extreme other end in terms of story content. Yet even first-person shooters generally have some sort of story setup to give gamers a context to play in and a goal to strive for, and interactive stories generally have some components of gaming. "When you discard all aspects of gaming, how do you motivate people to move through the narrative?" Roach asked rhetorically. "The fundamental mechanisms of games are valuable because they provide the basic tool sets."

One of the challenges Roach sees in constructing a nongaming interactive story is the task of providing the player with motivation, an incentive to spend time working through the narrative. But he suggests an answer as well. Roach believes

that people like to solve problems, the tougher the better, and feels that a major distinction between games and stories is the types of problems they present, plus the tools you can use to solve them. In a game, he suggested, the problem might be getting past the monster on the bridge. In a story, the problem might be getting your son off drugs and into rehabilitation.

As difficult as it may be to construct interactive narratives without relying on game models, Roach feels that creating such stories is not impossible. He says he sees glimmers of such work being produced by students and developers in Europe. There, he says, people take more of a "garage band" approach to creating interactive works, as opposed to the big business approach that dominates software companies in the United States. "I feel confident in saying yes, I have total faith, that interactive media can be a vehicle for fiction," he asserted. And, as we shall see later in this chapter, in the section entitled *Stories That Are Not Games*, we can already find a number of examples of nongaming interactive narratives, and these works are supported by a variety of different platforms.

TYING GAMES AND STORIES TOGETHER

Like Greg Roach, game designer Celia Pearce sees similarities between games and stories, as well as certain qualities that tend to push them apart. Pearce, now on the faculty of the University of California at Irvine, and before that, a Visiting Scholar at the University of Southern California, has done a great deal of speaking and writing about interactive media. In an article she wrote for the Winter 2002 issue of *Computers and Graphics*, Pearce suggests that characteristics of games can successfully be tied to a narrative structure. She said this is particularly true if you make "...the character goal and the player goal synonymous, and motivate the player to move forward the character's agenda, even while discovering what it is." She feels a number of adventure and role-play games have done a good job of putting the player in the role of a character to advance the story. Among her examples are *Resident Evil*, *Deus Ex*, and the *Zelda* and *Final Fantasy* series, as well as earlier games like the *Indiana Jones* series from LucasArts and the entirely different but enormously popular *Myst*.

GAMES AS ABSTRACT STORIES

Janet H. Murray, a faculty member at M.I.T. and the author of one of the best-known books on interactive narrative, *Hamlet on the Holodeck*, takes things a step further than either Roach or Pearce. She asserts in her book that games and drama are actually quite closely aligned, and that games are really a form of "abstract storytelling."

To underscore the close connection between stories and games, Murray points out that one of our oldest, most pervasive, and popular types of games—the battle between opposing contestants or forces—is also one of the first and most basic forms of drama. The Greeks called this *agon*, for conflict or contest. Murray reminds us that opposition, or the struggle between opposites, is one of the fundamental concepts that we use to interpret the world around us (big/little; boy/girl; good/ evil).

Although Murray does not say so explicitly, every writer of screenplays is keenly aware of the importance of opposition, and realizes that unless the hero of

the drama is faced with an imposing challenge or opponent, a script will lack energy and interest. For a video game to work, it too must pit opposing forces against each other. Thus, games and dramas utilize the same key dynamic: opposition. As we will see in Chapter 6, which focuses on character, this concept of opposition is so key to drama that it defines how we think of our heroes and villains.

Opposition is not the only way that games and drama are alike, Murray believes. She suggests, in fact, that games "can be experienced as symbolic drama." She holds that games reflect events that we have lived through or have had to deal with, though in a compressed form. When we play a game, she says, we become the protagonist of a symbolic action. Some of the life-based plot lines she feels can be found in games include:

- Being faced with an emergency and surviving it;
- Taking a risk and being rewarded for acting courageously;
- Finding a world that has fallen into ruin and managing to restore it; and, of course,
- Being confronted with an imposing antagonist or difficult test of skill and achieving a successful outcome.

Interestingly, Murray finds life-like symbolic dramas even in abstract games—games of chance like throwing dice or playing the lottery, and even in the computer-based puzzle assembly game of *Tetris*. In *Tetris*, players have to maneuver falling puzzle pieces so they fit together and form a straight row. Each completed row floats off the bottom of the game board, leaving room for still more falling puzzle pieces. "The game is the perfect enactment of the overtasked lives of Americans in the 1990s," she says, "of the constant bombardment of tasks that demand our attention and that we must somehow fit into our overcrowded schedules and clear off our desks in order to make room for the next onslaught."

Games, Murray asserts, give us an opportunity to act out the important conflicts and challenges in our lives, and to create order and harmony where there was messiness and conflict. In many ways, her view of games is much like Joseph Campbell's view of ritual ceremonies—activities that provide us with a way to give meaning to important life experiences and to provide us with emotional release. In its most powerful form, this emotional release is experienced as a catharsis.

STORIES THAT ARE NOT GAMES

In debating the story/game dichotomy, let us not forget what designer Greg Roach asserted: that it is possible to create interactive stories that are not based on game models. Several different types of interactive stories already exist. One small enclave of such narratives is called, fittingly enough, Interactive Fiction (IF). Works of IF can be found on the Internet and they are also available on CD-ROMs. Though the creators and fans of IF are a fairly small group, often found within academic circles, they are dedicated to advancing this particular form of storytelling.

True works of IF are entirely text-based (although the term is sometimes used for adventure games and other works that are animated or are done on video). To see/read/play a work of IF, you need to be sitting in front of a computer, inputting

your commands with a keyboard. The story advances and reveals itself as the user types in commands ("open the door" or "look under the bed" or "ask about the diamond"). Unlike hypertext, you must do more than click on a link; you must devise phrases that will give you the most meaningful and useful reply.

IF stories can be about almost any topic, and can be written in just about any fictional genre, although they work best when the plots call for you to be active, to explore, and to make things happen. They need not be plot driven, however. *Galatea*, written by Emily Short, is an intriguing character sketch that is constructed as a dialogue between the user and a Nonplayer Character (NPC)—a character controlled by the computer. The story is based on the Greek myth of Pygmalion, a sculptor who carves a beautiful statue, Galatea. The statue comes to life after he falls in love with her. It is the same myth that inspired the Broadway hit, *My Fair Lady*. In this interactive version of the myth, you visit the art gallery where *Galatea* is displayed and discover that you are able to talk with her. As you converse with her, you gain insights into her history and troubled emotional state. Her responses to your questions vary, as does her attitude toward you, depending on how you treat her. (See Figure 4.3.) *Galatea* won Best of Show at the IF Art Show in 2000.

IF stories resemble text-based adventure games as well as online MUDs and MOOs. Unlike MUDs and MOOs, however, they are played by a single individual rather than with a group. Furthermore, they do not have the win/lose outcomes that are so much a part of adventure games, though they do often include puzzles that must be solved in order to progress. These narratives cannot be as tightly plotted as linear fiction, but they do generally have overarching storylines. Conceivably, the IF genre could be used as a model for interactive stories that are not merely text based, but are told in moving images as well.

Another type of interactive fiction, one that can be found only on the Internet, is the Web soap opera. The most famous of these, *The Spot* (first mentioned in Chapter 2), let users pry into the lives of the fictional characters by reading their journals and poking around elsewhere on the site. *The Spot* provided a two-way experience, giving users the opportunity to communicate back to the show's

```
>ask about eyes
"What was it like, having your eyes carved?" you ask.

"He drilled at the corners," she says.  "And that was
agony -- waiting to see whether he would go too deep.  He
never did, but there was always doubt."

>ask about seeing
"When did you first begin to see?" you ask.  "Was it when
your eyes were finished, or could you somehow see before
that?"

"Before that," she says.  "Certainly before he began to
drill in the corners.  It was a gradual thing: everything
was dim and shadowed, and it grew brighter and sharper
the closer he came to the surface of my eyes, until I
could recognize colors, and know his face."

>ask about face
She just shrugs.
```

Figure 4.3 A segment of the IF work *Galatea*, designed and written by Emily Short. It is a character study based on the Greek myth of Pygmalion.

creators. Their messages often provided ideas for plot twists which were then incorporated into future episodes.

The Spot might not be high art, but its popularity spawned a wave of imitators and led to successive attempts to tell new kinds of stories on the Web. Some of them have used video and extremely innovative forms of interactivity. A few have incorporated game elements, but many have not. (For more on Web stories, please see Chapter 13.)

DVDs are providing one of the newest platforms for interactive narrative. A few digital artists are using DVDs as a vehicle for small screen interactive cinema, and some works of interactive cinema have already been produced for CD-ROMs. How much or how little new stories in this area will lean on game models remains to be seen. One such movie, *Uncompressed*, is a nonlinear drama with six intersecting storylines and contains no gaming elements at all; it is pure nonlinear storytelling. As for large screen interactive movies, the few being made at this time are relying heavily on gaming elements, and also contain robust story content. (For more on *Uncompressed* and interactive cinema, see Chapter 18; for more on DVDs, please see Chapter 20.)

But other kinds of interactive stories can be enjoyed in quite different settings. For instance, virtual reality environments and certain types of location based entertainment attractions let you wander through three-dimensional space, interacting with objects you see through a special headset, or with characters projected on a large screen, or with animatronic characters. And a smart doll will tell you a story that is shaped to a large degree on how you interact with her. These interactions are triggered by when and how you use the props and sensors that serve as her cues. (For more on Virtual Reality and Location-Based Entertainment, please see Chapter 19. For more on smart dolls and other smart toys, please see Chapter 16.)

As all these examples illustrate, it is possible to create interactive stories that do not rely on gaming models.

CONCLUSION

Interactivity, as we have seen, profoundly changes the way we experience a work of entertainment. We go from being a member of the audience to becoming a participant. Instead of passively watching, listening, or reading, we take on an active role. Interactive works are immersive. They involve us in an extremely absorbing and intense way, requiring not only our intellectual attention, but also drawing on most of our senses as well, including sight, hearing, touch, and sometimes even smell.

Interactivity takes many forms, but all of them impact the creator's role in some way: They make the telling of a fixed, sequential, linear story impossible, and have the same effect on the presentation of nonfictional material.

Experts do not see eye to eye on the great story-game controversy, disagreeing on how much story can be told in a game, and whether it is possible to create an engaging interactive story that does not rely on game mechanics. However, we can see that in certain fundamental ways, games and stories are not so very different. Some games certainly have minimal story content, and in some interactive stories, it is difficult to spot anything that is game-like. But in the end, both

game mechanisms and story mechanisms play a prominent role in interactive entertainment. Furthermore, they are often used in conjunction with each other. Without either story or game elements, what would make an interactive work entertaining at all? It is hard to imagine how such a work would be able to entice people to participate in it or what about it would keep them connected to the material.

The special qualities of games and stories are equally valuable when it comes to projects that are designed to be more functional—works that marry entertainment to some other task. Such projects are used for education (*edutainment*), information (*infotainment*), and advertising (*advergaming*). They also serve a role in training, promotion, and marketing. Game and story elements can make such interactive works far more palatable to the target users, and more successful at accomplishing their intended mission. (For more on projects that blend entertainment with functional purposes, please see Chapter 8: *Blending Entertainment with Other Goals*.)

IDEA-GENERATING EXERCISES

1. Describe an event or occasion where you went from being a passive observer to an active participant. How did this shift affect the way you experienced the event? Your example could be something as simple as going from being a passenger in a car to actually driving the vehicle, or it could involve a more complex situation, like the *Las Posadas* procession described in this chapter.

2. If you are working on a project for a specific interactive medium or platform, make a list of the types of interactivity the medium or platform lends itself to most strongly, and the types of interactivity it does not support well or not at all. Is your project making good use of the platform's strengths and avoiding its weaknesses?

3. Take a very simple, familiar story and work out different ways it would be changed by injecting interactivity into it, as with the Garden of Eden example. Your examples might be a story from the Bible, a child's nursery rhyme, or a little human-interest piece from a newspaper or magazine.

4. Using a simple story like one chosen for the exercise above, redesign it as two different interactive experiences: one that is very story-like, and the other that is very game-like.

5. Based on what you know about interactivity, do you believe it is possible to create a satisfactory interactive story that is not a game? Why or why not? What is it that you believe makes interactive storytelling a particular challenge?

CHAPTER 5

Old Tools/New Tools

What is the key lesson that storytellers in any medium can learn from games?

What can an ancient Greek like Aristotle teach us that we can apply to interactive entertainment?

What ten entirely new tools must we learn to use when we move from linear storytelling to telling stories in interactive entertainment?

AN ASSORTMENT OF TOOLS

Embarking on a new interactive project, even when you are an old hand at such work, can be a daunting experience. The sheer volume of material contained in most works of digital entertainment can be overwhelming, and projects often tend to mushroom even further in scope during development (a phenomenon known as *project creep*). Furthermore, each new project seems to chart new ground. Some call for a unique creative approach; others utilize new technology. And those who work in the newer areas of interactive entertainment—creating content for wireless devices, cross-media projects, and for innovative types of immersive environments—are faced with having to break new ground almost every time out. No wonder starting work on a new interactive project can feel like plunging into chaos.

Nevertheless, even though we may feel we are starting from scratch, we actually have a wonderfully serviceable set of proven tools and techniques at our disposal, some of which we glimpsed in Chapter 1. A number of these tools were first articulated by Aristotle over 2000 years ago. Others go back still further, to preliterate storytellers. And we can also borrow plenty of tools from more recent storytellers—from novelists, playwrights, and screenwriters. Furthermore, we can raid the supply of tools originally developed for preelectronic games.

As is to be expected, of course, the majority of these borrowed tools and techniques need to be reshaped to some degree for digital entertainment. And at some point, we finally run through our old tools and reach the point where we need to pick up and master some entirely new implements. Ultimately, it is a combination of the old and the new, seamlessly integrated together, that enables us to create engaging digital entertainment.

LEARNING FROM GAMES

Some of the most effective tools of storytelling, tools that can inject an intense jolt of energy into any type of narrative, were not even developed by storytellers. They originated in games. Games are one of the most ancient forms of human social interaction, and as we saw in Chapter 1, the oldest games were often performed as a religious ritual and symbolized profoundly emotional themes.

Storytellers in both linear and nonlinear media have borrowed heavily from games. Above all else, games teach us the critical importance of having a clear-cut goal. In a good game, as well as in a good story, the best goals are

- Specific,
- Simple to understand,
- Highly desirable, and
- Difficult to achieve.

In games, significant obstacles stand in the way of achieving the ultimate goal, which is to win the competition. In solo or team sports, the most daunting of these obstacles is the opposition from the other side, either another solo player or an entire team. Participants in sporting games must also contend with physical challenges—getting the ball over the net or into the hoop or batted out of the park.

These physical challenges must be accomplished within a strict set of regulations— by using only approved types of equipment, or employing a restricted set of maneuvers, or within a limited number of tries. Without such challenges, victory would be too easy and the game would lack interest.

The essential mechanics of stories are remarkably similar to games, especially when it comes to goals and obstacles. In a story, the protagonist also wants to achieve a goal. The objective may be to find the gold; win the love of the adored one; be victorious in court; track down the killer; or overcome mental illness. A goal provides motivation for the main character, a sharp focus for the action and a through-line for the plot, just as a goal provides motivation and focus for a game. Try to imagine a game without a goal. What would the players be trying to do? What would keep spectators interested in watching an activity that has no clear objective? What would hold things together?

We could ask the same question about story-based entertainment: If the protagonist lacks a goal, what keeps us involved? Of course, some novels and works of short fiction present narratives in which the protagonist has no apparent goal, and so do some art house films. But even though such "slice of life" stories may be interesting character studies or be admirable for some other artistic reason, the narration will usually feel flat because nothing is at stake. It is difficult for such works to attract an audience.

The clearer the goal, and the more daunting the obstacles that stand in the way of achieving it, the greater the drama. The very first storytellers—those who invented the ancient myths and who recited the epics of their culture's greatest heroes—understood the importance of goals and obstacles. Later storytellers, working in succeeding waves of media from classic theatre to television and everything in between, recognized the value of goals and obstacles just as clearly. And these fundamental story ingredients are just as useful in the creation of digital entertainment.

Games have provided storytellers with other valuable tools as well. From games, we learn that the most engrossing competitions are those that demand the most from a player—the most skill, the most courage, the most strategizing. Similarly, a good story demands that the protagonist give his or her all to the struggle. In an interactive work, the same demand is made on the user or the player. The greater the personal investment and the tougher the challenge, the more satisfying the ultimate victory.

Games also follow a set structure or format, though the specifics vary greatly among types of games. For example, a football game begins with a kickoff; a baseball game has nine innings; a basketball game is divided into quarters. No doubt, the first players of ancient sports soon found that without structure or rules, their games would quickly disintegrate into anarchy, and one side would use tactics that seemed completely unexpected and unfair to the other side. Structure and format provided an equally fair, consistent playing field to all players.

For the same reason, stories in every medium have a structure and format for how they begin, how they develop, and how they end. Furthermore, although stories don't follow set rules, they are guided by internal conventions. This ensures that behaviors and events within the fictional universe are consistent and logical and make sense within the story. Even a fantasy universe like the one portrayed in the Harry Potter novels, films, and games must remain faithful to its own internal set of rules. For instance, if it is established that characters cannot pass through physical structures unless they recite a secret spell, Harry or one of his classmates

should not suddenly be able to blithely walk through a wall without using the spell. That would violate the rules of magic already established in the story. Internal conventions provide a narrative equivalent of a fair playing field.

LEARNING FROM MYTHS

Contemporary storytellers, whether working in linear or interactive media, are also indebted to the great mythmakers of ancient days. These master tellers of tales built their stories upon themes with deep emotional and psychological underpinnings. As noted in Chapter 1, in many of these old stories, the main characters undergo a form of death and rebirth, sometimes in a symbolic way, sometimes in a more literal way.

In many myths, the young hero must triumph over a series of harrowing obstacles before finally reaching his or her goal. Versions of this myth can be found in the literature of cultures around the world. Joseph Campbell, introduced in Chapter 1, analyzed the core elements of the hero's journey in 1949 in his seminal work, *The Hero with a Thousand Faces*. He found that such myths contained characters that were remarkably similar from story to story, and that the myths contained extremely similar plot points. He held that the hero's journey tapped into the universal experiences shared by humans everywhere, reflecting their hopes and fears, and thus resonated deeply with the audience.

More recently, Christopher Vogler interpreted Campbell's work for contemporary readers and writers in a book called *The Writer's Journey*. The book profiles the archetypal figures who commonly populate the hero's journey—characters with specific functions and roles to play—and he describes each of the twelve stages of the journey that the hero must pass through before returning home with his prize.

The hero's mythic journey has had a deep influence on storytellers throughout the world. Countless works of linear fiction—novels, plays, comic books, and movies—have been built on the model provided by the hero's journey. Among them are the films made by the great filmmaker George Lucas, who has often spoken of his debt to Joseph Campbell and the hero's journey. Even the magnificent animated film *Spirited Away*, made all the way across the world, in Japan, closely follows the twelve stages of this ancient myth.

This enduring model works equally well for interactive narratives. For example, the immensely involving game, *Final Fantasy VII*, contains many of the elements of the hero's journey. And a number of MMOGs also contain aspects of it, as well. After all, as a player, you set off for a journey into the unknown, meet up with various helpful, dangerous, or trickster characters along the way, find yourself tested in all sorts of ways, and do battle against powerful opponents.

Do writers, producers, and designers of these interactive versions of the hero's journey deliberately use this genre as a model? In some cases, yes, this modeling is conscious and deliberate. For example, Katie Fisher, a producer/designer for the game company Quicksilver Software, Inc., is quick to acknowledge that she based the game *Invictus* on the hero's journey, and used Christopher Vogler's book as a guide. In other cases, though, the hero's journey is probably an unconscious influence. After all, it is a story that is familiar to us from childhood—even many of our favorite fairy tales are simplified hero's journeys. And many a

designer's most beloved movies are also closely based on this model, too, including such films as the *Wizard of Oz* and *Star Wars*. Obviously, elements in the hero's journey strike a deep chord within audiences both past and present. There is no reason why creators of interactive entertainment should not be able to find inspiration, as Katie Fisher has, in this compelling model.

LEARNING FROM ARISTOTLE

Mythological themes have provided fodder not only for our first narrative tales, but also for our earliest theatrical works. As noted in Chapter 1, rituals based on the myths of Dionysus led to the development of classic Greek theatre. Aristotle, one of the greatest thinkers of the ancient world, closely studied Greek theater, particularly the serious dramas, which were then always called tragedies. Based on his observations, he developed an insightful series of principles and recorded them in a slender, densely written volume, *The Poetics*. Though drafted in the fourth century B.C., his ideas have held up astoundingly well right up to the present day. The principles discussed in *The Poetics* have been applied not only to stage plays, but also to movies, TV shows, and, most recently, are finding their way into interactive narratives.

Aristotle articulated such concepts as dramatic structure, unity of action, plot reversals, and the tragic flaw. He also made perceptive comments about character development, dialogue, plot, and techniques of eliciting a strong emotional response from the audience. Furthermore, he warned against using cheap devices that would undermine the drama. One such device he felt was unworthy of serious theater was the *deus ex machina*, Latin for "God from a machine". This device was called into play when a writer was desperate for a way to get a character out of a predicament, and would solve the problem by having a god suddenly descend to the stage from an overhead apparatus and save the day. Aristotle decried such techniques and believed that plot developments should be logical and grow naturally out of the action.

One of Aristotle's greatest contributions to dramatic theory was his realization that the effective dramas were based on a three-act structure. He noted that such dramas imitated a complete action, and always had a beginning, a middle, and an end (acts I, II, and III). He explained in *The Poetics* (Chapter VII, Section 3) that "A beginning is that which does not itself follow anything by causal necessity, but after which something naturally is or comes to be. An end, on the contrary, is that which itself naturally follows some other thing, either by necessity, or as a rule, but has nothing following it. A middle is that which follows something as some other thing follows it. A well-constructed plot, therefore, must neither begin or end at haphazard, but conform to these principles."

Entire books have been written on the three-act structure, derived from this short passage, applying it to contemporary works of entertainment, particularly to films. One of the most widely used in the motion picture industry is Syd Field's *Screenplay: The Foundations of Screenwriting*. The book breaks down Aristotle's points and expands on them in a way that modern writers can readily understand. The three-act structure is so widely accepted in Hollywood that even nonwriters, professionals like studio development executives and producers, feel completely comfortable talking about such things as "the first act inciting incident," "the second act turning point," and the "third act climax."

The idea of the three-act structure has also found a place in interactive media, most noticeably in games. But it is used in other types of interactive entertainment as well, including virtual reality simulations, location-based entertainment, interactive movies, and webisodics. Of course, inserting interactivity into a narrative project impacts enormously on its structure, so additional models must be called into play. Often they are used in conjunction with the classic three acts first spelled out by Aristotle. (For a more detailed examination of structure in interactive works, please see Chapter 7.)

Aristotle also had valuable things to say about character motivation. He noted that motivation is the fuel which leads to action, and that action is one of the most important elements of drama. Just as the players' striving toward a goal is the driving force in a game, a character striving toward an objective is the driving force of a drama. Aristotle believed that there are two types of human motivation. One, he felt, is driven by passion and based on emotion. The other, he said, is based on reason or conscious will. In other words, one comes from the heart, the other from the head.

In interactive media, motivation is also of tremendous importance. It is what pulls the player/user through a vast universe of competing choices. By understanding motivation, we can create more compelling works of interactive entertainment.

Aristotle also believed that drama could have a profound effect on the audience, eliciting such emotions as pity and fear. The most effective dramas, he felt, could create a feeling of catharsis, or emotional purging and relief—the same sort of catharsis Joseph Campbell said occurred when people took part in a reenactment of a powerful myth. Creators of interactive works have not, as a rule, put much effort into trying to produce projects with an emotional punch. Today, however, more attention is being paid to this subject, and it will be discussed in more detail in Chapter 6.

LEARNING FROM CONTEMPORARY STORYTELLERS

When it comes to interactive entertainment, we can also learn a great deal from the creators of linear narrative, particularly from film and TV. These forms of entertainment already have great similarities to interactive media because they are stories told in moving images and sound, which is also how most interactive narrative is conveyed.

Two of the most important skills that can be ported over from film and television are character development and story construction. These are the fundamental building blocks of any type of narrative. Of course, they cannot be adapted without some adjustments, for interactivity has a profound impact on all aspects of the creative process. (Character development in interactive media will be more fully discussed in Chapter 6, structure in Chapter 7, and the creative process in Chapter 10.)

Having made the transition myself from television and film into the interactive field, I am well aware of how closely the techniques of character and story development used in one arena work in the other. For example, one of my first jobs in interactive media was as a freelance writer doing some work on Broderbund's pioneering *Carmen Sandiego* series, a game that had kids playing the part of a detective and trying to track down the thieving Carmen or one of

her henchmen. My assignment called for me to create four new characters for the game and to write dialogue for two of its already-established characters, the Chief of Detectives and Wanda, his assistant. These tasks were almost identical to work I might have done for a TV show, except that I had to write numerous variations of every line of dialogue. Thus, I found myself coming up with about a dozen different ways to say "you bungled the case."

Another early assignment had me working out an adventure story for children based on an idea by actress-producer Shelly Duvall. Called *Shelly Duvall Presents Digby's Adventures* and developed by Sanctuary Woods, the CD-ROM was a story about a little dog who goes exploring, gets lost, and tries to find his way home. It was the kind of tale that could have easily been a kid's TV show, except for one thing: this was a branching, interactive story, so the little dog gets lost in three completely different ways. Each version offers the player numerous opportunities to become involved in the dog's adventures and help him find his way back.

Aside from character development and story construction, what else can be borrowed from traditional storytelling? One excellent tool is humor, a great favorite in traditional media for at least as far back as the ancient Greeks. Just as movies and TV shows contain many different types of humor, so do works of new media. Among the possibilities are slapstick humor, screwball comedy, sight gags, verbal humor (puns, plays on words), character humor, political humor, spoof, satire, and off-color or scatological humor. Children's titles are frequently laced with comic touches, but even a gritty title like *Grand Theft Auto, Vice City* has its funny moments.

INCREASING TENSION

Other useful techniques that can be culled from film and TV include a cluster of devices to increase dramatic tension. One reliable method to do this is to put your main character (who, in interactive media, is often an avatar controlled by the player) into great jeopardy. He/she might be in danger of being attacked by enemy forces or be risking physical dangers such as falling off a cliff or being crushed by a rockslide. The jeopardy need not be something that could cause bodily harm... the risk of losing anything of great value to the protagonist can produce dramatic tension. Thus, the jeopardy could involve the risk of being rejected by a loved one or failing to solve an important murder case or being unable to secure a job promotion.

Dramatic tension can also be increased by introducing an element of uncertainty. Which of the characters that you encounter can you trust? Which ones are actually enemies in disguise? Which route through the forest will get you to your destination quickly and safely, and which one might be a long and dangerous detour? Uncertainty is a close cousin to suspense, which is the burning desire to know how something will turn out. It is the feeling of suspense that keeps us turning the pages of a novel until long past our bedtime, and keeps us glued to a television movie when we know we really should be paying bills or doing something similarly responsible.

One of the most adrenaline-heightening tools of all is the ticking clock, a well-known device from all kinds of stories. With a ticking clock, the protagonist is given

a specific and limited period of time to accomplish his goal. Otherwise he will suffer defeat and possibly even death. A ticking clock is an excellent way to keep the momentum of a story going. The ticking clock can even be found in children's fairy tales. In *Cinderella*, the girl has to get to the ball, dance with the prince, and return home before the clock strikes twelve, or else she will be caught in public in her humiliating rags. The ticking clock is also extremely familiar to us from the movies. Alfred Hitchcock and every other great filmmaker, and almost all of the lesser ones, too, have employed it to great effect. For instance, in a typical heist scenario, the protagonist and his buddies must open the safe, scoop up the money, and make their escape before the bank opens in the morning.

In interactive media as well as in movies, the awareness of time running out can increase one's heartbeat and make one perspire heavily. It is a device that keeps the players or users riveted to the material. That's why so many interactive games contain a ticking clock, or even a series of them.

A SCREENWRITER'S VIEW OF NEW MEDIA

Writers moving from the linear world of Hollywood screenwriting into the field of interactive media are often as struck as I was by the similarities in crafting scripts in these two seemingly antithetical arenas. A number of people interviewed for this book remarked on this. Among them was Anne Collins-Ludwick. Collins-Ludwick comes from the field of mainstream nighttime television and had worked on such successful television series as *Vegas*, *Fantasy Island*, and the mystery series *Matlock*. In 2002, she made a major career switch and became a scriptwriter and producer for Her Interactive, which makes the *Nancy Drew* mystery-adventure games. It was her first professional exposure to interactive media and she plunged in headfirst. In just a little over a year, she helped develop four new titles, including the recently released *"The Haunted Carousel."* (See Figure 5.1.)

"The parallels between what I do here and working on a weekly TV show are phenomenal," she told me. "Lots of the elements are just the same." Chief among them, she noted, were the development of characters and the story and the designing of the environments (though they are called "sets" in Hollywood). She also found the working conditions quite alike, especially the pressure of having to pump out a great deal of material under a tight schedule. "I found I knew everything I needed to know," she added. "It was just a different application."

For Collins-Ludwick, accustomed to the taut linear scripts of Hollywood, the one major difference was the way interactivity impacted on the story. "Giving the player choices was the hardest part for me," she recalled. "We want to give the players as much freedom to explore as possible, but we also want to relate a story. We need to move them from A to B to C." The challenge was to find a way to reveal the mystery while also offering the players a significant amount of choice, and to balance the need to tell a story against the need to give players the opportunity to explore.

The other big challenge for her, and what she considered to be her steepest learning curve, was mastering an interactive script format. She had to learn how to flag material so that once the player had performed a certain task, something could happen that could not have happened previously. For instance, if a player found a hidden letter, she could now ask a character an important question, or could enter an area that had previously been off limits.

Figure 5.1 Nancy Drew mystery-adventure games like *The Haunted Carousel* utilize many tools drawn from linear screenwriting.

"It was a lot to keep straight in my head; there was a lot of logic to get used to, and a lot of details. It's a matter of training your brain to think in a certain pattern," she said. But she was taken in hand and helped by a staffer with a great deal of technical savvy, and she also found that the company's thorough documentation process helped her keep track of things. "It's easy now," she reports, "but in the beginning it was very intimidating."

Max Holechek, the creative director of Her Interactive, also comes from the field of linear media, where he worked in TV, film, and audio production. Like Collins-Ludwick, he said that a great deal from his previous background comes in handy in the interactive world. For example, because of his background in audio, he was familiar with ways to effectively heighten the drama of a scene. He recalled a situation in a *Nancy Drew* title where audio was used to create a sense of spookiness in a night scene set in the woods. He said the company received many comments from players remarking on the scariness of exploring those woods at night, even though nothing actually happened there. Other techniques Holechek said he utilized from his previous life included lighting and camera placement—determining the most effective angle to show an object, character, or action.

Thus, a great many techniques used in established media also find a home in an interactive environment. Of course, many interactive works also include *cut scenes*—linear story segments that either introduce the work or advance the action, usually triggered after a player has reached a certain point within the material. These scenes are essentially no different from scenes you'd find in a movie or television show. Thus, any of the cinematic or dramatic techniques

employed in these older media can be used just as successfully in the cut scenes of interactive works.

OTHER NARRATIVE TECHNIQUES

Writers of linear dramatic narrative can typically convey information in only one of two ways: through dialogue or through action. But in interactive media, a number of other methods are also utilized. For instance, you want to give users some information about a character's backstory or motivation, or about events that transpired in the past. If you didn't want to do this through dialogue, you might insert the information in a journal, a series of letters, legal files, newspaper clips, or a diary—all things that users can discover as they investigate the virtual world of the story. Writing this kind of story material is much like writing fiction, and in such cases, techniques of short story writing or novel writing can be employed—another instance where tools from older media can come in handy.

Some projects require the presentation of factual information, and this material may be offered in either a text or audio format. Models from traditional media can be useful here, too. Writing nonfiction text for interactive projects is quite a bit like journalistic writing for newspapers or magazines, although text for a new media project often includes hyperlinks, especially if it appears on the Web. (For more on writing for the Web, please see Chapter 13.) Writing nonfiction audio scripts for interactive projects is no different from writing an audio script for a documentary film. Documentaries also serve as good models for conveying information visually instead of through words, and for pairing visual images to an audio track. Nonfiction audio scripts may be found in a variety of new media genres, particularly in training and in educational and informational projects, and the nonfiction segments are sometimes combined with story elements. (For more on such blends, please see Chapter 8.)

HOW MUCH STORY?

As we have seen, many techniques first developed for linear storytelling also work extremely well in interactive media. However, works of digital entertainment vary enormously when it comes to how much or how little story material they include. Some new media projects are pure games and contain no characters and no plot. At the other extreme, we have projects with richly plotted through lines, extremely well fleshed out characters, and even subplots. Given the fact that there is such a vast spectrum of interactive entertainment media, and a great variety of genres within each of the media, it is not possible to formulate a set of rules to govern the "right" amount of story that is appropriate for a given project. The best guide is the project itself.

As an example, let's look at a children's edutainment product like the enormously successful *JumpStart* titles, which are developed by Knowledge Adventure, part of the Universal Vivendi portfolio of game companies. The *JumpStart* products are lots of fun for kids, but their actual purpose is to drill the young users in specific skills they need to master at school, like multiplication or

spelling. The drills are incorporated into games that are so entertaining that they feel more like play than like learning. So where does story fit in here?

According to Diana Pray, a senior producer on the *JumpStart* titles, story is important to give the game a context; story drives the game toward a particular desired outcome. The *JumpStart* titles feature a cast of highly appealing animated characters, and, in a typical storyline, one or more of the characters has a problem, and the child's help is needed to solve it. "The story encourages kids to reach the end goal," she explained. "We give them enough story so they feel they are in the game. The storyline gives them the incentive to play the games and get the rewards. Incentives are embedded in the story. But kids want to play; they don't want a lot of interruptions. So we don't do very deep stories. We don't want to risk boring the child. We have to be efficient in the storyline."

Some projects can hold only a slender amount of story, even less than a *JumpStart* game, but still, the story that's there serves an essential function. This is the case with an experimental virtual reality (VR) simulation called *DarkCon*. It is being produced for the United States Army by the USC Institute for Creative Technologies (a research arm of the University of Southern California). *DarkCon* is part of the *SEE Project*, an endeavor by the Army to create effective ways of training military personnel by using digital media to put them in life-like situations, but without subjecting them to real danger.

The *DarkCon* simulation immerses the participant, a soldier, in a frighteningly realistic long-range surveillance mission (the name *DarkCon* comes from "dark reconnaissance mission"). The soldier's assignment is to observe members of a rogue Balkan paramilitary troop suspected of stockpiling illegal weapons. The mission is set in a dark culvert near a bridge and an abandoned mill. (See Figure 5.2.)

Writer Larry Tuch, who wrote the initial demo script for the *DarkCon*, compares it to a silent movie. It contains no dialogue, but it does have a great deal of action. And the lack of dialogue does not mean there is no sound; sound effects, such as dripping water or the scurrying of a rat, play an important role.

Figure 5.2 *DarkCon* is a VR simulation that utilizes many traditional screenwriting techniques.

The participant will even hear the sound of his own footsteps as he moves through the virtual landscape, and they'll match the terrain he's moving over—mud, water, gravel, and twigs. They'll also be synced up to his movements. If he runs, the footsteps will be quicker than if he's walking.

The realism of the simulation is further enhanced by something called a "rumble floor," which is the surface the participant walks over during his mission. The rumble floor vibrates when cued by certain events, such as a truck passing over the bridge.

The participant—the trainee-soldier sent on the surveillance mission—is the main character, and is equipped only with a red-lens flashlight. In a sense, the trainee acts as a computer cursor. By moving to position A, one type of response from the program will be triggered; moving to position B will trigger another. During the mission, the soldier must move closer and closer to the members of the rogue unit but avoid attracting their attention; otherwise the consequences could be fatal. There's also a stray dog whose barking could cause serious trouble.

Tuch, a professional screenwriter with a Hollywood television background, was called upon to create a context for the surveillance mission and a structural spine for it, as well as ways of ramping up the tension and the soldier's sense of jeopardy. He also scripted in a number of objects, events, and visual clues for the soldier to discover during the mission. One of them was a child's broken doll, which was possibly abandoned by a family of fleeing refugees. Another was a blood-spattered wall, possibly evidence of a slaughter. From his television experience, Tuch was used to developing stories with three acts, and used this model for *DarkCon*, though he said the third act was left open ended, without a resolution. The first act set up the mission and the second act introduced a series of complications, much like a typical Hollywood script.

Tuch has worked on several immersive environment projects for ICT and the Army, and finds that the major story points of these simulations generally revolve around making decisions and the resulting consequences. "Look," he said to me, "these aren't Harold Pinter plays, with subterranean rivers of emotions. This is the Army. You are going to find trouble, or trouble will find you." Although *DarkCon* might not contain as complex a story as a Hollywood movie, it does contain many important narrative elements: a protagonist, opponents, a goal, obstacles, a structural spine, and an increasing degree of jeopardy. It utilizes all the story elements necessary for the simulation to be gripping and effective. However, it is not burdened with additional elements that might seem cool but would not have served a useful function and could have just gotten in the way. (For more on *DarkCon*, see the section in Chapter 6 called "The Role of Emotion".)

As demonstrated by the *JumpStart* games and the *DarkCon* simulation, the demands of each project must be respected. When it comes to how much or how little story to use, or which narrative techniques to employ, the decision is based on how best to create an engaging project based on the nature of the project. In other words, you need to consider its goals, its intended audience, and the nature of the interactivity.

THE DISRUPTIVE IMPACT OF INTERACTIVITY

Even the most reliable tools borrowed from traditional storytelling can be troublesome to use in digital entertainment. What makes the difference, of course,

is interactivity. Unlike digital storytellers, traditional storytellers can hang their plot points and characters on a fixed linear through line. Once they determine the sequence of events for their narrative, everything stays firmly planted in one place. Not so with interactivity. A fixed sequence of events is impossible when you offer users the freedom of choice. And without the ability to order scenes in a specific way, as you do in a novel or a play or a film, how can you build a narrative?

Interactivity impacts every single aspect of traditional storytelling. For example, interactivity makes it more difficult to construct complex characters and give them an arc. Without a fixed sequence of events, how do you reveal a character's flaws, needs, and special gifts? How do you show the character changing and growing? How can you even produce a vivid portrait of your protagonist when that character might never even be seen, because your user has stepped into that character's shoes and has "become" your protagonist?

The lack of a fixed sequence also makes it difficult to reveal key pieces of information in an incremental way and at an optimal time. This can obviously be a big problem in a mystery or character drama, but also makes for difficulties in almost any kind of story. And how do you ratchet up the spookiness of a scary story when you can't control when the player will see the shadowy figure outside the window, or hear the scurry of footsteps on the roof, or find the dead dog in the refrigerator? Building up to any type of dramatic climax is more challenging when you don't have a fixed sequence.

Obviously, creators of interactive entertainment have found ways to deal with the lack of fixed sequence. We will be exploring many of these techniques in succeeding chapters.

TEN NEW TOOLS

Although many well-seasoned tools of traditional storytelling can, with certain modifications, still be used in new media, working in this arena also requires utilizing some entirely new tools. We'll be looking at ten of the most important of them, all unique to interactive media.

But before learning how to use these new tools, something else has to happen: an attitude adjustment. In order to create digital entertainment, we must release our mental grip on sequential narrative and be open to the possibilities interactivity offers us.

This is not only true for those coming from traditional linear media, as Anne Collins-Ludwick did, but also applies to anyone who has grown up watching TV and movies. It can be less of an issue for those who, from childhood on, have played video games or surfed the Net. But even members of this group might find they have some mental resistance to nonlinear storytelling. The reason for this resistance may be that the need to control narrative is hard wired into the human brain. Could this be true? Dr. Daniel Povinelli, a psychologist from the University of Louisiana, believes it is. He theorizes that the human species has an inborn impulse to connect the past, present, and future, and in doing so, to construct stories. As reported in the magazine of the *Los Angeles Times* (June 2, 2002), Dr. Povinelli feels this ability differentiates humans from all other animals and gives our species a unique advantage. For example, it would enable us to foresee

future events based on what has happened in the past; it would give us the ability to strategize; and it would help us understand our fellow human beings and behave in a way that is advantageous to us.

If Dr. Povinelli is correct about our impulse to tell linear stories, that would help explain why some of us have difficulties creating nonlinear ones. As one producer of interactive media recently confided to me, she was continually frustrated by the fact that the writers she hired for her Mattel Interactive projects could not grasp the special nature of nonlinear media. They just didn't "get" interactivity and couldn't function in a nonsequential story world.

But, assuming that one is able to make the adjustment, it is still necessary to become comfortable with ten major tools of interactivity. These tools will be discussed in more detail in succeeding chapters, but in the meantime, here is a brief rundown:

1. Interface and navigation: The players/users/participants of an inter-active work need a way to connect with the material, control it, and move through it. They cannot just passively sit back and let the story come to them, as they would if watching a movie or TV show. Here they have an active role to play, but exactly how do they participate? This is where interface design and navigational tools come in. They provide a way for people to understand how the program works, and give them a way to make their wishes known and control what they see and do. The many visual devices used in interface design and navigation include menus, navigation bars, icons, buttons, cursors, rollovers, maps, and directional symbols. Hardware devices include joysticks, touch screens, and VR wands.

2. Systems for determining events and assigning variables: In order for the events within an interactive project to occur at an appropriate time, and not have the narrative self-destruct into chaos, there needs to be an orderly system of logic that will guide the programming. Most members of the creative team are not expected to do any programming themselves, but they still must understand the basic principles governing *what* happens *when*.

 Logical systems that determine the triggering of events are often called algorithms. They determine such things as what the player needs to do before gaining access to "X" or what steps must be taken in order to trigger "Y." Algorithms are a little like recipes, but instead of the ingredients being foods, they are events or actions. For instance, an algorithm for opening a safe may require the player to find the secret combination for the lock, get past the growling guard dog, and dismantle the alarm system. Only then can the safe be opened.

 Logic in interactive games is often expressed in *if/then* terms. If the player does "A," then "B" will happen. Another way of expressing the steps needed to trigger an event is through *Boolean logic*. Boolean logic is based on only two variables, such as 0 and 1, or true and false. A string of such variables can determine a fairly complex sequence of events. Boolean logic can be regarded as a series of conditions that determine when a "gate" is opened—when something previously unavailable becomes available, or when something previously undoable becomes doable. Boolean logic is also used to do searches on the Web.

Typically, an interactive project involves a great number of variables—types of characters and their attributes, weapons and what they can do, and so on. Sometimes it is useful to construct a *matrix*, a table-like chart with rows and columns, to help assign and track the variables. For instance, when I worked on the *Carmen Sandiego* series and was writing a list of clues to help identify various suspects, I was given a matrix to use. It organized the variable characteristics of the suspects by categories, such as hair color, eye color, favorite hobbies, favorite sport, and favorite foods, and then listed all the possibilities for each category. I was to write four clues for each variable.

3. The role of the user: In a work of interactive entertainment, the "audience member" becomes an active participant. Users have many possible roles they can play. Sometimes they become the major character in the story, as they do in the *Nancy Drew* series, where the player takes on the part of Nancy herself. Sometimes they are called upon to act as a helper to one or more members of the fictional cast, as children do when they play the *JumpStart* games. Sometimes people play as themselves, as the soldiers do who participate in the *DarkCon* simulation. A number of other possibilities exist as well: You can be a voyeur, a playmate, a pal, or even a deity-like figure. In addition, many projects are constructed to allow many people to participate simultaneously, which adds a further dimension of complexity.

4. New types of characters: Thanks to new media, a strange new cast of character types has sprung into being. Among them are avatars, bots, and chatterbots. In some cases, digital characters have artificial intelligence: they seem to understand what the player is doing or saying, and act appropriately in response. Characters in digital media are either under the control of the player or under the control of the computer. In either case, the way they are developed and given personality calls for considerations never encountered in linear media.

5. New ways of combining media: In linear entertainment, the various media elements—audio, graphics, moving images, and text—come "glued" together and cannot be pried apart, but in interactive media, media assets can be presented or accessed as separate entities. This is readily apparent in projects designed for the Web, CD-ROMs, and DVDs, where users can choose whether to read text, hear one of several audio tracks, or select a still or moving image to see. The elements within a frame need not be static either; a portion of the frame may contain a continuously scrolling series of images or text. Furthermore, the user/player can trigger a media asset to be seen or heard—a sound effect, a little animation, or a line of dialogue.

6. The use of puzzles, mini-games, and other activities: In order to reach the end goal of an interactive work, users must often solve puzzles, answer trivia questions, or play a series of mini-games. They may also be offered the opportunity to engage in amusing pursuits not directly linked to the end goal, such as dressing the character up in a new wardrobe or reading a character's deleted email.

7. Rewards and punishments: Rewards are an effective way to keep participants motivated. They may be in the form of points, play money, or a valuable object for one's inventory. Players may also be rewarded

by rising to a higher level, getting a career promotion, or receiving extra powers for their avatars. Penalties and punishments, on the other hand, keep players on their toes, and add an agreeable level of tension and excitement. The ultimate punishment, of course, is a virtual death.

8. New building blocks: Most forms of linear narrative use the same basic building block or unit of organization: the scene. Each scene is set in a specific location, calls for a specific group of characters, and allows specific actions to take place. Scenes move the overall story along, but are also complete little dramas in themselves. They even have their own miniature three-act structure. Interactive media, however, uses very different units of organization. They may be called environments, worlds, modules, levels, or Web pages. Each of these units offers a specific set of possibilities—things the user can do or discover within them.

9. The use of time and space: Time and space are far more dynamic factors of interactive narration than they are of linear media. Games may present a persistent universe, where time moves on and events occur even when the game is turned off. This requires more alertness from the players/users. For instance, a virtual pet might need to be fed and cared for on a regular basis; if neglected, it could die. Or by not logging onto the MMOG you've subscribed to, you may forego the opportunity to take part in an exciting adventure. In a different use of time, the interactive medium may keep track of things like holidays and important anniversaries in your personal life. For instance, a smart doll may wish you a happy birthday or a Merry Christmas on the appropriate dates.

 In many fictional interactive worlds, time is cycled on a regular basis, so that during a single session of play, you might experience dawn, the midday sun, and sunset. You might also experience different seasons of the year, and sometimes the changing of a season will trigger a dramatic event in the story. In some games, you can slow down time or speed it up.

 Geographical space is experienced on a different scale and in a different way in interactive media than in linear media. Some games contain multiple parallel universes, where events are going on simultaneously in more than one place. If you leave the universe you are currently in to travel to another one, you will miss out on events that are taking place in the one you just left. The geographical scope of a game can be vast, and it can take hours or even days for the player to travel from one point to another.

10. Sensors and special hardware: Certain forms of interactive entertainment require sensors or other devices in order to simulate reality or control or trigger events. For example, a smart doll might have a built-in sensor that can detect light and darkness. When it grows dark, she might tell her owner that she's sleepy and wants to go to bed. In a VR installation, visitors need to don a special head-mounted device or stereo glasses in order to see the images, and use a wand to control virtual objects. Other devices include scent necklaces, rumble floors, and moving chairs. As a member of the creative team of a project

that uses sensors or other special hardware, you will need to know enough about what the devices can do so that you can use them effectively in your project.

THE COLLABORATIVE PROCESS

Working with an unfamiliar and complex set of tools—even a single new tool—can be an anxiety-producing experience. For someone who has never worked in interactive media, the first exposure can be something of a culture shock. Fortunately, professionals in interactive media seldom work in a vacuum. It is not a field populated by hermit-like artists slaving away in lonely garrets. On the contrary, it is a field that almost evangelically promotes the team process. Colleagues are encouraged to share ideas in freewheeling brainstorming sessions. Even staffers low on the totem pole are encouraged to contribute ideas. Since almost every company has its own idiosyncratic methods of operating, newcomers are taken in hand by veterans and shown the ropes.

Take, for example, the experience of Anne Collins-Ludwick, who came from the highly competitive, dog-eat-dog world of prime time television. She was immediately struck by how different the working conditions were when she first began her job on the *Nancy Drew* titles for Her Interactive. "This is one of the most collaborative works of fiction I've ever been involved with," she reported enthusiastically. "It was collaborative from Day One, when I was first brought into the game." At many software companies, Her Interactive included, a project is developed by an entire team rather than by a single individual. The team typically includes specialists from several key areas, such as game design, project management, art direction, and programming. Thus, no one person has the burden of having to be an expert in every facet of the project.

CONCLUSION

Interactive entertainment utilizes an array of tools, some drawn from extremely ancient sources, others from contemporary linear storytellers, and still others that are unique to new media.

From games, we have learned how important it is to have goals, obstacles, and internal conventions. From myths, we have learned to tap into universal life experiences, hopes, and fears. And from Aristotle's observations of Greek drama, we learned about the three-act structure, character motivation, and the arousal of the participants' emotions. From storytellers in linear media, we can borrow a number of techniques of story construction, character design, and ways of increasing dramatic tension. We can also look to linear media for ideas about using humor in all its varieties.

Nevertheless, we must go beyond these sources in order to create stories in digital media, because here we have an entire array of new tools we must learn to use. Often, the greatest challenge in using them is overcoming the discomfort of working with something unfamiliar to us. Depending on our mindset, the chance to pick up these new tools and figure out what to do with them can either be exhilarating or intimidating.

But, as Collins-Ludwick and others have been pleased to discover, digital entertainment is an enormously collaborative field, and even when the learning curve is steep, newcomers will usually get the help they need from their teammates.

IDEA-GENERATING EXERCISES

1. What technique used in traditional storytelling do you think is most similar to something you can use in interactive entertainment? Can you describe how, if it all, this element must be handled differently in an interactive project?
2. What aspect of traditional storytelling do you believe is the most difficult to port over to interactive entertainment? What about it do you think makes this so difficult? Have you seen any interactive projects that have found a satisfactory solution to this? If so, describe how it was handled.
3. Pick an interactive project that you are familiar with, and describe what was built into this material that would make a user or player want to invest their time in the project. What would keep them interested and involved?
4. Which of the ten tools unique to interactive storytelling do you feel is the most challenging or intimidating? Why do you feel this is so?
5. Which of the ten new tools do you feel is the most creatively exciting? Can you describe something you'd like to try to do with this tool?

CHAPTER **6**

Characters, Dialogue, and Emotions

What are some of the most effective techniques of creating characters for interactive media?

Why is it worthwhile to give time and attention to creating your bad guys?

How does interactivity affect the way characters communicate with us?

What can you do to increase the participant's emotional response to an interactive work, and why is this matter even worth considering?

ENDURING CHARACTERS

Vivid new characters from computer games—characters like Mario, Sonic the Hedgehog, Lara Croft, Freddie Fish, and Carmen Sandiego—have begun to take their place alongside other icons of popular culture like Dick Tracy and Mickey Mouse. The day may not be far off when a character created for a website or a wireless game joins their ranks. Already at least one character from the world of smart toys has achieved celebrity status—the furry space alien who goes by the name of Furby.

In the short time that interactive entertainment has existed, it has proven that it is capable of producing enduring characters, characters who have what it takes to become household names and to sell everything from plastic action figures to lunch boxes. But even digital creations that don't manage to attain this level of success can be an enormous asset to a project. Here are some of the things they can do:

- They can attract a large and dedicated group of users, even drawing people to a project who might not ordinarily be interested in interactive entertainment.
- They can increase a project's perception of being fun or fascinating, even if the underlying purpose of the project is educational or instructional.
- They can give people entry into an unfamiliar or intimidating world and allow them to explore it in a way that feels comfortable and safe.
- They can keep people hooked, willing to spend hours immersed in the character's life and environment.

Are characters really that essential to an interactive project? Richard Vincent, for one, believes that they are. Vincent is president of the Montreal-based software company, Kutoka Interactive, which makes edutainment titles. In 1998, Kutoka created an original character named Mia, a fetching little mouse with enormous eyes and a perky, can-do personality. (See Figure 6.1.) Mia has become an international hit, available in 40 countries and 12 different languages. She's helped Kutoka win 70 national and international awards. The little mouse will soon be starring in her own TV series, making the leap from games to linear entertainment.

"Games really end up being about character," Vincent asserted. "If people don't identify with the character, they won't play it. I admit in the beginning I wasn't thinking like that; I wasn't thinking characters were that important," he told me. But the success of Mia convinced him of the important role characters play, and the company has changed its preproduction process accordingly, devoting time to preparing a complete bible of all the characters, their personalities, and their worlds.

Characters aren't just important to games; they play an equally important role in other forms of digital entertainment, from smart toys to immersive environments to iTV projects. One of the truly unique aspects of digital characters, as opposed to characters created for movies or traditional TV, is that you don't just *watch* them; you can actually *be* them. Or, at the very least, you can *interact* with them. And if you can create a main character that a great number of people really want to be or interact with, you probably have a winner. After all, why is it that so many people love the *Tomb Raider* games? Is it their interest in archaeology?

Figure 6.1 Mia, created by Montreal-based Kutoka Interactive, has captivated kids around the world. Image Courtesy of Kutoka Interactive.

No, of course not. Is it a chance to fight exotic villains or contend with ingenious obstacles? Well, that's part of the fun. But the primary reason people love the games is because they love Lara Croft. Lara not only leads an exciting life, but she's rich, beautiful, brave, and a phenomenal athlete. Lara is a great aspirational figure for girls, and, as a plus for the guys, well, she's plenty sexy. (See Figure 6.2.)

Figure 6.2 Lara Croft in a screen capture from *Lara Croft Tomb Raider: The Angel of Darkness*. Lara Croft exemplifies the enormous drawing power of a well-conceived character. Image courtesy of Eidos Interactive.

WHERE DID ALL THE CHARACTERS GO?

If good characters add so much appeal to a work of interactive entertainment, how can it be that some immensely popular games don't have any characters at all? After all, the world's oldest commercial computer game, *Pong*, consisted of only a ball and paddle, yet it was such a hit that it triggered a massive interest in computerized entertainment. *Tetris*, an ever-popular puzzle game, lacks characters, too. And so does the simple but addictive wireless game, *Snake*. In *Snake*, you try to lengthen a skinny snakelike shape by "eating" dots, but if you bump into the frame of the screen, it's game over.

True, none of these games has characters; nor do a number of other popular digital contexts. But they all have something that linear media lack: players. Players actually share many of the qualities possessed by protagonists in linear works, and to a great degree fill in for a missing main character. They are active; they strive for a goal; they are challenged by obstacles. Furthermore, they are personally invested in the outcome of the game. Their actions, not those of a fictional character, will determine how things turn out. This is an entirely different situation from traditional narrative works, where it is only possible to watch the action from the sidelines.

A virtual reality simulation without characters can be gripping for the same reason. For example, let's imagine an immersive jungle environment, and in this jungle, your assignment is to find a rare orchid with valuable medicinal properties. Yet the jungle is also home to venomous snakes and spiders, choking vines, and hungry alligators. Such a simulation could offer plenty of excitement, even if you were never to encounter a single character. As with a game, you, the user, have a clear-cut goal, you face significant obstacles, and the choices you make will determine the success or failure of your mission. If you were to take away the user, though, what would you be left with? Not much of anything. It is the user who brings an interactive construct to life. Users have a pivotal role in all works of digital entertainment, and they introduce special challenges as well.

THE ROLE OF THE USER

Who the user "is" as a character, and what the user can see and do in this role, becomes an extremely complicated affair in interactive media. As we saw in Chapter 4, it's not even easy to come up with a universal word to call someone who interacts with digital material. Player? Visitor? User? Participant? Interactor? And not only do we have a basketful of possible terms, but we also have a great number of possible ways these individuals can interact with the content. They can move through it in a virtual fashion, by controlling the action on a screen, or move through it physically, as one does in an immersive environment. It can be a solo experience in one's home, or it can be a group experience with other flesh and blood individuals in a theatre. Or it might be a community experience that takes place in cyberspace.

And then there is the question of the part you play while engaging in this activity. In some interactive experiences, you step into the role of the protagonist and "become" the main character in the drama. In other instances, you play the assistant or helper of the main fictional character and help this character

reach a particular goal. Who are you in a case like that? You might be thought of as a sidekick, but you could also claim to be the protagonist, since your actions will determine how things end. Sometimes you become a deity-like figure, controlling the destiny of a virtual world, or of your particular piece of it. Sometimes you become a voyeur, and have the ability to spy on the characters in a story. As still another possibility, and quite a common one, you just play yourself.

The amount of control a player/user/participant has over the material also varies greatly. Sometimes the control is limited to choosing which block of material to view, as is true in an interactive storybook or on certain websites. Sometimes one can explore an interactive environment freely, but has limited ability to determine what will happen within it. But sometimes one has maximum control, especially when one is the protagonist, and can manipulate where the character goes, what it does, and what it says.

POINT OF VIEW

One of the most unique aspects of interactive entertainment is its use of point of view (POV). The player/protagonist has two, or possibly three, very different ways of experiencing the interactive material: via the first-person and third-person POV. Some would argue that there is a second-person POV as well.

With a first-person perspective, we see the action as if we were actually right there and viewing it through our own eyes. We see the world around us, but we don't see ourselves, except for perhaps a hand or a foot. It is the "I"experience... I am doing this, I am doing that. It is much like the way we experience things in real life. For instance, I don't see myself as I type on my computer, though I can see my hands on the keyboard. This is the same way first-person perspective works in interactive media. It is how we experience an immersive environment, simulations, a first-person shooter game, and many other types of interactive situations. (See Figure 6.3.)

With the third-person POV, we are watching our character from a distance, much like we watch the protagonist in a movie. We can see the character in action, and can see their facial expressions, too. (See Figure 6.4.) Cut scenes show characters from the third-person POV, and when we control an avatar, we are observing it from this POV as well.

Some professionals in the field also contend that a number of interactive works offer a second-person POV as well, a view that combines the intimacy of first person with the objectivity of third person. In a second-person POV, they hold, we largely see things as if we were really in the scene, but we also see a little of our avatar—the back of the head, perhaps, or a shoulder. It's almost like being right on top of your character, but not "inside" the character. Others would argue that the so-called second-person POV does not actually exist, but is actually a variation on the third-person POV.

The first- and third-person POVs each have their advantages and disadvantages. The first-person perspective gives us great immediacy and immersiveness. However, we never get to see what our characters look like and cannot watch their reactions. It's also difficult to portray certain kinds of actions with the first-person POV. How can you show the character drinking a glass of water, for instance, or hugging another character? The third-person POV allows us to see the character's

Figure 6.3 With a first-person POV, as in this example from *Thief*, we do not see the character we are playing, except perhaps a hand or a foot. In this screen capture, the character we are playing is holding a sword. Image courtesy of Eidos Interactive.

movements and facial expressions, but because the character is so well defined visually, it is more difficult for us to identify with it. Thus, it can create a sense of disconnect between the user and the material.

Many interactive works try to get around the perspective problem by offering different POVs in different situations. They give the user the first-person POV

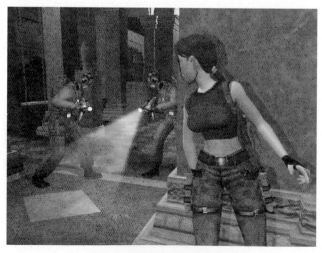

Figure 6.4 In a third-person POV, as in this screen capture from *Lara Croft Tomb Raider: Angel of Darkness*, we can fully see the character we are playing, much as if we were watching a movie. Image courtesy of Eidos Interactive.

for the most adrenaline-intense action scenes, and use the third-person POV for exploratory situations. However, the jump between the different perspectives can be jarring.

Determining which point of view to use for your project is an important decision, and one that must be made early on, because so many other factors will be impacted by it, from character design to types of interactivity.

THE TWO CLASSIC ARCHETYPES

Let's now turn to the basic character types of traditional storytelling, and see how these models might serve us in interactive media. The two classic characters, the must-haves of every work of linear storytelling, originated in the classic Greek theatre. The first is the protagonist, our hero. This character is the central figure of the drama, whose mission, goal, or objective provides the story with its forward momentum. The second is the antagonist, the adversary who stands in the way of the protagonist, and whose opposition gives heat to the drama and provides the story with exciting conflict.

For anyone who might still have a lingering doubt about the critical role competitive games have played in the origin of drama and storytelling, consider this: The words "antagonist" and "protagonist" are both formed around the same Greek root, *agon*. As mentioned in Chapter 4, the word *agon* means a contest for a prize at a public game. The protagonist is literally one who goes after the prize and the antagonist is the one who tries to prevent this; their struggle is the core of the story.

In works of linear storytelling, the protagonist is the character the audience is rooting for. Audience members invest their emotions in the protagonist's struggle and want to see this character succeed. In an interactive work, the emotional investment is often even greater, for in many cases, the protagonist and player are one and the same. A protagonist in an interactive work can give the player an opportunity to live out a fantasy by virtually walking in that character's shoes. It's a chance to do something that would be too dangerous or too expensive to do in real life, or to have an experience that would be impossible, such as traveling to a different time zone or visiting outer space.

CHARACTERISTICS OF THE PROTAGONIST

As we have learned from traditional media, a protagonist need not be a saint. After all, Tony Soprano in the HBO series, *The Sopranos*, is hardly a man of virtue. He's the head of a Mafia family, a murderer and a philanderer, and yet is unquestionably the protagonist of the series. It is easy to find tarnished protagonists in interactive media as well; we need look no further than the enormously success-ful video game *Grand Theft Auto: Vice City*. Our protagonist here is Tommy Vercetti, also a Mafioso, and one who delights in causing mayhem. Some protagonists aren't even human beings. In recent movies, we've had fish (*Finding Nemo*), toys (*Toy Story I* and *II*), and vampires (*Interview with the Vampire*). And in interactive media, we've got fish again (*Freddie Fish*), dead people (*Grim Fandango*), and more vampires (*Vampire: the Masquerade*).

Many authorities in drama, beginning with Aristotle, have contended that the most interesting characters are not perfect. In classic Greek theatre, as with Shakespeare's plays, the main characters are afflicted by what is often termed "a tragic flaw." Though noble in many ways, they also possess some weakness—jealousy, self-doubt, ambition—a trait that leads to their undoing. In lighter stories, protagonists usually have flaws, too, though of a less serious nature. These dings in their personality will not lead to tragic consequences, but will often cause them trouble, and can also be the source of comic moments. Not every protagonist in interactive media has a flaw or a quirk, but such weaknesses are not uncommon. After all, even the little mouse, Mia, has a foible: She is an enormously curious creature, a trait that lands her into trouble.

What all protagonists do need are qualities that make them likable, believable, and attractive enough for you to want to spend time in their company. We need to understand why they have chosen to go after the particular goal they are seeking—their passion to do this must make sense to us. After all, we must be able to identify with them. In other words, we need to be able to imagine ourselves in their position and feel what they are feeling. This becomes even more important in interactive media, where in so many cases, we actually take on the role of the protagonist. If the main character is distasteful to us, or if the character's motivation baffles us, we are not going to want to invest our time in this particular work of digital entertainment.

THE ANTAGONIST

While it is impossible to conceive of an interactive work without a protagonist, or at the very least, without a player/participant, can the same be said for the necessity of an antagonist? Is it essential to include an oppositional character or series of them in every work of digital entertainment?

In order to answer this question, you must first consider the nature of your project. Where does it fit within the overall entertainment spectrum, where on one end we have stories and games, and on the other end, free-form experiences? If it leans more toward the free-form end, you probably won't need an antagonist. Such projects tend to be more like unstructured play (activities involving smart toys, for example) or offer the user the opportunity to construct items with digital tools (artwork, simulated neighborhoods, or a doll's wardrobe). Activities like these can be quite engrossing without inserting an antagonist; in a sense, the challenges they offer serve the same function. Even so, however, some users feel the need to create story-like narratives in these interactive environments. Children will often invent a story for their smart toy that involves some kind of conflict, and there have been reports of this sort of thing happening with *The Sims*, where users have constructed imaginative scenarios involving adversaries, creating an obnoxious Mr. Jones down the street, for example. For the most part, however, antagonists can be an unwelcome and disruptive presence in projects that are on the free-form end of the spectrum, unless they are supplied by the users themselves.

On the other hand, interactive experiences that have clear-cut goals, obstacles, and the other hallmarks of games, or that aim to offer a more story-like experience, will definitely require oppositional forces. Most frequently, these forces will be

characters. However, opposition can also come from natural forces, such as violent storms, or from physical challenges, such as negotiating a boot camp obstacle course. Opposition may also come from nonhuman threats, such as the spiders, snakes, and alligators in the mock jungle simulation sketched out earlier.

While nonhuman forces or obstacles may successfully serve as the sole form of opposition, it is generally true that the use of opposing forces in the form of characters will make the conflicts more dramatic and more "personal." Being pitted against a sentient opponent will ratchet up the participant's feeling of danger and jeopardy. An opponent who is capable of reason and strategy is far more formidable and far scarier than any inanimate obstacle can be.

Even games made for young children, like the *JumpStart* titles discussed in Chapter 5 and the Kutoka titles mentioned earlier in this chapter, usually include villains of one kind or another. The opponents in projects for young children tend to be humorous bad guys, rather than the truly menacing opponents that are found in works for older groups. For instance, one of the bad guys in the *JumpStart* line is a certain Dr. O, a snail who defaces buildings in JumpStartVille. Senior producer Diana Pray described him to me as "spineless, armless, slimy and silly, sort of a family-friendly villain." She told me that research had shown that kids really like to have bad guys in their games, and that parents didn't mind as long as the characters weren't evil. As with *JumpStart*, the bad guys in the Kutoka titles are done with a light touch. In the new *Didi and Ditto* game, the antagonist is a wolf, but not a vicious, carnivorous one. This wolf happens to be a vegetarian, and he's a little embarrassed about his unusual food preferences.

Even humorous opponents fill an important function:

- They help sharpen the conflict.
- They supply obstacles.
- They pit the protagonist against a force that is easy to comprehend.

CREATING WORTHY OPPONENTS

Just as the time spent developing your protagonist pays off in a more engaging product, so does the time invested in creating your antagonists. Well-drawn antagonists can give your work depth and richness. This is especially true if you are able to break away from stereotypes and create new kinds of antagonists. In interactive media, opponents are almost always violent and evil characters who cannot be overcome except by the use of physical violence. But is it inevitable that they must follow this model?

Keep in mind that in linear media, we can find very different kinds of opponents. Sometimes they are quite nice individuals who just happen to cause the protagonist a great deal of trouble. This is typically the case in a romantic comedy, where the protagonist's love interest is the opponent and a major source of conflict, yet otherwise a highly attractive individual. In domestic dramas, too, the protagonist is usually pitted against a mostly decent, likeable person, often a parent or spouse or other family member. Such adversarial relationships are the staple of novels, independent films, and television sitcoms and soap operas. They demonstrate that opponents do not have to be villainous or pose a physical threat in order to be compelling.

Here are a few other factors to keep in mind when you are creating an opponent for your protagonist:

- For maximum sizzle, make your antagonist and protagonist evenly matched. If your opponent is too menacing or overpowering, the protagonist's struggle will seem hopeless, and the participants will be tempted to give up. On the other hand, if the antagonist is too weak or soft, the player will lose interest, perceiving the struggle as unchallenging.
- Provide your antagonist with an understandable motive to explain what is compelling this person to block the hero's way. The more intensely motivated the antagonist, the more dramatic the story. The reason for opposing the protagonist must seem logical, at least to the opponent, and must seem justified.
- In certain genres, such as mysteries and detective stories, you don't want to reveal the identity of the ultimate antagonist until the end. However, you will still need to do some foreshadowing to indicate who this character might be, or else players will feel cheated. Thus, you will want to lay in bits of information pointing to this character and his or her motivation, though without giving things away prematurely.
- In cases where you are not trying to conceal the identity of the antagonist, remember the old saying "Know thy enemy." The more the hero knows about the opponent, and the more the opponent knows about the hero, the more interesting the battle will be. It will be more personal, and it may also be more clever. For instance, if your bad guy knows your heroine is desperately frightened of spiders, he might try to lure her into a basement filled with spiders. Or, if your heroine knows the villain has a passion for antique cars, she may use an antique car as a lure to snare him.

A MULTIPLE NUMBER OR SUCCESSION OF ANTAGONISTS

In some interactive works, the protagonist might be pitted against multiple opponents, one after another. Or, in a mystery, the protagonist might encounter a number of suspects, each of whom might be the one "who done it." In both such cases, you will have a far more interesting project if you make each of these opponents unique and intriguing. Often, the creative team will cut corners in this area, and offer a series of opponents who are practically indistinguishable from one another.

The legendary game designer Ernest Adams, in an article for *Gamasutra*, the game developer's site (*www.gamedevelopers.com*), complained about outer space war games that were guilty of this. He noted that games about aliens, particularly the ones about "bug-eyed monsters," all tended to be alike. "Either we want their planet or they want our planet; they're trying to assimilate us or we're trying to wipe them out," he said. "War games about aliens are usually about as subtle as a can of Raid."

Unfortunately, many other types of games share this tendency. All too many feature a stream of look-alike creatures who seem to be stamped out of the same batch of cookie dough. However, this need not be the case. The creative team of

Figure 6.5 Vesuvius, one of the Sentient Warriors in *FightBox*, each of whom has a particular set of characteristics.

the *Nancy Drew* games, for instance, goes to great lengths to develop multidimensional suspects for each of their mystery titles. Creative director Max Holechek told me that they make sure they each have an individual point of view and voice.

Even projects that revolve almost entirely around physical combat can offer more than the equivalent of "bug-eyed monsters." For instance, take a look at *FightBox (www/bbcfightbox.co.uk/)*, the BBC TV show/website-game competition first mentioned in Chapter 3. In this project, the virtual characters created by members of the general public have to fight against a cast of in-house characters called "Sentient Warriors." These bad-guy cast members are hardly look-alikes. The developers have worked out a unique personality, appearance, and fighting style for each of them, and have also figured out their backstories and their relationships with other fighters. The character Vesuvius, for instance, looks like he's made of glowing chunks of lava; he's an aggressive, hot tempered contender and fights with fire. (See Figure 6.5.) Banshi, on the other hand, prefers hiding in the shadows until it's time to attack, and when she does, she's likely to hurl spines at her intended victim.

UNIQUE DIGITAL CHARACTERS

Many of the same types of characters found in linear stories also make their appearance in works of interactive media. In both, you will not only find protagonists and antagonists, but various kinds of supporting characters as well. But interactive media also contains an assortment of character types that are unknown in traditional entertainment. All digital characters can be placed in one of two broad categories: those that are under the control of the player or user (player characters,

or PCs), and those that are operated by the computer (nonplayer characters, or NPCs).

PCs often appear on the screen in the form of an avatar—a graphic representation of the character. The avatar's movements and choices are determined by the player. Sometimes the avatar is prerendered, but in many cases, the players can construct their own characters out of a selection of heads, body parts, and attributes, which will then appear on the screen or become part of their persona. The make-it-yourself avatars are extremely common in MMOGs and in many video games, and are also used for the player-controlled warriors in the *FightBox* games. As a third possibility, players can sometimes pick their character from several possible prerendered choices.

However, PCs are not always visible on the screen. Sometimes they are represented only by a cursor, as with the *Nancy Drew* titles—here the cursor is Nancy's magnifying glass, which serves as her stand-in, indicating what Nancy is investigating in the scene. In still other cases, the player may actually be physically present in the digital experience, for example, when interacting with a smart toy or participating in VR installation.

NONPLAYER CHARACTERS

NPCs, as with player-controlled characters, come in many varieties. Sometimes they behave much like the equivalent characters in linear works, particularly in the cut scenes of a game or an interactive movie. But in interactive sequences, they take on far more expanded capabilities, and sometimes an NPC might make an appearance in a way we would never find in a linear work. For instance, we might have a little animated character pop up on a field of text and "speak" to us via comic book-like voice bubbles, or an NPC may behave like a virtual guardian angel, looking after our welfare.

A special group of NPCs are the bots (short for robots), who may not be visible to the participant but who may interact in a variety of ways, engaging in instant messaging and joining in the discussion in a chat room. Sometimes bots are so well programmed that they possess a degree of artificial intelligence. They seem to comprehend what the player is saying or doing, and respond in a way that seems uncannily like a real person. A close cousin of the bot is the chatterbot, introduced in Chapter 2. Chatterbots typically interact through typed conversations. These characters, too, may be sophisticated enough to have artificial intelligence. Digital characters often serve specialized functions within a work of interactive entertainment. Some take on the role of the host, welcoming you to the virtual world and explaining how things work within it. Others serve as helper figures, giving you advice or hints when you are stuck. Helper figures are sometimes heard but not seen. Sometimes the player summons such characters by clicking on a help button. In other cases, a player communicates with them via a virtual telephone, as in the *Nancy Drew* games, where the player can call Nancy's old friends from the novels, Bess, Ned, and George, and ask for advice. Players can even seek help from the Hardy Boys (yes, the same famous Hardy Boys of the old mysterybooks).

More commonly, however, NPCs serve the same purpose as the nonprotagonist characters in a movie or TV show. They may be allies of the protagonist, the

henchmen of the villain, or even the actual antagonist. Alternatively, they may be neutral figures who are not affiliated with either side. Such characters are often needed to populate an environment, give out pieces of information, and supply comic relief.

Even minor characters, if well developed, can help inject richness and original- ity into a project. A wonderful story about the making of the classic animated movie, *Snow White and the Seven Dwarfs*, helps illustrate this point. Evidently, when Walt Disney was in the beginning stages of making this film, he was planning to make all the dwarfs alike; they'd all just be little old men. But then he decided to give them each a name that reflected something about them. They were dubbed Sleepy, Dopey, Sneezy, Bashful, Happy, Doc, and Grumpy. Suddenly these little guys had sprung to life. Each became a vivid individual in his own right. Many adults can still remember and name these beloved characters long after having seen the movie in childhood.

THE CHALLENGES OF DEVELOPING DIGITAL CHARACTERS

Developing characters for digital stories can be a challenging business. For one thing, the scenes and dialogue exchanges in interactive media tend to be short, leaving little time to work in clever character touches. Furthermore, unlike a work of linear narrative, we cannot show things the participant (the protagonist in a linear work) cannot see, which eliminates another avenue of character development.

In linear media, where there is a fixed sequence, writers can provide a buildup for the characters before the audience meets them, and lay in some information to help introduce them. But in a nonlinear work, because of the interactive factor, it is far more difficult to orchestrate this buildup. It requires a careful construction of triggers that will release information at the optimum time (for a discussion of triggers, please see Chapter 7).

Interactivity also makes it difficult to portray a character growing and changing—going from being self-centered and egotistical, for example, to loving and caring, or going from cowardly to brave. Such change is a staple element of linear drama. Thus, fictional members of a digital work are usually not given a character arc. They tend to remain essentially unchanged from the beginning to end. In a sense, they resemble the characters in a TV sitcom. Such characters stay just the same from show to show and from season to season. In animated sitcoms, even their costumes don't change.

WAYS TO ALLOW FOR CHARACTER CHANGE

Even though most works of digital entertainment contain static, unchanging charac- ters, there are ways around this, and techniques that can be used to show your protagonist growing, learning, and evolving, or affecting the behavior of other characters.

One technique is to employ a structure of levels for your work. Within such a structure, the protagonist, a player-controlled character, starts at the bottom level, accomplishes certain necessary tasks within it, and then is able to advance to the next level, proceeding level by level to the ultimate goal. Using such a structure,

you can show change in the protagonist each time a new level is attained. As an extremely simple example of this, let's say your protagonist is terrified of water; she has a real phobia about it. In level one, she might demonstrate this fear by refusing to go near a swimming pool. In level two, though, she might be forced to wade across a river to escape one of the living dead, which forces her to deal with her fear. Then, in level three, when she encounters water again, she is no longer frightened of it.

A second technique is to allow your participant-protagonist to attain new strengths or attributes by earning them through succeeding at certain challenges, by trading with other players for them, or by buying them. This is a common device in video games and MMOGs, and is also a feature of the BBC project, *FightBox*. Although primarily used in settings which feature physical challenges, quests, and combats, and lacking the subtlety of the kind of change one would find in a good linear drama, there's no reason it couldn't be used in an interesting way in other types of digital stories. For example, consider a digital melodrama about a young man who is poor and uncouth but extremely ambitious. You could give him a series of challenges, which, if he succeeds at them, would enable him to acquire a smoother set of social skills, a higher degree of business savvy, and a more ruthless way of dealing with people, along with a better wardrobe and a country club membership. Ultimately, he might reach his goal, becoming the suave CEO of a Fortune 500 company and marrying a beautiful socialite.

A third technique is one that is employed in interactive training projects, particularly ones that focus on behavioral skills. The trainee-protagonist works through a module on a particular topic, such as how to deal with dissatisfied customers. Then, to test the new abilities, the trainee takes part in a simulation calling for encounters with a series of rude, impatient, demanding people. By handling these situations well, and by successfully completing the simulation, the trainee demonstrates the mastery of the new skills, and receives positive feedback. The protagonist in such cases is a real person, not a fictional character; but even so, this technique could be used in story-based environments to test out new skills and demonstrate change.

In a fourth technique, the actions of the protagonists themselves can lead to changes in other characters. For instance, if your protagonist treats another character rudely or disdainfully, that character, who would normally have been helpful, will grow cool and distant, and may withhold important information. Certain patterns of behavior on the part of the player/protagonist will affect how the NPCs treat the player and ultimately how the player experiences the interactive work. Interactive designer Greg Roach, introduced in Chapter 4, described this technique to me. He said: "Characters can be thought of as state engines which evolve over time according to the player's accumulated choices. So one approach we've investigated uses a dual axis model: Love-Hate/Fear-Respect are charted as the matrix for determining character attitudes toward the player."

But even with these various techniques, is it possible to build a dramatic character arc in an interactive work like one you'd find in a novel, a movie, or a play? Could you show a character changing as the father does in the animated movie, *Finding Nemo*? If you've seen this picture, you'll recall that the farther, Marlin, a clown fish, starts off as a timid, anxious character who is overprotective of his son, Nemo. But in the course of the story, he not only develops personal courage but finally also learns to trust his son and to stop hovering over him. At this point, it is not possible to name any interactive work that includes a character arc

that is as profound as this, but it is not impossible to imagine. In fact, some computer games come close. Among them is *Final Fantasy VII*. In this game, the protagonist, Cloud, starts out as a self-interested mercenary, but evolves through the course of the game into an idealistic individual committed to a larger goal. During his odyssey, by the way, Cloud moves through many of the stages that are characteristic of the classic hero's journey described in Chapter 5.

How would you go about constructing a character arc in a digital work that is as significant as the change in *Finding Nemo*? For one thing, you would almost certainly need to use a structural form that would push the protagonist along enough of a predetermined path so that he or she would go through certain specific experiences. In other words, you need some degree of linearity, even while giving the player the illusion of free choice. To use *Finding Nemo* as a model, these critical scenes, or mandatory beats, might have you encountering a scary trio of sharks or dealing with a school of stinging jellyfish, encounters that would test your courage, and, if handled well, would boost your confidence. You'd also want to be able to see other characters change as you change, perhaps by using the technique described by Greg Roach. As you become less timid, the other characters might treat you with greater regard, and expect you to act bravely, which would then reinforce your own growing sense of confidence.

TECHNIQUES FOR DEVELOPING DIGITAL CHARACTERS

Though developing characters for digital entertainment is a challenging business, it's worth the effort. Our projects benefit when they are populated by dynamic, unique, and memorable characters. Here are some pointers that can help you create them:

1. Probe deeply: Invest time in working out the character's backstory and psychological profile. What kind of family is he or she from and what kind of upbringing and schooling did he or she receive? Is the character from a small town or a big city? What are the special skills and talents of this person, and what are the kinds of things he or she simply can't or won't do? What is the romantic and marital history of the character? What is your character most afraid of? What does the character most hope for? Though you may never use most of this information, it will help you develop a rich and interesting character, and sometimes a small detail will give you just the inspiration you need to give the character a unique and unforgettable touch.

2. Motivate the character: What is it the character is striving for in this narrative? Why is it so important? Each character should have a goal, not just the protagonist and the antagonist. The motivation should be something that is easy to understand and doesn't require much explaining.

3. Make the character vivid: Interactive media does not leave any room for subtlety. The user needs to be able to "read" the character quickly—to understand the essence of that character. The character's most important traits should shine through clearly and should not be blurred by too much detail or by contradictory personality clues. Thus, you need

to decide what essential things you want to project about each character and focus on those. For a model, look at comic strips, comic books, and animated movies, all of which do a good job of using shorthand techniques to convey character.

4. Avoid stereotypes, or alternatively, play against them: When you have limited time or methods to reveal who your character is, it is extremely tempting to fall into the use of stereotypes. Yes, the participants will be able to quickly recognize the thick-necked bully, the eccentric scientist, and the gossipy next door neighbor. But they will just as quickly yawn, because stereotypes make your work seem predictable and bland. It is much more interesting to take a stereotype and twist it. How about a thick-necked bully who has a tender spot for little old ladies? Or making the eccentric scientist a little girl? Or having the friendly next door neighbor be mute?

5. Give the character a distinct look: Designing a unique look for your character is tremendously important in telegraphing who this person is. You can indicate a great deal about your hero or heroine by their body language, how they hold themselves, and how they move (arms clenched to their bodies, a stoop, a swagger). Their clothing can also provide clues. All these things factor into the character design.

6. Make them fun: Not all characters can be humorous, but people do love characters that are amusing. By giving characters a droll appearance or an eccentric quirk or an amusing way of speaking, it will help them stand out.

7. Give them a standout name: Some designers are fervent in their belief that a catchy name is critical. They assert that a character with a good name has a much better chance of catching on than one with an ordinary name. A good name, they hold, will suggest what makes that character unique. It can also suggest how we should regard them, whether with amusement or with awe. Certainly we can find some distinctive names from the world of games: Duke Nukem, Max Payne, Earthworm Jim, Pajama Sam, and Sonic the Hedgehog, to name a few. We can also find a host of popular characters with less arresting names. But certainly a good name can't hurt. And the right name can help you clarify what your character is all about.

8. Use dialogue to help convey personality: Dialogue can do more than impart information; it can reveal information about the character's personality, background, and occupation. For more on dialogue, please see the section of this chapter "Dialogue and Other Forms of Verbal Communication."

THE CUTENESS FACTOR

What are the pros and cons of making your characters cute, as opposed to cool? Are animal characters a plus or a minus? The answer lies, in a part, as it always does, with your target audience. It also depends on what type of project you are making.

Richard Vincent, President of Kutoka, the company that created Mia, has given this question a great deal of thought. Mia is a very cute mouse, and Vincent feels

that the cute look has given her a definite advantage in international markets. "Anything that is cartoony travels well," he told me. This has certainly been the case with the Mia titles, which are now sold in 40 countries. Vincent has found that when a character is more on the cartoon side of the spectrum, as opposed to the realistic side, people are more accepting of it. The closer you get to realism, he says, the more resistance you get, even with little details like the clothes the character is wearing. For a highly realistic character, he finds, people may criticize the outfit and call it unfashionable. However, if the same outfit is worn by a cartoony character, users are far more likely to think it's just fine. In other words, people have different expectations of realistic characters than they do of more fanciful ones.

One person who is a great champion of cuteness, for adults as well as kids, is Shigeru Miyamoto of Nintendo. Miyamoto came up with one of the digital world's most popular characters, the internationally celebrated Mario. According to Miyamoto, Mario fits in well with the company's top objective, which is to make games that are fun [as reported in an article by Marc Saltzman for *Gamasutra* (*www.gamedevelopers.com*)].

Another project that scores high on the cuteness scale is the Disney MMOG, *Toontown Online*. This game has attracted a large number of adult players as well as children, in part because it includes jokes and visual humor geared for grownups as well as for kids. (For more on *Toontown Online*, please see Chapter 12.)

Obviously, there's no one character style that is going to appeal across the board. So, if you are weighing cuteness versus coolness, or cartoonyness versus realism, or animals versus humans, it might be a good idea to study other entertainment products your intended audience enjoys. If possible, you might do some focus group testing as well.

ADAPTING CHARACTERS FROM ANOTHER MEDIUM

Frequently, a character who is "born" in one medium—a novel, a movie, a TV show, a comic book, or even a board game—will be ported over to a work of interactive entertainment. Such an adaptation calls for careful handling, especially if it involves a well-known figure. The primary consideration is to be as faithful as possible to the original. Otherwise, you risk disappointing, or possibly angering, the character's fans. You may also be under the watchful eye of the character's owners, and they will be most unhappy if you do any serious monkeying around with their property.

One company that is familiar with this adaptation process is Her Interactive, which develops the *Nancy Drew* mystery titles. Each title is based on one of the novels in the Nancy Drew novels, books that have been popular with young girls since 1930. By transporting Nancy Drew from a thirties-era print series to a contemporary interactive game, Her Interactive has managed to retain Nancy Drew's core personality and values while updating her devices. Yes, Nancy now has a laptop and a cell phone, but she still has the same enthusiasm for sleuthing she had decades ago. Her spunky personality is nicely conveyed via voice-over dialogue spoken by actress Lani Manella, who delivers Nancy's lines with convincing zest.

The decision to do these games from a first-person POV and not to show Nancy on the screen was a significant one. It affords every player the opportunity

to see herself (or himself—a large number of boys play the games, too) in the role of Nancy. This first-person point of view matters a great deal to the fans, Creative Director Max Holechek told me. Its importance was underscored when, through an oversight, Nancy's hands appeared in a shot in one of the titles. He said the company received a great deal of flak about it, and since then everyone has been extra vigilant to maintain the strict first-person vantage point. "We don't want to ruin the player's perception," Holechek asserted. "If we don't show Nancy, she can be anybody, no matter what their weight, body size, or skin color."

Anne Collins-Ludwick, the writer-producer of the Nancy Drew games, told me that the move from a linear medium to an interactive one hadn't impacted the character at all. "Nancy doesn't change or develop; she's an icon," Collins-Ludwick asserted. Nancy's friends from the novels, Bess, George, and Ned, are also continuing characters in the games, and for the most part they haven't changed, either. About the only modification that Collins-Ludwick could cite was that Bess was a bit less boy-crazy in the games than she had been in the novels. But this minor adjustment was done to make her more like contemporary girls and didn't have anything to do with being in an interactive medium.

When you are dealing with the adaptation of minor characters, however, you have far greater latitude to make changes than you do with one who is well known, and often such changes are necessary. For example, adapting the Nancy Drew books requires paring down the ten or twelve characters typically found in each novel to only four on-screen characters in each game, the optimum number for these games. In developing the four, the needs of the game are put ahead of faithfulness to the novel. Sometimes a couple of characters from the novel are combined into one; sometimes they are provided with backstories or with motives not found in the novel; sometimes they need to be given a more dimensional personality. The primary reason for these changes is to make sure that each of them is a plausible suspect in the mystery and to come up with a diverse and interesting mix of characters.

A special challenge in adaptation comes when you take a popular character and give it a role it didn't have in the original work. This was the task I faced when I was hired to write the script for *The Toy Story Animated Storybook*, Pixar's interactive version of the hit movie *Toy Story*. Neither actor who played the two main characters in the movie, Woody and Buzz, was available to play the role of the host-narrator of the interactive version, so we needed another character to do this. The job went to Hamm, the piggybank, who is one of the most amusing minor characters in the movie. John Ratzenberg, who did the voice of Hamm in the movie, would do the same in the interactive version, but this decision meant that Hamm would be elevated to the central figure in the adaptation, and everything would be told from a pig's eye point of view.

As the scriptwriter, I had to figure out what a piggybank might have to say about the events portrayed in the movie, and what his feelings about them might be. In order to capture the essence of this character, I had to study the movie closely and then put on a "piggybank hat" and imagine Hamm's take on the story. From his few lines in the movie, I had to extrapolate a far more dimensional character, while making sure it still remained faithful to the original. In doing this, I discovered one interesting difference between how Hamm was presented in the movie and how he would be presented in this interactive work: His relationship with the audience changed completely. In the movie, he was a remote though funny stranger viewed from a distance, but in the interactive version, he became a personal

acquaintance, a friend; the connection became far more intimate. He addressed each child individually, speaking one-on-one, as if he were telling a new pal about a dramatic episode in his life.

INTELLIGENT CHARACTERS

Within the vast population of nonplayer characters, just as within the human population, you can find a great range of mental capabilities. On the low end, they can be extremely dumb; on the high end, they can be impressively bright. The dumbest of the computer-controlled characters do not have the ability to communicate and do not have variable behavior. In the middle range, users and characters can "converse" with each other, though the ability of the computer characters to understand and react is limited. Users can only convey their end of the conversation by selecting from a limited menu of canned choices. Sometimes the behavior of these moderately intelligent characters will be affected by the user's choices and sometimes it will remain static. But on the smartest end of the scale, we have characters who seem to understand human language and who respond in a life-like way to what the users are saying to them.

When a character can "understand" the words the user freely types or says, and is able to respond appropriately, it is called a "natural language interface." Two old-time computer characters who operate this way are *ELIZA*, introduced in Chapter 2, and Jeeves, of Ask Jeeves fame (*www.ask.com*). Jeeves is actually not much of a character—he's actually a sophisticated search engine disguised as a nonanimated cartoon butler. When visitors to his website type in questions ("Where is Zimbabwe?" or "What causes high blood pressure?"), Jeeves will recognize the essence of what they are asking and will direct them to websites that can provide the answers. Characters in works of interactive fiction can also sometimes engage in conversations using natural language interface. We saw an example of that in Chapter 4, in the discussion of the *Galatea* project. But these characters, with the exception of the line drawing of Jeeves, never appear on screen. They only appear as text.

However, this doesn't mean that far more robust intelligent characters using natural language interface cannot be developed, and that they cannot appear on screen. In fact, one family of such characters is already at work. Designed and built for roles in military training simulations, they were first made for a project called *ALTSIM* (The Advanced Leadership Training Simulation), a joint venture by Paramount Digital Entertainment and the USC Institute for Creative Technologies (ICT). Unlike *ELIZA* and her kin, these smart computer actors, or synthetic characters, are actually visible and capable of a wide range of behaviors.

ADVANCED SYNTHETIC CHARACTERS

The first synthetic character devised for *ALTSIM* served as a mentor figure to trainee-soldiers taking part in a strategy planning simulation. More recent ones, however, take on a variety of roles, adding realism and dimension to the fictional world of the game-like simulation they populate. According to Nick Iuppa, Vice President and Creative Director of the Paramount Simulation Group, the newer

computer-generated characters have individual attitudes and agendas, and their behavior toward the trainee is influenced by how their conversations go. The backgrounds, personalities, and motivations of the synthetic characters have been developed in depth and are set down in a character bible, in much the same way as major characters are developed for feature films and television scripts, he told me.

To engage in a conversation with a synthetic character, trainees type in their part of the conversation, phrasing things any way they wish. Specific words trigger a particular prerecorded response from the dialogue bank of the synthetic character, who speaks the line on camera, on the trainee's computer screen, with life-like facial expressions. The goal is to make these exchanges feel emotionally authentic. And, depending on what the trainee says, the attitude of the synthetic character might be affected, possibly going from cordial to miffed-hostile, or from aloof to helpful. If the trainee handles the conversation in one way, the synthetic character might choose to withhold information, but if it goes a different way, the character might reveal something of importance.

This made me wonder if, at some point, it might be possible for trainees to actually speak to the synthetic characters, communicating orally instead of by typing in their part of the conversation. In other words, would the synthetic characters ever be capable of voice recognition? Iuppa believes that in order to achieve fully successful voice recognition with his synthetic characters, four goals must be accomplished:

1. The synthetic character (actually, the computer) has to be able to understand what a person is saying;
2. The synthetic character (the computer) has to be able to formulate and express a verbal response;
3. The synthetic character must look convincing in the way he or she converses, with the lip movements in sync with the words and with appropriate facial expressions; and
4. The synthetic character must sound convincing, with natural inflections and speech rhythms.

"We don't have the technical ability yet to do all this that well," Mr. Iuppa said. However, based on early testing, he noted that their synthetic characters are already smart enough to make participants feel like they are conversing with real people and carrying on a real conversation, which is, after all, the ultimate objective.

LET'S MEET LUCY

One synthetic character who is already doing a good job at holding conversations is a chatterbot named Lucy. Lucy lives on the Web (*www.speak2me.net*) and works for a company named Oddcast, which makes conversational characters. I met Lucy one day as I was doing some online research. Unlike *ELIZA* and Jeeves, Lucy actually speaks out loud, although you still have to type in your end of the conversation, and she also appears on screen. She's an attractive young woman, and her facial movements are synced to her voice. Lucy and I were getting acquainted, as women do, and I asked her if she had a boyfriend. When she

answered in the negative, I asked why not. She startled me with her candid reply. "It doesn't sound like fun to me," she said. I pressed her a bit, asking her why she felt that way, and she snapped "I don't have to give you a reason for everything, Carolyn." Our budding friendship cooled off a little after that.

WAYS OF REVEALING CHARACTER

Whatever kinds of characters you are using in your project, once you've developed them, you'll want to make use of every opportunity available to you to let the participant know who these characters are and what they are like. Here are the five fundamental ways of letting users understand your onscreen characters, which, to some degree, can be applied to your first-person avatars, too:

1. Their physical appearance: this includes not only their face and body, but also how they dress and how they move.
2. What they say: Unlike linear films and TV, where characters can only communicate through dialogue, we can learn things about our digital characters through their emails, diaries, notes, and other forms of written communication. We can go through their drawers to find clues about them, and read their computer files, too.
3. Their interactions with other characters: The way characters act with each other can reveal a great deal about their emotions and feelings for each other.
4. What they do: Behavior can indicate emotional states like anxiety, anger, and sorrow. It can also indicate slyness and the readiness to be aggressive.
5. What other characters tell us: We can learn about a character's history from what other characters say about them.

DIALOGUE AND OTHER FORMS OF VERBAL COMMUNICATION

Characters in movies, plays, and TV shows communicate their thoughts and feelings most directly through words—the dialogue they exchange with other characters. Dialogue is used to advance the story and to supply critical information necessary for understanding the story. It's also a way to gain insight into the characters, their relationships, and their feelings about each other.

Dialogue in interactive entertainment fills exactly the same role, and serves other functions as well. It can also be used to:

* Welcome participants to a program;
* Explain the program's interface;
* Provide help functions;
* Impart educational or informational material; and
* Offer up clues.

In the new media arena, not only does verbal communication serve more functions than in linear media, but we also have a more varied communications palette to

work with. For one thing, characters not only talk with each other, but also speak directly to us, which makes for a far more personalized experience. And, in many instances, we can have a part in this dialogue, choosing lines for the protagonist to say, and receiving an intelligent response in return.

But in addition to dialogue, we have many other forms of verbal communications we can use, written as well as oral. For instance, in many entertainment works, users can find and read old newspaper clippings, diaries, letters, and documents of every kind, all of which can provide important information about characters and events. They can also "turn on" a TV or radio and hear a news broadcast that contains key information. Characters also communicate through telephone calls—and often users themselves, as the protagonist, can place the calls. In many cases, users can take a look at what's on a character's computer and read their electronic files, even "deleted" ones.

The idea of learning about a character by poking around inside his or her computer probably originated with a clever website called *Dawson's Desktop*, which is unfortunately no longer up and running. *Dawson's Desktop* gave us a rare look into the personal life of the fictional characters on the popular TV show, *Dawson's Creek*, a dramatic series about adolescent angst centering around a character named Dawson Leery.

In addition to being able to look at the documents in Dawson's computer (including an early draft of one of his screenplays), all the main characters had Web pages of their own, done in the character's own style. Each of these highly personal websites contained links to other websites, primarily ones that had been devised just for the world of *Dawson's Creek*. Links on these faux sites might lead to the official high school website or to the online newspaper of the fictional town, which gave updated nuggets of news relating to the characters in the series. These sites, in turn, had hyperlinks of their own. The town newspaper, for example, contained an ad for a local bed and breakfast. If you were curious about the inn, you could click on a link button that would show you a streaming video "virtual tour" of it, a Web commercial that was "produced" by one of the fictional characters in the TV show.

Using contemporary electronic devices like cell phones and laptops, characters have an abundance of new ways to tell us about themselves and to vastly expand the storyline. These techniques sometimes pop up outside the parameters of the story world and insert themselves in the real world of the people who are taking part in the digital entertainment. Characters might make phone calls to registered participants, or send emails, faxes, and text messages on wireless devices. They also sometimes engage in instant messaging. These techniques have been incorporated in cutting-edge cross-media productions like *Push, Nevada* and *Majestic*. They blur the distinction between the story world and our everyday lives in an extremely innovative way, though some people have found these techniques invasive and disconcerting. (For more on cross-media projects, see Chapter 15.)

CLASSIC DIALOGUE

Despite all these new ways of communicating, dialogue is still a supremely important tool in most forms of interactive entertainment. It is a tool that has been refined and shaped though centuries of use. Even Aristotle, in his typically pithy way, offered some good pointers on writing effective dialogue. In the *Poetics*

(Chapter XI, Section 16), he explained that dialogue is "... the faculty of saying what is possible and pertinent in a given circumstance." In other words, the character's lines should be believable and reveal only what is possible for him or her to know. And the speech should not ramble; it should be focused on the matter at hand.

A little later (Chapter XI, Section 17), Aristotle goes on to say that the words an actor speaks should be expressive of his character, showing "... what kind of thing a man chooses or avoids." Thus, the words the character speaks should reflect his goals, and probably his fears as well. Aristotle's remarks on dialogue have stood the test of time, and are as applicable to interactive media as they were to Greek drama.

In addition to Aristotle, we can learn about dialogue from modern day screenwriters. One of the most valuable things they can teach us is to use dialogue sparingly, only when there is no other means of conveying the information. "Show," they advise, "don't tell." But when screenwriters do resort to dialogue, they make sure the exchanges are brisk and easy to understand. They use simple, clear words, knowing this is not the place to show off one's vocabulary. And they break the exchanges between characters into short, bite-sized pieces, because long speeches make an audience restless. These are all practical principles we can port over to digital media.

INTERACTIVE DIALOGUE

Many writers and producers in interactive media have discovered that dialogue needs to be even leaner than it is in traditional media. Users become impatient with long stretches of speech; they want to move on to the action. This seems to be true for every type of interactive audience, not specific to any particular demographic. According to Diana Pray of *JumpStart*, "The dialogue has to be short and sweet. This kind of writing isn't going to have the type of richness you'd find in a movie or a book. It has to be spare. The writer has to be able to communicate something rich and beautiful in a spare way."

In interactive media, exposition can be a particular challenge. Exposition is information that is essential for the understanding of the story. It includes the relationships of your characters to each other, salient facts about their backstory, and their goals. Many writers are tempted to dump a huge amount of exposition in one speech, very near the beginning of a work, and are relieved at having disposed of it. But beware! When characters reel off a big lump of exposition, the speech sounds unnatural. It brings everything to a halt while it is being delivered. The trick is to work it in naturally, in small doses. And if you can find ways other than dialogue to slip in some of this exposition, all the better.

Interactive dialogue doesn't lend itself very well to subtlety, either. In traditional media, when actors say a line of dialogue, we look at their faces for an indication of their emotional state. But the computer-generated animation in most digital programs is usually not up to the task of conveying shades of emotion. Thus, we are better off using more direct language than we would in a play or film.

When dialogue is written as text rather than spoken, we have additional limitations. We don't have the cues available to us that an actor's voice would give us, so it is difficult to suggest nuances such as irony or sarcasm. Written

dialogue also rules out some common devices available in oral speech. How do you have a character angrily interrupt another? How do you show a character speaking with hesitation? How can you have two characters excitedly talking at the same time?

Even with such limitations, it is still possible to convey personality and emotional state without spoken dialogue. As an example, *Final Fantasy VII*, though made a number of years ago, did an excellent job of revealing character, past histories, hidden desires, and even character change, all through written dialogue. And a more recent game, *Grand Theft Auto: Vice City*, which does use oral speech, contains dialogue that is on par with a first-rate motion picture: it's witty, punchy, and fun to listen to. It's so good that I know college students who play the game primarily to get to the cut scenes—the reverse of what most players want to do in a game. Of course, they love stealing the cars and using the weapons and flying the helicopter, too. But if a high-voltage action game can contain dialogue that is that compelling, it suggests that the same is possible for other types of interactive works.

CONCATENATION

Space is always at a premium in interactive media. Dialogue is an asset that takes up space, so to deal with this problem, a technique called *concatenation*, borrowed from computer programming, is sometimes employed to use sound as efficiently as possible. Concatenation is a system of getting the most mileage out of words, phrases, and sound effects by reusing them. For example, a character might talk about her blue skirt, and later refer to her friend's blue eyes. The word "blue" would be pulled out of the word data bank and be used twice. Concatenation is especially important with smart toys that talk, since memory is a particularly precious commodity with these digital playmates. (For more on the use of concatenation in smart toys, see Chapter 16.)

CHOICE AND DIALOGUE

Many interactive programs give the participant the ability to pick the dialogue that the protagonist says. There are a number of possible ways to offer this sort of choice. Sometimes the participant is offered a text selection of two or more lines of dialogue. The chosen line may then be spoken by the protagonist, and the character who is being addressed will reply out loud as well. But in some cases, the whole exchange is done in text. Sometimes we never hear the protagonist speak the line, though we do hear the other character's response. And sometimes, instead of choosing from several possible lines of dialogue, we instead get to select an attitude or an intent. Our choices in a particular situation, for example, might be "patronizing," "seductive," or "bored." We will then hear our protagonist speak a line matching the attitude we selected, and may get a physical reaction as well. Usually the types of choices given for attitudes or intents are provocative, and are designed to elicit a strong response from the other character. The most advanced form of dialogue is natural language interface, which we discussed previously.

In terms of the user's part of the exchange, the important question is how this dialogue will impact the narrative. Will it have consequences, and if so, how profound might they be? This varies greatly from project to project. In some cases, the impact is minimal. But in other cases, your choices can lead you down many possible paths, each with a different outcome. Your choices will change the way the person you are speaking with regards you and treats you, and will determine whether they help or hinder you. Sometimes what you say to one character, and the attitude you convey through your dialogue, will even impact the way associates of that character treat you. Suppose you are kind to character A, a ragamuffin child. Character B, the child's mother, becomes aware of your kindness and is pleased by it. She is in impoverished circumstances, but she has a valuable item she is willing to give you because of how you treated her child. This may significantly advance your progress in the narrative or game.

With so many ways to handle dialogue, it is no easy matter to decide which approach might be best for your project. As with other creative questions that need to be addressed, it's a good idea to study the projects that are doing well with your target market, and see how they handle dialogue. Budget and time will also play a hand in guiding you, because the most sophisticated of these approaches is also usually the most time consuming, difficult, and expensive to execute.

GUIDELINES FOR VERBAL COMMUNICATIONS

Many people are of the opinion that writing good dialogue is a talent that one is born with and that cannot be acquired. They might be correct to some extent, but nevertheless, by keeping certain pointers in mind, we can all produce dialogue that's serviceable. It might not be fancy, but it will get the job done, and without calling attention to itself. Here are some guidelines for dialogue and other communications delivered by speech:

1. As Aristotle indicated, keep speeches focused. They should be short and to the point.
2. Do as screenwriters do, and use clear, simple words and informal language and grammar. Short sentences are preferable to long ones, and avoid complex sentence constructions. Don't let your characters deliver long blocks of speech.
3. The lines a character speaks should be "in character." In other words, what the character says should reflect his personality, his age, his mood, his educational level, his profession, his goals, and his point of view.
4. If writing lines to be delivered by a voiceover narrator, you will want to use a somewhat more formal style than you would in dialogue. But it is still important to use easy to understand words and to avoid complex sentence construction.
5. If writing for a telephone conversation, study how people talk on the phone. Such exchanges tend to be breezy and brief.
6. If writing a fictional news broadcast, study the format, pacing, and style of a professional news show. Use a stopwatch to time out elements, too, and listen to how the announcer "teases" an upcoming story.

7. Read what you have written out loud, listening for inadvertent tongue twisters, awkward phrases, unnatural speech, and overly long lines. Then cut and polish.

And here are a few guidelines for written communications:

1. If producing a document that one of the fictional characters supposedly wrote, the writing should be "in character," as with #3 above.
2. To make the document look authentic, include some typos or misspellings—but only if your character is likely to make such mistakes.
3. Keep the document short. People don't what to spend much time reading.
4. If writing an email, model the telegraphic style of real emails, and even include an emoticon or two.
5. In the same way, model any other specialized type of written communication—including Web pages, blogs, and newspaper articles—on real life examples. If you know anyone who works in that field, have that person read what you've written and give you feedback. Strive to make the piece of writing as authentic looking as possible. From a participant's point of view, part of the fun of stumbling across a fictional document is the sense that it could be "real."

THE ROLE OF EMOTION

In character-centric media like movies and novels, not only do the characters in the stories experience strong feelings, but so do the readers or the audience members. Even the most macho of movies, pictures like *The Terminator* series, contain easy-to-detect emotional elements—fear, tension, hope, and so on. For some reason, however, most people do not associate interactive projects with deep emotion.

Yet emotions can and do play a role in digital storytelling; the contribution of emotions can be extremely significant. They can make the work seem less computerized and more real and add richness and dimension to the narrative. Above all, they make the experience more immersive and compelling, intensifying the connection between the user and the material. Some experts in digital media even assert that when an interactive work is emotionally potent, it becomes more memorable. In other words, the work will make a greater impression on you than an emotionally barren work, and you will not easily forget it.

Thus, building emotion into an interactive edutainment project or training project could, if this theory is correct, help people remember the instructional content for an extended period of time. Certainly, it is possible for edutainment projects to have a powerful impact, as was demonstrated by an interactive movie about ocean pollution and endangered sea life that was produced by the Canadian company, Immersive Studio. Members of the audience played in teams, trying to save the sea creatures, and, via a sophisticated set of controls, they could have a direct impact on the outcome. According to a report in *The Los Angeles Times* (July 28, 2001), a group of kids exited the movie in tears because they were unable to save the marine animals. (For more on interactive cinema, please see Chapter 18.)

The potential of digital storytelling to stir the emotions has sparked the interest of a number of people in the new media industry. Many of the people interviewed for this book were consciously developing ways to inject emotion into their work, and a number of the projects I investigated contained strong emotional elements.

One such project is *Cisco's Journal*, developed as a dual screen iTV project to be watched simultaneously with the PBS series, *An American Family*. The series is a family drama about the Gonzalez clan, a Latino family undergoing major changes. Cisco, a 19-year-old member of this family, is a budding artist. According to the conceit of the show, *Cisco's Journal* is his online journal or *blog* (Web log) (*www.Gonzalezfamily.tv* or *www.pbs.org/americanfamily*). It's a way for Cisco to express feelings he cannot easily discuss with his family; it's his personal outlet. Each week, he posts his artwork on the blog, which always relates in some way to that week's TV episode and is timed to correspond with the airing of the show. Steve Armstrong, whose company, Artifact, produced *Cisco's Journal*, described it to me as "an emotional extension" of the character and of the TV show. Cisco's artwork, much of which is interactive, gives us insight into the young man's conflicts and turbulent feelings—almost never through words, but through powerful images and evocative sounds. For example, one of Cisco's art pieces shows a pearl necklace that had belonged to his deceased mother. It is coiled in such a way that it spells out her name, Berta. If we roll our cursor over the necklace, we can watch and hear the pearls drop to the floor one by one, like teardrops. According to Armstrong, the pearl necklace was a way to "portray Cisco's visceral connection with his mother." Cisco's art is rich in metaphors; it gives us a nonverbal window into Cisco's emotional state. (For more on *Cisco's Journal*, see Chapter 14.)

A completely different manifestation of the use of emotion can be found in a smart toy project, an interactive cat, made by Hasbro as the debut species in its FurReal Friends line. Designer Leif Askeland wanted to come up with a robotic toy animal that did not act robotic, and so he produced a cuddly creature that responded with cat-like emotions to the humans who played with it. The cat purrs happily when you pet it, but should you ever pull its tail, it will arch its back and hiss at you. Askeland concentrated totally on the human-cat behavior of his creature, and on giving it life-like movements and flexibility. He did not even attempt to build in a mechanism to allow it to walk; this cat is made for sitting on laps, not for chasing mice. And its personality is so winning that the cat is not only being adopted by kids, but also by the elderly in nursing homes—a group that yearns for the companionship of pets, but cannot cope with the hassle of shopping for cat food or cleaning kitty litter.

Turning from furry toys to the grittiness of armed combat, let's take another look at the *DarkCon* virtual reality project first mentioned in Chapter 5. Jacquelyn Ford Morie, who is producing this project, explained to me that making the simulation emotionally powerful was a deliberate and stated goal. So important is putting an emotional bang into *DarkCon* that Morie has actually designed what she calls an "emotional score," a document not unlike a musical score. It maps out the high and low points the participant can experience—feelings of anxiety as well as feelings of relief—pacing the emotions for maximum impact. (See Figure 6.6.)

"Studies show you remember emotionally charged events better than neutral ones," she said. The simulation is designed to test this hypothesis, and to see if an emotionally intense experience can improve training. It will also be tested to see whether its effectiveness will change, depending on whether the trainees believe

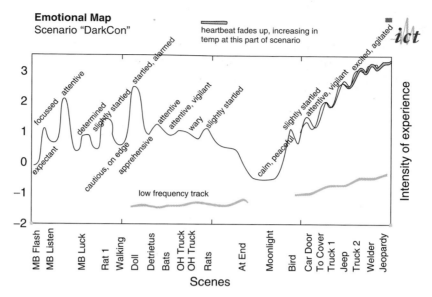

Figure 6.6 The emotional score for *DarkCon* maps out the feelings a participant can experience.

they are playing a recreational game or taking part in a serious training exercise. *DarkCon* is a work in progress; new elements are being added on a regular basis to intensify the emotional impact of the simulation. For example, in the beginning, the trainee-soldier was sent on an open-ended surveillance mission, but now is charged with a specific and dangerous goal: to plant a GPS device at a target location. And a "scent necklace" is currently being manufactured for the simulation. When completed, smell will be added to the experience. Among the aroma "candidates" are the odor of decaying mud, with a touch of rat and sewer; fresh river smells, including pine or other trees; and a wet dog smell. (For more on *DarkCon*, see Chapter 5.)

Though the *DarkCon* scenario is designed to induce feelings of tension and fear, Morie believes many other types of emotions could be incorporated into a simulation and could also have a powerful impact. She is currently working on another VR project, *Memory Stairs*, that centers on an entirely different set of emotions. (For more on this work, please see Chapter 19.)

These are but three examples of what people are doing to enrich the emotional content of digital creations. Design teams are working with many other techniques, a number of which will be explored in later chapters. Of course, some might want to make the case that emotion has no place in interactive works. But is that really true? Even an abstract puzzle game like *Tetris* arouses the emotions. One definitely tenses up as a new cluster of blocks descends, knowing one has just moments to position them in a good place; and one feels a little surge of elation when a row is neatly filled out and it magically drops away, increasing one's score.

If *Tetris* can have this kind of an effect, when it contains no characters and no plot, why should it not be possible for interactive works that are actually built on story content to have a proportionately greater emotional impact? Perhaps it is even possible for an interactive work to induce the ultimate emotional experience that Aristotle described in his analysis of drama: the feeling of catharsis,

the profound sense of release. After all, the creators of interactive stories have a powerful tool that wasn't available to Greek dramatists: immersiveness. Our "audience"—our participants—can actually step inside the story world and experience it in a highly personal way. With immersiveness and the other tools at our disposal, we have the potential to produce highly charged works of entertainment, should we choose to do so.

CONCLUSION

Characters in digital media behave differently than they do in linear media, and play roles that are unique to an interactive environment. Thus, when we develop fictional beings for our projects, we have to ask ourselves questions we'd never need to ask in creating a traditional story. But before we can even start working on characters, we need to give thought to what role our users will be taking on. Will they be controlling the protagonist, and if so, how will the two be interconnected? If not, exactly who are the participants in this world, and what is their task, their ultimate goal? From what point of view will they be seeing the fictional landscape? How will communication take place between the participants and the fictional characters?

But despite the new kinds of questions we need to ask, we can still utilize many of the techniques developed by traditional storytellers to create vivid characters. We don't have to completely reinvent the wheel. The same is true for composing the words our characters speak and write. The verbal communications in interactive media use many of the same techniques first developed for traditional media, though we also have many new ways to communicate information in a fictional interactive universe. One of the most difficult questions we have to address in terms of communication is the issue of dialogue. Will participants be able to choose what they want to say, and if so, what consequences might this have on how the narrative develops?

Finally, we need to give thought to the emotional content of our digital works. Where and how might emotions fit in? Do we want to give our participants an intense emotional ride, and if so, what can we do to orchestrate this ride?

The questions that come up around character design are never simple to answer. They are among the most demanding issues that we have to deal with in creating a work of digital entertainment. But when they are addressed thoughtfully, and the necessary time is invested in them, they can help us produce outstanding characters—ones who may someday even join the ranks of other virtual superstars and become another Lara Croft perhaps, or a Sonic the Hedgehog.

IDEA-GENERATING EXERCISES

1. Create two characters for an interactive work, a protagonist and antagonist, coming up with brief descriptions of each. Try, however, to avoid using the familiar good versus evil model or the need for either one to resort to violence. Instead, strive to invent an antagonist who has some positive qualities, but who, for some reason, is creating trouble for the

protagonist. Is it difficult to create an antagonist for an interactive work who is not evil or violent, and if so, why?

2. Using the antagonist you developed in the exercise above, come up with three characters who might act as his henchmen. Do a brief character description of each, striving to make each unique and different from each other.

3. Using one of the techniques described in this chapter under *Ways to Allow for Character Change*, sketch out a scenario that shows a character changing in some way. Or, if you can think of a different way to demonstrate character change, explain how it works and sketch out a scenario employing this method.

4. Take a small story point—a clue, a trait of one of the characters, or an important piece of background information—and list as many ways as possible to communicate this point to the participant, either through spoken words or through written words.

5. In your opinion, does emotion add value to a project? Why or why not? Use examples from interactive projects you are familiar with to illustrate your opinion.

Structure in Interactive Media

How is it possible to organize an experience that is all about free choice... how can you order something that is supposed to be nonlinear?

What kinds of structural "building blocks" exist in interactive media, and how can you use them to help build a work of digital entertainment?

What do you need to know or to decide before you begin to structure a new project?

STYROFOAM PEANUTS

Structure: it is the unseen but all-important method of organizing a work of interactive entertainment. The structural "bones" of a project support all the fleshy elements that the user encounters. They also help determine the nature of the interactivity. When the bones are thoughtfully assembled, the body functions well and the user has a pleasing experience. But a poor structural foundation can seriously undermine a project that otherwise has excellent elements.

Without question, structure is one of the most daunting aspects of creating a work of interactive entertainment. Yes, character design and the issues that go with it create a host of challenges, as we saw in the previous chapter, but the questions springing up around structure can make one's head spin. How do you organize and shape an experience that is supposed to be free flowing? How do you create a pathway through a nonlinear environment, and when is trying to do that even a good idea? Where do you find usable structural models, when a great many people in the field can't even name the models that they are currently using? When you're dealing with interactive structure, it can be extremely hard to find anything solid enough to grasp hold of—it can feel somewhat akin to trying to construct a house out of Styrofoam peanuts.

The job of doing the actual design work usually falls to specialists—the game designers in the game world, the information architects of the Internet and information-based projects, and the engineers and computer programmers and designers and inventors in other fields of interactive media. But even if you are not tasked with doing the design work yourself, that doesn't mean you can just cover your ears and ignore the topic, much as you might like to. That's because every member of the creative team needs to have a basic understanding of the structure that's being used in order to do his or her job. Furthermore, each member of the creative team has valuable input to give, since each is viewing the structure from a unique professional vantage point.

Curiously enough, considering that structure is such an essential aspect of creating an interactive project, the language we have to describe it is still largely unfixed. Even basic words like "node" or "level" may be used one way at company A and in quite a different way at company B. As for company C, it is very possible they have no terminology at all to describe the structural model that they use and reuse for their projects. Yes, they will probably be able to describe the structure in a loose sort of way, but if you really want a clear understanding of it, you'll have to work your way through several of their projects to learn how they are put together.

Fortunately, we do have some basic structural concepts and models that we can use as a starting place to discuss structure. Furthermore, the fundamental questions of structure are essentially the same across the board, for all types of interactive media. And, as always, we can look to traditional linear entertainment for some initial guidance.

THE BASIC BUILDING BLOCKS OF DRAMA

Before launching into a discussion of structure, it might be helpful to first clarify what we're talking about. According to the ever-reliable Webster's dictionary,

structure is "something made of interdependent parts in a definite pattern of organization." In other words, small units of material—the parts—are assembled into a greater, interconnected whole. The units are your basic building blocks, and they may be combined together to form still larger building blocks until you've got your largest elements, which are then assembled and become the final product.

In a linear work of drama, such as a movie or play, the smallest building blocks would be the story beats. They'd then be organized into scenes, and from there into acts. If we look at classic drama, as we did in Chapter 5, we see that Aristotle believed that every effective theatrical work contained three acts, with Act I being the beginning, Act II being the middle, and Act III being the end.

Now let's see how this structure applies to a motion picture. Here is how my colleague, Dr. Linda Seger, describes it. Dr. Seger, who is an internationally known script consultant and author of many books on screenwriting, told me: "In film, a catalyst begins the action—an event that gets the story going and orients the audience to genre, context, and story. The middle (which is usually twice as long as Acts One and Three) develops and explores conflict, relationships, and theme, using action and events (whether large or small) to move the story forward. The end is the consequence of the work of Act One and Act Two, paying off all the development, strategizing, and struggle that went on throughout Acts One and Two."

Although Aristotle was talking about classic Greek drama, and Dr. Seger was talking about motion pictures, the same basic three-act structure can be applied to interactive media as well, as long as the work has at least a thread of a story. This includes not only games, but also immersive environments, like the *DarkCon* simulation described in Chapters 5 and 6. It can also include interactive movies, Internet entertainment like webisodics, location-based entertainment, edutainment projects, cross-media productions, and even certain activities with smart toys. In other words, interactivity and the three-act structure are not mutually exclusive; on the contrary, this structure still plays an important role even in the most cutting edge kinds of storytelling. Sometimes the three acts can be hard to spot. Take, for instance, the interactive movie *Uncompressed*, which was initially discussed in Chapter 4. This movie features six characters or sets of characters, each with a different take on the same core event. You can enter the fictional world of this movie at any point and exit at any point, so it seemingly has no first act and no third act; and because of that, it seems to have no middle act, either. Yet once you work through each of the six character lines, the pieces begin to form a coherent whole and the story emerges, much as a picture becomes visible once you've assembled enough pieces of a jigsaw puzzle. Sure enough, the story of *Uncompressed* does indeed have a beginning, middle, and end—the classic three acts.

At some companies, the creative teams are highly aware of the three-act structure and use it consciously. In other organizations, however, it may be employed in a less conscious fashion, although it still shapes their products. After all, we are inundated almost since birth in story-based material organized around the three acts. How could this degree of exposure not affect our interactive storytelling?

One company that finds the three-act structure a useful organizational tool is Her Interactive, the company that makes the *Nancy Drew* mystery-adventure games.

Creative Director Max Holechek told me that they definitely think in terms of a beginning, middle, and end. "We have to make sure there's a good story that keeps evolving," he told me. "And the characters have to evolve in one way or another." He also talked about the importance of the second act to the overall game, echoing some of the things Dr. Seger said. "In the middle act we do things like up the dangers, or put in some plot twists, or add some intrigue," he said. "These things help keep the game fresh."

Katie Fisher, a producer-designer for Quicksilver Software, also consciously employs the classic three-act structure. Her company has developed dozens of strategy, simulation and action/role playing games, including *Master of Orion 3, Invictus, Castles, Star Trek: Starfleet Command*, and *Shanghai: Second Dynasty*. Fisher told me without equivocation: "The three-act structure is the backbone of everything we do here." But she also noted that the nonlinear nature of games added a special wrinkle. "How you get to the plot points—that's where interactivity comes in." That, of course, is the critical question. How and where does the interactivity come in, and how do you structure it into your story world? How do you combine story and interactivity—and gaming, as well, if you are making a game—into one organic, seamless whole?

THE BASIC BUILDING BLOCKS OF INTERACTIVE MEDIA

In order to integrate interactivity and story, and to build your structure, you need to work out both your smallest and your largest building blocks. At the most basic level, you have your decision or action points—the places where the user can make a choice or perform an action. You thus have to determine what kinds of things users can do in this interactive environment. Can they pick things up? Shoot weapons? Converse with characters? Rearrange objects? Can they freely choose which building to enter or what world to visit? On the macro level, you'll need to work out the nature of your biggest units or divisions. Some designers refer to the largest organizational units as "worlds" or "nodes" (though others use the term "node" to indicate a point where a user can make a choice).

If you are using a world structure, your project may be divided into different geographical spaces—like the rooms of a house, or different parts of a town, or different planets. Another type of organizational unit is the "module," which is often used in educational and training projects. Each module customarily focuses on one element in the curriculum or one learning objective. Another way of organizing is by the use of levels, generally of increasing difficulty. In such a structure, users work their way up to the final goal, ascending level by level. Still other projects are organized by missions, where users are given assignments they must complete one at a time. Yet other types of interactive projects may be divided into episodes, as a webisodic is, or into chapters, as DVDs often are. Or, if this work is being made for the Internet, your largest units may be Web pages.

Once you know the type of large building blocks you'll be using, you can begin to determine specifically what each will be, how many you will have, and what the user does in each one. You'll also be able to begin populating them with characters. Thinking in terms of large building blocks can help bring order to the organizational process.

TYPES OF CHOICES

Let's take a moment to think about the types of choices a user can make. Sometimes these choices are deliberate and direct, and users know exactly what to expect. For instance, clicking on a menu item on a DVD or a cell phone will take you to a specific location (a scene; a block of information; or to further menu choices). Clicking on a hyperlink on a website will give you a specific image, audio file, or piece of text.

In other choice scenarios, users are given several options to choose from. For example, let's say we have a game in which the PC is a young woman, and let's say she's being followed down the street by an odd looking man. The user can decide whether to have the young woman A: run, B: turn and confront the stranger, or C: ask a policeman for help. Each choice will result in a different outcome.

Choices can be indirect as well, and not necessarily perceived as a "choice." By doing actions A and B, for example, situation C might be triggered. As an example, let's use a hypothetical simulation for a training project, a CD-ROM about food safety. In this simulation, you, the trainee, play the part of a bakery clerk. Customer A comes up to your counter and requests a dozen peanut butter cookies. You scoop them up with a spatula and put them in a bag. Now Customer B comes up and asks for some chocolate chip cookies. Without following company policy and checking first to ask her if she has an allergy to peanuts, you use the same spatula to scoop up the new order. The spatula taints the chocolate chip cookies with peanut butter, and the unwitting customer takes a bite and has a life-threatening allergy attack, a consequence you certainly did not willingly choose. But the earlier choices you made—to reuse the spatula, and to not follow company policy of asking about allergies—did lead to this outcome. Scenarios in which the user makes a choice and an action causes a reaction are usually referred to as if/then links. In other words, if the user does A, then B will happen. Or, to put it slightly differently, doing A will link you to B. In the example above, the "if" is whether the user will scoop up the cookies with the tainted spatula, and the "then" is the customer having an allergy attack. The if/then link is the most fundamental way of expressing choice and consequence, action and reaction, and has been used since the earliest days of interactive media.

In Chapter 5, we briefly talked about Boolean choice models, which allow for two possible outcomes for every choice (yes/no; go/stay; live/die). Having only two possible options is also sometimes called "binary choice." However, there's also a more subtle type of choice mechanism available, the *state engine* approach, which allows for a greater range of stimuli and responses instead of a simple if/then. The state engine approach was discussed to some degree in Chapter 6, when designer Greg Roach talked of how the concept could be applied to character change. But now let's look at it more closely and see how it applies to choice.

To illustrate how a state engine works in terms of a character's actions, Roach used the example of a player who wants to open a wooden crate. With the Boolean model, the crate would have only two states: broken or unbroken. It would remain in its unbroken state until the user smashed it with an axe, the one tool that was available to him. At that point, Roach said, its state would switch to broken. But, Roach explained: "A state engine approach works differently. It tracks cumulative force and damage, allowing for a richer set of player choices. Each player

can make a different set of choices and the state engine construct will respond appropriately. So a player who chips away at the crate with a pen-knife will take ten times longer to get it open than a player who runs it over with a vehicle and breaks it open with a single move."

At this time, the term "state engine" is not used universally by all developers of interactive media, but nevertheless, most today are looking for ways to offer users a broader range of actions and responses than simple binary choice.

BRANCHING STRUCTURES

The interactivity of most of the earliest interactive projects operated by using a model called the *branching structure*, and variations of it are still in use today. A branching structure works a little like a pathway over which the user travels. Every so often, the user will come to a fork in the path, and will be presented with several different choices. Upon selecting one, the user will then travel a bit further until reaching another fork, with several more choices, and so on. (See Figure 7.1.) To see a script using a branching structure, please see the pages for *Pop Quiz* in Chapter 10.

The problem with a branching structure is that in a very short time, it escalates out of control. After just two forks in the path, with three choices at each, you'd have racked up 13 possible choices, and by the third opportunity for choice, you'd have a total of 39 possible outcomes. Although the user would only experience three of them, you'd still have to produce the other 36, in case the user made a different selection. A branching structure like this squanders valuable resources.

Designers employ a number of techniques to rein in runaway branching. One is the "faux choice." In a faux choice construct, the user is presented with several options, but no matter which is picked, the end result will be the same. For instance, the user might go into a bus station to purchase a ticket. When the clerk tells her the cost, she will either choose to buy it or not buy it. If she decides she cannot

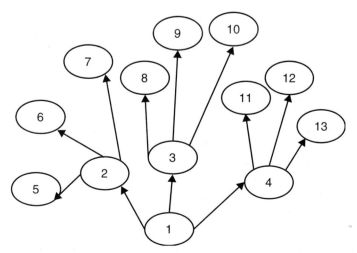

Figure 7.1 The simple branching structure can easily escalate out of control.

afford it and leaves the ticket counter, she will then find an unused bus ticket on the floor, and so will end up riding the bus either way. This technique and its more sophisticated cousins give users the illusion of interactivity, but actually forces them down a single path. The same result can be engineered by a "lady and the tiger" approach. Here again, the user is offered several choices, but only one yields a positive outcome. The term "lady and the tiger" comes from a classic story in which the hero could choose one of two doors. A man-eating tiger lies in wait behind one, while a beautiful woman steps out from the other.

Runaway branching can also be contained by cul-de-sacs, loop backs, and barriers. Cul-de-sacs are areas off the main story path that the user is free to explore, but these areas are walled in, and ultimately force the user back to the main story path. In a loop back construct, the user must return to a previously visited area in order to fulfill a task or acquire some necessary information. For instance, a character might offer to give you the treasure map you want, but only if you bring him a flagon of ale. You remember seeing a pub in a town you'd previously visited, so you loop back to fetch the ale. In a barrier construct, the user can only activate a choice or move forward by first succeeding at a "gateway" task, such as solving a puzzle.

Some designers rein in runaway branching trees by constructing more modest branching shrubs, each with a specific subgoal. The branching shrubs all link to the major story path, but the branching is more contained. For instance, the ultimate goal might be to save the princess in the tower. Subgoal number one requires that you poison the dragon (shrub #1); subgoal number two requires that you pass over the bridge guarded by ogres (shrub #2); and subgoal number three requires that you outwit the princess's evil stepsisters who are keeping her locked up (shrub #3).

Other designers strive for an illusive structural form called "bushiness," which offers a maximum amount of choice but which prevents unlimited branching by having many of the links share communal outcomes.

THE RANGE OF STRUCTURES

In works of digital entertainment, the underlying structure has a great impact on the overall user experience. Structures can range from quite restrictive in terms of choice to being extremely free ranging. The structure for a particular project is typically determined by the type of interactive experience the designers want to provide.

If the project is essentially a story-based one, such as an adventure game or mystery, it will need a fairly restrictive structure that invisibly nudges the user down a central path. But if the goal is to allow users to be able to explore freely, interact with other users, and construct their own adventures, the structure will be designed for maximum openness and the least amount of restraint.

THE CRITICAL STORY PATH

Many professionals within the new media industry refer to the linear narrative line through an interactive work as the *critical story path*. This path contains all

the scenes a user must experience, and all the information that must be acquired, in order for the user to achieve the full story experience and reach a meaningful ending point.

The *Nancy Drew* mystery adventure games, for example, utilize a critical story path. Players can travel down this path in many different ways and can collect items and clues at their own pace. In the *Haunted Carousel* game, for instance, they can do things like ride the carousel and visit most of the attractions and buildings at the amusement park almost from the very beginning.

"We want to give players as much freedom to explore as possible," writer-producer Anne Collins-Ludwick told me. "But we also want to relate a story, so we have to move them from A to B to C." She said sometimes the methods to get the players to move down this path will be obvious, but sometimes they go on behind the scenes. "For instance," she said, "you might not be able to get inside a certain environment until you've done something else."

The company's creative director, Max Holechek added that although players must move down this critical story path to solve the mystery, it is not desirable for them to race down it too quickly, or else the experience won't feel like a game. "So we give them puzzles and activities and challenges; various kinds of obstacles to pace out the game and slow things down." Yet, while engaged in these challenges, the story will still be advancing.

He described a hypothetical situation that might be used as a pacing device and also move the story forward. "Suppose there's some information you want from a particular character," he said. "Now, if it were just a story, the character would probably give it to you directly. But this is a game, so we might have the character say: 'I'd love to tell you what you want to know, but my blood sugar is dropping and I don't feel well. Maybe if I had some pie...'" That would give the player the push she needed to collect the ingredients for a pie—which might offer its own series of challenges. Once the user had collected the ingredients for the pie and was in the process of baking it, the game engine would recognize that the player had done parts one, two, and three of the pie activity, and that she was now at scene 1004, which would trigger another event. For example, Nancy's cell phone might ring, and the caller might have an important clue for her.

While the creative team of the *Nancy Drew* titles uses the term "critical story path," over at Quicksilver Software they use a different way to talk about the through-line for their games. Producer-designer Katie Fisher calls it a *malleable linear path*. She said: "Even though we use a three-act structure, we give the players lots of ways to get to the end. We want to avoid the need to hang things on one specific event to move the story forward. We don't know what order things will happen in, but we can say that five different things will happen before X happens."

THE STRING OF PEARLS AND OTHER LINEAR STRUCTURES

An often-used way to describe the linear story path is as *a string of pearls*. Each of the "pearls" is a world, and players are able to move freely inside each of them. But in order to progress in the story, the player must first successfully perform certain tasks. Sometimes they cannot enter a new pearl until every task in the prior one is completed; sometimes they can enter other pearls, but access to certain areas within them will be blocked. (See Figure 7.2.)

Figure 7.2 With a string of pearls structure, the player progresses through a series of worlds.

Game designer Greg Roach calls this type of structure *a rope with nodes*. The nodes offer a rich degree of interactivity, but they are strung together in a linear fashion. According to Roach's model, players can do three different things in each node:

- They can "grow food"—a term he uses for tasks that must be performed in order for the story to proceed;
- They can "consume candy"—by which he means they can do enjoyable things that enrich the experience, but don't move the story forward; and
- They can trip triggers—they can do things that bring about a change in the experience.

In this model, players cannot move to the next node until they have grown all the required food (completed the required tasks) inside the node they are currently in.

A number of other structures also channel users down a linear path, some more restrictive than others. Most are applicable both to story-based material and to nonfiction material. One that offers the least amount of freedom is *sequential linearity*, a structure that I like to call the *passenger train*. It was the model used in the first children's interactive storybooks. It is still used for this purpose, and is also commonly employed in interactive training applications. It is similar to the string of pearls structure.

In this model, users begin at the engine end of the train and work their way down car by car until they reach the caboose end. They can explore the interior of each car at will, but usually cannot leave until the program releases them—sometimes they must first listen to some narration, or watch some animation, or work through some exercises. They also must move in sequence; they cannot jump, say, from car number two to car number six.

Once users reach the caboose, they are usually able to explore more freely. Many projects built on this model offer a menu to allow users to revisit a particular car or to go directly back to a specific game, activity, or exercise.

MODULAR STRUCTURES

Another format that is often used in education and training is a modular structure. These kinds of projects often open with a noninteractive introduction, and then the user is offered a number of modules to visit, which they can do in any order. Once all the modules have been visited and the required tasks in each have been completed, the program may end with a linear wrap-up or the user might be offered a "reward" activity. At *JumpStart*, they refer to this structure as a *hub and spoke* model. The main screen is the hub, and it leads to all the modules. (See Figure 7.3.)

Figure 7.3 The main screen of *JumpStart Advanced First Grade* illustrates the hub and spoke structure. The modules, represented by the various structures, are accessed from the main screen—the hub of the wheel. The reward activity takes place in the Race Arena (upper left of the main screen). Image courtesy of Knowledge Adventure, Inc. and used under license.

FUNNELS, PYRAMIDS, COAL MINES, AND PARALLEL WORLDS

Other types of structures are called into play for other types of projects. One, primarily used in games, is sometimes called a *funnel* and sometimes called a *pyramid* (a pyramid is essentially just an upside down funnel). In this type of structure, players start at the "fattest" end, where there is a great deal of freedom of movement and nonlinearity. But as they work their way through the game and are nearing the conclusion, their choices become more constrained, though they also may be more challenging.

In interactive environments that call for users to "drill down"—a term frequently used in regard to the Internet—we can find several different types of structures. In general, however, they can be clustered together as *coal mine* models. The coal mine is most common on the Web, but it is also employed on DVD and CD-ROM projects—or any project that encourages a burrowing process for fictional or informational material. In a coal mine model, you gather new material via a series of links, and move through lateral as well as vertical passageways.

Another quasi-linear format composed of multiple layers is the parallel world model, sometimes called *parallel streaming* or even *harmonic paths*. It is built on the premise that multiple lives are being lived simultaneously in different universes. You, the player, can witness or take part in any one of them—although you have to choose carefully, because while you are visiting one, events in the others are moving forward in time.

ROUNDED AND ANGULAR MODELS

If you look closely at interactive models, you might see that they fall into two broad groups, rounded and angular. Rounded structures do not support much of a story thread, but do promote a great deal of freedom and exploration. On the other hand, angular structures tend to channel users along a particular path and have a more linear core. Some people refer to an unrestricted, free-range environment as an *exploratorium*. I prefer to think of this structure as an *aquarium*, because it is so much like a three-dimensional fish bowl. Users can navigate through it in any direction, and though it may be dotted with "islands" of story elements. It is better suited for experiential interactive journeys or "scavenger hunt" types of experiences than for dramatic narratives.

The aquarium model is frequently found in MMOGs, which typically offer a number of free-ranging worlds through which players can journey. A MMOG universe can be vast in scale. Robert Pfister, senior producer of *EverQuest*, told me that his game contains about 220 adventure zones. It would take months for a player to visit them all. And Ben Bell, producer of the PlayStation2 version of *EverQuest*, said of MMOGs in general that: "Most are loosely structured in terms of plot and level design." He feels that in such games setting is more important than the story, because "supporting thousands of players in a single game world is prohibitive to supporting a single story line." He said designers of these games generally convey a linear plot through suggestions in a handful of subplots. "Quests, items, and the movement of NPC populations are all tools that we use for plot exposition."

OTHER MODELS

Other models may blend angular elements with rounded elements. There's a form I like to call the *python* because it resembles a snake that has just swallowed a pig. I came up with this term to describe a project I was pitching to a company as a simple online project, because I needed a term that could convey what I had in mind. In this model, the head portion, or entrance to the story, is narrow, and the tail portion, which is the exit, is also narrow. But the middle is fat, and here is where most of the interactive events occur. Though you can experience these events in any order, you must spend your time wisely in the "pig" section, or else you will not succeed in accomplishing your goal and will be forced to exit from the snake prematurely. Thus, the beginning and the end are essentially linear, while the middle is rounded. This form lends itself well to a goal-oriented narrative experience. Multiple pythons can be connected together in various ways to produce a more dimensional experience, somewhat like lumpy strings of pearls.

Another model I took the liberty of naming is one of my favorites: *the balloon man*. Like the python, it combines angular and rounded elements, but it is far more complex. The balloon man can be an effective vehicle for exploring psychological themes and revealing hidden facets of a character. It resembles a hand holding a cluster of strings, and every string is attached to a balloon—each a world in the balloon man's universe. Your mission begins in the hand, and from there you choose which string—or pathway—to move along. When you reach a balloon,

you experience events much as you would in the interior of the snake, except that you are free to leave at any time. To visit another balloon, you must first travel back to the balloon man's hand and select another string. Each journey along the same string produces new experiences or yields new insights. Once you have neared your overall goal, the ultimate revelation or triumph often awaits you back in the balloon man's hand.

DETERMINING A STRUCTURE

It is one thing to talk about structure in an abstract way, and to examine a variety of models; it is an entirely different thing to decide which structure to use for a particular project or line of titles. Often, the decision is guided by practical considerations or by the type of experience the creative team wants to provide for the user.

For instance, when I talked with Senior Producer Diana Pray of Knowledge Adventure, asking her why they use the hub and spoke model for their *JumpStart* edutainment games, I was surprised to learn that the needs and desires of the ultimate purchasers—the parents—are heavily factored into this choice. Of course, the needs and desires of the end-users—the kids—are also given consideration. Of the hub and spoke structure she said: "It's an easy kind of navigation. We have tried more complex ways, but parents had trouble with them. They don't want to spend time showing the kids how to do the game. They want to cook dinner, do the laundry. They don't want to hear: 'Mom, I'm stuck!'"

Speaking of what the kids want, she said: "Kids don't like the computer to tell them what to do; they like to choose. They like a game that gives them the power to go where they want. If the kids don't like the style of game play in a particular module, they can go into another module. They aren't locked into one path. The modules are not meant to be story dependent. We give them incentives for playing all the games in all the modules, but we don't force them along one story path."

Other factors come to the forefront at other software companies. For instance, at Training Systems Design, which makes interactive training programs, they regularly use a modular structure with an open architecture because it can accommodate a variety of ways of presenting material and multiple learning styles. Dr. Robert Steinmetz, the company's president and senior designer, told me they like to promote "discovery learning" rather than a tutorial approach. A modular structure with an open architecture lends itself well to this type of learning.

Another factor often taken into consideration is the genre of the interactive work. Gary Drucker and Rebecca Newman told me that when they were creating new children's titles for Sidewalk Studio, the structures they used were largely determined by the genre of the titles. Each one was essentially different from the others. "We had so many structures," Drucker said. "*Cartoon Jukebox* was, well, a jukebox. *Sandy's Circus Adventure* was a branching story. *Berenstain Bears* put the viewer in the world of the story with the same goals as the fictional characters... and so forth and so on."

One of their later titles, *The Crayon Factory*, was done seven years after their first, and according to Newman, everything they had learned doing previous titles came together for them in doing this one. While the structures of the earliest titles were extremely simple, she said this title was "the most fluid, with a free

Figure 7.4 Screen capture of the factory clock in *The Crayon Factory.* The clock was used to provide a beginning and ending to each play session with this title.

navigation.'' The title contained a linear story about a crayon factory and then allowed the young users to actually ''work'' in the factory, mixing colors, making crayons, and even coloring the linear story they had viewed.

Newman told me that because children were used to entertainment experiences that had a beginning and an ending, they wanted to supply this title with a beginning and an ending, too. The device they chose was a factory clock, which served to ''book end'' each play of the title. The children would punch their time card into the clock at the beginning of each session, and punch out at the end. (See Figure 7.4.) When they punched out, the time card would give them a record of everything they'd accomplished in the session—the crayons they'd made, the colors they'd mixed, and so on, along with the actual time they'd done these things.

At the time they made *The Crayon Factory*, they did not have a term to articulate their structure, though when I recently talked with them about this, they said the phrase ''annotated story'' best fit the central role narrative played in the title. Newman added: ''There's also the concept of 'parallel worlds' where the user gets to play in the fantasy world created in the story.'' (This approach was also used for their *Berenstain Bears* disc, as indicated by the title: ''The Bears on Their Own—And You on Your Own.'')

WHICH IS RIGHT?

Even though many companies cannot name the structures they use, we've still been able to identify a number of working models here. But how do you go about deciding which of them is best for a particular project? Obviously, there is no one ''perfect structure'' for every type of project. And in some cases, you might find that no off-the-shelf model will work for what you want to do, and it may be necessary to customize a unique structure for your project. Your decisions

about structure will be determined, to a large extent, by the project itself. Here are some questions you can ask that will help guide you:

1. What platform or device is this project being made for, and what structures are most suitable for it?
2. What projects like it already exist, and what structural models do they use? What can you learn from them, in terms of where they work well and where they are weak?
3. How important is it that the users move down a predetermined story, informational, or training path?
4. How important is it that users can navigate freely?
5. What kinds of choices will be offered?
6. What kinds of large building blocks will be most useful in organizing this project?

CONCLUSION

Currently, we only have a handful of structural models that are widely recognized throughout the interactive entertainment community. Perhaps, because of the evolving nature of digital media, we will never reach the point of having one standard set of models, each with a specific name and architectural form. In any case, because there are now only a limited number of models that can readily be named and described, it is often left to the creative team to shape their own structures.

Fortunately, it is not necessary to completely start from scratch. Aristotle articulated the three acts of dramatic structure for us, and screenwriters have shown us how to apply this structure to contemporary narrative. Furthermore, we can deconstruct already-made projects to see how they work. To obtain a good cross-section of models, we can study successful examples from a wide range of interactive media.

And, as we begin to shape one of our own projects, we can be guided by its specific purpose and requirements. Once we do that, we will find that it is not as impossible as it might seem to give order to an experience that should, to the user, feel free of constraint. In actuality, we do have more to work with than Styrofoam peanuts.

IDEA-GENERATING EXERCISES

1. Select a work of interactive entertainment—one that you are very familiar with, or have access to—and analyze its structure. What are its smallest structural units and how are these units organized into larger building blocks? How does the participant move from one building block to another? Is it possible to travel anywhere in this interactive environment right from the start, or do certain activities need to be performed before wider access is allowed? Why (or why not) do you think this structure works well for this particular project?

2. Come up with an example of an if/then choice and reaction. Express the same situation using a state engine approach.

3. Develop a simple branching structure for a story or nonfiction work, building it out to at least three levels. Then see what techniques you can use to rein in some of the branching, changing the core material, if necessary.

4. Are you familiar with any structural models that have not been identified in this chapter? If you have, and wanted to explain this structure to a colleague, how would you describe it, and what name would you give it?

5. Imagine that you have been given the task of structuring a work of interactive entertainment for a brand new platform or device—perhaps a novel kind of convergence project. Before coming up with a structure for this project, what kinds of questions would you need to ask, and get answers to?

CHAPTER **8**

Blending Entertainment with Other Goals

In what ways can interactive projects that have purposeful objectives, such as teaching or promotion, benefit by being made entertaining?

Why are organizations as different from each other as the United States Army, a major athletic shoe company, and a state parks system all turning to interactive entertainment to help them fulfill their objectives?

In a goal-oriented interactive project, how do you determine how much entertainment content is too much, or too little?

In what important ways should projects with purposeful objectives, such as teaching or promotion, be approached differently from projects whose only goal is to entertain?

ENTERTAINMENT'S CONTRIBUTION

Many tasks in life are important, but not necessarily appealing. Of such tasks, Mary Poppins had some wise advice, declaring that "a spoonful of sugar helps the medicine go down." What's true of swallowing medicine is also true of other activities that are usually regarded as uninviting—such as doing schoolwork or undergoing on-the-job training or being subjected to advertising. In interactive media, that spoonful of sugar is an infusion of entertainment content, and it helps many less-than-welcome things go down without objection.

But what do we actually mean when we say something is "entertaining"? Essentially, an entertaining work is one that engages us and engrosses us. We perceive the experience of consuming it to be pleasurable. The opposite of entertainment is drudgery and dullness. Entertainment is attractive and we gravitate to it; drudgery and dullness are things we wish to escape from. When we talk about a film or a book or other medium as being entertaining, we may mean it has a good story or that it makes us laugh, or that it contains interesting characters, or that it is game-like in some way. Many kinds of interactive projects with serious objectives benefit from a spoonful of entertainment. They include projects designed to:

- Teach;
- Train;
- Inform;
- Advertise; and
- Promote.

Some awkward words have been devised to reflect this blend of earnestness and fun, words like *edutainment*, *infotainment*, and *advergaming*. Though these new terms lack a melodious ring, they do reflect an important concept: that making something entertaining can boost its appeal. The combination of entertainment and interactivity is particularly potent when used for education. And when used to promote or sell, the target audience may actually welcome the content instead of tuning it out as they normally might.

In many cases, projects that blend entertainment with more purposeful goals employ a game-like format. This is particularly true of educational projects, which are often presented as games. But these blended projects employ other entertainment techniques as well. Some rely on compelling storylines and dramatic narrative. Others use appealing characters to put a human face on the material, characters that the users can identify with. Many projects employ humor as their primary form of appeal. Still others, particularly those that are informational in nature, use techniques of nonfiction narratives similar to those employed in documentaries. And some projects use a Chinese-menu approach, with a variety of entertainment techniques. The challenge is to find the right balance between the serious stuff and the fun stuff—between the medicine and the sugar.

INTERACTIVE ENTERTAINMENT AND LEARNING

The idea of integrating entertainment and education is not new. Our grandparents, and probably our great grandparents, too, learned to read from schoolbooks that

looked just like attractive children's storybooks. They played with educational toys like building blocks and magnets, and took part in costume dramas where they reenacted important moments in history. It's also not a new concept to use the latest technology to teach. Both film and video, for example, were quickly put to use in the classroom as soon as it became possible to do so.

What is entirely new, however, is the use of interactive technology as a vehicle to teach, and the packaging of educational content in a format that is both entertaining and interactive. Furthermore, this unique hybrid is an effective way to engage adult learners as well as children. It has been put to work for everything from teaching basic math and reading skills to training sophisticated leadership techniques to business professionals.

Both interactivity and entertainment bring great benefits to the educational party. Interactive content engages multiple senses and offers multiple ways of acquiring information and new skills—via hearing, reading, viewing moving images, viewing still images, and by manipulating content and communicating in a variety of ways. Instead of just obtaining information from a textbook or a classroom lecture, for example, learners may take part in interactive simulations where they are called upon to observe their surroundings, converse with various characters, manipulate objects, search for clues, and analyze data. This type of educational experience requires them to be fully alert and active, and the wealth and variety of stimuli make for a deeply engaged learner.

Moreover, interactive learning is highly flexible: The same program can usually accommodate different levels of learners and different learning styles. Many interactive titles offer several levels of difficulty and various kinds of learning activities, making it more likely that users will be challenged—but not beyond their ability—and will find material that matches their preferred personal style of acquiring new knowledge. Unlike traditional classroom learning, the students can proceed at their own pace. They are not held captive by the teacher's need to get through certain curriculum points by a certain time. They are also not held back by other students who may be slower at catching on than they are. Nor are they in danger of finding themselves lost if the rest of the students are ready to move on while they are still struggling to understand a key point in the lesson. Students who are having difficulty usually have many options in an interactive learning course. They can repeat a section of the program, drop down a level, or access a help function or tutorial for extra guidance.

Thus, these programs accommodate struggling learners as well as ones who learn more readily. And they can be enormously empowering to students of all abilities. As learners work their way through an interactive program, they gain a satisfying feeling of mastery and accomplishment. The interactive features give users the opportunity to have a direct impact on the material and to chart their success.

REWARDS

Typically, interactive educational projects use some sort of a rewards system to encourage users and keep them involved. Rewards can be powerful motivators, even for adult learners. Rewards come in many different forms, including:

- Being praised by a synthetic character;
- Receiving a good score;

- Winning some kind of prize;
- Obtaining a coveted item;
- Moving up a level;
- Being promoted in rank or power within the fictional world of the project;
- Making some type of significant advance within the game or story context; or
- Achieving a successful outcome in a simulation.

Rewards are earned when the learner successfully completes a task, solves a puzzle, or works all the way through a quiz. To be effective, the rewards system employed in an educational project should be geared for the age of the audience and should be related to the project's content. Programs for young learners tend to be generously sprinkled with rewards, while those made for adults normally use rewards more sparingly, but they are strategically placed to give them maximum punch.

WHAT ENTERTAINMENT CONTRIBUTES

As we've seen, interactivity can successfully be utilized to stimulate the students, customize the educational experience, accommodate different styles of learning, and motivate the user by offering rewards. But what does entertainment add to the interactive educational experience?

Most importantly, entertainment makes the material attractive and engaging. Learners willingly spend time working their way through the content instead of trying to dodge it. Furthermore, an entertaining environment is not perceived as intimidating. Let's face it: classroom learning can be extremely uncomfortable for many people. In this public environment, surrounded by your peers, you are expected to perform and seem knowledgeable. No one relishes making a mistake in such a setting. But interactive education, especially when it is entertaining, is not only private but is also perceived as nonthreatening and nonjudgmental. Thus, learners don't feel the need to put up their defenses. They are more relaxed and receptive, more open to the educational objectives.

TYPES OF EDUCATIONAL TITLES

Educational programming that is both interactive and entertaining is made for a variety of settings, including school use, home use, businesses, and institutions like museums and historical sites. It is used for adult training, for online university courses, for adult education, and to provide information in cultural venues. Even drivers who make an illegal left turn or run a red light may end up doing their coursework for traffic school as an online course. The ratio of entertainment to education in these programs varies enormously, but most have at least a sprinkling of entertaining elements.

The educational programs with the highest entertainment value tend to be the ones made for children, particularly those designed to be used in a home setting. Such titles were the first to be called "edutainment" and were among the biggest

success stories of the early CD-ROM days in the 1990s. Among the big hits were the *Carmen Sandiego* series and the various *Math Blaster* and *Reader Rabbit* titles.

Children's edutainment software continues to be highly popular today, both in homes and in schools. Some of these titles are curriculum specific, geared for a particular school grade, and cover several core skills which need to be mastered for that grade, such as *JumpStart Advanced First Grade*. Other titles target just one subject, such as *Mia: Romaine's New Hat*, which focuses on science. Some of these single-subject titles are tied to the curriculum of a specific school grade while others are appropriate for several grades. Still other edutainment titles have a softer focus. They may center on such subjects such as wildlife or geography, or they may be designed to develop a child's reasoning skills or appreciation of art. Such titles are not curriculum specific, and are meant to be inclusive of a broader age group.

THE PERCEIVED VALUE OF EDUCATIONAL SOFTWARE

Edutainment titles have done so well in part because parents perceive them as a great boon to their children's education, and a way to counter the problem of overcrowded classrooms and the mediocre education children receive in many public schools. They are especially popular in homes where both parents work or that are headed by a single parent. In such households, parents have little time to spend reading to their kids or taking them to museums or reviewing their homework. It is comforting for these parents to know their children are occupied by a wholesome learning activity, and that their minds are being stretched.

Families who are struggling to make their way up the economic ladder also welcome computers and edutainment software into their homes whenever they can afford them. They see them as important tools to help their kids attain success in life. This faith in computer learning was eloquently demonstrated by a decision made by the tribal leaders of the Sandia Pueblo in northern New Mexico. Although the tribe had many competing and pressing financial needs, the tribal elders elected to use revenues from their casino to purchase computers, monitors, and printers for every family in the pueblo, along with free training (the *Santa Fe New Mexican*, July 24, 2003).

In explaining the reasons for this expensive computer give-away, the young governor of the pueblo, Stuwart Paisano, commented that Native Americans have typically been stereotyped as being unable to compete in the modern world. He said: "This is my council's initiative to try to give our community the tools in order to be not only a productive member in his community but also in society. It allows them to compete with everyone else." While acknowledging that the computer purchase was a substantial expense, he said: "There's no way to place a value as to what this will do for each household and each member. It's very difficult to place a monetary value on someone's knowledge and learning capabilities." And an elder member of the tribe, Rose Hinkle, who is 60, expressed her excitement about the purchase. She said that she felt the computers would be a big asset to the pueblo's children. "I think it's going to help them with school. I think it's great because we didn't have nothing when I was growing up."

FINDING THE RIGHT MIX

To a certain extent, edutainment titles build on the inborn desire of all children to acquire new skills and information. Diana Pray of Knowledge Adventure, which makes the *JumpStart* titles, noted this when she said to me: "Younger kids love learning, even when it means lots of repetition. They love learning stuff. When they accomplish something, you can see the pride and pleasure in their faces. They think it's fun."

Edutainment titles like the *JumpStart* line offer a great deal of repetitive practice, and this genre of game often goes by the name of "drill and kill." Though not an especially flattering term, it reflects that a certain amount of repetition is necessary in order to master basic skills. Although children obviously learn from these drill and kill games, the companies that make them do not necessarily feel that they "teach," in the true sense of the word. Pray believes their value lies in offering an interactive supplement to what the children are learning in school. "The products are meant to help kids practice their skills, never to replace the teacher. They are not a substitute to what goes on in the classroom," she said. And the students enjoy these games far more than the more traditional way of practicing skills, which used to call for hours spent with flash cards.

The key to a successful edutainment title seems to be in finding the right mix of educational material and entertainment. But what guidelines can be used to work out the ratio of fun to education? In other words, how do you integrate the "edu" and the "tainment," and balance the two? Does a veteran company just go by the seat of its pants and rely on past experience, or do they follow established in-house guidelines? Does the ratio of "edu" and "tainment" differ from title to title? And what guidelines would be helpful to a company that was foraying into educational waters for the first time?

Pray told me that at *JumpStart*, they look to balance the education and entertainment, but always start with the educational goals of the product. Despite the fact that Knowledge Adventure has been turning out successful edutainment games for over twenty years, the creative team of a new *JumpStart* game always begins by soliciting the input of outside experts in setting the educational objectives. Typically, they are classroom teachers who teach the grade or subject matter of the title, and who give their advice both about content and teaching techniques for that grade or subject. In some cases, they also use subject matter experts—specialists in a particular field—particularly when a title focuses on a specific topic. For instance, when they developed *JumpStart Artist*, which dealt with the visual arts, they used art experts from the Los Angeles County Museum of Art.

SETTING THE CURRICULUM

Developing the curriculum for an edutainment title can be a major challenge, because curriculum standards vary widely from state to state, and standards can change quickly. Furthermore, some companies market their products internationally, and standards can vary significantly from country to country. For instance, Pray reported, in France they don't teach subtraction until third grade, while in the United States it is taught in first grade. Adding to the challenge is the teachers themselves, who often have strong opinions about what is age appropriate and what is not.

JumpStart handles these challenges in part by offering three levels of difficulty within each game, expecting that a child will fit inside one of these levels. The parent or child can set the level of difficulty, but the games also include an assessment tool that automatically sets the level for a child, and offers up games that have a natural progression in difficulty.

In working out the curriculum, many companies not only consult with teachers and content experts but also turn to resources that specialize in curriculum information and that offer compilations of curriculum standards. One good online resource for curriculum compendia is McCrel (Mid-continent Research of Education and Learning), which is at *www.mcrel.org*. At *JumpStart*, they not only use McCrel and other published resources, but also create their own nationwide compendium of curriculum standards.

MIXING IN THE ENTERTAINMENT

In terms of the "tainment" part of the edutainment equation, children's software companies use a variety of approaches to make their titles engaging, guided in part by the title's educational objectives. Most of the games contain generous amounts of humor because children enjoy it so much. Some companies, like *JumpStart*, offer a great many small games within a larger game context, while other companies focus on developing a more involving storyline. Attractive characters are also an important draw, as are settings that children enjoy—realistic places like the beach, a zoo, or an amusement park, or fantasy settings like outer space or an underground "alternate" universe.

Rewards, as noted earlier, are always alluring to children, and are a regular feature of edutainment titles as well as pure works of entertainment. At *JumpStart*, the storyline and the rewards system work hand in hand. The incentives are embedded in the story; the story motivates the kids to play the games and get the rewards. "With rewards, the kids want to play longer, so they are 'powered up,'" Pray explained.

For instance, one project I worked on, *JumpStart Artist*, is set at a carnival-like art fair, with various art-related games and activities available in each of several tents. But at the start of the game, the most exciting part of the art fair—the section where the carnival rides are located—is out of operation. In order to get the carnival rides assembled and ready to ride, the learner has to win coveted pieces of blueprints—the rewards. These blueprint pieces, which look something like jigsaw puzzle pieces, are won by playing the educational games and doing the activities in the Art Fair tents. When enough of them are collected, one of the rides can be put together and the child can actually take a ride on it. One of my tasks as a writer was to keep coming up with fresh ways to remind the learners that by doing the various activities, they had a chance to win these blueprint pieces. It was the old carrot and stick approach, but without the stick.

Along with major rewards, like the blueprint pieces in *JumpStart Artist*, many titles also offer smaller rewards each time the child successfully completes an individual exercise within the game. These rewards are the equivalent of a friendly pat on the back. Sometimes a character, usually off screen, will congratulate the learner with a "good work" or a "bravo" or some other words of praise. Sometimes a snatch of triumphant music will be played. And, in almost every instance,

a brief piece of reward animation will be activated. Usually something will happen on screen to indicate a successful answer and also show the learner's progress in the game. For example, in the game *Mia: Just in Time*, the learner must solve ten math equations to earn parts of a lock that plays an important part in the story. Each time the child solves one equation, a piece of the lock appears on screen. Ten right answers earn the child a completely assembled lock.

Rewards are not necessarily seen or heard. Often they work as invisible passes, granting the user the ability to advance in the game, as we saw in Chapter 7, with the pie example from *Nancy Drew*. Another powerful type of reward is an elevation in status. For example, in the *Carmen Sandiego* games, you start out as a rookie investigator, but as you solve more cases, you work your way up to the rank of detective. And sometimes rewards serve as a little morale booster given for general alertness. In the *Mia* games, for instance, if you keep your eyes open, you will find hidden "sparklies"—gem-like objects that are the equivalent of money in Mia's world. Not only are they of value in the game, but Mia gets really excited each time you find one.

PUTTING EDUCATION FIRST

Ideally, the fun of an edutainment title is seamlessly mixed in with the learning content, making for an enjoyable experience. But as essential as the entertainment is, the pedagogical goals still must be considered first: The "edu" must come before the "tainment." Even a small and relatively new company like Kutoka, which didn't make its first title until the late 1990s, goes to great lengths to make sure their titles are built on a solid educational footing. Kutoka is the Montreal software firm that develops the *Mia* line of edutainment titles, first introduced in Chapter 6. Educational content is taken so seriously there that the company even has a full-time "educational guru" on its staff, Dr. Margie Gollick, who doubles as a producer. Dr. Gollick, a child psychologist, is a specialist in how children learn, and when the company sets out to do a new title, she helps work out the teaching goals. The storyline is then built around these goals.

Like most successful edutainment companies, Kutoka takes care not to shortchange the entertainment experience. Much attention is given to the animation and the development of the characters, and the game is supplied with ample doses of humor, more with each subsequent title, according to Vincent. Above all else, however, each title is built on a dramatic premise. For example, in *Mia: Just in Time*, which focuses on math skills, the game begins with a blazing fire that burns down the quaint Victorian cottage where Mia lives. Soon after, Mia learns she has a chance of reversing the fire, and possibly finding out who set it, if she can just manage to assemble and operate an old time machine. But four essential parts are missing, and she needs you, the learner, to help her find them, a quest that requires the solving of many math problems. The adventure takes you deep underground into a mole's hole and into a gadget-filled inventor's cave, and finally, if you find all the parts, on a flight on a time machine. (See Figure 8.1.) The way the game has managed to blend fun and learning has earned high praise from critics. The *Houston Chronicle* noted: "What's exemplary is how well the "edu" and the "tainment" are always working together. Neither overshadows the other. Rather, each furthers the adventure."

Figure 8.1 Mia points to the time machine, which two of the perpetrator's inept cousins are trying to steal from her. Image courtesy of Kutoka Interactive.

As with the *JumpStart* titles, children are given numerous rewards as they work their way through the game, and they can adjust the difficulty level, too—these titles offer four different settings. However, one of the biggest attractions of *Mia: Just in Time* is something that is impossible to quantify: its enormous charm and a slightly off-the-wall sensibility. Though intended for 6- to 10-year-olds, I found it impossible to resist, and kept playing long after other duties called. (For more on developing projects for children, please see Chapter 9.)

BUT WHAT ABOUT MORE ADVANCED STUDENTS?

While just about everyone would agree that computers can be an excellent vehicle for young students, and while hundreds of edutainment software titles have been developed for children since the early 1990s, far less work has been done in terms of developing entertaining educational titles for older students. Complex subjects like Newtonian physics and microbiology have been considered too difficult to teach in a game-like format. However, this reluctance to develop educational games for advanced subjects may soon change, if the work being done by a group of scholars at MIT manages to demonstrate gaming's potential and to serve as a model elsewhere.

Called the *Games to Teach* project (*www.mit.edu/games/education/index.html*), it is being done as a partnership between Microsoft and MIT. Launched late in 2001, it has brought together an eclectic mix of specialists from various fields—game designers, teachers, media experts, research scientists, and educational technologists. Their goal is to develop conceptual prototypes for a new generation of games that are based on sound educational principles. These games tackle difficult subject matter in science, engineering, and humanities, and are geared for advanced placement high school students or lower level college students. By taking advantage of the latest technology and design principles, these games are meant to excite the curiosity and imagination of the students while giving them the opportunity to explore complex systems and concepts. Most of these projects offer networked

gaming environments, which allow a number of learners to participate simultaneously. Thus, they are somewhat like educational versions of the enormously popular MMOG, *EverQuest*.

In such immersive game worlds, users are deeply engaged with the content and are also competing, collaborating, and interacting with their peers, overcoming challenges in a communal environment. According to the scholars at the *Games to Teach* project, these qualities make them potentially powerful vehicles for learning, and research suggests that the kind of trial and error experimentation and problem solving that takes place in such environments can promote the retention of newly gained knowledge.

The *Games to Teach* project is under the umbrella of MIT's Department of Comparative Media Studies. Professor Henry Jenkins, director of this department, serves as principal director of *Games to Teach*. Discussing the philosophy behind the project in an article published on the TechTv website (*www.techtv.com*), Jenkins made an interesting comment about what games can do. "Games push learners forward, forcing them to stretch in order to respond to problems just on the outer limits of their current mastery," he said. He also emphasized the value of peer-to-peer learning, in which learners help each other solve problems and work together to carry out tasks. He noted that researchers have found that such peer-to-peer learning reinforces mastery.

Like Diana Pray of *JumpStart*, Jenkins believes that the role of educational games is not to replace teachers, but to enhance what they do. Games help make the subject matter come alive for students, he noted in the article; they motivate them to learn. He feels educational games could be of particular value in the areas of science and engineering because they offer "rich and compelling problems" and model the scientific process.

Thus far, the *Games to Teach* project has developed concepts for 15 games. Though the subject matter of most of them seems dry and unpromising, the games themselves sound like enormous fun. Take, for example, a game called *Hephaestus*, which focuses on mechanical engineering and physics. In this game, players find themselves on a formidable volcanic planet. Here they must work together to build and operate a workforce of specialized robots in order to survive. Another game, this one a role-playing adventure game that teaches optical physics, is called *La Jungla de Optica*. Set in the Amazon jungle, it involves an archeologist and his niece who must contend with a bunch of criminally minded marauders... kind of a *Tomb Raider* for the physics set. Still another, *Xtreme Sports*, teaches algebra and physics.

BREAKING NEW GROUND IN INTERACTIVE EDUCATION

The work being done by the *Games to Teach* initiative has already begun to bear fruit, having inspired at least one pioneering educational project. With the working title of *Virtual State Parks*, this ambitious role-playing history game is being developed 3,000 miles across the country from MIT, in California's capital, Sacramento. This multiplayer role-playing game is the brainchild of Elizabeth Prather, a designer who works in the park design and construction division of the state's Department of Parks and Recreation. As of this writing, the project is in its pilot stage, which Prather is overseeing. When completed, the project will give school children the opportunity to virtually experience significant periods in the state's history while

being immersed in a real-time 3D-networked environment. The game is illustrative of how the ideas being spun in the lofty halls of MIT can be applied to real-world educational objectives.

The Game and Its Evolution

The idea for the project grew out of an experimental real-time 3D environment Prather was building of the Fort Ross State Park, which was part of the work she was doing in developing architectural 3D real-time walk-throughs of various California parks. The success of the real-time 3D work inspired her with the notion of using it as the foundation of an educational game.

While in the first stages of developing the game, Prather learned about the *Games to Teach* project, and it made a deep impression on her. She studied every one of MIT's initial ten prototypes (now 15) as she did the storyboarding, and many of the *Games to Teach* objectives have found their way into the *Virtual State Parks* project. It incorporates three qualities that are emphasized in the MIT proto-types: peer-to-peer learning, learning by doing, and high entertainment value. But it's directing these concepts at a much younger age group: elementary school children. The third, fourth, and fifth graders the curriculum is geared for will learn history, cultural anthropology, natural history, and social skills while taking part in an experiential narrative drama.

The Game's Objectives

The game builds on one of the most important missions of the California state park system, which is education. With 277 parks and 86 million visitors a year, the state's park system is the largest in the world. It contains a diverse collection of properties, from glamorous Hearst Castle to tranquil Spanish missions to lonely ghost towns, and the game will focus on ten of these parks. With this game, students who do not normally venture far from home will have the chance to "virtually" visit some of these culturally rich sites. Even well-traveled students will experience these places in an entirely new way, by engaging in dramatic reenactments of history.

Prather's supervisor, Dr. Mark Schrader, who is Deputy Director of the Acquisition and Development Division of the California Department of Parks and Recreation, has been an enthusiastic supporter of the project. He said he regards the game as an educational tool for today's environment, and called it livelier and more mentally stimulating than "the typical static exhibit, which is looking at something through glass." Support for the project extends to the highest level of the California State Parks system, to the Director herself, Ruth Coleman. She said of the project: "California State Parks is committed to bringing parks closer to people, both by acquiring lands in urban areas, and by using technology. This project can make history come alive for all students, even if they don't have the opportunity to visit the parks in person."

The Pilot Phase

History-rich Fort Ross State Park, a settlement originally built by Russian traders, was selected as the setting for the pilot. During the game, the children will role-play real historical figures, recreating both the daily activities of the settlement

and significant events in the characters' lives. In short, it is a bit like a historical version of the *Sims*—if you set the *Sims* in California in the early 1800s and threw in some international explorers, Russian traders, Alaskan seal hunters, and local Native Americans.

The pilot will serve as a proof of concept, and once it is completed, the Parks Department will look for additional funding. Prather estimates the game could cost between $5 and $10 million dollars to complete.

Developing the Pilot

During the first months of building the pilot, Prather worked as a one-person shop, doing everything herself—the research, the design work, the storyboarding, the writing, even some 3D real-time environments and animations. She keenly felt the burden of breaking new ground, saying of the experience: "I was in an area where there was no area." Her storyboards alone, presented on a graphically vibrant PowerPoint slide show, ran to about 300 slides. To develop the curriculum, she utilized material written by Park Interpretive Specialist Robin Joy, who had worked out a set of grade-appropriate educational goals for students who visit Fort Ross.

Once the pilot was funded, Prather was able to bring on board a full-time assistant, Kirk Hockinson, for six months. Hockinson, a subcontractor from the Pendergast Group, once worked on the *Sims*. At *Virtual State Parks*, his role calls for him to help Prather with the 3D modeling and animations and to produce real-time environments, avatars, and other kinds of characters.

For the prototyping of the pilot, Prather has selected software packages from Virtools, including the Virtools Artificial Intelligence Pack, which can actually program NPCs with behaviors and reactions. For instance, if a sea otter "sees" a hunter coming, it will beat a quick retreat. Ultimately, she said, she would like to bring a writer aboard to tap into the rich historical material she has unearthed, and to give the game a dramatic punch.

The Entertainment Content and Game-Play

During the early development stages, Prather spent many months working out ways to make the learning more engaging. She was elated when her research uncovered a colorful real-life romance that could serve as the dramatic centerpiece of the game. The tragic couple, a Russian trader and a young, highborn Spanish beauty, both instrumental in the early history of Fort Ross, will act as the ghostly "host" and "hostess" of the game. Prather also uncovered other intriguing links between Fort Ross and world history, including a connection to the legendary Captain Bligh of *Mutiny on the Bounty* fame.

Bligh and other dashing historic figures will be incorporated into the game with the goal of making the experience as engaging as possible to young players, who will have the opportunity to "step into the shoes" of these fascinating characters. While role-playing historical figures, students will go on challenging quests, competing and cooperating with each other in various missions while attempting to fulfill specific assignments. Tasks will include such diverse jobs as constructing a wooden windmill and grinding flour for the Fort's residents; navigating a boat through local waters; and going on a hunting expedition to a nearby island. (See Figure 8.2.)

Figure 8.2 A PowerPoint slide from the *Virtual State Parks* project showing a sample task.

Each grade level will have its own educational focus, although students from all three grades will be playing simultaneously. The entire group will come together at the end for a final joint assignment. Players will be able to communicate in character by "talking" in text boxes, and they can also take part in chats on the game's chat boards, which will give them a forum for assisting each other with the tasks they are trying to complete. Prather anticipates that these chat boards will serve a valuable function in the game, serving as an important component of peer-to-peer learning. Help and information will also be offered by three-dimensional characters reconstructed from historic photos and wax figures, and animated by motion-sensor technology.

For the pilot phase, students at different locations will be connected by a networked system and 15 to 30 students will be able to play at once, using PCs and controlling the action either by keyboards or joy pads. Eventually, users might be able to play the game right at the parks, using kiosks with touch screens. Prather hopes that in the finished product, the game will have no upper limit as to how many people can play at the same time. She is also exploring the possibility of making true VR a part of the game.

INFORMATION AND INTERACTIVITY

Along with edutainment projects like the *Virtual State Parks* project and the *JumpStart* games, we also have another genre of "tainment" programming—infotainment—which blends information and entertainment. But where do you

draw the dividing line between educational material and informational material? They are so closely related that it is hard to know whether they are kissing cousins or siblings. After all, the bulk of what goes on in an educational setting is the imparting of information.

Perhaps the chief difference between them is not the content itself, but where and why they are delivered, and the attitude of the recipient of this material. Education is usually directed by an institution—a school or a college. Its intentions are purposeful—to make the recipient learn something—and the recipient is obliged to learn. Information, on the other hand, can be delivered less formally, often in a domestic or recreational setting, and it is generally something the recipient seeks out voluntarily. For example, you can learn about the Civil War at a school classroom lecture or at home by watching a documentary on TV. The first experience would generally be regarded as educational, while the second would likely be thought of as informational. Yet another subtle difference exists between imparting something as information, and imparting the same content as education. When you deliver content as information, the emphasis is on the facts. But when you deliver content as education, you are examining what these facts mean in a larger context, and are considering how they fit in with other knowledge.

These differences can help determine how you might approach the same core material for an interactive project, shaping it one way if the intent is educational and another if the intent is to inform. Let's go back to our Civil War example and see how this might work. For an interactive edutainment project, you might want to use a networked experiential game format, like the Fort Ross pilot of the *Virtual State Parks* project. This would not only teach students the facts about the war, but the role-playing opportunities offered in the game would let the players experience the issues and conflicts that sparked this national crisis. For an infotainment approach, you might choose to do an iTV show, using a documentary as the core material and offering interactive enhancements like timelines, additional documentary material, scholarly interpretations, and even trivia games.

ENHANCING INFORMATIONAL CONTENT WITH INTERACTIVITY

Let's look at one real-life example of how informational material can be enhanced via interactivity. The challenge of finding ways to do this kind of thing is one that Jackie Kain faces on a daily basis. Kain is VP of New Media at KCET, the public TV station in Los Angeles. Her job calls for her to find ways of supporting the station's content through various new media venues, including the Web, DVD, and iTV. Much of the material she deals with is informational in nature, such as the three-hour biography of Woodrow Wilson that was made for the *American Experience* series and first aired in 2002.

Charged with enhancing the *Woodrow Wilson* documentary with a new media application, Kain studied the core material and noted that the documentary was "a rich story that was narrative driven." She therefore decided to capitalize on its narrative qualities. The initial medium she selected for doing this was iTV. But midway into the iTV development she ran into universal access questions. With the availability of iTV still being quite limited, it was apparent that only a few of the station's viewers would be able to access the documentary in this format.

A better way to go, she decided, would be to do the enhancements on both a web-site and a DVD. It would be the first DVD to be produced by KCET. The two interactive media, working in conjunction with each other, would greatly expand the material offered in the TV documentary. By spreading the information over multiple media, viewers would have a variety of different ways to acquire infor-mation about Woodrow Wilson. An additional plus: Both the website and the DVD would be readily accessible to great numbers of the KCET viewing audience.

Furthermore, the time already invested on the iTV show would not be wasted, because the development team realized it would be able to use the design work originally intended for the iTV application as the organizing principle for the DVD. They'd be able to use the same "graphical thrust" as well. Dale Herigstad of H Design (the company was later reorganized as Schematic LLC), who headed up the design team for the iTV version, would now do the same for the DVD and website.

Thematically, it was decided, both the website and the DVD would focus on Wilson's domestic policies. Because of time constraints, this part of Wilson's career could not be covered in depth on the TV documentary, but now, with the two interactive venues, it could be explored in great detail. The website would be more text based, while the DVD would contain more video, thus coming at the same subject matter in somewhat different but complementary ways. They would be tied by a similar design as well.

The enhancements for the website (*www.pbs.org/wgbh/amex/wilson/*) included an interactive timeline; commentary by historians; period photos of America's poor (taken by master photographer Jacob Riis); poster art from World War I; and additional information about the people, issues, and events that were important in Wilson's life. One of the site's most engaging and imaginative features was an activity called "Win the Election of 1912." It challenged users to run their own political campaign to see if they could do better than other contenders in that historic race, a political contest that included not only Wilson, but also Theodore Roosevelt, William Howard Taft, and Eugene Debs. Users got to invent the name of their party and then decide their stance on certain critical issues of the time. Based on their selections, they either won or lost the election.

The DVD contained 80 minutes of video expressly produced for it, material not included in the TV show. This additional footage, broken into small, "consum-able" chunks, consisted of mini-documentaries and interviews with scholars. Kain described them as "short documentaries that tell you a story." Thus, the DVD and the website enhanced the TV documentary, and did so in a highly engaging manner. (For more on DVDs, see Chapter 20; for more on Web projects, see Chapter 13.)

OTHER INFOTAINMENT APPROACHES

Although the *Woodrow Wilson* project did not become an iTV show as originally planned, other infotainment projects have found a home in this medium. The BBC has been extremely active in this area, and TV networks in the United States are venturing into these waters, too. Among them is ABC, which, in the spring of 2003, broadcast an iTV show called *The View: His & Her Body Test*. A primetime version of a popular daytime talk show, this live special gave viewers at home

a chance to answer 30 health-related questions while the show was on the air. The on-air experts then commented on their answers. Viewers had three different means of participating: via a set-top box, via an Internet-connected computer, and via a mobile phone. The interactive TV service was provided by Wink, which at the time reached about 7 million homes. According to one ABC network executive, the goal of the interactive elements was to enable viewers to form a deeper and richer connection with the content.

Although iTV is still a relatively new medium for interactive infotainment, the Web is an old hand at offering such programming. One of the granddaddies of Web infotainment is *The Motley Fool* (*www.fool.com*), a financial site that takes a breezy approach to personal investing. The site has been up and running since 1994, starting out at first as a service of AOL and then soon moving to the Web. Its motto is "to educate, to amuse, to enrich." Other infotainment sites focus on health, entertainment, travel, and sports.

No site for adults, however, can rival a certain kid's infotainment site called *Yucky.com* (*www.yucky.com*) when it comes to outrageous humor. This site, which proudly bills itself as "the Yuckiest Site on the Internet," offers legitimate scientific content, but it does so in an extremely off-the-wall way. It is hosted by a slimy reporter named Wendell the Worm, who offers features on disgusting (but fascinating) subjects like poop, zits, sweat, and dandruff—all as enticements to learn more about how the human body works. One of Wendell's fellow denizens on the site is Ralph Roach, who keeps a diary reflecting the daily life of a cockroach. His entries include hair-raising escapes from near death and the violent murder of his brother Clifford (done in by a cat). The site also offers audio to underscore various points. On the poop page, for example, visitors can click on a button and hear a toilet flush. No, this isn't particularly appetizing content for adults, but it is an effective way to grab kids' attention and inform them about biology.

INTERACTIVE TRAINING

Interactive training would seem to be a world away from the bathroom humor and slimy characters of a site like *Yucky.com*. However, it, too, often relies on engaging material (appropriate for its target audience, of course) to involve its users in the material to be learned.

Training is an essential activity to business. Sooner or later, almost everyone who holds a job will be asked to participate in a training session, whether the employee is a new hire whose job it is to stock shelves or a seasoned manager who oversees a large staff. Training sessions can cover anything from a basic company orientation to leadership skills, and from customer service to complex legal or scientific topics. At one time, such sessions were usually led by a facilitator and conducted much like a school or college class. Increasingly, however, training is done via computer technology, including CD-ROMs, the Internet, DVDs, and various blends of media.

Digital training has many of the same advantages as edutainment titles made for children:

- It is participatory and active;
- Users learn at their own pace;

- It offers learners helpful feedback;
- A single program can accommodate many different styles of learning; and
- The users often find such programs more stimulating and engaging than traditional classroom training.

Furthermore, digital training has another advantage that appeals to businesses: It is cost effective. Employees can do the coursework sitting at their workstations, eliminating the need to fly them halfway across the country to a training seminar.

CAN INTERACTIVE TRAINING BE ENTERTAINING?

Given the fact that training takes place in a business setting, and that the users are obliged to take these electronic courses, it is reasonable to wonder if it is necessary, or even possible, to make them entertaining. Nevertheless, the companies that make such courses, as well as the companies that purchase them, recognize the value of making them engaging, and understand that entertainment elements can help hold the users' attention. And they are also mindful of the fact that interactive training is competing to some extent with other forms of interactive programming, particularly games. This is especially true when the training material is directed at younger learners.

For example, Dr. Robert Steinmetz, who heads Training Systems Design and who was introduced in Chapter 7, said that he was very aware of the developments in interactive gaming and of the expectations of the younger generations for interactivity and for visual richness. Dr. Steinmetz, who holds a Ph.D. in Instructional Technology and Educational Psychology and has had over 20 years' experience in training, has a good grasp of what these courses need to be like in order to make them effective with the designated learners. He said it was necessary not only to take the expectations of the younger learners into consideration but also to consider the older learner, the person who says "just give it to me in spoon-sized bites. Don't overwhelm me."

To accommodate both types of learners, his company employs an open architecture that can provide for multiple learning styles. Typically in their courses, the subject matter is divided into modules, and each module is given an engaging and appropriate theme. A single interactive course may contain a great variety of interactive approaches, including game-like activities, simulations, and modules that offer a user-directed path through informational material.

THE POWER OF SIMULATIONS

Like many others who work in the arena, Dr. Steinmetz believes that simulations are a particularly powerful tool for training. Of course, the term "simulation" can be used to mean many different kinds of experiences within an interactive environment, and vary considerably, depending on the degree of immersion. Dr. Steinmetz defines a simulation as "a re-creation of a real world event, an unfolding drama, in which the user controls the outcome." In other words, users learn by becoming involved in a realistic and dramatic scenario in which their choices determine how things turn out.

The company is currently building a new course called *Code Alert*, which utilizes several different simulations. The goal of the course is to educate employees about office safety and get them to observe safe office practices. It is designed as a generic course, meant for a broad spectrum of companies rather than being custom-made for a single organization. *Code Alert* is a "blended" product, partly delivered on a CD-ROM and partly delivered via the Internet, with the media-rich content contained on the CD-ROM.

One of its modules is a tense simulation featuring an angry, disgruntled employee who is armed and potentially dangerous. You, the user, have to calm him down and get him to leave the office without the encounter erupting into violence. Another simulation module has you dealing with a suspicious package that has just been delivered to your office and that could contain an explosive device. If you don't handle the situation correctly, the device will go off. Without question, such gripping simulations give users the sense that a great deal rides on whether they make the right decisions. Immersive dramas like these are likely to keep them highly involved in the training program.

True to the company's philosophy of offering different types of learning experiences, *Code Alert* contains not only simulations, but also other, quite different, approaches to its subject matter. For example, one module is a game called *Save Your Co-Worker*. The user must navigate around the office and spot things that could be unsafe. (See Figure 8.3.) Potential "hot spots" include a man with a necktie bending over a shredder; a man perched high on a ladder; a top-heavy file cabinet; and a supply closet containing a bleach and cleanser side by side, chemicals which could make a poisonous gas if accidentally mixed together. If you leave the office without spotting all the potential hazards, you will witness the disastrous consequences. For instance, if you have failed to note the man on the ladder, he will topple over backwards. For those learners who respond better to more traditional learning, a mentor can be accessed from the upper right corner of the screen and is available to give a tutorial on the subject.

Still another module is called *Dumb People Tricks* and documents foolish accidents people have had on the job. The module called *When Violence Strikes* focuses

Figure 8.3 A screen capture from the *Save Your Co-Worker* game of *Code Alert*. The objective is to spot potential hazards like this man on the ladder, and to prevent accidents from happening. Image courtesy of Training Systems Design.

on natural disasters and how to deal with them. The module *How Safe Are You?* is a Cosmo-style quiz about the user's own office safety practices. Thus, *Code Alert* offers a diverse array of activities, some game-like, some with touches of humor, some highly dramatic. "We took a topic which most people would say 'ho hum' to," Dr. Steinmetz said of *Code Alert*, "and tried to make it engaging and attention sustaining." As *Code Alert* illustrates, entertainment techniques can play an important role in enhancing the effectiveness of interactive training.

ONLINE COURSES

The *Code Alert* course uses both the Internet and a CD-ROM as its modes of delivery, but many courses are taught entirely online, either for training or for educational purposes. Online education and training is often referred to as *e-learning*. College courses, university extension courses, and adult education courses are all offered as e-learning opportunities. When e-learning is used for training, it often takes place over an organization's Intranet service.

Aside from technical limitations, training done online can be much like CD-ROM based training and can contain many entertainment features, including game elements, animation, and the use of story and simulations. However, as with CD-ROM training programs, the entertainment components must be used judiciously, and care must be taken to integrate the entertainment elements with the training content, so they do not distract from the content that is to be learned.

Among the many specialists who believe that entertainment elements have a definite place in online training programs is Dr. Ann Kwinn. Dr. Kwinn received a Ph.D. in Instructional Technology from the University of Southern California and is Director of e-learning for Clark Training and Consulting. "I see an e-learning program as a work, a piece, just like any other, and as such it must hang together aesthetically and communicate a clear message," she told me. Although story scenarios can be effective teaching tools, online training specialists like Dr. Kwinn recommend that they be set in a workplace environment in order to make them meaningful to the user. The more similar a story scenario is to real life, and to a real workplace situation, the easier it is for the learner to see the relevance of the training to the work.

Games, like story scenarios, can be very attractive to learners and can be valuable teaching tools. Care must be taken, however, to make sure they reinforce the training message and don't divert attention away from it. Like story scenarios, they should be as closely related to the users' jobs as possible. Games, simulations, and story-based scenarios can all be part of the courses' mix, offering users a variety of ways to learn and to transfer the program's message to their own jobs. However, certain entertainment techniques, particularly animation and audio, are such attention grabbers that they can be distracting. Dr. Kwinn recommends that they be used sparingly, "like exclamation points."

ONLINE EDUCATION

While training courses for corporations and other organizations can accommodate plenty of bells and whistles, online courses for schools and adult learning

institutions tend to be extremely lean when it comes to the use of entertaining elements. E-learning courses offered by colleges and universities are often put together by the instructors themselves, and most lack the time and the skill to make them anything but "plain vanilla." Another consideration is bandwidth. Many students work on dial-up modems, and thus the downloading of big files, especially ones containing video, takes too much time. Furthermore, some instructors believe that students want their course materials to contain just the bare essentials. Thus, a great number of online educational courses are presented as straightforward text, essentially containing written lectures, examples, and quizzes, perhaps with a sprinkling of graphics.

However, as with everything else, the exception proves the rule, and some professors are offering more when it comes to livening up their online courses. One such professor is Dr. Sandra Chrystal, who teaches at USC's Marshall School of Business, in its Center for Management Communication. She offers a course called "Advanced Writing for Business," a "blended" course that is taught partly in the classroom and partly online. The online materials contain cartoon figures and pop-ups that are contributed by the Marshall School's e-learning team. Dr. Chrystal also makes ample use of other graphics, such as photographs, charts, and documents.

Perhaps the strongest application of entertainment techniques in Dr. Chrystal's course is her use of story—story in the true-life documentary sense rather than the fictional sense. For example, in one module, she uses a dramatic case history about a manager who sent out a badly written memo during a snowstorm, resulting in confusion about company policy and damage to employees' morale. The case history, illustrated with photos of the blizzard, helps dramatize her points about effective memo writing. She further engages her students by challenging them to use their skills in memo writing to show how the situation might have had a more positive outcome, had the manager sent out a better-worded memo.

USING OTHER INTERACTIVE TECHNOLOGIES FOR TRAINING

CD-ROMs and the Internet, while the most customary delivery modes of interactive training and education, are not the only possible options. The United States Army, for example, is developing VR simulations to prepare soldiers for dangerous missions, as we saw with the *DarkCon* project in Chapters 5 and 6; we will be looking at other kinds of military simulations in Chapter 19. Even smart toys have successfully been pressed into service to act as teachers (see Chapter 16). In the future, it is quite conceivable that DVDs, interactive kiosks, and iTV may be utilized for training and education as well.

INTERACTIVE ADVERTISING AND PROMOTION

Educating, informing, and training are not the only human endeavors that avail themselves of interactivity and entertainment. Promotion and advertising also use new media, with the goal of attracting people to certain goods and services. However, promotion and advertising are somewhat different in terms of their end goals. While promotional activities are designed to attract favorable attention, advertising goes one step further and tries to encourage a purchase.

One of the most desired outcomes of both advertising and promotion is something called *branding*. Branding is a way of establishing a distinctive identity for a product or service, an image that makes it stand out from the crowd. By successful branding, the product is distinguished from its competitors and is made to seem alluring in a unique way. Thanks to interactivity and the Web, organizations now have a whole new way to strut their stuff and do some effective branding—advergaming. Advergaming, as the name suggests, combines gaming and advertising. Such games began on the Web, but are now also appearing on wireless devices, where they work equally well. They are generally short, designed as a quick burst of fun.

Advergaming is popular with advertisers because of its ability to:

- Increase brand awareness;
- Encourage consumer interaction; and
- Induce potential customers to register and provide e-mail information.

Effective as advergaming can be, not everyone who makes these games is fond of the term. For instance, Steve Zehngut, President of Zeek Interactive, which specializes in advertising games, prefers to call these entertainments "promotional gaming." Though he might dislike the term advergaming, however, he relishes the job of creating such games. At Zeek, the way each game is developed depends to a large extent on what the client wants and needs. Some clients come to the company with a game already in mind. Others may only know what element of the product they want to underscore, but don't have a particular approach in mind. Zeek works closely with each client to come up with the right mix of game and advertising.

When possible, the company comes up with a little backstory for each game, something that will set it up and put it in context. But often, the amount of backstory that can be offered is limited by time constraints. "We do as much story as we can," Zehngut said, "but users want to get into a game as soon as possible... unless the backstory is funny. Then we can spend a little more time on it."

As one example of a promotional game, let's look at *The Race to School Game* that Zeek made for Reebok athletic shoes. The game promotes a shoe called the Traxtar, and in this particular case, Reebok knew in advance what they wanted the game to do. They wanted it to promote the shoe as a product associated with fitness and competition, and to show off the shoe's desirability for running and jumping activities. The game Zehngut's company came up with features a character named Sammy Smartshoe. In the backstory, we learn Sammy has missed his school bus and has to get to school in time for an important math test. So Sammy decides to beat the bus to school. As the player, you help Sammy race against the bus, making him leap over a variety of obstacles. You almost must help him avoid hazards like slippery mud puddles. Sammy's jumps in the game have a springy, bouncy quality that sends him effortlessly over obstacles—surely a subtext indicating what the user can look forward to if he purchases this particular brand of shoe.

BLENDING PROMOTION AND ENTERTAINMENT

In some cases, entire websites blend promotion and entertainment. Among the most entertaining promotional websites are those made for movies, and almost

every film released these days gets one. The first giant success in this area, of course, was the website for *The Blair Witch Project*, discussed in Chapter 3. And, to point to a more recent example, one need look no further than *The Official Harry Potter Website (www.HarryPotter.com)* which promotes all the Harry Potter movies and the books as well. It offers games and activities that are seamlessly in keeping with the world portrayed in the original properties. For instance, young visitors can enroll in Hogwarts, the gothic-looking school of wizardry that Harry attends; they can practice Quidditch, the favorite game of the budding wizards set; or they can go shopping for that perfect wand.

As for television series, many of them, too, have websites that build on the fictional characters in the show. One of the most imaginative was the *Dawson's Desktop* website mentioned in Chapter 6, which was made to promote the series *Dawson's Creek*. And an innovative new venture at ABC is using not only the Web, but also a wireless phone tie-in, to promote its daytime soap opera, *All My Children*. The promotional campaign even has its own name, *The Sexiest Man in America*, and the campaign is fully integrated into the soap's plot. In the show's storyline, two of the fictional characters are about to launch a cosmetics company and are searching for a great looking male spokesperson to represent it. Candidates vying for this spokesperson's job will appear on the soap opera as part of the plot, and viewers at home can vote for their favorite via the Web or wireless phone. Those who vote using their mobile phones will receive a bonus: One of the show's fictional characters will send them an advance "scoop" about an upcoming development in the soap opera's story.

Non-entertainment products are also being promoted online in attention-grabbing ways. For example, BMW has taken advantage of broadband to offer up a series of high-budget, slickly produced short films (*www.bmwfilms.com*), all of which, of course, show off BMW cars. These films were made by heavy hitters like directors Guy Ritchie, John Frankenheimer, and Ang Lee. One of them even stars Madonna. (For more about the use of entertainment on the Web, please see Chapter 13).

PROMOTION IN OTHER INTERACTIVE MEDIA

Other new media venues are also being used for promotional purposes. One cutting-edge example is the VR installation made for the German company, RAG Coal International. This installation was built for the Hanover Fair, the world's largest industrial trade show. Even in such high-tech surroundings it created a sensation. Participants were taken on a dazzling VR journey that included a trip beneath the earth's surface into a coal mine. Obviously, the content of the installation was only part of RAG's message; the other part was that the company was innovative enough to sponsor a VR project like this. The installation was made by the German company Fraunhofer.

But promotion and marketing have also found a home on the oldest of all new media venues, video games. A wildly successful example of this is a game made by the United States Army, designed to recruit new soldiers. The game, called *America's Army*, is perfectly aimed at its target demographic, the young men and women who love to play video games. It is actually two games blended into one. *Soldiers* is a role-playing game, while *Operations* is more of a first-person action game.

America's Army realistically portrays army life and combat, taking players from boot camp training right through to dangerous combat missions. The weaponry and tactics are all authentic. The developers took great pains to be accurate, while focusing, of course, on the exciting and glamorous parts of military life; KP and pushups are not featured in the game. To make sure they were getting everything right, the developers even rode in Blackhawk helicopters and jumped out of airplanes in parachutes.

The game was made with a state-of-the-art real-time gaming engine that personalizes each player's experience. *America's Army* cost $5 million to make, but it has been an enormous hit, and the military considers it a worthwhile investment because, without a national draft system, it is essential to get young men and women to voluntarily enlist in the armed services. The game is offered for free on the Web on the game's two special websites (*www.armygame.com* or *www.americasarmy.com*), which also offer regular updates. The online distributor, Gigex, called it the company's most successful product launch ever, with over one million downloads to date and a flurry of 50,000 downloads on the first day. The game is certainly far more enticing and effective in attracting prospective recruits than the old way of doing things, when some old Army guy in a dreary recruitment office tried to sell young kids on life in the military. So, just as Mary Poppins said, if you add enough sugar (the entertainment components), the medicine (the recruitment message) will go down easily.

TACKLING A PROJECT THAT BLENDS ENTERTAINMENT WITH OTHER GOALS

Obviously, big differences exist between making an educational game, a promotional website, and a training program—all of which, along with many other types of interactive projects, can use entertainment to further a pragmatic goal. Yet the process of developing such projects all begins with the same basic considerations and questions. Here are some of the things that need to be thought out at an early stage:

- What is the need for this particular project? What is the ultimate goal of the organization that is sponsoring it?
- Who is the intended audience? And what kind of entertainment most appeals to this group?
- What medium is it intended for, and how best can you tell this "story" in this particular medium? What are the technical or other restrictions in this medium? What do users of this medium expect or desire in terms of content?
- What will the core content be? And who will assist in gathering it, making sure it is accurate, that it is suitable for the intended audience, and that it is designed to meet its intended objectives?
- How will the content be organized?
- What will the users do, and how will they be immersed in the material?
- What is the best way to integrate the entertainment with the purposeful content of this project?
- What will the balance be between the "fun stuff" and the "serious stuff"?

The answers to these questions, along with the ten-step development guide offered in Chapter 10, will help you shape almost any project that blends entertainment with another goal.

CONCLUSION

Projects with workhorse missions like educating, informing, training, and promoting might at first seem to be unlikely venues for entertainment. Yet, as we have seen here, they can successfully be blended with traditional techniques of storytelling and contemporary techniques of gaming.

Unfortunately, because these projects are not "pure" entertainment, they may be perceived as lacking the glamour of areas like video games. Yet, as the projects described in this chapter illustrate, they can be extraordinarily creative and cutting-edge, just as much so as projects that have no other mission but to entertain. Furthermore, endeavors like these perform a genuine service in the world. And, it should be pointed out, they also offer a great many employment opportunities. As the use of interactive media has spread, so too has its appropriation for pragmatic purposes. We have every reason to think that this growth will continue into the future, with a steady demand for people with the creative ability to stir sugar and medicine together and turn it into a palatable, tasty brew.

IDEA-GENERATING EXERCISES

1. Pick a topic that is taught in elementary school, and devise a concept for an edutainment game that would teach this subject.
2. In your opinion, what are the elements contained in a website like "The Yuckiest Site on the Internet" that manage to get kids interested in science? What other kinds of informational topics aimed at young audiences do you think might be made enticing by utilizing such an approach? Do you think such an approach could work for adults, too, and if so, on what types of subjects?
3. Choose a product or organization that you are familiar with, and devise a concept for a promotional game that would highlight its strongest qualities.
4. In terms of promotion, can you think of any products or types of organizations that definitely do not lend themselves to an approach that is entertaining? Why do you think entertainment elements would be inappropriate or unwelcome in such cases? If you are exploring this question as part of a group, see if anyone else in your group can think of a way to promote this product or organization that is both interactive and entertaining.
5. Pick a subject that could be the focus of either an educational lesson or an informational program, such as the Civil War example given in this chapter. Describe an approach you might use to turn your subject into an edutainment product, and a different approach for turning it into an informational product.

Tackling Projects for Children

What special considerations must we be aware of in designing an interactive project for children?

How much of a role, if any, do parents play in determining their children's access to interactive media, and what are their chief concerns in this area?

In making products for kids, how useful are professional experts, focus groups, and testing?

What Seven Kisses of Death can doom a new media project for children, and what are some strategies for combating them?

THE SPECIAL CHALLENGES OF CREATING WORKS FOR KIDS

Across the board, children and teenagers are among the most enthusiastic fans of digital storytelling of any segment of the population. Furthermore, they often lead the way when it comes to adapting a new form of interactive entertainment. Yet even though the individuals who make up this particular demographic are young, relatively unsophisticated, and hungry for amusement, don't let yourself be fooled that it is a simple matter to produce products for them. Success in this arena requires an awareness of many special considerations, including:

- The developmental stages of childhood;
- Gender considerations;
- The desires and fears of parents;
- The desires and aspirations of children;
- An understanding of what sort of content is most appealing to young people; and
- An awareness of the kinds of things that can repel young people and be a Kiss of Death.

CHILDREN AND INTERACTIVE MEDIA

As we saw in Chapter 2, children and teenagers have been ardent enthusiasts of interactive media since its earliest days, beginning with the introduction of the first video games in the 1970s. This attraction to interactive entertainment has never faltered. For example, even though the average age of gamers is gradually climbing, gaming is still predominately a young person's activity. According to the Entertainment Software Association (once known as the Interactive Digital Software Association, or IDSA), 37.9% of console game players in the year 2002 were under 18, as were approximately 30% of computer game players. (For more on video games, see Chapter 11.)

Young people also quickly gravitated to the Net as soon as it became available in private homes and in schools. In fact, youths now spend more time online than they do watching TV, even when email activities are discounted. This historic toppling of TV on the top of the entertainment pyramid was documented in the summer of 2003, by a survey conducted by Harris Interactive. The survey found that youths ages 13 to 24 spent 17 hours online each week, compared to only 14 hours watching TV and 12 hours listening to the radio. The same survey also found that the majority of respondents also "multitasked" while online, simultaneously talking on the phone, listening to the radio, or watching TV. (For more on online entertainment, see Chapter 13.)

This ability to multitask is particularly strong in young people, and bodes well for the future of interactive TV, which generally requires the ability to split one's attention between several streams of information. In fact, creators of iTV programming are well aware of its potential to appeal to young viewers, and have already undertaken many projects for this segment of the audience. More are now in the production pipeline, including an ambitious 65-episode iTV show called *ArtVentures*. As its name suggests, the show focuses on art. It will teach children to color and draw and will also include segments on art history, painting,

and sculpture. It is being coproduced by iLoveTV Entertainment, based in Toronto, and Craftsman & Scribes Creative Workshop, based in New York City. (For more on iTV, see Chapter 14.)

Along with the Web and video games, young people have also taken to wireless devices, using them not only for talking but also for sending text messages, for playing games, and for hooking up to the Web. Many cross-media entertainments (projects which utilize several media to create a large interactive entertainment universe) now usually contain a wireless component, recognizing that this feature particularly appeals to young people. (For more on wireless entertainment, see Chapter 17.)

Theme parks, which are also primarily geared for young people, include many interactive attractions, which often go under the heading of "immersive environments." Cultural institutions, too, recognize the innate appeal interactivity has for children, and they build interactivity into their exhibits whenever their budgets permit. These offerings may be in the form of kiosks, immersive environments, or even interactive movies. (For more on immersive environments, see Chapter 19.)

One entire segment of the interactive market, smart toys, is devoted almost exclusively to kids, as is an entire category of software, the edutainment game, as we saw in Chapter 8. And now, even an arena that was once the exclusive domain of older teens and young adults, the MMOG, has an offering for young kids, Disney's *Toontown Online*. (For more on *Toontown Online*, please see Chapter 1 and Chapter 12; for more on smart toys, see Chapter 16.)

Thus, interactive entertainment for children spans a vast spectrum of media and products. Yet, as different as a smart toy might be from an interactive movie, or a wireless game might be from an immersive environment, creating sound projects for young people requires the observance of certain universal principles. One of the most fundamental of these is knowing as much as possible about your audience.

UNDERSTANDING THE YOUNG USER

When it comes to creating interactive projects for children, we face two substantial problems. First, we must deal with a huge gap between ourselves and our audience. The fact is, we are adults. No matter how well we may think we remember our childhoods, we are still working from an adult point of view. And we are making products for citizens of an entirely different nation, the nation of children. The individuals who inhabit this land have an entirely different set of customs than we have. They have their own culture, their own language, their own values. In order to be able to make things that will appeal to them, we have to understand them.

And that brings us to problem two: We cannot lump this audience into an all-inclusive "them." A product that will delight a six-year-old is virtually certain to make an eleven-year-old yawn. And a product that an eleven-year-old might enjoy will be far too complicated for a six-year-old. Children at different ages are vastly different from each other in terms of what they enjoy doing, are capable of doing, and are able to understand. Furthermore, along with age differences, we must also consider gender differences.

Because of the variance between children of different ages and genders, products made for young people are generally targeted for specific age groups and, for the older children, are further aimed at either boys or girls. The most common age categories are:

- Preschool and kindergarten (3 to 6);
- Early elementary (5 to 8);
- Upper elementary (7 to 12; also sometimes called "tweens"); and
- Middle and high schoolers (12 and up, the teens).

But how can we know whether the product we've made for the preschool set will not be over their heads, or if the one we've made for teenagers will actually hold their attention? Fortunately, we have several forms of guidance available to us: developmental psychologists, educational specialists, and children themselves. In addition, we can study the market and analyze the most successful products made for the group we wish to reach. By doing this, we can glean useful clues about what works in terms of subject matter, tone, humor, characters, and graphical style.

LEARNING FROM DEVELOPMENTAL PSYCHOLOGY

Studying the marketplace has its limitations, of course, especially when we hope to forge something original and fresh. Thus, we may well need to seek expert help as we shape our project. One excellent place to turn for such help is the field of developmental psychology. The specialists in this area make it their business to study the different stages of childhood, and understand how a child progresses mentally, physically, and emotionally from the diaper stage to the drivers' ed stage.

The study of child development is a fairly new science. Until sometime in the seventeenth century, children were regarded as small adults who, in almost every regard, were just miniature versions of their elders. In the eighteenth century, however, Jean-Jacques Rousseau proposed a radical idea for his time: that children started out as immature creatures, but went through distinct stages of development as they grew up. Each stage, he proposed, had its characteristic thought patterns and interests, and each built upon the earlier stages.

Other intellectuals came to agree with Rousseau and endorsed his theories, but none more articulately than Jean Piaget, the great twentieth-century Swiss psychologist. Piaget systematically and scientifically explored the mental growth of children and documented his findings in 1948 in his seminal work, *The Origins of Intelligence in Children*. Although other psychologists have weighed in since with amplifications or alternate theories, Piaget's work remains the touchstone study of the stages of childhood. Almost everyone who develops products for children and who is concerned with age appropriateness uses Piaget's work as a guide.

THE STAGES OF CHILDHOOD

Piaget divided childhood into four stages. His divisions are much like the categories generally used for children's products, except for an earlier dividing line between

toddlers and the next age group. His first stage ended at two years of age, and his second stage ran from two to seven. Otherwise the clusters are essentially the same. Within each of these stages, he asserted, children have a particular preoccupation. According to Piaget:

- Toddlers love to experiment with objects;
- Children 2 to 7 are fascinated with symbols, such as letters and numbers;
- Children from 7 or 8 to 12 like to try out their reasoning skills; and
- Teenagers are most concerned with trying to understand abstract concepts and testing out hypotheses.

For those of us who create interactive entertainments for children, Piaget's theories regarding play are particularly relevant. He felt that play was serious business for children, a critical activity necessary in order to achieve a healthy adulthood. He held that play was a form of mental gymnastics which helped train and exercise the developing mind and prepared the individual for the challenges of life.

Each stage of childhood, Piaget found, had a preferred type of play. The youngest kids were preoccupied with activities involving practice: They loved to repeat a task over and over until mastery was accomplished. During the next stage, they were absorbed with fantasy pastimes: pretend games which gave players a chance to try out different roles and to feel powerful and unafraid. Children in the third stage preferred play activities that emphasized rules, order, and predictability. Finally, in the last stage of childhood, he said, youngsters took up activities that involved constructing things and making models.

Although Piaget linked each form of play to a specific stage of childhood, he recognized that these preferences were not etched in stone. For example, toddlers might experiment with forms of play that were characteristic of older children, such as making simple models. Furthermore, older children might well still enjoy activities associated with earlier developmental stages, and incorporate those earlier play patterns into their current games. Thus, a game for teenagers might incorporate all four play patterns. The core activity might revolve around simulation (constructing a prehistoric world), yet it also might require practice (such as using a bow and arrow to slay a wooly mammoth); fantasy play (pretending to be a caveman or woman); and rules and predictability (setting requirements like the need to obtain a specific amount of meat for your clan).

The principles laid down by Piaget and other developmental psychologists can thus help us build age-appropriate interactive entertainments, and can also guide us in making products that will appeal to a broad spectrum of young people.

HELP FROM OTHER EXPERTS, LARGE AND SMALL

While obtaining the assistance of a developmental psychologist or child psychologist might not always be feasible, it certainly makes sense to become familiar with the literature of Piaget and others in the field. Also, it is usually possible to seek help from educational specialists, professionals who deal with children and how they learn, and who are almost certain to be familiar with the tenets of developmental psychology. Educational specialists include professors of education,

consultants to schools and cultural institutions, and classroom teachers. As we saw in Chapter 8, most software companies that make edutainment products regularly consult with such specialists. But even when a project is intended for pure fun, with no educational goals whatsoever, such experts can offer invaluable advice about age appropriateness.

A final and excellent source of help can be obtained from children themselves. You can seek this type of help by forming focus groups; by visiting classrooms (with permission from the school, of course); or by talking with individual children. A word of warning here, though. While it may be helpful to observe your own children or young relatives at play, do not ask for their opinions on the project you are making. Children are kind, and those who know you will try to please you and tell you what they think you want to hear. It is thus best to seek the opinions of young strangers.

FOCUS GROUPS AND TESTING

If you choose to go the focus group or testing route, as most companies do who make products for children, it is advisable to obtain the assistance of a person experienced in this area. Such a person can help determine specific areas to be tested, design the testing strategies and procedures, and also serve as moderator.

How testing is done and what is tested varies from company to company and sometimes from project to project. With the *JumpStart* games, for instance, one thing they test is their storylines, paying particular attention to whether or not the content seems too young or too old for the test group. Producer Diana Pray told me that boys in particular may have a hostile reaction if they feel the storyline is too young, which may happen, for example, if the title has animals as the main characters. Though small children are extremely fond of animal characters, she noted that this changes after second grade, when kids want to move on to human characters or to fantasy creatures like robots. Older kids also want the material to be a little edgier.

At Kutoka, the Canadian company that makes the *Mia* titles, they do several levels of testing. When developing their first *Mia* title, they put a great deal of effort into establishing the character design for Mia that would most appeal to their target audience. They tested 19 different versions of her, ranging in style from extremely realistic to extremely cartoony. The children were asked questions like "Which characters would you most like to color?" and "Which of these characters would you like to be your friend?" After this testing work, they then built one level of the game and tested that, paying special attention to whether or not the children had difficulty with the navigation. A third round of tests focused specifically on the educational content. Based on the various rounds of testing, the creative team realized it needed to make a number of changes. The company's president, Richard Vincent, made a critical observation about the testing experience, saying: "Our assumptions about what kids understand is very different from what they do understand."

Testing often turns up unexpected but fixable problems and can lead to significant improvements in a product. For instance, at Her Interactive, in the early days of making the *Nancy Drew* titles, they tested one of the interactive mysteries on girls who had never played games before. They discovered that the girls hated it when

something they did triggered the dreaded "game over" point. It meant that they would have to start all over again, even if they had already invested ten hours in the game. Unlike experienced boy gamers, the girls had not anticipated such a setback. Because of their reaction, the company added a popular option called "Second Chance," which allows players the opportunity to pick up where they left off. Now the players sometimes deliberately put Nancy in jeopardy just for the fun of watching the consequences, which are often depicted in an amusing way. (At Her Interactive, they avoid graphic violence and look for other, more clever methods to dramatize the consequences of a major mistake.) After one of these detours, the players know they will be able to resume the game.

AGE APPROPRIATENESS AND GENDER ISSUES

In testing for age appropriateness, as Pray indicated, one thing that must be asked and answered is whether a character or story feels too young to the target audience. Children like to feel they are more grown up than they really are and as a rule prefer to have their characters be a bit older than they are, too. To borrow a term from the child psychologists, kids have "aspirational" desires. In other words, they aspire to accomplish certain things or behave in certain ways that seem attractive and grown up to them, and they look to their favorite characters to serve as models. Even a character like Barbie is seen as an aspirational figure: She is older, more glamorous, more sophisticated, and more accomplished than are the children who play with her. Aspirations are engines that help push children toward maturity and hence serve a useful purpose in development. It is understandable that when a product seems too babyish, a child will be insulted and will not want to have anything to do with it.

Along with age appropriateness, one must also determine whether a product will appeal across both genders or be more attractive either to boys or to girls. Entertainment products made for very young children, as well as for older teenagers, may well be acceptable to both genders, but this is far less true of products made for children in between these age extremes. Thus, many children's products are marketed either to girls or to boys.

The idea that girls inherently like one kind of thing and boys inherently like another is not a popular one in today's world. A fierce debate has raged throughout modern times about the origins of gender preferences—it is a major issue in the famous nature versus nurture debate. Proponents on the nature side assert that gender preferences are inherited, and are among the traits one is born with; those on the nurture side, on the other hand, contend that such preferences are determined by one's social environment and by how one is raised. In the end, however, one's opinions about gender do not matter. Gender preferences are a reality in today's world, and one must be aware of them.

In broad strokes, here are a few major differences that experts in child development have noted between what boys like in play experiences and what girls like:

- When playing with others, girls prefer play that is collaborative while boys like activities that are competitive;
- Boys are drawn to activities that involve objects while girls are drawn to activities that involve other people or animals;

- Girls are good at activities that employ fine motor skills; boys prefer activities that call for gross motor skills;
- Boys look for opportunities to be aggressive, while girls are more comfortable in nonviolent, socially peaceful play situations; and
- Girls enjoy activities that call for organizing and arranging; boys like activities that require building, digging, and constructing.

Gender differences between boys and girls can even involve such minute matters as color preferences. Girls are notoriously fond of two colors: purple and pink. At the mention of the color pink, *JumpStart* producer Diana Pray sighs and moans: "Oh, the tyranny of pink." One of the regular characters in the *JumpStart* series is a pink elephant named Eleanor. Pray says Eleanor's color makes her a particular favorite of girls. And girls' fondness of purple is so well documented that one software company that made girls' titles called itself Purple Moon. (The company, unfortunately, was not able to find a sustainable business model and eventually went out of business.)

Even though gender differences and age-based play preferences are a reality, it is essential to keep in mind that any type of classification is just a generalization, and that exceptions always exist. Many of the most successful works of interactive entertainment cut across age and gender lines. Furthermore, preferences can vary from culture to culture. This is an important consideration if a product is to be marketed internationally. For instance, Richard Vincent, president of Kutoka, has found that the cute animated animal characters in his *Mia* titles do not appeal to boys in North America after the age $8\frac{1}{2}$, though, he said, "we never lose the boys in Asia. They love their cuteness."

One line of games that has avoided being pigeonholed in terms of gender and age is the *Nancy Drew* series. These games are played not only by girls but also by boys, as documented by the numbers of boys among the registered users. Not only that, but many of the players aren't even children; they are full-scale adults, some as old as 80.

How is it that this series has managed to cross gender and age lines? Megan Gaiser, President of Her Interactive, has several theories about this. She feels it is partially because Nancy Drew herself is such an iconic figure, already beloved by generations of readers long before she ever turned up in video games. Gaiser also feels the games appeal to players because of the sense of satisfaction they get by stepping into the shoes of a spirited, independent character like Nancy Drew and solving a seemingly baffling mystery. In addition, she believes the activities players engage in along the way are a big draw—solving puzzles, investigating suspects, and escaping danger—along with the various rewards players receive. "You get to be a detective and find out firsthand what it is like to be brilliant," she said. "Around every corner you've got another mystery to solve. It is a cumulative 'aha' experience."

In terms of cross gender appeal, Gaiser says they do keep female preferences in mind as they make the games, avoiding violent scenes and not portraying female characters as victims. However, Gaiser points out, that doesn't make the games "girlie." Boys like to play them, she feels, because the mysteries are a true challenge, requiring brainpower and resourcefulness to solve. Gaiser stressed that at Her Interactive they did not consider gender labels in designing their games, "making it this way for males, that way for females." Instead, she said, they approached

the making of their games like the making of a film, which, above all else, must have a good story and other strong content elements.

Another interactive entertainment that is doing extremely well across gender and age lines is *Toontown Online*. It not only appeals to a wide age-range of children but also to the parents of the young players. The creative team that developed it consciously built in elements they believed would be enjoyable both to children and adults, and did a great deal of testing before the official launch. Even so, they have been pleasantly surprised at the number of childless grownups who have become dedicated players. (For more about this MMOG, see Chapter12.)

It is a tricky business to make assumptions about how people will respond to your product. Unfortunately, you may miscalculate, and your project may skew younger or older than you intended. Or kids may hate your color scheme, or be frustrated by the navigation system. In order to prevent unpleasant surprises once your product hits the marketplace, it is thus wise to get feedback as you go along. Give serious thought to bringing in the experts, whether they come in the large size (adults), or the small size (kids).

THE PARENTS' POINT OF VIEW

In designing products for children, you cannot afford to concern yourself only with what the young users might like or not like. You must consider their parents' attitudes as well. After all, in most cases, it is the parents who will be purchasing the game or the smart toy, or allowing access to a particular website, or buying the ticket to that theme park with the cool VR attraction. Just take these sample statistics regarding video games as one example: According to a 2002 survey conducted by the Entertainment Software Association, 89% of kids under the age of 18 reported that their parents were on hand when they purchased video games, meaning that their parents either okayed the purchase or actually bought the game.

So what are parents looking for in interactive entertainment for their kids, and what do they NOT want it to contain? On the positive side, they are hoping for a product that offers high quality entertainment. They want the content to be wholesome and supportive of family values. Furthermore, as we saw in Chapter 8, parents see it as a big plus if the work is educationally enriching. On the negative side, almost without exception, they do not want their children exposed to graphic violence, and they are equally against products that contain sexual content.

When it comes to the Internet, parents have more specialized concerns. The things they most fear revolve around the three Big Ps: Predators, Privacy, and Pornography. They are afraid that by allowing their children to freely surf the Web, they will become the target of sexual predators or stumble upon (or deliberately seek out) unsavory adult content. They also worry that their children will be manipulated into giving away personal or financial information to strangers—the privacy issue. For this reason, many sites for kids build in safety features which restrict communications that can occur between users. Many also restrict which sites the young users can link to, making sure whatever sites they can visit are safe. Although this makes for a less expressive, freewheeling experience for the child, it provides some measure of reassurance to the parent.

A BRIEF LOOK AT GENRE

As discussed earlier in this chapter, interactive entertainment for children covers a vast landscape of different products deployed across a great variety of media. Some of these product types can be further broken down into genres—categories of programming that contain characteristic elements. If you are making a product that is to fit within a specific genre, you will want to make sure it reflects the basic characteristics that define the genre. Otherwise, you risk disappointing the children who will be using it and the parents who have purchased it. They will have come to your product with certain expectations, based on their experiences with other products in this genre, and if your product doesn't contain what they are anticipating, they will be unhappy.

Let's look at some of the major types of computer and game console software products for children. They include:

- Interactive storybooks: animated, interactive versions of picture books, which the user advances page by page. They usually contain clickables, games, activities, and songs.
- Drill and kill games: educational games that drill children in particular skills. See Chapter 8 for more details.
- Creativity tools: programs that let the child create artwork, cards, doll clothes, and so on.
- Reference tools: encyclopedias and other organized works, often with audio and sound, and sometimes with "host" figures to guide the young user around.
- Informational works: factual information about subjects children find particularly interesting, including animals, dinosaurs, outer space, and so on.
- Activity centers: entertainments that contain a number of games and activities often based on a particular favorite movie or character.
- Games: games for pure fun can be broken into a number of subgenres. A more detailed description of video game genres can be found in Chapter 11, but games for children can be broken into the following genres:
 - Platform games: fast-paced games that require quick reflexes and manual dexterity. You must make your character jump, run, climb, dodge objects, and move through various levels.
 - Adventure games: story-based games with a clear-cut mission and that invite the exploration of various environments. They generally involve a quest and call for the solving of riddles or puzzles.
 - Mystery or mystery/adventure games: games in which you must solve a mystery, with some of the same elements as an adventure game.
 - Role-playing games: games in which you play a character with a specific set of attributes, defined by such things as species, occupation, physical abilities, and various skills.
 - Simulations: junior versions of sim games in which you have god-like powers over a world or an enterprise and must make critical decisions regarding the sphere you control.
 - Sports games and racing games: games in which you compete as a solo player or control a team.

> – Fantasy games: games that you play with a favorite story-book character, popular doll, or cartoon figure or movie character, or actually become that character.

Another extremely robust arena for children's entertainment is the Internet. As with video games, websites for young people are often geared for particular age groups, from preschoolers through teens, and they may also primarily target one gender or the other. However, children's websites, unlike children's software, cannot easily be broken into genres. Instead, most mix a variety of approaches and types of content. For instance, a single site may contain informational material, stories, polls, games, cartoons, and contests. However, although children's websites cannot easily be broken into genres, they do tend to have a central focus. Some primarily offer information; others revolve around a popular character from TV or the movies or toy world; still others offer personal guidance and support. One of the newest types of Web offerings for children, as mentioned earlier, is the MMOG, the first of which, *Toontown Online*, debuted in 2003.

Interactive toys can also be divided into various categories, from educational toys to companion dolls, and doll types can further be broken down into subcategories. The newest forms of children's interactive entertainments, such as iTV shows and wireless games, have not been around long enough to develop an array of distinct genres, but in time they well might. Already a few distinct types of entertainments are emerging in the wireless world, including adventure games, trivia games, puzzles, and "personal communications" from fictional characters.

If you are working in an emerging area, you will need to familiarize yourself with as many of its products as possible, and note whether they can be grouped into categories and what the common denominators are of the categories that most interest you.

BRANDING

As we saw in Chapter 8, one way companies make their products stand out in the public mind is by branding. Branding is a way of giving a commodity a distinct and desirable identity and to make it a "star." Once a product has been successfully branded, it becomes easier to market. What is true for a type of toothpaste or automobile is just as true for fictional characters and entertainment products. For example, it becomes much easier to sell Harry Potter video games and toys once the novels and movies have become a big hit; Harry Potter is a brand name.

For this reason, many interactive products for kids are based on already branded properties. For example, an entire line of video games is based on the doll character, Barbie; sports games are released under the well-known banner of *Sports Illustrated*; edutainment games are made under the *Sesame Street* umbrella; and *SpongeBob SquarePants* of TV fame has found new life as a console game. Earlier in this chapter we talked about the success of the *Nancy Drew* games, which are adaptations of the classic novels so popular with generations of girls.

Branded products are increasingly dominating the children's entertainment marketplace, to the degree that one may well wonder if an original product stands a chance. Yet we can find ample significant evidence that original products can and do make a place for themselves, though such products face an uphill battle.

But the little mouse Mia, a tiny underdog (or underrodent) if there ever was one, is certainly proof that an original line of games can become a true success story. And she is far from the only original character to make a name for herself. For example, Putt-Putt, Freddie Fish, and Pajama Sam, three characters created by Humongous Entertainment, have all become stars of the children's interactive world. And every character in the *JumpStart* line is an original, too, as is the world-famous thief, Carmen Sandiego. Several original smart toys have also become hits, too, including Furby and Amazing Amy. To create a successful original product, however, generally requires more of everything than a branded product does: more effort, more creativity, more attention to content, more testing, and more investment in marketing. Plus a little something that is beyond anyone's control: luck.

ADAPTING FROM ANOTHER MEDIA

While creating a project from scratch is unquestionably an enormous challenge, that is not to minimize the task of adapting a project from another medium, even one with major brand recognition. It is not possible to simply port over a property from one medium to another and expect it to flourish in its new venue. Adjustments will have to be made so that it is suitable for the new medium. However, bringing a property from a linear medium to an interactive one calls for special considerations. Above all else, you must consider what about the linear work lends itself to interactivity, and what opportunities you can build in that allow the user to participate in the work.

For example, in building a website to promote the Harry Potter films, *The Official Harry Potter Website (www.HarryPotter.com)*, Warner Brothers came up with some wonderful ways to let the children become part of the story. As we saw in Chapter 8, children can become students at Hogwarts, the school of wizardry that Harry attends. When they "enroll" in the school, they go through a special initiation process that involves an interactive exam by the school's famous Sorting Hat. Once enrolled, they can play the school's unique sport, Quidditch, an aerial form of field hockey. They can even visit the street where Harry buys his magical school supplies and try out a selection of wands. Thus, the features offered on the website are true to the books and movies, but in addition, they give young users an active way to participate in Harry's world, quite different from the passive experience of reading the novels or watching the films.

In a very different type of adaptation, Playmate Toys adapted the Belle character from Disney's movie, *Beauty and the Beast*, and turned her into an interactive doll, part of their *My Interactive Princess* line. The challenge here was to find a way to have the doll come to life and tell you about her romance with the Beast, but to do so without it being a passive experience, with the doll telling the story and the child just sitting there listening. The solution that Playmate Toys came up with was to give the child an opportunity to participate in Belle's story via an array of props and "costume changes."

For example, when you remove Belle's workaday pinafore and dress her up in her magnificent yellow ball gown, she will tell you the part of the story in which she and the Beast spin happily around the dance floor. And by changing the pictures in her magic mirror and putting the mirror in her hand, you can help make

Belle's dreams of love come true, and learn how the Beast is transformed into a handsome prince. Some of the props, when placed in Belle's hand, even speak in their character voices from the movie. Among them are Mrs. Potts, the chatty, motherly teapot, and Lumiere, the candelabra, who speaks with a French accent.

The team at Her Interactive, the company that adapts the *Nancy Drew* novels into interactive games, has found that the first challenge in the adaptation process is to choose a book from the approximately 300 novels in the series that will lend itself to an interactive approach. They look for a story that has strong characters, interesting locations, and opportunities for puzzles. The adaptation process usually calls for some nips and tucks in the story, though they are careful not to remove anything that a devoted reader of the book might notice is missing. And in terms of what may need to be added, the major task is to figure out ways to intimately involve the user in solving the mystery, throwing up enough obstacles, twists, puzzles, and surprises to keep things interesting. As Max Holechek pointed out in Chapter 7, if users just followed a straightforward path that led directly to the solving of the mystery, the experience would not be very game-like or involving. In Chapter 6, we also discussed some of the issues Her Interactive must consider in bringing the novels' characters to a video game.

ORIGINAL PROPERTIES

But, if unlike the team at Her Interactive, you are developing an original property instead of working with an already established one, where do you begin? We will be discussing a ten-step creative process in Chapter 10, but one of the most important early steps in a children's project is the development of your main character. How will this fictional being pull children into your interactive world? What will make this character appealing to kids? What will the relationship be between the user and this character, and what will the user's role be in the character's story? Or will the user actually "become" the character?

For Richard Vincent and the Kutoka team, developing Mia's personality was something of a trial and error process. Vincent said he was planning to use four primary characters in his first game and one of them was going to be a cowardly little mouse. But as work on the project developed, the three other characters were dropped and the character of the little mouse changed dramatically. All that remained of the original concept of her was her small size and the fact that she needed help. "She ended up being strong, having chutzpah," Vincent said. "Her personality was molded by the needs of the game."

To be the major mover and shaker of an adventure game, Mia had to become courageous where once she was timid. She had to be able to fearlessly slide down furniture, scale tall walls, and hurl herself into the unknown, something she does in *Mia: Just in Time*, where she plunges into a dark, seemingly bottomless mole hole. Mia evolved into something of a role model for kids, with a spunky, helpful, positive personality. She acquired an irrepressible sense of curiosity and a nice sense of humor, able to laugh at herself even when things fell on her head. But because of her diminutive size, just $3\frac{1}{2}$ inches tall, kids could understand why Mia needed their assistance, Vincent said. Mia's physical appearance was likewise not just a matter of a quick sketch or two. As we saw earlier, the company put together a portfolio of different versions of how she might look, and then put the images through a testing process.

Figure 9.1 Romaine the Rat is never up to any good in the *Mia* titles. Image courtesy of Kutoka Interactive.

The appearance and personality of the chief villain of the *Mia* titles, a greedy, ugly rat by the name of Romaine, came together far more quickly. "We wanted a character who could immediately be recognized as a bad guy," Vincent said. They concentrated first on communicating his nastiness through his looks, then worked out details of his character and personality. "Romaine would sell his own mom for sparklies (valuable gem-like objects)," Vincent said. "Sometimes he slips and does something good, but he quickly catches himself." (See Figure 9.1.)

The development of characters in many children's products may be influenced, as it is at Kutoka, by the overall needs and goals of the project. At Knowledge Adventure, the cast of regular characters for *JumpStart* was recently revamped to make them more efficient within the educational context of the titles, although even with the retooling, they remained consistent with their original personalities. As a guideline for the new character work, the *JumpStart* team used the concept of "multiple intelligences" developed by Project Zero at Harvard's Graduate School of Education. The concept holds that a person can excel in one of many different forms of intelligence, or in combinations of intelligence. In other words, people can be smart and shine in different ways. For instance, one child might be gifted in verbal/linguistic skills, another in interpersonal skills, another in logic and mathematics, and so on. Thus, for *JumpStart Advanced First Grade*, they assigned one form of intelligence to each of the main characters, collectively calling them the Learning Buddies. (See Figure 9.2.) For example, Frankie, a lovable dog, excels at interpersonal skills and is the group's leader and everyone's best friend. Eleanor, the pink elephant, is gifted in linguistic skills and hosts the reading modules.

Users are matched with a Learning Buddy by taking a learning profile test, which identifies the child's particular learning style. The child's Learning Buddy will serve as his or her personal mentor and tutor, offering help in a way that is consistent with the child's learning style. In the *JumpStart* line-up, for example, Kisha, the artist of the bunch, helps her special friends by showing them visual examples, like pictures.

But even at *JumpStart*, where educational objectives are taken with great seriousness, they recognize that perfection can be a little boring. Thus, the cast is

Figure 9.2 Each cast member of *JumpStart Advanced First Grade* excels in one type of intelligence, and the user is matched with one of these characters to receive special attention. Image courtesy of Knowledge Adventure, Inc., and used under license.

being given some little flaws and personality details to make them more fully fleshed out, Producer Diana Pray reported. For example, Eleanor, although very smart and dependable, has something of an impatient streak, which emerges when another character messes things up. She's also somewhat self-conscious about her size, though she loves to dance. As for Frankie, he occasionally gets into trouble, carried away by overzealousness. "We are building in more conflict," Pray said. "We aren't the 'village of the happy people' anymore."

When it comes to designing new characters, as opposed to working on the regular cast, Pray says the *JumpStart* team goes through a mental questioning process. They ask themselves: What role will the character play? What are his or her motivations? What are the character's quirks? If a companion character is also being developed for this new character, how do they get along or contrast with each other? What age group will be playing with this character, and how will this character appeal to kids in this age range?

THE USE OF HUMOR

Kids love to laugh, and an interactive product that is full of humor will make it extra attractive to them. But comedy is a slippery beast, especially when you are working in children's media. Despite the willingness of kids to be amused, it is not necessarily easy to make something funny for them. What tickles them is sometimes quite different from what we adults consider amusing.

For one thing, kids' taste in humor is often what many adults regard as bad taste. They are drawn to content that causes nice grown ups to squirm. They giggle at bathroom humor, at foul language, at odd-looking people, and at characters who break the rules of polite society. Most mature developers of kids' products are not big fans of this kind of humor, and in any case, it is difficult to slip it into a product without the parents objecting to it. Exceptions can be found, however. In linear media, we can point to the series, *South Park*, which is rife with "offensive" kids' style humor. And the website *www.yucky.com* turns this kind of humor on its ear and makes it serve a higher purpose, to teach biology.

Kids also have a great sense of the absurd. They see what a silly place the world is, and they appreciate anything that celebrates its ridiculousness. Humor that pokes fun at adults, or that has a rebellious tinge, is therefore greatly relished. They love humor that is wacky, unexpected, and off the wall.

In general, visual humor works better than verbal humor; puns and word play will mostly go right over the heads of younger children. The young ones, on the other hand, love to click or roll over an object and have something silly or unexpected happen—an amusing piece of animation or a funny sound. But if you want to expand the age range of your product, it is a smart strategy to include humor that appeals to children in different age groups. And, if you think they may be playing along with their parents, throw in some funny things for the adults, too, as they're doing at *Toontown Online*. The adults will appreciate it, and the kids won't even realize that they've missed a joke or two. You can observe this strategy at work in the most successful family films, which are popular not only with kids but also with their parents, and are even enjoyed by adults who don't have children. Some good examples are the movies *Shrek*, the two *Toy Story* films, and *Finding Nemo*.

Overall, the best kind of humor in children's interactive works is not very different from the best kind of humor in children's linear works: It is built into the character or into the situation, and is integrated into the work from the concept stage on. It isn't just pasted on as an afterthought. So, if you want your projects to be truly funny, begin factoring in the humor from the earliest development stages. One final thought about humor: To be on the safe side, test your comic elements on kids, to make sure they think things are as funny as you do.

THE SEVEN DEATH KISSES

As must be apparent by now, the process of creating interactive projects for children is riddled with possible pitfalls. Some of these pitfalls are particularly sly and seductive, and over the years I have given them a name: The Seven Kisses of Death. They are dangerous because they seem to make so much sense. Typically, we commit these Death Kisses because we are no longer children. Children, you can be sure, would know better than to make these kinds of mistakes.

I regret to say that I am personally familiar with each of these Death Kisses. I have either committed them myself, or people I was working with urged me to commit them. I first encountered these kisses when I worked in traditional children's media, writing for children's television. I encountered them once again, in somewhat different guises, when I moved into interactive media. Thus, I speak from personal experience when I say that they can be deadly. And they can easily invade our projects because they seem to be so logical, intelligent, and attractive.

The good news is that these blights can be overcome by various strategies, and I'll be reviewing them after describing the Death Kisses. The Seven Kisses of Death are:

Death Kiss #1: Kids Love Anything Sweet

Yes, it is true that children love all kinds of sugary things—candy, ice cream, sugar-frosted breakfast cereals. But this doesn't mean they also like their entertainment

to be sweet. For some reason, however, when adults design projects for kids, they often tend to heap on the sugar. And even if they don't do it for boys' products, they still tend to do it for products targeted to girls. That isn't to say girls don't like things that are cute, but cute and sweet are two different things. And, at the risk of gender-typing males, it is usually the men who tend to push the sweetness more than the women, perhaps because men feel protective of little girls and have an idealized image of them.

In reality, however, neither girls nor boys will tolerate much sweetness except when they are very young. Sweetness is an adult concept of what kids should enjoy. Many adults feel a compulsion to make all their characters kind, gentle, and loving, and to portray the world as a sunny, happy place without conflict. But kids aren't dumb. They know this isn't true, and they don't appreciate being fibbed to any more than adults do. Real breathing kids above toddler age appreciate something with an edge, something that has some reality or bite to it, even in a fantasy game.

Death Kiss #2: Give Them What's Good for Them

This second Kiss of Death is a close cousin of the first one. However, instead of being too sugary an approach, this one is too medicinal. It is usually committed by adults who are sure they know what's best for children, and they are determined to give it to them whether the kids like it or not. This type of thinking often plagues educational products.

All too often, people approach educational products with a great earnestness and a zeal to make something that will be really good for children. Their goal is to stuff the kids full of useful material, to smarten them up fast. In truth, though, this approach never worked in traditional media and it won't work in interactive media, either. Kids are no more attracted to things that are good for them than adults are. They prefer dessert to vegetables any old day. That doesn't mean, of course, that interactive works for children can't have solid educational content. But the educational components must be handled with great skill, and integrated with entertainment, as we discussed in Chapter 8 in the section on edutainment. Otherwise, the kids will just shut down on you.

Death Kiss #3: You've Just Got to Amuse Them

You could call this kiss the "junk food approach." In other words, you just give the kids what they want. Often it's coupled with the idea that it is far easier and cheaper to make products for children than products for adults, because children are less discriminating—a fatal assumption right there. Children are actually quite discriminating—though in different ways than adults.

The truth is, a product lacking real substance is about as satisfying to kids as a meal devoid of genuine nutrition. Yes, it is possible to make a passable product that is light on quality and content, but you'll never make anything exceptional with this approach. And that's because while kids love to be entertained, it is also true they're hungry for content. If a product is fun, but has no substance, you might not have

any trouble getting kids to play it, but they'll get bored with it quickly and move on to other things.

Death Kiss #4: Always Play It Safe!

This particular Kiss of Death is a yawning pitfall, and everyone who works in children's interactive media teeters on the brink of it. In the desire to avoid violence, sex, and controversy, it is all too easy to go to the other extreme and produce something so safe that it is boring.

Yes, we do want to avoid graphic violence. We don't want to show the use of guns, knives, and other weapons; we don't want to portray dangerous or antisocial activities that kids might model. But that doesn't mean we have to forgo excitement, action, and jeopardy. We've just got to come up with different ways to keep the adrenaline pumping. Otherwise, we may as well be singing the children lullabies.

Death Kiss #5: All Kids Are Created Equal

This particular Death Kiss is committed when we are trying to make a product that will appeal to an extremely broad demographic, without taking into account how different children are at different ages. But, as we saw earlier in this chapter, children go through distinct stages of development, each with characteristic interests and play patterns. Still, ignoring this truth is a Death Kiss that even seasoned professionals can make.

Several years ago, I was working with a group of subcontractors for one of the largest toy companies in the United States. We were creating a cutting-edge interactive toy system for girls ages 6 to 10. In the middle of the project, the toy company suddenly decided to change the demographics on us, now targeting it for girls 8 to 12. They didn't seem to realize how vastly different children in these two ages ranges were, or that we would have to rethink almost everything about the project. Under the guidance of the excellent child psychologist who was our consultant, we informed ourselves about the girls in our new target demographic, learning about their favorite activities, how they related to their friends and family members, how they felt about boys, and how they felt about themselves. Armed with this new information, we redesigned the product. But the moral here is that you can't just make something for a homogeneous group called "children"; you have to know and understand your target demographic.

Death Kiss #6: Explain Everything

Here again we fall into a very adult trap. We want to be so clear with children, and we are so afraid that they might miss something, that we overdo it, and drown them with words. It is hard for us to realize that kids are really clever at figuring things out, and aren't nearly as averse to the trial and error process as we grownups are.

Children have little patience for lengthy instructions or explanations. They also don't like to sit through long pieces of narration or exchanges of dialogue without any action, or worse yet, a single talking head. These kinds of presentations

send a message to kids that we don't care enough about them to give them a good time. We're being lazy when we do this, because we aren't doing the tough creative job of devising better ways to convey information.

Death Kiss #7: Be Sure Your Characters Are Wholesome!

Death Kiss #7 is particularly slippery because it seems so laudable. Why wouldn't we want our characters to be wholesome? What's wrong with positive role models? Well, ask any child, and you will learn that characters that are totally good are dull, predictable, unrealistic, and uninteresting.

Adults fall into three big traps when they design characters for children's products:

1. The white bread approach. With the "white bread" approach, all the characters will be nice, white, middle-class people who are pretty much like the people making the product. Even when the characters aren't all white and middle class and nice, they still look as if they were all stamped out by the same cookie-cutter—whether they are human characters, or little bears, or space aliens. They lack individuality and shadings of personality.

2. The lifesaver approach. The "lifesaver" approach is often utilized as a direct counter to the white bread approach. Here, instead of each character resembling all the others, every character is a different color of the rainbow. Each represents a different race or ethnic group—just like the colors in a roll of lifesavers. You've got one African-American, one Asian, one Native American, one Caucasian, and so on. But instead of having life-like characters, you end up with a dull pint-sized version of a United Nations General Assembly meeting. The characters don't have any distinct qualities except for the color of their skin.

3. The "off-the-shelf" approach. This approach to character design relies heavily on familiar stereotypes. You've got your beefy kid with the bad teeth; he's the bully. You've got the little kid with glasses; he's the smart one. You've got your red-haired girl with freckles; she's the feisty tomboy. And then you've got your two blue-eyed blondes. The boy blond is your hero and the girl blonde is your heroine. Using these tired clichés is a bad habit that we tend to slip into when we are rushed and are unwilling to invest the energy in designing original characters. You won't fool the kids, though; even the small ones will recognize them for the stereotypes they are.

You've got to get beyond wholesome if you want to have truly interesting characters. And if you don't have interesting characters, you're missing one of the key ingredients of a successful product.

THE ANTI-DEATH KISS STRATEGIES, OR HOW TO INFUSE YOUR PROJECTS WITH LIFE

Now that we've isolated the Seven Kisses of Death, we can look at methods of combating them. In keeping with the life and death theme, I'm calling these

strategies "Infusions of Life." I've listed ten of these strategies here, as opposed to the seven Death Kisses. This is good news, for it indicates that life has a substantial edge over death. Here are the ten strategies:

1. Build Your Project on a Compelling Mission

This tactic counters the "play it safe" Kiss of Death, and also the junk food approach. In fact, it is powerful against all the death kisses. In addition, it solves one of the greatest dilemmas of interactive media: how to keep your audience engaged without the built-in momentum of a traditional plot or story structure.

What every children's interactive product needs most crucially is a good strong hook, something that will involve the players so completely that we won't lose them, even though they can move around freely and explore the interactive environment any way they wish. So how do we keep them hooked? The answer is: with an absorbing challenge or purpose. We can give the child a mystery to solve, or a quest to go on, or a secret to discover. Or, if this is a creativity tool, we can give them something enormously desirable to make. If it's a simulation, we can give them the ability to control a fascinating miniature world or enterprise. The hook should be clear-cut and readily identifiable; it won't serve its purpose if the players don't know what it is. This is not the place for subtlety.

2. Inject Meaningful Tension

Along with having a well-defined hook, another useful technique is to keep things tense and the outcome uncertain. Tension is an excellent antidote to Death Kiss 4, "Always play it safe." It's a dynamic way to add excitement without falling back on violence. One effective method of adding tension is through conflict. You devise an opposing force of some sort—villains or a rival group who are competing for the same end goal your players or heroes are. For techniques of designing strong antagonists, refer back to Chapter 6. The type of conflict you select depends in part on the genre of product you are making and on your target age group, but every product becomes more lively and engrossing when it includes some sort of hurdles or challenges or obstacles. The more personally involving they are, in terms of the player, the more effective they will be.

You can fortify the challenge or purpose by using an excellent device known as "the ticking clock." You build in a time limit for solving your mystery or outwitting the bad guys or saving the fish in the ocean, and you make your player keenly aware of it. The best ticking clocks are meaningfully connected to your story and the environment you're creating. And the consequences of time running out should be meaningful, too, and the more dramatic, the better. One warning, though, when you are creating a project for kids, you really should not threaten them with the ultimate consequence. And the ultimate consequence, of course, is death.

Projects that are not story based or game based have a particular challenge when it comes to adding tension, but one creative technique is to harness the child's own curiosity. Curiosity itself produces tension; it is an intense anxiety to find something out, or to see how something is resolved. Even a creativity tool can draw on the force of the child's curiosity, especially if it is leading toward a big finale or reward once the project is all put together.

3. Offer Genuine Substance

This infusion is also very powerful. It works especially well against Death Kiss #1, "Kids love anything sweet," and Death Kiss #3, "You've just got to amuse them." The truth is, it's a mistake to sell children short. They really do want more than a good time. Kids are like sponges; they are eager for information about what the world is really like, and how to live in it. Don't assume that just because they are little, they aren't able to comprehend serious themes. If you think about the best children's theatrical films, you'll see that they offer more than mere entertainment. Consider the Disney animated movie, *The Lion King*, and of the powerful human themes it included—themes about treachery and courage, jealousy and friendship, and life and death. And I am sure that any of us who saw *Bambi* as children will never forget it, or forget that terrible moment when the hunters killed Bambi's mother.

The best story-based children's interactive works have rich themes as well. Even when your target age group is the preschool set, you don't have to duck the fact that their world contains certain things that can be upsetting. They contend with a fear of the unfamiliar, with sibling rivalry, and with anxieties about being abandoned, just to name three issues that concern them. Note that successful TV shows like *Barney* and *Sesame Street* aren't afraid of dealing with things that little kids really worry about. Older kids have different concerns, of course, including peer pressure, conflicts with parents, and the yearning to be accepted.

When you layer meaningful themes or goals into your products, however, be sure they are portrayed from a child's point of view, and are well integrated into the overall frame of the work. Obviously, whatever themes you choose should be age appropriate.

4. Create Multifaceted, Dynamic Characters

Good characters are powerful ammunition against all seven Death Kisses, but most particularly against Death Kiss #7, "Be sure your characters are wholesome." They add interest and excitement to your product and bring it to life. We've discussed techniques of character design earlier in this chapter, as well as throughout Chapter 6. When designing your characters, don't forget to pay attention to the opponents, if opposition characters are appropriate for your project. They can be even more fun to design than your heroes, and the more multidimensional and unusual they are, the more energy they will give to the work.

5. Offer Satisfying Challenges and Rewards

As we discussed in Chapter 8, rewards are a powerful motivator. A key strategy for grabbing the attention of children is to break the content into a series of small, exciting challenges, and to offer rewards each time a challenge is met. Challenges should increase in difficulty as the child's mastery increases, thus keeping the work interesting.

Rewards provide positive reinforcement, and also serve as a measuring stick for how well the child is doing. The trick is to emphasize success and to play down failure. If the player makes a mistake, soften the sting with a little humor, and with words of encouragement from one of the characters. You don't want

your players to feel like morons if they do something wrong. You want to keep them involved and eager to do more, rather than become discouraged and quit.

6. Make the Product Easy to Use and Understand

This guideline will help you deal with Death Kiss #6, "Explain everything." When it comes to guiding a child through your product, good interface design is the best way to reduce the need for lengthy explanations. The more intuitive the interface, the less the need to give instructions about how to navigate through it.

If your product calls for text, make sure it is as readable as possible. Your font should be attractive and large enough for children to read easily, and the words shouldn't be crowded closely together. Remember, it is daunting even for adults to wade through a big chunk of text on a screen. Think what it must be like for new readers. You can learn a great deal about design, and the interplay of visuals and text, from fine picture books for children.

And whether it is text, audio help, narration, or dialogue, go "lite" with the words. I'm talking about "lite" in the way the food industry talks about products that are low in fat and calories. But here, of course, what you want to get rid of is excess words. Nothing is more boring to children than an endless assault of verbiage. So, whenever possible, use visual images and action rather than spoken or written words to get your message across.

7. Make the Product Adjustable to the Child's Abilities

When it comes to age appropriateness, interactive works have a great advantage over linear works: They can be built with different degrees of difficulty. Many products let the child or parent set the difficulty level. In some products, the difficulty level even invisibly adjusts to the user's ability. Having different levels of difficulty means that less accomplished users will not be frustrated and more skillful users will continue to be challenged. By building in a system of levels, you are also giving your project greater repeatability. Children will come back to it again and again, because they will find new challenges every time they play. Levels of difficulty are an excellent way to disarm Death Kiss #5, "All kids are created equal."

8. Supply Liberal Doses of Humor

This is one of best ways to gun down all of the Death Kisses but #3, "You've just got to amuse them." But even here, if you take humor seriously, you'll be taking amusement to a higher level. Humor is the perfect antidote to sweetness and blandness. It adds life and color. Almost any product you make for children has room for humor, so put some quality time into thinking up ways to inject it. We've discussed some of the things kids find funny earlier in this chapter.

9. Build in Meaningful Interactivity

The interactivity in your product should be well integrated into the overall content. The players' role in the work should make sense, and make a difference. Your young users should not have to sit through long stretches of passive material

before finally reaching the parts where they can actually do something. They should be able to be active participants throughout.

10. Be Respectful of Your Audience

Here is a strategy, or actually a philosophy, that is a powerful defense against every single one of the Death Kisses. Being respectful means not talking down to the young users or patronizing them. Children detest it when you do that, and conversely, they greatly appreciate it when you treat them like the intelligent beings that they actually are. They'll appreciate it even more if you show your respect by creating a product for them that is richly entertaining, age-appropriate, and contains meaningful content. Being respectful shows you care enough about your young audience to custom-make something especially for their enjoyment.

A HELPFUL RESOURCE

To stay up-to-date on children's software, websites, and smart toys, you might consider subscribing to *Children's Software and New Media Revue* (*www.childrenssoftware. com*). It publishes four print issues a year, and a subscription also gives you access to its online archives, which include a stash of 7000 product reviews.

CONCLUSION

Clearly, designing a successful interactive project for children calls for an awareness of many factors. One needs to be informed about the developmental stages of childhood; gender issues; the desires of the parents; and the tastes of the children themselves. Certain issues also arise in adapting a work from another medium, and a different set of issues comes into play when creating an entirely original work.

Furthermore, you need to be vigilant when it comes to the Kisses of Death. If for some reason you don't agree with my list, make up your own. But be assured, Death Kisses lurk everywhere, and they can invade your work with great ease. We are especially vulnerable to them when we are under pressure. These Kisses come to us quickly, and seem inviting because they offer seemingly attractive solutions to creative dilemmas. So never let down your guard. Scrupulously examine your products for Death Kisses every step of the way. When you find them, root them out, and apply one or more of the counter-Death Kiss strategies. In fact, if you begin with these strategies, you will probably avoid Death Kisses altogether.

The issues and concerns brought up in this chapter may seem a little overwhelming, and may cause us to lose sight of one extremely important thing: that the reason most people design projects for kids in the first place is because it's fun! And it is not only an opportunity to give pleasure to children and enrich their lives—it is also a chance to contribute something worthwhile to society.

IDEA-GENERATING EXERCISES

1. Why do you think teenagers spend more time online (not counting email activities) than watching TV? What is it about the Web, do you think, that appeals to them? How would you capitalize on this appeal if you were creating an entertaining website for teens?

2. Make a list of the ways an interactive project for children can be exciting without being violent.

3. Take a familiar myth or children's fairy tale (like *King Midas* or *Cinderella*) and analyze what the "template" or core story is; in other words, what its "bones" are. Then discuss how this template could be used as a framework for an interactive work (a video game, toy, website, or any other interactive medium) that would appeal to different age groups: to toddlers, to lower elementary-aged kids, to upper elementary-aged kids, and to teens. Do you think your ideas could appeal equally to boys and girls in each of these age groups, or would a different approach be needed for each?

4. If possible, have a child give you a "tour" of a favorite interactive work, like a video game, a website, or an interactive toy. Try to determine what it is about this work that the child especially enjoys. What, if anything, about this child's-eye-view of the work surprised you?

5. Work your own way through an interactive game or other project designed for children, and analyze its strengths and weaknesses. What about it do you think would hook children and keep them involved? What kinds of rewards does it offer? Has it committed any of the Seven Kisses of Death?

6. Choose a noninteractive children's property—a book, a TV show, a toy, a comic book figure, or even a breakfast cereal mascot—something that to your knowledge no one has yet turned into an interactive project. Come up with a concept for adapting this property to an interactive medium. What about this project lends itself to interactivity and to this particular medium? What would the particular creative challenges be in the adaptation process?

Creating a New Project: The Development Process

What are some of the most common mistakes people make when developing an interactive project?

What are the advantages to using a collaborative team approach, as opposed to a top-down hierarchical approach, for the development process?

Is it really necessary to go to the trouble of generating various kinds of documents before you begin a new project?

What are the ten most important questions that must be addressed before production begins?

THE DEVELOPMENT PERIOD AND WHY IT IS CRITICAL

Before a work of interactive entertainment is ever built—before the interactivity is programmed, or the visuals are produced, or the sound is recorded—a tremendous amount of planning must first take place. This phase of the work is known as the development process or the preproduction period. It is a time of tremendous creative ferment. In its own way, it is not unlike the period described in ancient creation myths, the time at the beginning of the universe when all was nothingness and then, after a series of miraculous events, the earth and its myriad living beings were created.

The creation of a work of interactive entertainment is a totally human endeavor, of course, but it, too, begins with nothingness, and to successfully bring such a complex endeavor to fruition can almost seem miraculous. To achieve the end goal, a tiny sliver of an idea must be modeled and shaped, amplified and refined. And, instead of miracles, it involves a tremendous amount of hard work. Bringing a project up to the point where it is ready for production requires a team of individuals possessing an array of extremely diverse skills. The work that takes place during the development process is diverse as well. Some of it is entirely conceptual, and that work may take place in solitude or in boisterous group brainstorming sessions. Other parts of the work call for the generating of complex documents or for highly detailed artwork. Still other aspects of preproduction call for the crunching of numbers or for various types of testing.

Surprising though it may be, the work that goes on during preproduction is much the same for every type of interactive project, whether the end product is a video game, a VR simulation, a smart toy, or a wireless game. The specific documents that are called for may vary, and the specific technical issues or marketing concerns may be different, but the core process is strikingly similar no matter what the platform or interactive medium.

A well-utilized preproduction period can save not only time and money during production, but can also help avert the risk of a product that fails. Furthermore, the documents generated during development can go a long way toward keeping the entire team on track while the project is actually being built. Good documentation can mean that everyone is working with the same vision of the end product in mind. It helps avoid confusion, prevents mistakes, and reduces the likelihood of work having to be redone. And if a new member is added to the team midway through, the documentation can quickly bring that individual up to speed.

The tasks that take place during the development period include the conceptualizing of the project; addressing marketing issues; producing design documents and other written materials; making flowcharts, concept sketches, and storyboarding; building prototypes; and doing testing. This process typically lasts an average of six months. However, the preproduction process can be as brief as a few days or as long as a year or more, depending on the complexity of the project and on the experience of the creative team and the organization that's making it. An extremely innovative and technically challenging project is likely to take far longer than a new title for a well-established line. But at the end of the development process, the company should be ready to swing into full-scale production.

SOME ALL-TOO-COMMON ERRORS

In creating a new work of interactive entertainment, certain mistakes are made over and over again. Many of these errors are caused by inexperience. They are often fueled by the team's admirable intention of making something remarkable, yet being unable to rein in their ideas and set reasonable limits. Another large set of errors is committed because the creative team is eager to plunge into preproduction and is too impatient to invest sufficient time in planning. Here are five of the most common and serious errors that occur during the creative process:

1. Throwing too much into the project. In cases like this, the creative team may have become intoxicated with a promising new technology or with exciting new ways to expand the content. But this sort of enthusiasm can lead to many problems. It can cause the project to go over budget or require it to carry too expensive a price tag for the market. The project may take far longer to produce than the time originally slotted for it, causing it to miss an important market date. Or the finished product may be too overwhelming for the end-user to enjoy. Producer Diana Pray of Knowledge Adventure commented wryly on this type of "more is better" attitude, saying: "We have to understand that we are adults and can't do everything we want all the time."

2. Not considering your audience. This error can be fatal to a project. If you do not have a good understanding of your audience, how can you be sure you are making something it will want, or will have the ability to use? This mistake is one that is made repeatedly and with innumerable variations. Sometimes products are produced for a platform or device or technical capability that most people in the target audience do not possess. Sometimes projects center on subject matter that people in the audience are not interested in, or may even find distasteful. Or, if the product is intended for children, it may not be age appropriate. If designed for training or teaching, it might not cover the points that the learners need to know. The variations of this error could easily fill an entire book. A great many interactive projects fail for the simple reason that the developers misjudged the product's intended audience.

3. Making the product too hard or complicated. This error can stem in part from Error #2, not knowing your audience. You need to understand what the end users are capable of doing, and not make unrealistic demands on their abilities. Sometimes this error is caused by poor design, and is allowed to slip by because of inadequate testing. Whatever the cause, an overly difficult product will lead to unhappy end users. As game designer Katie Fisher of Quicksilver Software said: "When a game becomes work, it's not fun for the player." Her comment is true not just of games but for any work of interactive entertainment, be it a smart toy, an immersive movie, or an iTV show. If it is too hard to figure out, users are not going to want to invest their time playing it.

4. Making the product too simple. This is the other side of the coin for Error #3. We are not talking here, however, about the product being too simple to use—simplicity in functionality is a good thing. We are referring to overly simple content. The content of an interactive work needs

to be challenging in some way; otherwise, users will lose interest. It should also contain enough material to explore, and things to do, to keep the users absorbed for a significant amount of time. If it is too thin, they will feel they have not gotten their money's worth. To gauge the appropriate amount of playing time for your product, it is advisable to become familiar with similar products on the market. Focus group testing is also helpful in this matter.

5. Not making the product truly interactive. In such cases, the content does not fully involve the users; they are not given the opportunity to participate fully in it or have a significant impact on it. This error occurs when the creative team does not fully understand the potential of interactivity or fails to harness it adequately. In a case like this, the product they make may turn out to be primarily a linear piece dressed up with a sprinkling of interactive features. When this happens, the flaw can usually be traced back all the way to the initial concept. In all likelihood, the premise that the product was built upon was weak in terms of its interactive potential, even if it might have been an interesting one for a noninteractive type of entertainment. In a successful interactive product, the interactivity is not an afterthought; it is an organic part of the project from the outset. If the product does not lend itself to meaningful interactivity, then the creative team must do a very painful thing: kill it.

THE COLLABORATIVE APPROACH

The process of creating a work of interactive entertainment is generally a highly collaborative one, employing a team approach and encouraging the sharing of information. This collaborative spirit is very much a part of the culture of the software world, perhaps because most interactive projects are so complex that it is difficult for any one person to control every element or to be knowledgeable about every detail. With a collaborative approach, the team members pool their knowledge and problem-solve together. Team brainstorming is almost always a regular feature of the development process, and ideas are welcomed from every member of the team, whether the suggestion falls within that person's specific area or not.

However, this is not to say that the development period is a wild free-for-all verging on anarchy. To help keep order, one person serves as leader. This person may be the project manager, the producer, the creative director, or, in a small company, even the organization's CEO. The team leader shepherds the concept through its development and production, and may even have been the one who came up with the concept for the project in the first place.

For example, at Kutoka Interactive, developers of the *Mia* titles discussed previously, President Richard Vincent is the one who starts the ball rolling. He initiates the core idea for a new title, lays out the basic direction for the game and story, and roughs out the navigation and educational activities. He writes all this up in an eight-page document, the "Project Description Document." The concepts sketched out in the document are fleshed out through brainstorming. On the other hand, at Knowledge Adventure, brainstorming may begin when a team member proposes

an idea for a new title. If it is felt to have merit, this nugget of an idea is set in front of the creative team and used as a starting place. The team then brainstorms the game style, the setting, the storyline, and the characters.

Where the initial idea comes from varies from medium to medium, company to company, project to project. In the toy business, a concept for a new smart doll might be devised by a toy inventor. For a promotional website, the idea might start with someone in the marketing department. For an interactive TV show, it might begin as the brainchild of a network executive.

Once the initial brainstorming has taken place and the project gets underway, most companies continue to use a team approach, and meetings are called on a regular basis. Not only do these sessions spark creative ideas, but they also serve as a forum for exchanging information and for supplying members with the information they need to move forward. For example, a writer might have an innovative idea for the script, but he isn't sure if their software is capable of performing what he has in mind. But at a team meeting, the programmer would be sitting right across the table from him, and she could quickly clarify what is possible, and suggest the best way to handle the idea in the script. But if it turns out that this particular notion cannot be done, members of the group could offer alternative ways of doing what he had in mind.

Many experienced production executives believe that a team approach produces superior products, though they stress that good communications skills are essential for this kind of collaboration to be effective. Among the proponents of the team approach is Mary C. Schaffer, who currently teaches interactive multimedia design, development, and production at California State University at Northridge, and has headed up production teams at such companies as Disney Interactive, AND Communications, and Geocities. Schaffer feels the team approach works best when the group is composed of representatives of every discipline— each of the specific production areas—and when these team members are conscientious about sharing information. "If the software designer doesn't know why things are happening, or what the goals are, he's just a code writer," she said. "And if the art director isn't informed, he's just a pixel pusher. And if they come up with something great, but don't communicate it with the others on the team, then it won't be great."

Schaffer also believes it is extremely important for team members to share the information from the meeting with their entire department. "You don't want to have people saying 'I didn't know about that,'" she said. Furthermore, this exchange should go two ways. Not only should the team representatives debrief their departments, but they should also be open to hearing new ideas or learning of potential problems from their staff members. Schaffer acknowledges that not every team leader is enthusiastic about this kind of back and forth communication, complaining that it will take up too much time. But, as Schaffer points out, by not spending a half-hour communicating, they could lose weeks of time further down the road.

WHO IS ON THE TEAM?

As we mentioned above, the creative team is generally made up of representatives from each of the major departments; they are usually the head person in the

department. The specific titles may vary from company to company, but the key people on the creative team would normally include:

- The project manager or producer. This person manages the project, oversees the budget and schedule, and makes sure that the established milestones are met. In addition, if the project is being financed by another organization, the project manager or producer is usually the one who serves as the liaison between the client and the team.
- The creative director or art director. This individual is in charge of the visual elements for the project—the animation, the graphics, and the video. In some cases, this individual may supervise all the creative components of the project, including the script and the audio elements.
- The lead designer. This person, who might also be called a game designer, interface designer, graphics designer, or instructional designer, is in charge of one or more aspects of the project's design—the invisible bones upon which the project is built.
- The head writer. This individual is the head of the writing staff and may actually carry out many of the nontechnical writing duties, as well as contributing to conceptual aspects of the project, such as story, game-play, character design, plot, and structure.
- The software engineer or head programmer. This is the person who is in charge of all the code writing, and has the best understanding of the project's engine—the computer programming that operates the project in the specific way it does.

In addition to these specialists, the team might also include:

- A puzzle master. This person devises the project's puzzles.
- A content expert. This individual offers expert advice on the informational, educational, or training content.
- An information architect. This person organizes the intellectual content and works out how the user will interact with it.
- An electrical engineer or sound engineer. This person provides expertise on specific engineering matters.

Certain interactive arenas may include additional specialists, some of them with fairly exotic expertise. For example, the team working on an intelligent doll may include a hair designer or sculptor among its members; a VR team might include an expert in artificial smell; a simulation may call for an expert in voice recognition or artificial emotion.

In addition to the regular members of the team, another person may also occasionally participate during the creative process: a marketing expert. This person may be an employee of the client or may be an in-house staff member who works for the software company. Marketing people have valuable information to share, especially about the audience for the product. Though their research and insights may not always be foolproof, they generally have a good grasp of the product's target audience. They know their needs, their degree of technical sophistication, what similar products they've liked or disliked, and how much

money they might be willing to pay for the product. As the project moves along, this marketing person needs to be kept in the loop and notified if any changes occur in the schedule.

ESSENTIAL TASKS DURING DEVELOPMENT

During the development period, a number of questions need to be answered, issues addressed, documents written, and artwork produced. Not every task done during this period deals specifically with creative issues, although invariably everything does impact the content, including the drawing up of budgets and schedules and the preparing of marketing plans.

The process begins with deciding what, in essence, the new project will be... its core premise. During brainstorming, even the wildest ideas are encouraged, in order to explore the full potential of the project. Sometimes this starting session also serves as the ending point of the company's prior project, with an informal post mortem discussion of the lessons that were learned in making it and how these lessons can be put to good use in the new project.

THE PREMISE

Once a consensus of the premise of the new project begins to emerge, a description of the idea needs to be articulated in a way that adequately reflects the group's perception of it. Ideally, one person on the team will boil the concept down to a single sentence that vividly describes the premise. This sentence should indicate where the project's energy will come from and what will hook the users. For example, a description of the premise of a new game might sound something like this: "Players are thrust into the glamorous but cut-throat world of the fashion industry, where they play the head of a small fashion house competing against powerful rivals and try to come up with the winning line for the new season." Or a description for a smart toy might be described this way: "Perry the Talking Parrot can not only be trained to repeat phrases, but also has a mind of his own and will delight his owners with his unexpected and clever remarks." In the film business, they call this one sentence description a "log line." The term got its name from the concise descriptions of movies given in entertainment guides. However, the idea of boiling down a premise to a few words is equally useful for interactive entertainment. By nailing it down this way, the team will have a clear grasp of what it is setting out to do. They will also be able to communicate this vision to everyone who will be working on it, or whose support will be needed to bring the project to fruition.

OTHER EARLY DECISIONS

Early on during the development period, the team will need to decide what medium and platform the project will be made for, and what genre it will belong to, assuming these key factors are not already tied to the initial concept. Once the basic "What is it?" question has been answered, the creative group can begin

to consider marketing issues. It is important to determine as soon as possible who the target audience will be, what the competing products are, and what the intended price tag will be. All these things can have a significant impact on the design.

For example, your marketing expert might determine that the idea you have in mind sounds too expensive for your target audience, and if you don't want to overprice your product, you will need to rethink the design and leave out some of the cutting-edge features you were hoping to build in. Or perhaps your marketing expert tells you your product would have a better chance with a different demographic than you had in mind. This information would require a different kind of adjustment. For instance, if you found out it would have a higher appeal with teens rather than with preteens, you may need to make the product more sophisticated and edgier than you'd intended at first.

Somewhere early on during the development period, the project manager will also be working out a preproduction and production schedule which will include specific milestones—dates when specific elements must be completed and delivered. A budget for the project will also be drawn up. Now, armed with a clearer idea of your project and its parameters, the team can brainstorm on refining the concept and begin to develop its specific features. Unlike the very first brainstorming sessions, where the sky was the limit, these later brainstorming sessions are tempered by reality. As game designer Greg Roach points out, you only have limited resources, and you have to decide how you want to use them. "It's like being given five pounds of stuff," he said. "You can't do everything you want." In other words, you have to make trade offs—if you build in Feature X, then you may have to do without Feature Y.

BRINGING IN OTHER EXPERTS

Many projects require the input of content experts. Projects designed for educational, informational, or training purposes will inevitably require help from advisors who are experts both on the subject matter and on the target learners. But even when the sole goal of the project is to entertain, it might be necessary to seek expert help on content, or to assign someone to do research. For instance, if you are actually doing a game about the fashion industry, you will want to find out everything you can about the world of high fashion, from how a new line of clothes is designed to how a fashion show is staged. Based on this knowledge, you can build specific challenges and puzzles into the game, and make the project far richer and more realistic than it would be if you had attempted to rely on your imagination alone.

As the project develops, the team will be setting the ideas down in various types of documents. They will also be producing flowcharts, character sketches, and other visuals to further refine the interactivity, characterization, and look of the project. The various documents and artwork will be described in more detail a little later in this chapter, in the section entitled "Documents and Artwork."

At various points during the development process, ideas and visuals may be tested on representative members of the target audience. If a client company is involved in this project, it will also need to be briefed on ideas and shown visuals.

Based on the feedback that is received, further refinements may be made. The final step in preproduction is often the building of a prototype, a working model of a small part of the overall project. This is especially typical in cases where the project incorporates novel features or new technology, or is the first of an intended line of similar products.

The prototype will demonstrate how the project actually operates, how the user interacts with the content, and what the look and feel of it will be like. For many interactive projects, the prototype is the make or break point. If it lives up to expectations, and funding for the product and other considerations are in place, the project will receive the green light to proceed to development. But if the prototype reveals serious flaws in the concept or in its functionality, it may mean back to the drawing board or even the end of the line for that particular project.

A TEN-STEP DEVELOPMENT CHECKLIST

As we've noted above, the process of creating an interactive project involves the asking and answering of some fundamental questions. Based on my own experience and on the interviews done for this book, I have put together a list of ten critical questions that must be addressed early in the development process, each with its own set of subquestions. These questions and subquestions apply to virtually any type of work of interactive entertainment. The answers will help you shape your concept, define your characters and structure, and work out the project's interactivity. The ten questions are:

1. PREMISE: What is the premise of the project... the core idea in a nutshell? What is its primary challenge, or what about it will make it engaging? Try to capture its essential qualities in a single sentence.
2. PURPOSE: What is the purpose of the project: To entertain? To teach or inform? To make people laugh? To sell? What information will you need to gather in order for your project to meet this purpose? How will you obtain this information?
3. MODE OF PRESENTATION: What medium will be used for this project and what type of platform? What special technology, if any, does it call for? What genre does it fall into? What are the special strengths and limitations of the medium, platform, and technology, and how will the project take advantage of these strengths and minimize these limitations? What are the key characteristics of its genre, and what competing products in this genre are already out in the marketplace?
4. AUDIENCE: Who is this project intended for? What kinds of things are important to people in this group? What type of entertainment do they enjoy? What are their needs, hopes, and fears? How technically sophisticated are they?
5. SETTING, WORLDS, AND CHARACTERS: What is the central fictional setting or world of your project? Into what kinds of smaller worlds can it be divided? What kinds of actions or events might take place in these worlds, and what kinds of characters might inhabit them?

Who would the main character and other good guys be, and who would be the bad guys? What challenges or dangers are inherent to these worlds, and what kinds of special talents or abilities are required to operate successfully within these settings?

6. USER'S ROLE: What role will the user play in this interactive environment and what will he or she do? What is the nature of the user's involvement? How will the user effect the outcome? How do the project's characters, if any, interact with the user? How will the user navigate through the environment and control things within it?

7. GOAL: What is the overarching goal of the fictional construct, and what mission is the user given in terms of trying to achieve this goal? What kinds of things can the user do to enable the goal to be fulfilled? What kinds of intermediate and smaller goals will the user be given along the way? What will hook the user, and make this person want to spend time achieving the overarching goal?

8. OPPOSITION AND TENSION: What is the nature of the oppositional forces that the user will encounter? What kinds of obstacles or challenges will need to be dealt with? What will add tension to the experience? Will some kind of ticking clock be built into the project?

9. REWARDS AND CONSEQUENCES: How will the user be rewarded when he or she succeeds at a task? What kinds of setbacks might the user encounter and what happens when a setback occurs? Will any type of help be offered, and if so, what will it be? Will the project be built with levels of difficulty, and if so, how will the difficulty levels be set? What happens if the user fails at a task... what kinds of consequences will result? Will the user have to begin again, or will a less severe option be offered? How will the user know if he or she is doing well or not doing well?

10. STRUCTURE: How will the project be structured? What will the general organizing principle be? Over how long a time is the fictional experience supposed to last, and how will the passing of time be indicated? How will users be made aware of the structure, and how will they know how to navigate within this interactive universe?

Once you have answered these ten questions as completely as possible, you are ready to more fully develop your characters, story elements, interactive components, structure, and interface, as well as the gameplay and puzzles, if your project has gaming elements. If your project is one that blends entertainment with other goals, such as education or promotion, it will be helpful to also review the checklist given in Chapter 8, in the section entitled "Tackling a Project That Blends Entertainment with Other Goals."

DOCUMENTS AND ARTWORK

While each organization may have its own unique twist on doing documentation and preproduction artwork, certain types of written materials and visuals are universal throughout the interactive entertainment universe, even though their names

may vary from company to company. The most frequently used forms of documentation and visual presentations are:

1. The Concept Document

The concept document is a brief description of the project and is usually the first written document to be generated. It includes such essential information as the premise, the intended medium and platform, and the genre. It also notes the intended audience for the project and the nature of the interactivity, and gives a succinct overview of the characters and the main features of the story and game. Concept documents may be used as in-house tools to give everyone on the team a quick picture of what the project will be, and to spur on the initial brainstorming. As we've seen, this is the function it serves at Kutoka Interactive, where it is called a Project Description Document. Concept documents can also be used as sales tools to secure support or funding for a project, in which case they would be written in a vivid, engaging style that will convince readers of their viability. Concept documents tend to be quite short, generally under ten pages in length.

2. The Bible

A bible is an expanded version of a concept document, and it is strictly an in-house working document. Bibles are most frequently used for complex, story-rich projects; they may not be written at all for certain types of interactive projects, such as puzzle games. A bible fully describes significant elements of the work. It includes all the settings or worlds and what happens in them and all the major characters, and may also give the backstories of these characters (their personal histories up to the point where the story or game begins). Some bibles, called character bibles, only describe the characters. Bibles vary quite a bit in length, depending on the breadth of the project and their intended purpose within the company. In some companies, such as Her Interactive, the bible is a collection of all the preproduction documents written for the project.

3. The Design Document

The design document serves as a written blueprint of the entire interactive work. It vastly expands the information given in either a concept document or bible, and contains specific technical information about the interactivity and functionality. It is the primary working horse document of any new media project. At some companies, the design document evolves from the concept document or bible; at other companies, it is written from scratch.

The design document is a living document, begun during preproduction but never truly completed until the project itself is finished. As new features are added to the project, they are added to the design document, or if a feature is changed, the design document is revised accordingly. Because a design document is such an enormous and ever-changing work, and because so many different people contribute to it, it is vital that one person takes charge of overseeing it. This person coordinates and integrates the updates and makes sure that only one official version exists and that no outdated versions are still floating around.

Design documents are organized in various ways. Some are organized by structure, with a section for each module, world, environment, or level. Others are organized by topic. For instance, the design document for the strategy game *Age of Empires* contained a section just on buildings and how they worked.

To get an idea of the type of information that can be included in a design document, let's take a look at a few pages of one prepared for *JumpStart Advanced First Grade*. (See Figure 10.1.) The document is organized module by module; this module is for Hopsalot's Bridge, a sorting game. It is hosted by a character named Hopsalot, who is a rabbit. At the top of the first page is a picture of what Hopsalot's Bridge looks like, from the POV of the player. Beneath it is listed the curriculum points the game will teach, followed by brief summaries of the introduction speeches, one for first-time visitors and one for repeat visitors. This is followed by a detailed description of the game play, levels, and functionality. The full documentation of this module would also note what objects on the screen are clickable and what happens when the player clicks on them—what the pop-ups will be and what the audio will be, as well as a description of all the buttons on the screen and on the tool bar, and what each of them does. It would also indicate every line of dialogue that Hopsalot would speak, and would include special notes for the programmer and graphic artist.

Hopsalot's Bridge Module
(Hb)

Access

Click Hopsalot's House, on the Main Menu Screen to get here.

Page Description

The curriculum for this module is the <u>Sorting</u> of:
- <u>Parts of speech</u>
- <u>Words</u>
- <u>Geometry</u>: shapes
- <u>Science</u>: Health/Nutrition, Animals, Weather

On Your First Visit:
Hopsalot gives long intro. Hopsalot's turbo carrot juice is one of the most prized power-ups for the scooters. Or at least he thinks it is, so he has gone to extremes to protect his supply.

Return Visit:
Gives short intro.

Gameplay

Hopsalot has made an island to hide his high-octane carrot juice on and he has to build a bridge to get to it. He has columns in the water that divide the bridge into 3 sections. He has also created little remote controlled balloon blimps to drop into place and create the bridge.

Figure 10.1 A few pages from the design document of *JumpStart Advanced First Grade*. Document courtesy of Knowledge Adventure, Inc., and used under license.

Each balloon has a word or picture on it (depending on the content selected for the session). For example: each word would be a Noun, Verb or Adjective. You must sort the balloons so that each column of the bridge has the same type of word. Use the left and right arrow keys to steer the balloons and use the down arrow key to make them drop faster.

If you send a balloon into the wrong column it will bounce back up into the air so that you can try again. Hopsalot will also hold a pin that will pop the balloons that you don't need (distractor blimps in L2 and L3).

When the bridge is complete, Hops will run over to grab a carrot power-up and bring it back. Now for the fun part! He can't leave the bridge up or Jimmy Bumples might sneak across, so you'll need to repeat the activity, but this time matching object will pop the balloon underneath.

Reward:
After you've destroyed the bridge, Hops will reward you with the power-up.

Content Leveling

Note: the levels are related to each topic.

1. Parts of speech
Level 1: Verbs, Adjectives and nouns
Level 2: Verbs, Adjectives and nouns
Level 3: Verbs, Adjectives and nouns
Add words that do not fit into the category such as an adverb or preposition.

2. Syllables
Level 1: 1 to 3 syllables; pronounced
Level 2: 2 to 4 syllables; pronounced
Level 3: 2 to 4 syllables; regular pronunciation

3. Health-Nutrition (food groups)
Level 1: 3 categories: Grains, Meats, Dairy
Level 2: 4 categories: Grains, Meats, Dairy, Fruits
Level 3: 5 categories: Grains, Meats, Dairy, Fruits, Vegetables

4. Animals
Level 1: Habitat: water, land, air
Level 2: Attributes: scales, fur, feathers
Level 3: Zoological type: mammals, reptiles, insects; amphibians as distracters

5. Science - Weather
Level 1: 3 categories: sunny, rainy, snowy; outdoors activities
Level 2: 3 categories: sunny, rainy, snowy; outdoors activities + clothes
Level 3: seasons: winter, spring, summer; fall as distracter

6. Geometry – Shapes and Forms
Level 1: 2D shapes: squares, triangles, circles, rectangles
Level 2: 3D shapes: cubes, cones, cylinders, spheres
Level 3: everyday objects by their 3D shape: cubes, cones, cylinders, spheres

Game Play Leveling

Level 1: Slow falling pieces.
Level 2: Medium speed falling pieces.
Level 3: Fast falling pieces.

Functionality

I. On entering the Module:

 A. Play Background: BkgG1HbBackground
 B. Play Background Music: G1HbAmbient.wav

II. Introduction Functionality

 A. Long Introduction (played the first time a player visits this module)
 Follow standards for interruptability
 a) Play Hopsalot waiving at Player
 ■ Hopsalot's Body: AniG1HbHopsalot, FX Wave
 b) Play Hopsalot giving his Long Intro
 (Note: during Intro, Hopsalot will be Pointing at item as he speaks about them; items will highlight, and Hopsalot will have corresponding "Point" FX going on)
 i) Long Intro:
 ■ Hopsalot's Body: AniG1HbHopsalot, FX Point01
 ■ Hopsalot's Talk: AniG1HbHopsalotTalk, FX LongIntro01
 ■ Hopsalot's VO: DgG1HbHopsalotTalkLongIntro01.wav
 c) Go to Gameplay

Figure 10.1 Continued.

B. Short Intro (played on any return visits)
 Follow standards for interruptability
 a) Play Hopsalot giving one of the 3 Short Intros: (Random without repetition)
 ■ Hopsalot's Body: AniG1HbHopsalot, FX Point{01-03}
 ■ Hopsalot's Talk: AniG1HbHopsalotTalk, FX ShortIntro{01-03}
 ■ Hopsalot's VO: DgG1HbHopsalotTalkShortIntro{01-03}.wav
 b) Go to Gameplay

III. Gameplay Interaction

A. Display
 1. <u>Hopsalot</u>
 a) Hopsalot's Body: AniG1HbHopsalot, FX Still
 b) Hopsalot's Talk: AniG1HbHopsalotTalk, FX Still

 2. <u>Device to throw Balloons</u>
 a) Device: AniG1HbDevice, FX Still

 3. <u>Falling Balloons</u>
 (note: will appear on screen one after the other, according to order set for current level;
 those will be the same sprite, replicated at {x} instances; use datadict for coordinates)
 a) Play first Balloon ready on the Device: AniG1HbBalloon, FX Still

 4. <u>Carrot Case</u>
 (note: at the right side of screen = case containing the power-up)
 a) Case standing there: AniG1HbCarrotCase, FX Still

 5. <u>Labels</u>
 (Note: located at the bottom of each section of the bridge, they will display the name of
 each category; they will appear one by one when Hopsalot gives instruction: see below)
 a) Labels sprites are not visible when entering the module

Figure 10.1 Continued.

Because design documents incorporate such a vast amount of detail, they sometimes reach 1,000 pages or more in length. Some companies also produce a "lite" version for a quicker read. Many companies will keep the design document on the organization's Intranet so it can be readily available to everyone on the team.

The design document is an enormously important document, guiding the entire creative staff during development and production and keeping things on track. Furthermore, it is the point of origin for many other critical documents. For example, the programming department will use the design document for creating its own technical design document and the test team will use it to prepare a list of all the systems to be tested. The design document also helps the marketing group put together promotional materials and prepare for the product launch. If a manual or clue book or novelization is to be written for the project, the design document will come into play for those endeavors as well.

4. The Script

The script is the document that sets down all the dialogue that will be spoken during the interactive program. Scripts also describe the visuals and the actions that accompany the dialogue. The dialogue is either spoken by characters on the screen (animated figures or actual actors shot in video), or spoken voice-over by characters who are not visible. Their voices may be heard via a telephone, a radio, or some other device, or the dialogue may be delivered by an off screen character who is offering help and support. In cases when only voice-over actors will be used, and no live characters appear on screen, a separate voice-over dialogue script will be prepared that contains nothing but lines of dialogue.

Formats for interactive scripts vary widely. Sometimes they resemble the format for feature films, but incorporate instructions for interactive situations, such as the demo script, *Pop Quiz*, written by Terry Borst for a class he was co-teaching in interactive design for the University of Southern California. (See Figure 10.2.) The script employs a simple branching structure. A modified feature film format like this works well in story-rich projects and games in which the level of interactivity is not too complex.

<div align="center">

"POP QUIZ"

BY TERRY BORST

</div>

FADE IN:

[LOCATION ONE] [VIEWPOINT ONE]

1 EXT. USC - LUCAS BUILDING COURTYARD - DAY 1

Pretty quiet place, for a university campus.

2 EXT. COURTYARD - USER POV 2

If we think of the courtyard as a baseball diamond, User stands at home plate. (This would be just outside the Student Affairs floor, facing out to the courtyard.)

To the LEFT (EAST): trees and a stone walkway, pretty shaded.

AHEAD (SOUTH): benches and a corridor filled with doors, one of them open.

To the RIGHT (WEST): The bridge offers an archway that beckons to the world beyond, but standing by it is a STUDENT ARTISTE: plugged into a Walkman, studying his PDA intently.

User must CHOOSE which way to go...

IF USER CHOOSES EAST (Viewpoint 1):

3 EXT. COURTYARD - DAY 3

An Equipment Guy (known as THE ROCK) steps forward out of the shadows.

<div align="center">

THE ROCK
You can't go here. We've got a shoot
in progress.

USER
Right. Sorry.

</div>

User retreats to his starting point.

Go to Location 1, Viewpoint 1.

IF USER CHOOSES SOUTH (Viewpoint 1):

4 EXT. COURTYARD - CORRIDOR OF DOORS - DAY 4

User approaches the open door and enters.

Go to Location 2, Viewpoint 1.

IF USER CHOOSES WEST (Viewpoint 1):

5 EXT. COURTYARD - BELOW BRIDGE - DAY 5

User takes a short walk towards the Student Artiste...

Go to Location 1, Viewpoint 2.

IF USER AGAIN CHOOSES EAST (Viewpoint 1):

Figure 10.2 Sample pages from *Pop Quiz* written by Terry Borst. The script uses a modified screenplay style of formatting to demonstrate a simple branching format. Script courtesy of Terry Borst.

6 EXT. COURTYARD - FACING THE ROCK AGAIN - DAY 6

The Rock looms out of the shadows once again.

 THE ROCK
 Don't make me come and get you.

User retreats to the starting point.

> [LOCATION ONE] [VIEWPOINT TWO]

7 EXT. COURTYARD - BELOW BRIDGE - DAY 7

BEHIND the User (EAST) is The Rock, still lurking in the shadows.

To the LEFT (SOUTH) is the corridor of doors.

To the RIGHT (NORTH) is the starting point (vending machines).

AHEAD (WEST) is the Student Artiste.

IF USER CHOOSES WEST (Viewpoint 2):

8 EXT. COURTYARD - BELOW BRIDGE - STUDENT ARTISTE - DAY 8

As User nears, the Student Artiste looks up and unplugs himself from the Walkman.

 STUDENT ARTISTE
 Pop quiz. Miss it and I sic The
 Rock on you.
 (gestures to The Rock)
 Harold Lloyd: influence on Samuel
 Beckett, or spectacular failure as a
 presidential candidate?

User *can* navigate back to his starting point, but:

IF CONVERSATION RATHER THAN NAVIGATION IS ELECTED:

9 EXT. COURTYARD - STUDENT ARTISTE - DAY 9

User may CHOOSE an answer.

 USER
 (1) It's Buster Keaton, actually.
 (MORE)

Figure 10.2 Continued.

Some companies, however, prefer to use a multicolumn format. This formatting style roughly resembles the traditional audio/video two-column format used in the making of documentaries and other types of linear programs. It is particularly prevalent in linear projects that primarily use voice-over narration instead of actors who appear on screen. In the linear version of this type of format, one column is used for visuals (the video) and the other is for voice and sound (the audio). Interactive scripts, however, may use several more columns. At Training Systems Design, for instance, they use anywhere from three to five columns, which varies from script to script and module to module. The number of columns used depends on the needs of the programming and graphics groups. Their scripts also contain artwork indicating what will appear on the learner's screen. The company calls this type of formatting "scripts and screens."

One example of a five-column scripts and screens format is the company's script for the *Save Your Co-Worker* game, part of the *Code Alert* training program discussed in Chapter 8. (See Figure 10.3.) The script for the game was written by Dr. Robert Steinmetz. The artwork depicts the setting for this portion of the game,

an office cubicle, and also shows the bar that keeps track of the learner's score, as well as an icon the learner can click on to receive help (upper left). Column one, labeled Spot, indicates the hot spots on the screen—objects the learner can click on to get some sort of response from the program. Column two, Programming Instructions, gives notes to the programmers, explaining what needs to happen when the user clicks on a specific hot spot. Column 3, Value, shows how the learner's choice will effect his or her score. Column 4, Audio Label, gives the code for the audio that will be heard in Column 5. Column 5, Sound Effect/ Voice-Over, describes the audio effects that will be heard and the voice-over dialogue that the narrator will speak.

Scene 2: Toni & Joseph Cubicle
5.1.2-1

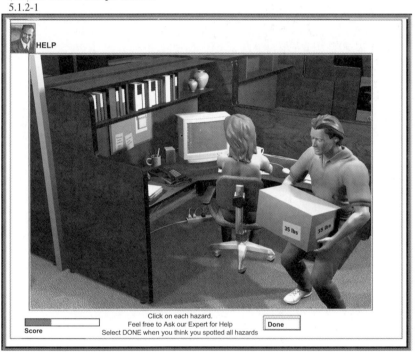

Spot	Programming Instructions	Value (if selected)	Audio label	Sound effect / voice over
1 Printer	If selected, add value to score bar, play good beep and play audio VO 5.1.2-1A	1	5.1.2-1 A	(Good Beep) it all depends on frequency of use. But, based on where she has her mouse, we can assume this person is right handed, therefore it might be better to swap the phone position and the printer. However, sometimes it is good to move things around to avoid repetitive motion syndrome.

Figure 10.3 The script for the *Save Your Co-Worker* game written by Dr. Robert Steinmetz for the *Code Alert* training program. It utilizes a five-column scripts and screens format. Document courtesy of Training Systems Design.

2: Phone	If selected, add value to score bar, play good beep and play audio VO 5.1.2-1A	1		
3: Monitor	If selected, add value to score bar, play good beep and play audio VO 5.1.2-1B	3	5.1.2-1B	(Good Beep) Right! She really should orient herself so that her eyes are level with the monitor and her neck is in a neutral position
4: Head position	If selected, add value to score bar, play good beep and play audio VO 5.1.2-1B	3		
5: Keyboard	If selected, add value to score bar, play bad beep and play audio VO 5.1.2-1C	1	5.1.2-1C	(no beep)The problem isn't really with keyboard…though you could consider it part of a larger overall work habit problem.
6: Mouse	If selected, add value to score bar, play bad beep and play audio VO **5.1.0-3**	0		
7: Lifting position	If selected, add value to score bar, play bad beep and play audio VO 5.1.2-1D	0	5.1.2-1D	(Bad Beep) Nope, he is lifting with his legs, and he is tucking the load in toward his torso.

Figure 10.3 Continued.

Some companies create their own in-house software programs for script formatting, but off-the-shelf programs are available as well. Two of the better-known commercial products, both of which format linear types of scripts as well, are Final Draft and Movie Magic Screenwriter.

5. Flowcharts

Flowcharts are a visual expression of the narrative line of the program, and illustrate decision points, branches, and other interactive possibilities. Flowcharting often begins early in the development process as a way to sketch out how portions of the program will work. As the project evolves, flowcharts serve as a valuable communications device for various members of the team, everyone from writers to programmers. They are also useful for explaining the project to people not directly on the team, such as marketing specialists or clients. As a visual method of illustrating how the program works, they can be much easier to grasp than a densely detailed design document.

Flowcharts vary a great deal in style and appearance. The least adorned ones, such as the one designed by Terry Borst to illustrate the interactivity for his *Pop Quiz* script, are composed of lines and geometric shapes like a simple diagram. (See Figure 10.4.) More detailed, higher-level flowcharts may also be made for programming, with each element coded to reflect specific functions or types of content.

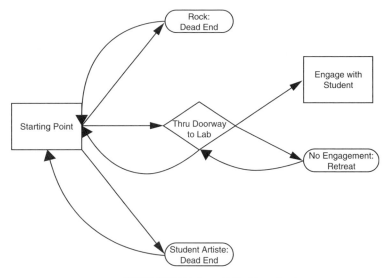

"POP QUIZ" Interactivity Flowchart

Figure 10.4 The flowchart for *Pop Quiz,* made by Terry Borst, illustrates the narrative flow of the script and the various branching points.

More elaborate flowcharts may include detailed visuals of the screens and short explanations of functionality, such as the flowcharts produced for *Code Alert*. (See Figure 10.5.) Flowcharts like these are particularly useful for explaining the program to the client or to potential investors.

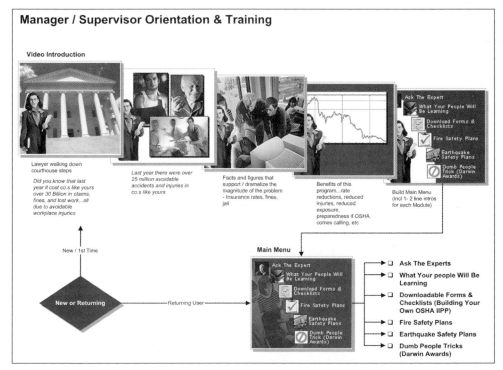

Figure 10.5 The macro level flowchart for *Code Alert* uses screen images and short explanations to describe how the program works.

According to Dr. Steinmetz, the president of Training Systems Design, the company uses two levels of flowcharts. A macro level flowchart, like the one pictured here, gives an overview of the training program and is the type of flowchart that would most likely be used in a company proposal. Such flowcharts are made once the major instructional objectives have been identified. A more detailed flowchart, made later in the development period, would indicate all the branching. It would be produced once the specific teaching points had been identified, and would be cross-referenced to the document that laid out the teaching points.

As with scriptwriting, many off-the-shelf software programs are available to make flowcharts. Two that are popular with people in the software industry are Inspiration and Microsoft Visio.

6. Concept Art

Concept art, also called concept drawings or concept sketches, is a visual rendering of some aspect of the program. Such artwork is often used to depict characters and locations. They may be used as trial balloons, to test possible character designs or settings on the team or on focus groups. They will then be refined until a consensus is reached, and the team agrees on a final version.

When members of the art department are working on a character design, they might make a series of poses for each character. For example, at Her Interactive, for the *Nancy Drew* games, each character is given a set of eight different poses that reflect the character's personality and emotional state. The clothing the character is wearing can serve as a useful way to reveal character, too. For instance, a depressed young woman may be wrapped in layers of dark clothing, while a cocky politician may stick his thumbs in his suspenders.

7. Storyboards

Storyboards are graphical illustrations of the flow of action and other elements of the content, and are displayed sequentially. They are somewhat similar to illustrated flowcharts. In the feature film world, movie directors storyboard every scene before filming begins to work out the details. Storyboarding is often used in interactive media in much the same way. At some companies, they are used primarily for linear sequences, though other companies use them to work out interactive elements as well. For example, every shot of the game *Grim Fandango* was storyboarded during preproduction before the game was made.

Storyboards resemble comic book art in that each frame advances the story. Each frame will indicate the location of the objects within the scene, the placement of the character or characters, the position of the camera, and the direction of the movement within the scene. Because storyboards are so visual, they are simple to comprehend. They are a useful preproduction tool for many kinds of interactive projects, including VR simulations, immersive environments, and interactive movies—in short, for any interactive endeavor that contains rich visual sequences.

8. Prototype

As noted earlier in this chapter, a prototype is a working model of a small portion of the program. It is the ultimate preproduction test of a concept. Many people within the interactive community consider it a more useful method of trying out the concept's viability than flowcharting or storyboarding because it gives a more accurate indication of the look, feel, and functionality of the program. It's a chance to find out how the navigation works and to actually interact with the material. Prototyping is not necessarily done only at the end of the preproduction process. Small prototypes might also be built along the way to test out specific features. Also, it should be noted that prototyping is not necessarily done for every interactive project. For example, if the company has already made many similar products and if this is just another product in an already-established line, prototyping may not be called for.

9. Pilot

A pilot is like a larger-scale version of a prototype. Prototypes, however, are generally only made for in-house use, as a proof of concept, while a pilot may actually be made available to members of the public, much as a pilot for a TV series may actually be broadcast. For example, the pilot of the *Virtual State Parks* project, described in Chapter 8, is expected to be made available to visitors at California state parks. Pilots are actually part of the production phase, not the development phase, of a project. They are expected to function correctly and be bug-free. Generally, pilots are only made for extremely large projects.

SPECIALIZED DOCUMENTS AND ARTWORK

As mentioned earlier in this chapter, other types of documents will also be generated during the development process as well, although they will not specifically focus on the creative aspects of the project. They include a technical document containing the technical specifications; a budget; a schedule; a marketing plan; and a test plan.

In addition to the fairly ubiquitous types of documents, visuals, and models already described, many companies work with customized tools that are particularly helpful for the type of project they are creating. Within the world of smart toys, for example, inventors and designers create something they call a skeleton logic chart or logic flow document. This tool illustrates how the toy and the child will interact with each other, and shows the direction of the narrative line. And for projects that are designed to train or teach, a document is often prepared that lists the main teaching points or training goals. Cross-media productions rely on still other forms of documentation. In these kinds of projects, a number of different media work in conjunction with each other to create an extremely deep entertainment universe, and keeping track of everything requires specialized tools. For example, the creative team that worked on *Push, Nevada*, a project that will be more fully discussed in Chapter 15, developed a document called an "integrated media bible," which explained how the various media components worked

together. They also put together a specialized flowchart called an "integrated media timeline."

Even game companies may find it helpful to create specialized documents. For example, at Her Interactive, they use several kinds of documents when they make the *Nancy Drew* games. One is the "critical path document," which lists the events that must occur, the discoveries that the player must make, and the obstacles that must be overcome in order to successfully reach the end point in the game. This critical path document is extremely succinct, about a page and a half of bullet points. Another document they produce is the "environmental synergy document," which is organized around specific environments (locations) in the game. For instance, for an interior of a room, it would note how the furniture is arranged, how the room is decorated, what "plot critical" objects it contains, what other less essential clues can be found here, and information about any characters who will be found in this room. It also notes what puzzles need to be solved within this environment. In addition to these two documents, the company also creates a highly detailed puzzle document, which lists all the game's puzzles and specifies how they work. All these documents are cross-referenced and collected together as a project bible, so that if a team member needs more information on any aspect of the game, it will be easy to find.

CONCLUSION

As we have seen here, during a well-utilized preproduction period, a concept for an interactive work moves from an extremely rudimentary premise to a well-thought-out project that is detailed enough in every regard to be moved into production. This outcome is only obtainable, however, when teams go through the steps described here, or through similar steps that might be more appropriate to their particular project.

Unfortunately, though, teams are sometimes tempted to jump into production before they've worked out important details, thinking they can do the detail work as they move along. Perhaps this is because doing the hard work of writing documents or making storyboards may seem less appealing than actually building the product. But moving into production prematurely can be a costly mistake.

Interactive projects are almost always extremely complex, and without good documentation, misunderstandings and mistakes can easily occur. Even before members of your team tackle the design document or produce any visual presentations, however, an even more important task needs to be done: conceptualizing. The creative team needs to work out exactly what the project is, whom it is for, and how people will interact with it. Above all, what about the project will make people eager to spend their time engaged with it? Finding satisfactory answers to questions like these, plus going through the other preproduction steps, can go a long way toward helping you create a viable project with genuine appeal.

IDEA-GENERATING EXERCISES

1. Pick an interactive entertainment project that you have just begun to work on or that you are interested in doing. The work can be in any medium or for any type of platform. Take this project through the

Ten-Step Development Process. Which aspect of the project seems to need more thought or would need to be strengthened before you could move deeper into development? Have any of the ten steps raised a red flag indicating that this might not be a viable project for interactive entertainment? Conversely, have any of the ten steps helped you discover potential about this project that you had not recognized before?

2. Using the same project from #1 as your model, determine what types of specialized tasks would need to be done during the preproduction process. What types of specialists would you need to develop the work? In other words, whom would you need on the creative team?

3. Again, using the same project as above for your model, determine what kinds of documents you would need to generate in order to effectively take this project through the preproduction stage. What would each type of document contain?

4. Using the same project as your model, consider your marketing specialist. What information do you think this person could give you and the rest of the team that would be helpful? And what documents do you think your team could give to the marketing specialist that would be useful in terms of launching the product?

Media and Models: Under the Hood

Video Games

What are some of the most important genres of video games, and why is it helpful to know what the different genres are?

In what ways are games growing more cinematic?

What is it about video games that makes them so appealing to gamers?

What can we learn from video games that we can apply to other forms of interactive entertainment?

LOOKING BACK

The video game is the first form of computer-based fun ever devised, making it the granddaddy of all digital interactive entertainment. The arcade version of *Pong*, the oldest of all commercial games, debuted in 1972, almost two decades before the introduction of the World Wide Web and long before the development of wireless games, DVDs, virtual reality, and other forms of interactive entertainment.

It would be impossible to write a book about digital storytelling without a deep bow of acknowledgment to this pioneering form of entertainment or without exploring what we can learn from it. We reviewed some of the landmarks of video games in Chapter 2. What we will do here is review the major types of games, investigate who plays them, and study what today's games are like. Most important of all, we will consider what lessons video games can teach us that we can apply to other forms of interactive entertainment.

CATEGORIES OF GAMES

Broadly speaking, most video games made for home use can be played on just two types of devices: personal computers or game consoles, with some games also available for DVD players. In many discussions of games, those made for computers and those made for consoles are lumped together and are simply called video games. However, significant differences exist between them, and for some years they have been waging an informal battle to dominate the market. Each has had a turn at the top. Typically, the figures for console games spike when a hot new console hits the market, while sales of PC games inch up in other years. The latest consoles now have features that were once exclusive to PCs: They can support online game play and have excellent graphics. Many gamers like the fact that they can sprawl on the living room couch and play on the TV set, as opposed to sitting at a desk playing on a computer. Furthermore, console games are better suited to multiplayer situations, while computer games tend to be played alone.

Although at times the sales of PC games have sagged significantly, experts believe they will continue to be a viable format. Some kinds of games play better on a PC than on a console, particularly ones that call for high levels of control or are especially deep. Games that appeal to casual players also do well on the PC—activities like puzzle games and card games—as well as certain types of simulations, particularly the highly popular *Sims* series. Console gamers, on the other hand, are particularly fond of fast action.

WHO IS PLAYING AND WHAT ARE THEY PLAYING?

As noted previously in this book, the average age of gamers is rising steadily, though those who play on consoles tend to be younger than those who play on PCs. The 2003 survey of the ESA found that 62% of the console players were over the age of 18, a rise of 8% over the previous year. The same survey showed 70% of the PC gamers were over 18, a rise of 4%. Women and girls still continue to be significantly under represented, while those who do play favor the PC over game consoles. Only 28% of console gamers were female, while 42% of the computer gamers were women and girls.

An increasing number of video game players are also playing games online and on mobile systems. According the 2003 survey of the ESA, 37% of gamers reported playing online and 39% reported playing on mobile devices, including handheld systems, PDAs, and cell phones. The rise in wireless gaming was particularly striking, rising from 4% the previous year to 18% in the 2003 survey. (MMOGs, a highly successful subset of online games, are discussed in the next chapter; wireless games are discussed in Chapter 17.)

UNDERSTANDING GAME GENRES

Films, novels, and other forms of linear narratives are often divided into categories, called genres, and the same is true of games. We touched on genre to some degree earlier in this book, particularly in Chapter 9, in the discussion of children's software. Works within a specific genre follow the same conventions, almost like a formula. These commonalities include having similar settings, characters, values, subject matter, action, style, and tone. Television can be categorized into genres such as sitcoms, movies of the week, and one-hour dramas, while movies can be classified as romantic comedies, musicals, and horror films, among other possibilities. In some cases, the same genres can be found in a number of linear media, like detective stories, Westerns and romances. Video games, however, have quite a different set of genres.

But, you might wonder, why should we care what genre a game falls into? What does it matter? Well, for one thing, knowledge of genres gives us a handy kind of shorthand to refer to different games and to understand their prominent characteristics. Being able to identify the major genres is also helpful because it makes it easier to track the market, and to see how the different types of games are faring. With this kind of information, game companies are better able to decide what kinds of products they want to develop.

Knowledge of genre is also important when it comes to pleasing the customer. Gamers are usually quite familiar with the various genres and have their clear favorites. When they go to purchase a new game, they are likely to pick one that belongs to the genre they like best. They have certain expectations for what their new purchase will be like. If the game turns out to be significantly different from other games in that genre, the player is likely to be disappointed; in short, you have an unhappy customer. Thus, software developers need to understand genre conventions when they are designing a new game.

Finally, an understanding of video game genres is useful for anyone interested in interactive entertainment. By studying the various genres, one gets a sense of the scope and variety of experiences possible within interactive media, and begins to see how some of these elements can be ported over to other forms of interactive entertainment.

THE MAJOR GENRES OF GAMES

As important as it is to have an understanding of genre, the process of assigning a particular game to a particular category can be a bit tricky. No two experts will agree to exactly the same definition of a genre, and no ruling body exists to regulate



Figure 11.1 A scene from *Deus Ex, Invisible War*, which falls into the action genre. It tells a complex story involving global conflict and intrigue. Image courtesy of Eidos Interactive.

what game belongs where. Furthermore, the dividing lines separating genres can sometimes be blurry, with a particular game having characteristics of more than one genre. Even so, we can still list the major genres of games and describe their general characteristics. Here are the most common ones, and the ranking of the top five genres at the 2003 E3 video game trade show, which indicates their relative popularity:

- ACTION GAMES: These games are fast-paced, full of physical action, and often call for a great deal of hand-eye coordination and strategy. Some, like the popular *Deus Ex* and its sequel, *Deus Ex, Invisible War*, contain a great amount of story. (See Figure 11.1.) The top-selling *Tomb Raider* series and the *Grand Theft Auto* series are action games, as is *Max Payne*. This is one of the most popular of all genres and was the top-ranking game at E3.

- SPORTS AND DRIVING GAMES: These games focus on various types of team or individual sports, or on car racing. The sports games are highly realistic and call for strategy as well as good control of the action. Gamers may play as an individual team member or may control an entire team. A number of major athletic organizations license their names for sports games, including the National Football League and the National Hockey League. Star athletes, such as Tiger Woods, also license their names to sports games. In driving games, players may either race against a clock or against other competitors, maneuvering around difficult courses and dodging hazards. Driving games include *Indy 500* and *Street Racer*. Sports and driving games were the second most popular genre at E3.

- ROLE-PLAYING GAMES (RPGs): In this genre of game, the player controls one or more characters, which are defined by a set of attributes, such as species, occupation, skill, and special talents. These games evolved from the precomputer version of *Dungeons and Dragons*. Contemporary descendents are highly popular as online games (*EverQuest* and *Ultima Online*). Computer RPGs include the *Final Fantasy* series and *Neverwinter Nights*. RPGs were the third most popular type of game at E3.

- STRATEGY GAMES: These games, as the name suggests, emphasize the use of strategy and logic rather than quick reflexes and hand-eye coordination. In these games, the players manage resources, military units, or communities. Examples include *Command and Conquer* and the *WarCraft* series. Some people would also put *The Sims* series here, while other put *The Sims* in the simulation genre. Strategy games were the fourth most popular genre at E3.
- ADVENTURE GAMES: More than any other type of game, adventure games feature the strongest use of story. Typically, the player is sent on a quest or has a clear-cut mission and must solve a number of riddles or puzzles in order to succeed. Players also explore rich environments and collect items for their inventories as they move about. These games have a very old history, dating back to text-based games such as the *Colossal Cave Adventure*. More recent adventure games include *Beyond Good and Evil* and *The Grim Fandango*. A subgenre of the adventure game is the mystery-adventure game, which includes the *Nancy Drew* series. At the 2003 E3 show, the adventure game was the fifth most popular genre.
- SHOOTERS: Shooters, as the name suggests, involve shooting at things— either at living creatures or at targets. Players are pitted against multiple opponents and are themselves vulnerable. However, they may be given multiple lifetimes in the game, so they can come back for another round if they are killed. Examples of shooter games include *Quake*, *Doom*, and *Half-Life*. In a first-person shooter (FPS), you are given a first-person point of view of the action. You play and control the protagonist, but you cannot see yourself. You can, however, see the weapon you are holding.
- PUZZLE GAMES: Puzzle games are generally abstract and highly graphical and call for the solving of various types of puzzles. Some would also assert that the genre includes games that offer story-based environments that are generously studded with puzzles. *Tetris* is an example of the abstract type of puzzle game, while *Myst* and *The 7ᵗʰ Guest* would be examples of the story-based type of puzzle game.
- FIGHTING GAMES: In these games, players confront opponents in an up close and personal way. The encounter may lead to death, or at least to a clear-cut defeat for one of the opponents. The games typically emphasize hand to hand combat instead of guns or other modern weapons. Examples include *Mortal Kombat* and *Tekken*.
- SIMULATIONS: A simulation may offer the player a physical experience such as flying a plane or parachute jumping, or may offer the opportunity to create a simulated living community. Examples of the first type include the *Fighter Ace* series and *Naval Ops: Warship Gunner*. The community-building type of simulation would include *The Sims* series, *SimAnt*, and *Sid Meier's Civilization*, although some would argue that these games belong to the strategy category.
- PLATFORM GAMES: These fast-paced games call for making your character jump, run, or climb through a challenging terrain, often while dodging falling objects or avoiding pitfalls. Such games require quick reflexes and manual dexterity. Two well-known games in this genre are *Donkey Kong* and the *Super Mario Brothers*.

As noted earlier, some genres are more popular on game consoles, while others are more popular on computers. To further underscore this, figures compiled in 2002 by the ESA show that the three best-selling genres for game consoles were completely different than those for PCs. The favored three genres for game consoles were action (25.1%), sports (19.5%), and racing (16.6%), while for PCs, the top three were strategy (27.4%), children's games, (15.9%) and shooters (11.5%).

THE GROWING CLOUT OF GAMES IN THE ENTERTAINMENT UNIVERSE

Video games have become major players in the overall entertainment landscape, and games and other forms of entertainment are increasingly intersecting with and influencing each other. As we observed in Chapter 2, the sale of games now brings in more money every year than the ticket sales of movies in the United States. And in Chapter 3, we examined the phenomenon of games being adapted into movies, and movies being adapted into games.

Television is also reflecting the pervasiveness of games, with video game-oriented programming beginning to turn up on traditional TV. A large part of this new programming is motivated by business, pure and simple. TV executives are eager to lure gamers to their networks, regarding them as a choice demographic. But the hours they spend watching television has been declining steadily over the years, and broadcasters want them back. If the gamers are drawn to their networks, they reason, the advertisers will follow. The appeal of gamers to advertisers is understandable: They comprise a substantial portion of the population, numbering 145 million people in the United States alone. On average, they are 28 years old, male, and are good spenders, as illustrated by the $11.7 billion they plunked down in 2002 for games and consoles. These gamers are a prime target for purveyors of cars, soft drinks, and other assorted merchandise.

As a result, many TV networks are actively developing video game-oriented programs, or have already added such shows to their schedules. Consider, for example, the UPN animated sitcom, *Game Over*, developed as a 2004 midseason replacement. The series, produced and owned by Carsey-Werner-Mandabach, LLC, centers around a world in which make-believe video game characters are actually "alive," and apart from their day jobs in video games, lead otherwise normal suburban family lives. (See Figure 11.2.) Mom, for example, plays a monster-fighting secret agent in her gaming life, while Dad is a crash-prone race car driver. The supporting cast includes a quirky mélange of characters from the world of video games—everything from the kinds of figures you'd find in combat-style first-person shooters to monsters, zombies, and elves. UPN bills *Game Over* as the first-ever prime time show to be done in CGI (computer-generated imaging).

Game Over seems to be part of a growing trend of adding video games-related shows to the television slate. In the summer of 2003, Spike TV, a male-oriented cable TV division of MTV, had four of them in development. Not to be left in the dust, The Game Show Network announced plans to introduce a two-hour weekly block of programming for gamers in the fall of 2003. But why stop at two hours when you can broadcast video game-oriented shows around the clock? That's the

Figure 11.2 The animated sitcom, *Game Over*, features a family of fictional video game characters, and demonstrates the crossover between games and older forms of entertainment. Image courtesy of Carsey-Werner-Mandabach, LLC.

philosophy of G4, a cable network backed by Comcast. G4, which debuted in the spring of 2002, calls itself "TV for Gamers." It broadcasts seven days a week, 24 hours a day. Fittingly, G4 made its launch by showing the original *Pong*, the historic game that started the whole video game explosion. This same trend is taking place in the UK, too. As we saw in Chapter 3, the BBC has introduced a series called *FightBox*, an innovative on-air game in which human players control virtual fighters in front of a live audience.

GAME DEVELOPERS AND HOLLYWOOD

The interest that traditional Hollywood media has been taking in games is being reciprocated by the game makers themselves. In the 1990s, one heard a great deal of talk about the "marriage of Hollywood and Silicon Valley." However, many of the alliances made back then were as short-lived as the fickle romances of Hollywood stars. In 2003 and 2004, however, several developments indicated that the flirtation between Hollywood and the gaming community was being rekindled, but in a more grounded, realistic way. The first of these developments was the announcement by Electronic Arts, the powerhouse game publisher, that it was moving its headquarters from Silicon Valley down to a new campus in Los Angeles. The facility, dubbed EALA, was located in a beach-adjacent part of town called Playa Vista, and EA planned to hire 300 digital artists, special effects experts, and script writers to work there and to eventually double its staff.

In talking about the move to Los Angeles, EA executives told the *Los Angeles Times* (January 30, 2003) that their goal was to be located in proximity to the Hollywood creative community and to be able to utilize the talent from that community. They made it clear, however, they were not hoping to fuse games

and motion pictures into one single type of entertainment—the illusory Holy Grail of convergence held by many during the frenetic days of the 1990s. Instead, the executives stressed that they understood movies and games were quite different entities, though they felt each could borrow from the other. Speaking of movies, EA vice president Rick Gioloto noted: "They create environments you look at. We create environments you live in." But he indicated the common ground between the two by saying that making games now "requires much deeper storytelling, better character development, more immersive environments."

Another EA vice president, John Batter, explained his view of why the company was drawn to Hollywood. "It always felt to me that this is an area rich in talent," he said. "This is the kind of talent that we'd need more of in the future—writers, animators, actors, lighters. To make the best games, we're going to need the best people. And many of them exist right here." And David E. Davis, another EA executive interviewed for the article, summed it all up by saying that today's games are "less about hard-core software engineering and more about entertainment."

EALA is not the only indication of this renewed Hollywood-gaming community relationship. Top-tier Hollywood screenwriters are now being hired to write games, and several prominent talent agencies have opened new divisions with the stated goal of brokering relationships between the game community and Hollywood. Even major film studios are looking at games with renewed interest. For example, in 2004, Warner Brothers announced plans to open an interactive entertainment division to leverage its brands to make games and other forms of digital entertainment.

TODAY'S GAMES

As the executives of EA indicated, today's games are growing ever more cinematic. They are utilizing high-quality visual effects, sophisticated sound effects, original scores, and more compelling plots. They are also hiring top Hollywood stars to read the voice-over lines of the characters, and the dialogue these actors are reading is becoming more polished and more extensive. For instance, for the *Spider-Man* game, the scriptwriters wrote all the dialogue from scratch, borrowing nothing from the movie, so all the lines would be custom-made for the game. At the same time, Toby McGuire and Willem Dafoe did the voices of the characters they had played in the movie, giving the game an authentic *Spider-Man* feel.

One striking thing about so many of today's games is how much their plots sound like movies—good movies, in fact. For instance, listen to the description Rockstar Games gives on its website for *Max Payne 2: The Fall of Max Payne*, the sequel to its award-winning game, *Max Payne*. It calls the game "a violent, film-noir love story... dark, tragic, and intense... a thrill ride of shocking twists and revelations." From the description alone, one would be hard pressed to recognize this as a game and not a film.

And here is how the Eidos Interactive catalogue describes *The Angel of Darkness*, the most recent (as of this writing) game in the *Tomb Raider* series. "A series of grisly murders brings Lara into conflict with a sinister alchemist from the past, and [with] a secret alliance of powerful individuals shrouded in

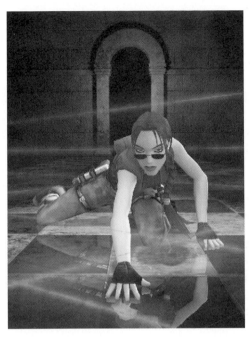

Figure 11.3 Lara Croft becomes enmeshed in a dark, movie-like plot in *Tomb Raider: The Angel of Darkness*. Image courtesy of Eidos Interactive.

mystery. Accused of the murder of her one time mentor, Von Croy, Lara becomes a fugitive on the run. Pursued by the police, she follows the alchemist into a dark world of blood, betrayal and vengeance spanning across hundreds of years. It is up to her to defeat this unholy alliance and stop them from unleashing their incredible powers on the world." (See Figure 11.3)

Even some first-person shooters are getting into the act, adding more interesting characters and, in some cases, a more complex psychological context to their games. For instance, in the ultra-violent first-person shooter *Postal 2*, published by Whiptail Interactive, you can choose whether to play with all-out aggression or in a pacifist mode, either of which will have an impact on the way you experience the life of "the postal dude." A self-described "psychological thriller with a punch line ending," the game includes over 100 NPCs, a wild mix of characters that includes both humans and animals, with policemen, protesters, marching bands, and elephants among them.

When the first-person shooter genre is married to an action game, the story and character possibilities become even greater, as do the gaming possibilities, as illustrated by Ubi Soft's *XIII*. Its main character, known only as XIII, is a secret agent with complete amnesia who must try to uncover a massive political conspiracy while being hunted by the FBI agents who believe he assassinated the president of the United States. To do the voice of XIII, Ubi Soft hired actor David Duchovny, who had starred in the *X-Files* TV series and had also performed in the *X-Files* video game. Speaking to *Business Wire* about the game (July 14, 2003), Duchovny said: "*XIII* isn't like any video game I've ever seen—it plays like a suspenseful movie with a conspiracy-ridden storyline filled with enough twists and turns to keep everyone guessing. Players are in for a lot of surprises with

this game—things are never what they seem, making for good drama and a great game."

A CLOSER LOOK AT *GRAND THEFT AUTO: VICE CITY*

The action game is not only an excellent vehicle for story and character but offers great gaming potential, as well. Rockstar Games hit on all three of these cylinders to produce *Grand Theft Auto: Vice City*, a game of enormous and enduring popularity. This much-maligned game is often held up as a corrupter of the world's youth, accused of glorifying violence and antisocial behavior. Actually, however, it is highly entertaining and clever, and most players regard its violence as tongue in cheek, certainly not as a prescription to go out and commit such acts in real life.

The game's plot takes after many Mafia films, particularly *Goodfellas* and *Scarface*. It's set in the 1980s and abounds with well-observed period details. You play Tommy Vercetti, a tough Mafioso just out of prison. At the start of the game, your godfather sends you off to a Miami-like place called Vice City to make good. But your first attempt to prove yourself, an easy sounding drug deal, goes horribly wrong. You've been set up and the drugs and money are stolen from you. Now you're in big trouble. You have to find out who was behind the set-up and get the goods back. That goal, and your struggle to claw your way to the top of Vice City, are the driving motives of the game.

Enhancing the storyline are well-developed characters, high-quality cut scenes, witty dialogue, and voice-over talent provided by leading actors, including Ray Liotta and Dennis Hopper. The game action is equally impressive. You can steal and operate at least 100 different kinds of vehicles, including cars, motorcycles, ambulances, fire trucks, helicopters, golf carts, and boats. You can also avail yourself of a huge medley of conventional and unconventional weapons. The missions you go on require brains as well as weapons, and you can test out your underworld business smarts by buying nightclubs, laundering money, and dispatching your enemies.

One of the game's most outstanding qualities, and what makes it entirely unlike a film, is the immense freedom you have to move around and do things. You are in no way locked into a linear path. Vice City is a fascinating place to explore, with a rich atmosphere of glamour, corruption, and decadence, and a color palette of 1980s pastels and neon. The game offers you a vast canvas to serve as your playground. You can fly over the sprawling city in a helicopter, which gives you a sense of its vast size, or visit approximately 50 buildings. You can also interact with dozens of characters, a colorful mix of ethnicities, including Cubans, Haitians, South Americans, and Anglos. Meanwhile, night changes into day and day into night, giving a sense of the passage of time. The game also offers some amazing bonus features. For example, when you steal a car, you can flip on the radio and play up to eight hours of music. You can even tune in to different stations, each with their own DJs and musical style. Or, if you prefer, you can listen to talk radio.

Thus, on the one hand, *Grand Theft Auto: Vice City* offers a highly cinematic experience, with a dynamic storyline, interesting characters, first-rate dialogue, and a rich background. But on the other hand, it also functions effectively as a

game, giving you a huge tool set of objects to control, a world you can freely explore, and the opportunity to forge your own destiny.

WHAT MAKES VIDEO GAMES APPEALING?

Now that we've looked at some popular genres and examined a few specific games, let's explore what lessons we can learn from video games that we might be able to port over to other forms of interactive entertainment. First of all, what makes games appealing to those who play them?

Certainly, part of their appeal is the way they take you out of your ordinary life and into a rich fantasy world. You get to play an exciting role and do things you'd never be able to do in reality, and all without any actual risk to yourself. You are given plenty to do in these game worlds and can pretty much decide how you want to interact with it. In other words, you control the shots—often literally. You are in control. As game designer and producer Katie Fisher of Quicksilver Software says: "Games allow the player to make decisions that can make the experience unique and there is always that pause button for potty breaks." As to what keeps people hooked, she believes it is the urge to discover what is just around the corner. She also believes people appreciate the opportunity to set their own terms "...without being forced to play by somebody else's rules."

Another very basic reason people like to play games is that they are fun. They satisfy a desire we all have to play, and that desire doesn't go away even after we've left our childhoods far behind. Games offer us a socially acceptable form of play at any age, and an enjoyable stimulus to the imagination. To maintain the sense of fun, a good game offers just the right amount of challenge—not too little, or it would be boring, and not too much, or it would be discouraging.

These are some of the basic qualities that draw players to games. However, as William Fisher, the founder and president of Quicksilver Software, points out, not everyone plays games for the same reasons. Fisher, a seasoned games professional, who was in the business even before founding his company back in 1984, told me he has observed several kinds of "classic gamer personalities." People may play, he believes, for one of several reasons. It may be because they are:

- Looking to escape;
- Want to blow off steam;
- Enjoy the intellectual challenge; or
- Want to compete with other people.

"What hooks people initially is the visual and conceptual part of the game—what it looks like, and what it's about," he said. "What keeps them [hooked] is the progressive challenge of the game, the gradual increase in difficulty that keeps them scaling the mountain one step at a time." In other words, the challenges continue to escalate, keeping the player alert and involved.

Veteran game producer and designer Darlene Waddington, who worked on the classic game *Dragon's Lair*, described another reason people get hooked on games: the adrenaline rush. She believes the players become caught up in the intense struggle to work out or overcome a challenge, absorbed to the point of tunnel vision, and when they finally do succeed, they are rewarded with a gratifying sense of release.

WHAT GAMES DO WELL

Clearly, games do many things extremely well, but let's take a moment to ponder what distinguishes them from other major forms of entertainment. Pioneering game designer Greg Roach, first introduced in Chapter 4, notes the differences succinctly. "Novels tell; movies show; games do," Roach asserts. In other words, games are all about doing, about action—things that you, the player, do. Games are performance experiences.

Beyond that, games are also extremely good at making things life-like and responsive in ways that are not possible in linear entertainment, where everything is locked into place. With AI, computer-controlled characters can behave much more like real humans, altering their responses and behaviors in accordance with how they are treated. Games are also extremely good with "the physics of objects," as designer Darlene Waddington puts it. In other words, objects seem to have properties like weight and density, and react to natural forces like gravity or heat. Using an apple cart as an example, Waddington noted that if a player bumps into it, the apples will fall off and roll around in a manner that seems extremely natural, each apple behaving in its own unique way. But Waddington also notes a major weakness of many games. "Games are good at how things work," Waddington said, "but they tend to be all about the 'hows' and not about the 'whys.'" Waddington feels, for instance, that games are good at getting the player into a combat situation, but are less good at probing the psychological or human reasons for getting into combat in the first place.

THE LIMITATIONS OF GAMES

Waddington's point about the focus being on action, or how things happen, while giving scant attention to motivation, is a criticism that is often leveled at games. While games are now offering more fully developed characters and storylines, they are still on the shallow side when compared to older forms of entertainment. With few exceptions, they do not look deeply into the human psyche or deal with a full spectrum of emotions. Characters may be fueled by anger, fear, curiosity, vengeance, ambition, or the desire for success, but that is about as far as feelings go. How often do we encounter or play characters who are motivated by love, compassion, rebellion, shame, guilt, grief, or the dozens of other emotions we humans feel? Yet such emotions are the underpinnings of dramas we regularly see in the movies or on TV or the stories we read in novels.

Many game developers will assert that the nature of nonlinearity makes it too difficult to portray complex emotions in games. Yet many professionals in the field who were interviewed for this book believe that the medium itself is not to blame, and that it is indeed possible to build games with deeper psychological shadings. The problem, they assert, is that game publishers and their sales and marketing departments are simply uninterested in exploring new territory, preferring to stick with the tried and true.

Another related tendency of games is to portray fantasy worlds or violent combat situations—Arthurian England, the battlefields of the world wars, or a post-apocalyptic universe, for example. One finds few games set in contemporary times, unless the plot revolves around a deadly conspiracy plot or a psychopath

on the rampage. Again, some in the industry assert that games can indeed be set in today's world, and can depict more realistic scenarios, but blame market-driven forces for standing in the way of the development of such games.

Apart from these criticisms, virtually everyone who works in games would agree that certain things simply don't work in these interactive environments. Certainly, as Katie Fisher says, they are not the place for linear stories. They are also not a viable format for intellectual debates, and it is extremely difficult to imagine a game that is also a musical comedy. One might also argue that games are an unsuitable medium for portraying complex political issues. Yet, even here, it is possible to imagine a game in which opposing characters are fueled by intense and conflicting political agendas. Would it not be possible, for instance, to loosely base a game on the revolutions led by Ho Chi Minh or Pancho Villa? The Villa game, for instance, could include characters representing the clashing ideologies of the privileged hacienda owners and the destitute peasants, as well as action-filled segments when the charismatic Villa leads his troops on dangerous maneuvers. In truth, many of the limitations we place on games may be self-imposed, and it is quite possible we have not yet fully explored what games are capable of.

WHAT CAN WE LEARN FROM GAMES?

Let's review some of the things we've learned from games, both in this chapter and in prior chapters, that can be applied to other forms of storytelling. They include:

- People regard games as play, and expect the experience to be pleasurable.
- Story and game need to be in balance with each other. Although games are becoming more cinematic, with better-developed plots, characters, dialogue, and sound tracks, they falter if they focus on the cinematic elements at the expense of the gaming elements. Short-changing the games' interactivity may well lead to frustrated players.
- Games are most effective when they give participants an opportunity to do things—to actively engage in an experience.
- To keep players involved, games use devices like ticking clocks, a rewards system, an ever-escalating series of challenges, and a build-up of suspense and tension.
- A well-designed interface serves an important role in making for a pleasurable experience. Players do not wish to struggle with an ungainly control system or be baffled by how to navigate through the game. Players appreciate a logical, convenient, well-organized interface.
- Games should be challenging enough to be interesting, but not so difficult that they become frustrating.
- Many players are drawn to games for a variety of reasons, and they cannot all be lumped together. By understanding what attracts your particular audience, you will be better able to design a game that will please them.

These pointers can be applied to virtually any type of interactive story experience just by removing the word "game" and substituting the appropriate interactive medium. Although some interactive entertainments will lean more heavily to the

gaming end of the spectrum and others toward the narrative end, the basic principles will still apply.

CONCLUSION

As our oldest form of interactive entertainment, games have a great deal to teach us. Yet we have to wonder if games are reaching their full potential as an entertainment medium. If they were, would the demographics of the players still be as skewed toward young males as they are? Or is it possible to develop games that would appeal to greater numbers of women, and to the mature segment of our population? What could games be like if market forces and the culture of the game industry did not discourage the development of new genres? While games continue to push the envelope in terms of technological and graphical elements, what might they also do in terms of theme and emotional depth if game developers were rewarded for innovations in these areas?

At the 2003 E3 conference, Douglas Lowenstein, president of the ESA, warned against the dangers of complacency and laziness. Emphasizing the value of innovation, he noted that "games with original content have done the best over the past three decades." He urged the games community to remember that "innovation is the way to push forward progress."

Certainly, games have made a light year's worth of progress since the first games were introduced back in the 1970s. One need only compare *Pong* to *Grand Theft Auto: Vice City* to see how far they have come. What kinds of games might we be playing a few decades from now? And what role will games play in the overall universe of interactive entertainment, and entertainment in general? If only we could consult one of the wizards who populate so many role-playing games and learn the answers to these questions!

ADDITIONAL RESOURCES

To learn more about video games, here are some excellent online resources:

- The video game information site, Gamespot (*www.Gamespot.com*).
- The site for the International Game Developers Association (*www.igda.org*).
- The game information site Gamasutra (*www.gamasutra.com*), which is hosted by the IGDA. Also refer to the bibliography of this book.

IDEA-GENERATING EXERCISES

1. To test your understanding of genre, take a game you are familiar with, name its genre, and then assign it an entirely different genre. What elements would need to be added or changed, and what could remain, to make the game fit the conventions of this new genre?
2. What genre of game do you personally most enjoy, and why? And what genre do you least enjoy, and why?

3. Analyze your own experiences in playing games. What about them makes them appealing to you? What makes you feel involved with a game, and what makes you want to spend time playing it? What emotions do you experience as you play?
4. Consider recent movies or TV shows that you have seen. What kinds of storylines, characters, or themes have they contained that you've never seen included in a game? Do you think it would be possible to include this kind of content in a game? How?
5. What experience from real life have you never seen tackled in a game but believe could be? How do you think this idea could be implemented?
6. What do you believe is the single most important thing games can teach us that can be applied to other forms of interactive entertainment? Why do you think this idea is particularly important?

CHAPTER **12**

Massively Multiplayer Online Games

What is it about Massively Multiplayer Online Games (MMOGs) that makes them such a potent form of entertainment, to the point that some players become addicted to them?

How much story content can such sprawling games support, and what kinds of story elements serve them best?

How important are characters to these kinds of games, and what types of characters generally populate them?

What can be done to attract new kinds of players to this type of game, expanding the market for it beyond the small group of dedicated fans it typically attracts?

THE NEW KID ON THE BLOCK

You're walking down a street lined with drab gray skyscrapers, interspersed here and there with colorful low-rise structures. Robotic looking characters wearing business suits hurry by, fellows with names like Number Cruncher, Flunky, and Head Hunter. You carefully sidestep a guy named Pencil Pusher, who has a pencil point for a head, and then dodge another unfriendly looking gentleman, Micromanager, whom you certainly want to avoid, because he'll tie you up in red tape if you fall into his clutches.

No, these characters are not escapees from a *Dilbert* comic strip. They're actually NPCs in *Toontown Online*, Disney's lighthearted Massively Multiplayer Online Game, or MMOG. With its launch in mid-2003, *Toontown* joined one of the most rapidly growing and financially lucrative forms of interactive entertainment ever to be devised. MMOGs are mere youngsters compared to video games—the first major ones out of the box, *Ultima Online* and *EverQuest*, were not launched until the late 1990s. Yet they've already drawn an intensely dedicated fan base, and their success has not gone unnoticed by Hollywood studios or by publishers of stand-alone games, many of whom are making plans to launch MMOGs of their own in the near future.

THE CHARACTERISTICS OF THE MMOG

Toontown Online was the first MMOG to be made for children and families. With its cartoon sensibility, humor, and lack of violence, it would seem to be a sharp departure from the earlier generation of MMOGs. Up until *Toontown*, MMOGs had a reputation for promoting fierce competitiveness and bloody combat, and they were almost exclusively the domain of young male players. Most MMOGs revolved around so-called "sword and sorcery" medieval fantasies. Still, if you were to strip the flesh away from *Toontown* and examine its bones, you would find that it closely matches a traditional MMOG. Furthermore, *Toontown* falls into one of the MMOG's most popular subcategories, that of a MMORPG, or Massively Multiplayer Online Role-Playing Game.

MMOGs, sometimes also called MMOs or MMPs, have several characteristics that set them apart from other games, even online games. For one thing, they are played simultaneously by tens of thousands of people, and the interactions between the players are a significant part of the experience. They are set in sprawling fictional landscapes that usually include multiple complex worlds, all of which may be populated. These game worlds are also persistent universes, meaning that the stories continue even after a player has logged off, just as in the real world things continue to happen even when we go to sleep. And although they contain a certain amount of story material that has been created by the production team, they also contain stories that the players themselves have initiated. The MMORPG subset of the MMOG observes many of the characteristics of RPGs discussed in Chapter 11 on video games. Players create and control one or more avatars who are defined by a set of attributes, such as species, occupation, and special skill. These player-controlled characters strategize with each other, go on quests, and explore. Players work hard to advance their avatars' powers.

MMOGs have another trait that distinguishes them from other games: the business model that underpins them. These games are supported by subscriptions. To play them, players pay a regular monthly fee, much like a magazine subscription (although in some Asian countries, where MMOGs are typically played in cafes, players may pay by the hour). In addition to the subscription, players usually have to purchase the initial software, often sold on a CD-ROM. Many games also come up with periodic expansion packs, and players are encouraged to buy them so they can have access to new features of the game. The subscriptions produce a steady income stream, and the additional software contributes further to their revenues. A MMOG needs only to attract a few hundred thousand players to generate a considerable income, and over the course of several years, a successful MMOG can take in more money than even a hit video game or movie. It's hardly surprising that so many game publishers and Hollywood studios are considering producing MMOGs of their own.

Yet most are proceeding cautiously, because in order for the market to support a new generation of MMOGs, it will have to attract a wider demographic, expanding beyond the typical fan base of young single males. Because MMOGs demand so much attention from their players, it is generally believed that most people will only subscribe to one at a time. Thus, the key to success for a new crop of MMOGs is to appeal to a new audience. Recent entries into the field, including *Toontown Online*, the *Sims Online*, and *Star Wars Galaxies*, are all being watched with great interest to see if they succeed in doing this.

Launching a new MMOG can be a risky venture. A study by Zona, Inc. and Executive Summary Consulting, *State of MMOGs 2002*, found that MMOGs now cost an estimated $6 to $10 million to develop. They demand a major investment of time as well, taking three to four years to build. They are also costly to maintain, requiring twenty-four-hour customer service, technical upkeep, and a production staff to add new features on a regular basis. Thus, even though the potential profits are alluring, the losses incurred by an unsuccessful game can be enormous.

Yet, despite the specter of losses, two key developments will probably encourage companies to move forward with new projects. First, the growing availability of broadband may well help popularize MMOGs because they are far more enjoyable to play on a high-speed connection than with a dial-up modem. Second, the introduction of online-enabled gaming consoles may spur their popularity because many players prefer playing games on consoles rather than on PCs. Furthermore, MMOGs are growing in popularity throughout the world, meaning that a game has the potential to tap into a vast international audience. In fact, the world's most popular MMOG, *Lineage*, with 4 million subscribers, comes from South Korea. MMOGs are popular all over Asia, as well as North America, Western Europe, and Russia. It should be noted, however, that not all countries like the same types of MMOGs. Though MMORPGs are the dominant genre in North America and Asia, European players prefer strategy games.

THE ORIGINS OF TODAY'S MMOGs

Today's MMOGs can be traced back to the early 1970s, to the original *Dungeons and Dragons*, which first began as a live action role-playing game (LARP). The idea for it was conceived by Gary Gygax and Dave Arneson, who were inspired in part by

a tabletop war simulation game called *Chainmail* and in part by the fantasy world of Tolkein's *Lord of the Rings*. The two also coined the term "role-playing" for the type of game they created. Gygax and Arneson formed a company called Tactical Studies Rules (TSR) to market *Dungeons and Dragons*, which, of course, went on to become a towering success.

The original concept called for the use of miniatures like the war simulation games, but players were soon taking on the parts of individual characters and acting them out directly. The basic necessities for the live-action games were some maps, a multisided die, a manual of rules, and a player who acted as the "Dungeon Master." The Dungeon Master would help shape the action, serve as the game's referee, and manipulate the game's nonplayer characters. Players were given the opportunity to shape their own character, selecting from a menu of races (dwarf, human, halfling, and so on) and class (fighter, thief, cleric, etc.). They would work toward steadily advancing the character's skill set and prowess. This continues to be an important element in today's MMORPGs.

Dungeons and Dragons and the RPGs it has spawned are not only close cousins of war simulation games but also of improvisational theatre. Players are given some broad strokes to work within, but otherwise make up the "story" on the fly, responding to encounters with other players and to events that develop in the game while they attempt to further their fictional goals.

The first RPG for the computer, as we saw in Chapter 2, was the text-based *MUD*, developed at the University of Essex in Great Britain in 1978. As with today's MMOGs, it could support the simultaneous play by a great number of participants. The first widely successful graphic MMOGs, *Ultima Online* and *EverQuest*, bear a close family resemblance to their ancestor, the British *MUD*. However, instead of being entirely text based, players interact in a world of animated graphics, though they still communicate via text dialogue.

THE ADDICTION FACTOR

Much to the fascination of journalists and to the dismay of psychologists, parents, and spouses, MMOGs are such a potent form of entertainment that some players have actually become addicted to them. These games are sometimes referred to as "heroinware" and one of the most popular, *EverQuest*, has been nicknamed "EverCrack." Gamers who cross the line from recreational play to something more serious exhibit all the classic signs of addiction. They use games to escape from everyday pressures and as a relief from stress. They lie about the time they spend playing. They develop problems with work, school, or relationships. Their sleep patterns change. They are unable to stop playing, even when they try, and play to the point of neglecting everything else in their lives. It is a serious enough problem that the Harvard University-affiliated McLean Hospital even has a special unit, the department of Computer Addiction Services, to treat such people and those with related problems.

While few players develop such severe problems, most fans of these games do spend a surprisingly large amount of time on them. For example, *EverQuest* players invest, on average, 20 to 40 hours a week on the game, and the majority play every day. Anyone with a professional interest in this arena has to wonder what it is that makes these games so compelling, and wonder if these factors can

be incorporated into new games—not to make more MMOG junkies, of course, but in order to attract new players to this arena.

Richard Bartle, co-designer of the world's first *MUD*, has some interesting thoughts on the topic. Surprisingly, Bartle does not consider MMOGs to be games at all. In an article written for *Business Week Online* (Dec. 13, 2001), he noted that MMOGs, unlike games, were unpredictable and offered a sense of community, which he believes makes them more like real life. This, he feels, is an important part of their appeal. He said he regards MMOGs as "places" rather than games, noting: "When you visit those places, you can play, sure but you [also] can talk, you can explore, you can boss people around. They are environments, and they have real people in them." Many experts in the field agree with Bartle that the social aspect of MMOGs, and the friendships formed while playing, are a major reason why people are drawn to them. Furthermore, the games are heavily goal oriented, and each time a goal is reached, and a new one enticingly looms ahead, motivating the player to keep on playing. We'll be exploring additional reasons for the MMOGs' strong appeal throughout this chapter.

A PLAYER'S POINT OF VIEW

But it is one thing to discuss MMOGs in a theoretical way; it is another to observe an actual user playing one. In order to gain a better understanding of how a fan experiences one of these games, and what in particular appeals to them, I spent an afternoon with 15-year-old Michael Loeser as he played the *Dark Age of Camelot*, an extremely popular medieval fantasy game developed by Mythic Entertainment. Loeser, who had been playing the game for a month or so, said he liked it because it had good character control, was easy to use, and he could make his character look really cool. He also thought it was fun playing with other people. "I don't like games that are too difficult," he told me. "They are more annoying than fun." For him, he said, most of the satisfaction of this kind of game comes from "working up levels and getting cooler stuff and going into battle."

The Camelot world is spread out over three realms, each an island and each informed by its own mythology and legends. Albion is British, homeland of the late King Arthur; Hibernia is Celtic; and Midgard is populated by the Norse. Loeser's favorite realm is Albion, with its references to Arthurian legend. He said he particularly likes medieval games because of their magic and swordplay, and also because he thought it was an interesting time frame. He took me on a tour of the realm, via his avatar, a poor but strapping warrior. I was struck by the lush exterior environments and the beautifully detailed interiors of the taverns and shops we visited. (See Figure 12.1.) The landscape was vast. Loeser said it could take hours to cross the island on foot, though if you were in a hurry and had money, you could buy a ticket to ride a horse. Day also changes to night in this game, and Loeser told me weather could also be a factor in the game play. Just as in England, it can be foggy and rainy here, making it difficult to spot your quarry.

Loeser enjoys playing in character, and demonstrated how he does this, begging a passerby, a wealthy looking nobleman, for some coins by way of a courtly typed message sprinkled with *thees* and *thous*. To my surprise, the passerby generously complied. And what would Loeser do with his newfound bounty? "If ou have money, you may as well make your character look good," he told me.

Figure 12.1 A misty landscape in Albion, one of the three realms of the *Dark Age of Camelot*. Image courtesy of Mythic Entertainment.

"But I only buy things that are useful." With that, he promptly spent a significant sum of money to have all his clothes dyed red, plus as much of his equipment as he could afford. Clearly, this game was some kind of medieval fashion show. But Loeser justified the expense by explaining "people are more eager to put you in their group if you look cool."

Joining a group is a major lead-up to action in *Camelot*. Players hook up with others within a realm to go on monster hunts. But if they want to fight other players, they must travel outside their island for realm versus realm (RvR) combat; it is not possible for players to battle others within the realms. This is a protection, in part, for new players, who in many games are picked off by so-called *griefers*. Griefers are players who enjoy killing off new players and otherwise making life miserable for them. They are the bane of many a MMOG and the reason many newbies stop playing. Most new games build in some kind of mechanism to shield players from griefers.

To show me how one goes about joining a group, Loeser activated a function that signaled he was looking for company, and in short order we hooked up with about a dozen other players and were off on a monster hunt. The fog was rolling in and dusk was falling, reducing visibility, but just enough light was left for the group to track a lumbering, furry looking creature, to surround it, and to do it in—the conclusion of a good day's work in Albion.

LOOKING UNDER THE HOOD

A player's point of view can be extremely illuminating, certainly in terms of what is perceived as fun—it would never have occurred to me, for example, that having

Figure 12.2 *EverQuest*, the most popular MMOG in the western hemisphere, covers a vast fantasy landscape. Image courtesy of Sony Online Entertainment.

all one's clothes dyed red would be the first thing a player might want to do with his money. But in order to more fully understand what makes these games tick and how they are put together, I turned to three expert sources: the duo that heads up production for the classic version of *EverQuest*; the producer of the console version of *EverQuest*, designed for the PlayStation 2; and the creator of Disney's *Toontown Online*.

 EverQuest, developed and published by Sony Online Entertainment, is a medieval fantasy game. (See Figure 12.2.) With a subscriber base of about a half a million people, it is the most popular MMOG in the western hemisphere, second only in the world to Korea's *Lineage*. At *EverQuest*, the two people who head up the day-to-day production work are Rich Waters, Design Director, and Robert Pfister, Senior Producer. If anyone would know what designing and producing such a massive game is like, it's these two.

 Waters and Pfister told me (answering my questions jointly) that one of the greatest challenges of producing *EverQuest* is its vast scope. They compared what they did to running a small city, requiring the juggling of multiple and highly demanding responsibilities. About 100,000 players are online every night, logging in from all over the world, including China, Japan, and South Korea. The game has 220 adventure zones, 16 city zones, some 65,000 objects, and some 40,000 NPCs. "That's a lot to look after, each day, every day," they pointed out, an under-statement if ever there was one. And, on top of that, they are continually writing new stories and developing new features.

ESSENTIAL QUESTIONS

Designing a new MMOG, they told me, is a multiyear project requiring a staff of 20 to 70 people. The first questions you must answer are the game's genre (role-playing? action? strategy?) and the setting (medieval times? space?

post-apocalyptic?). Then you must determine the basis of the game's conflict, which might be player versus player, group versus group, player versus computer, or a combination of all of these. Another key question, they said, is how players will be rewarded for the risks they take.

The two elements that demand special attention, they said, were story and character. "Story is very important to a game," they asserted. They emphasized that the storyline should be clear. "If you're creating a world in which to play, that world has a history.... Depending upon the depth of your world, it can be introduced in a two-minute cut scene at the beginning of the game, or can be spread across the world in books, tales told, and in quest backgrounds.... The richer you make your world, the more likely people are to come to visit and stay." To emphasize the point, they noted that people travel to Europe and Asia to absorb the thousands of years of history associated with those places while, conversely, they quipped, "no one goes to Buffalo... except, maybe for the wings."

The characters in MMOGs, as with video games, fall into two broad categories: the NPCs and the PCs (avatars). In *EverQuest*, the NPCs may be monsters you fight or human characters like shopkeepers or guild masters. The monsters fall into a category called a *MOB*, short for *Mobile Object*, which is an object in the game that moves, as opposed to an inanimate object like a door or chest that you must "attack" in order to open. In developing an NPC that will have a role in a new quest, the design team works out what its function will be in the overall quest, what its backstory is, how players will interact with it, and what lines of dialogue it will speak. The artists will then do concept drawings of the new NPC, working with the designers to refine the look, and then add clothing and "attachments"— things like shields and hats. The final step is to animate the character, giving it actions like running, swimming, fighting, casting spells, or dying. That done, the character is imported into the game.

The design process for the avatars is somewhat different, particularly because the players themselves are given the opportunity to choose and shape them. In *EverQuest*, the basic character types are either drawn from standard mythology (archetypes like ogres, trolls, elves, and gnomes) or else from *EverQuest's* own mythology. Waters and Pfister said that the critical thing, when designing a new class or race, is to take care that it does not create an overwhelming advantage to one particular group of characters. They consider how the character will work on its own, how it will play in a group, how it will play in a large raid, and what effect it will have on all the different types of NPCs.

THE STRUCTURE

In terms of structure, Waters and Pfister said, *EverQuest* falls into the category of a "class based game." In other words, the basis of play is the interaction of a number of different classes, such as warriors, magicians, necromancers, paladins, and clerics, who come together and use their special skills to achieve a goal, such as defeating an NPC. New players start out at level one. They are "born" in a city, meet their guild master, receive their first set of instructions, and gradually make their way in the world. In the beginning, they have limited powers, and start out fighting very small monsters. This raises their skills and abilities, and meanwhile they are becoming acclimated to the game, meeting other players, joining guilds, and becoming part of the community.

PRIMARY CONSIDERATIONS

Because a MMOG like *EverQuest* has to accommodate hundreds of thousands of players, many things must be considered before any new features are added, imagining all the different ways it might be used and how its presence might impact the game. For example, Waters and Pfister told me they recently added horses to the game. In doing so, they had to address such questions as: Can people steal horses? Can horses be killed? What role will horses play with the most competitive players? With more casual ones?

They also cautioned against making a game too technically demanding, noting that many people did not own the latest computer equipment or have the patience to install a dozen CD-ROMs. Instead, they stressed, you have to be sure that "all the elements of your game add up to a fun and enjoyable experience for the player.... You can have the most detailed online world imaginable down to the cracks in the sidewalk... but if it isn't fun, no one will play."

This brings us back to our original question: What makes a MMOG fun? They pointed to a few specifics: the excitement of the "day-to-day work of adventuring;" the online friendships; the pleasure of being something you can't be in your personal life—a hero or a figure of awe. But rather than "fun" being just one thing, they indicated, it's the entire experience. They said it's a little like going on a vacation, but without having to leave home. "Wherever you go, there is always something exciting to see and do. Players can, and do, spend years exploring *EverQuest* and find that every inch is covered with lore and story.... By the same token, we put in very specific adventures for people to complete—fight this dragon, defeat this god, rescue that person—which gives you a completely immersive experience in which to play. That, coupled with the vast community—friends from all over the world and all different walks of life—coming together to play each day means you're never at a loss for things to do or people to do it with."

DESIGNING A MMOG FOR A GAME CONSOLE

Until quite recently, MMOGs could only be played on computers with Internet connections, but they are now beginning to be developed for a new platform, the online-enabled game console. The first one to be made for this new arena is Sony's *EverQuest Online Adventures*, made for the PlayStation 2 and released in February 2003. As the name suggests, it's an adaptation of the classic *EverQuest* game. Like the original game, it covers a vast geographic space, a landscape of 323 square miles.

Ben Bell, the producer of the twenty-seven-member development team for *EverQuest Online Adventures*, believes game consoles can play an important part in popularizing MMOGs and attracting novice players to them. However, to move beyond the hard-core MMOG enthusiasts and to attract new people, adjustments need to be made, and the beginning player must be considered in every feature that is designed. Referring to the older generation of MMOGs, Bell said: "These games can be immensely complicated. Presentation will be critical if the audience is to be widened."

As he and others at Sony Online have pointed out, significant differences exist between the way people play games on consoles and the way MMOGs have typically been played. While veteran MMOG enthusiasts may be happy to invest

many hours a day in these games, Bell said console users are more typically looking to play in short stretches—maybe 15 minutes or half an hour. They want the experience to be action oriented, with quick rewards and advancement. Furthermore, since game consoles are generally used in a living room setting, the imagery used needs to be appropriate for a far broader demographic than is usual for a MMOG. The gory violence and rough language of the old-line MMOGs are not going to be welcome in this environment.

Nevertheless, Bell feels that console players will be attracted to many of the same elements of MMOGs that attract the hard-core enthusiasts, and they have built these elements into the console version of the *EverQuest*. One of these attractions, he says, is the friendships the players form online. *EverQuest Online Adventures* eases new players into the experience of playing with others. "We try to encourage players to group by creating challenges that can only be overcome by groups of players," Bell explained. "We introduce grouping slowly, first by suggesting it through quests in the game and later by asking the player to travel to dangerous places. We do this because we feel that the social component of MMOGs is what players enjoy the most." Another thing that he believes is a "huge factor" in attracting players to MMOGs is flexibility in character creation—the ability to customize avatars and make each character distinctive. Thus, the designers of *EverQuest Online Adventures* are offering ample opportunities for customization, giving players a choice of nine different races and fourteen different character types.

Players also greatly relish achieving goals that give them a sense of mastery, Bell feels; they enjoy overcoming challenges and working their way up through escalating levels of complexity. However, he noted that it is important to ramp up the challenges slowly, "so that users can learn the game without being frustrated by challenges." Finally, to keep the players involved over a long time frame, *EverQuest Online Adventures* will continue to add new characters and features, just as its older brother, the classic *EverQuest*, does.

BREAKING FRESH GROUND

The challenges of adapting *EverQuest* to a new platform and introducing it to a broader audience were substantial, requiring a careful consideration of many factors, as we have seen. But imagine what it would be like to start with a blank sheet of paper and come up with an entirely new sort of MMOG—one that was a steep departure from the familiar "swords and sorcery" motif. And further imagine the challenge of trying to make this new kind of MMOG attractive to both young kids and mature adults, an audience that has not previously been reached by MMOGs. This was the daunting task faced by the creators of Disney's *Toontown Online*, the game portrayed at the beginning of this chapter.

Toontown Online is a colorful world inhabited by Toons, or cartoon characters, many of which are avatars controlled by the players. (See Figure 12.3.) All is not well in Toontown, however. This cheerful place is being threatened by business-minded robotic creatures called Cogs with a single-minded agenda: to take over the Toons' buildings and convert them into drab office structures. As a player, your mission is to protect Toontown from the Cogs. To battle these robots, you launch "gags" at them—the Toontown version of ammunition. For example, you can pelt them with cream pies or drench them with your personal rain cloud.

Figure 12.3 *Toontown Online* is a cheerful place full of friendly Toons, but the Cogs threaten to make unwelcome changes. This is the playground in Toontown Central, one of the six Toontown neighborhoods. Image courtesy of © Disney Enterprises, Inc.

This innovative, humorous approach to the MMOG was dreamed up by Mike Goslin, Vice President of Disney's Virtual Reality Studio. The idea came to him late one night in 1999, as he was working on an attraction for DisneyQuest, an urban-style indoor theme park in Orlando. It was born out of a "what if" question: What if you took the skills and experience acquired from designing theme parks and applied them to a MMOG? He told me it was like a light going on overhead, especially as he realized that a MMOG was really "a place more than a game, and we know how to build places." Strikingly, though he was coming at it from a totally different set of experiences, Goslin's vision of the MMOG as a "place" closely echoed that of Richard Bartle, discussed earlier.

Goslin felt this was the kind of opportunity Walt Disney himself would have recognized. After all, he had seen developments in transportation as opportunities to expand the Disney universe. He realized that newly constructed highways and the family automobile would make it possible for families to visit Disneyland Park, and later, that jets would make it possible for them to come to Florida, to visit Walt Disney World Resort. Now, thanks to the Internet, families would be able to enjoy a cyber version of a theme park.

EARLY DEVELOPMENT WORK

Once the project received the green light from Disney higher-ups, including Ken Goldstein, Executive VP and Managing Director of Disney Online, it took the creative team approximately three and a half years to develop. The early part of

the work focused on the software and technical tools. Since no off-the-shelf products were available, they had to make their own proprietary software, though in some cases they were able to modify programs used in theme park attractions. They knew from the start that though their core audience would be 7- to 9-year-olds, they wanted to attract the entire family. They felt confident their theme park background would be useful here, since the parks are also designed for family entertainment. They also realized that since they were using a subscription model, they would need to build something that would keep people involved for a number of months, not just a week or so. Another early decision was to include minigames in the MMOG, something else they understood well from their theme park work.

The idea of the MMOG being set in Toontown did not come into sharp focus right at the beginning, Goslin said, but once that concept was nailed down, things started to fall into place. One important point was the nature of the core conflict in this world—the Toons versus the Cogs. Another was the geography of Toontown. It would consist of six neighborhoods, each with a distinctive flavor and set of characters. For example, Donald's Dock would have a nautical theme and seafaring characters, while Minnie's Melody Land would have a musical theme, with something of a surreal, abstract look. Each neighborhood would have its own central playground, where Toons could go to relax and rejuvenate after encounters with Cogs—they would be Cog-free zones. From there they could take trolleys to the various minigames. These games were not only fun, but an important factor in their Toontown "lives," because by playing them, they could earn valuable jelly beans—the equivalent to money in Toontown—to purchase the commodities they would need to participate in this universe (see Figure 12.4).

THE CHARACTERS

Just as with MMOGs for adults, *Toontown Online* would be populated both by NPCs and PCs. The NPCs would fall into two basic categories: Cogs and other Toons.

Figure 12.4 The cannon game is one of the many minigames which Toons play in order to earn valuable jelly beans. Image courtesy of © Disney Enterprises, Inc.

The creative team came up with 32 different types of Cogs, all based on the theme of big business. Four different variables would determine each Cog's persona: its name, physical appearance, dialogue, and mode of attack. For example, a Cog named Cold Caller would have a block of ice for a head, and his mode of attack might be to throw a telephone; when encountered in the street, he might say something like "Sorry to interrupt your dinner." The game would replenish any defeated Cogs; there would be no end to them.

The other group of NPCs, the Toons who were controlled by the computer and not by players, would mostly be shopkeepers, and about 800 of them would be dispersed around Toontown. Like Cogs, their names would reflect something about them. These Toons would be on hand to interact with player-controlled Toons and to give them tasks to do. Along with these working Toons were also some "star" Toons of the Disney universe, familiar characters like Mickey, Minnie, and Pluto. They would circulate through Toontown, and thrill players when they appeared.

Players would get to design their own avatars, molding them from a million possible combinations. (See Figure 12.5.) They could choose from six possible species—dog, cat, mouse, horse, rabbit, or duck—and pick different body types, color combinations, and clothing styles. They would then get to name their Toon. During the game, they would be viewing their Toon from a third-person point of view, which Goslin termed "the wing man view." It would be as if the camera were tethered right behind the Toon.

Toons would have plenty to keep them busy. They could play minigames, shop for gags, socialize with other Toons, and run errands for Toon merchants

Figure 12.5 Screen capture showing the "Choose Your Clothes" activity of Toontown's "Create Your Toon" feature. Players of *Toontown Online* get to design and dress their own Toon, and with a million possible combinations, it is unlikely that any two Toons will look the same. Image courtesy of © Disney Enterprises, Inc.

to earn extra jellybeans. Also, since each Toon received a house when first joining the game, they could decorate their abodes and embellish them with all manner of purchased furnishings. But their chief occupation would be fighting the loathsome Cogs.

REACHING A BROAD DEMOGRAPHIC

One of the most important tasks during preproduction was to take every possible step they could to ensure the game would appeal to the broad demographic they were hoping to attract. Thus, they did not merely rely on their theme park background, but also read social science research; studied Jean Piaget (for more on Piaget, see Chapter 9); did focus group testing; consulted with experts in children's content; and used play testers. And well in advance of the official launch, they put the game up on the Internet for free to see how it worked and to see what kind of feedback they would get.

During development, they considered each demographic group they wanted to attract and built in elements that would appeal to each. For adults, for example, the primary attraction would be the game's sophisticated workplace humor and wordplay, such as the puns in the Toontown shop signs. Working in things for boys was not difficult, Goslin said, because, based on the history of how boys have responded to prior games, "we know what they like." But shaping the content to appeal to girls was harder, he noted, because "no one's done it before." The team felt girls would respond well to the emphasis on cooperative play and to the social aspects of the game, and would enjoy being able to customize the avatars. They also considered the tastes of girls in the visual design, with Toontown's bright colors and rounded shapes.

Furthermore, to make *Toontown* a good experience for newbie players, they made it easy to get started, but to keep the players hooked, they made it difficult to master. They also made sure the technical entry bar was low enough for the average family. Thus, players would not need broadband to play. For those with narrowband, a CD-ROM was available that would speed up installation.

The design team also took steps to ensure that the game would not be plagued with griefers who could make life miserable for other players. One way they handled this was by preventing unrestricted chat, short-circuiting the ability of ill-mannered players to verbally harass others. To enable players to communicate with each other, they set up a "speed chat" system, with a selection of words and phrases the players could choose from. The chat system had a well-organized menu and was smart enough to recognize where players were in the game, offering appropriate choices for various situations. With this system, the worst thing one player could say to another was "You stink!"—hardly harsh by aggressive MMOG standards. By restricting chat this way, the game also protected young users against predators and the invasion of privacy, an important consideration for families. The downside, of course, was that it would somewhat limit the social aspects of the game. However, with parental approval and a special code, kids could enjoy free chat privileges with people they knew from outside the game.

To further ensure a positive experience, the game encouraged good behavior by rewarding cooperation and team play. It offered no incentive to compete, and no opportunities for player versus player battles. It thus circumvented the bloody player attacks prevalent in most MMOGs. Even the battles between the

Figure 12.6 Screen capture of a battle scene: the Toons (on the left) versus the Cogs (on the right). In *Toontown Online*, the Toons use gags, not swords or guns, to fight their enemies, the Cogs. Image courtesy of © Disney Enterprises, Inc.

players and the Cogs were non-gory affairs, emphasizing strategy and humor rather than physical force. (See Figure 12.6.) Not only would the Toons use gags for ammunition, but the Cogs would retaliate in kind. For example, they might spray a Toon with ink from a fountain pen, or fling half-Windsor neckties. Defeat in battle did not mean "death" for a Toon as it would in adult MMOGs. Instead, the Toons' vital "laff points" would be reduced and they would become sad, but by returning to a playground, their laff points could be built up again.

THE ROLE OF THE TREADMILL

One feature that can be found in classic MMORPGs like *Ultima Online* and *EverQuest* is a device called a treadmill, and this device was built into *Toontown* as well. A treadmill is an internal structural system that keeps the player hooked, cycling repeatedly through the same types of beats in order to advance in the game.

In an old-line MMOG, the treadmill might require players to kill monsters to earn money to buy swords to kill more monsters. But in *Toontown Online*, the treadmill works like this: Toons play minigames to earn jelly beans; Toons use the jelly beans to buy gags; Toons use the gags to fight the Cogs, at which point their inventory of gags is depleted; then, once again, the Toons must play minigames to earn jelly beans. Players cannot advance in the game without using the gags, and the gags get better—more effective and more fun—as players work their way up. For instance, one line of progression begins with throwing cupcakes, advances to slices of pie, and then to entire wedding cakes.

Goslin noted that the treadmill is one of the most powerful motivators of a MMORPG, and the best treadmills are integrated into the game in a natural way,

as part of the overall game world. But treadmills are not the only inducements to keep players involved. Goslin feels players also keep playing because of the personal investments they've made in the game. Among these investments, he says, are the amount of time they've spent developing and playing their characters, the relationships they've formed with other players, and the effort they've made in decorating their houses. Overall, he said, "it's a big investment in time and emotions." But the development team isn't taking any of this for granted. In order to continue to keep players involved and prevent them from losing interest, they will add significant new content about every three months.

STORY AND STRUCTURE

One of the toughest challenges Goslin found in developing *Toontown* was dealing with the story. In a shared world like a MMOG, he said, "It is a unique challenge to do storytelling... you stretch the limits of storytelling in this kind of thing." As he pointed out, in a traditional story, you have one story structure featuring one hero and one major encounter. But in a MMOG, each player is the hero of his or her own experience of the game. Furthermore, you need a reusable climax, something that can be played through by each person. This precludes having a fixed ending. And finally, you don't want the game to come to a conclusive and final end, because this would undercut its subscription basis.

Goslin sees stories in MMOGs as operating on three levels—high, medium, and low. The high-level story, he feels, gives players a context and meaning to the overall state of affairs that they find in this world and for the core conflicts that exist there. In *Toontown*, this would be the backstory of who the Cogs are and how they became unleashed on the Toons. The medium-level story, he feels, is a template everyone can share, perhaps a quest experience. For instance, *Toontown* has recently added a new neighborhood with its own built-in story. Here, persevering players can make some interesting discoveries and can take on a multistep challenge. Goslin sees medium-level stories as being a little like the season finale of a TV show, tying up some loose ends and shedding some new light on the high level story. The low-level story, he suggests, is about the individual player's role in the story, that player's personal narrative within the game.

Even in the freewheeling story environment of a MMOG, Goslin believes the three-act structure still comes into play. However, he notes each player experiences his own path through the three acts; they are not simultaneous for the entire group of players. In *Toontown*, Act One would be the player's introduction to the world of the Toons. It would include the tutorial and the process of learning to get around in this world, lasting up to the first conflict. In Act Two, the player would experience the treadmill events and learn to advance in the game. And in Act Three, the player would engage in a major battle with the Cogs... an event that would give this player great prestige.

HOW *TOONTOWN* HAS BEEN RECEIVED BY THE PLAYERS

Toontown Online launched in June 2003, and although the numbers of subscribers were not available as of this writing, Disney surveys indicate that the thorough

planning and testing have paid off. For example, the young players are split evenly between boys and girls, which, Goslin noted, "is pretty amazing for a MMOG." They've also been surprised to find how many adults in households without any children have become dedicated fans. A core group of particularly enthusiastic players devotes hours a day to the game, not just the 10 or 15 minutes the developers anticipated would be the average length of play. The fans of *Toontown*, they are finding, fall into two major categories: those who are highly achievement oriented, and those who are more interested in the social aspects of the game. However, Goslin said, players migrate between these categories; the dividing line between them is permeable rather than fixed.

THE FUTURE OF MMOGs

Goslin believes that the potential audience for MMOGs is still largely untapped, and a number of genres have yet to be explored. Among them are horror stories and sports-based games. But he advises anyone venturing into this arena to be careful of making assumptions about the game's potential players. "If you think you know how they will use it, you will probably miss something," he asserts. He recommends thoroughly testing every aspect of the game before releasing it, and thinks the testing process should continue for weeks, even months. He also believes this is not an area for the timid, though it requires discipline, and "keeping your eye on the ball." It also requires passion. "It's not a mistake to aim high," he asserts. "If you aren't aiming high, you can't hit high."

CONCLUSION

Now that we've studied several MMOGs, looking at them both from the point of view of the player and from the developer, we can begin to see what kinds of things are most apt to appeal to a broad range of new players, as opposed to the relatively small niche of hard-core MMOG enthusiasts. And by looking at these games from the reverse angle, we can see what kinds of things are most likely to disenchant newcomers to this arena. We've seen that most new or casual players don't like MMOGs that:

- Are difficult to learn or play;
- Make them vulnerable to attack by griefers;
- Demand an enormous investment of time;
- Are technically demanding;
- Are too violent and combat oriented; and
- Are set in an environment that does not interest them.

On the positive side of the ledger, people enjoy playing MMOGs that:

- Give them an easy-to-understand way to start playing and gradually introduce them to more challenging tasks;
- Are free of technical glitches;
- Offer them a variety of places to explore and things to do;
- Encourage socializing and making connections with other players;

- Offer opportunities to customize their avatars and their residences;
- Allow them to be the hero of their own story;
- Give them the opportunity to master new challenges and advance in power;
- Give them the sense they can discover something new around every corner; and
- Stay fresh and interesting by having new content added on a regular basis.

Both the positives and the negatives can serve as guidelines for those who wish to bring MMOGs to new groups of players. In addition, it is prudent to keep a few other factors in mind. For one thing, MMOGs take a number of years and many millions of dollars to develop. Well in advance of releasing a new MMOG, it is invaluable to test it out on the target audience, to ensure it is a game that players will be willing to commit to over a period of many months, both financially and in terms of their time. And finally, remember that once a MMOG is launched, it will still require heavy-duty, full-time maintenance. Clearly, the process of developing a MMOG is not suited to those with short attention spans or shallow pockets. But in addition, MMOGs present daunting creative challenges. Their vast scale, coupled with the fact that they must be able to support tens of thousands of simultaneous players, has substantial impact on story, structure, and character development. These games require that their creators be able to let go of familiar narrative techniques and regard storytelling in a bold new light.

IDEA-GENERATING EXERCISES

1. Analyze a MMOG that you are familiar with, noting the kinds of worlds it contains and the kinds of characters that populate it (NPCs as well as player-controlled characters). What is its core premise? What is its treadmill? What about this game do you think makes it attractive to players? If you have not personally played a MMOG, track down someone who is a regular player of such games and ask for a personalized tour of one. Then analyze the game with these same questions in mind.
2. Sketch out a premise for a MMOG. What world or worlds would it be set in? What would the fundamental goal of the players be? What would be the central conflict?
3. What about this idea might make it inviting to the people who do not ordinarily play MMOGs? Can you think of ways to make it broaden its appeal?
4. Can you construct a treadmill for this game? What would its basic beats be?
5. Sketch out some ideas about the characters in the game. What kinds of avatars could the players build? What character categories would they be able to choose from? What kinds of NPCs would inhabit the game? How would they look and how would they behave? Which group of them, if any, might pose a threat to the player-controlled characters?

The Internet

What are the unique characteristics of the Internet, and how can you make the most of them when creating entertainment content for this medium?

In terms of story-based entertainment on the Internet, what do users find particularly attractive and what kinds of things risk being kisses of death?

What are some effective techniques that can be used on the Internet to combine entertainment with other objectives, such as teaching, promoting, or informing?

A PREMATURE FUNERAL

If the Internet were a human being instead of a communications medium, it would probably be undergoing psychiatric treatment by now, suffering from an identity crisis of massive proportions.

Beginning life in obscurity, and with an entirely different name—ARPANET—it was first brought into the world in the late 1960s to assist the military during the Cold War, as we saw in Chapter 2. But in a little over two decades, it underwent a name change and morphed into the more populist communications tool known as the Internet. Developments like the World Wide Web and graphical browsers caused Internet traffic to surge. Suddenly this somewhat plebian transmitter of information, now known as the Web, was being touted as the most wondrous new medium to come along since the printing press. Its promoters made extraordinary claims for it: Not only would it revolutionize the merchandizing of products and the dissemination of information, but it would also turn the world into a global village and bring about world peace. Mixed into these proclamations was the heady assertion that the Internet would become a world-class medium for entertainment. Scores of websites were launched with this dream in mind; this was the dot com boom time. But in a few short years, just after the new millennium arrived, it became evident that these websites were not generating the anticipated profits. The plug was pulled on many a site and we were suddenly looking at the dot com bust.

Though the Internet was obviously still up and running, many were led to believe that its early promise of becoming a vibrant medium of entertainment was dead. But was this really true, or was this just the other side of the hype coin—promoted unrealistically on the one hand, and torn down just as unrealistically on the other? The disparaging talk about the Internet that came on the heels of the dot com bust brings to mind the scene from *Tom Sawyer*, when Tom, generally believed to be dead, sneaks into his own funeral, alive and well. Clearly, the Internet is still with us, too. But what is its true state as an entertainment medium? What might the psychiatrist say about this to help his identity-challenged patient regain a sense of reality?

THE INTERNET AS AN ENTERTAINMENT MEDIUM

Like most psychiatrists, this fictitious doctor might have the patient recall its early years in the hopes of gaining some insight into its present state of being. In this case, such an investigation would reveal that right from the start, the Internet demonstrated its potential as an entertainment medium. After all, as we saw in Chapter 2, people were playing the first *MUD* as far back as the 1970s. The *MUD* was the precursor of the MMOG, a form of entertainment unique to the Internet and one of its unqualified success stories, from both a creative and a commercial point of view, as we saw in the last chapter.

True, not every genre presented on the Internet has been as successful. Many developers placed their hopes on a form called the *webisodic*, a story-based serial told in short installments using stills, text, animation, or video. The first such webisodic, *The Spot*, debuted in 1995 and was an enormous hit at the time.

Many other sites were built around the webisodic model and launched in later years. Most faded away with the dot com bust, though a few remain and are doing well. Among them is Urban Entertainment (*www.urbanentertainment.com*), one of the few sites that managed to fulfill another early promise of the Internet: to produce so-called "backdoor pilots." The idea was that the Web would serve as a launch pad for properties that would then be snatched up by more traditional mainstream media like the movies or TV. Though this did happen with Urban Entertainment's webisodic, *Undercover Brother*, which was made into a feature film, the Internet's promise as a nursery for mainstream media has largely gone unfulfilled.

However, entertainment has been used with great success on the Web in some other ways. For example, it has been creatively blended with promotional objectives to bring attention to products, organizations, and Hollywood properties, as we will see later in this chapter. We will also see many inventive ways entertainment is being combined with educational and informational content. In addition, in Chapter 15, we will explore the role the Web has been playing in an area with extremely imaginative and story-rich projects, cross-media productions, where a property simultaneously "lives" across several different media. In yet another use of the Internet as an entertainment vehicle, the next chapter will show how websites are being synchronized with TV programs to produce a form of interactive TV.

Looking toward the future, we can anticipate that entertainment on the Internet will quite likely be spurred by the growing numbers of households with broadband connectivity. We will almost certainly be seeing an increase in Internet content that is best enjoyed with high-speed access, particularly programming that includes video. To some extent, the promise of broadband has already encouraged the development of an updated form of the webisodic, where the story is largely carried by video. One such series, *SoLA*, is featured on the Warner Brothers site (*www.warnerbros.com*). It's a fourteen-part drama about eight friends in Los Angeles. Another, Sony's *Rachel's Room*, is described later in this chapter.

All in all, a probing of the Internet's "psyche," including its past performance and present state, will reveal a balanced pattern of ups and downs—a disappointment here, a surprising success there. As this chapter will illustrate, it is by no means delusional to regard the Internet as a sound vehicle of entertainment, an assertion that can be verified by a session of web surfing on any given day.

THE QUEST FOR "STICKINESS"

The Internet has many attributes which, when taken individually, may mirror other media, but when bundled together, make it a unique venue for obtaining information and for enjoying entertainment. When a website contains a great many of these attributes, it is also likely to possess a quality known as *stickiness*. Though stickiness is unwelcome when it comes to door handles or upholstery, it is an extremely desirable attribute for a website. It connotes the ability to draw people to the site and entice them to linger for long periods of time. If you want to create an entertainment site that is sticky, and hence appealing to users, you will want to include as many of these attributes as you can, providing, of course,

that they make sense in terms of your overall objective. Users are attracted to the Internet because it offers them experiences that are:

- COMMUNITY BUILDING. One of the most unique aspects of the Web is that it allows individuals to communicate with each other and share their thoughts, concerns, and opinions. When they visit a website, particularly one that focuses on a topic they especially care about, they look for community-fostering options like message boards and chat features.
- MEDIA RICH. The Internet supports a full array of media, including text, still images, audio, animation, and video. Although users with dial-up modems may find it slow going to download video, a steadily growing number of users are connected to broadband, and they are able to enjoy media-rich content.
- PERSONAL. The Web allows users to express themselves, to develop relationships with each other, to be creative, and to customize content in various ways. It is far more of a subjective experience than a linear experience such as watching television.
- DYNAMIC. Well-maintained websites are refreshed on a regular basis, and users look forward to seeing new features on sites that they visit frequently. The adding of fresh content gives the website a vibrant, responsive quality. Websites that are not updated begin to seem stagnant and "canned," as if they had just been stuck up on the Internet and then abandoned.
- PARTICIPATORY. Users want to interact with content; they look for ways of becoming involved with it. Participation in story-based entertainment on the Web can take many forms. It can mean chatting with a fictional character; suggesting new twists in a plot; snooping around in a character's computer files; or, in the case of a MMOG, creating an avatar and becoming an active character in a fictional world.
- DEEP. Users expect websites to offer them opportunities to dig down into the content. Even story-rich environments can offer a variety of ways to satisfy this expectation, from reading diaries "written" by the characters to viewing their "home movies" to visiting the online newspaper of their fictional hometown.
- EDGY. The Internet has something of the persona of a cheeky adolescent. Users enjoy irreverent humor, opinions that challenge conventional thinking, and content that they are unlikely to find in mainstream media like television and newspapers.

In order to attract and hold visitors, it is also helpful to keep the following practical guidelines in mind:

- Determine the interests and needs of your visitors; consider what might draw them to your site and what benefits they will receive from the experience.
- Keep text to a minimum, and break it into small chunks, because most people do not like to do extensive reading online.
- Make things easy to find on your site, with well-designed menus and navigational tools; consider adding a site map if you have a content-heavy website.
- Design the website for visitors with both dial-up modems and broadband.

TV AS A ROLE MODEL?

Because the Web supports audio and video, and because it is viewed on a monitor that looks much like a TV screen, inexperienced Web developers are sometimes lulled into the belief that creating stories for the Web is much like creating stories for TV. While some important similarities do exist, so do significant differences, and ignoring those differences can seriously undermine a project.

This was one of the most important lessons learned by writers and producers who worked on the Web serial, *The Spot*, a drama centering on a group of young singles living in a California beach house. Each of their stories was told from a first-person point of view, largely through journals. And somewhat like the movie *Rashomon*, the characters gave different versions of the same events. Stewart St. John, a writer-producer with an extensive background in television, served as the Executive Producer and Head Writer of *The Spot* during its last year, from 1996 to 1997, and admits that he had to learn the hard way not to approach *The Spot* as he would a TV show. "In the beginning, I brought my conventional TV background to the stories," he told me. "I plotted the soap weeks and weeks in advance and expected the storyline to stay true to what I wrote, never straying. It was the kiss of death. The fans went berserk. They didn't feel emotionally connected. It was too much like television." But his work on *The Spot* quickly taught him to appreciate the differences between the two media.

"You can't think in terms of the way you'd create for television," he asserts. "The Internet is its own world, and the language of that world is interactivity. This is the biggest mistake I've seen over the past few years; creators creating Internet sites using a television format. It won't work." He stresses that the Internet is a "live" medium and that users want to experience it that way. "It's a place for people to go and chat and discuss topics and issues," he said. "If you want to fully utilize the Internet, make your website an interactive experience. Build it and maintain it and be there to communicate with your audience and they will come."

To allow for more user participation, St. John said he learned to integrate input from the fans to shape the direction of the plot. By loosening his control and becoming more flexible, he was able to provide an experience that was both narrative and interactive. Over time, he came to realize that it was particularly effective to build consequences—both positive and negative—into the choices the fans are offered in the narrative, believing this pulls them more deeply into the story. For instance, if the audience decides a character should take a plane to a particular destination instead of driving, even though the weather is dicey, and the plane goes down in a bad storm, they are going to feel a sharper pang than if their decision had had no consequences. St John's production company, Stewdiomedia (*www.stewdiomedia.com*), is now using this technique in developing interactive television programming.

Another *Spot* graduate, Ken Martino, one of the writers of the groundbreaking webisodic, now works on the website of a major Hollywood studio and shares St. John's conviction that stories for the Internet should not ape television. "People don't go to the Internet to watch a 30-minute story," he told me. "They expect to interact with it. The Web is not a passive medium, so you have to have something for the fans to do. They have to feel a part of something for it to be effective." With *The Spot*, he said, members of the staff would actually go online in character and chat with the fans. Some of these exchanges would be

mentioned in the online journals "written" by fictitious characters, even weaving the users' names into the accounts. Not only did this give the fans a few minutes of glory but it also made the show seem all the more real. In fact, many fans of *The Spot* were under the impression that the characters were actual people, which put extra pressure on the writers to keep them consistent and believable. If they tried to spice up a storyline by having one of the residents of the beach house do something out of character, like go on a drinking binge, "we'd lose the audience," Martino said, "and we couldn't go back and make it real again."

AN ORGANIC APPROACH

Let's fast forward about six years, from the launch of *The Spot* to the launch of another narrative project, *Rachel's Room*, which has also pushed the envelope of the Web as a medium to tell stories. *Rachel's Room* debuted in 2001 as part of Sony's ambitious broadband initiative, *Sony Screenblast*, which caters to users with high bandwidth. Like *The Spot*, *Rachel's Room* was a serialized story, but while *The Spot* was limited by the technology of the time and had to rely primarily on text and still photos, *Rachel's Room* made heavy use of video, offering fifty video installments running between 3 and 5 minutes. (Although Rachel's Room is no longer live, many of its features can still be viewed at *www.spe.sony.com/screenblast.rachelsroom*.)

Rachel's Room is a story that could only exist on the Web—the very fact that it takes place on the Internet is an integral part of the concept. Here is the conceit: 16-year-old Rachel Reed is at a crisis point in her life. Her father has recently passed away and she is at war with her mother. Like Holden Caulfield in *The Catcher in the Rye*, she feels misunderstood by everyone around her. So, in order to get a handle on things, she makes a radical decision: She will open herself up to strangers in the outside world. To let them see who she really is, she places webcams around her bedroom and lets them roll (though she plans to edit out the "boring parts" before putting the videos up on the Web). Furthermore, she will keep an online journal and also go into a chat room every night to talk with members of her cyber support group. (See Figure 13.1.)

Arika Lisanne Mittman, who served as Producer and Head Writer of *Rachel's Room*, feels one of its great strengths was in being so organically tied to the Web. A narrative on the Internet "shouldn't be just another kind of television," she told me. "It shouldn't be imitative. There should be a reason that it is on the Web, and not just because you couldn't get it on TV." Mittman had gained an understanding of the Web and of teen fans as the producer of the innovative *Dawson's Desktop* website, a fictional extension of the *Dawson's Creek* TV series that had a devoted following among young adults. (*Dawson's Desktop* was previously discussed in Chapter 6). She had also worked as a writers' assistant on the *Dawson's Creek* TV show. This previous work had given her an excellent foundation for cocreating *Rachel's Room*, which she did in collaboration with Chris Pike, Director of Development for Sony Digital Entertainment.

PLAYING TO THE STRENGTHS OF THE WEB

Rachel's Room utilized both familiar and novel methods of telling Rachel's story and offered various ways for the audience to participate in it. Pieces of Rachel's story

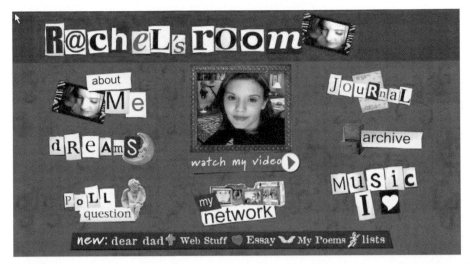

Figure 13.1 *Rachel's Room* appeared to be the website of a real teenager, but was actually a professionally written drama with parts played by actors. Image courtesy of Sony Pictures Digital.

were revealed via the video episodes, her journal, and the chat sessions, and all three were coordinated in terms of content. Viewers could express themselves via message boards, emails, chats, and in certain special ways, such as the "Dreams" section of the site. The chat sessions were an important part of the *Rachel's Room* experience, with Mittman herself going on every weekday night, playing the part of Rachel. Sometimes these sessions contained serious discussions of teen-related issues, but sometimes they also advanced the story. In a clever blending of reality and fiction, she has Rachel meet a boy fan during one of these sessions, a charmer whom Rachel believes to be her soul mate. Against all common sense, she invites the boy (actually an actor playing a fan) to her room, unaware that he's made a bet with his friends that he could seduce her on camera. Naturally, the relationship ends badly, but it alarmed many of Rachel's real fans, many of whom were convinced that Rachel was a real girl and not a character in a fictional drama. Mittman says she developed this subplot in part as a cautionary tale for the site's visitors.

DRAWING FROM TRADITIONAL MEDIA

By having Rachel share her most personal thoughts and her teenage angst, often breaking the fourth wall by addressing the viewers directly, the character touched a nerve among the site's fans. They closely identified with her and were intensely concerned with what happened to her. In creating such a compelling protagonist, *Rachel's Room* was actually borrowing a valuable technique from older forms of storytelling: good character development. "It's wrong to think characters for the Web don't need much depth," Mittman asserted. She believes character development is as important for the Web as it is for any other medium. She strove to create a multidimensional, realistic teen, tapping into her "inner teenager" to do so. But though she says Rachel had a certain mopey cynicism and did dumb things at

times, she was not a bad kid and not amoral. In other words, she was flawed, which helped her seem real, and contributed to her appeal.

Mittman also took pains to develop an overall good story for the series, "arcing it out" (constructing an arc for it) as would be done for a television drama. For the Web, Mittman believes, "you have to try that much harder to keep people coming back." Such stories, if done well, can have an addictive quality; people fear if they skip an episode, they'll miss something important. But, to make the videos appear as if they had really been done by a kid, she varied their style and tone. Some were just everyday slices of life; some had her addressing the camera; some were highly dramatic. They also had a rough, homemade visual quality, with objects out of frame or out of focus. Every one of them, however, ended in a cliffhanger.

MOVING BEYOND TRADITIONAL MEDIA

Not only did Rachel's Room look different from TV, it also was different in terms of content. Because it was on the Web, the producers had more freedom to deal with adult subject matter and to tackle issues that were serious concerns to contemporary teens, using language that would not be acceptable on broadcast TV. In one episode, for example, Rachel and her friend buy sex toys online; in another, Rachel kisses a girl.

One thin line upon which *Rachel's Room* had to skate was the fact that the video episodes were shot months before the site was launched. Thus, they could not refer to events currently happening in the world or reflect the viewer's input. To get around this problem, Mittman used Rachel's journal as a vehicle to keep the series contemporary. Thus, when the disaster of 9/11 struck, Rachel wrote about it in her journal. And, of course, the site contained live features like the message boards and chat sessions, and new features and updates were added on a weekly basis.

The result of all this work was a devoted following of fans, a number of them in such far-flung spots as Peru, Australia, and certain islands Mittman said she had never even heard of. And although they expected it to skew more toward females, as had been the case with *Dawson's Creek*, they actually attracted as many males as females, and drew not only teens, but adults as well. Mittman feels one reason they attracted such a loyal audience was because the fans felt so involved. "You have to keep them in mind," she said, "and keep in mind why they are going to come back. You have to make them a part of it."

SHORT ENTERTAINMENTS

While *Rachel's Room* and *The Spot* were designed as deeply immersive, participatory serials, the Web has also fostered a boom in noninteractive entertainment in the form of short films, documentaries, and animation. One short film that made a splash on the Internet, for example, was a work called *405*, made in the year 2000. It was a three-minute *tour de force* about a jet landing on the 405 freeway in Los Angeles. A combination of live action video and computer-generated special effects, the short was made by two friends working on nights and weekends, but

it brought them an enormous amount of attention. According to the pair, the special effects were made on the kind of computer equipment that can easily be purchased at a consumer electronics store.

Like *405*, many shorts during this boom time were made specifically for the Internet, and a number of sites specialized in them, acting as a vast entertainment library, sometimes holding thousands of shorts. And, like a public library, their collections were available to enjoy for free. The business models they employed called for them to earn revenue in various ways, with advertising considered the most promising. Such sites flourished for a few years, starting in the late 1990s and peaking in the year 2000. Many, however, were victims of the dot com bust. When venture capital dried up and their business models did not work as anticipated, they either disappeared or changed direction, as was the case for such sites as IFILM, Eveo, and Icebox. One of the biggest, however, AtomFilms (*www.atomfilms.com*), is still going strong as of this writing.

Though the Web no longer holds out a giant welcome mat for shorts, it is still a hospitable environment for short works of video and animation that are produced for specific purposes, such as promotion or information. The creators of shorts made during the earlier boom times helped pave the way for these later works and other types of Web entertainment that use moving images, demonstrating what was particularly effective and what was not. Here are some general guidelines that we can extrapolate from them:

- Web shorts gain the most attention when they are built around a strong subject or have an unusual point of view, though they should not be blatantly offensive.
- Powerful emotional themes are always an important element of stories, on the Web or anywhere else, though handling them well takes significant writing skill.
- Web audiences enjoy humor and like being surprised, and these elements, when used skillfully, can add to the effectiveness of a piece.
- Brevity is important. Some of the most effective pieces are only a few minutes long; most are less than ten. Individual installments of episodes rarely run more than five minutes. Some people refer to Web fiction as "sandwich break" entertainments.
- When it comes to a visual style, strong, simple images work best. The Web is the ultimate small screen, and images on it may be not much larger than the size of a postage stamp. It thus has trouble handling visual busyness or quick cutting. Close-ups work better than wide shots, and backgrounds should be uncluttered. Shots in which you are close enough to see a character's eyes are far more effective than ones in which you see the same character walking down a crowded sidewalk.

PROMOTION-BASED ENTERTAINMENT

One area where entertainment has done extremely well on the Web is in promotion. Promotion-based entertainments are games or story-rich material that is used to attract favorable attention to a product or to raise public awareness of an issue. Such promotions can be extremely imaginative, particularly when they are applied

to an already existing narrative property like a film or TV show. In such cases, the online material may be a seamless building out of the core property and may further immerse visitors in the story; in other words, promotions like this are extensions of a fictional universe. They closely reflect the offline property in terms of content, visual style, and tone.

One of the first websites to make a major success of this technique, as we saw in Chapter 3, was the one constructed in 1999 for the movie, *The Blair Witch Project*. In this instance, the website (*www.blairwitch.com*) had the same documentary look and feel as the movie, and supplied an abundance of additional news footage, written reports, and artifacts relating to events depicted in the film. Many visitors who explored the site came away with the impression that everything about *The Blair Witch Project* was fact, not fiction, and resolved to see this disturbing movie for themselves, which helped this low budget feature become a big hit.

An approach like this that tightly binds a website with an offline entertainment property, extending the core story, falls into the category of a cross-media production. As we will see in Chapter 15, the cross-media approach is not necessarily prompted by promotional objectives. It is sometimes done to stretch the canvas of a narrative or game, to add interactive possibilities, and to increase its scope. However, the great majority of websites that extend a fictional universe are initiated as part of a publicity strategy, though some take pains to conceal this, by eschewing such traditional promotional elements as cast bios, trailers, and "behind the scenes" videos.

EXAMPLES OF EXTENSIONS OF FICTIONAL UNIVERSES

One of the first websites to create a deep fictional extension of a television show was made in 1996 for the ABC drama series, *The Practice*, about a Boston law firm. Another milestone endeavor in this area was *Dawson's Desktop*, previously mentioned in this chapter and described in more detail in Chapter 6. Like *Blair Witch*, it presented its fictional components as if they were real. Visitors felt as if they were actually hacking into the computers of the main characters in the show and getting a surreptitious look at their emails, love letters, and other highly personal documents.

Using a somewhat different approach, *The Official Harry Potter Website* (*www.HarryPotter.com*), previously discussed in Chapters 8 and 9, excels at giving visitors an opportunity to interact in the fictional world of the stories. If you saw the second movie in the Potter series, *Harry Potter and the Chamber of Secrets*, you will probably recall a scene where the Hogwarts students are taking a class in herbology and are required to transplant a mandrake (which resembles a baby with leaves growing out of its head). Well, here on the Potter website, you, too, take a herbology lesson and attempt to learn the finer points of growing a mandrake. (See Figure 13.2.) The first order of business is to yank the mandrake out of its rooting container, which, if done correctly, causes it to give a piercing shriek. Once transplanted, you must then keep it alive, much as you would a Tamagotchi pet.

Not all extensions of fictional universes are as interactive as the Potter site, though the most satisfying offer an abundance of material to explore. Consider, for example, how Warner Brothers enhances the *Smallville* television series, which

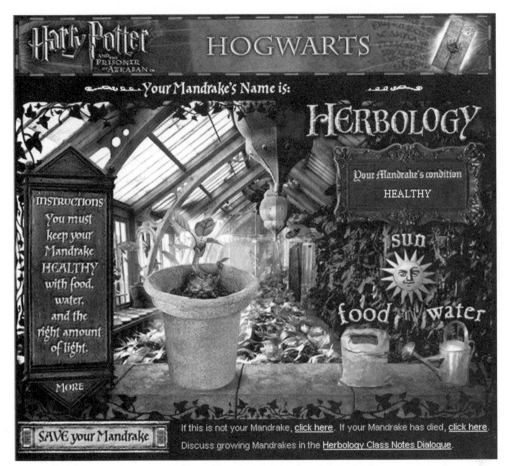

Figure 13.2 When you visit the *Official Harry Potter Website*, you can become a student at Hogwarts and, among other things, take a class in herbology, where you learn to raise a mandrake. Image courtesy of Warner Bros. HARRY POTTER and all related characters and elements are trademarks of and © Warner Bros. Entertainment Inc. Harry Potter Publishing Rights © J.K. Rowling. (s04)

revolves around Superman's boyhood years in Smallville, Kansas, back when he was just known as Clark Kent. To do this, they have constructed an online newspaper, the *Smallville Ledger* (*www2.warnerbros.com/web/smallville/ledger*), that chronicles the events in this sleepy Midwestern town. Its folksy style and low-key news items resemble what you'd expect from such a place. However, among its stories about the Lady's Auxiliary Chamber of Commerce and its classified ads about lost, somewhat overweight pigs, you will also find articles about dramatic events that affect Clark Kent directly. You can also follow a link to his high school newspaper, the *Smallville Torch*, to experience more of his world.

OTHER ENTERTAINING PROMOTIONAL TECHNIQUES

One extremely effective way to promote items on the Internet is through games. The technique of weaving a product into a game, as we learned in Chapter 8, is

called advergaming. Such games can be found all over the Web. For example, Microsoft's gaming site, *The Zone* (*http://zone.msn.com*), offers a racing game called *Toyota Adrenaline*, starring a Toyota truck. According to Chris Di Cesare, the site's group product manager, what advertisers want are things that are compelling and engaging for the consumer, and "that's what games are" (David Becker, *CNET News*, Jan. 25, 2002). The Toyota game, he said, "turns out to be a real win-win for the game player and the sponsor. With *Toyota Adrenaline*, we were able to give gamers an advanced 3D racing game that really pushed the envelope as far as graphics, and Toyota got great exposure."

But are games the only way to sell products on the Web? BMW certainly doesn't think so. Beginning in 2001, in a radically different approach, the car manufacturer began promoting its sleek, high-end vehicles online via a series of sleek, high-end short films (*www.bmwfilms.com*). The films are collectively called *The Hire,* and are united by a recurring character, a mysterious driver-for-hire, who operates the car in all the little movies. No overt advertising is contained in any of them. As noted in Chapter 8, these handsome films were made by some of the world's top directors. The campaign carries a subtle message: that if directors this cool are making films featuring the BMW, then maybe I'll be cool, too, if I drive one. The films have received many accolades and have even been screened at Cannes. And BMW must believe its unusual approach to Internet promotion is working, having adding a second series of shorts to the first group.

USING ENTERTAINMENT FOR PUBLIC ADVOCACY

Entertainment on the Web can not only help sell products; it can help sell ideas, too. For example, consider the case of a clever little Flash movie called *The Meatrix* (*www.themeatrix.com*), which debuted late in 2003. *The Meatrix*, a parody of the popular film, *The Matrix,* tells the story of a naïve young pig, Leo, who is introduced to a ghastly alternate reality by a cow named Moopheus, an underground resistance fighter. At the beginning of this two-minute cartoon, Leo is blithely under the impression that the bucolic family farm where he lives is real life. But when he takes the red pill Moopheus offers him, he learns the shocking truth: Family farms are mostly a fantasy, having been stomped out by agribusiness and replaced by inhumane, unhealthy, and diseconomic factory farms (see Figure 13.3).

Obviously, *The Meatrix* is a little movie with a big message, but because the message has been so skillfully integrated into an entertaining format, it comes off more like fun than like a sermon, though its serious points shine through clearly. Within two months of its launch, it was seen by 3.5 million people, an unqualified success story for an advocacy movie. Those who were moved by its message were not left hanging. The website gave them options for following up in various ways.

The Meatrix was created by Free Range Graphics (*www.freerangegraphics.com*), a design and publicity company with a stellar client list of advocacy organizations. One of its specialties is making little Flash movies on behalf of its clients. This particular project was unusual, however, in being the winner of its first-ever grant competition. The company's head of business development, McArthur (who goes by a single name), told me they had run the grant competition for three reasons: to generate new business, to be able to have more creative control over a project, and to give something back to the community. The winning proposal,

Figure 13.3 A scene from *The Meatrix*, with Leo and Moopheus silhouetted in the foreground. Moopheus is explaining the reality behind the Meatrix. Image courtesy of Free Range Graphics and GRACE (Global Resource Action Center for the Environment).

submitted by the Global Resource Action Center for the Environment (GRACE) (*www.gracelinks.org*), was chosen out of a field of fifty submissions.

McArthur, who was the account manager of the project, said her company and GRACE developed the cartoon in close collaboration with each other. GRACE supplied the facts, background information, and guiding philosophy while Free Range did the creative work of devising and producing the movie. The concept of playing off *The Matrix* was the brainchild of Jonah Sachs, one of the company's founding partners, while the distinctive Flash animation, done in bright innocent primary colors, was the work of the other founding partner, Louis Fox. The two cowrote the script.

McArthur said *The Meatrix* more than met its expectations. For one thing, it turned the spotlight on a subject that usually floats under the radar. "Factory farming is not an issue people want to talk about," she noted dryly. *The Meatrix* showed the value of having a smart script, a striking visual style, and the right balance between entertainment and message. It also demonstrated the enormous power of using popular iconography like *The Matrix* to help get an idea across. *The Matrix* put *The Meatrix* in a context people could readily understand, avoiding the need for heavy explanations, and the witty parallels were almost certainly a major reason for its success. While they were hoping for perhaps 250,000 hits, they actually received over ten times that many. Furthermore, the positive attention *The Meatrix* enjoyed, did, as hoped, result in new business for the company. The grant competition proved so beneficial to Free Range that they are planning to run it again.

USING ENTERTAINMENT TO INFORM AND EDUCATE

As we have previously discussed in Chapter 8, entertainment can be utilized with excellent results to make educational or informational content more palatable,

approaches known as edutainment and infotainment. Let's look at an example of how this approach has been put to work in an edutainment website called *The Mesoamerican Ball Game* (*www.ballgame.org*). The site was built by Interactive Knowledge, Inc. (*www.interactiveknowledge.com*) in conjunction with a traveling art exhibit mounted by the Mint Museum in North Carolina. The subject of the exhibit was the ritualized ball game played in Central American and Mexico before the arrival of Europeans, a fairly obscure topic to the average person (though, as discussed in Chapter 1, relevant to those of us involved in interactive entertainment). The design company, much to its credit, found a host of ways to bring the subject to life and make learning about it fun. They used interactivity, sound effects, and Flash animation to good effect, enlivening the subject and exciting the visitors' curiosity about it, starting with the essential mystery of why athletes would play a ball game that might end in their beheading.

To pull visitors into the subject, they offered activities like "suiting up" a ballplayer in his ceremonial costume or bouncing one of the traditional balls to learn how they were made. Most entertaining of all, you can join a team of players and experience the game first hand, playing in an arena just like the ones discovered in Mesoamerica. But when you are tossed a ball, you are also tossed a quiz question. If you answer correctly, the spectators cheer. If you lead your team to victory, you are rewarded with louder cheers, music, and a cascade of flowers. But what if your team loses? Here the website makes a concession to modern sensibilities. Instead of being beheaded, you only suffer embarrassment, not beheading. This fascinating website has received numerous awards, including being named the Best Museum Website of 2002.

WEB ENTERTAINMENT FOR KIDS

Children's online entertainment is in a category by itself. Although content geared for kids can be found in abundance on the Internet, creating websites for youngsters necessitates dealing with issues that are unique to this demographic. These include concerns about safety, the wholesomeness of the content, and age appropriateness, as we saw in Chapter 8. It also calls for an awareness of the self-regulatory guidelines known as CaRu (*www.caru.org*) that cover the promotion of merchandise to children under 13. These regulations were established by the Children's Advertising Review Unit, part of the Better Business Bureau. In addition, developing content for children requires an understanding of what children find entertaining, covered in Chapter 9.

Because of fears over the three Ps (predators, privacy invasion, and pornography), parents have been reluctant to allow their children free access to the Internet, which has put something of a damper on the development of websites for children. But the year 2003 saw two ambitious online ventures for kids being launched. Both were backed by major media companies and were designed with grown-up concerns in mind, offering built-in parental controls and safety features. One of these sites, previously discussed in Chapter 12, is Disney's *Toontown Online*, a MMOG just for kids (though adults are finding it good fun, too). The other is the AOL Time-Warner "playground" called *KOL*. It is a massive overhaul of AOL's Kids' Only Channel, and free to subscribers of AOL 9.0.

KOL, which requires broadband to be fully enjoyed, is loaded with kid-oriented attractions, including about fifty games, interactive story books, and tantalizing features like a big red button that, when pushed, emits surprising noises. Geared for 6- to 12-year-olds, it offers six heavily animated environments with themes like the ocean, space, and the jungle. AOL Time-Warner's motives for developing this new service were not, as can be imagined, entirely altruistic. AOL has been losing customers to less expensive rivals, particularly those offering cheaper broadband service. No doubt they figured that in a world where children play a big role in family decisions about entertainment, a kid-friendly, enticing environment like *KOL* could help stem the leakage and even attract new subscribers. After all, what kid wouldn't want the chance to push the big red button?

CONCLUSION

As we have seen here, entertainment on the Web is far from dead. While it has not been able to live up to the frenzied hype that started building in the late 1990s, and while the glittering promises of "striking gold in cyberspace" have not materialized, it must be remembered that the Internet is still a young medium. It has already proven to be a robust vehicle for new kinds of entertainment experiences, particularly those that blend interactive fun with other objectives such as promotion or information. And we have seen some compelling examples of how stories on the Web can be told differently than in any other medium. These new kinds of dramas are participatory; they use a variety of components to tell the story; they break the fourth wall; and they blur reality and fiction in intriguing ways.

Every day, more people are signing up for broadband, and the spread of broadband will almost certainly encourage the development of more Internet entertainment. High-speed access makes for a different, more enjoyable, more narrative-friendly experience. As the Web matures, the work produced by its early pioneers should serve to advance the art of telling stories on this medium, stories that take advantage of its unique attributes.

IDEA-GENERATING EXERCISES

1. Select a website that has story-rich content. What demographic do you think this content is designed to attract and why do you think users would find it appealing? What makes it sticky? What about it, if anything, do you think users might dislike? Can you suggest anything that might make it more enjoyable?

2. Select a website that combines entertainment with another purpose, such as promotion or education. What is the overall objective of this site? How does the entertainment enhance this objective, and do you think the entertainment is well integrated with it? If not, how do you think a smoother blend could be achieved?

3. Sketch out an idea for a narrative that you think could work on the Web. What demographic would this story appeal to? What is its premise? How could users become involved with the content?

4. Choose a product, an educational topic, or a social issue and sketch out an entertaining way to package this subject as a website. Could users participate at all in this website, and if so, how? What could you do to keep them coming back to this site? What could you do to keep it fresh?

CHAPTER 14

Interactive Television

What are some of the major creative hurdles that developers of iTV programming are faced with?

In creating interactive programming for television, what kinds of enhancements work best, and what tends to detract from the linear content?

Is it possible to create effective interactive enhancements for a drama or comedy, and if so, how can this be done in a way that does not interfere with the core program?

WINNING OVER THE COUCH POTATO

OK, Mr. or Ms. Couch Potato, which will it be?

- The chance to compete with other viewers and win prizes in a trivia competition based on the TV show you are watching?
- The chance to see highly personal and emotional "bonus" material from the point of view of one of the characters in a serialized drama?
- The chance to determine which camera angle to watch the NASCA race from, including one placed inside the cockpit itself? Or. . . .
- The chance to examine clues, dig up more information, and perhaps even solve tonight's mystery on your favorite crime show?

In truth, the most likely answer is "none of the above." Though all four of these iTV scenarios have been produced and broadcast, and though they indicate the great range of iTV programming that is available, most viewers are not aware of them and would have trouble seeing them even if they wanted to. As we discussed in Chapters 2 and 3, iTV is an area that has progressed in fits and starts, and has suffered highly publicized setbacks. The forward strides it has made in recent years have been less thoroughly brought to the public's attention, and as a result, most viewers are under the impression that iTV is a dream of the future, not something available in the here and now.

Unfortunately, iTV must overcome many problems before it becomes a mainstream form of entertainment. Among them is a serious image problem. Even professionals within the industry are hard pressed to agree on a uniform definition of what it is, or what to call it. Along with iTV, it is also referred to as enhanced TV (eTV) and smart TV. Forms of video interactivity cover many possibilities, and not everyone agrees what actually constitutes true iTV. Here are some of the types of video experiences that people in the industry have placed under the iTV and enhanced TV umbrellas:

- Interactive programming furnished via a digital set top box provided by a satellite or cable company, known as single screen interactivity.
- The synchronization of content on TV and the Web, calling for a secondary device like an Internet-connected computer or cell phone, known as dual screen interactivity.
- Video on demand (VOD), in which viewers can order movies or other video content from their TV sets.
- Devices like TiVO, which are known as personal video recorders or digital video recorders (PVRs or DVRs) and which offer viewers more control than VCRs, including features like pausing live TV and skipping commercials.
- Electronic program guides, which offer viewers an interactive menu of programs.
- Noninteractive enhancements in which additional information appears on the screen as a graphical overlay, and which may be personalized information that viewers have requested, such as financial news or sports scores, or may be enhancements that are added on after a show's initial run as a value-added feature.

Many of these devices and enhancements have little to do with each other, even though they all involve television in some way. For our purposes, let's keep things simple and say that iTV is programming that allows viewers to interact in some meaningful way with the content of a television show.

MAJOR HURDLES

Even though our definition of iTV might be simple, little else about it is. This is especially true in the United States, where the field is far less advanced than it is in the UK, in Europe, and in parts of Asia. Deployment in the United States has been slow because no one uniform standard of iTV broadcasting has yet been adopted. Though several satellite and cable companies offer iTV service, they are not compatible with each other. Also, only a small number of homes are equipped with digital set top boxes that are robust enough to receive iTV programming. Interface devices pose another hardware obstacle. The most common type of interface device in the United States is the remote control, which is not as easy to use for iTV as the color-coded "fast keys" system found in the UK and Europe.

In order to reach as many homes as possible, broadcasters often deliver interactive content over both set top boxes and dual-screen computer-TV set-ups, sometimes adding programming for a wireless device as well. For example, ABC developed three sets of interactive programs for the 2003 Daytime Emmys: one for set top boxes; one for its website; and a third for cell phone users, all synchronized to the live telecast. This type of triple-screen interactivity puts a heavy burden on the developer of the iTV content.

But developers face an even more difficult challenge when it comes to the creation of programming, and it is this: How do you design content for the interactive aspects of the program that enhances, and does not detract from, the linear content? This is the fundamental conundrum of all iTV developers, and one for which no clear answers have yet been found. Among the other creative challenges they deal with are these:

- No strong financial incentives exist among cable and satellite services, broadcasters, or advertisers to press for iTV, leaving the creative end of the field under-supported and under-promoted to the public.
- Competing iTV set top systems and a lack of uniform standards means developers must make difficult choices and leads to consumer confusion.
- The field is so new that few successful models exist, and little user testing has been done thus far to see how viewers respond to iTV enhancements. Thus, creators are left without informed guidelines.
- Most iTV content is added after the linear TV show has already been produced, preventing iTV developers from integrating the interactivity from the ground up.
- Producers of linear TV shows are generally unwelcoming of iTV producers who want access to the set to shoot additional material for iTV elements.

With so many hurdles, it is not surprising that development has not been more rapid or that television viewers have largely been left in the dark about what is happening in the field. If Mr. or Ms. Couch Potato is ever going to become excited about iTV and eager to try it, many of these hurdles will have to be overcome.

THE VIEW FROM THE FRONTIER

But despite the impediments that are slowing the progress of iTV, a number of dedicated professionals in the industry are persevering. They remain upbeat about its potential and are managing to create extremely interesting work in this area. One such person is Dale Herigstad, introduced briefly in Chapter 2. Herigstad, who is considered a visionary in the field, has probably brought inter-activity to more American television shows than anyone in the business. He's been involved in iTV since Time Warner introduced the Full Service Network in Orlando, Florida, back in 1994. Currently one of the partners in Schematic, a design and production firm specializing in iTV, he has designed and produced such pioneering projects as ten interactive episodes of the PBS documentary series, *Life 360*, and all thirteen interactive episodes of *Survivor Africa*, plus a number of experimental prototypes.

"This is the frontier," he told me, speaking with relish, not distress. "There are no books on this, no classes on this. We have to invent the rules and figure things out for ourselves. It's a learning experience for all of us." But he admits to a certain impatience at how slowly the business side of things is moving. "My mind is exploding with stuff, and it's frustrating because the boxes aren't there, and the money isn't there."

Herigstad's best known project is probably his groundbreaking work on the hit CBS series, *CSI (Crime Scene Investigation)*, which was America's first inter-active prime-time network drama. He and his company designed and produced single-screen iTV enhancements for every show in the first two seasons, a total of forty-eight episodes. The interactive version of *CSI* was available to viewers with set top box services from Ultimate TV and Microsoft's Web TV. In the linear version of the show, viewers watch a team of investigators as they visit crime scenes and uncover clues, using logic, experience, and scientific tools to solve their cases. Viewers fortunate enough to be able to see the interactive version of this show could probe more deeply into the cases, getting additional information, for example, on the science of fiber analysis or about the geographical relationships between the different locations in the mystery. But the most unique aspect of the interactive version was the chance to solve the case alongside the fictional investigators, as if you were one of the team. You begin as a cadet, and if you do extremely well, you can work your way up to the rank of Level 3 Investigator, which is the same level held by the characters on the show.

Herigstad termed *CSI* "the perfect show to work on" because it was so well suited for enhancements. Curiosity about the clues and the desire to figure out the mystery gave viewers a powerful incentive to utilize its interactive features. To develop the interactivity for *CSI*, Herigstad worked closely with David Katz of CBS, the Senior VP of strategic planning and interactive ventures. The enhancements, however, had to be added after each show had already been shot.

His company would get the work print of the show and watch it with an eye toward elements that would lend themselves to different types of enhancements. His writer would then write the questions and other material, which then had to be vetted by the *CSI* writers.

A "PERFECT WORLD" VISION

Although Herigstad called the *CSI* assignment "a dream job" and said he learned a great deal from it, he indicated that in a perfect world, he would have done some things differently. For example, he would have added more of an emotional dimension to the interactive enhancements, and in a visionary mockup for CBS, he demonstrated how this could be done. The "perfect world" version shows a scene of one of the characters, Katherine, who is asked by another character about her past as an exotic dancer. She casually shrugs it off, but in the enhancement, we see a painful flashback of her memory of that experience. Herigstad said he also would have liked to offer the viewer a choice of camera angles for important scenes, and also demonstrated how this could be done in the mockup.

He also felt the enhanced version could have been richer if his team had had access to more assets, such as B roll footage (scenes that focus on details or general shots rather than on the main characters), or even better, had had a production crew on the set. Had that been possible, they could have shot special footage just for the enhancements. It would have also been valuable, he said, to have his team brought in at a much earlier stage, before shooting began, so they could have suggested what special footage would have been of value for the enhancements. But though CBS was generally supportive, the network had concerns about giving Herigstad's group more freedom, citing possible legal rights questions and contract issues. For example, would they have to pay the talent more if they appeared in this additional footage? Perhaps, he now thinks, doing enhancements for a hit network show, where your freedom is restricted, is not the best place to experiment with enhancements. Perhaps it would be more productive to hook up with an independent producer of a new show.

Despite the creative breakthroughs they did manage to achieve in the iTV version of *CSI*, the network will not be doing additional interactive episodes for now. It is curtailing all its work in single-screen interactivity until more viewers have iTV-enabled set top boxes. According to Katz of CBS, this decision is partly driven by the advertisers. He says they prefer to "spend their dollars where the eyeballs are, until the one-screen world figures itself out and standards get resolved." (As reported in the online newsletter, *Interactive TV Today*, Oct. 13, 2003.)

GENERAL LESSONS

Herigstad, nevertheless, remains enthusiastic about the possibilities of iTV, and shared some general lessons he has gleaned about developing iTV programs. The work he has done so far has shown him that:

- Interactive enhancements should be choreographed to the program, and not forced upon it; the pacing is important.

- 90% of what you are trying to figure out is the balance between the passive and the interactive elements.
- What constitutes a value-added experience is different for every show and what is successful for one will not necessarily be appropriate for another.
- Because TV viewers are sitting back and can't see the TV very well, they need the visuals to be very clear and simple.
- They don't want to read much text.
- They like things to be easy and prefer to respond, not to initiate.

Herigstad says he has a mantra about enhanced television, and it is this: Enhanced TV is television, television, television. It's not the Web and it's not something else. And television, above all, has always been a simple experience.

PUSHING THE ENVELOPE

One institution that is committed to pushing forward on the creative front is the highly regarded American Film Institute, which runs an interactive television think tank and lab called the Enhanced Television Workshop (*www.afi.com*). The workshop was founded in 1998 to stimulate the creation of compelling work in iTV and to serve as an evangelist for the medium. Its first sponsor, the Corporation for Public Broadcasting, has now been joined by a number of others.

Each year the workshop coordinates the production of eight to ten iTV prototypes, using already-existing television programs as the linear base. Production companies wanting to explore the possibilities of iTV vie for the chance to have their shows prototyped. Some of the selected shows are already on the air, while others are newly completed. To create and build the prototypes, representatives from the linear TV production company are matched by AFI with a team of iTV professionals who volunteer for mentorships. The mentor group typically includes a production manager, an interactive designer, a programmer, and a commercial strategist who guides the team toward the deployable and commercial aspects of the project. The prototypes are produced on a six-month cycle that begins with the workshops' annual three-day kick off event in July and culminates with the unveiling of the prototypes in December.

The July event is, in itself, an important component of the workshop's mission, because it brings together an international group of experts on iTV. The first day, the "Creative Showcase," is open to the public, and attendees are given up-to-the-minute reports on the state of the industry as well as a look at outstanding examples of iTV programming, demonstrated by the creators themselves. The second two days are devoted to hands-on work on the prototypes and is open only to the production teams.

The shows selected for prototyping have run the gamut of TV fare, including sports, news, and award shows; comedies, dramas, documentaries, and commercials; and informational and kids' programs. Each type of show has raised a unique set of questions and had led to unique solutions, adding up to a stunning array of prototypes.

For instance, in doing the prototype for the HBO show *Arli$$* (a project Dale Herigstad participated in as a mentor), the team had to address the issue of how to enhance a comedy. Comedy is tricky because, as Marcia Zellers, the workshop's

director, points out, the danger "is trumping the joke." Still, she said, the enhancements need to have a comic touch. *Arli$$* is a show about a slick sports agent who has misplaced his moral compass, and the team's solution to the challenge was to devise a fantasy "morality" game that enabled viewers to play along with the show. The game featured a "decision meter," and the decisions they made would propel them up or down from the mail room to the coveted top floor corner office, depending on their own moral compass.

For the Disney Channel's children's show, *Kim Possible*, the prototype team came up with a trading card game. The cards are embedded within the episode, and the chance to collect them is expected to give young viewers the incentive to watch each episode multiple times. And for the Sci Fi Channel's *Battlestar Galactica*, a reprise of a classic TV series, the team took a suitably futuristic approach, creating a hybrid experience that uses the Xbox game console as a platform. Part interactive story, part game, viewers can not only participate in the narrative but will also be able to fly aircraft into battle.

With dozens of prototypes now under its belt, the Enhanced TV Workshop has succeeded in breaking ground in many new directions. Yet its director, Zellers, believes much still remains to be discovered. "We are in the early stages of this medium," she told me, noting that the participants are still wrestling with the essential puzzle of interactive TV—how to enhance the content without being distracting. "It is a very tough thing to do," Zellers said. "I don't think we've found the golden nugget yet." However, a few general rules can be extracted from the work done so far. She said they've found that:

- Anything that makes it difficult to follow the story is distracting.
- Networks and advertisers don't want attention taken away from the commercials.
- Enhancements that are too fast or too difficult or that require too much thinking can be distracting.
- The user interface must be clear, and must not be hard to figure out while looking at the TV screen.
- The typically chunky style of Web design is distracting on TV.
- The interface should reflect the fact that TV is a polished, sophisticated medium.

In speaking of where further work needs to be done, Zellers said: "I think we still need to keep hammering away at it. What is the right interface? What truly enhances the program? Technology is just bells and whistles. But how do the enhancements make television more compelling than if we didn't have this technology?"

SETTING OBJECTIVES

In its year-end production review for 2002, the workshop clustered the prototypes it had done to date by the essential objective of the enhancements. Their categorization indicates some of the major purposes for doing enhanced programming. It also suggests a useful question that should be asked at the starting point of any

iTV project: What is the objective of the show's enhancements? Here are the objectives AFI came up with:

- To add dimension to the show's characters (which can pertain to real people in documentaries, reality shows, and sports programs as well as fictional characters).
- To allow viewers to delve more deeply into the subject matter.
- To reinforce an entertainment brand.
- To serve as an educational springboard for young learners.
- To provide an opportunity for self-exploration.
- To explore sensitive social issues and offer a forum for community building.

WHEN iTV BECOMES "JUST TELEVISION"

One often hears this wistful phrase at events held by AFI's iTV events: "Someday we'll just call it television." In this vision of the future, iTV will have become so widespread that it will just be a normal part of the entertainment landscape. Though still a ways off in the United States, the dream is already largely realized in the UK, thanks primarily to the BBC. Over half the homes in the UK, representing 25 million people, have access to two-way iTV services from the BBC. And these people don't just have access to iTV; they avail themselves of it. For example, during the 2002 Wimbledon tennis competition, 64% of those equipped with iTV technology took advantage of it to watch the tournament.

Surprisingly, the success of iTV in the UK has been an extremely swift development. In November 2001, the BBC created BBCi as a one-stop-shop for all of the BBC's interactive content. This initiative spanned a number of media, including television, the Web, and broadband and mobile devices, and its goal was to give the BBC audience access to interactive content at any time, any place, and in practically any way. At a presentation at AFI's 2002 Creative Showcase, the BBC's visionary Director of New Media, Ashley Highfield, noted that usage of iTV had surged from 0 to 8.1 million people in a single year. "It took us 8 years to do the same on the Internet. If people say interactivity is not possible, they are wrong," he said.

The works Highfield demonstrated at the showcase illustrated the diversity of approaches the BBC takes toward iTV. For example, during the Wimbledon broadcast, viewers could switch between the action going on in one of five different courts, made possible because the BBC was broadcasting multiple streams of video. With the *Antiques Roadshow*, the BBC employed an interactive overlay on top of the video that let viewers guess the value of the heirlooms being examined. This interactive gaming element helped the BBC solve a vexing problem, Highfield said—that of drawing younger viewers to a show that had primarily attracted an older demographic. The gaming overlay not only brought in a new audience, but did so without changing the show itself. The BBC used still another approach for documentaries, adding several different layers of audio and video information, somewhat like a DVD.

One of the most provocative shows Highfield demonstrated was one called *Diners*. This series is set in a restaurant where, as you would expect, people are

eating and chatting. The twist here is that cameras are aimed at diners all over the room, and the viewer can decide which table they'd like to "visit," and then eavesdrop on the conversation going on there. The diners are all real people, not actors, and viewers flood the BBC with letters volunteering to be on the show and describing what they'd talk about. Their pitches range from the romantic—a guy who'd propose to his girlfriend—to the racy—a pair of transsexual prostitutes who'd discuss their clients. The multiple camera approach used on *Diners* suggests some intriguing possibilities for a drama. One can imagine what Robert Altman could do with this.

Since the 2002 Creative Showcase, the BBC has continued to experiment with new formats. For a documentary about the pyramids in Egypt, for instance, it developed an interactive mystery-adventure game involving pyramids. Instead of being playable while the show was on the air, however, it was designed to be played afterwards. Though this gaming approach was particularly suited to younger viewers, the BBC has a large audience of older people, and wants to bring such viewers into the interactive tent, too. For this demographic, the interactive features are designed to be uncomplicated but satisfying. Thus, the BBC designs shows for older viewers that gives them an opportunity to vote on matters they care greatly about, and when feasible, these votes trigger an action. For example, in *Restoration*, a show about Britain's historic houses, they invited viewers to vote on which structure was the most deserving of a renovation. The building with the most votes was awarded a large grant for repair work. This type of interactivity has proven to be highly popular with the over-forty crowd.

APPLYING iTV TO DRAMA

Moving beyond these formats, the BBC has even begun to experiment with interactive drama. Late in 2002, in a trial in the north of England, it began to air daily three- to five-minute segments of a month-long episodic drama called *Thunder Road*. (See Figure 14.1.) The drama was set in a real town, Hull, where the trial

Figure 14.1 The BBC's interactive episodic drama, *Thunder Road*, offered viewers a variety of ways to interact with the story. Image courtesy of the BBC.

was taking place, and was presented as a blend of fiction and faux documentary. It revolved around a couple who takes over a rundown pub, the Thunder Road, and has to make a success of it in thirty days or risk losing not only the pub, but also their livelihood and possibly their marriage. Each little episode ended on a cliffhanger.

Among the interactive possibilities was the chance to see, via VOD, additional "documentary footage" about the story. These were monologues of each of the characters, shot with a hand-held camera to heighten the documentary effect, in which they revealed their thoughts and feelings about the unfolding events. Viewers could also participate in message boards and quizzes. In addition, they had various options on how they would view the story: in individual episodes, in weekly collections, or as one ninety-minute film. The additional scenes did not change the story itself but gave viewers a greater understanding of the characters. As Chris Charlton of the BBC explained: "*Thunder Road's* award winning writer and co-director, John Godber, did not see great narrative value in offering multiple-choice endings. Yet *Thunder Road* still allowed viewers to find their own path through the drama by providing extra footage behind almost every scene in the film." He reported that the extra scenes were highly successful, with well over a third of all video file requests being for the additional content.

One reason that the BBC has been able to produce so many breakthrough iTV projects is because of the broadcaster's approach to creating them: These projects are created from the very beginning to be interactive, instead of the interactivity being pasted onto already-produced linear shows. As Ashley Highfield explained to me in an email after the 2002 Creative Showcase: "Regardless of genre, all our interactive applications begin from the ground up at the time of the programme's commission. They are not considered 'bolt ons' to the linear programme." The BBC's approach encourages far greater freedom in designing the overall program, and also means that the interactive elements can be produced at the same time as the linear ones, using the same actors, sets, and other assets.

THE DUAL-SCREEN EXPERIENCE: A REAL-LIFE EXAMPLE

While the UK has an established infrastructure for single-screen interactivity, the same is not yet true in the United States, as we've noted. Thus, the relatively small number of Americans who have experienced iTV have mostly done so in a dual-screen configuration. So far, such shows have only been offered on a scatter-shot basis, although ABC-TV has aggressively developed and promoted dual-screen iTV for a number of its programs, primarily awards and sports shows. The History Channel is another broadcaster that has been actively involved in dual-screen interactivity.

To get a sense of what such an iTV experience is like, let me give you a first hand account of one I participated in, called *Boys' Toys*. It was a week-long series on the History Channel about gadgets and vehicles that set the male of the species' hearts to racing, things like motorcycles, private planes, and convertibles. The series ran for two hours a night, with a different topic covered in each hour. The interactive programming was available not only on PCs but also on ATVEF-enabled

set top boxes. (ATVEF, for Advanced TV Enhancement Forum, is a set of standards that allows Web-based entertainment to be broadcast on TV.) The interactive features were powered by technology developed by GoldPocket Interactive (*www.goldpocket.com*), which is a leading provider of iTV programming and has produced over 8,000 hours of it.

The main attraction of *Boys' Toys* Interactive was the quiz game that viewers could play along with the show. Those with the highest scores for the week could win prizes in the sweepstakes. I logged onto the History Channel's website (*www.historychannel.com*) in order to register and to check starting times and subjects. Scanning the schedule, I decided to go for the one on private planes, which sounded like the most fun. To play, I'd need Macromedia's Shockwave plug in, which I already had. The registration process was easy. I was asked to give my time zone, a password, a user name, and some contact information. Unfortunately, not seeing ahead, I typed in my real first name as a user name, never stopping to think how uncool a name like Carolyn would look if I were lucky enough to make the leaderboard (the list of top scorers).

A few minutes before the show was to start, I logged on and waited, not knowing what to expect and a little worried that my pokey 56K modem might not be up to the job. The action got going right at 9 p.m., and the interactive interface popped up on my computer monitor without a hitch. It had an appropriately high-tech gadgety look, complete with gears, reflecting the theme of the series. (See Figure 14.2.) Soon I was engaged in the nonstop business of trying to accumulate points. I had no trouble watching the TV show while keeping up

Figure 14.2 The interface for *Boys' Toys*, as it looked on a computer screen. The interactivity was synchronized to the TV broadcast. Image courtesy of A&E Television Networks. Reprinted with permission. All rights reserved.

with what was happening on my computer, and the synchronization worked flawlessly; but the quiz kept me plenty busy, too busy to think of trying the chat feature. Some of the questions were giveaways, earning you points just for participating in a poll ("if you could have your own private aircraft, which would you choose?"). But some required prior knowledge of aviation (a subject I knew pretty well, being a frequent flyer) and some were based on information already imparted on the show, and you had to stay alert. Slyly, some of the questions were based on commercials run by the sponsor, IBM, so you couldn't slip out for a bathroom break while they were running. The most stressful questions were those that had you wagering a percentage of your accumulated points, and being right or wrong here could drastically affect your total score.

The first time the leaderboard popped up, I was thrilled to see my name on it, number 6! Though I hadn't intended to play for the whole show, I was hooked. But I certainly wished I'd picked a better user name, especially because my fellow high scorers had such macho ones—Gundoc, Scuba Steve, and White Boy. No time for reflection, though; the game was on again, and my adrenaline was pumping. Next time the leaderboard appeared, I had risen to number 5. But then came one of those wager questions, and I answered incorrectly. My score plummeted by 600 points and my ranking to 7. It was now the final stretch of the game and I vowed to regain those points. Sure enough, when the game ended, I had risen to number 4! I felt proud of upholding the honor of my gender, though if I were to do it again, I'd pick a name like ToughChik or SmartyPants, just to give the guys a poke. But overall, it was a completely enjoyable and engaging experience. The interactivity added a whole other dimension to TV viewing and kept me glued to the two screens. I had only one complaint with this interactive TV experience, as opposed to a more laid-back linear one: It was impossible to snack.

DIMENSIONALIZING A DRAMA: A CASE STUDY

Using gaming techniques to draw viewers into a linear program, as *Boys' Toys* did so compellingly, has become a fairly standard strategy in iTV, with voting, polling, multiple camera angles, and informational overlays being other popular strategies. But it is far more difficult to find projects that have used storytelling techniques to add interactivity and to enrich the linear program. One rare exception to this is the PBS series, *American Family*, produced by El Norte Productions. The project, first introduced in Chapter 6, was initially developed for dual-screen interactivity, but when it became apparent that the technology was not yet up to what the producers had in mind, the iTV applications were scaled back. The online component that was built to enhance the series, *Cisco's Journal* (*www.Gonzalezfamily.tv* or *www.pbs.org/americanfamily*), had strong conceptual links to the series, but did not offer synchronous interactivity with it. However, each new installment of the website was launched at the same time as the corresponding TV episode, and could be enjoyed along with the television broadcast. And even without synchronous interactivity, *Cisco's Journal* is a stunning achievement. It illustrates, in a way that is completely different from *Thunder Road* or *CSI*, how a drama can be enhanced using an iTV-like approach.

As we noted in Chapter 6, the series revolves around a multigenerational Latino family in East Los Angeles. One of the members of this large family is Cisco, a talented teenager who is an aspiring filmmaker and artist. In episodes of *American Family*, we see him shooting images with a digital camera and at work on his art. Each week that the series was on the air, Cisco would post his artwork online on his blog. It was his way of expressing himself and reaching out to the world beyond his family and his community—a little like Rachel did in *Rachel's Room*, described in Chapter 13. It is this intensely personal artwork that comprises *Cisco's Journal* and enhances the linear TV show.

The idea of employing a character's blog as an enhancement to *American Family* was part of the show's concept right from the beginning, and the part of Cisco was developed with the enhancement in mind. Barbara Martinez-Jitner, the show's supervising producer, writer, and director (sharing writing and directing tasks with producer Gregory Nava), loosely based the fictional Gonzalez family on her own family experiences growing up in East Los Angeles. As a Mexican-American, Martinez-Jitner wanted to develop a TV series that would portray the complex dynamics of a contemporary Latino family to the American public, and to do so in a way that would be illuminating without being pedantic. She believed *Cisco's Journal* could help her accomplish this. It would supply pieces of the backstory and explanations about Latino culture in a highly personal, engaging way—from the perspective of one of the characters—and would also add additional emotional texture to the story. Thus, the journal was envisioned as an integral part of the fictional world of *American Family*.

"I was interested in this as a storyteller, and I wanted to see what you could do with this as a narrative experience," she told me. She felt it could be a powerful tool, especially with younger viewers, and might help draw them to the show. But it was not always easy for her to keep her vision intact. The first iTV team that worked on it wanted to use a mindless kind of polling approach, having viewers weigh in on such questions as which guy one of the female characters should date. To Martinez-Jitner, they relied too much on cliched approaches and seemed more interested in the technology than in "how to transport people emotionally." But when she brought her colleague Steve Armstrong and his company, Artifact, into the project, she found someone who shared her vision and was just as eager as she was to explore how iTV could be used as a narrative extension of a story.

The journal that Armstrong and his group produced is more akin to an artist's sketchpad than to a diary. Yet the use of visuals, sounds, and interactivity proved to be a surprisingly effective way to add dimension to the story of the Gonzalez family and to get underneath the skin of the characters, particularly that of the journal's fictional creator, Cisco. Cisco is a young man who is wrestling with his identity as a member of his family, as a Latino, and as an American, and all of this is reflected in the pages of the journal. It is a densely layered portrait of a complex character. In order to be able to produce the journal, Armstrong told me, "I became Cisco." He immersed himself in Latino culture, spent time with people Cisco's age, and listened to the music Cisco would listen to. He also worked closely with Martinez-Jitner and read all the scripts. The picture he developed of Cisco was one of an undisciplined youth who, when we first meet him, is a little detached from things. But in the course of doing the journal, he matures. He comes to appreciate himself more, discovers his powers as an artist, and gains a deeper appreciation of his culture. In other words, he moves through a classic character arc.

Figure 14.3 This diptych from *Cisco's Journal* is a memorial to his mother, who had recently passed away. Image courtesy of Twentieth Century Fox Film Corporation, PBS, and KCET.

Cisco's growth as a character is portrayed viscerally, through his artwork. Each new entry is thematically tied to a specific episode in the series and is presented as a diptych, an artwork made up of two parts, which Armstrong said is a traditional Latino form. It is reminiscent of an altarpiece made up of two tablets, though in this case, the two parts are two pages of an open journal, with the spiral spine down the center. Sometimes Armstrong would use the diptych form as a way to show complementary versions of the same subject, as in the tribute to his recently deceased mother. (See Figure 14.3.) In this diptych, her memorial candles are on one side (and they light up when you roll your cursor over them); on the other side is her beloved sewing machine (which clatters when you run your cursor over it). Sometimes, however, he would use the form as a way to show conflict, as when he portrays how his brother's feelings are torn between the love for a ballerina and his duties as a firefighter. In this case, we see a dancer twirl on top of a tinkling music box on one side, and a fire flickering on the other.

Armstrong used a mixture of artistic styles to convey what Cisco is going through at any one time, often referencing Latino artistic styles and folkloric traditions. One work features dancing Day of the Dead figures; another is an old-fashioned linoleum cut; still another models popular mural art. Most contain an interactive element that lets the viewer participate in the story in some way. For instance, for an episode about the importance of art to the community's young people, you, the viewer, could test your own ability as a spray paint artist. (See Figure 14.4.) In another, you can wish upon a star and actually have it join the scrolling wishes of other viewers; in still another, you could play a retro video game and try to rush a character who has overdosed to the hospital.

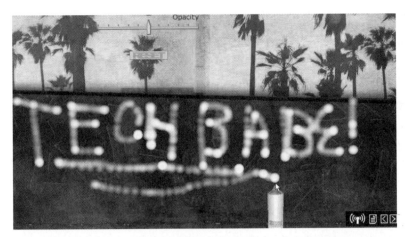

Figure 14.4 In this entry of *Cisco's Journal*, the viewer can become a spray paint artist. Image courtesy of Twentieth Century Fox Film Corporation, PBS, and KCET.

However, Armstrong did not want everything in these entries to be immediately obvious. "I wanted it to be a process of discovery," he said. "I wanted people to say: 'Oh, I didn't know that was there!'" He uses this technique in the diptych with his mother's pearl necklace, described in Chapter 6. In the TV episode, his father is about to go on his first date since his wife's death, but the idea of going out with another woman has stirred up some powerful feelings. As you roll your cursor over the pearls, they fall like tears on the matrimonial bed. But if you happen to look carefully at the opposite page, you can see the face in the mirror change from the image of the mother to the image of the other woman.

At first, PBS did not quite grasp what Armstrong and Martinez-Jitner were trying to achieve, and regarded *Cisco's Journal* as just another website. They wanted Armstrong to put a PBS banner across the top and add typical Web drill-down features about the show and its cast. But Armstrong stoutly denied that it was a website, contending that it was a fictional extension of the *American Family* story. To add banners and other Web features, he asserted, would eliminate its believability in terms of the story. For the same reason, he did not want to include the traditional navigational features of the Web, menus and buttons and so on, maintaining that Cisco was an artist, not a Web master. Ultimately, PBS came to understand the journal's conceit, recognizing that everything in it was done as if it were the work of the teenage character. This concept served as the touchstone of the entire *Cisco's Journal* project and was fully endorsed by Jackie Kain, VP of New Media at KCET, the PBS station that produced the journal. "It was all done in the persona of Cisco," she said. "It was a very clearly-decided creative choice. It can drive you crazy sometimes, but that's Cisco." And PBS is clearly pleased with how it turned out, having ordered new episodes of both the series and the journal.

Looking back now on the unique work they managed to produce, Armstrong maintains that they were not consciously trying to push the envelope. "We just wanted to solve the creative and character development issues as we confronted them," he said. "We would just ask 'who is Cisco, how would he react, and what are the materials he has on hand?'" As simple as these questions seem, by staying focused on them, they were able to create a completely new way to enhance a

television program, one that portrays a sophisticated character arc and resonates on a deep emotional level, all with a minimum use of words.

CONCLUSION

It would be nice to think that iTV, like Cisco, could move through a character arc and could metamorphose from an unsure adolescence to a more mature and dependable entity, capable of supporting strong artistic visions. Certainly, we can find some hopeful indications that this day is coming. We know that when television viewers have the opportunity to try out iTV, they find it engaging. Audiences in the UK have demonstrated that even middle-aged couch potatoes, when presented with something that interests them, will happily participate. And we can also find a number of creative individuals who believe in its potential and are pushing forward on the development front. If and when the technological and financial hurdles are eventually surmounted, it is possible that iTV may finally become, in the words of the folks at AFI, "just television."

IDEA-GENERATING EXERCISES

1. If possible, watch and interact with either a single- or dual-screen iTV program. Analyze the experience, noting whether the interactivity detracted from the linear program or whether it made you feel more involved with it. What aspects of the interactivity, if any, did you think worked particularly well? What aspects did you think were less than successful? What changes would you suggest making?
2. Record a non-story-based TV show, such as a cooking show, a news analysis show, or a children's show, so you can study it. Once you are extremely familiar with it, work out some ways to add interactive enhancements to it.
3. Record a TV documentary, drama, or comedy. Once you have studied it closely, work out some ways to add interactive enhancements to it, first deciding what the goal of these enhancements should be.
4. Sketch out an idea of an original iTV show, either a single program or a series, in which the interactivity is integrated into the concept. What would the objective of these interactive elements be and how would they work with the linear content?

15

Cross-Media Productions

How can you tell a story by integrating the content across several different media, and what makes this approach so compelling?

In the cross-media projects thus far implemented, what techniques have proven to be most successful, and which have not worked out?

How is the cross-media approach being used for nonfiction endeavors like documentaries and reality-based projects?

A NEW FORM OF IMMERSIVENESS

At three cities across the United States, dozens of people attend passionate rallies sponsored by a group opposing the emancipation of robots. The rallies are real, although they pertain to issues set in the future, in the year 2142, not in 2001, when the stormy protests actually take place. At about the same time, a young girl sends a moving email to her friends, mourning the death of her grandmother, and she receives 340 sympathetic condolence messages in return. The young girl is a fictional character, but the people who write to her are real. And within that same few weeks, at some unidentified location, a musician tunes up his lute and prepares to play a piece of sixteenth-century music, hoping it will help him find clues to a murder mystery.

What exactly is going on here? As it happens, these people have not collectively lost their minds. Instead, they are all participating in a deeply immersive, narrative-rich game, a murder mystery. Nicknamed *The Beast*, it was made by Microsoft to promote the Dreamworks movie, *AI*, by Steven Spielberg. The game belongs to a new genre of interactive entertainment called a cross-media production.

A DIFFERENT APPROACH TO CONTENT

Until recently, the majority of entertainments were created for a single and specific medium—for the stage, for example, or for the movie screen, or for a video game console. But cross-media projects take a different approach. In these productions, a property is designed from the ground up to "live" simultaneously on multiple platforms, at least one of which is interactive. Cross-media productions are relative newcomers to the interactive entertainment scene, first introduced in about 1999, yet they have the potential of becoming the way an increasing number of entertainment projects will be developed in the years to come.

The cross-media approach is such a new way of thinking about entertainment that we still do not have a commonly accepted terminology to use for it. While many are calling it "cross-media production," it is also known as "networked entertainment," "integrated media," "cross-platforming," and "cross-media platforming." When used for a project with a strong story component, it may be called a "distributed narrative." Gaming projects that use the cross-media approach may be called "pervasive gaming" or sometimes "trans-media gaming." When this kind of gaming blurs reality and fiction, it is often called "alternative reality gaming" or an "ARG." All these terms indicate an adherence to the same principles:

- That the project in question exists over more than a single medium.
- That it is at least partially interactive.
- That the different components are used to expand the core material.
- That the components are closely integrated.

Cross-media productions must combine at least two media, though most utilize more than that. The linear components may be a movie, a TV show, a newspaper ad, a novel, or even a billboard. The interactive elements may be the Web, a video game, wireless communications, or a DVD. In addition, these projects may

also utilize everyday communications tools like faxes, voice mail, and instant messaging. Some of these projects also include live events. As many as one million people, sometimes more, may actively participate in a cross-media entertainment. In terms of what media such a production may include, the choice is totally up to the development team; no fixed set of components exists for these projects. Any platform or medium that the creators can put to good use is perfectly acceptable in these ventures.

As we saw in Chapter 3, which dealt with convergence, the first such project to make a splash in the United States was *The Blair Witch Project*, which debuted in 1999. Though it was made up of just two components, a movie and a website, it dramatically illustrated the synergistic power of using two media to tell a story. Since then, many production companies have used this technique to promote movies or TV shows, often using a story-rich website to expand the fictional world depicted in the linear property.

Recently, however, a new kind of cross-media project has been introduced, far more ambitious and innovative in nature. This new form of entertainment contains both story and gaming elements and utilizes multiple components. It may also use common communications tools to eerily simulate real life. Among the most significant of these are *Majestic*, from Electronic Arts; *Push, Nevada*, from LivePlanet; and the project described at the beginning of this chapter, generally known as *The Beast*, which is believed to be the first such project to be introduced to the public. Another major entertainment brand to employ the cross-media approach, although in a somewhat different way, is the cluster of properties developed around *The Matrix*. The cross-media approach is also starting to be used for nonfiction properties as well, particularly for public television projects.

The use of the cross-media approach is spreading throughout the world. In South Africa, for example, the reality show *Big Brother Africa* has been designed from the ground up to span a variety of media, as has the Danish music video show *Boogie*. From Finland and Sweden, we can find a cluster of clever cross media games centered on mobile devices (discussed in detail in Chapter 17). Great Britain is by no means being left in the dust here, particularly thanks to the BBC's mandate that all its programs include an interactive element. The BBC is no longer thinking in terms of single-medium programming but is consistently taking a more property-centric approach. We saw one example of a show that grew out of this way of thinking in Chapter 3, *FightBox*, a TV show with virtual warriors that are built and trained on the Web.

To get the most from the cross-media approach, production entities that work in this area usually tackle such a project as a total package, as opposed to pasting enhancements onto a linear project. This is the philosophy that guides the South African firm Underdog, for example, which has helped develop the three *Big Brother* series. Underdog specializes in cross-media and is the leading producer of such projects on the African continent. Luiz DeBarros, Underdog's Creative Director and Executive Producer, stresses the importance of considering the total property instead of a single aspect of it. He says that at Underdog, they take the approach that a brand or property is separate from the platform. "Today, they are no longer the same thing," he emphasized. "In other words, we develop brands, not TV shows or websites, and we aim to make them work across a number of platforms. The brand dictates the platform, not the other way around."

DeBarros went on to give an excellent nutshell definition of the cross-media method of development, saying "a cross-media brand is a property that has been

created specifically to be exploited across several media in a cohesive and integrated manner." He said that his company's mission grew out of the growth of new technologies, including the Internet, "that allow for interaction and communication." His company has found that television programmers are eager to develop new ways to connect with the audience, and to employ content and strategies that will help accomplish this.

THE CREATIVE POTENTIAL OF CROSS-MEDIA PRODUCTIONS

While some of the motivation to create cross-media properties stems from promotional goals or the desire to build a more loyal audience, commercial considerations are not necessarily the primary attraction for those who work on them. Some creative teams are drawn to this approach because of its untapped creative potential. In fact, I was fortunate enough to consult on such a project with my colleague Linda Seger. We were invited to assist with a highly innovative project from Denmark called *E-daze*, which was entirely original (not based on any existing property) and was self-funded by its three creators.

A contemporary story of love and friendship set against the turbulent background of the dot com industry, the *E-daze* story followed the same four characters across five interconnected media: the Web, a feature film, an interactive TV show, a novel, and a DVD. Each medium told the story from a somewhat different angle, and in its use of the website and the interactive TV show, *E-daze* found clever ways to involve the audience and to blur the lines between fiction and reality. Unfortunately, its creators were not able to secure the necessary financial backing to move it beyond the development stage, although it attracted considerable interest. Nevertheless, the *E-daze* project illustrated the unique ability of a cross-media approach to import a rich dimensionality to a property, and to tell a story in a deeper and more life-like, immersive way than would be possible via a single medium. It is no wonder that many creators of such projects find the experience exhilarating despite the many complexities they inevitably generate.

THE BEAST

Although such projects are fascinating from a creative standpoint, they are also extremely challenging to produce, and each project undertaken in this area has its own special demands. Take, for example, the project made in conjunction with the movie *AI*, generally known as *The Beast*. Although it was created to promote a movie, it was a stealth kind of promotion that depended on viral marketing to make itself known. No elements of *The Beast* even referred to the movie. No announcements were made to direct people to the game. The project was not even given a formal name—it received its nickname, *The Beast*, because at one point its asset list totaled 666 items, the numeric sign of the Devil. *The Beast* name stuck, no doubt in part because its puzzles were so fiendishly difficult to solve and because its story elements were so complex and challenging to piece together. The people who played it were united by a common goal: to figure out who killed a fictional scientist named Evan Chan, and to learn why he was murdered. It attracted over a million participants (some peg the number at two and one half

million) and unfolded much like a live drama. Its creative team had to work at a feverish pace to keep one step ahead of the players.

A GAME OR NOT A GAME?

But was *The Beast* even a game? Its creators stoutly refused to acknowledge that it was. For one thing, it was as much a story as it was a game, with structured story arcs, fully developed characters, and an emotional punch. Yet it was a totally new kind of story, scattered across a multitude of websites and other elements. Furthermore, it eschewed most of the common elements of gaming. It had no rules, no prizes, no stated objective. Instead, one of its most compelling qualities was the way it played with the line between reality and fiction, and the manner in which it invaded the participants' lives.

The Beast communicated in part via everyday methods of communication like telephone calls, faxes, and emails. It penetrated the real world even further by staging live events, like the anti-robot rallies mentioned earlier. Most of the game and story elements, however, were meant to be uncovered by visiting dozens of websites, all of which were completely realistic looking and bore no traceable link to the movie or to Microsoft. The copy on these websites, as well as their graphic design, was entirely in keeping with the various organizations or individuals who were purported to own them. Only one aspect of these websites indicated that they were not as authentic as they seemed to be: They all pertained in one way or another to the future, to the year 2142. Though the players recognized that the mystery was a fiction, and that the story was set decades in the future, the realism of *The Beast* made it possible to temporarily suspend disbelief and to plunge the players into the drama of the story.

As one scholar who has extensively studied *The Beast* pointed out, the game offered a new kind of "virtual reality." Jane McGonigal, a Ph.D. candidate at the University of California at Berkeley, noted that until *The Beast* came along, VR was always created artificially, using hardware like wired gloves or headsets. But in this project, she says, "the immersive aesthetic proposed by *The Beast* sought to use *natural settings* as the immersive framework." She goes on to say: "*The Beast's* alternate reality required no tool or vehicle outside of a player's ordinary, everyday experience.... *The Beast* recognized no game boundaries; the players were *always* playing, so long as they were connected to one of their many everyday networks" (*Fine Arts Forum*, Volume 17, Issue 9, August 2003). She also points out that *The Beast* does away with the line that normally demarcates a game from regular life. Though she does not state it in these terms, what she is referring to is *The Beast's* similarity to the way certain playwrights, particularly Luigi Pirandello, dissolved the fourth wall in their works for the theatre. Woody Allen did much the same thing in *The Purple Rose of Cairo*. (For more on this technique, see Chapter 1.)

THE ORIGINS OF *THE BEAST*

The *AI* game is such a groundbreaking project that it deserves to be studied closely; many important lessons about cross-media productions were learned in the process

of doing it. It all began early in January 2001, when the creative team of *The Beast*, who came to be called "the Puppetmasters," assembled at Microsoft and began to lay out the bones of the project. The team consisted of four members: Jordan Weisman, who created the core idea of *The Beast*, served as Executive Producer. Elan Lee and Sean Stewart were the project's co-lead designers, and Stewart would also be the lead writer. Pete Fenlon would write segments of the game and handle contracts.

Because the team was not allowed to alter the movie plot in any way, they set the story forty years into the future of the movie's world, somewhat like a sequel. This gave them the opportunity to take a child character from the movie and put him in the game as an adult, giving him a personal agenda that is rooted in the film. Furthermore, they were able to tap into major themes explored in the movie, like the status and rights of sentient beings—robots with highly sophisticated AI. In fact, the first clue that tipped people off to the existence of the game was a strange piece of information included in a trailer for the movie. A woman named Jeanine Salla was given credit as the film's "sentient machine therapist"— in other words, a shrink who treated robots. A little online research by a curious observer of this credit would uncover the puzzling looking Salla family website, made by Dr. Salla's granddaughter (see Figure 15.1). It in turn linked to a number of other odd websites, all set in the future, and the game was off and running.

Looking back now on *The Beast*, it is possible to see a similarity between it and *The Blair Witch Project*. After all, both projects were designed to promote a movie, and both did so in a manner that obscures the line between reality and fiction. However, the Puppetmasters refute the idea that *Blair Witch* was an influence for the project. Instead, they say Weisman's inspiration came from the Beatles, with their "Paul is dead" mock mystery. The Beatles planted clues about Paul's supposed demise in song lyrics and record album jackets…clues that ardent fans tried to decipher. Weisman, fascinated by what the Beatles had created, proposed that they spread their story and puzzles around in a similar way, but using the new technologies which were now available. He also proposed another daring idea: that they design the game's puzzles in such a way that no single person could solve them. Their solution would require a massive collaborative effort on the part of the players.

AN ENORMOUS GAMBLE

The Puppetmasters worked together for three months before *The Beast* went live, building websites and puzzles and putting together an outline of how the game and story would develop. But they had no way of knowing whether or not the players really would work together, or, if they did, if they would manage to solve any puzzles. Finally it was the moment of truth—the game was launched. And much to their mingled delight and horror, the players not only collaborated, but did so so effectively that they solved the first batch of puzzles in a single day—some of which the Puppetmasters considered so difficult that they were uncertain if they could ever be solved, at least not without additional clues.

Faced with such a powerful degree of amassed brainpower, the creative team realized they would have to throw away their outline and work at a frantic pace to produce new material for the game, and do so on a continual basis. They were

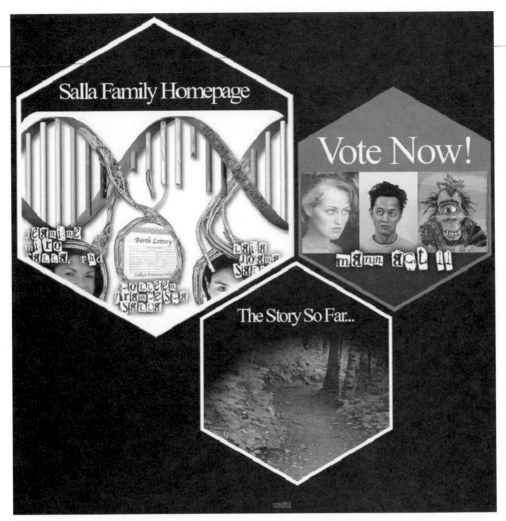

Figure 15.1 The Salla family home page on the Web was the portal through which most players entered the futuristic world of *The Beast*. (Image courtesy of Microsoft.)

also committed to being responsive to the players' reactions to the story material. So, instead of just blindly following the plot they'd laid out, they reshaped things as *The Beast* progressed. For example, one character, the Red King, whom the Puppetmasters had regarded as just a minor figure, so intrigued the players that they significantly enlarged his role.

Soon after the game went live, several thousand hard-core players joined forces and worked together in a tightly knit online association, the Cloudmakers. They collaborated in finding and interpreting clues and solving the puzzles, and posted thousands of messages speculating with each other about the twists and turns of the story. Two of its members, the brothers Adrian and Dan Hon, wrote a walkthrough (*The Trail*) and an exhaustively detailed guide to the game as it was unfolding. The group grew to about 7500 members by the end of the three-month period over which the game took place. The relationship between them and the Puppetmasters was somewhat symbiotic, and each side appreciated and admired what the other side was doing. In fact, it was the Cloudmakers who

gave the games' creators the respectful title of Puppetmasters, and they held them to a high standard. So proud were the Cloudmakers of their puzzle-solving skills, and so fond were they of *The Beast*, that they have continued to maintain their website (*www.cloudmakers.org*). The site contains links to its archived websites, Dan Hon's walkthrough, and Adrian Hon's guide, which includes an excellent postmortem. The materials on the site comprise a fascinating study of the game.

THE WEBSITES MADE FOR *THE BEAST*

Although *The Beast* would not publicly admit to being a game, it did contain two elements of classic interactive games: puzzles and a narrative line. In order to follow the story of Evan Chan and the half-dozen or so other major characters, and to be able to solve the murder mystery, it was necessary to solve the puzzles. Although some of the story material and puzzle pieces were relayed via emails or faxes from characters, or by other forms of communication, the bulk of the narrative and the puzzles were embedded in a multitude of websites.

The websites were the workhorse component of *The Beast*. The game contained close to four dozen discrete URLs, but when secondary links and pages were tallied up, the websites numbered in the hundreds. Many could be accessed only after solving a puzzle. They not only contained text and graphics, but often Flash animation and audio as well. Some also contained video clips—about thirty minutes of video were shot for *The Beast*.

Like websites in the real world, these varied enormously in style. The copy for each was written in a style appropriate for its owner, just as a character in a screenplay speaks in his or her own unique voice. The diversity of writing styles was much appreciated by fans of the game, who enjoyed it as much for its high-quality writing as for its clever puzzles. Some of the websites were folksy personal home pages; some were elegant corporate sites; others were the utilitarian sites of government or educational institutions; still others were stridently militant in nature, arguing for a social cause. Although in the ordinary world, websites are meant to serve a pragmatic purpose, the websites designed for *The Beast* could actually be considered little works of art, of a new kind of dramatic narrative. Each was a tiny fictional universe, capturing the essence of one of the story elements of the game—a character, a cause, or a business. (See Figure 15.2.)

One of the websites, made for a fictitious magazine, *Metropolitan Living Homes*, was so cleverly done that it even caught the attention of *Architectural Digest*, which offered to judge the houses described on the site for a competition. The bulk of the *Metropolitan Living Homes* material was written by Puppetmaster Pete Fenlon, who managed to capture the essence of the promotional style of the upscale home design market and simultaneously skewer it at the same time.

THE PUZZLES

The most game-like elements of *The Beast* were, of course, the puzzles. In order to promote collaborative puzzle solving, the Puppetmasters had to design them in such a way that they required a greater sweep of knowledge than any single individual was likely to possess. Some, in order to be solvable, also required critical

Figure 15.2 The Belladerma Web home page from *The Beast* promotes the sexy artificial companions the company manufactures. One of its products, a robot named Venus, is a suspect in the murder mystery. Image courtesy of Microsoft.

pieces of information found in geographically separate places. Still others called for unusual devices or special technologies like a certain type of Japanese cell phone or sound editing software. Many required fairly uncommon skill sets like translating archaic languages or analyzing pixels. The collective intelligence of the puzzle solvers, all put to use in the game, included the ability to read and play sixteenth-century lute tablature, translate medieval Japanese, derive meaning from lines plucked from assorted works of classic literature, and find clues in a strip of DNA. Of the four members of the creative team, Elan Lee was considered the master "Puzzle Guy." He poured his artistry and imagination into the task, creating puzzles that subtly reflected the personalities of the fictional characters who supposedly made them. The ones "designed" by a character named Sencha, for example, had an austere, Japanese aesthetic, while those of the eighteen-year-old Red King were geeky and math oriented.

Not all the puzzles were meant to be tremendously hard to solve. Some, especially at the beginning of the game, were designed to appear baffling but to be fairly simple to figure out, to give players confidence in their ability. For example, the game's chemistry puzzle looks extremely intimidating (see Figure 15.3), but can be worked out by pretty much anyone who thinks of downloading the periodic table of the chemical elements. The puzzle is written as an equation, with pluses and minuses between each element. To solve it, you use the abbreviated alphabetic

Figure 15.3 The chemistry puzzle from *The Beast* seems much harder to figure out than it actually is. Image courtesy of Microsoft.

symbols of the puzzle's elements (Co, Hg, and O, for example), string their symbols together, and add or subtract as indicated. When you do, the letters spell out "coronersweborg," which is clearly the URL for a website—a coroner's office. If you visit it, you might be able to learn more about the murder victim, Evan Chan.

A NEW FORM OF STORYTELLING?

Sean Stewart, the lead writer and codesigner of the project, regards *The Beast* as a prototype for a new form of fictional narrative, calling it "the storytelling of the twenty-first century." Stewart's perspective of the project is that of a novelist, which is his primary occupation. Before being tapped for *The Beast*, he had written a number of highly regarded works of literary science fiction and fantasy. He had been recommended to Weisman by Neal Stephenson, author of the classic cyberpunk novel, *Snow Crash*. But what sealed the deal for Weisman was the fact that Stewart was an experienced player of live role-playing games. Furthermore, Stewart had not only been a games' master but had also designed some games. Weisman knew Stewart's understanding of role-playing games would come in handy.

Describing himself as not the sort of person whose spare time revolved around Zelda and BattleTech, Stewart took up the challenge of the *AI* project with the same high standards he brought to his novels. He treated the story and its characters with respect and worked hard to give the narrative an emotional depth. He considered himself a pioneer in a new kind of literature, and found the experience liberating. "When you are writing novels," he said, "the bar has been set a long time ago." That bar is extremely high, he noted; you are judged against works like *Pride and Prejudice* and the books of William Faulkner. But in this form, you aren't dealing with that kind of preestablished competition. "It's refreshing to know you can trump any character in *Donkey Kong*," he commented.

His efforts did not go unnoticed by the games' players. They became deeply attached to certain characters, and on the Cloudmakers' website they commented positively on the story. This new kind of storytelling was also appreciated by journalists covering the *AI* game. For instance, Josh Robertson, writing for *Yahoo! Internet Life* (July 2001) said: "Here we have sites, images, sounds, words, plot, nuance, intrigue—a ripping good and often poetic yarn that's as much a work of art as any novel or movie."

What made the project totally unique from Stewart's point of view was the way "little packets of information, fragments of narrative" were scattered around in so many places, on the Web and beyond. Looking back now on what the Puppetmasters had created, he considers *The Beast* to be a new genre, one that he terms "distributed narrative." This type of storytelling, he notes, places the onus on the audience to gather the pieces and make sense of them, somewhat like assembling a jigsaw puzzle.

Though working on the game required Stewart and the other Puppetmasters to be trailblazers, and had them bushwhacking through some totally unexplored territory, Stewart recognized that in some ways his writing role was not too unlike what other writers had done before him. Essentially he saw himself as following the old-fashioned craft of serial writing, a form of fiction that Charles Dickens had practiced so successfully in the nineteenth century. But, of course, a few things made this particular writing job unique. The story was being told via methods of communication that had never before been used for telling stories before, such as the Internet and phone calls, and was a collaborative experience between the authors and "the audience."

These critical differences turned the job of creating a serial into something quite different, and it was the new technology that made it possible. He and the others were just learning what could be done with it, and it was impossible to foresee how this new genre might develop. As Stewart pointed out, the novel could not exist until someone invented the printing press. In a similar way, a narrative like *The Beast* could not exist without the development of interactive communications devices. "Anything that allows you to lie will become an artistic medium," Stewart asserted. After all, what are stories, but artistically presented lies? Stewart believes that someday people will look back at *The Beast* the way we now look back at the quaint "horseless carriage." These early motorized automobiles closely resembled the buggies they replaced, because buggies were the logical model for the manufacturers to draw from. Perhaps, he speculates, *The Beast* will seem more like a narrative version of the horseless carriage than of a sleek modern car, though he hopes the Puppetmasters managed to push the genre beyond its most primitive possibilities.

Interestingly, Stewart discovered just how distinct a genre *The Beast* was when he tried to turn it into a novel. He found that it resisted adaptation. "As a distributed narrative," he said, "you came to know the characters in bits and pieces, in little scraps." Though this technique had worked well in its original milieu, it just wasn't very satisfactory in a novel.

THE PLAYER-CREATOR RELATIONSHIP

From Stewart's experience as a game master, he recognized that an interactive game like *The Beast* had to be a two-way process. The creators could not just put some-

4

thing out there on the Net and leave it at that. They had to be responsive to the players, and give them a certain amount of behind-the-scenes direction. As he put it: "Once you let them drive the car, you have to stay in the car."

The game was updated on a weekly basis. The pressure to add new elements and to stay ahead of the players was "remorseless," Stewart said. He estimates he spent five or six hours a day on the phone with Elan Lee, collaborating on the story and puzzles. For the seven months he worked on *The Beast*, he thinks he put an average of a hundred hours a week into it. He compared working on the project, during the period in which it was live, to the intensity of performing at a three-month-long rock and roll show—like being on stage when things are really clicking, he said. On the one hand, he said, you are feeding off the energy of the audience, but on the other hand, you have the nervous apprehension that you might stumble in some embarrassing way. And if you do, thanks to modern communications technology, your lapse will be broadcast instantly to everyone.

He looks back now on the harrowing experience as something of a lifetime high, a little like a World War II vet regards his time on the battlefield. "I'm never less than jubilant that I had the chance," he reports. Yet he couldn't help but feel relieved when it came to an end. And it needed to end for the players' sake, too, he thought, because while they were playing, some of them became so wrapped up in it that they jeopardized their jobs and their relationships. As Stewart says, people had to get back to their lives. "It was exhausting. You can't live like Sherlock Holmes all the time."

THE STORY AND THE PLAYERS' IMPACT ON IT

Stewart described the basic structure of the story as having five arcs, something like the acts in a play or the movements of a symphony. These arcs had a certain degree of closure, but also contributed to the building of a larger story. The plotlines started as far away as possible from the story in the film, but they gradually converged and pointed to the events portrayed in the movie. And although Stewart and others on the creative team controlled the basic beats of the story, they did give the players a hand in deciding how it would end. The ending revolved around whether or not the robots would be freed, and the Puppetmasters put that decision up to the players, and let them vote on it. They videotaped two possible versions of the ending, one for each way the vote might go, and in the end, the players voted for the robots' emancipation. "The players genuinely affected the world," Stewart said. "Their vote determined the fate of intelligent machines." But though it gave the players an illusion of control, the vote actually had little effect on other elements of the overall story. "It just drove the way I wrote the wrap-up pieces, and determined which of the videos we aired," Stewart said.

That being said, Stewart said that like all pieces of art, *The Beast* was open to multiple interpretations, and even the games' two protagonists voted differently. "I think it's just fundamental to good art," he asserted, "that one tries to present a complex situation in some completeness, respecting the integrity and dignity of the characters, and allow people to draw their own conclusions on the meaning of what they have seen."

WHY SO ADDICTIVE?

As indicated by the amount of time the players poured into the game, *The Beast* had a certain addictive quality. What made it so powerfully engaging? Certainly, part of it was the desire to solve the mystery, to uncover the secrets hidden in the story, to see the plotlines resolved. Stewart points to another possible reason: Because *The Beast* entered the players' daily lives in the way it did, it pulled them right into the drama. The game gave them a heightened sense of reality, of their lives being less humdrum and more dramatic and intense. Every aspect of their lives had the potential of being part of the unfolding murder mystery. When the phone rang, a player would never know whether it was his mother on the line, or one of the characters in the game.

Stewart also suggests that the game empowered the players in a highly intoxicating way. It gave them the sense that by working together, they could solve any challenge; that collectively they were incredibly smart, far smarter than they were as separate individuals. He compared their collaboration to the way scientists in the seventeenth century worked together, each delving into one specific area, convinced that if they applied themselves and combined their findings, they would soon be able to unravel all the secrets of the universe. The Cloudmakers felt so empowered, in fact, that some of them actually believed they could "solve" the 9/11 terrorist attacks. Others had to remind them of the significant differences between dealing with a real-life event and solving a game like *The Beast*.

THE POWER OF THE PUZZLES

The games' puzzles were another intensely powerful draw. Stewart admits that their appeal was more than just good design work on the part of the Puppetmasters—they were actually presented in such a way as to be addicting. This is an admission not unlike the tobacco industry's acknowledgment that they added extra nicotine to their cigarettes to hook the smokers. Of course, the game was a benign activity, an entertainment, not something that threatened anyone's health. Yet the Puppetmasters did apply a scientific technique to the puzzles to keep people riveted to the game. Stewart termed it a "variable ratio reinforcement schedule," something used successfully with laboratory rats. In the lab, rats are rewarded for doing a particular task at irregular intervals, so the rat perceives that if he keeps repeating a particular action, he will eventually be rewarded. The unpredictability and the desire for the reward keeps him engaged. Stewart noted that the same principle applies when people play the slot machines. Varying the difficulty level of the puzzles, but making them "crackable," enabled players to trust that if they kept at it, they would be rewarded.

This element of trust, Stewart said, is important to games like *The Beast*. Players must trust that the time they invest in the game and its puzzles will have a payoff, even though they might have to endure periods of being confused or frustrated. Some of the best puzzles, he believes, have a way of showing you that you are going in the right direction as you work them out, giving you little rewards along the way. Without the faith that the game is worth their time, players will not be motivated to continue playing. One way to build this trust, according to Stewart, is to give them a major reward when they solve a puzzle, commensurate with the

difficulty of the puzzle. "If they work hard on a puzzle, there had better be a really exciting thing on the other side of the door," he stressed.

CAN YOU TAKE AWAY THE PUZZLES?

But what if you took away the puzzles, or had players who simply didn't want to spend time solving them... could *The Beast* just be enjoyed as a story? Stewart says many participants experienced *The Beast* in just that way. The Puppetmasters referred to them as "lurkers." They followed the events of the story and the puzzle-solving by reading the discussions on the Cloudmakers site. This way, they could enjoy the vicarious pleasure of seeing puzzles solved without having to do the work themselves. They could receive emails, call the phone numbers of the fictional characters or institutions, and visit the websites that interested them. "Most people are lurkers," Stewart said. "They like to eavesdrop. You've got to make things fun for them, and not obligate them to play."

Nevertheless, Stewart believes both the story and the puzzles were critical parts of *The Beast*. The story was important, he said, because "if you don't have a cool story, you are dead. Narrative always works. It is a very well-tested medium." As for the puzzles, he said, they added the important element of interactivity and provided an impetus for the players to collaborate and form a community.

WHO PLAYED THE GAME?

As one might expect, when the game was first launched, it attracted far more males than females, and the typical player was a young guy in his sophomore year in college. But interestingly, this began to change as the weeks went on, and more women joined in. During the last six weeks, Stewart said, fifty percent of the new players were women. He largely attributes this to the fact that *The Beast* had a compelling story and characters, and had emotional depth. "You'll lose your lurker female real fast if it doesn't have emotional depth," he said. "But guys like a story that gives them emotional satisfaction, too." He also believes that it was a big asset to have a major character who was an attractive, complexly drawn young woman, because she appealed to both male and female players.

EXPANDING THE DEMOGRAPHIC

Could this genre, the distributed narrative, work for a larger audience? Stewart believes that it could, with certain modifications. For one thing, he suggested, you could lower the bar by making it less dependent on technology and more about story. "The alphabet never crashes," he noted. Furthermore, you could make it less game-like and less about puzzles, though "once it involves a computer, you can scratch your elderly aunt." But, he believes, a story in this genre does not have to be restricted to science fiction or fantasy. For a different kind of audience, he thinks you could even tell a story like *The Bridges of Madison County*.

But what about the ultimate challenge: creating a work of distributed narrative that satisfies both the hard-core gamers and the people who are just after the story?

Stewart thinks many possible strategies could be used to accomplish this. For instance, you could develop a story with six major characters to follow. Five out of six could be followed without the need to solve puzzles, but pursuing character number six would require some serious puzzle work—giving something to both kinds of players. As for the other strategies? Well, it's still early in the game. Stay posted. After all, it took years for the horseless carriage to stop looking like a buggy and evolve into the modern auto.

SONS OF *THE BEAST*

When *The Beast* wrapped up in July of 2001, many of its players hoped that similar games would be forthcoming. Indeed, several new ARGs made their appearance in the months that followed. Unfortunately, none of them lived up to the expectations that *The Beast* had raised. Just months after *The Beast* came to an end, a group of players who had been active in the Cloudmakers announced they would be launching their own ARG, code-named *Lockjaw*. Modeled closely on the *AI* game, it unfolded over multiple media, contained a narrative, and called for the solving of puzzles. Close on its heels were the ARGs named *Chasing the Wish*, *Acheron*, and *Plexata*. Although none of them managed to stir up the widespread enthusiasm enjoyed by *The Beast*, the fact that they were made illustrates the interest in this new form of entertainment. To further underscore this interest, several websites have been established that focus exclusively on ARGs, including the ARG Network (*www.argn.com*), Unfiction (*www.unfiction.com*), and Martha's Boarding House (*www.marthasboardinghouse.com*). In addition, the Cloudmakers' website continues to serve as a clearinghouse for this type of game.

MAJESTIC WADES INTO THE WATERS

Although the majority of ARGs that debuted after *The Beast* are little known, one heavyweight contender in this genre did enter the market, the highly anticipated *Majestic*. Produced by Electronic Arts, the game revolved around a contemporary story with an intense conspiracy-driven plot. It was largely played on the Internet, and its characters communicated with the participants by instant messaging and email, though they also sent faxes and made phone calls. Players could uncover clues and follow the narrative by carefully investigating realistic looking websites. They could also download videos that had been "shot" by the characters and listen to audio messages.

 Majestic was by far the most ambitious and generously funded ARG since *The Beast*. It was also well publicized, and unlike any of the others, it managed to penetrate the consciousness of even nongaming members of the public. Unfortunately, it fared poorly in the marketplace. The game was never able to achieve the critical mass it needed to sustain itself, and EA had to pull it just several months after its launch.

 Because *Majestic* made its debut several months after *The Beast* did, in the summer of 2001, many people erroneously believed it was imitating the Microsoft game. In truth, however, the development teams of the two games just happened to be working along parallel tracks. The emergence of these games within such a close span of time was sheer coincidence. Certainly, however, they were both

spurred by similar perceptions: that the Internet was robust enough to use for a new type of gaming; that various communications technologies could be used in conjunction with the Internet to simulate real life; and that people might enjoy a game that blurred the lines between games and reality.

However, significant differences existed between the two games. For one thing, *The Beast* took a surreptitious approach to making itself known, depending on viral marketing, and hiding the fact it was a fiction, while *Majestic* mounted a multimillion dollar marketing campaign to publicize itself, and in doing so, flagged the fact that it was a game. This certainly undermined its ability to make the events of the story seem real and believable. For another thing, *The Beast* was free, while *Majestic* was a subscription service, charging about $10 a month. And *The Beast* was a continuous, unbroken playing experience, while *Majestic* was divided into episodes.

But perhaps more significant than these differences were their dissimilar approaches to content. *Majestic* was designed for solo play and did not lend itself to the collaboration so important to playing *The Beast*. Furthermore, players had virtually no way to have an impact on *Majestic's* storyline or to affect the way the game proceeded. It was stubbornly unresponsive. The Puppetmasters of *The Beast*, on the other hand, stayed keenly in tune with their players. They tooled and retooled the game with them in mind, gave them ways to feel involved, and let them decide on the ending.

TWO MASTERS

Quite possibly, *Majestic* tried too hard to serve two masters, and was unable to please either one sufficiently well. According to Neil Young, the EA executive who created *Majestic*, the game hoped to attract both the newbie player and the experienced gamer. The company believed that by having an exciting story, by painting the game on a new kind of canvas, and by inventing a compelling concept—"the game that plays YOU"—they would draw people who did not normally play games. They also felt that by offering the game in monthly episodes, with about thirty minutes of playing time a day, they would appeal to older gamers. These gamers, it was felt, still yearned for interactive entertainment, but no longer had the time for demanding games like *EverQuest*, due to career and family responsibilities. This game would let them play in short bursts.

But serving two masters well is an almost impossible juggling act, and often both parties feel shortchanged. That certainly proved to be the case with *Majestic*. The newbies complained about having to download the tools needed to play the game, and had trouble following the clues and solving the puzzles. Meanwhile, the experienced gamers grumbled that the puzzles were too easy and that *Majestic* was not challenging enough.

Nevertheless, EA's enormous investment in the game, estimated at some $10 million, was not entirely wasted, and many believed *Majestic* had true potential. The game started out well, with 100,000 players signing on for the free pilot. Some of the websites created for the game looked so real, and the organizations that supposedly owned them seemed so authentic, that a number of people even sent them their resumes, hoping for a job. Fans actively got into the act, creating thirty biographic websites for secondary characters, and producing an additional

380 fan sites. The game's assets were generally of high quality, with video and audio segments made by Hollywood professionals, and it utilized a clever IM system in which bots realistically conversed with the players.

The story, too, seemed promising. Written in part by a Hollywood feature film writer, it got off to an ingenious start. Soon after players signed up for the game, they would receive a shocking fax saying that the game had to be suspended—a fire had destroyed *Majestic's* development company, Anim-X studios. The fax was on the EA letterhead and signed by the EA customer service department; it looked completely authentic. Actually, of course, the document was just part of the game. It was an effective way to thrust the player into a tale involving youthful high-tech professionals—people probably much like themselves or their friends—who become unwittingly sucked into a conspiracy involving aliens, government mind control experiments, and New Age mysticism.

Soon after the game was underway, it was clear it was in trouble. But it was too late for the developers to make any midpoint corrections effective enough to turn things around. Although the free pilot episode attracted 100,000 players, only 13,500 actually went on to shell out the money to subscribe. Many who were initially drawn to the game did not even make it to the free pilot. *The Los Angeles Times* (Sept. 26, 2001) reported that nine out of ten potential players balked at having to download the tools needed to participate. The game only brought in about $600,000 in revenue, hardly a worthwhile return on the $10 million investment. But though *Majestic* did not succeed as hoped, it was a bold attempt to try something new, and game developers can learn some useful lessons from it.

WHAT WENT WRONG?

Having an interesting concept, a good story, and well-produced assets were clearly not enough to ensure *Majestic's* success. In the postmortem examination of the game, a number of factors have been cited for its disappointing reception, both by players and by game critics. In addition to the ones already discussed here, other reasons include:

- Inability to move at one's own pace. Players, especially the experienced ones, disliked the episodic system, which doled out the game in small chunks that they could zip through fairly quickly. This meant they had to wait for a long stretch until they received the next episode and could move forward again.
- Too intrusive. Even though people signed on knowing they would receive phone calls and faxes from the characters, some found these realistic features too spooky and too invasive in their lives.
- Suffered in comparison to *The Beast*. Many of *Majestic's* players came to the game after having participated in the *AI* game, and felt *Majestic* let them down. They particularly missed its community spirit.
- Unsatisfactory buddy system. Some players felt *Majestic's* buddy system (in which each player was assigned sixteen buddies, some of whom were bots, and some of whom were humans) was too skimpy, especially if compared to the enormous player support that was part of *The Beast* experience.

- Unsatisfactory story. Players complained that the story was too weak to support the long waits between episodes. One player compared the plot to "one I might expect from a bad *X-Files* episode." Others felt it was too linear for a game.
- Unsatisfactory puzzles. Players felt that some of the puzzles were rigged to fail and did not offer the anticipated rewards, making for an unsatisfying gaming experience.
- Limited availability. The game could only be played in the United States, disappointing many overseas gamers, especially those who had enjoyed playing *The Beast*, which had had a large international following.
- Unfortunate timing. The game was launched just before the 9/11 terror attacks, and in the aftermath, many people had no taste for conspiracy stories. This, of course, was totally outside the control of the developers, but it did hurt the game.

PERVASIVE GAMING GOES PRIME TIME

For the most part, pervasive gaming in the United States has centered around the Internet, supported by a variety of adjunct communications components. But in the fall of 2002, a bold new kind of ARG was introduced to the public. Entitled *Push, Nevada*, it was the first ARG to use a primetime TV drama as its fulcrum. Produced by LivePlanet, a company founded, in part, by Ben Affleck and Matt Damon, it had some of Hollywood's coolest talent behind it. With a first-class production team, network television backing, and over a million dollars in prize money, *Push, Nevada* would be taking pervasive gaming from a minor league techie kind of pastime and thrusting it into the majors. For the first time, the pervasive gaming concept would be tried on a mass audience. But would a mass audience go for it? Nobody really knew.

Despite the fact that *Push, Nevada* was a mainstream venture, LivePlanet remained true to the core concepts of the ARG, and did not water down the project just to try to make it a crowd pleaser. The TV show, although obviously a critical element, was just one of several components employed to tell the story and support the game. Other elements included a number of fictional websites, wireless applications, a book, and telephone messaging. Live events were planned as well, where characters from the drama would be spotted in public places—not as actors, of course, but as "real" people. Like every good ARG, great attention was paid to the development of both the story and the puzzles.

THE *PUSH, NEVADA* STORY

The components that made up the *Push, Nevada* galaxy revolved around a quirky mystery that was devised to unfold in thirteen sixty-minute television episodes on ABC. The unlikely hero of the story is an IRS investigator, Jim Prufrock, a clean-cut and earnest young man, played by Derek Cecil. Prufrock receives a fax one day alerting him to an irregularity, possibly an embezzlement, in the finances of a casino in a town called Push, Nevada. He sets off to Push to investigate, and becomes entangled in the strange goings on of this extremely peculiar town.

The mostly unfriendly residents clearly have something—perhaps many things—to hide. An uneasy aura of corruption hangs over the town, and the tone of the television show is intriguingly off center, reminiscent of the old TV series *Twin Peaks*. With its complex plot, allusions to T.S. Eliot, and unresolved episode endings, the series was not the kind of TV fare that most viewers were used to.

But, of course, *Push, Nevada* was not just a TV show. It was also a game. The clues were embedded in the story world set in this strange little town, and the websites and other interactive components radiated out from it. Viewers, however, did not have to participate in the game. LivePlanet designed the project in such a way that *Push, Nevada* could be enjoyed passively, just as a TV show, or actively, as a game with puzzles to solve. Speaking to a group of professionals at the American Film Institute shortly before the airing of the first episode, LivePlanet's CEO, Larry Tanz, described it as "a treasure hunt for waders, swimmers, and divers." In other words, members of the audience could determine the degree of involvement they wished to have.

THE INTEGRATED MEDIA APPROACH

The concept behind *Push, Nevada* was exactly in keeping with the thrust of LivePlanet's strategy at the time, and which they continue to use now with projects that lend themselves to it. The company describes this strategy as an "integrated media" approach. Just weeks before the first episode aired, Larry Tanz discussed the integrated media approach with me, and talked about how *Push, Nevada,* fit in with it. At LivePlanet, he said, the goal of an integrated media approach is to develop a property and have it operate over three platforms: traditional media (TV, film, and radio), which would be the "driver" of each project; interactive media (the Internet, wireless devices, and so on); and the physical world. The goal was to have these three platforms overlap in such a way that they would be integrated at the core. (See Figure 15.4.) Another goal was to draw in sponsorships from an early point, and creatively integrate them into the project as well.

LivePlanet had already successfully used the integrated media approach with a nonfiction property, *Project Greenlight*. A novel kind of competition for aspiring screenwriters and directors, *Project Greenlight* utilized the Web (for soliciting the scripts and film samples); real life (for the shooting of winning screenplay by the winning director); and traditional media (for the theatrical release of the completed film and for a televised documentary series on the making of the film). Now for the first time, LivePlanet would be using the integrated media approach with a narrative-based property, which was something the founders of the company had been interested in from the beginning.

The story of *Push, Nevada* was devised by Ben Affleck and Sean Bailey, another of the company's founders, who came up with the concept as they were traveling on a plane together. According to Bailey, whom I interviewed after the show had run its course, he and Affleck asked themselves "who is a hero we've never seen before?" and IRS agent Jim Prufrock was the result. During that same plane ride, they worked out many elements of what would become *Push, Nevada*.

In terms of the integrated media aspect of the project, Bailey said their models were, to some extent, *The Blair Witch Project*, the *AI* game, and *Majestic*. But the

Figure 15.4 With LivePlanet's integrated media approach, properties are developed across multiple platforms and are integrated at the core. Image adaptation courtesy of LivePlanet.

primary influence was a British children's picture book called *Masquerade*, written by Kit Williams and popular in the 1980s. The lushly illustrated book was more than a story; it also furnished clues to a real treasure, a jewel buried somewhere in the English countryside. Thus, *Push, Nevada* was modeled on a work of fiction that had an actual component in the real world, a story that included puzzles and offered a valuable prize. The project offered them an opportunity to fulfill one of the company's most important goals, which Bailey described as "using technology to tell stories and get closer to the audience." They wanted to spin tales that were not constrained by a particular time slot, stories that would be bigger than that.

THE DEVELOPMENT PROCESS

It took Affleck and Bailey a month to get their idea worked out well enough to present to the networks, and once they got a commitment from ABC, it took a year to develop it for its first airing. The network welcomed the idea, Bailey said, because they saw it as a way to bring viewers closer to a show, and they gave LivePlanet the freedom to develop the project as they saw fit.

Bailey and Affleck served as executive producers of the show, along with the company's other founders, Matt Damon and Chris Moore. Bailey and Affleck worked out the story beats for each episode and handed off the outlines to a team of eight or nine TV writers. In addition, a separate game team was in charge of the puzzles as well as the content for the websites, the wireless applications, and the guerilla marketing campaign. Another two writers wrote the book (which would be downloadable from the Web) that detailed the conspiracy upon which the mystery was based. One of the most important members of the creative team was

Figure 15.5 Portion of the Integrated Media Timeline developed by LivePlanet for *Push, Nevada* to keep track of how the story and game unfolded across multiple platforms. Image courtesy of LivePlanet.

the puzzle master, who was the project's first hire. He was the well-known Doug TenNapel, creator of the games *Earthworm Jim* and *The Neverhood*.

It was Bailey's task to oversee the development of the content and keep track of the big picture. One of the greatest challenges, he said, was that he always had to think about how a particular idea might affect all the other platforms. To keep track of the project, LivePlanet developed a document called an Integrated Media Bible, which explained how the various media would work together to tell the *Push, Nevada* story and offer clues to the game. They also developed an Integrated Media Timeline, which showed the relationship between the various media as the story and game played out over a number of weeks (see Figure 15.5).

Two important components of the *Push, Nevada* world that required special handling were the websites and the puzzles. Websites were created for the most important entities in the fictional town of Push, including the newspaper, the Chamber of Commerce, a dance hall, and the casino. Another major site was "Enoch Online," which was a kind of reservoir of deep throat revelations. Bailey said the team in charge of the websites was given access to all the assets of the TV show, including audio and visuals, and when needed, they could have the actors do extra lines.

In terms of integrating the story and the game, Bailey said, one of the big challenges was working the puzzles smoothly into the show, and in a way that didn't draw attention to them. "You couldn't just flash them across the screen," he said. Of course, television is a medium that relates narrative material through sound and pictures, not through written text. That meant the clues had to be done as much as possible through visuals and audio, too. It was TenNapel's task to design clues that would work well in this medium. Many used both sound and picture. For instance, one character is seen pulling a squeaky cart around. The wheels of this cart are actually squeaking in Morse code. In another episode, a clue is planted in a scene where a character is playing the piano, repeatedly striking the key of G—a letter cue. The clues also had to be laid carefully into the series as a whole so that they built gradually toward the solution, and in such a way that it would be impossible to figure out how to win the prize until the final

episode. During shooting, security was a major concern, Bailey said. When clues were being filmed, they would remove every person from the set except those who were absolutely necessary to do the scene, and they would shoot each clue in multiple ways to keep people off the track.

Despite all the attention to detail, however, Tanz said the project was not market survey driven. They felt they had a good sense of the audience that would be drawn to it, and felt there was no need to do any psychographic testing to get a better understanding of their target demographic. "When you do a *Lord of the Rings*," he said, "you know who will like it." Once *Push, Nevada* was actually on the air, however, the creative team watched closely to see how people were playing. They found that large numbers of players were forming online groups and communicating with each other via message boards. By reading the messages on these boards, the *Push, Nevada* team could tell when players were having trouble with certain clues. When this happened, the game team would modify the *Push, Nevada* websites to give them some help. In other words, they were "staying in the car," as Sean Stewart put it when talking about *The Beast*. But *Push, Nevada*, with its TV episodes locked into place, was not able to be as responsive as *The Beast* had been.

In addition to the media components, two corporate sponsors figured prominently in the overall game. One was Sprint, which sponsored a wireless game based on the show (for more about the Sprint game, see Chapter 17 on wireless devices). People could also sign up to receive news on their cell phones from the *Push Times*, the newspaper of the fictional town. Another important sponsor was Toyota. All the major characters in the town of Push drove various makes of Toyota, including the bad guys, who drove the expensive Lexus models. The Toyota website even proudly announced the opening of a Toyota dealership in Push.

HOW DID *PUSH, NEVADA* FARE?

Despite the high hopes for the project, and despite the fact that the interactive components proved to be extremely popular, TV viewers did not respond well to the series. After only seven episodes, ABC discontinued the show. LivePlanet was still legally obligated to give away the prize money, however. This posed a dilemma, because they had to come up with a way to announce the final clue in such a way that everyone in the forty-eight contiguous states in the United States would have an equal chance to win, despite the different time zones. They solved the problem by delivering the final clue during a live nationwide broadcast of *Monday Night Football*. Within two minutes, a twenty-four-year-old assistant editor of a New York publishing company put all the pieces of the puzzle together, called the phone number the clues had led him to, and won the prize money— $1,045,000. Within the next twenty minutes, an additional 500 people called the number; by the end of one day, 10,000 had called. Clearly, some people were paying attention.

By many different measurements, it was clear that many people were closely following *Push, Nevada*, though, unfortunately for LivePlanet, they were doing so in ways that didn't help the all-important TV ratings. About 200,000 people visited the *Push, Nevada* websites, making it one of the largest online

games in history, according to ABC's calculations. Over 100,000 viewers followed the clues closely enough to figure out the phone numbers of fictitious people on the show, call the numbers, and hear the characters give them recorded messages. In addition, about 60,000 people downloaded the "Deep Throat" conspiracy book. All told, ABC estimates that 600,000 people actively participated in the game.

Push, Nevada was one of the most TiVoed shows of the fall season, indicating it was a hit with the technologically savvy viewer. The LivePlanet team believed these people were TiVoing the show to be better able to decipher the clues. The TV show also did unexpectedly well with people over fifty, who were perhaps more attracted to the offbeat mystery story and the intelligent writing than to the gaming aspect of the project. Many critics also gave the show good reviews, and it went on to win some awards in Europe.

Unfortunately, *Push, Nevada* had the bad luck of being up against two hit series, sharing the same time slot with *CSI* and *Will and Grace*, and this certainly did not help its ratings any. And, in some gaming circles, participants were disappointed in the game play, and also complained that the solution to the overall puzzle was unsatisfactory. They felt they had come up with more elegant solutions in their own online groups.

WHAT WENT WRONG?

After *Push, Nevada* went off the air, Larry Tanz and Sean Bailey shared their thoughts with me about why it had not had more success as an integrated media property and where things might have gone wrong with it. Tanz said *Push, Nevada* had shown them the difficulties of doing integrated programming for a mass audience—that it was difficult to engage ten to twenty million people in such an experience. In a project like this, having good online traffic is not enough; it isn't sufficient to bolster the TV ratings, he said. He acknowledged that trying to do two things well—to be both a TV show and a game—was a difficult undertaking and might have required too much of the typical viewer. "Trying to tie participation to a TV show was hard to do for a mass audience. People couldn't just kick back, get a few laughs, and move on."

But he did feel they learned some positive lessons from the experience. For example, what he did believe worked well was their approach to production. It was particularly effective, he thought, to have one creative producer who drove all the disparate media and had a clear grasp of the entire project. In considering the content, though, he felt that the TV episodes might have been too demanding for a mass audience, and that people might have been happier if each program had been less open-ended and more clearly resolved. "People want to come away with a sense of satisfaction," he said. "Not with 'oh, my gosh, it's even more cryptic now!'"

Perhaps, he thought, a more targeted venue would have been better for the project. On the Sci-Fi Channel, with a different kind of audience, he believed *Push, Nevada* might well have been a hit, and without necessitating any alterations. But making the same show appealing for a mass audience, he said, would require some retooling. It would need to be simpler and easier to follow, and viewers would need to be given more help. For instance, they could be directed more

clearly to the important websites. In essence, he was saying that you need to shape a project like this for its intended audience.

Like Tanz, Sean Bailey observed that the show might have been too complicated for the ABC viewers, too difficult to follow and a little off-putting with its literary references. He also felt that playing the game might have felt like too heavy an obligation for many people. He noted that when people watch TV, they are usually not doing so with their full attention. "They get up, mind the baby, come back," he said. TV is a lean back kind of medium, he noted, as opposed to games, which are a lean forward experience... "and here we are, asking them to do both." In retrospect, he feels that maybe it was too radically different from what TV viewers were used to, and that it might have been better to try an approach like this in small increments. "We might have tried too much, too soon," he said. And, like Tanz, he wondered if something like this might have done better in a different venue—on a cable network, for example, or even in a movie theatre.

Still and all, he found it encouraging that it had done as well as it had, particularly within the Web community. The interactive technology aspects of it were a success, he pointed out. Unfortunately, though, "when you look at the totality of the experience, it didn't work. The show was cancelled after seven episodes." And, he went on, "when *Majestic* fails, and *Push, Nevada* fails, the big companies are going to be hesitant to try something like this again. It slows down the advancement of this kind of approach."

WHAT WAS LEARNED?

As Tanz and Bailey noted, *Push, Nevada* fell short of its commercial goals. Unfortunately, the same thing was true of *Majestic*, which was unable to attract the number of subscribers it wanted. It was also true of *The Beast*, which, despite its popularity as a game, was not a successful promotional vehicle for the movie, *AI*, which did poorly at the box office. Yet all three of these projects were stunning achievements in breaking new narrative ground. As different as they are in many ways, we can learn some important general lessons from them that can be applied to other cross-media projects:

- As always, you need to understand your audience, and provide it with an experience they will perceive as enjoyable, not as too difficult or too simple, or too confusing or overwhelming.
- In a pervasive game, story elements and gaming elements are both extremely important, and neither can be shortchanged without weakening the overall project.
- Members of the audience want to be able to participate in a meaningful way, and have some impact on the story or game.
- The creative team cannot set the game in motion and then walk away from it; they need to "remain in the car" and be responsive to the players.
- If you have online components, you must be committed to updating them.
- The barriers to entry should be set as low as possible, so you don't discourage those who are less technologically sophisticated from participating.

- If possible, provide a way for people who are not hard-core gamers to enjoy the experience, but on the other hand, don't cater to the newbies to such an extent that serious gamers will be disenchanted.
- When at all possible, develop all components of a project simultaneously, from the ground up, and work out how they will be integrated from the beginning, too. Don't just paste new components on an already existing property.
- Construct the property in such a way that it will foster community development and collaboration. Pervasive games that encourage group play, as opposed to solo play, tend to fare better.

OTHER APPROACHES TO CROSS-MEDIA PRODUCTIONS

Blending a story and game together is just one of many possible ways the cross-media strategy can be applied to entertainment properties. It can also be used to expand a fictional narrative without using games, as illustrated in the Danish project, *E-daze*. Furthermore, it can be used to enhance nonfiction programming, including documentaries, reality-based shows, and music shows. Almost certainly, it can be used for innovative entertainment projects that do not fall within any established category and may not have even been conceptualized yet.

Probably the most highly publicized manifestation of the cross-media approach, one that sparked feature stories in countless print publications and TV news shows, was *The Matrix* phenomenon. In making the two movie sequels to the original *Matrix* film, *Matrix Reloaded* and *The Matrix Revolutions*, the visionary Wachowski brothers simultaneously also built a video game, *Enter the Matrix*; a DVD, *The Animatrix*; and a website, *ThisistheMatrix.com* (*www. ThisistheMatrix. com*). This high-tech, new media cross-over was particularly apt, given that the *Matrix* story depicts a society in which the digital and physical worlds collide, and in which virtual reality runs amok.

Each component of the *Matrix* collection of properties tells a different piece of the *Matrix* story. The DVD, for example, is a collection of nine short animé films, each of which fills in a little bit of the *Matrix* plot. But the aspect of the *Matrix* cross-media project that has drawn the most attention is the way in which the two movie sequels and the video game were developed—as one single project. The brothers Wachowski, Andy and Larry, reputed to be avid gamers, were at the helm of all three projects. All were shot at the same time. Not only did the Wachowskis write and direct the two movies but they also wrote a 244-page dialogue script for the game and shot a full hour of extra footage for it—the equivalent of half a movie. In terms of the filming, the movies and game shared the same twenty-five characters, the same sets, the same crews, the same costume designers, and the same choreographers.

The actors found themselves doing things they had never done before. One actor who faced many special demands was Jada Pinkett Smith, who is one of the two main characters in the game. She had to memorize a script for the game that ran far longer than her lines in the movies and also had to spend an extra six months doing motion capture work, face mapping, and full-body scanning. The acting for the game had unusual challenges as well, calling for her to do scenes in which she had to react to invisible explosions and run away from invisible

pursuers. She told *Wired* magazine (May 2003): "It was like being a kid again. Everything had to be created through my imagination."

Although it is not necessary to see the movies in order to play the game, or vice versa, the games and movies, when experienced as a totality, are designed to deepen *The Matrix* experience and give the viewer-player a more complete understanding of the story. For example, in *The Matrix Reloaded*, the audience will see a character exit from a scene and return sometime later carrying a package. But only by playing *Enter the Matrix* will people understand how the character obtained that package.

The game contains all the dazzling special effects that are hallmarks of the movies, such as walking on walls and the slow motion bullets, known as "bullet time." It was one of the most expensive video games in history to make and took two and a half years to complete. But in this particular case, the crossover approach seems to be paying off in a major way. By the time the game and first sequel were released, both on the same day in May 2003 (a first in media history), the game had already sold four million units, which alone was expected to bring in about $200 million dollars.

USING THE CROSS-MEDIA APPROACH FOR NONFICTION PROJECTS

As we have seen earlier in this book, developing a project across multiple media can also work for nonfiction projects, not just those that have a fictional story, gaming elements, or both. For example, as we discussed in Chapter 8, the approach can be used for a television documentary, as was done with *Woodrow Wilson*. In this particular case, a DVD and website were used to enhance the story of Wilson's life, which was the subject of the TV documentary, and the two interactive components were designed in conjunction with each other. And, in Chapter 3, we took at look at the BBC project, *FightBox*. This cutting-edge project makes use of the Internet, television broadcasting, and gaming technology. Participants create and train virtual characters online, which they then pit against each other and against the show's in-house gladiators, the FightBox Sentients, in front of a live TV audience. During the show, the program's host and hostess (real humans) chat informally with the FightBox Sentients. What makes this so tricky, of course, is that neither the six FightBox Sentients nor the warriors controlled by the contestants actually exist in real time and space—they are strictly digital creations.

Still other approaches to nonnarrative cross-media productions are being taken by the South African company, Underdog, introduced earlier in this chapter. The company specializes in developing properties across a number of platforms—it's an approach that is integral to everything they do—and they've used this strategy both for their own projects and for those of their clients. So far, all of their work has been on nonnarrative projects, a diverse array of works like the three *Big Brother* series; *Mambaonline*, a gay lifestyle property; *All You Need Is Love*, a teenage dating show; *Below the Belt*, a variety show; and *loveLife*, an HIV awareness project. This is not to say, however, that Underdog is not interested in using cross-media for a story-based project; the company has developed a fully scripted dramatic show called *Junction*, but it has not yet found a home.

Underdog's involvement in interactive media dates back to about 1994. They were the first production house in South Africa to have an online presence, and they began offering cross-platform production services to other companies, utilizing the new technologies as a way to facilitate interaction and communication. Luiz DeBarros, who cofounded the company with Marc Schwinges, explains that they took their name, Underdog, because they were relatively young when they started out, and because "we felt like we were the Underdogs." In describing why they believe the cross-media approach is so important, DeBarros explains: "There is a passion to connect with audiences in new ways and to find content and strategies that best do this."

In developing a property across multiple media, their goal is to do so using "a cohesive and synergistic strategy," DeBarros says. The technologies and media they utilize include cinema, television, DVD/CD-ROM, telephony, the Internet, games, wireless, and print, choosing whichever platforms are the most appropriate for the property. For example, *Big Brother Africa* utilizes the following: websites and webcams; interactive TV; telephony via IVR (Interactive Voice Response); and wireless, with SMS (Short Message Service). The concept of the TV series is much like others in the *Big Brother* franchise. A group of strangers is isolated in a house for a long period of time. Video cameras are planted around the house and run twenty-four hours a day, and viewers get to observe what happens. At various intervals, viewers vote on which housemate they want to have ejected until only one remains. To keep things lively, the housemates are given various challenges to perform. In the case of *Big Brother Africa*, the show starts with twelve housemates, one each from twelve different African countries. The technology utilized in producing the show allows viewers to watch the housemates online via streaming video as well as on TV. They can also communicate with other viewers in various ways, as well as read online features and news about the various contestants. While the program is being broadcast on TV, viewers can send in SMS messages, which are then scrolled across the bottom of the TV screen. Often these messages are written in response to something that is going on in the house, and they frequently trigger messages from other viewers, creating a kind of onscreen SMS dialogue on live television. In addition, it is the viewers who determine the fate of those in the house, voting online or via SMS or IVR.

And, as Sean Stewart pointed out when talking about *The Beast*, the *Big Brother* production group is well aware that it a good idea to "stay in the car" if you let participants "drive the car." Endermol, the company that produces *Big Brother Africa*, stays on top of what the audience is saying by reviewing the content of online forums, chats, and email that has been collated by Underdog on a weekly basis. They often use this input to give a new twist or direction to the show, DeBarros said. As for the importance of the interactive components, he stressed that the show simply would not work without them. "There is a strategy that aims to create an audience loop that pushes people from TV to telephony, to iTV to the Internet, and back to TV," he said.

When Underdog undertakes a new project, it prefers whenever possible to build in the cross-media components right from the beginning, while the project is still in the conceptual stage. And it believes that during the development process, regular communication with designers, directors, producers, and other team members is critical. Among the biggest challenges DeBarros cited was working with external team members or clients who have no experience with cross-media productions. "They tend to understand their unique area of expertise and neglect

those they don't fully comprehend," he said. Other potential problem areas, he noted, revolved around logistics, limited budgets, and a failure of one group to alert the rest of the team to issues that could impact on the rest of the project.

Aside from good communications, what does Underdog believe is the most valuable element in a successful cross-media production? Flexibility, DeBarros asserted; it's of the utmost importance in situations where the audience is interacting with a property. A process needs to be established that can "assess audience impact and what is working and what isn't, and adapt accordingly," he said.

CONCLUSION

As we have seen from the projects discussed in this chapter, the cross-media approach can offer the audience-member/participant a new and extremely involving way to enjoy entertainment and to interact with content. Many members of the creative community are excited about the new tools it gives them for telling stories and enhancing informational content. Forward-thinking broadcasters are looking at this approach as a way to potentially strengthen the connection between their viewers and their programming, an especially important goal as television audiences steadily decline.

Unfortunately, however, not all projects utilizing the cross-media approach have been successful, not even when supported by high budgets and produced by highly talented individuals, and we have investigated some of the reasons for this. Yet it should always be kept in mind that creative ventures inevitably carry the possibility of failure, even in well-established areas like motion pictures and television. The risk is even greater when undertaken in a relatively uncharted area such as cross-media productions.

Hopefully, the fact that some of these projects have met with success will encourage others to try the cross-media approach, and the failures of other projects will not be a major deterrent. Those who develop projects in this area will benefit by learning from the creative teams who have gone before them, both those who have succeeded and those whose projects fell short of expectations. Clearly, the cross-media approach is an area that invites exploration. Almost certainly, content creators will be able to find innovative new ways of combining media and technologies, or use prior combinations in ways not seen before, to create exciting new entertainment experiences.

IDEA-GENERATING EXERCISES

1. What kinds of projects do you believe are best suited to a cross-media production approach, and why? What kinds of projects would you say do not lend themselves to this, and why? If you are doing this exercise as part of a group, see if someone else in your group can come up with a cross-media approach for the type of project you think is less well suited to an integrated approach.
2. Many cross-media productions include complex puzzles, and such puzzles often require the collaboration of many players in order to be solved. What specialized areas of knowledge do you have that might

lend themselves to the development of puzzles? Can you suggest how a puzzle might be constructed based on one of your special areas of knowledge?

3. A variety of different media and communications tools have been employed in cross-media productions. Can you think of any media or tools that, to your knowledge, have not yet been employed? If so, can you suggest how such media or tools could be employed in an entertainment experience?

4. Discuss some possible cross-media approaches that could make a documentary or reality-based project extremely involving for the audience.

5. Try sketching out a story that would lend itself to a cross-media approach. What media would you use, and what would be the function of each in telling this story?

Smart Toys

What could smart toys possibly have in common with video games, virtual reality, or any other type of digital entertainment?

Don't smart toys discourage rather than encourage imaginative play?

How can a participatory storytelling experience be built into an interactive toy?

Can a toy ever be too life-like?

SMART TOYS: VENTURING INTO THE METAPHYSICAL

Imagine, for a moment, that you have just been tapped to join the creative team of a toy company, and your first assignment called for your group to accomplish one of the following tasks:

- To invent a life-like doll that incorporates a new type of nanotechnology, one never used before for a toy—and the toy must be developed in a way that fits with the traditional play patterns of small girls;
- To devise an original line of interactive talking playthings, each distinct from the other, and whose personalities can only be conveyed through their physical appearance, their wardrobe, their playpieces, and eight minutes of audio;
- To develop a doll that recreates a well-known story, doing so in a way that is interactive and draws the child into the experience; or....
- To create an interactive 3D dollhouse inhabited by miniature human characters and that brings stories to life as a child plays with it.

Each one of these assignments is a serious head-scratcher, but all four are typical of the challenges that people within the toy industry must deal with on a regular basis. In fact, I worked on one of these projects myself—the dollhouse—which was one of several smart toy assignments that I've had. Thus, I can say from personal experience that this intriguing sector of digital entertainment not only involves storytelling skills but also bends one's mind in ways you might never believe possible. These assignments alternate between fascinating and frustrating, but are never humdrum. Not surprisingly, you find yourself dealing with a host of creative, technical, and marketing issues. But in addition, you must also grapple with profound questions touching on psychology, human development, and even metaphysics. At one point or another, if you work in this area long enough, you will find yourself asking such questions as: "What makes something 'alive'?" or "What is intelligence?" You might also find yourself pondering this one: "Can a human have a meaningful emotional relationship with a mechanical object?" or this one: "Is it irresponsible to create objects that blur reality and make-believe to the point where it is difficult to tell them apart?" It is unlikely that any other sector of interactive entertainment raises as many questions as smart toys do that go to the heart of our identity as humans and as creators.

WHAT ARE SMART TOYS?

Before examining how smart toys are devised and what some of their special challenges are, let's first define what we are talking about. A great number of playthings fall into the category of smart toys. They are any type of plaything with a built-in microprocessing chip. The chips operate like tiny computers; they are programmable and hold the instructions and memory of the toy, controlling what they do. Smart toys can include educational playthings that are the equivalent of electronic flash cards. They can also be musical games, touch-sensitive picture books, or child-friendly computers designed for the toddler set (so-called "lapware"). For our purposes, though, we are going to focus on three-dimensional toys that represent living things—humans or animals or fantasy creatures—or playsets that tell a story.

Most such toys have various types of sensors that enable them to "perceive" things like sound, touch, or changes in position or light. Sensors can also enable them to "recognize" objects—pretend food, an article of clothing, or a playpiece like a sword or magic wand. They may also have sensors that enable them to recognize and interact with fellow toys. A number of smart toys also "talk"; some even have voice recognition and can carry on a simple conversation. They may also have individualized emotional responses and in turn may be designed to elicit emotions from their owners. Smart toys may develop intellectually and physically over time like a real puppy or human child. Many can remember things they are taught and they may be able to acquire new behaviors, sometimes via downloads from the Internet or by the insertion of a new memory card. It is no wonder that a toy that possesses many of these traits is called smart.

It is worth noting that smart toys are not only for children. Expensive robotic companion animals are designed primarily for adults, and some of the more cuddly virtual pets are enjoyed not only by youngsters but also by lonely seniors and by people who have allergies to dogs and cats. A type of smart toy is even being made for the U.S. Army. These life-sized soldier "dolls," simulating wounded patients, are used by medics in training to prepare them for field conditions. With realistic faces and the height and weight of adult men and women, they look extremely convincing. But what makes them even more compelling is the fact that their chests rise and fall with raspy or wheezy breathing sounds; they possess an artificial pulse; their eyes tear; and they bleed and expel mucus. Ten female "patients" can even give birth. And when the wounded soldiers are not given the proper medical treatment, they can also die.

Although computerized versions of living beings are a relatively new phenomenon, people throughout history have been beguiled by the idea of a nonliving creature coming to life. Myths, legends, and works of literature and popular entertainment are filled with such tales. One of the best known Greek myths, that of Pygmalion and Galatea, is about a sculptor whose carving of a beautiful woman comes to life—a story that was the inspiration for *My Fair Lady* as well as the work of interactive fiction, *Galatea*, described in Chapter 4. In medieval times, Jews told a story about the Golem, a mystically created monster made out of clay who was called upon to protect the Jewish community from attackers. Children have their beloved story of Pinocchio, of course, about the puppet who longs to be a real boy. Science fiction writer Brian Aldiss wrote a short story, *Supertoys Last All Summer*, based on a similar theme, about a robotic boy who longs to become human. Many believe it was modeled on the Pinocchio story, although Aldiss himself denies it. In any case, Steven Spielberg turned the story into the movie *AI*, which in turn was the springboard for the pervasive game, *The Beast*, described in Chapter 15. If you saw the movie, *AI*, you will remember that the little robotic boy has a smart toy of his own, a wise and endearing teddy bear. *The Beast*, of course, is all about robots who are disturbingly life-like and intermingle with humans.

MAKING THE IMAGINARY REAL

But robotic characters do not merely exist in works of the imagination. Almost as long as we have told tales about such beings, we have also tried to construct

them. Over two thousand years ago, for example, a brilliant Greek engineer named Hero of Alexandria was famous for inventing a number of astounding *automata*—self-operating mechanical figures that could move, and, in some cases, make life-like sounds. Among his works were singing birds; a satyr pouring wine; and a scene depicting Hercules shooting an arrow into a dragon, which hisses. The demanding craft of constructing automata was taken up by Arabians and then revived in Europe in the Middle Ages, leading to wondrous clocks that featured parades of mechanical characters when the hours were struck. One craftsman even invented a duck that could supposedly eat, digest food, and eliminate the waste. Many of the most illustrious scientists of the day worked on automata, leading to some important breakthroughs in science and engineering. The tradition continued into the nineteenth century, with no less an inventor than Thomas Edison applying his genius to the construction of life-like animated figures. Edison successfully created a talking doll, patented in 1878, which caused a sensation. It used a miniaturized version of another of his inventions, the phonograph record.

MORE RECENT INTELLIGENT TOYS

Still more recent history is sprinkled with animatronic figures, some used in theme parks and others devised as playthings. In 1985, every child wanted to own a Teddy Ruxpin toy, a teddy bear that sang and told stories as its lips moved in synchronization with its speech. To operate this mechanical toy, the parent or child inserted an audiocassette into its body. The first computerized life forms, the Tamagotchi key chain pets, were introduced by the Japanese in 1996. Though two-dimensional, not three, these virtual pets had entirely life-like needs—they had to be fed and cared for or they would die. They were so compelling that children would be grief stricken if their pets passed away, and Tamagotchi cemeteries were even established for the deceased creatures.

The Tamagotchi pets were not the only digital creatures to debut in 1996. The Tickle Me Elmo doll from *Sesame Street*, which would laugh when you tickled its stomach, was a big hit that year. It was the world's first commercial computerized 3D toy, and so popular that stores were quickly sold out of it that Christmas. Though it sold for only $30 retail, black market Elmos were going for $2500 to $3000.

From that point on, each Christmas season seemed to have its own star smart toy, with increasingly sophisticated features. In 1997, Interactive Barney was the big smart toy sensation. The stuffed purple creature had a vocabulary of 2000 words and played a dozen toddler-friendly games. The year 1998 actually had two stars. One was the stuffed toy, Furby, from Tiger Electronics, who allegedly came from a distant planet and could only speak Furbish when first acquired. Furby, however, could be "taught" English by its human owner. Actually, however, the toy was programmed to progressively speak more English as it was played with and did not have genuine speech recognition.

The second hit toy of 1998 was well named Amazing Amy from Playmates Toys. She was a pretty doll of about toddler age who could verbally express her needs and desires. And her owner could communicate back by squeezing her hand. Amy not only had built-in sensors but also a built-in clock, enabling her to know what time of day it was and act accordingly—wanting her cereal at breakfast time, for example, and getting sleepy at nap or bedtime. She came with a collection

of accessories such as plastic food and clothing which she could "recognize." She knew what she was being "fed" because each piece of plastic food had a tiny resistor, each with its own value, and when inserted into the contact in her mouth, she would know what the food was. Thus she could distinguish pizza from peas or a bottle of milk from a bottle of juice. She could identify what piece of clothing she was wearing by the same type of technology—a resistor on the garment, when plugged into the doll, would communicate what outfit you'd dressed her in and she'd protest if it wasn't the one she'd asked for. The idea of using resistors and contacts was a breakthrough feature of Amazing Amy and is still being used in today's smart toys.

In 1999, Sony introduced a sophisticated robotic "companion" dog named Aibo to the Japanese public. With a price tag of over $2000, he was definitely not a children's toy. Aibos have proven to be more than a novelty; they are still popular many years after their debut. Some adult enthusiasts acquire whole packs of them, and owners get together regularly with others for the equivalent of "play dates." These smart dogs can see, hear, walk, do tricks, and express canine-appropriate emotions. They love being petted and are responsive to their masters; their personalities are shaped by how they are treated.

The year 2000 was the year of the dueling babies, with three smart digital infants, each with its own unique attributes, vying to be top doll. My Real Baby from Hasbro matured cognitively and emotionally over time. Miracle Moves Baby from Mattel was programmed with thousands of life-like gestures and had skin as soft as a real baby's. My Dream Baby from MGA entertainment actually grew up in front of your eyes, becoming taller and learning to walk. It also had voice recognition technology; the child who owned it could teach it new words. Each of the three robotic babies had its own persona, just like a real human child. Caleb Chung, who was developing the Mattel baby doll, told Erik Davis of *Wired Magazine* (September 2000) that the personalities of these smart dolls must ultimately transcend the technology. "With these new toys," he said, "we are more authors than programmers. It's like writing a character in a book."

By the year 2000, the smart toy market was so well established that the data collecting company of NPD estimated that sales were approaching the one billion-dollar mark. Since then, they have ceased collecting figures in this area, reasoning that almost every toy on the market now contains a computer chip, making data collection virtually meaningless.

WHY ARE SMART TOYS WORTH OUR ATTENTION?

Some people feel that computerized toys do not seem to fit within the general umbrella of digital storytelling and they cannot understand why it would be included in a discussion of such recognized forms of digital entertainment as video games, iTV, and the Web. Yet if you pause for a moment to see what they have in common, you realize that, like other platforms that support digital storytelling, smart toys:

- Require computer technology to operate;
- Offer experiences that are entertaining and interactive; and, most importantly,
- Can be a medium for developed characters and narratives.

Smart toys vary considerably, of course, in how much story they include, with baby doll toys offering the least amount and dolls in the *My Interactive Princess* line offering a rich narrative experience. Some types of dolls, in fact, are primarily interactive storytellers. One such toy, Yano, made by The Original San Francisco Toymakers, is primarily an animatronic raconteur.

Smart toys utilize some of the most advanced technology of any of the interactive platforms, including voice recognition, artificial intelligence, and nano-technology. They also raise some of the toughest challenges of any of the interactive entertainment platforms. Thus, breakthroughs in smart toys can potentially lead to breakthroughs in other areas, just as the work done on automata in the Middle Ages led to advances in science and engineering. Furthermore, designers of 3D playsets deal with many of the same spatial, structural, and architectural issues as designers of video games and interactive cinema, potentially leading to a cross-fertilization of works in these areas. In addition, these toys blur the lines between what is alive and what is mechanical, having important implications for such areas as virtual reality and immersive environments, not to mention psychology and ethics.

As a small indication of the significance of smart toys, MIT's renowned Media Lab has been investigating this area for some years, and MIT Professor Sherry Turkle has done extensive work investigating virtual pets and smart dolls and their relationships with their human owners. She notes that these smart play-things inspire new kinds of questions about the nature of artificial intelligence. In an article for UNESCO's magazine, *Courier* (September 2000), she said "when we are asked to care for an object, when this cared-for object thrives and offers us its attention and concern, we experience it as intelligent, but more important, we feel a connection to it. The old AI debates were about the technical abilities of machines. The new ones will be about the emotional vulnerabilities of people."

THE CHALLENGES OF CREATING A SMART TOY

To illustrate some of the challenges one is faced with in designing a new smart toy, let's take a look at a project I was called in to work on, the dollhouse project mentioned at the beginning of the chapter. I was part of the development team assembled by a subcontractor to the large toy company that would be manufacturing it. The head of our group was an electrical engineer, a specialty that is a major asset for a smart toy project. We would also be working with a child psychologist, who would be invaluable when it came to discussions of play patterns and age-appropriateness.

The inventor and toy manufacturer had already done considerable ground-work in terms of the architecture of the house and its technical specifications, and had determined that the house would be inhabited by a family of four dolls: two daughters, a mother, and a father. Our job would be to work out what happened when a child actually played with the dollhouse—the nature of the interactivity and how the dollhouse could "tell" stories. We were to design the logic flow and write the dialogue and make sure what we devised could

fit within the amount of chip memory the budget allowed. We were given the creative freedom to filter everything that had already been established through these creative objectives. Some of the questions we had to figure out were:

- What kinds of stories could you tell in a 3D environment, especially when you did not know when a particular character would be present or what room they would be in?
- What genres of stories could work in an environment like this? Was the dollhouse best suited to realistic narratives, to fantasy, or to mystery? What about humor?
- What would the optimum floor plan and architecture be for an interactive experience?
- What kinds of sensors would we be using? What was their optimum placement within the dollhouse? How would their use affect the play experience?
- What kinds of controls could we give the child over the experience? Could we let the child determine the time of day, what the weather was, or the season? If so, how would these choices determine the narrative experiences?
- How could we control the action or flow of a story in this environment? What would trigger the advancement of the storyline? What kind of structure could work here?
- Should we offer different modes of play—different ways of playing within the dollhouse—and if so, what should these modes be?
- What would trigger sound effects and what kinds of sound effects would we use? Would they be randomized?
- For the target age group (a sweet spot of six) established by the toy company, what kinds of stories would be most suitable?
- What would the personalities be like of the family members who lived in the house and how would they relate to each other? Would they break the fourth wall and address us directly, or would they be oblivious of our presence?
- In addition to the miniature dolls—the family members—what other play pieces might be included, and what would happen if an important play piece got lost?
- What kinds of add-ons could be developed for expansions of the dollhouse—what additional rooms or structures? What new characters would come with each? How would these add-ons affect the narratives and characters we'd already established?

After much brainstorming and hair tugging, we managed to hammer out answers to all these questions. Unfortunately, although our client was enthusiastic about our work and built a prototype of the dollhouse, it was never manufactured. As with many smart toy ideas, the company did not have the resources to develop it in time to reach the market by its target date. The project is still alive, however, and the toy inventor who holds the patent on it is looking to place it elsewhere.

THE TOY INVENTOR'S PERSPECTIVE

The toy business is a cutthroat industry. Thousands of new toys are introduced each year, and they have to compete for limited shelf space and somehow manage to capture the fancy of the consumer. How does someone go about creating a smart toy that has a chance of becoming a winner? Let's hear what Judy Shackelford, a prominent toy inventor, has to say about the process. Shackelford's creations include the landmark doll, Amazing Amy, described earlier, as well as Amazing Ally, an older "girlfriend doll" in Playmates' "Amazing Family" line, plus many other groundbreaking toys. Before launching her own company, J. Shackelford and Associates, she had a ten-year stint at Mattel toys, where she ultimately rose to the position of Executive Vice President of Marketing and Product Development Worldwide.

The main challenge in inventing a new toy, Shackelford said, is to find the point of differentiation—to come up with something that hasn't been done before; something that makes it unlike other toys. This point of differentiation can be a look, a mechanism, or any number of other things. "People like me figure out new applications for interactive toys, often by incorporating technology used in computers or other electronics," she explained. "I invent something when there was nothing there before. I conceptualize it and then I hire the appropriate people to work on it on a for-hire basis to help get it born. In a sense, I'm the producer of the toy."

Shackelford describes the process as being highly collaborative, calling for an assortment of experts in various fields, from people who specialize in doll hair design to sculptors to various kinds of technicians. "No person in the field works all by themselves to get a toy invented and to market," Shackelford noted. "You need a total package of talents and skills." She believes an array of factors must be considered when inventing a toy.

One of these is its play pattern—what you want to happen between the child and the toy. You also need to consider psychographics—the psychological tenor of the marketplace. Pyschographics, she explained, has an impact on the willingness of parents and family members to buy a particular toy, and also on the willingness of retailers to take on something new. Price is another factor. In designing a toy, she warned, you have to avoid the temptation to throw everything into it that the toy could possibly do. "That would make it far too expensive. You can't make a toy the dumping ground for every new technology." And, she said, you have to be able to sell your invention to the marketing department of the toy manufacturer. "Their job is to know what kids want and what the parents want," she said, "and, as important, what the trade wants." Altogether, she said, it takes "an unbelievably complex blend of things to successfully bring a toy to market."

WHERE DO YOU START?

Shackelford has no fixed starting point in inventing a new toy—it varies from project to project. Sometimes, she says, the inspiration may be a new mechanism she learns about, and she thinks of a way it could be used in a toy. Or sometimes she thinks of something new a plaything could do and develops the toy from that idea. Toy designers often copy what people do in real life, she noted. For example,

Figure 16.1 Baby Bright Eyes utilizes nanotechnology for realistic eye movement, and she recognizes her bottle and her teddy bear. Image courtesy of Playmates Toys.

you might see someone roller blading and wonder how you could make that work for a doll. In fact, while she was still at Mattel, three toy inventors presented three different kinds of roller blading dolls. One was a toy on wheels that you pushed; one was operated by remote control, like a little car; and the third moved its legs and body from side to side very realistically, like a person. The third one was the winner. So it's not just the idea, she pointed out; it's the execution.

One of Shackelford's most recent inventions was a doll called Baby Bright Eyes, which was manufactured by Playmates Toys. In this case, her starting point was a new technology, a miniature motor developed by a company called Nano-Muscle. She realized that this tiny motor could be used to give a doll extremely realistic eye movements. Out of this idea Baby Bright Eyes was born, a doll who is about a year and a half old, with large expressive eyes and a sweet face. (See Figure 16.1.) Her eyes, Shackelford said, convey the doll's feelings and give her artificial intelligence. Though Baby Bright Eyes has the limited vocabulary of a one-and-a-half-year-old child, what she does say and do is synchronized with her eye movements.

"Although she's not as smart or as interactive as Amazing Amy," Shackelford explained, "that's not her essence; her essence is the eye movement." Shackelford believes that because of her eyes, she appears more life-like than a doll has ever looked. Like Amy, she recognizes objects. She knows when you put a bottle in her mouth or a teddy bear in her hand... and she'll look at these objects when you give them to her. She conveys shyness by partially closing her eyes or surprise by opening her eyes wide. A gravity switch enables her to "know" when she is being laid down to sleep, and when she starts to drift off, her eyes flutter in a very human way. The toy is an excellent example of using a complex technology to make a doll that is easy to understand, easy to play with, and fits in with a little girl's natural inclination toward nurturing activities.

THE PLACE OF SMART TOYS IN THE TOY UNIVERSE

Shackelford believes that smart toys reflect the increasingly computerized world around us. She notes that electronics have become so cheap and pervasive that

even toys for infants light up and sparkle. Microchips are coming down in price and size, so you can put them in more things and give them more to do. But even the smart toys made a few years back were impressively powerful. She made a startling observation: Amazing Amy had more computer power than the Apollo spacecraft that flew to the moon.

New technologies, such as the miniature motor used in Baby Bright Eyes, will give dolls the ever-increasing ability to model living creatures. Could dolls possibly become too realistic... even to the point of being scary, as some people allege? Shackelford insists this is not the case. "I think the kinds of interactive properties we design in dolls are gentle and natural. They're not scary," she asserted. "An adult may look at a life-like doll and say: 'Oh, that's spooky.' but it's not spooky to kids. It's just real." Referring to the graphic violence in many video games, she added: "Now, that's what I think is spooky!"

Shackelford dismisses another criticism of smart toys with equal firmness, the allegation that they stifle imaginative play. "I think people overdo the issue of imaginative play versus interactivity... kids can decide what to do and how to play even with interactivity," she said. "Smart toys have raised the bar to a whole new level in terms of play. In fact, toys with interactivity can thrust children into imaginative play at a much faster speed than conventional toys can."

A TOY MANUFACTURER'S PERSPECTIVE

An inventor like Shackelford must try to anticipate what toy manufacturers will find attractive. And what, in general, do they look for? Lori Farbanish, Vice President of Girls' Marketing for Playmates Toys, offered her perspective on this. Playmates is a leader in interactive dolls. It is the company behind, among other things, Amazing Amy, Amazing Ally, and Baby Bright Eyes, as well as the Belle doll from *Beauty and the Beast*, described in Chapter 9, and others in the *My Interactive Princess* line. According to Farbanish, for a smart doll to succeed, it must possess an illusive quality she termed as "magical"—the quality to excite the child and capture her imagination. This is one of the biggest challenges of toy design, she told me, trying to "bring magic to a toy in a totally different way."

In deciding whether to go forward with a new toy, cost must also be taken into account, she said. Since toys are regarded as luxury items, an expensive toy, no matter how wonderful, can be a tough sell. A number of factors determine the cost of a smart toy, with the chip being one of its most expensive elements. And dolls like Belle that are based on movie characters use well-known professional actors from the film to speak the characters' lines, so the cost of voice talent is another a major expense.

CONSIDERING PLAY PATTERNS

Playmates gives great consideration to how a child will most likely play with the toy and what type of play pattern it fits into, and looks for ways for the smart features to enhance the anticipated play experience. Doll babies like Baby Bright Eyes typically elicit nurturing play, with the little girl taking care of the doll much as a mother does a baby. Nurturing activities include amusing the baby with a

Figure 16.2 Little girls share in Belle's adventure by exploring the enchanted castle with her and attending the ball. The story is advanced by dressing Belle up in different outfits, and characters from the film talk to Belle and the child when placed in Belle's hand. Image courtesy of Playmates Toys.

plaything, giving it a bottle, and putting it to bed. A child can do all of these things with Baby Bright Eyes and receive a response back from the toy, both with her eye movements and her baby-like vocabulary.

In another type of play, the child relates to the doll as a friend or companion. Sometimes this companion doll is regarded as an aspirational figure—someone the child looks up to and hopes to be like. Belle, for example, is a companion doll who is also aspirational. (See Figure 16.2.) She invites the child to go on an exciting adventure with her, and the doll's smart features—her recognition of the characters the child puts in her hand and the garments she dresses her in—enhances their adventure and advances the story. With Belle and other dolls in the *My Interactive Princess* line, Playmates is trying to bring more substance to these aspirational characters, building in a subtext that it is not all about being pretty like a fairy-tale princess. Belle, for example, loves to read books and she's unafraid of the ugly Beast, and these characteristics are both emphasized in the toy.

A third type of play Farbanish mentioned was *fiddle play*. It's the kind of activity that keeps little fingers busy, doing things like pulling open little drawers or rolling tiny carts or opening and closing doors. Opportunities for fiddle play are built into many interactive playsets and certainly would have been abundant in the dollhouse project previously mentioned, had that gone forward. In working out how a smart toy will be played with, Playmates makes sure it offers not only interactive features but also opportunities for traditional imaginative play, things like combing the doll's hair, dressing it up, or inventing little scenarios for it.

To make sure they are on the right track with a new toy, Playmates conducts focus groups with children in the target demographic. By observing real children playing with their toys, they've made some significant adjustments to their products. For example, they found that small children had difficulty inserting playpieces into a doll's hand, so they opened up the doll's palm in a way that would make it easier. Farbanish said it is important to look at things from a child's point of view and not from an adult's. An adult may feel, for instance, that the doll is doing too much prompting, but to the child, the prompting does not seem excessive; instead it seems friendly and helpful.

THE ROLE OF THE CHILD IN THE PLAY EXPERIENCE

In developing a new toy, Playmates always considers what the child's role will be and how to draw her into the experience as fully as possible. With Belle, the toy allows the child to play within the world of a much-loved movie and to experience it in a participatory rather than passive way. The guiding principle in developing this project, Farbanish said, was to stay true to the Disney film, but to do so in a way that involved the child. The child has a meaningful role: She helps Belle explore the castle; gets her ready for the ball; and prepares her for her encounter with the Beast.

The adventure story the child shares with Belle is broken into two parts, roughly following the plot of the movie. Part one is devoted to the exploration of the castle and meeting some of its inhabitants. Part two, which is triggered when the child changes Belle into her party gown, takes place at the ball and climaxes when Belle dances with the Beast. The story is conveyed primarily through sound—by dialogue, music, and lively sound effects. As Farbanish puts it, "your imagination is the set." During the adventure, the child and Belle encounter three colorful characters from the film as well as a magic mirror who talks, and, at various points in the story, the child can determine which one of these characters to bring to life. In many of these little scenes, the characters acknowledge the child's presence as Belle's friend, as if she were standing there in the castle right beside Belle. These encounters help personalize the story for the child. Belle and other toys in the *My Interactive Princess* line are based on well-known movies, and can rely in part on the child's familiarity with the films in creating the narrative experience. Yet Farbanish believes the storytelling techniques they use could also work in original toys, though they'd need to be treated somewhat differently. Playmates is contemplating other structures and other ways of creating story-rich play experiences, including the possibility of adding some gaming elements. For instance, the child might have to solve some riddles in order to advance in the story.

A DEVELOPER'S PERSPECTIVE

Toy manufacturers like Playmates often collaborate closely with outside development companies when they are bringing out a new toy, and much of the actual work of creating a toy's personality and "intelligence" may be done by these specialists. One such company is Pangea Corp., which developed Belle, among many other smart toys. Two of the company's principals, John Schulte and John C. Besmehn, who use the titles "Big Dog" and "Little Dog," respectively, described to me their company's role in bringing dolls to life, and their observations of smart toys in general.

Schulte and Besmehn believe today's children are far more excited about playthings that offer a multisensory experience than they are about static toys, and will no longer settle for "inert chunks of plastic." But they also feel that if a toy is too smart, it becomes too limiting. Children, they say, become disenchanted when a doll is overly bossy, narrowly restricting their experience by demanding that they "do this; do this; do this." They believe that the best smart toys serve as a stimulus, kindling the child's own sense of imaginative play, and that's the approach they take with the dolls they develop. There's a lot to be said,

John Schulte told me, about technology "being used cleverly to open doors to parts of a girl's imagination she would otherwise ignore with a 'dumb' doll. That's why we try to imagine open-ended play patterns; we conjure up creative situations and scenarios that will evoke emotional responses, but allow for the girl herself to travel pathways of logic or illogic in a more open manner. We create the frame and provide the canvas. It's up to the girl to paint the picture as she sees it and feels it."

Interestingly, Schulte and Besmehn consider smart dolls to be "video games for girls," though housed in a doll's body. They feel smart dolls are every bit as much of a platform as video games, requiring many of the same considerations in terms of developing the characters, the interactivity, and the script writing. The toys they develop integrate smart features with plenty of room for imaginative play. The pointed out that Belle, for example, is not actually a more technologically complex doll than her predecessors, but she is more refined. Instead of forcing the child down a single narrative pathway, the toy promotes a sense of exploration and adventure, serving as a conduit to the imagination. The goal is to make the play experience as nonrestrictive as possible, letting the child feel in control, while inconspicuously channeling her toward an end goal.

THE TOY DEVELOPMENT PROCESS

In working with a manufacturer on a new toy, Pangea comes aboard the project at an early concept stage and stays involved until the chip is burned. The development process usually begins with a client meeting which addresses such issues as the marketing goals, the technology being used, the age of the target market, and the price point, all of which gives them an idea of what the parameters of the product will be. They then begin to flesh out each character and its world, looking for ways to harness the technology so that it will bring the character to life—by how it speaks or moves or reacts to a playpiece. Biographies are written for each character, sometimes done as autobiographies, as if written by the characters themselves. If they are developing a multi-toy line, they also consider the other characters in the line, looking for balance and variety. A great deal of noodling goes on, they say, as the ideas are developed and the personality of the dolls is fleshed out, a process that can take a month or two. The noodling, they say, always leads back to the essence of the toy: What is the play pattern and what will the child's experience of it be? These are the concepts upon which the toy is built.

Once they've gotten the basics nailed down, they begin to map out the interactivity, working out the variables and what ifs and laying down the protocols for the most likely and least likely choices the child will make. All of this is laid out in a document that goes by various names in the toy business: a logic flow chart, a logic script, a matrix, or a flow chart. Once the interactivity is worked out, a branching if/then script is written for the experience, much as it would be for any other interactive narrative.

One of the biggest challenges, they say, is writing the dialogue, because space is at such a premium on the chip, and it competes for room with programming code, sound effects, and music. The chip for Belle, for example, could contain a maximum of eight minutes of sound. To get the most mileage possible from the available

space, they use a technique called *concatenation*, which is the efficient reuse of words and phrases. For example, as Belle and the child roam through the enchanted castle, Belle might say: "Where should we go next? I know. Let's explore the...." This part of her dialogue can be reused for any room in the castle, with the specific room filled in as appropriate. The names of rooms—the library, the dining room, and so on—can also be reused in various pieces of dialogue. Concatenation, though a practical solution to the space problem, is a tricky thing to do well. It can make speech sound unnatural and it also relies on precision in script writing and in recording. If an actor improvises a line, for example, it can throw everything off.

Once the script is complete, they do a table reading and time it all out before giving it to the actors to record. For a toy like Belle, which was based on a hit movie, the stars of the film do the voices. For example, Angela Lansbury, who played Mrs. Potts in the film, does the voice of Mrs. Potts for the toy. Typically, they say, the actors are happy to work on a toy and often offer helpful suggestions about their lines, since they are so familiar with the characters they play. However, it's a major adjustment for them to work within the time constraints of a toy script, which may give them just 3.2 seconds per line to express their character's personality. Yet they manage to do a remarkable job of it and add a special charm to the fantasy world of the toy.

In summarizing the process of developing a toy, Schulte and Besmehn assert they do not have a mental "do not" list. Such a list, they say, would unduly restrict their creativity. If their first idea does not work, they take it back and come up with a more innovative solution. "Dolls are inherently powered by a girl's imagination," Schulte says. And that's the power they work hard to harness.

QUALITIES OF A SUCCESSFUL SMART TOY

No one can absolutely guarantee what toy will be a big hit with children or what moms and dads and grandparents will be willing to line up for in the December cold, hoping to snag for a special child for the holidays. Nevertheless, we can point to some qualities that successful toys have in common, based on comments made by the experts in this chapter, and use these as general guidelines. You may note that many of these qualities are the same as for any interactive product for children. And, if you remove the word "child" here, they apply equally well to smart toys for adults. A successful smart toy is:

- Age appropriate and fits with a typical play pattern for the target age group.
- Fun and has a special magic about it.
- Interactive, not passive, and gives the child a meaningful role.
- Easy to use and not overloaded with too many features.
- Engaging and surprising, keeping the child interested and involved.
- Rewarding in some way, making the child feel good about spending time with it.
- Designed so the technology enhances the experience and doesn't get in the way.
- Designed so that neither the human nor the toy dominates the experience, offering a balanced exchange between the child and the plaything.
- Priced well for the market.

OTHER RESOURCES

To learn more about smart toys, the following resources may be helpful:

- The virtual pet website, *http://virtualpet.com/vp/vpindex.2htm*. This site carries news on virtual pets and also has an excellent bibliography of articles on the subject.
- The Dr. Toy website, *www.drtoy.com*. Dr. Toy reviews toys, including smart toys.
- *Children's Software Review, www.childrenssofteware.com*, both a print magazine and a website, carries reviews of smart toys, primarily educational toys.
- The Toy Guy, *www.thetoyguy.com*, has news and reviews of all types of toys.

CONCLUSION

As we've seen, smart toys can most definitely support narrative experiences, but to accomplish this successfully, the story must be presented in a way that allows the child to be an active participant in it. The process of inventing and developing a smart toy requires a special blend of creativity, marketing expertise, and familiarity with technology. It also calls for an understanding of children and their play patterns. The creative challenges are as demanding, if not more so, as any platform in the digital entertainment universe and raises fundamental questions about the relationship of humans to technology. The making of smart toys also carries a special responsibility, because children are the most vulnerable segment of our population. A toy can have a powerful influence on their self-image and on how they perceive the world around them. A well-designed toy can spark their creativity and imagination and enhance their lives.

The question we've been asking here, of course, is just how do you go about creating a good smart toy? Lori Farbanish of Playmates Toys has a valuable overall piece of advice about this. "Sometimes," she says, "we think too much like adults. Sometimes you just have to dump all the pieces on the floor and play."

IDEA-GENERATING EXERCISES

1. Select a smart toy—one that has narrative features or a developed personality—and spend some time playing with it. Analyze what is compelling about the toy and where it may fall short. Do you think it could be improved, and if so, how? Can you see a way to use it as a model for another toy? How like or unlike do you think this toy is to other forms of interactive entertainment, such as a video game or VR installation?
2. Sketch out an idea for an interactive 3D playset "world." How would this playset tell a story? How would the child interact with it? What is the target demographic of your playset and what type of play pattern does it fit into?
3. Sketch out an idea for an interactive talking doll—human, animal, or fantasy creature. What is the target demographic of your doll, and

what type of play pattern does it fit into? How, aside from dialogue, would this toy communicate its personality to the child? Would it come with playpieces, and if so, what would they be and how would they add to the play experience?

4. Write some dialogue for the doll you've sketched out using concatenation.

CHAPTER *17*

Wireless Devices

What about wireless devices makes them an attractive medium for entertainment?

How can something as small as a cell phone deliver a full entertainment experience?

What are some of the innovative ways that wireless devices are being used to create new kinds of entertainments?

THE METAMORPHOSIS OF THE TELEPHONE

Just a few short years ago, we used our telephones for just one purpose: to talk with other people. It was a convenient method of verbal communications. But with the development of the modern digital wireless phone, the possibilities for this once strictly utilitarian device have exploded. Consider some of the things we can do with our current wireless phones that we never dreamed of doing with our old phones:

- Send and receive text messages;
- Take and send digital photos;
- Get updates on news, sports, and weather;
- Connect to the Internet;
- Listen to music; and
- Watch TV and movies.

Furthermore, we can use these phones to enjoy a wide variety of interactive entertainment experiences. For example, we can:

- Play classic board and card games like chess and poker;
- Try out our golfing skills or be a virtual football player;
- Pit our digital gladiator against a competitor's in a real-time match;
- Play games set in the worlds of our favorite movies;
- Partake in a single-player version of a popular MMOG hit;
- Choose plot developments for an ongoing serialized story;
- Take part in an international adventure story with thousands of other players; and
- Turn the phone into a virtual gun and shoot digital enemies in real life locations.

Clearly, the old rotary-dial telephone with its cumbersome cord has evolved into something far more sophisticated. The new digital wireless phones can accomplish all these new tasks because, unlike the old landline telephones (phones that are connected to wires and cables), they use delivery systems—microwave, satellite, and electromagnetic frequencies—that can transmit great amounts of data, including text and moving images. Text can be sent and received by SMS (Short Messaging Service), which is a text-only service for sending and receiving messages up to 160 characters in length. Photos, animation, and video, as well as longer text messages, can be sent and received via MMS (Multi-Media Service). Protocols like WAP (Wireless Application Protocol) enable mobile devices to access wireless services; protocols like Bluetooth and Wi-Fi enable mobile devices to have high-speed connections to the Internet and to connect with other devices, like game consoles and DVRs.

Wireless entertainment, or, as it is also called, mobile entertainment or mobile gaming, can be played on a variety of wireless devices, including cell phones, PDAs (Personal Digital Assistants), and mobile game consoles that double as phones. Most of these entertainments are games, and almost every genre of game is represented, though not every game is available for every model of wireless device. Because many wireless devices can only support primitive graphics, and because of the small size of their screens, simple games do well on them.

A number of old favorites like *Pac-Man* are finding new life on wireless devices, as are many other old games. Wireless entertainments are either built into the device, downloaded off the Web, or come on memory cards. It should be noted that although this type of experience is called "wireless," many games do not involve live interactions between participants, although an increasing number do.

THE BOOM IN WIRELESS PHONES

The spread of cell phones across the globe has occurred with remarkable speed. The first cell phones were tested in 1979 in Chicago and Japan. By 2003, in less than twenty-five years, close to a billion individuals were using them. Furthermore, technological advances in wireless devices have been made at a steady pace. We are currently on the cusp of what is commonly referred to as 3G (for *Third Generation*), which will enable high-speed, wireless access to the Internet. To a limited extent, 3G is already available in Japan and Europe, although North America is currently in a state somewhere between 2G and 2.5G. Cell phones have proven to be particularly popular in Asia, and have also flourished in Western Europe. Not surprisingly, Asia and Europe are also two parts of the world where wireless entertainment has done extremely well. Japan and Scandinavia, in particular, have been hotbeds of innovative development in this area.

THE PROGENITOR: A SNAKE

Given the short history of the wireless phone, it is astounding how much innovative entertainment has already been developed for this platform. By 2004, just a few short years from the introduction of the first wireless game, all the interactive entertainments mentioned at the beginning of the chapter were already available to consumers. Oddly enough, it was a serpent that started it all, the game of *Snake* (briefly described in Chapter 6). Nokia introduced *Snake* in 1997 as a novelty on a new line of phones. Though quite rudimentary by today's standards, this progenitor of all wireless entertainment is still popular. And, like the appearance of the serpent in the Biblical Garden of Eden, its arrival on the wireless scene served as a major eye-opener, bringing about a dramatic change in perception. Before the arrival of *Snake*, we regarded our telephone as a utility device; thanks to *Snake*, we were able to see its potential for entertainment.

Two years after *Snake* made its debut, the Japanese company NTT DoCoMo, the nation's largest provider of telephone service, made a major push in the area of wireless entertainment. It launched a new system for sending and receiving data, called i-mode, and initiated a revenue model extremely favorable to the content providers. It gave them the lion's share, 91%, of the subscription fees that its customers paid for the new wireless service. As to be expected, developers found this arrangement highly attractive and dozens signed on as official content providers. DoCoMo also established a universal software language for the content (an adaptation of HTML called cHTML) and a universal set of hardware standards for the handsets. Thus, it averted the problem of competing and incompatible technologies that has slowed the growth of many new media technologies. DoCoMo's forward-thinking strategies enabled Japan to rapidly become the world leader in wireless entertainment.

WIRELESS ENTERTAINMENT IN NORTH AMERICA

Unfortunately, North America has lagged behind Japan and Western Europe in wireless technology and entertainment. The excellent landline service in the United States and Canada has made this region less needful of wireless devices, and the smaller number of wireless subscribers has translated into a smaller potential audience for wireless entertainment. Furthermore, North Americans are more likely to drive to work than their counterparts in Asia and Europe, who usually rely on public transportation, and commute time is prime time for mobile gaming. In addition, the wireless phones available in North America are less advanced than elsewhere, and cannot support the robust forms of entertainment available in Asia and Europe. Moreover, North American telecom companies have not followed the Japanese model of establishing a universal set of software and hardware standards or devised an attractive business model for content providers, inhibiting development.

Despite all these impediments, however, wireless entertainment is catching on in North America, and many believe it is only a matter of time before it is as popular in this part of the world as it is in Asia and Europe. By the late 1990s, companies in the United States were beginning to perceive what Asia and Europe had already realized: The installed base of wireless customers represented a new frontier for entertainment. Not only were there many more people with cell phones than with PCs, but these people were also, to a large degree, a new audience for interactive digital entertainment. They were more demographically diverse and, for the most part, not hard-core gamers. Providing entertainment to this new group offered many possible benefits. To the wireless service providers, it could serve as a way to boost their subscriber base and revenues. To advertisers, it offered a new way to reach customers. And to game publishers and developers, it offered tantalizing and unexplored territory. As a further attraction, the development cycle for wireless games is far shorter than for a video game, and they are far less expensive to make.

THE YOUTH MARKET

Although all kinds of people use wireless technology, different segments of the population regard and use mobile devices quite differently. Working adults primarily regard these devices as utilitarian business tools, but teenagers and young adults look at them as a platform for entertainment. Young people are particularly ardent users of wireless devices; sixteen- to twenty-four-year-olds in Europe, for instance, are the continent's heaviest users of mobile technology. Young people are also a highly desirable demographic because of their discretionary buying power. For these reasons, many within the wireless industry have chosen to direct their initial entertainment offerings to this demographic.

This is true not only in Europe but also in the United States. For example, in 2002, Cingular introduced a service designed for youths fourteen to twenty-four called *shoutout* (*www.shoutout.cingular.com*). It offers a full suite of games and ringtones culled from pop hits so users can customize their phones. It also offers a variety of SMS and MMS options geared to please a group with a well-documented enthusiasm for messaging. And in Finland, Nokia has been

Figure 17.1 The Nokia N-Gage is not only a wireless phone, but also a game deck, radio, and digital music player. It also connects to the Internet. Image courtesy of Nokia.

hard at work designing products and games with the same demographic in mind. Late in 2003, it introduced the Nokia N-Gage game deck, which, as we saw in Chapter 3, combines a game console and a wireless phone, connects to the Internet, and also functions as a digital music player and an FM radio (see Figure 17.1). Users can enjoy real-time 3D multiplayer gaming on the N-Gage via Bluetooth wireless technology, and the N-Gage can support the social elements of gaming that have proven to be so popular with online games.

Clearly, Nokia is a company that thinks big, something that is reflected in its annual *Nokia Game*, a vast omni-media interactive narrative in which wireless devices play a prominent role. Like the N-Gage, the game is designed to appeal particularly to young adults. The most recent rendition of the game, *Nokia 2003*, its fifth incarnation, was played out over an eight-week period in thirty-five countries and in ten different languages, drawing over a million player participants. The game not only made extensive use of wireless devices and the Internet (folding in the newly released N-Gage), but also used all types of traditional media. Clues and plot developments were planted in radio announcements and in newspaper and magazine ads, and the story was advanced on wireless devices by Flash animations and text messages.

The game revolved around a virtual heroine named Flo, a professional "mobile reporter," champion online gamer, and avid snow boarder. When Flo's cell phone is stolen, she goes on a global search to find the criminals who swiped it, getting caught up in a dangerous conspiracy scheme in the process. Players joined in the search, uncovering clues, solving puzzles, and communicating with each other via SMS and email.

WIRELESS DEVICES AND PERVASIVE GAMING

The *Nokia Game* belongs to a category of interactive entertainment known as pervasive gaming, which we discussed in Chapter 15. These games exist over multiple media, involve at least one interactive platform, and continue around

the clock, even when a player logs off. Most such games, including *Majestic* and *The Beast*, have centered on the Internet, although a related project, the ground-breaking *Push, Nevada*, radiated out from a television series. But the *Nokia Game* brings a new twist to pervasive gaming, using wireless devices as the central component.

Another company that is pushing the envelope in this area is the Swedish game company, It's Alive (*www.itsalive.com*). They've produced two games that are played out in real physical locations, not just cyberspace, and make clever use of a mobile positioning system that enables players to locate other participants in the game and interact with them, blending virtual characters, fictional scenarios, and actual geographical settings. One of their games, *Suprafly*, is a virtual soap opera in which players compete to become cyber celebrities. They build their avatar, a celebrity-to-be, on the game's website and then create gossip about their character and try to get it publicized in a virtual newspaper, *The Hype*. They must also interact with other players in real locations so they can advance in the game, building up their glamorous wardrobe or boosting their gossip quotient.

In another of It's Alive's games, *BotFighters*, players go online to create robots—their avatars—and then battle other virtual robots in real urban settings, using their cell phones to locate and "shoot" other combatants. The cell phone acts somewhat like a joystick, serving as a way to interface with the game and to track and "kill" opponents. Like many popular online and video games, *BotFighters* mixes action with role-playing. And like the *Nokia Game* and Cingular's *shoutout*, it is designed for a young demographic. Sven Halling, the CEO of It's Alive, looks at both *BotFighters* and *Suprafly* as being similar to MMOGs, but played far away from the computer or game console. He told *The Boston Globe* (May 8, 2002): "Pervasive gaming takes the 'massively multiplayer' approach to the real world. We liked what *Majestic* did very much, also *EverQuest*. We're trying to bring *EverQuest* to the street."

BotFighters is being played in Sweden, Finland, Ireland, and Russia, but it requires a location-indicating system that is not yet offered by American wireless services. However, according to Halling, a time is nearing where such a system will be tested in the States. He's looking forward to that day, positive *BotFighters* will do well in the United States, because, he said, Americans "are more trigger-happy than Europeans."

WIRELESS DEVICES AS A COMPONENT OF CROSS-MEDIA PRODUCTIONS

Wireless devices are becoming a regular feature in pervasive games and other types of cross-media productions. However, as to be expected, their role varies from project to project. In *BotFighters*, *Suprafly*, and the *Nokia Game*, they are at the center of the action. But in other cases, as with *Push, Nevada* (described in Chapter 15), they are an entertaining adjunct to the dominant media, but not a critical part of it. Although the content of the *Push* wireless game was closely related to the TV drama, playing it could not help you solve its overarching mystery or win the prize money. However, playing the game did offer you a chance to interact with a small-scale version of the story, and to enjoy the drama in a new way.

In the game, you play Jim Prufrock, the hero of the TV drama, and try to solve a mini-mystery about the money that is missing from the casino—the same mystery Jim is trying to solve on the TV show. Your task is two-fold: to find out who stole the money and where they hid it. As Jim, you have a map that will take you to different locations and you can choose which of various characters to talk with at each location. These informants will reveal clues that will help you solve the mystery—much like the old *Where in the World is Carmen Sandiego* game. You are given three guesses to accomplish this; then it's game over. In each round of the game, the clues and the solutions are different, so it can be played many times and still stay fresh. The game was designed for an average play session of fifteen minutes and for solo-player play. Since it was not designed for player versus player competition, it had no leaderboard. It was meant to be a light divertissement, an enjoyable way to step into Jim Prufrock's shoes for a few minutes and experience first-hand the confounding mystery of the strange town of Push, Nevada.

Wireless communications were worked into *Push, Nevada* in other ways, as well. For example, Sprint, the wireless phone company that carried the game (and also a sponsor of the full cross-media production), issued a highly authentic-looking press release announcing that it reached an agreement with the Push Chamber of Commerce to be the exclusive provider of wireless communications for the town. The press release even went into great detail about how it would serve the community, noting its sponsorship of the town's Pin Drop Bowling League. In addition, interested parties could visit a website dedicated to Sprint's presence in Push. It is a fairly safe guess that the characters in the TV show used Sprint phones for all their wireless calls.

WIRELESS ENTERTAINMENT AND BRANDED PROPERTIES

If you examine the projects being made for wireless platforms, you will find that a great many began life in another medium—as a movie, TV show, or even video game. When a wireless entertainment is based an already established property, consumers are familiar with it, and fans of the original property are apt to be attracted to the wireless offering as well, giving it a helpful jump-start. Moving a well-known story from one medium to another is hardly a new idea… providers of wireless entertainment are simply following a pattern that has been in existence since antiquity. As we saw in Chapter 3, the ancient Greeks turned to their oral storytelling traditions—their myths and legends—for material for their theatrical works. It is far easier for a new medium to borrow content than it is to invent it from scratch. After all, the story and characters have already been worked out, tested on an audience, and found to be appealing.

Often this type of borrowing is called adaptation. It is similar, but not quite the same, as cross-media production, in that both the primary and secondary properties contain the same characters, storyline, point of view, or type of game play. But unlike a cross-media production, the secondary property is not an integrated element of the primary work and is not needed in order to understand it or play it. In other words, it is a stand-alone work.

Hollywood professionals often refer to the secondary use of a property as an *ancillary market*. Typical ancillary markets for movies and TV shows are videos,

DVDs, music CDs, and video games. The ancillary market is a major part of the revenue stream for a Hollywood property, often bringing in more money that the box office receipts, and Hollywood studies mine it as thoroughly as possible. Beginning in about the year 2000, the studios began to perceive that wireless entertainment could also be part of the ancillary market, and began to look for ways to develop wireless projects based on their properties. A number of Hollywood studios, including Sony, Disney, and Universal, now have in-house departments that actively pursue wireless opportunities for their properties.

THE FIRST BREAKTHROUGHS

One of the first companies to successfully jump into this new arena was the Finnish company, Riot-E. Although it came from far outside the Hollywood mainstream, Riot-E had the vision to realize that popular entertainment, particularly films, could be shaped into attractive entertainment for wireless devices. And instead of waiting for the arrival of the advanced technology needed for sophisticated graphics and interactivity, it used the technologies available at the time, like SMS and WAP, and used them creatively.

The company first grabbed attention in the UK in 2001 with its clever wireless adaptation of *Bridget Jones's Diary*, based on the novels and film. Subscribers received short daily SMS updates "written" by Bridget, the world's most miserable single. For instance, one of her communications, referring to her dismal text-messaging habits, reads: "Text messages from Daniel: 0 (bad). Text messages sent and received regarding lack of text messages from Daniel: 492 (very, very bad)." Bridget also conducted polls, asking her wireless friends their opinion of the following: "Valentine's Day should be banned by law. Reply with Y/N." Anyone familiar with Bridget would certainly know how she stood on that one. With *Bridget Jones's Diary*, Riot-E cleverly used SMS technology in a way that fit snugly with the persona of the fictional Bridget, and it was a big hit for its time.

The company went on to develop well-received projects for the *Lord of the Rings* and *Spiderman* and seemed to be headed for major success. It had established offices around the globe and was even represented by William Morris, one of Hollywood's top talent agencies. Unfortunately, though, it got caught in the downturn that plagued the wireless industry around 2001. Unable to raise the funds it needed to stay afloat, the company was forced to file for bankruptcy in 2002, one of many such casualties at the time.

OTHER APPROACHES TO BRANDED PROPERTIES

Another company that has developed many games based on Hollywood properties is the Scottish firm, Digital Bridges (*www.digitalbridges.com*). For example, it has made games from the old TV favorite, *The Flintstones*; from a more recent TV series, *The Weakest Link*; and from the animated hit movie, *Finding Nemo*. The *Finding Nemo* game is a close adaptation of the film. The player gets to step into the shoes (or fins) of Marlin, Nemo's anxious father. As Marlin, you must swim through the ocean, dodging various obstacles and enemies, trying to

find your son before your time runs out or before you lose the three lives that are allotted you. Like many video games, *Finding Nemo* offers levels of difficulty—four, in this case—which get progressively harder as you move up. Digital Bridges, unlike Riot-E, has been able to incorporate rich game play, full color, and animated graphics into its wireless entertainments.

At about the same time Riot-E closed its doors, Hollywood was becoming increasingly active in wireless entertainment. Of all the Hollywood studios involved in wireless games, Sony Pictures Entertainment has probably been the most aggressive, producing an ambitious slate of them in just a few years. Among their offerings are games made from the films *Men in Black*, *Stuart Little 2*, and *XXX*; wireless versions of its TV quiz shows *Jeopardy* and *Wheel of Fortune*; and a single-player version of its hugely successful MMORPG, *EverQuest*.

This last offering, *EverQuest: A Hero's Call*, is surprising deep for a wireless game, with an estimated forty hours of gameplay. It contains thirty-two dungeon environments to explore; thousands of monsters to dispatch; and up to one hundred and twenty spells to cast. As with an online MMORPG, players can customize their avatars, choosing from various classes and specialties and giving the avatar a name. The player starts off in a tattered shirt, with nothing more formidable than a rusty knife as a weapon, but gradually acquires experience and a better grade of weapon. Much like the classic hero's journey discussed in Chapter 5, the goal of the game is to succeed at a series of tests and overcome obstacles in order to finally emerge as a hero. The game has been well received by players, and Avery Score, writing for *Wireless Gaming Review*, called it "a terrific, traditional role-playing experience spanning dozens of hours of gameplay" and added "a fairly intricate plot adds to the game's atmosphere" (March 20, 2003). It is hard to believe we traveled from the extremely primitive *Snake* to the richness of *EverQuest: A Hero's Call* in just a few years' time!

WIRELESS ENTERTAINMENT AND STORYTELLING

The projects based on *Push, Nevada* and *Finding Nemo* illustrate that interactive games for wireless devices can be adapted from linear stories. But is it possible to take this relationship a few steps further, and devise interactive entertainments that directly effect the linear narrative? We can find two projects that do exactly that.

The first was made in conjunction with the ABC soap opera, *All My Children* (and was briefly mentioned in Chapter 8). Called *The Sexiest Man in America*, this ingenious promotion was integrated into the soap as a subplot. It involved some characters who were searching for a man loaded with sex appeal to be the spokesperson for their new cosmetics firm. Each week for five weeks, five different men from different parts of the country would appear on the show and vie to be chosen. Wireless subscribers watching from home could use SMS voting to select the one they liked best. (Viewers without wireless service could vote on ABC's website.) The five semifinalists were assembled in a final showdown on the climactic episode, and the man with the most votes won an ongoing role in the series. Thus, the viewers who participated in this event were able to determine the outcome of a narrative storyline.

The second project is even more innovative in its approach and gives far greater control to the wireless subscribers. Called *InYrShoes* (text-message speak for "In Your Shoes"), it is a British soap opera that unfolds in typical soap opera fashion. Each episode ends with a perplexing dilemma for one of the characters or with a dramatic cliffhanger. But at this point it departs from the customary, because at the conclusion of each episode, the wireless subscribers are invited to suggest how the dilemma or cliffhanger could be resolved. To encourage participation, the viewers with the winning ideas receive prizes and their ideas are woven into the plot. The idea of *InYrShoes* was conceived by Charlie Salem, a video game producer. He told *iTV Today* (Nov. 11, 2003) that when he learned that over a billion text messages were exchanged each month, he "had started to think of way SMS could be used as a narrative medium." Other wireless content providers have been thinking along similar lines, and subscriber input is already a regular feature of reality TV shows like *Big Brother* and its clones.

BEYOND ENTERTAINMENT

Just as with many other interactive platforms, including the Web, video games, and iTV, material developed for wireless platforms can be combined with entertainment to produce content designed to do such things as teach, advertise, or promote. MIT, for instance, in its *Games to Teach* project (first discussed in Chapter 8), is investigating the potential of wireless technology in educational simulations, and project members have developed a wireless role-playing game called *Environmental Detectives*. The *Games to Teach* website (*www.mit.edu/games/education*) describes the game as combining "the dramatic appeal of *Erin Brokovich* with the pedagogical value of inquiry-based learning exercises." The students are divided into five groups, each representing different professions and concerns, and in these roles they must investigate the causes of an environmental disaster and work out how to deal with its effects. The game is played on PDAs, which they use to gather and process data and to communicate with each other.

The *Games to Teach* project feels wireless handheld devices like PDAs have great potential in educational simulations because they:

- Are portable—they can easily be carried to the game's locations and used in the field;
- Encourage social interactions;
- Are context sensitive—enabling participants to collect data in specific locations and in real time;
- Offer connectivity—they can connect with other devices and other participants; and
- Are customizable to each individual's path through the material.

One could imagine these concepts being applied to other educational experiences, such as a geological or archeological field trip where students are sent on a specific quest. PDAs could also be incorporated into a historic role-playing game where students recreate a historic battle or other event and use wireless devices to communicate with each other and also to supply support materials such as maps or timelines.

While the educational potential of wireless technology is just beginning to be explored, a fairly substantial amount of work has already been done in the areas of promotion and advertising, particularly in Europe. These wireless campaigns are usually done as games and target young adults who, as we've noted, are heavy users of wireless devices and are more likely than older adults to regard them as an entertainment platform.

For example, Heineken used a wireless game in the UK to promote and sell its beer. The game was played in pubs and people were alerted to it by "tent cards" placed on tables. It was done as a trivia quiz, and if players answered three questions correctly, they could win a free pint of Heineken beer. In many cases, the pub-goers played so often, trying to win, that they spent more money on the SMS charges than the cost of the pint. Another campaign, also in the UK, was a quiz game that promoted the movie, *Planet of the Apes*. It offered an irresistible prize: a stay at the NASA space camp. The game spread rapidly by viral marketing (a marketing technique that encourages people to pass along a piece of information by email or SMS) and reached many more players than had been expected. A third campaign, this one for Pepsi and held in Finland, involved players in a wireless soccer match. In order to compete, participants had to collect "virtual skills" from the labels of Pepsi bottles. As an extra inducement, they could play digital matches with soccer great David Beckham or with the Manchester United team, both official Pepsi sponsors. The game was so popular that the sale of Pepsi spiked 13% during the campaign.

The three games went over so well that the sponsors are planning more of them. In an article in *MbusinessDaily* (February 2002) describing these campaigns, Leora Penchina, a manager at the international mobile technology company M-wise, said they were effective because the gaming aspect adds "a level of complex interaction that leaves users with a positive feeling and taps into a simple impulse: the desire to win."

A FEW GUIDELINES

Wireless entertainment is evolving so quickly that it is difficult to nail down specific rules for how such a project should be developed. However, a few general guidelines can be extrapolated from the examples we've studied here. In general, a wireless entertainment should:

- Be easy to understand and simple to do;
- Be geared for short periods of play;
- Be interactive, enabling the user to have some degree of control;
- Be goal oriented, offering a prize or the possibility of having an impact of some kind;
- If a game, be rewarding for the time invested, even if the player does not win;
- If story-based, the characters and their motivations should be well-defined; and
- If story-based, be short enough to be worked through in a limited amount of time or divisible into short installments.

ADDITIONAL RESOURCES

To learn more about wireless entertainment and developments in the wireless industry, some helpful resources are:

- *Wireless Gaming Review* (*www.wgamer.com*), which offers reviews of games and wireless devices as well as general articles on wireless entertainment;
- The Mobile Entertainment Forum (*www.mobileentertainmentforum.org*), a global trade organization for the mobile industry; and
- MbusinessDaily (*www.mbusinessdaily.com*), a magazine that covers wireless news.

CONCLUSION

From the projects we have examined here, it is quite evident that wireless platforms can support a diverse array of entertainment experiences, even story-based narratives. Some of these offerings are simple games much like the earliest computer and arcade games, but other projects being developed for this medium are surprisingly deep, as with *EverQuest: A Hero's Call*. Still other projects use wired devices in innovative ways to produce entertainment experiences unlike any we have known before, as with the *Nokia Game* and *BotFighters*. A few of the projects we examined here are using this platform as a way to extend a fictional world or enable participants a way to interact with a narrative, as with *Bridget Jones's Diary*, *The Sexiest Man in America*, and *InYrShoes*. Furthermore, this platform is being explored as an edutainment tool and as a medium for promotion and advertising.

When thinking about what can or cannot be done with wireless devices, we must bear in mind that the very first wireless game, *Snake*, made its debut in 1997, a relatively short time ago. This medium is still in its early formative years. We are just beginning to understand its potential, and to comprehend how it may be used as a tool for digital storytelling. Without doubt, innovative digital storytellers will make new breakthroughs in this area and will discover ways to use it that we have not yet imagined.

IDEA-GENERATING EXERCISES

1. Choose a film or TV show that you are familiar with and sketch out an idea for a wireless entertainment that could be based on its characters or story.
2. Pick a consumer product and devise a wireless entertainment that could promote it.
3. Select an educational topic and work out a way to develop it as a wireless edutainment experience.
4. Develop a premise for a story-rich original entertainment for wireless devices, possibly one that employs another entertainment medium as well.

Interactive Cinema

Movie stories traditionally follow a linear path, and moviegoing has always been a passive experience, so how do you open up a movie to a nonlinear narrative and give the audience a dynamic way to interact with the story?

What is "group-based interactivity" and how does it fit into an interactive movie experience? How is it similar to or different from group-based interactivity found in such areas as MMOGs and iTV?

What kinds of narratives are being told in small-screen interactive movies?

HOLD THE POPCORN!

Consider these three movie scenarios:

- An astroscientist, on a return trip from Mars, is struck by a mysterious and life-threatening illness after her space ship collides with some debris in outer space.
- A turbulent love triangle erupts between a husband, his mentally ill wife, and the nurse who has been brought in to care for her.
- Cloned twins confront the drug-addicted scientist who created them.

All three stories have an intriguing premise and would seem to promise good entertainment. But if you planned on watching any of them while munching popcorn and reclining in a movie theatre seat or on your couch at home, you'd have a problem. That's because all three are works of interactive cinema, and in order to enjoy them, you would need to be an active participant. This is no place for popcorn. You'd be too busy to eat it.

As we saw in Chapter 2, interactive movies fall into one of two quite different categories. One type is designed for a large theatre screen and usually intended to be a group experience; the other type is for a small screen and meant to be enjoyed by a solo player. Of the three movie scenarios described above, the first, the outer space story, was designed for a group experience in a theatre; the second and third are small-screen movies, one for a DVD and the other for a CD-ROM. Though the kinds of interactivity and the overall experience offered by the two kinds of movies are quite dissimilar, they do share some important characteristics:

- They are story driven.
- They have dimensional characters.
- Though they may have some game-like features, narrative plays an essential role.
- Choices made by the users profoundly affect how the story is experienced.

GROUND ZERO?

Because interactive cinema is a direct descendent of the movies, one of the contemporary world's most beloved forms of entertainment, and because movies are so heavily narrative driven, one might expect that interactive cinema would be ground zero for digital storytelling. But this not the case, at least in terms of production. Relatively little work is currently being done either for large-screen or small-screen interactive cinema. However, the work that is being produced continues to break fresh ground in terms of devising new ways to combine story and interactivity.

Large-screen interactive movies can primarily be found in museums and other cultural institutions. The field is dominated by one innovative company based in Toronto. As for small-screen interactive movies, most that have been produced to date have been made under the umbrella of academic institutions or government-supported film institutes, where interactive storytellers can get the necessary support to work in this field. Thus far, the marketplace has not been particularly

receptive to this type of entertainment, making it extremely difficult for a small-screen interactive movie to succeed commercially. The interest in them is stronger in Europe than in the United States, and some of these productions are now being shown at international festivals. Some are also being sold at brick and mortar bookstores and at online sites like *Amazon.com*, indicating that a market may slowly be developing in this area.

At present, the interactive movies that are being made are geared for one of three different purposes: for pure entertainment, for training, or for education. We'll be looking at examples of all three in this chapter.

LARGE-SCREEN INTERACTIVE CINEMA

As we saw in Chapter 2, large-screen interactive movies were first attempted during the early 1990s by a company called Interfilm. These movies were commercially unsuccessful, however, and their failure to generate any enthusiasm from the public pretty much killed off interest in this area for many years. Recently, however, one company, Immersion Studios (*www.imm-studios.com*), has shown considerable faith in this type of interactivity, particularly for projects that combine entertainment and education. Based in Toronto, the company has produced large-screen interactive films for a prestigious roster of international clients. They include Harvard University, the Smithsonian Institution, and Mystic Aquarium in the United States; La Cité in Paris; the Science Museum in the UK; the Museum of Victoria in Melbourne; plus various Canadian institutions. While their films are meant to be highly entertaining, they also include significant educational content. In other words, they are works of edutainment. Many of them tackle scientific themes, including human biology, pollution, and nuclear energy.

At Immersion Studios, they term the work they do "immersive cinema," and immersion is the operative word here. Their productions combine dramatic storylines with fast-paced gaming elements, and audiences are enveloped by surround sound and images projected on a large screen. These movies use both live action and 3D animation, sometimes in the same production. The interactivity they offer to audiences is far richer and more dynamic than the old Interfilm model, and more purposeful, too. The Interfilm productions used a three-button system embedded in the armrests of the theatre seats, and audience members were give a chance to make one of three choices at various points in the movie. Otherwise, they had no role in the film. With an Immersion Studios film, however, audience members are made to feel they have an important and meaningful part to play in the outcome of drama. In one case, for example, they play time travelers and their decisions help determine what species will survive into the present day. In another case, they take on the role of marine biologists and try to prevent a die-off of sea lions.

Furthermore, the interactivity is far more versatile and extensive. Each single-person or two-person team is given a touch screen console to work with. The touch screen serves as a way for participants to indicate their choices. In addition, it offers a way for audience members to dig deeply into the subject matter, somewhat like exploring a website. During the game-like segments, it serves as a virtual control panel to direct the action. Thus, the Immersive Studio approach combines an audience-shared large-screen theatrical experience with a more personal small-screen experience and control system. (See Figure 18.1.)

Figure 18.1 Immersion Studios' approach to interactive cinema combines a large-screen and a small-screen experience. Here, the audience is watching a film called *Vital Space*, interacting with it via touch screen consoles. Image courtesy of Immersion Studios.

GROUP-BASED INTERACTIVITY

While participating in an Immersion Studios film, audience members are called upon to interact with each other, sometimes by competing and sometimes by collaborating. Some exchanges are done electronically, but at other times, people communicate the old-fashioned way—by talking with each other. At least one of the Immersion Studios projects is also networked, linking students at several different institutions. This type of shared communications, *group based interactivity*, is the hallmark of an Immersion Studios experience.

The work done by Immersion Studios bears some interesting similarities to iTV and MMOGs. All three are enjoyed simultaneously by multiple users/viewers, and all offer both solo and group-based types of interactivity. Some of Immersion Studios' new work even gives the participants the opportunity to control avatars, as they would in a MMOG. But MMOGs and interactive movies are way ahead of iTV when it comes to integrating interactivity into the core content. In an Immersive Studios production, and also in a MMOG, users can affect the narrative itself, while with iTV, the audience primarily participates via trivia questions, polls, and the seeking of additional factual information—nothing that has an impact on the story. It remains to be seen if these three areas will cross-pollinate each other in ways that will lead to advances in group-based digital storytelling.

INVOLVING THE AUDIENCE

Stacey Spiegel, the CEO of Immersion Studios, believes their movies are highly effective teaching tools, and gives three reasons for this. First of all, the immersiveness of the stories facilitates the suspension of disbelief. In traditional media, he says, "you are outside the window looking in. But here, the window disappears and you feel you are a part of what's happening." The second factor that drives learning is that the members of the audience are put in the position of needing to

make decisions, and their decisions have consequences, which causes them to be extremely alert and mindful of the material they are dealing with. And third, Spiegel feels the collaborative social element—being an active participant in a group drama—augments the learning experience. The company's philosophy of audience involvement is reflected in the old proverb that goes: "Tell me and I'll forget; show me and I may remember; involve me and I'll understand."

The company's projects incorporate three different levels of interactivity:

- Individual, which the participant does independently of the group.
- Collaborative, involving joint decisions and working on a "majority rules" basis.
- Competitive, which involves game-like action in which participants vie with one another to achieve high scores while simultaneously working toward some goal established in the film.

Spiegel reports their research shows audiences respond strongly to gameplay, and his company is thus steadily increasing the amount of gaming in their productions. In fact, they have nicknamed the type of film they make a "goovie"—a combination of game and movie. Still, narrative continues to be an important element, giving the film a context and framework and contributing to its emotional power. The participants become deeply involved with the stories, to the point of shedding tears if their actions are unsuccessful. Though each film lasts only twenty to thirty minutes, depending on the amount of interactivity, the objective is to continue the educational experience after the film concludes by motivating the audience to want to learn more. To encourage this, the films are supported by collateral resources such as posters and websites.

A SAMPLE LARGE-SCREEN EXPERIENCE

To see how an Immersion Studios movie works, let's take a closer look at one of its films, *Vital Space*. The educational goal here is to give the audience an inside look at the major human body systems. The story, briefly sketched out at the opening of this chapter, is set in outer space. As the film opens, two space scientists, a married couple, have just completed a successful mission to Mars. Commander Susan Grant is examining a vial of Martian soil while her husband, Dr. John Osborne, is busy in another part of the space ship. Suddenly, the ship is struck by space debris, causing the soil sample to spill and contaminate the chamber where she is working. Thinking quickly, Commander Grant seals herself off in the lab to prevent further contamination, but she is already experiencing symptoms of a serious health problem.

At this point, just a few minutes into the movie, the audience is about to become intimately involved in the story, and their actions will determine Commander Grant's fate. Her husband informs us that since she has quarantined herself, making it impossible for him to examine her, the only way to diagnose and treat her illness is by using an experimental, remote-controlled medical system called VIVISYS, never utilized before under field conditions. And he'll need the help of those of us in "ground control" (the audience) to guide and direct VIVISYS, which we'll do via our touch screen consoles. From this point on,

Figure 18.2 Console screen capture from *Vital Space*, showing types of microrobots. During *Vital Space*, audience members control a virtual medical system via their touch screens. Image courtesy of Immersion Studios.

we are faced with a series of decisions, such as selecting which type of microrobot should begin the diagnostic process. (See Figure 18.2.)

In a race against time, we try to determine the cause of Commander Grant's illness by investigating the various systems of her body. But her condition worsens, and in a dramatic twist, VIVISYS picks up a second heartbeat—shades of the movie *Alien!*—and is at the point of destroying it. But at the last moment, Commander Grant, writhing in pain, orders the procedure halted. It is a good thing she does, because it turns out that the second heart beat belongs to her unborn child— unbeknownst to the couple, they have a baby on the way. As the investigation into her illness proceeds, the audience may or may not find the true cause of her problem: a lethal parasitic infection. If the audience does find it, the film turns more game-like, somewhat like a first-person shooter, with audience members trying to shoot down the intruders. Thus, the life or death drama of the plot helps keep the audience engaged in the film, and the combination of the large theatre screen and the small console screens gives them the means to become deeply immersed in this unique educational journey through the human body.

SPECIAL CHALLENGES OF LARGE-SCREEN INTERACTIVE CINEMA

According to Brian Katz, the company's VP of Corporate Development, most of the films made by Immersion Studios have been for museums and other institutions, who like them because they help attract visitors. Although such large-screen installations require a great deal of special hardware and servicing, which can be expensive, they further the educational goals of these institutions. Also, because these films are suitable for all ages, they offer visitors a positive family experience. However, not all audience members are comfortable with this type of media-rich interactivity, Katz says. While young people are used to multitasking and have no problems with the large-screen/small-screen configuration, he reports that

some older people become confused and wonder "where should I look?" Often the kids fall into the role of coaching their parents, he says.

Katz also noted some of the special creative challenges posed by large-screen interactive cinema, including:

- Devising a scenario that is gripping right from the start and that thrusts the audience members into the action.
- Avoiding a presentation that is overly complicated and could turn people off.
- Creating gameplay that is exciting and complements the narrative.
- Devising interactivity that calls for meaningful choices and not just guesswork.

In addition, Spiegel mentioned another challenge they deal with: integrating the content of the large and small screens, so they become a cohesive whole. As an example of how this is done, he described a scene from a film they'd made on the space program. On the large screen, astronauts are seen outside the space station working on a robotic arm system. But when they try to return to the space station, they find the door is locked, and as they futilely try to unlock it, their oxygen begins to run out. Meanwhile, audience members are called upon to work at their console screens to find a way to unlock the door for them. Thus the action on the large and small screens is closely tied together.

Immersion Studios is leading the way in terms of what can be done with large-screen/small-screen interactivity. But they also believe that some of their techniques can be successful outside the large-screen environment, particularly ways of encouraging collaborative social interactions. They are looking at ways to migrate their work over to corporate desktop applications. They are also looking into the possibility of doing large-screen episodic projects that will encourage people to return to the same venue week after week to see the next installment, much like the old Saturday afternoon movie serials.

With Immersion Studios racking up such an impressive collection of titles, one has to wonder why other companies are not entering this field. Katz speculates that it is partly a matter of cost and the lack of business models for it. But one other entity with an unexpected interest in large-screen interactive cinema is the U.S. Army, which, as we will see in the next chapter, is experimenting with this format for immersive training simulations. Large-screen immersive cinema experiences are also offered at theme parks, but these films do not offer audiences any way to interact.

SMALL-SCREEN INTERACTIVE CINEMA

Examples of small-screen interactive movies are somewhat easier to find than their larger relatives, but they are by no means abundant, even though most people have the hardware necessary to play them. These movies are made for DVD-ROM, DVD-Video, and CD-ROM, and thus can be played on computers, stand-alone DVD players, and game consoles. So far, however, only a small niche market exists for them, primarily among people in academic circles and those with a strong interest in cutting-edge storytelling.

Interactive movies are used for both nonfiction and fictional narratives, often taking on complex subject matter and probing sophisticated psychological themes, somewhat like the films one can find in art house movie theatres. They lend themselves well to telling a story from multiple points of view, which is the approach taken in *Uncompressed*, a work briefly introduced in Chapter 4.

UNCOMPRESSED: A CASE STUDY

At the opening of *Uncompressed*, we are presented with images of six different characters or pairs of characters, including the scientist and the cloned twins mentioned at the beginning of this chapter. Other characters include a telepathic grandmother and granddaughter, a man with a life-threatening illness, and a female ghost and the man who loves her. (See Figure 18.3.) By running your cursor over the image of any of the characters, they will reveal a brief bit about themselves. By clicking on them, you will go to their storyline.

The characters' paths cross at various points in the film, and the work ends with a cataclysmic scene in which a gun is fired and someone is shot. The question of who gets shot is left for the viewer to determine; the ending can be interpreted in various ways, depending on the viewer's perception of the story. If you wish, you can follow each of the six stories from start to finish, in a linear fashion, but you can also switch to another character's perspective at various junctions.

Figure 18.3 Each of the six characters and pairs of characters in *Uncompressed* will give you a different view of the story. Image courtesy of Margi Szperling and substanz.

Figure 18.4 The index of *Uncompressed* offers viewers a way to switch perspectives. Image courtesy of Margi Szperling and substanz.

In addition, you can choose specific scenes to watch by going to the index. (See Figure 18.4.)

Uncompressed was created by Margi Szperling as a master's degree project while she was a graduate student at the Art Center College of Design in Pasadena, California. Before becoming interested in new media, Szperling had been an architect, and feels the disciplines have much in common, since both deal with structure, the movement through space, and design issues. She now runs a Los Angeles-based new media design and development company, substanz (*www.substanz.net*) with her partner, Craig Ashby, who executive produced *Uncompressed* with her.

Uncompressed, made in 2000, was shot on digital video on a budget of only $35,000, and was done on a twenty-day shooting schedule. It required a crew of thirty to produce, many of them students from the school's film department, and the actors donated their services for free, helping to reduce costs. The final work runs thirty-six minutes, though it takes hours to play in all its variations. Despite the low budget, it has notably high production values, and this, coupled with its innovative design and intricately crafted story, has earned it nominations in about fifty international competitions and awards in several of them.

INTERACTIVE CINEMA AS A HYPERSTORY

Szperling terms the type of film she makes a *hyperstory*. Like hypertext, it links different elements, but here, instead of linking to another page or word, the viewer is linked to another version of the story. "Story becomes secondary to concept in our pieces," she told me. "We can tell different kinds of stories in this medium, from multiple perspectives. These are databases that respond to people's choices." Some of the works that influenced her, she says, are the novels of James Joyce and Thomas Pynchon and the movies *Citizen Kane, Rashomon, Repo Man, Buffalo 66, Pulp Fiction, Time Code,* and *Run Lola Run.* She also cites the theories of the Russian experimental documentary filmmaker, Dziga Vertov (1896–1954), who expounded an idea of "film truth," holding that fragments of film, when organized, could reveal a truth not perceptible to the naked eye. Unlike the typical Hollywood movie, *Uncompressed* does not have a central protagonist. Instead, each character or set of characters serves as the fulcrum of their individual storylines. Furthermore, each represents a particular theme and way of communicating. For instance, the grandmother and granddaughter are associated with a belief in the supernatural and communicate telepathically. To accentuate the differences between the characters, each is shot in a different style and each has a different color code. According to Szperling, the characters represent six archetypes and three forms of opposition. The scientist, for instance, represents the desire to dominate nature, while the cloned twins represent the desire to break free of control. These contrasts between the characters and the ideas they represent can only be perceived by playing the movie multiple times and observing the various points of view.

Szperling believes her hyperstory approach to filmmaking offers a deeper and more complex view of the world than the typical Hollywood linear movie. She says *Uncompressed* allows the viewer to "see between the panes of glass." Her hope in making this work, she told me, "was to create a series of subtle questions meant to discredit and validate themselves within the storyline of *Uncompressed.* I realize this is a conundrum, but most provocative artwork contains opposites. Every storyline shows how different the same reality can appear; it shows perspectives as they intersect with each other. This is where the strength of the piece lies. With this vast an amount of interactive content, much is learned by traveling in between the layers."

She calls *Uncompressed* "a workout for the imagination" and recognizes that it is fairly demanding of the viewer. She says each of the stories represents a viewpoint as valid as any of the others, and that the inconsistencies make the audience question their own prejudices. She feels that the film serves as a sort of "reflecting pool" that reveals aspects of the viewers to themselves. It is the process of observation and discovery, she believes, that keeps the audience involved in the piece.

THE DEVELOPMENT AND PRODUCTION PROCESS

In working out the content for *Uncompressed*, Szperling said, she first established certain criteria for the piece to meet. She wanted all the action to happen on the same day; all the characters to already know each other or have some previous connection with each other; and all the characters to end up together in the same

place in the final scene. She also established that six would be the optimum number of characters, feeling that this size would give the story enough flexibility without being confusing, and that it was the maximum that could be introduced in thirty-six minutes of time. With these parameters in mind, she and three others on the creative team brainstormed to determine who these characters might be and what themes they could offer that could be explored in the work.

Once they'd roughed out who their characters would be, everyone on the team wrote full bios of all six, and then they collectively drew elements from these bios to finalize their personalities and backstories. Once their characters were designed, they began to build a map showing the interconnections between them and their parallel realities, something Szperling believes is important to do early on in interactive cinema, prior to the writing of the script. She feels that the connections, where viewers can shift perspectives, should be embedded in the narrative in an organic way rather than pasted onto an already existing story. For *Uncompressed*, she worked out an image-based way for viewers to switch points of view rather than one that made them use a menu—a pulsating light around a character would signal that one could switch perspectives. The viewer could do this merely by clicking on the character with the pulsating light, an extremely intuitive and noncumbersome form of navigation.

Despite all the preproduction work and the documents the team had generated, Szperling said, they could not foresee by the text alone what their words would set in motion. During production, she found that the script constantly needed to be updated to meet the needs of the interface as well as the narrative flow of the work. The project was continually evolving. Production was a particular challenge for the actors, who had to read each line as many as five different ways, to portray the scene from various characters' vantage points.

LESSONS LEARNED

Looking back now on the making of *Uncompressed*, Szperling feels that if she were to do it again, she would try to simplify the process as much as possible. For example, instead of shooting each character in a unique style, she would shoot them in blue screen and add the stylistic elements during postproduction. She also feels the story might have been simpler, because certain aspects of the plot seemed to be difficult for some viewers to understand. Yet she believes this genre, the hyperstory, has great potential. She looks at *Uncompressed* as a prototype of what is possible. She believes this form can be used to tell many different kinds of stories, and can give us "a way to understand who we are and to understand the complexities of the world around us."

THE HYPERSTORY AS A VEHICLE FOR TRAINING

As at least one major corporation has discovered, the hyperstory can be a potent vehicle for training. The Boeing Leadership Center turned to Szperling's company to create and produce a CD-ROM-based hyperstory as a training tool to assist the company's employees who were making the transition from individual contributors to management-level positions. At Boeing, this amounts to about 1,400 employees

a year, and many of them find the promotion unexpectedly difficult. Boeing was attracted to the hyperstory idea because they felt it would help new managers deal with tough issues that had no black and white answers, particularly in matters involving communication. They also felt using a multiperspective story would stimulate dialogue, engage the trainees, and establish a nonthreatening learning environment.

To develop the film, *Transition to Management*, substanz worked closely with Boeing's instructional designers. They came up with a story set at a fictional magazine publishing company where an employee, Chloe, has just received a promotion to manager. Though under the impression that she's doing just fine in her new position, Chloe is actually causing potentially serious friction between herself and other staff members. As with *Uncompressed*, viewers get a chance to see things not only from Chloe's perspective but also from the perspective of other characters, two fellow employees at the publishing company. This technique gives Boeing's new managers a vivid insight into the mistakes Chloe is making—and hopefully helps them avoid making the same mistakes themselves.

While *Uncompressed* had six characters or pairs of characters and takes an ensemble approach, this film has one central protagonist and two supporting characters. Szperling said Boeing felt this approach to characters would work best in terms of conveying the training message. The work was further customized to Boeing's needs by having less subtle interaction points than in *Uncompressed*, and including additional voice-overs, reflections, and possible endings. "I believe that each project should have a specific approach to the story structure that fits the needs of the narrative," Szperling told me.

Transition to Management, completed in 2002, will be used for ten years at Boeing, and has already had an impact on the corporate culture there. When new managers slip up, they are given to say: "I pulled a Chloe." And the project has received recognition from the outside world as well, earning a Gold Plaque in Interactive Multimedia at the 2002 Chicago Film Festival.

OTHER APPROACHES TO SMALL-SCREEN INTERACTIVE CINEMA

Another company making small-screen interactive movies, Aftermath Media (*www.aftermathmedia.com*), has taken yet another approach to this form of digital storytelling. The cofounders of the company, Rob Landeros and David Wheeler, have impeccable credits in interactive media; they were two of the major creative forces behind the landmark games *The 7th Guest* and *The 11th Hour*. In their two interactive movie projects, however, they were determined to forego any gaming elements and find other ways to harness interactivity. Let's take a brief look at the two works they created.

Tender Loving Care, briefly described at the opening of this chapter, is a psychological thriller adapted from Andrew Neiderman's novel of the same name. It is the story of a woman who suffers a mental breakdown and becomes delusional after her daughter is killed in a car accident. Her husband seeks the help of a psychologist, played by actor John Hurt, who suggests that he hire a live-in psychiatric nurse to take care of her, which he does. However, the husband finds himself powerfully attracted to the mysterious nurse he employs, and the situation provokes more havoc within the household. The resulting conflicts form the core of

the movie. The twist here, in terms of the interactivity, is that the viewers themselves become integrated into the psychological drama. At various points in the story, the psychologist asks the viewers probing questions, and their responses are compiled into a psychological profile that helps shape what the characters do and how the plot unfolds. Viewers can even peek into their personal profiles. In addition, they can snoop around the couple's house to try to uncover secrets the characters are hiding. *Tender Loving Care* was shot on 35mm film and released on DVD-ROM and a DVD-Video as well as a theatrical motion picture. It has received awards both in North America and in Europe.

The second interactive film made by Aftermath Media, *Point of View*, employs a similar model of interactivity. The story revolves around a reclusive artist named Jane who is trying to escape from a nightmarish event in her past. The story is broken into twelve chapters, and at the end of each, viewers are asked questions which are used to build individual personality profiles, which then shape the behavior of the characters and the direction of the narrative. As with *Tender Loving Care*, viewers can also explore the locations where the story takes place. Although designed as a single-user experience, the film was shown to an audience of about 250 in Vancouver, projected onto a large screen. A master of ceremonies polled the audience for their responses, enabling them to jointly direct the interactivity. According to Landeros and Wheeler, the crowd got quite involved in the process and many stayed for the full 3 1/2 hours it took to reach the ending. This screening demonstrated that in certain circumstances, at least, a small-screen interactive movie can be effective in a theatrical setting.

Despite the positive reception Aftermath has gotten from these two projects, it is no longer making interactive movies. According to Rob Landeros, competition from major movie releases and the small market niche for this type of entertainment did not make it viable for them to continue. But, he said, they did find interactivity in movies to be well-worth exploring from a creative standpoint.

NONFICTION INTERACTIVE MOVIES

Works of nonfiction as well as fiction are being produced as small-screen interactive narratives. Documentaries, compiled as they are from a great mass of material, are particularly well suited to an interactive narrative treatment. In linear documentaries, the production team selects which materials to show the viewer and which to exclude; it arranges the order in which the materials will be seen; and it selects or writes the words for the voice-over narration. But in a nonlinear documentary, particularly on a DVD, a great amount of the raw material can be included. The viewers themselves can be given the opportunity of choosing what material to see and in what order. They might also get to choose among several different audio tracks. In Chapter 20, we will be discussing two projects that use nonfiction subject matter. One, *Manuela's Children*, is an interactive documentary. The other, *Bleeding Through: Layers of Los Angeles*, is an innovative blending of nonfiction with fiction.

Bleeding Through: Layers of Los Angeles was a coproduction of the ZKM Center for Art and Media in Karlsruhe, Germany, and the Labyrinth Project at USC's Annenberg Center for Communications. The Labyrinth Project, which is under the direction of cultural theorist Marsha Kinder, has produced a number of

interactive narratives that explore, as Kinder terms it, "the border between documentary and fiction." Kinder serves as executive producer of the works undertaken by this initiative. She calls these works *database narratives*. According to the Labyrinth Project's website (*www.annenberg.edu/labyrinth*), database narratives are those whose structure allows for both the selection and the combining of narrative elements from a number of categories. The site further explains: "Although a database narrative may have no clear-cut beginning, no narrative closure, no three-act structure, and no coherent chain of causality, it still presents a narrative field full of story elements that are capable of arousing a user's curiosity and desire."

The Labyrinth Project has undertaken a variety of disparate projects, many of them based on the works of artists and writers. The project's website says of the database narratives that they "frequently have a subversive edge. For, in calling attention to the database infrastructure of all narratives, they reveal a fuller range of alternatives. In this way, they expose the arbitrariness of so-called master narratives, which are frequently designed to appear natural or inevitable." Although the Labyrinth Project is probing the borders between fiction and nonfiction, it would be interesting to see what this approach could do with a narrative that was entirely story-based. Could a fictional story stand up to this approach, or would it fall apart without a three-act structure, a beginning or ending, and with no coherent sense of cause and effect? These are among the many fascinating questions that have yet to be answered in this arena.

CONCLUSION

As we have seen in this chapter, the field of interactive cinema may be small, but the work that is being produced here is dynamic and innovative. It encompasses both large-screen theatrical experiences and intimate small-screen interactivity, sometimes within the same work. The practitioners of interactive cinema employ many approaches for the works they create, as reflected in the variety of terms they use to refer to them: goovies, database narrative, hyperstory, and immersive cinema.

Each new venture in interactive cinema, whether for pure entertainment, for education, or for training, pushes the envelope of digital storytelling a little bit further. It is a field that cries out for more study and more experimentation. Advances, however, have been slowed by the dearth of successful business models. Even more daunting, however, has been the lack thus far of a receptive audience for this type of storytelling. Some critics have argued that interactive cinema has not caught on because it is simply not a viable form of entertainment, and that cinematic storytelling and interactivity cannot be melded together in a satisfactory way.

However, it must be remembered that in the early days of linear cinema, it too met with a negative reception. Audiences reacted to the first movies they saw with bewilderment and hardly knew what to make of them. With time and increased familiarity, however, they came to accept and understand the grammar of this new medium—techniques like the montage, the dissolve, and the flashback. In fact, if we look at the history of each new art form, we will usually find that the public reacts with skepticism and an initial lack of enthusiasm. Not so long ago, when music videos were first aired on TV, they too had a chilly reception,

especially from adults who had grown up watching the more stately paced movies of the mid-twentieth century. Many found music videos to be a dizzying barrage of unconnected images and could find nothing to enjoy about them. Although some people will never like them, they have become an immensely popular and influential part of contemporary culture.

As for interactive cinema, it is critically important that it, too, develop a support base of users. Otherwise, its creators are laboring in a vacuum. Josephine Anstey, who created the VR work *A Thing Growing* (described in Chapter 19), stated this dilemma eloquently when she said: "We need practitioners and experimentalists, but we also need an increasingly sophisticated audience and the feedback between the two. No interactive fiction can be made without constant testing and feedback from users." (*Computer Graphics World*, February, 2001.)

Hopefully, as more people are exposed to interactive cinema, they will begin to develop an understanding and appreciation of a new cinematic language and a new storytelling art form, and this promising arena will receive the support it needs to move forward.

IDEA-GENERATING EXERCISES

1. Pick an educational or training topic that you think might work well as an interactive movie. Do you think this topic would be better suited to a large-screen experience or a small-screen experience, and why? Work out a premise for this topic. What would the story be? How would the audience interact with it and what would they learn?

2. Sketch out a premise for a fiction-based or documentary movie, one intended as pure entertainment. Do you think this work would be better suited to a large- or small-screen experience, and why? What kinds of interactivity would this premise offer, and how would the player's involvement affect the ultimate outcome?

3. If one of your ideas for an interactive movie involves a large-screen and small-screen configuration, as with the Immersive Studios model, work out one sample idea that offers group-based interactivity. What would be happening on the large screen, and what would participants be doing on the small screen?

Immersive Environments

What is meant by an "immersive environment?" What are some of the typical elements that have been called into play to create them? What are some of the more exotic elements?

What are some of the greatest challenges in creating a story-based experience for a virtual reality environment?

How can virtual reality and immersive environments be used for teaching and training?

SCIENCE FICTION TERRITORY

In real life, it is highly unlikely you'd get a chance to design and ride your own roller coaster, or fly a stunt plane, or engage in a sword fight with comic book villains. And unless you had a very large travel budget, you'd be hard-pressed to have the chance to tour a Hindu temple in India. And you'd need a magical time machine to be able to travel backwards in time to relive your earliest memories. But thanks to virtual reality (VR), you can experience all of these things simply by donning some special gear and stepping into a VR installation.

When we move into the world of VR, we are entering serious science fiction territory—but science fiction that has become entertainment fact. One of the most dramatic visions of this type of experience, as portrayed by the media, was given to us by the classic *Star Trek* TV series, with a device called the holodeck. In this make-believe vision of VR, the crew of the starship Enterprise and then Voyager could entertain themselves in their off hours by visiting the holodeck and immersing themselves in computer-generated dramas. These experiences were much like novels that had come to life, complete with props, sets, life-like characters, virtual food, and scenarios capable of inducing intense emotions. The holodeck was such a compelling vision of the possibilities of VR that Janet Murray even named her book on the future of storytelling after it, calling it *Hamlet on the Holodeck*. The idea of a computer-generated alternative reality has continued to fascinate storytellers. In more recent times, this concept played a major role in the *Matrix* movies. The plot of this epic revolved around the idea that the contemporary world was only a convincing fabrication, a VR simulation controlled by powerful machines for their own sinister purposes.

To date, of course, nothing as convincing and detailed as the alternate reality of the *Matrix* or *Star Trek* has been achieved here on Planet Earth. However, computer scientists and VR producers, progressing in small increments, are moving ever closer. Before we investigate what they've accomplished, and discuss the implications their work has for storytelling, let's first take a moment to pin down what we are talking about.

DEFINING VR, IMMERSIVE ENVIRONMENTS, AND LOCATION-BASED ENTERTAINMENT

What do we mean by VR and immersive environments, and how does a closely related construction, the location-based entertainment (LBE), fit in here? A true VR environment is an extreme form of cyberspace, a 3D artificial world generated by computers that seems believably real. Within such a space, one is able to move around and view the virtual structures and objects from any angle. But a VR world requires special hardware to be perceived. In one of its most common forms, visitors are outfitted with a helmet-like head-mounted display (HMD), earphones, and gloves, which give them the ability to perceive and manipulate the computer-generated representations. A second type of VR utilizes a device called a BOOM (Binocular Omni Orientation Monitor), which is like an HMD, but mounted on a rotating arm rather than on one's head. A third type of VR, the CAVE, surrounds the user with rear view projection screens and the 3D images

are seen through stereoscopic glasses. VR environments may also utilize motion and smell as well as video and audio, involving as many of the senses as possible.

It should be noted, however, that we are talking about immersive VR experiences here, and that VR is not necessarily a space that one enters. Some VR creations are designed just for observation purposes. They may be quite small, just of tabletop size. Such VR creations are chiefly constructed for scientific, engineering, or architectural purposes, not for entertainment. To make matters even a bit more complicated, the term "virtual reality" is often applied indiscriminately to experiences that have some, but not all, of the components of true VR. Furthermore, it is not always possible to draw a clear dividing line between immersive environments and VR; sometimes the terms are used interchangeably to refer to the same experience, and an immersive environment may include some VR components.

The goal of an immersive environment, as with VR, is to give users the impression that they are in a physical space that seems real, though it is, in fact, artificially created. However, immersive environments use a different palette of techniques than VR to create their fantasy worlds, and are less dependent upon the user wearing heavy-duty hardware. Sometimes the immersive effect is produced via a large curved screen in a specially equipped theatre, and the seats may move in synch with the story's action (motion base chairs). In this type of experience, called a "ridefilm," one stays seated and cannot move around as one can in a true VR space; it offers little or no opportunities for interaction. To further enhance the immersive experience and trick the senses, designers may call upon artificial smell, tactile stimulation, artificial weather effects, temperature change, sound effects, virtual characters, and animatronic figures. The vote for the most ingenious effect should possibly go to the *Honey, I Shrunk the Audience,* a 3D ridefilm attraction at Disneyland. Guests, who are under the illusion that they have been reduced to a tiny size, are confronted by a large dog, and when the dog suddenly sneezes at them, they are spritzed by a powerful mist (via a device built into the theatre's chairs).

A special branch of immersive environments is location-based entertainment. LBE, which often overlaps with immersive environments and may also include VR, is a large category of entertainment experiences that take place outside the home. It includes various kinds of theme park attractions and ridefilms as well as multiplayer interactive computer games, like racing simulations and outer space combats. It also includes immersive experiences set in museums, aquariums, and other cultural institutions.

While most individuals have had at least one experience inside an immersive environment, usually as a ride at a theme park, true VR installations are much harder to come by. Except for a small handful of theme parks, most VR is confined to the research divisions of academic, military, or industrial organizations.

WHERE DID VR COME FROM?

The first work in VR began with a pragmatic purpose: to provide a safe way to train pilots to fly. The notion of building what would eventually be called a flight simulator belonged to Edwin Link. In 1929, when he was only twenty-five, Link came up with the idea for a training device that would give inexperienced pilots

the feeling of operating a plane's controls, without the danger of crashing. But it took fifteen years for Link's concept to come to fruition, which it did during World War II, when the United States Air Force put Link's flight simulator to work to train military pilots.

Some years later, another milestone was achieved, a strikingly visionary one. Unlike the flight simulator, this VR construction was built entirely for entertainment purposes. Devised by Morton Heilig and patented in 1962, it was an arcade game called *"Sensorama."* It provided a multisensory experience utilizing motion, scents, moving images, and even an artificial breeze. One scenario had the participant riding a motorcycle through Brooklyn, with tactile feedback provided via the bike's handlebars. Another featured a belly dance performance—though what tactile experience was offered here, if any, has not been documented. The visuals for these experiences were provided by a special set of stereoscopic goggles, which provided 3D views. Unfortunately, Heilig's VR rides were far ahead of their time and failed to make any money.

The term "artificial reality" was coined many years after Morton Heilig invented his revolutionary rides. The first published use of the word was in a 1974 doctoral dissertation written by Myron Krueger, a student at the University of Wisconsin. In it, he explored the interaction between humans and machines as a possible art form. Later, in 1983, he published his ideas in a book called *Artificial Reality*, and described this concept as full-body participation in "computer-created telecommunications experiences." About a decade later, VR pioneer Jaron Lanier founded VPL Research, Inc., to help develop and produce VR products (VPL stands for Visual Programming Language). And it is Lanier who is credited with coming up with the term "virtual reality."

In 1989, Mattel marketed an interactive device, the Power Glove, to go with the Nintendo Entertainment System. The Power Glove was based on Lanier's work, and a far more high-end version of the glove was first used in the NASA space program. By slipping on the Power Glove, players could control certain Nintendo games and interact with the content in a life-like way. For example, they could make a fist and "sock" an enemy. The glove allowed them to control the action without using a joystick, and with greater dexterity. The Power Glove was the first VR device to be made available to consumers. Versions of this glove are used in many of today's VR installations as an interface device.

THE CAVE

Moving still closer to the fictional holodeck and the artificial world of the *Matrix*, we come to a room-sized installation called the CAVE, a kind of VR theatre that was premiered at the 1992 SIGGRAPH convention. (SIGGRAPH is an organization for professionals in computer graphics.) Participants donned a pair of stereo glasses, and when they stepped inside the CAVE, they were surrounded by 3D visuals and sound—they were truly inside a virtual world. They could wander around freely and the computer-generated images would still remain in focus. The CAVE was the creation of a team from the Electronic Visualization Laboratory (EVL) at the University of Illinois at Chicago. The name they gave it, the CAVE, stood for CAVE Automatic Virtual Environment, but it was also a nod to *Plato's Republic*. In this ancient work, the philosopher talks about how reality can be inferred from

the shadows projected on the walls of a cave. Eerily, the CAVE installation worked in much the same way, via images projected onto large rear-projector screens.

The CAVE was the first VR environment that could accommodate multiple users. It offered a large-angle of view, and users were not encumbered with bulky hardware, needing only to wear lightweight stereo glasses and wired sensors to track their heads and hands. As many as twelve people could fit into the CAVE at one time, though only one person at a time could actually drive the experience.

The CAVE, however, was not designed to be the next generation of video game platform or to serve as a new kind of flight simulator. Instead, it was created to be a tool for scientific visualization. At SIGGRAPH, it attracted the attention of numerous scientists in the fields of astrophysics, neuroscience, and other specialties. They recognized its potential for communicating ideas and for teaching, and this is the way the CAVE is often used. It now comes in different models and sizes—with four to six flat surfaces, with curved walls, and even in portable tabletop sizes. Participants inside the immersive models carry a wand, a device with three buttons, which allows them to grab objects and interact with the VR environment. A location sensor tracks their movements, and the digital images they see are corrected and updated as they move from place to place.

USING VR FOR ARTISTIC EXPRESSION AND STORYTELLING

Not only is the CAVE used for a variety of scientific, commercial, and technical endeavors, but it is also being used for artistic and story-based purposes. Most of this adventurous storytelling work takes place within academic institutions, where professors and students are keen to push the boundaries of this medium and have more latitude to experiment than they would in the outside world, where commercial considerations are often constricting. At Iowa State University, for example, faculty and students have worked together within the university's Virtual Reality Applications Center (VRAC) to produce two projects with strong narrative lines. In fact, VR research at Iowa State is headed up by one of the veterans of the original CAVE, Dr. Carolina Cruz-Neira.

One of these narrative projects, *Ashes to Ashes*, is an emotional memorial to the victims and survivors of the New York City terrorist attacks on 9/11. It was built for a six-sided CAVE called the C6, which offers 360-degree immersion (though the work actually made its debut in a more portable four-sided CAVE). In a C6, the ceiling, walls, and floor are all stereoscopic screens, and it has a 3D sound system as well. An extremely ambitious undertaking, *Ashes to Ashes* combined abstract dance, music, and narrative accounts of the survivors and witnesses, all in a technical environment which did not normally support any of these things. (See Figure 19.1.)

Nothing about the work was "off the shelf," especially the music. The experimental score was written by Assistant Professor of Music Anne Deane, who combined computer-generated sounds with a musical technique called "text painting"—the use of spoken words—to weave together an emotionally evocative composition. Music plays a particularly important role in this piece, Prof. Deane told me. As opposed to cinematic works, where music and sound design play a supporting role to the visual elements, the audio drives the experience here.

Figure 19.1 *Ashes to Ashes,* using music, dance, images, and eyewitness commentary, commemorates the devastating events of 9/11. Here, the viewers are listening to the final comments of the survivors surrounded by the rubble of the World Trade Towers. Image courtesy of the Virtual Reality Applications Center of Iowa State University.

"The script, visuals, and interactivity are integrated through the audio and support the drama found in the stories," she explained.

To help shape the work and give it a narrative cohesion, the VRAC team brought in writer Larry Tuch from Los Angeles. Tuch had had a positive experience working on the *DarkCon* VR project for the Army (described in detail in Chapters 5 and 6), and understood many of the challenges of story creation in a VR environment. The VRAC team, viewing everything in this piece in musical terms, termed what he would be constructing as the "libretto." And they saw the participants as being the work's conductors, triggering the dancers and the narrative elements with their baton-like wands.

CREATING A NARRATIVE PATH

Tuch found the project a tough nut to crack. He felt it "would not jell unless it had structure and meaning for the participant," he told me. And he wrestled with how to integrate all its disparate elements. "You have to decide what experience you want to offer people," he said, "and how you'll use these elements you have—the cube, the surround sound, the dancers, and so on—to give them that experience." He was also well aware of the risk of basing an experimental artistic work on such a well-known, profoundly emotional tragedy. If handled in the wrong way, he could inadvertently trivialize it. Yet, handled in the right way, the work had the potential to be truly cathartic.

Another tough challenge was the C6 itself, which to him seemed like an unnatural space for a narrative experience. "Who'd want to tell a story in a box?" he wondered. Designing for the cube meant taking everything into account, including the floor, which, like all the other walls, was a projection surface for digital images. But he didn't want the C6's shape to impose on the experience. "Literalness is the enemy," he said. "You aren't just doing it for four or six walls." In other words, you have to try to make those walls disappear, to push the experience beyond the physical boundaries. So he worked on devising ways to help participants forget they were in a cube.

Fortunately, he had one major asset going for him: Prof. Deane had made audiotapes of survivors giving eyewitness accounts of the event. From these, he shaped a through-line using the harrowing account of a fireman named Billy, with other survivor's stories branching out from it. The narrative line was divided into four major emotional beats, or acts: anticipation (the early morning activities of the victims-to-be); terror (the attacks); shock and response (the initial reaction of the survivors); and release (the aftermath). This yielded the framework that enabled participants to relive the drama of that fateful day.

THE VIRTUAL TEMPLE PROJECT

The second narrative-based project at Iowa State, *The Virtual Temple*, invited visitors to explore a Hindu temple and experience a traditional devotional ritual. *The Virtual Temple* was far less complex in terms of its content than *Ashes to Ashes*, though it had its own set of technical challenges. The project was initiated by Whitney Sanford, an associate professor of religion and philosophy at the university. She was intrigued by the possibilities of using VR to tell the story of the Hindu religion. She felt sure that a 3D immersive scenario would be far more effective than classroom lectures on the topic, and far more feasible than taking the students on a field trip to India.

Working with Cruz-Neira and a team of students, the project was developed for a four-sided VR system, considerably less costly than the six-sided C6. The centerpiece was to be a simulation of an actual temple in India, the Radharaman Temple. *The Virtual Temple* would include not just the temple structure, but also priests and worshippers engaged in religious ritual. The principal technical challenge was the requirement that everything be highly realistic, unlike *Ashes to Ashes*, which was an abstract piece. It required detailed 3D modeling of the temple building, based on video footage and photos.

An operational version of *The Virtual Temple* was demonstrated at the big SC2000 computer conference in Dallas, but Sanford still considers it a work in progress. In a report written for the VRAC website (*www.vrac.iastate.edu*), Sanford says she hopes to develop it to the point where participants can assume one of the roles in the narrative, or be guided through the ritual by a virtual friend. "In this version," she says, "it's almost like entering a story. As the technology improves, we'll be able to have it even more interactive." In discussing the possibilities of projects like this, she comments: "Digital storytelling is an exciting new field in which we can utilize the skills of the humanities and information technology." She feels that the techniques developed for *The Virtual Temple* could be utilized for many types of educational purposes. "Ultimately, with this concept of digital storytelling—creating narratives where people go into a site or an historical place—we can create an entire new generation of immersive scenarios that can be used in a variety of disciplines."

OTHER NARRATIVE EXPERIMENTS IN VR

As noted earlier, the majority of story-based VR projects are being developed within an academic or research context. Let's take a look at a couple of others, to see what creative areas the developers of such projects are exploring.

One project to emerge from academia is a piece called *The Thing Growing*. A work of pure interactive fiction, it was based on a short story written by its creator, Josephine Anstey, for her Master of Fine Arts thesis project at the University of Illinois. This university is the home of the original CAVE, and the project was built specifically for a CAVE environment. In doing this work, Anstey wanted to portray a particular type of relationship and personal struggle—one in which a person (the protagonist, or user) tries to escape a destructive, abusive relationship. The antagonist in this scenario is an abstract computer-generated creature made up of pyramid shapes, called the Thing. The participant in this installation is meant to feel the emotional claustrophobia of a destructive relationship, and is forced by the Thing to jump through a series of emotional hoops. Ultimately, the user participant can confront the Thing and put an end to the torment by shooting it. As with all classic drama, the piece is structured in three acts. Act One introduced the protagonist and the goal; Act Two centered on the struggle to reach the goal; and Act Three was the resolution.

Another project that sharply focuses on the emotions of the participant is *Memory Stairs*, a work in progress as of this writing. Its creator, Jacquelyn Ford Morie, is designing it as a part of her Ph.D. dissertation at the London Institute's Smart Lab. Morie is a fine artist, which very much informs her approach to VR. She's also the producer of the *DarkCon* military VR simulation which, like *Memory Stairs*, explores how emotions can be integrated into a VR experience. (The emotional components of *DarkCon* were previously discussed in Chapter 6.)

The physical centerpiece of *Memory Stairs* is a spiral staircase. (See Figure 19.2.) Each stair that the participant steps on will trigger a memory experience, nine recollections in all, from prebirth to old age. The stairway thus serves as a linear pathway, and the participant ascends it as if going on a chronological journey through key life experiences. Participants will wear HMDs and other devices to be able to see, hear, and smell the virtual memories, and use a joystick to maneuver through the 3D images.

Morie is creating the project in part to explore how personal memories can be translated into universal ones. Another important goal for her is to explore the possible "grammar"—artistic principles or rules—that can be employed in VR. She feels VR still relies heavily on older concepts borrowed from movies, video

Figure 19.2 A concept rendering of the spiral stairway of *Memory Stairs*. Spectators can watch the screens on the sides to view the images that the participant is seeing. Computer concept rendering by Jared Leshin. Image courtesy of Jacquelyn Ford Morie.

games, and other forms of entertainment, in part because the practitioners in this field have placed more emphasis on developing hardware and software than on exploring content. As a result, it is short on artistic ideas that are specifically geared for VR's unique attributes. Every new medium requires its own artistic vocabulary, but that takes time to develop, and audiences often have trouble at first in interpreting what they are experiencing. For instance, when the jump cut was first introduced in the early development of cinema, people didn't understand what it meant. "We've gotten used to the tools of books and films," she told me, "but what is the equivalent of a 'jump cut' in VR? Can you do a break in time and make it work? When you have a persistent universe, can you do a shift in time? And is there a way for the participant to control time?" These are some of the questions Morie would like to see addressed in VR works. She feels that answers to these and other questions will come from the artists who are working in VR, not from the technologists. "I think the artists push more than the technologists," she asserted. "We are the ones demanding that the technology bend to the effects we want to achieve."

VR IN OTHER ENDEAVORS

Artists like Jackie Morie are not the only ones pushing content development in VR. Significant work is going on in three other areas:

1. TEACHING AND TRAINING: VR is being used by the military to prepare personnel for such things as leadership positions and potentially hazardous assignments. The military, as we saw, was actually one of the early adopters of VR, using it for flight training simulations. VR is also being used in the classroom to teach difficult subjects. For instance, a VR program on chemistry lets students play a game where they catch protons and electrons and make atoms.
2. PSYCHOTHERAPY: VR is being used by therapists to help patients overcome phobias, such as the fear of spiders, the fear of driving, and the fear of flying. By giving them the virtual experience in a non-threatening environment, the patients become desensitized to their fears.
3. PROMOTION: Several industries are using VR to promote themselves and their products and services. One company, Ferris Productions, specializes in producing VR applications for such marketing endeavors, and even makes a suitcase-sized portable VR unit that comes with an HMD device with a built-in scent dispenser. Buick commissioned such a unit from Ferris so it could take potential customers on a virtual test drive. The "drivers" are treated to the scent of fresh cut grass as they tool along the virtual road. Red Baron Pizza also commissioned a portable VR kit to give people an exciting ride in a stunt plane. And in Chapter 8, we saw how the German company, RAG Coal International, put a VR installation to work to promote itself.

It is quite possible that forward progress in one of these arenas, such as the suitcase-sized VR kits, could spur new advances in using VR for entertainment purposes.

VR IN ENTERTAINMENT

To an extremely limited degree, VR can also be found in commercial entertainment venues. Probably the most impressive example of this is the *DisneyQuest* indoor theme park. Within this five-story structure in Orlando, *DisneyQuest* offers a diverse array of VR amusements via HMDs, CAVE environments, and simulators. For example, visitors can take a ride on Aladdin's magic carpet, go on a jungle riverboat ride, or have a swashbuckling laser sword fight with super villains from the world of comic strips. They can even design their own roller coaster at a touch screen kiosk, and then, via a simulator, take a ride in it. But few commercial venues other than DisneyQuest are currently offering guests the opportunity to sample VR.

As we have seen from the various VR projects we've examined, developing story-based projects for VR can be difficult due to a number of factors, including:

- Creators must deal with an entirely new paradigm. In traditional media, such as movies, television, and theatre, viewers watch something that takes place in front of them. This is true even with video games. But in VR, the participant is *inside* the entertainment content and is surrounded by it. We do not yet have a body of experience to guide us in creating content for such a medium.
- VR tends to be a technology-centric field, with many of the developments in the area spurred by scientific interests, not by entertainment objectives, and technology has tended to dominate the field.
- Creators in the field have a lack of models to draw upon—few successful projects are available to serve as examples.
- The field still lacks a developed aesthetic grammar of its own, and has not yet found commonly recognized ways of dealing with creative issues.

All of these factors call for developers in this arena to stretch themselves creatively, and to be willing to break new artistic ground, as a number of people working within an academic framework are attempting to do.

IMMERSIVE ENVIRONMENTS

Unlike VR, the broader field of immersive environments is a robust area for entertainment-based projects and for projects with a strong narrative line. Immersive environments are less dependent than VR on cumbersome devices and equipment. Furthermore, projects using a large-screen format can draw upon cinematic tools that the creative community is already quite familiar with, and these large-screen experiences lend themselves well to taking participants on a fantasy journey. Immersive environments are used for everything from training simulations (where they are called immersive simulations) to pure leisure-time fun. Attractions featuring immersive environments can be found in theme parks, in urban entertainment centers, in cultural institutions like museums and science centers, and even in a few Las Vegas hotels.

One organization with a lively interest in immersive simulations is the United States Department of Defense (DOD). The military has for some time regarded

simulations as a low-cost, safe, and flexible way to train military personnel in a variety of skills. But it has also recognized that in order for simulations to be effective, they need to fully engage the trainees... in other words, they need to be entertaining. In 1996, this realization led to an historic event: a two-day workshop with leaders from Hollywood and the military world. The goal was to explore how these different communities, with extremely different cultures, might benefit by joining forces to work on immersive simulations. The workshop helped forge a working relationship between the entertainment and defense worlds and articulated how each could benefit from this collaboration. As the participants saw it, the military would gain access to experienced producers of entertainment and Hollywood would be able to utilize cutting-edge technology developed by the military for its own creative endeavors.

Not long after this meeting, the U.S. Army made a $45 million grant to the University of Southern California to establish the Institute for Creative Technologies (ICT), a research center to develop immersive simulation technologies. Hollywood professionals and members of the gaming community were to be heavily involved, as well. ICT's mandate was to devise experimental training prototypes, many of them using new techniques or technologies to develop virtual characters, AI, immersive sound, and VR.

HOLLYWOOD AND THE MILITARY: STRANGE BEDFELLOWS

Larry Tuch was one of the writers selected to work on ICT simulations, and he applied his Hollywood background—writing for primetime television and Paramount Pictures—to the task. He found that much of the work he did for ICT was not too different from what he might be doing on a TV show, particularly the job of creating well rounded characters and compelling storylines. The fact that he wasn't a technologist wasn't much of an obstacle, he said, though he admitted to me that sometimes constraints of technology—"the geek stuff"—got in the way of developing effective narratives.

Two of his projects, both produced by Paramount Simulations Group, were geared to teach trainees to deal with fast moving crises. One, *ALTSIM*, centered strictly on military scenarios; the other, *Crisis Decision 2008*, dealt with tense international situations in the world's trouble spots. Both simulations were played on networked computers and made use of communications tools the trainees would be familiar with, using some of the techniques of alternate reality games (ARGs) to make the scenarios seem real. Story elements were conveyed by email, voice mail, electronic video mail, intelligence and situation reports, briefing documents, and military maps. Story content was also delivered via realistic looking TV news broadcasts of a network called ZNN—closely modeled on CNN. The pacing was controlled by human Dungeon Masters (the instructors), who could toss in complications to heighten the pressure.

Two of Tuch's more unusual jobs were to lay traps in the scenarios for the trainees to fall into (to teach them not to rush into solutions) and to develop characters, some of them virtual, that would function effectively within these simulations. In *Crisis Decision 2008*, he wrote traditional Hollywood-style "character bibles," providing details that ranged from the characters' early years to their professional histories and included events that would shed light on their

Figure 19.3 *Mission Rehearsal*, an immersive simulation made for the U.S. Army, makes use of a large curved screen, surround sound, and virtual characters. Image courtesy of USC's Institute for Creative Technologies.

personalities and motivations. In *ALTSIM*, the character bibles focused specifically on the traits most likely to influence their decisions in a military operation. Tuch also created personal agendas for the characters—some of them hidden—that would add to the challenges facing the trainees.

Tuch's work for ICT included another, very different, kind of simulation. Called *Mission Rehearsal*, it used an entirely different set of components. Instead of being played on a computer, it utilized a giant curved screen and surround sound. The scenario was set in present day, war-ravaged Bosnia, and the trainee, a young officer, must make a series of decisions within a volatile situation involving a child who has been severely injured by a military vehicle. The trainee stands in a physical space surrounded by the life-like virtual characters on the screen and has the sense he's really in the midst of an emotionally charged situation. (See Figure 19.3.) To deal with the crisis, he actually talks with virtual computer-generated characters on the screen who understand him and respond.

In this project, Tuch found the characters didn't need nearly as deep a backstory or as fully developed emotional profiles as the other two projects. "We don't need to know that they had a bad childhood," he quipped. But they did need to have clear professional values, priorities, and personalities. The descriptions he wrote of the characters would be used as guides by the computer scientists who were doing the programming and he didn't want to just hand them a lifeless inventory of personality traits. So, to turn them into flesh and blood individuals, he wrote the profiles as mock interviews, letting the characters speak in their own words.

As part of the development work, Tuch needed to give each of the major onscreen characters a *task model*: a sequence of actions they had to perform in order to achieve their goals. The soldiers' task models included maintaining security, treating the injured boy, and getting him evacuated by helicopter. The TV cameraman's task model was to get good footage of the accident scene. But, in the case of the boy's mother, instead of a task model, she was given an emotional arc. It was a trajectory of behavior based on her concern for her injured child, and it

was driven by her interpretation of moment-by-moment developments and how they might affect her son.

A great deal of AI had to be crammed into the central onscreen figure, a platoon sergeant. Not only did he have to be given voice recognition and the ability to respond, but he also had to be able to recognize what people or vehicles were in the vicinity and know what they were doing. Furthermore, he had to know enough about the platoon's mission, procedures, and the unfolding crisis to be able to speak believably with the trainee.

With all three immersive simulations, events unfold at a relentless pace, with unexpected twists and turns. Unlike a TV set, it cannot be turned off. "You're inside the story," Tuch said, "and there's no pausing or doing it on your own time. It doesn't wait for you."

WALT DISNEY AND "DIMENSIONAL STORYTELLING"

Possibly the most expansive idea of all regarding immersive environments comes from the master storyteller himself, Walt Disney. According to Roger Holzberg, Senior Show Producer of Walt Disney Imagineering, Disney's concept of "dimensional storytelling" was the impetus behind the creation of Disneyland Park. Holzberg told me that Disney wanted parents and kids to be able to become a part of the stories he'd created—and Disneyland was a way to give them that experience.

Holzberg believes that everything done by Walt Disney Imagineering (the division of The Walt Disney Company that designs and builds the theme parks and attractions) is a story of some kind, "Though it isn't always traditional storytelling," he said, "it *is* storytelling. Writing, filmmaking, and interactive design are what the storytelling of today is all about." Holzberg noted that although the emotional and technical tools of immersive storytelling have advanced somewhat since the original Imagineers first began work on Disneyland, the heart of the concept remains unchanged, "still grounded by a cast of cherished characters, already known and loved—this is the emotional core." The tools now include ride systems, Audio-Animatronics, 3D cinema, motion-based platforms, live performers interacting with film, even smell. "In the eyes of a child," Holzberg said, "this type of immersive storytelling takes a story from make-believe to real, and there is nothing like it anywhere else on earth."

He then shared with me a moment at Disneyland that personally brought the concept of dimensional storytelling home to him. "I'll never forget my daughter, at age 4, pulling Alice in Wonderland down to the curb on MainStreet U.S.A., gripping her hands and asking, 'Did it tickle when you fell down the rabbit hole? Weren't you scared being away from your Mom and Dad?!' And Alice gave her the answers. And the story of Alice was no longer a story–it was real."

MAKING THE STORY COME TO LIFE

One of the hallmarks of an immersive experience at a Disney theme park is the way fantasy is brought to life. Sometimes this works so well that even the very big kids—the adults—are unable to accept that what they are experiencing is just

pretend. This was the case with a marine attraction Holzberg created called *DRU*, short for Dolphin Robotic Unit. As the name suggests, *DRU* is a life-like robotic dolphin, a free-swimming Audio-Animatronics puppet. It is the exact size and weight of a real dolphin and its swimming motions are precisely like a living dolphin as well. *DRU* is controlled by an operator using real-time puppetry. The puppet dolphin "communicates" with humans by nodding or shaking its head or opening its mouth and splashing water, all in a friendly manner.

DRU was tested as a potential enhancement to the six million-gallon aquarium at The Living Seas at Epcot, as a way of giving guests the experience of interacting with ocean creatures without having to capture real marine mammals and take them out of the ocean. Holzberg terms the concept "the next generation marine theme park." During performances, *DRU* swam around in the giant tank with real fish and a scuba diver and interacted with guests in the underwater viewing arena. The show built around *DRU* was classic edutainment. Visitors learned some interesting facts about dolphins and other forms of sea life, but also got the chance to operate the puppet dolphin's controls. Despite its highly realistic appearance and movements, however, Holzberg said *DRU* didn't fool the real dolphins at Epcot for one moment. They knew *DRU* wasn't real, and regarded him as a curious kind of play toy.

But a strange thing happened when *DRU* was taken out of the Epcot tank and given a chance to swim in the real ocean, as part of a prototype "swimming with the dolphins" attraction for snorkelers at Disney's private island, Castaway Cay. (See Figure 19.4.) As with all good immersive environments, a story was created to enhance the experience. Holzberg describes it as a mix of scientific fact and Disney fantasy. The idea was that a pod of intelligent dolphins lived just off the island's coast. By successfully summoning one of them (*DRU*, of course, who was actually controlled by an operator disguised as a fellow guest), the friendly animal would give the snorkelers a personal tour of the ocean from a dolphin's perspective. And even though all the swimmers had been told in advance that *DRU* was not a living creature, Holzberg says "every single human being who swam with the Audio-Animatronics dolphin believed it was real." He told me

Figure 19.4 *DRU*, an Audio-Animatronics dolphin project conceived and tested by Walt Disney Imagineers, on an ocean swim with a Disney cast member. Image courtesy of © Disney Enterprises, Inc.

that at one point they were considering adding a shark to the performance, but knowing how convincing *DRU* had been, they were afraid that the sudden appearance of a shark, up close and personal, might be a bit more than a swimming guest's comfort level could handle.

MAKING DREAMS REAL

Quite a different type of immersive experience was designed for an attraction called *One Man's Dream*, created for the Disney MGM Studios theme park to celebrate the centennial of Walt Disney's birth. Appropriately enough, Disney himself is the subject of this dimensional storytelling environment. *One Man's Dream* takes guests on a decade by decade interactive walkthrough of Disney's life and the company he built. One of its most popular features is an animatronic figure that children can actually operate, using a set of interactive controls to move the face, hips, and head. Six people at a time can operate the figure, creating their own little performance.

Summing up what *One Man's Dream* is all about, Holzberg said: "If there's one overall message, it's this: 'If you can dream it, you can do it.' Disney was one of the ultimate dreamers of the twentieth century, and this celebrates the dreamer in all of us."

CONCLUSION

More than any other set of technologies, immersive environments and VR give us the ability to make fantasies come to life in real physical space. But while immersive environments have become successful arenas for entertainment, the same has not yet been the case for VR. The VR technology is expensive, and the installations can only accommodate a few individuals at a time. Thus, profit-minded enterprises have little commercial incentive at present to develop VR attractions. If costs decrease, or if new techniques are developed that can make VR more of a mass entertainment experience, this may well change. After all, VR has all the components of other engaging forms of digital entertainment: It supports sound and moving images as well as interactivity and computer-generated intelligent characters. In addition, because it can involve so many of the senses, VR can offer powerfully immersive experiences. But, considering the technical and financial obstacles it poses, it will require visionary and pioneering individuals to devise ways to harness its potential for digital storytelling.

IDEA-GENERATING EXERCISES

1. Describe an immersive environment that you have personally visited. What about the experience made it seem believable to you? What about it did not feel like "real life?" If you could improve anything about this particular immersive environment, without having to consider cost or technical impediments, what would it be?
2. What kind of entertainment experience could you imagine creating via VR or an immersive environment? Sketch out this experience, describing

some of the visuals, sounds, and other elements it might contain. Describe how it would start and how it would end.

3. What kinds of educational or training situations do you think lend themselves particularly well to an immersive simulation approach? Choose one possible topic and sketch out the concept a little, describing its objectives, its target audience, and the elements it would include.

4. Can you think of any component or element that might be used for an immersive environment, but to your knowledge, has not thus far been used? How would you use this element? What kind of experience could it help create?

DVDs

DVDs are most commonly thought of as a convenient medium for watching movies at home, but how else are they being used for entertainment purposes?

What effect are DVDs having on the way movies are made and viewed, and what does this have to do with digital storytelling?

What are some of the characteristics of the DVD that make it an attractive platform for interactive entertainment?

When creating content for a DVD, what are some important things to keep in mind?

A PUZZLEMENT

In terms of interactive media, the DVD is something of puzzlement. Although an enormous hit with consumers, becoming the most swiftly adapted electronics platform of all time, very little original entertainment content has been developed for it, and almost no interactive entertainment.

Introduced just a short time ago, in 1997, it has quickly become American's most popular way to enjoy entertainment, beating out spending on movie tickets, books, and video games, according to figures compiled by the DVD Entertainment Group, a nonprofit industry organization. By the end of 2003, an important benchmark was expected to be reached: Over half the homes in the United States, or 55 million households, were expected to own DVD players. The DVD Entertainment Group also estimates that by 2010, 90% of the homes in the nation will be equipped with DVD players. Furthermore, DVDs are catching on with equal speed in many other parts of the world. Globally, about 100 million households owned DVD players in 2002, and the figure was expected to jump significantly in coming years.

A single DVD disc can hold a great quantity of high-quality video, and this one factor, coupled with the ease of use of DVD players, has helped boost its popularity, particularly for watching feature films and compilations of favorite TV series. To most consumers, the DVD is just an improvement over VHS—a convenient way to watch linear entertainment—and they aren't expecting much more from it. Aside from the bonus features that accompany feature films and TV shows, it is extremely difficult to find any type of original programming for DVDs. The great majority of DVD content we see today has begun life in another medium—as a movie, a TV series, a documentary, or a classic video game—before being ported over to this new platform.

This dearth of original production is a strikingly different state of affairs than the CD-ROM phenomenon in the early and mid 1990s. Back then, developers swiftly recognized the CD-ROM as a vast improvement over the old floppy discs, particularly when it came to audio and video. They seized upon the new platform and churned out hundreds of original games, interactive children's projects, and a variety of interactive nonfiction works. Though the CD-ROM boom faded in the latter half of the 1990s, a great many original titles are still made every year for this platform, while the potential for DVDs to support original programming largely goes untapped. Could this be because developers sense that consumers are quite satisfied with what they are being offered, and have no interest in other kinds of programming? Or are developers simply unsure of how to exploit the features of this platform when it comes to original programming? As we will see a little later in this chapter, a modest amount of original work is being made for DVDs, but for the most part it is coming from outside the mainstream. Nevertheless, now that so many households have DVD players, it may motivate developers to offer fresh kinds of content for this platform.

THE FEATURES OF THE DVD

As noted in Chapter 2, DVDs come in several different formats, each used for a different purpose. Consumers are most familiar with DVD-Video, a playback format that carries both sound and images, and is usually just called DVD (which

we will do throughout this chapter). Other familiar formats include DVD-Audio, which is audio-only and growing increasingly popular with music fans, and DVD-ROM, used on computers in much the same way as CD-ROMs, but holding much more data. At the present time, producers of original interactive-rich content prefer to develop for DVD-ROM rather than for DVD-Video, because most DVD players are not well equipped to handle robust interactivity. This may change as sophisticated players become more widespread.

The DVD disc, with its round shape, overall dimensions, and shiny surface, looks virtually identical to a CD-ROM—so much so that one would be hard-pressed to tell them apart. Yet the DVD is capable of storing a vastly greater amount of information. For example, while a CD-ROM may be able to hold approximately twenty to thirty minutes of video, the DVD can contain a full two-hour feature-length film. Some types of DVDs can actually contain the equivalent of four feature films, or as much as eight hours of video.

THE SPECIAL FEATURES OF THE DVD

Along with the DVD's ability to store great quantities of data, a number of other characteristics make it stand out from other popular technologies and make it highly attractive from the point of view of the developer and the consumer. Consumers like DVDs because:

- They are extremely easy to install and use, and do not require any competency with computers or technology.
- The video and audio are of extremely high quality.
- It is simple to go directly to any scene or any bonus feature, via an easy-to-understand menu system.
- They offer features like fast forward, freeze frame, and multiple camera angles.
- They can be operated by a device consumers are already familiar with, the remote control.
- They are lightweight and highly portable.
- They are warp resistant, not susceptible to magnetic fields, and do not get worn out by being played, making them highly durable.
- They are versatile in how they can be used, since they can be played on computers, stand-alone players, game consoles, and portable devices.

Content developers for DVDs like them for many of the same reasons and also because:

- They offer multiple audio and subtitle tracks, opening up a variety of content possibilities.
- Various degrees of interactivity can be built into them, from basic menu choices to the more diverse experiences of video games.
- It is relatively simple to produce content for them, especially if using digital video.
- Unlike CD-ROMs, they do not have narrow restrictions in terms of audio and video.

- Compared to the Web, they can easily support video.
- The technology of DVD players is consistent, alleviating the need to format for different devices.

DVD CONTENT—A BIRD'S EYE VIEW

As we've noted previously, the most popular use of DVDs is as a medium to watch feature films, compilations of TV shows, and documentaries. This approach to content is known as *repurposing*, which is the taking of material from one medium and porting it over to another. Hit DVDs mirror to a large extent the same movies that were hits in the movie theatres. However, households that have recently acquired DVD players are more apt to use them to watch family fare than were the early adopters, because these newer users are more likely to have children at home.

DVDs are also becoming an increasingly common platform for games, especially since current game consoles are equipped to play them. Games are also being played on PCs equipped with DVD drives, and gamers appreciate the fact that a game that might take up five or more CD-ROMs can be stored on a single DVD-ROM. Some classic video games from an earlier era are now making their way onto DVDs, including the beloved *Dragon's Lair*, an arcade hit in the early 1980s. Surprisingly, a large number of people who own DVD-equipped game consoles are using them to watch movies.

When it comes to original nongaming content for DVDs, the two most popular categories are fitness programs and music, with an extremely small number of titles devoted to nonlinear story-based material. DVD music videos and video-taped concerts of popular performers are a big hit with music fans because of the excellent quality of their sound. In addition, DVDs are being used to market products and services and for corporate promotion. Outside of the commercial arena, DVDs are being pressed into service as electronic high school yearbooks, as repositories for family histories, and to commemorate special occasions.

THE BONUS FACTOR

When a property is repurposed as a DVD, it is almost invariably enhanced in ways that have become fairly standardized. To access the various bonus features, viewers make their choices from the menu, and that is about as interactive as most commercial DVDs get. On a typical DVD you will find:

- The core material is broken into chapters or scenes.
- Bonus features, such as a "making of" documentary, interviews with the cast and others involved in making the film, and deleted scenes from the original property.
- Several sound tracks are offered, offering such things as a choice of languages, a track of the director's comments, or a sound effects-only track.
- If a feature film, sometimes a choice of screen format, usually meaning either a wide screen format (the aspect ratio used in movie theatres), or the customary aspect ratio used for television.

Yet even these standard bonus features are beginning to have an impact on how films are viewed, and even on how filmmakers approach the process of making a movie. The home audience, playing a movie on a DVD, can look at scenes from various angles, watch deleted scenes and alternate endings, and hear the thoughts of the filmmakers regarding how the scene was made. This gives them new insight into the movie making process. Furthermore, by viewing material that did not appear in the theatrical version of the film, something else interesting is happening: The home audience is beginning to perceive that the stories told in films are more malleable and fluid than they had previously realized. Such an insight might bring them closer to an appreciation of nonlinear narrative.

Filmmakers themselves are making movies with their DVD "afterlife" in mind, as noted in an extensive article written by Richard Natale for the *Los Angeles Times* (April 7, 2002). According to the article, highly regarded filmmakers such as Oliver Stone, Francis Ford Coppola, and M. Night Shyamalan are paying serious attention to how DVDs can augment their creative work and give them an additional, and in some cases, nonlinear, palette with which to paint their stories. Speaking of how DVDs affect films, DVD producer Van Ling went so far as to say: "Interactivity empowers both the filmmaker and the consumer. Now we have the chance to interact with storytelling and filmmaking. What's starting to happen is that the DVD has gone from being just another ancillary avenue to becoming part of the filmmaking process itself." With Oliver Stone's work, for example, the theatrical and DVD versions of a film may be quite different from each other. The DVD version of his film, *Any Given Sunday*, a football drama, included unused takes and deleted scenes and gave audiences alternative versions of the story. Referring to movies on DVDs, Stone said: "They are like novels that are being rewritten." And Francis Ford Coppola said "the DVD gives the participant the controls over the movie in a creative way."

Even the capability to select which scenes to watch and in what order, virtually ubiquitous on all DVDs, is a radical departure from the linear experience one has in a movie theatre. But some bonus features give home viewers even more profound ways to alter a film. For example, with *Star Wars: Episode I The Phantom Menace*, viewers can edit characters out of scenes; in the DVD version of *Shrek*, viewers can substitute their own voices and lines for the ones spoken by the characters in the film.

Other bonus features offer home viewers quite different ways to gain insight into the source material or to experience it in new ways. Some DVDs contain little interactive games to play, using characters from the movie. Others offer extensive documentary material about how the film was made. For example, the three-disc deluxe set of *Toy Story* and *Toy Story 2* offers an entire disc of supplemental features, a virtual college course on how Pixar makes its amazing CGI movies. The disc delves into character design, story development, music and sound design, storyboarding, and various facets of the animation process. In the character design section, one can even view 3D rotating models of each of the main characters, getting a chance to study them from every angle. One especially amusing feature of the three-disc collection is a tongue-in-cheek interview with Woody and Buzz, the two animated stars of the movie.

While fiction is immensely popular on DVDs, documentaries also fare well on this platform, and many TV documentaries are making their way onto this new platform. Viewers appreciate the opportunity to study an interesting topic in greater depth. One such documentary, introduced in Chapter 8, is the *Woodrow*

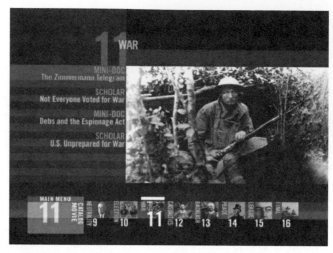

Figure 20.1 A chapter menu for the *Woodrow Wilson* DVD. The features on the left, the "mini docs" and the interviews with scholars, were made just for the DVD version of the biography. Image courtesy of PBS, WGBH, and KCET.

Wilson biography that was part of the PBS series, the *American Experience*. The two-disc DVD set was produced by KCET in Los Angeles. It contains not only the original three-hour TV biography, but also over eighty additional minutes of video shot specifically for the DVD. (See Figure 20.1.)

 Much of the new material on the set is in the form of "mini documentaries," each about three to five minutes long. According to Jackie Kain, VP of New Media at KCET, these supplemental documentaries were purposely kept short so they would not compete with the film itself. They were seen as supplements to the film—supporting elements, not the main attraction. Based on her experience with the *Woodrow Wilson* project, Kain was impressed by the ability of DVD to present material in a way that could make people excited. "For nonfiction TV, the DVD is an extraordinary medium to be exploring," she said. "It's an amazing platform for aggregating information."

ORIGINAL PROJECTS

As we've already noted, original projects for the DVD are few and far between. Nevertheless, a few innovative examples of original DVD content do exist. In Chapter 18 on interactive cinema, we discussed two works made by Aftermath Media, *Tender Loving Care* and *Point of View*. Let's now look at two other original projects, *Manuela's Children* and *Bleeding Through: Layers of Los Angeles*.

 Manuela's Children, released in 2001, was the first interactive documentary made by the Danish Film Institute. Created by artist Eva Koch, it is a true-life, highly personal saga of five Spanish children torn apart by personal and national tragedy. Soon after their father dies, their mother, the Manuela of the title, becomes too ill to care for them. When the Spanish Civil War breaks out, the children are separated and scattered to various places. One dies in infancy and another ends up in Scandinavia—the woman who is destined to become the mother of

filmmaker Koch. Years later, Koch travels back to Spain to reconstruct her family's history on film and reunite as many of her kin as she can.

However, instead of taking the familiar documentary approach, which would force her to take a restrictive linear path, she chose to use the interactive features of the DVD, which offered her a more fluid, open framework. She gives the siblings' accounts as individual but parallel chronological journeys. Each account contributes a different layer to the narrative. Viewers can choose to follow one sibling's story at a time, or, more provocatively, can switch back and forth between them, allowing them to view this family's drama from alternate viewpoints. This approach reflected the reality of the situation: Each member of the family had a unique and personal view of their family's history. To try to present their memories as a single united version of the truth would have done their stories a disservice.

Bleeding Through: Layers of Los Angeles, as the title suggests, also takes a layered approach to narrative, but goes beyond *Manuela's Children* by boldly intertwining historic fact and invented fiction. Set in downtown Los Angeles and spanning over sixty years of time, from 1920 to 1986, it tells the story of a fictitious woman named Molly (based on a real person) who may—or may not—have murdered one of her husbands. The work is the creation of Norman Klein, a novelist, historian, and cultural critic, and he wears all three hats in this interactive narrative. The creative team for this project was rounded out by Rosemary Comella and Andreas Kratky, who served as co-interface designers and also share directing credits with Klein. The work, a DVD-ROM, was an international coproduction of the ZKM Center for Art and Media in Germany and the Labyrinth Project at USC's Annenberg Center. The DVD comes with a novella written by Klein and additional commentary written by others on the team.

Although Molly is an invented character, her story is shaped by the history of her time and place. It is set in downtown Los Angeles during a period when that part of the city was undergoing profound cultural change. *Bleeding Through* uses vintage film clips, maps, reconstructed scenes of actual events, historic photos, and contemporary interviews to tell Molly's story. (See Figure 20.2.) Klein himself appears in a window on the upper right inviting users to sift through the archival material to piece together their own version of Molly's crime. As we saw in Chapter 18, Klein and his colleagues at the Labyrinth Project refer to this genre of interactive cinema as *database narrative.* Klein notes: "We're a civilization of layers. We no longer think in montage and collage; we multitask in layers more and more" (*San Francisco Chronicle,* in a story by Glen Hellfand, Sept. 18, 2003). It is also, according to codirector Comella, about "the bleeding of the past into the present."

As with *Manuela's Children, Bleeding Through* takes advantage of the DVD's unique capabilities to tell a new kind of story—in this case, combining a vast amount of archival data, video footage, an intriguing premise, and a user-controlled interactive selection process. Like other database narratives produced by the Labyrinth Project, it is highly cinematic and visually arresting. One particularly striking feature is the way old and new photos of Los Angeles, taken from exactly the same angle, are layered on top of each other. By sliding between them, users can see the images literally bleed through each other and watch landmarks appear and disappear. (For more on database narratives, the Labyrinth Project, and the use of DVDs in interactive cinema, please see Chapter 18.)

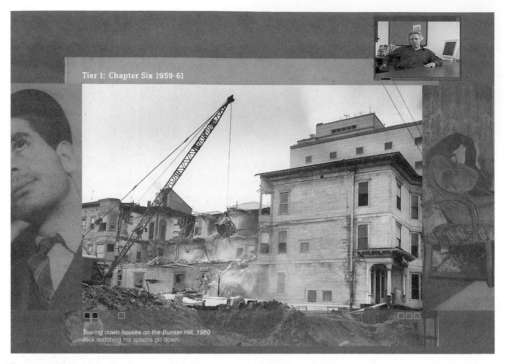

Figure 20.2 *Bleeding Through: Layers of Los Angeles* is a multilayered narrative that blends history and invented narrative. Image courtesy of the Labyrinth Project of USC's Annenberg Center for Communication and the ZKM Center for Art and Media.

A FEW GENERAL GUIDELINES

Like websites, DVDs are relatively easy to author, but are demanding in terms of design. Aside from the bonus features on repurposed properties, creating original material for them is still relatively uncharted territory, and we only have a few models to serve as examples. However, we can offer a few general guidelines based on the projects described here, plus some additional thoughts shared by people interviewed for this book, including John Tollett, coauthor (with Robin Williams and David Rohn) of *Robin Williams DVD Design Workshop*. Here are some things to keep in mind:

1. Because DVDs can hold so much data, particularly video, it can be tempting to shoot a great deal of footage, thinking you can edit it down and organize it later. However, it is far better to resist this temptation and instead to plan in advance what the work will contain and how it will be organized. Not only will production proceed more smoothly, but your work will be stronger and more focused as a result.

2. When determining an organizational approach to your project, try to break up the material (or, as some like to say, "chunk it up") into categories that will make sense to the user. Each unit of material should be small enough to be a "consumable" piece, as Jackie Kain puts it—a manageable size that will not be overwhelming in scope. The material should be indexed in a way that is useful and makes the information readily available; in other words, it should be user friendly.

3. For an especially pleasing presentation, think of ways to make your menu relate in some way to the content itself, either visually or thematically. The supplemental disc for the *Toy Story* DVD did this effectively by integrating images from the movies into the menu of each section. For instance, the choices for the section on story development were displayed on the speller toy; the choices for character design were displayed on the "Etch-a-Sketch" toy; the choices for music and sound design were presented on the instrument panel Buzz Lightyear wears on his wrist.

4. If you are creating bonus features for a property ported over from another medium, let the core property be the "star" of the DVD. Bonus features should augment the primary material and enhance it, not dominate it.

5. If the project will consist of a core property produced for another medium (such as a TV documentary or feature film) as well as DVD bonus features, plan and produce both at the same time if at all possible. That way you will be able to more easily utilize locations and individuals from the core property for the bonus features, and the bonus features you produce will be well integrated into the project as a whole.

6. If you are making an original narrative-based DVD, consider what device your DVD will be played on. Game consoles, stand-alone DVD players, and computers all lend themselves to different kinds of experiences. Factor this into your planning.

CONCLUSION

Though the DVD has only been available to us since 1997, it has caught on with consumers at lightning speed. Unfortunately, however, most content is repurposed and follows a standardized formula. Only a few projects have managed to break out of this mold and illustrate how DVDs can be used as a platform for original narrative. It remains to be seen whether other creative individuals will also step forward and use DVDs to tell new kinds of stories, or whether this promising platform is going to fall victim to its own success, continuing to churn out titles that endlessly imitate each other.

Another intriguing possibility exists as well: DVDs of feature films and television programs may gradually acclimate viewers to nonlinearity and accustom them to choosing their own path through narrative material. Thus, the ubiquitous bonus features on commercial DVDs may serve as a stimulus to the DVD becoming an established platform for digital storytelling.

IDEA-GENERATING EXERCISES

1. Choose several DVDs of repurposed properties—feature films, compilations of TV shows, or documentaries—and analyze and compare them. How are they organized? What sort of menu system do they use? What types of bonus features do they offer? Of these DVDs, which approaches do you think were the most effective, which the least effective, and why?

2. Choose an already-produced narrative property you are familiar with, but one that has not, to your knowledge, become available on DVD. Sketch out several DVD bonus features for this work that you think would enhance it. Try to come up with ideas that go beyond the standard features offered on most DVDs (like the "making of" documentary and cast biographies).

3. Sketch out a concept for an original DVD project that utilizes the special features of the DVD platform. What is the premise, and what are its interactive elements? What makes the project particularly well suited for a DVD? How would this project be organized?

CHAPTER **21**

Kiosks

How can something as utilitarian as an electronic kiosk be transformed into an attractive medium for entertainment?

Why do museums and other cultural institutions often incorporate kiosks into their exhibits?

What are the most important considerations to keep in mind when developing a kiosk project?

What are some of the features that make kiosks especially desirable for use in public places?

A HUMBLE BEGINNING

The electronic kiosk, sometimes also called the multimedia kiosk or the interactive multimedia kiosk (IMK), is perhaps the most modest and unassuming of all interactive platforms. Essentially, electronic kiosks are simply booths or other small structures that offer the user an easy-to-operate computerized service, often via a touch screen. Kiosks are so universal and so much a part of our everyday landscape that we barely give them a second thought, though we are constantly using them to obtain cash, buy gas, or find books in the library. Yet these Plain-Jane devices are capable of supporting some surprisingly creative projects, and can be transported into excellent vehicles for entertainment or infotainment. In a way, they are a bit like an electronic version of Cinderella—the scorned stepchild who metamorphoses into a beautiful young woman when her fairy godmother dresses her up for the ball.

The electronic kiosk had a humble beginning, devised for an entirely pragmatic purpose: to reduce the number of tellers in banks. Thus, the first electronic kiosk was the handy Automated Teller Machine (ATM), introduced by Chemical Bank in 1969. Since then, however, kiosks have been used for a vast array of purposes, and not all of them as utilitarian as the ATM. They are particularly suited for use in public places, either indoors or outdoors. Their popularity continues to grow as the cost of computer technology drops and the speed of computers increases, making kiosks ever more affordable and useful. Furthermore, members of the public have become so accustomed to using ATM machines that it is not much of a leap for them to use a touch screen system to perform many other kinds of tasks.

WHAT KIOSKS CAN DO

Kiosks are immensely versatile in how they operate and what they can do. They can:

- Operate via a computer hard drive, CD-ROM, or DVD.
- Read credit cards.
- Print out receipts and other documents.
- Accommodate both single users and small groups.
- Be equipped with video conferencing capability, as well as Intranet and Internet access.
- Be networked together so users can communicate with each other and share interactive experiences with people in distant places.

Furthermore, the content for a kiosk program can include anything that can be enjoyed via any other computerized system, including text, audio, video, and real time 3D animation. And although a great many kiosks are operated via touch screens, which are extremely easy for people to use, they can also by operated by keyboards or by specially designed controls, some of which can be quite fanciful in nature.

Kiosks are particularly useful in spaces with high pedestrian traffic, such as shopping malls, airports, trade shows, and theme parks. Because they are

typically rugged and designed for ease of use, they require no staffing and little maintenance. They have the excellent advantage of being operational twenty-four hours a day, seven days a week. Furthermore, they are quite portable, and thus are highly suitable for traveling exhibits. In terms of cost, they are cheap to run and relatively inexpensive to build, although special hardware and design features can certainly up the price. A report on kiosks done by the Canadian government in 2001 (*E-Government Services Report on eKiosk*) tagged their starting price at about $2,500, and estimated they ran up to about $65,000 (in Canadian dollars).

HOW KIOSKS ARE USED

With all these positive features, it is no wonder that the kiosk has been put to work in so many areas. They are chiefly employed in four areas:

- To process transactions.
- To promote products.
- To provide information.
- To entertain.

As simple as a kiosk seems, it is capable of performing a number of sophisticated tasks. For example, they are used in Home Depot stores as a tool for recruiting and screening prospective employees. Job hunters can use the in-store kiosks to fill out an application form, submit a résumé, take a screening test, and go on a virtual tour of the store's various departments. As another example, the government of Ontario in Canada runs an aggressive kiosk program to provide its residents with routine services. At sixty different kiosk locations, people can renew their hunting and fishing licenses; change addresses; pay fines; order personalized license plates; and perform a variety of other tasks.

Though a great many of the services provided by kiosks are strictly utilitarian, the jobs they do so well can be harnessed equally well for entertainment or infotainment. If you can create a virtual tour of a Home Depot store, for example, can you not just as easily create a virtual tour of the solar system, or of a historic battleground, or a theme park? And if you can ask a kiosk to print out a receipt or hunting license, can you not also ask it to print out a reward of some kind for a game, or a list of fun facts?

DEVELOPING CONTENT FOR THE KIOSK

As one might expect, the process of developing content for the kiosk, either for entertainment or for information, is somewhat different from developing content for other interactive platforms. The differences are guided by two important factors: First, kiosks are usually placed in public spaces, and second, they are typically used by individuals from an extremely wide demographic pool. Users will be of different ages, educational backgrounds, and socioeconomic groups, and they will have different attitudes about computer technology as well. With these

factors in mind, here are some key guidelines for developing entertaining or informational content for kiosks:

1. The kiosk should capture the attention of passersby with an enticing onscreen visual. In the kiosk world, this visual is known as the "attract mode" or the "attract routine." This little visual tease should loop continuously until a user engages with the kiosk and triggers the opening screen. The attract mode should be friendly and welcoming.
2. The program should be easy to start. It should not require any training, the need for a manual, or detailed written instructions.
3. The interface and navigation should be as intuitive as possible. Prompts and other kinds of help should be built in to assist users who are having trouble. Whenever possible, audio prompts should be used instead of written ones. The need for written instructions should be kept to a bare minimum.
4. If at all possible, user input should not require a keyboard. Keyboards are prone to break, and not all users are comfortable at typing.
5. The content should be extremely engaging, and presented in as visual and interactive a manner as possible.
6. The script or text should be written with a general audience in mind, suitable for users of different educational backgrounds. The vocabulary and grammar should be simple, though expressive. Difficult concepts should be explained in an engaging way. The user's role should be clear. On the other hand, the material should not be over-simplified in such a way that it sounds patronizing.
7. The program should be designed to be a brief experience from start to finish, just a few minutes in length. Keep in mind that many users stop at kiosks on impulse, on their way to do something else. Also, others may be waiting to use the kiosk.
8. As with all interactive content, it is wise to test your program on a representative group of users before making it available to the public.

UNDER MICKEY'S HAT

To get an idea of how the humble kiosk can be transformed into a medium for a richly inventive and entertaining experience, let's take a look at a project developed for the four Walt Disney World Resort theme parks near Orlando, Florida. Called *Discover the Stories Behind the Magic*, these forty-two kiosks were built as part of the *100 Years of Magic* celebration held in 2001 to celebrate the centennial of Walt Disney's birth. According to Roger Holzberg of Walt Disney Imagineering, who was creative lead for the celebration project (and was previously introduced in Chapter 19), the goal of the kiosks was to give park guests an appreciation of the breadth of Walt Disney's imagination. And, for people who knew nothing about Disney history, and thought Walt Disney "was just a brand name like Sara Lee," they wanted to demonstrate that a real person existed behind the familiar name, Holzberg said. To do this in a way that would be enjoyable for the guests

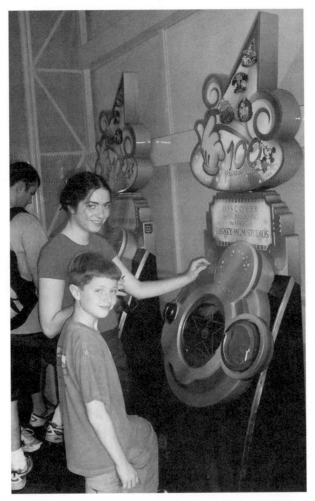

Figure 21.1 Each of the forty-two kiosks designed for Disney's *Discover the Stories Behind the Magic* resembles Mickey Mouse. Visitors spin the ears and push the nose to interact with the content. Image courtesy of © Disney Enterprises, Inc. and Roger Holzberg.

and appeal to younger visitors, who were not likely to know "Walt", they decided to present the content in the form of a game.

Each of the Florida theme parks (Disney-MGM Studios, Epcot, Magic Kingdom, and Disney's Animal Kingdom) had its own style of kiosk and its own game, though all four games employed the same fundamental approach, interface, and style. The housing for the four kiosks had a distinctive feature in common as well: The main body of all four models resembled Mickey Mouse. And they all operated in the same way, too. Visitors spun Mickey's ears and pushed his nose to interact with the content. (See Figure 21.1.)

One special feature of this kiosk project was its multiuser design. It was envisioned as an experience that parents could enjoy with their children. Thus, the interface was designed in such a way that two to four people could play the game in tandem. A stair step was even built into the kiosk to make it easier for small children to play.

OTHER PHYSICAL COMPONENTS OF
DISCOVER THE STORIES BEHIND THE MAGIC

On its own, a kiosk is not a particularly imposing structure, but there's no way guests at the Disney-MGM Studios park could overlook these particular kiosks: They were set beneath an amazing looking edifice built to resemble Sorcerer Mickey's hat from the movie *Fantasia*. The hat was a towering twelve stories tall and weighed 27 tons. If little Mickey were to somehow grow tall enough to wear a hat this size, he would have to be 350 feet in height. Kiosks at the other three parks were set in special locations of their own, each in keeping with the park's theme.

As tall as the Disney-MGM Studios' hat was, another feature of the kiosk project was tiny: the Magic Moment Pins. Five different styles of interactive collectable pins were made for the celebration (see Figure 21.2). The pins were embedded with tiny lights that lit up and became animated when the guest interacted with the kiosk, as well with other attractions and entertainment in all four theme parks. Holzberg, one of the inventors of the pins and one of the three people who contributed to the patent, calls the concept "merchant-tainment." In other words, they are physical items that you can purchase and that will contribute to the entertainment experience.

Although guests didn't need to wear a pin to enjoy the kiosks, Holzberg said, it added "an additional interactive overlay." The pin would start to flash as the guest approached the kiosk, and if the wearer did well in the game, he said, "it would go crazy." A concept like the Magic Moment Pins had never been tried before; they were a first in the history of interactive entertainment. When Holzberg was asked if designing the pins was difficult, he replied, "No more difficult than getting a 27-ton twelve-story hat to appear to float in the air." But, he added wryly, "No one ever said making magic was easy."

The design of the little pins was echoed in the design of the kiosks themselves. The marquees, or headers, of the kiosk structures were giant versions of the pins,

Figure 21.2 These interactive Magic Moment Pins, when worn by a guest to one of the Disney parks in Florida, would light up and become animated as the guest approached and used the kiosks. Image courtesy of © Disney Enterprises, Inc.

done in the same five patterns. Like the pins, they lit up in response to the guest's interactions.

THE GAMES FOR THE *DISCOVER THE STORIES BEHIND THE MAGIC* KIOSKS

All four games used the same attract mode. Pixie dust floated across the screen and set the interface aglow. Text appeared, inviting the guest to "spin the ear." (See Figure 21.3.) In addition, Mickey's nose flashed, as did the lights in the kiosk's marquee. When a guest pressed Mickey's nose or spun his ear, the attract mode dissolved into the primary interface screen of the game.

The interface was a stylized map of the theme park the player was in. To move through the map and select a particular land, the player spun Mickey's ear. The movement through the park was synchronized with the direction in which the ear was spun. Instead of a cursor, an area would be lit up to indicate it was "hot." A hot item would be selected by pressing Mickey's nose.

To play a kiosk game, guests answered multiple-choice questions about various attractions in the particular theme park they were visiting. (For a sample script, see Figure 21.4.) The games were designed in such a way that children would know some of the answers and their parents would know others. To avoid unhappiness, guests could not lose the game; they could only win, or win bigger. Each time they answered a question, they'd learn a little bit about the attraction and how its inspiration had been drawn from Walt Disney himself. When a question was answered correctly, the guest would be rewarded by seeing a 3D animated model of that attraction materialize on the screen. By answering all the questions correctly, the entire theme park would be assembled and Mickey himself would congratulate the guest. Thus, guests would be using Disney's imagination to build a theme park; they would literally be experiencing the connection between Disney's imagination and the parks he inspired.

Figure 21.3 The attract mode for the *Discover the Stories Behind the Magic* kiosk game. Image courtesy of © Disney Enterprises, Inc.

The signature animation of the Sorcerer's Hat plays. The hat lifts up, magic spills out and the camera pushes into the hat.

Beauty shot image of Cinderella Castle.

> NARRATOR
> Cinderella Castle at the Magic Kingdom in Walt Disney World is taller than Sleeping Beauty Castle at Disneyland in California. Can you guess how much?

Cinderella Castle "slides over" and makes way for Sleeping Beauty Castle as it slides into frame and stops next to its east coast sister. To start out, the two side-by-side castles are the same size.

> NARRATOR (cont'd)
> Is it 10 feet taller?

In the side-by-side comparison, Cinderella Castle grows 10 feet (accompanied by slide whistle sound effect).

> NARRATOR (cont'd)
> 32 and 1/2 feet taller?

Cinderella Castle grows 32 and 1/2 feet taller.

> NARRATOR (cont'd)
> Or 112 feet taller?

Cinderella Castle grows 112 feet taller!

TEXT APPEARS: TURN EAR AND PRESS BUTTON TO MAKE A SELECTION.

> NARRATOR (cont'd)
> Turn Mickey's ear to select your answer and press his nose when you're ready.

As guest turns ear, each answer choice highlights in sequence. If guest leaves a choice highlighted for more than a second, the NOSE BUTTON flashes.

WHEN GUEST MAKES A SELECTION, his or her magic pin activates.

Montage of concept sketches of Sleeping Beauty Castle.

> NARRATOR (cont'd)
> When Walt Disney was designing Disneyland, he dreamed of having a beautiful fairy tale castle at the heart of his Magic

Footage of the first-ever children running through.

> NARRATOR (cont'd)
> And when his dream came true, Sleeping Beauty Castle, at 77 feet tall, was just the right size for his 50-acre park.

Footage of Walt pointing to a map of central Florida.

Figure 21.4 A script for *Magic Kingdom: Cinderella's Castle,* one of the *Discover The Stories Behind the Magic* kiosk games, written by Kevin P. Rafferty, Senior Concept Writer and Director, Walt Disney Imagineering. Script courtesy of © Disney Enterprises, Inc.

NARRATOR (cont'd)
But when Walt started dreaming about Walt Disney World, he had nearly 30,000 acres to build on! That's twice the size of Manhattan Island!

Special effect of Cinderella Castle popping into the New York City skyline.

NARRATOR (cont'd)
And even though there was enough land to build a skyscraper-sized castle...

Overlay of Sleeping Beauty Castle against Cinderella Castle.

NARRATOR (cont'd)
...Cinderella Castle measured in at 'only' 112 feet taller than its little sister in California.

Footage of fireworks exploding over Sleeping Beauty Castle.

NARRATOR
After all, it's not the size of the castle that counts...

Tinker Bell flies in and changes the scene with her magic wand to fireworks exploding above Cinderella Castle..

NARRATOR (cont'd)
...it's the size of the magic in the Kingdom!

IF GUEST HAD SELECTED "112 FEET TALLER," TEXT APPEARS: "YOU'RE RIGHT!"

MICKEY MOUSE
You're right! Great job!

IF GUEST HAD SELECTED ANOTHER ANSWER:

MICKEY MOUSE (cont'd)
Gosh, I didn't know that!

Figure 21.4 Continued.

To design the kiosk project and other elements in the *100 Years of Magic* celebration, Holzberg worked with a large team that included filmmakers, writers, software engineers, graphic artists, a project manager, an architect, a landscape architect, and maintenance and operations personnel. He said that one of the biggest challenges for a project like *Discover the Stories Behind the Magic* is the short timeline they usually have to work within. But, he said, "It is always an 'ah ha' moment when you see everything come together and work for the first time. And I loved it when a mom and a kid walked up to one of these kiosks and had a collaborative experience together, because this is a game about the collaboration of imaginations. To see it click was a big moment."

USING KIOSKS FOR AN INFOTAINMENT EXPERIENCE

By taking a close look at the *Discover the Stories Behind the Magic* project, we have been able to see how kiosks can be used for entertainment purposes.

But even though they lend themselves well to entertainment, not too many organizations thus far have taken advantage of their potential in this area. On the other hand, kiosks are frequently utilized for educational and informational purposes, particularly in museums, historic sites, and in other cultural settings. Quite often, the content is presented as infotainment, a blend of information and entertainment.

To make a successful infotainment program for a kiosk, it is helpful to be aware of the general considerations outlined earlier in this chapter that relate to all kiosk projects. In addition, the following pointers will be useful, particularly for kiosks that are to be used as part of an exhibition:

- The kiosk program should offer visitors as much choice as possible about what they can see or do. Keep in mind that different users will come to the kiosk with different degrees of interest in the subject matter it presents, and they will also have different degrees of knowledge about it. Some of the choices you offer should be geared for those who just have a passing curiosity about the subject, while other choices should be suitable for those with a more serious interest.
- If the kiosk is part of a larger exhibition or installation, its content should augment some aspect of the exhibit it is accompanying. Ideally, it will offer the user an opportunity to experience some element of the exhibit in greater depth, or in a way that would not otherwise be possible. For instance, in its exhibit of antique Greek vases, the Getty Museum in Los Angeles designed a kiosk that let visitors examine a precious vase from any angle they chose, as if they were holding the vase in their own hands. They could also study it as closely as they wished, as if examining it through a magnifying glass. In reality, of course, a museum visitor would never be allowed to touch such a vase, so the kiosk offered them a special experience.
- The content of the kiosk should be devised at the same time as the rest of the exhibit so that it tells part of the same story. It should be thematically in keeping with the exhibit as a whole, both visually and in terms of style and approach. This integrated approach is similar to the philosophy of designing a cross-media production, discussed in Chapter 15.
- As with all educational or informational programming, it is a good idea to first work out the instructional/educational goals and then build the entertainment aspects around these goals. For more on how to blend purposeful content with entertainment, refer back to Chapter 8.

INITIAL DEVELOPMENT STEPS

In undertaking a kiosk-based infotainment project, many of the initial development steps are similar to those of any other infotainment project. However, they need to be undertaken while keeping the unique characteristics of the kiosk in mind. As an example, let's take a look at an air pollution project on which I served as a consultant. The client was a California county government department, its environmental protection agency. The developer was a production company that specialized in documentaries. This would be its first kiosk project. Here are

some of the questions we needed to address right at the start of the project, and how we answered them.

1. What is the goal of the project? We established that the goal was to increase the kiosk visitor's awareness of air pollution, especially pollution produced by motor vehicles.

2. Who would our target audience be? We determined that the program would be directed at adult drivers. However, because the kiosks would be placed in various public spaces, we realized we could have no direct control over who might be visiting them, so we had to make the program meaningful to others as well.

3. What was the project's objective? We established three objectives. First, to raise awareness that the air pollution problem in California was not "solved," and that motor vehicles were a large part of the problem. Second, to educate visitors about the harmful effects of air pollution. And third, to inform users of simple steps they could take, as drivers, to reduce air pollution.

4. What format would we use to get our message across? Since this would be reaching an extremely broad demographic, we wanted to make the program as entertaining and engaging as possible. Thus, we decided to design a game that would be fun and that would not take long to play.

5. What would the thrust of the game be, and how would it be structured? We built the game around the idea of an imaginary road trip, appropriate for a target audience of drivers. The player would travel along a highway and could stop at various roadside attractions along the way, advertised by humorous looking billboards. Each attraction would be a module devoted to one aspect of air pollution and would contain a brief, light introduction and a trivia game relating to the topic.

6. How would we reward the players for playing the game? In addition to verbal rewards for answering the trivia questions correctly, we decided to make use of the kiosk's ability to print. Players would receive a souvenir bumper sticker for each of the attractions they visited (thus serving as a reminder of what they learned in the module) and one random "air pollution resolution"—an easy-to-apply idea for reducing motor vehicle emissions. They'd also get discount coupons for purchasing gas, which we could promote as a valuable inducement for playing the game.

Based on these initial decisions, we could then go ahead and do the other development tasks that needed to be done. These included working out a concept for the attract mode, deciding on the theme of each module, and determining the game's overall visual style. Finally, we'd turn to the time-consuming job of filling in the details: putting together a list of the facts we wanted to impart; writing the trivia questions; and designing the icons.

HARNESSING THE KIOSK TO CURRENT TECHNOLOGY

One of the most attractive attributes of the kiosk is its versatility and the ease with which it lends itself to various add-ons. In a way, the kiosk is like a bland

food, such as chicken, that can be dressed up in an endless variety of sauces and served in many delectable ways. Just as chefs make good use of the adaptability of the chicken, we can put our inventive powers to work to plumb the possibilities of the kiosk.

As one example of how the kiosk can be used in conjunction with various technologies, let's look at a project called *An Imagined Place*, developed by designer Greg Roach. Roach, who was first introduced in Chapter 4, describes *An Imagined Place* as "a way to be a tourist in time," and to virtually travel to some of the greatest archeological sites in the world. The project has been developed with the encouragement of Microsoft, Cambridge University, and UNESCO. Although still in its conceptual stage, with its ultimate destiny still unknown, enough groundwork has been done on it to illustrate how a specially outfitted kiosk can transport users to a lost civilization and allow them to have a unique interactive journey.

Roach named the prototype for his project *Virtual Luxor* because he conceived of his idea while visiting the tombs of ancient Egypt. In one of the restored tombs, he was struck by vivid jewel-like paintings on the walls. He realized that the decorations actually portrayed various Egyptian structures—temples, columns, obelisks, and so on—and that by using computer-generated 3D graphics, he could recreate these structures. With this 3D software, the painted structures could be given dimensionality and be brought back to life, somewhat like reconstituting freeze-dried food by adding hot water to it. Furthermore, Roach could see a way to insert modern-day visitors right into these virtual spaces. His concept called for the use of teleconferencing technology and a networked system of geographically dispersed kiosks.

STEPPING INTO THE PAST

The portal into this lost world of ancient Egypt would be through a specially outfitted kiosk. (See Figure 21.5.) Once visitors entered the kiosk booth, high bandwidth Internet connections and videoconferencing would be used to transport them back in time to the temple complex at Luxor. There they would see their own image inside the ancient tomb complex (via the teleconferencing technology) and be able to interact with virtual characters from ancient Egypt. These computer-generated actors, whom Roach refers to as "synthespians," would represent all the major Egyptian classes from slaves to priests. The kiosk visitor would also be able to see and communicate with other modern-day travelers who were participating in *Virtual Luxor* from other sites. Although they were physically at widely dispersed locations, they could all meet in this virtual space, thanks to the "teleporting" capabilities of these high-tech kiosks.

Players would navigate through the virtual space by means of a track-ball device just below the display screen. They could also interact with the content by touching icons on the touch screen. In keeping with the Egyptian theme, the icons resembled Egyptian hieroglyphs, each representing a different topic (Egyptian religion, science, art, and so on). When a visitor touched an icon, a synthetic character would tell the person a little something about the subject. As players moved through the environment, they could also acquire various objects relating to life in ancient Egypt. The objects could be handed to the synthespians

An Imagined Place

Video conferencing camera

LCD display/ touch screen

Trackball

Shared CPU unit

Blue screen surface

Figure 21.5 The specially outfitted kiosk booth for *An Imagined Place* utilizes a videoconferencing camera (upper right) to transport the visitor to ancient archeological sites. Image courtesy of Hyperbole Studios.

to trigger an action or a speech. The objects were another device to learn more about this long vanished culture.

Although some elements of *Virtual Luxor*, particularly the use of objects to trigger actions on the part of the synthespians, might seem a little game-like, Roach does not envision this project as a game. He points out that as a kiosk project, the experience must be contained within a relatively short period of time, which he estimates to be ten minutes or so. Instead, he sees *Virtual Luxor* as an open-ended exploratory experience.

Although the project calls for a large cast of virtual characters, Roach is confident they would not be unduly complicated to make and include. He pointed out that while working on *The X-Files Game* and other projects, he developed effective techniques of using synthetic characters, and believes that methods he implemented for these earlier projects would work equally well for *Virtual Luxor*. The technology for producing a project like *Virtual Luxor* would seem to be extremely expensive and perhaps difficult to execute, but Roach asserts that this is no longer the case. He points out that thanks to advances in graphics, bandwidth, and computing power, a project like this can almost be done with an "off the shelf" approach.

Roach believes the model he worked out for *Virtual Luxor*, which he terms a "distributed telepresence installation," would work for any important archeological site, giving users a chance to learn about ancient cultures in a uniquely immersive way. Although the project offers players a ticket to the past, Roach looks to the future in describing the potential he sees for it. He says that such an installation can "foster understanding of our shared human condition through the use of telepresence and shared virtual spaces."

OTHER RESOURCES

News and feature articles about kiosks can be found in *KIOSK* magazine, available both as a print publication and online (*www.kiosk.com*). The publication, which was begun in 1999, carries information on all aspects of interactive kiosks.

CONCLUSION

The kiosk is an exceptionally democratic tool, well suited for use in public places and for all types of users. It offers interactive experiences to any and all, usually free of charge. And even those who might normally consider themselves techno-phobic are apt to find kiosks user-friendly and not at all intimidating.

Although the basic kiosk is quite simple—just a computer and screen placed within some kind of rugged housing—it can be dressed up in a great variety of ways as the occasion warrants. Because of its versatility, the kiosk can readily be combined with other technologies to give users unique kinds of experiences. By taking a look at projects like *Stories Behind the Magic* and *Virtual Luxor*, we have seen how the humble kiosk can be transformed into a dynamic medium for entertainment, education, and information.

Although the kiosk started out as the pragmatic ATM machine, it has come a long way since then. Kiosks adapt so readily to new technologies that we can be sure that innovative designers and content creators will be putting them to work in ways we cannot yet imagine as new technologies come down the pike.

IDEA-GENERATING EXERCISES

1. List the various things you have been able to do via electronic kiosks, including utilitarian tasks as well as other kinds of experiences. What was the most inventive use of a kiosk that you've personally encountered? Are there certain things you think could be done via a kiosk, but have not yet seen offered?
2. Pick a topic that one might find as the subject of a museum exhibition, historic site, or other type of cultural or recreational institution. Sketch out an idea related to this topic that could be explored via an electronic kiosk. How would this kiosk program broaden the visitor's understanding of the exhibit? What kinds of things would it allow the user to do?
3. Imagine that you were in charge of a large public facility such as a hospital, train station, or theatre lobby—a place where people often have time on their hands. What type of entertainment experience could you provide via a kiosk that would be appropriate to your facility? If money were no object, what kind of design would you choose for the physical housing of this kiosk, and for the interface devices?

Career Considerations

CHAPTER **22**

Working as a Digital Storyteller

How do you find work as a digital storyteller?

If you've got a great idea for a video game or other work of interactive entertainment, how do you sell it?

How do you build a career in such a quickly changing field as interactive entertainment?

A NEW OCCUPATION

The pioneering individuals that we've met along the way in this book are all practitioners of a new type of creative endeavor, a craft that did not even exist a few decades ago. They are digital storytellers. The work they do spans an assortment of technologies, and the projects they create are a contrast in opposites—everything from talking baby dolls to gritty virtual reality simulations for the military. Some of these creations appear on the tiny screens of wireless devices, while others play out on huge movie screens. The venues where these works are shown run a gamut of possibilities, too. They may be seen in one's living room, in a theme park, in a schoolroom, in an office—even in the ocean, as with the robotic dolphin, *DRU*. Yet, despite the great differences among them, the works they create have significant points in common. All of them:

- Utilize digital technologies.
- Tell a story.
- Are perceived as being entertaining.
- Engage the users in an interactive experience.

Even though being a digital storyteller is a relatively new occupation, it is a type of work that is increasingly in demand. True, you won't find jobs for "digital storytellers" listed in the want ads. That's because the jobs in this arena go by a great variety of titles and call for various kinds of skill sets. This chapter will explore ways of finding work and developing a career in the field of digital storytelling.

THE LIFE OF A DIGITAL STORYTELLER

If you were to round up ten people who could be described as digital storytellers and ask them how they got started, the chances are that they would give you ten entirely different answers. Many, especially the younger ones, will probably have had some kind of college training in the area, but almost certainly, their career paths will not have been straight ones. Most will have come to their present job by following a dream, by hard work, and by a willingness to take chances.

Kevin P. Rafferty's career is a perfect illustration of this. Rafferty is a senior concept writer and director for Walt Disney Imagineering, the group at Disney that designs the theme parks. It's work that Rafferty and other Imagineers refer to as the "dimensional entertainment" side of the storytelling fence, as we saw in Chapter 19. As you may recall, Rafferty was the writer of the kiosk script in Chapter 21 for the *Discover the Stories Behind the Magic* project. Rafferty's job calls for a mixture of tasks besides writing. He also creates ideas for theme park rides and attractions and helps to take them from concept all the way to completion. In addition, he writes original music; casts and directs voice and camera talent; and directs show programming and figure animation... and that's just a partial list of his responsibilities.

Not surprisingly, Rafferty's dream job at Disney didn't start out on this level. His career path actually started with a humble dishwashing job at Disneyland while he was still in college. Although he was an art major in college and was hoping to become an animator, he discovered an affinity for writing while working

at an ad agency. When he heard that the WED division of Disney (the group that later became Disney Imagineering) was hiring people to work on the new Epcot theme park, he applied for a job as a writer, figuring he knew something about theme parks from his old dishwashing job. He succeeded in getting hired, but not as a writer. Instead, he found himself dusting show models and cutting mats for artwork. Eventually, he was promoted to a dull job doing "scope writing" work for project management. But still, he had his foot in the door at Epcot, and made the most of the opportunity. Working on his own time after hours he created and developed some original ideas and ran them by a friendly vice president, and "after paying a lot of dues and trying to prove my creative worth," he said, "I was finally and officially accepted into the creative division."

What made his new position particularly gratifying, Rafferty recalls, was that he had the chance to learn the theme park business from the people who had invented it and who had been hand-picked by Walt himself to design and develop Disneyland. Thus, a path that began with dishwashing led to an exciting array of assignments at various Disney theme parks. Looking back on his experience, Rafferty quips in classic Disney fashion, "I guess it's true what they say: 'When you DISH upon a star, your dreams come true.'"

Rafferty's career path is typical of many others who have found their way into digital storytelling. A straight, clear-cut route is quite rare. It's not like deciding you want to go into dentistry and know that step number one is going to dental school, and step number two is joining an established dental practice or starting a practice of your own. In Rafferty's case, his career aspirations evolved over time, and once he knew what he wanted to do—to become a creative part of Disney Imagineering—he focused his efforts and sacrificed his free time to get where he wanted to be.

SELLING AN ORIGINAL IDEA

But what if, unlike Rafferty, your dream is not to work within a particular company or hold a particular job, but instead to sell your own original ideas for a game or other type of interactive entertainment? No question, this is an appealing goal, one shared by many hopeful individuals. Sad to say, however, it is highly unrealistic, for several reasons.

For one thing, ideas are plentiful, to the point that most companies are flooded with their own internal ideas generated by employees of the company, and thus they are not looking for ideas from the outside. For another thing, as they say in Hollywood, ideas are cheap; execution is everything. An idea can be developed in one of many possible ways, as we saw in the chapter about smart toys, with the example of a roller blading doll that was presented to Mattel in three quite different ways by three different inventors. Execution is where the real challenge lies, and execution takes experience, talent, time, and often an investment of money. To convince a company that your concept has merit, you'll need more than an idea. You'll want to have something to show them—a concept document, a design document, or, even better, a working prototype. And you'll also need to consider your marketing and pitching strategy. Who is the target audience for this product, and why would they like it? What competing projects already exist, and how is yours different and better? And how would your project be

a good fit with other offerings in the company's line? When you pitch your idea, you'll also want to include this information, either orally or as part of your written proposal.

But even if you've done all the necessary groundwork, the companies you are planning to approach are unlikely to give you a warm reception if you are an unknown quantity to them. Developing a game or other work of interactive entertainment is a risky proposition that can cost millions of dollars. If a company is interested at all in hearing pitches from outside vendors, they will be far more likely to be receptive to a known developer with a proven track record than they would be to a stranger. This is even more true at present than it was back in the halcyon days of the 1990s, when there was plenty of venture capital money to go around and companies were more open to pitches from new talent.

In today's world, if your desire is to create original works of interactive entertainment, your best bet to is to form your own development company and build a reputation in your chosen area. Of course, before you do that, you'd be well advised to get some experience under your belt by working within the industry. As an alternative, you could work for a development company and create ideas in-house, although if you did come up with some workable ideas, they would most likely belong to the development company and not to you.

Still, if you are convinced that you have a stellar idea and want to have a go at trying to sell it, you can obtain some practical guidance from a document called the *Game Submission Guide* prepared by the International Game Developers Association (IGDA), the premiere organization of game developers. Members can download the guide from the organization's website, *www.igda.org*. The guide includes a checklist of what you will need to do to make a professional-looking submission; it also offers information about the pitching process. Although the guide is prepared with video games in mind, the information can be applied to other forms of interactive entertainment. The IGDA site also contains a column written by game industry veteran Tom Sloper called *The Games Game*, and you can find archived articles there about submitting game ideas.

THE DIFFERENT EMPLOYMENT PATHS

As Rafferty's story illustrates, it is usually necessary to pay your dues before being given the opportunity to propose your own ideas or to work on choice projects. First, you'll need to gain some professional expertise in a position that enables you to work in the creative side of interactive media. Almost inevitably, when you first start out, you'll have to accept a junior role. As we've seen throughout this book, the people that we would consider to be digital storytellers carry many official titles, including designer, graphic artist, information architect, producer, project manager, writer, and director. In Chapter 10, in the section called "Who is on the Team," we laid out what these people do, and mentioned other typical positions on interactive projects as well. The most visionary of the digital storytellers may work across a number of different platforms and media, and some companies, as we saw in Chapter 15, specialize in developing a single property across multiple media.

A surprisingly wide variety of businesses employ staff members who work in interactive media. The most obvious are the game publishers and game developers.

The publishers have deeper pockets than the developers, and may either develop projects in-house or farm them out to developers, who do the actual creative work, which the publishers then package and market. These publishers and developers do not necessarily restrict themselves to video games. They may also make games for wireless devices and for the Web, including MMOGs. Keep in mind that a number of these companies specialize in edutainment projects for children, if that's an area that particularly interests you.

In addition to game publishers and developers, another group of entities focuses on interactive media: the design firms that deal with interactive media. Some of them specialize in Web design work, while others pursue cutting edge projects in iTV and DVDs. Some, like Schematic LLC, which designed the iTV version of *CSI*, described in Chapter 14, work in a wide sweep of interactive media. In addition to iTV projects, they do work in kiosks, wireless devices, the Web, and DVDs.

In considering possible employers, do not by any means overlook major corporations. Most of today's large companies have internal divisions that produce content for the Web and other interactive media, work that is often done under the umbrella of the promotion or marketing departments. Other entities that do work in interactive media are toy companies, ad agencies, and PR companies, as well as companies that specialize in interactive training programs. Another group of organizations to consider are the cultural institutions—museums, historic sites, aquariums, and so on—all of which use interactive displays to make their exhibits come to life. And theme park companies employ people like Kevin Rafferty to create attractions that take advantage of the latest interactive technologies. In addition, government agencies sometimes produce interactive programming for edutainment or informational purposes, as we saw in Chapter 8 with the game being developed by the California Department of Parks and Recreation.

One entire industry that is becoming increasingly involved in interactive media is the Hollywood entertainment business, as we saw in Chapter 11. Not only are movie studios making games based on their films, but they are also promoting their films on the Internet and on wireless devices, sometimes using highly creative approaches. Television networks also promote their shows via new media and in some cases enhance their offerings via iTV. Public broadcasters are particularly aggressive in using interactive media to maximize the content of their programming, developing projects for the Web, DVDs, and iTV. Thus, traditional entertainment studios and broadcasters are definitely worth investigating for employment opportunities.

COMMON ENTRY POINTS

Despite the fact that so many kinds of organizations are involved with new media in one way or another, it is not necessarily an easy task to find an actual job at one of them. That said, a couple of traditional routes do exist. One is by becoming a beta tester, which is particularly attractive to people who want to work in games. Beta testers are hired to look for bugs in games before they are released to the public, and this type of work is often a stepping stone to a higher level job within the same company.

Another proven route is via student internships. The best of these programs are well supervised to make sure the students are not being exploited and gain

useful experience in return for their work. Internships offer first-hand exposure to a professional new media work place. Not only are they educational, but such experiences are also good to have on a résumé. And, best of all, they can lead to full-time employment. For example, I know of one young man who worked as an intern at a big cable company while he was a senior in college. He just had a low-level assignment, primarily running around delivering budgets, but he interfaced with the executive secretaries and the executives and also faithfully checked out the company's job board. By the time he graduated, he was hired to stay on full time to work in the company's publicity department doing interactive projects.

Aside from scoring an internship or a job as a beta tester, the pathway into digital storytelling is much like that for any other kind of work. You need to research the field to determine which segment of the industry would offer you the most potential, given your particular talents, interests, and skill set. It is quite helpful to become adept at networking and to attend industry events, which we will be discussing in more detail later in the chapter. And before setting out on a job search, you'll want to give serious consideration to creating a portfolio of sample work, which is discussed in detail in Chapter 23. For other information about breaking into interactive entertainment, particularly the games area, be sure to check out the IGDA's website, and go to the section called "Breaking In." It has a number of excellent articles on the subject.

WORKING AS A FREELANCER

But what if you would prefer to be your own boss rather than to be a full-time employee of an organization—is this an option in new media? The answer is a tentative yes. It depends on your experience, on your specialty, and the tenor of the times. Back in the 1990s, it was quite customary to be hired to work on a specific project and then move on once the project had been completed. Currently, most companies work entirely with full-time staffers. One of the few professional areas that still offers opportunities to freelancers is in writing, my own specialty. The more credits you have and the more people you know in the industry, the more likely you are to find freelance writing work, though it is more difficult than it used to be.

The work one does as a freelance writer varies tremendously from project to project. Some of the assignments you get are not much different from doing piece goods work in a factory. You may be expected to churn out hundreds of lines of dialogue, sometimes with little variation between the lines, and the work can be quite tedious. On the other hand, some writing jobs are highly creative. You may have a chance to collaborate on the overall design and content of a project and to develop original characters; you may also be able to develop what the interactivity will be and how it will work. Each type of interactive medium poses its own challenges. Writing a script for a kiosk will be quite different from writing one for a smart toy, and both will be different again from writing an edutainment game for a CD-ROM or a pervasive game involving multiple media.

One of the most stimulating things about being a freelance writer is being able to take on projects that are quite different from each other; your work is always creatively challenging. However, being a freelancer also means dealing

with issues that one does not have to worry about as a full-time employee. For example, you might have to chase after a client to get paid, or find yourself mired in an unpleasant situation called *project creep*, in which a project grows much bigger than it was originally understood to be. Project creep can cause you to spend many more weeks than you had planned on an assignment, but without receiving additional compensation.

Fortunately, freelance writers do not have to go it entirely alone anymore. The Writers Guild of America, west, the Hollywood union that has traditionally been made up of writers of motion pictures and television, now also offers membership to qualified new media writers. It also offers two special contracts for writers who work in this area. The first, called the Interactive Program Contract, or IPC, covers writing for most types of interactive media, including video games, CD-ROMs, and wireless games (see Figure 22.1). The second, called the Made for Internet Contract, covers original writing done specifically for the Internet (see Figure 22.2). An employer who signs either of these contracts agrees to make specified contributions to the Guild's health and pension plans, and this can help writers qualify for medical insurance and be vested in the pension plan. Furthermore, writers who work under these contracts can become associate or full members of the Writers Guild, which is a recognized badge of honor in the entertainment business. Ultimately, the WGA is planning to add new protections to these contracts, once they are more widely known and used; for now, they make them as user-friendly as possible to bring more producers "under the tent." Several other Hollywood guilds also offer contractual protections to their members, including SAG (the Screen Actors Guild) and the DGA (the Director's Guild of America). The Writers Guild, however, was the first to offer special contracts in this area.

LEGAL CONSIDERATIONS

At some point or other, if you are working in new media, you are bound to run into legal situations. For example, you are quite likely to be faced with issues involving intellectual property (IP). Intellectual properties are unique works of human intelligence—images, writings, music, pieces of animation, even game engines or an invention for a toy—that are given certain legal protections, which include copyrights, patents, and trademarks. Intellectual properties can be extremely valuable, and they are fiercely guarded in interactive media with a zeal bordering on paranoia. You may become involved with IP questions when it comes to protecting your own creations; you may also run into IP issues when you want to use the creative work of others in a project.

IP issues can be highly complex, but one thing about them is quite simple: You don't want someone stealing your intellectual property and you don't want to be accused of stealing intellectual property that belongs to someone else. The first situation can result in your losing a significant amount of income; the second can result in an ugly lawsuit. To prevent either situation from occurring, you need to familiarize yourself with the basics of intellectual property law. One place to start is with the website of entertainment and new media attorney and IP specialist Michael Leventhal (*www.wiredlaw.com*). The site contains a good primer on IP, called *IP 101*, plus a number of links that will take you to more information on the subject.

INTERACTIVE PROGRAM CONTRACT
2001 Letter of Adherence--Single Program Only

Company: _____ Telephone:() _____

Street Address: _____

City: _____ State: _____ Zip Code:_____

Email: _____ Website Address: _____

FORM OF BUSINESS ORGANIZATION (TYPE OF BUSINESS STRUCTURE)

Corporation ☐	Partnership ☐	10% or more owner ☐
Joint Venture ☐	Sole Owner ☐	DBA ☐

If Corporation, name of State in which Corporation is registered: _____ Fed ID #_____
If Corporation, names of officers and principal owners: _____

If Joint Venture or Partnership, names of Partners or Joint Venturers:_____

TITLE(S) OF PRODUCTION(S): _____
FORMAT(S):_____
COMPENSATION: (Writing and/or Designing Services)--attach employment contracts or deal memos if more than one writer: _____

WRITER(S) EMPLOYED UNDER THIS CONTRACT--attach additional pages, if necessary:

Name:_____ SS#_____

Name:_____ SS#_____

On behalf of the writer(s) employed on the above-named Interactive Program, the undersigned Interactive Program Producer ("Company") agrees to make contributions to the Producer-Writers Guild of America Pension Plan ("Pension Plan") and the Writers Guild-Industry Health Fund ("Health Fund") as set forth in Article 17 of the 2001 Writers Guild of America Theatrical and Television Basic Agreement ("2001 WGA MBA"), by reference incorporated herein and available upon request. Company agrees to be bound by the terms and conditions of the Pension Plan Agreement and the Health Fund's Trust Agreement.

The current Article 17 contribution rates are six percent (6%) of gross compensation for writing services to the Pension Plan and seven and half percent (7.5%) of gross compensation for writing services to the Health Fund.

Accepted and Agreed:

_____ _____
 (Company) *(Date)*

By: _____ _____
 (Signature) *(Print Name and Title)*

WRITERS GUILD OF AMERICA, WEST, INC. on behalf
of itself and its affiliate, WRITERS GUILD OF AMERICA EAST, INC.

By:_____

-- For Office Use Only --
Accepted this ____ day of _____, 20__, Producer-Writers Guild of America Pension Plan and Writers Guild Industry Health Fund. By:_____ Title: _____

RETURN COMPLETED FORM TO: **FOR QUESTIONS CALL:**
Organizing Department (323) 782-4511
Writers Guild of America, west, Inc.
7000 West Third Street, Los Angeles, California 90048

Figure 22.1 The Interactive Program Contract of the Writers Guild covers writers who work on interactive projects. Document courtesy of the Writers Guild of America, west.

MADE-FOR INTERNET CONTRACT—2001 LETTER OF ADHERENCE
Single Program or Multiple Programs

Company: _____ Telephone:() _____

Street Address: _____

City: _____ State: _____ Zip Code:_____

Email: _____ Website

address:_____

FORM OF BUSINESS ORGANIZATION (TYPE OF BUSINESS STRUCTURE)

Corporation ❑	Partnership ❑	10% or more owner ❑
Joint Venture ❑	Sole Owner ❑	DBA ❑

If Corporation, name of State in which Corporation is registered: _____ Fed ID #_____

If Corporation, names of officers and principal owners: _____

If Joint Venture or Partnership, names of Partners or Joint Venturers:_____

TITLE(S) OF PRODUCTION(S): _____

FORMAT(S)--Internet/Website or Other (please describe):_____

COMPENSATION: (Writing and/or Designing Services)—attach employment contracts or deal memos if more than one writer: _____

ESTIMATED LENGTH OF TIME FOR WRITING SERVICES: _____

WRITER(S) CURRENTLY EMPLOYED UNDER THIS CONTRACT--attach additional pages, if necessary:

Name:_____ SS#_____

Name:_____ SS#_____

On behalf of the writer(s) employed on the above-named Made-For internet Program, the undersigned Made-For Internet Program Producer ("Company") agrees to make contributions to the Producer-Writers Guild of America Pension Plan ("Pension Plan") and the Writers Guild-Industry Health Fund ("Health Fund") as set forth in Article 17 of the 2001 Writers Guild of America Theatrical and Television Basic Agreement ("2001 WGA MBA"), by reference incorporated herein and available upon request. Company agrees to be bound by the terms and conditions of the Pension Plan Agreement and the Health Fund's Trust Agreement. The current Article 17 contribution rates are six percent (6%) of gross compensation for writing services to the Pension Plan and seven and a half percent (7.5%) of gross compensation for writing services to the Health Fund.

In addition, the provisions of Article 6 "Guild Shop" of the 2001 WGA MBA apply to this Contract. Therefore, if the Company employs a writer who is not a member of the Writers Guild of America ("WGA") to perform writing services on the above-titled Program(s), any such writer shall, on or before the thirtieth (30th) day of employment, become a member of the WGA if otherwise eligible to do so under the WGA's membership criteria.

Accepted and Agreed:

_____ _____
(Company) *(Date)*

By: _____ _____
(Signature) *(Print Name and Title)*

WRITERS GUILD OF AMERICA, WEST, INC. on behalf
of itself and its affiliate, WRITERS GUILD OF AMERICA EAST, INC.

By:_____

-- For Office Use Only --

Accepted this ____ day of _____, 20__, Producer-Writers Guild of America Pension Plan and Writers Guild Industry Health Fund. By:_____ Title:_____

RETURN COMPLETED FORM TO: **FOR QUESTIONS CALL:**

Organizing Department (323) 782-4511

Writers Guild of America, west, Inc.

7000 West Third Street, Los Angeles, California 90048

Figure 22.2 The Made for Internet Contract of the Writers Guild is for writers who create original content for the Web. Document courtesy of the Writers Guild of America, west.

Another legal matter you will need to be familiar with is a document called a Non-Disclosure Agreement, or NDA, often used in high tech circles. You will no doubt become aware of NDAs if you are submitting a project to a company in the hopes of selling it or if a company is interested in hiring you for a project, but first needs to share with you what has been done with the project to date. Both situations raise the risk of valuable information being seen by strangers who might possibly use it without authorization. To avert such a risk, it is customary for one party to request the other to sign an NDA. When someone signs such a document, he or she promises to keep the information they are receiving confidential. (See Figure 22.3.)

If you are working as a freelancer or are running your own development or design company, you will also need some legal protections in the form of a contract. You will definitely want a contract if you are entering into a new employment relationship; that is, if you or your firm is being hired to do some work for another entity. A good contract specifies what your responsibilities will be and what you will be paid at each juncture, often tying payments to the completion of various milestones (points when particular parts of the project are due). It will spell out what happens if the work expands beyond what has been assigned, thus avoiding the problem of project creep, discussed earlier. The contract may also include language about the kind of credit you will receive and where the credit will appear, and may note who will hold the copyright to the completed work. If you are inexperienced in negotiating contracts, you would be well advised to seek the help of an attorney. Even if you think you are savvy in such matters, it is always a good idea to have a lawyer look things over before signing.

But even before you reach the contract stage, you need to take some steps to protect yourself against an unscrupulous or inept employer. (Working for a well-intentioned but inexperienced client can be as perilous as working for one that intends to take advantage of you.) Before going too far in any discussion with a new client, try to learn as much about the company as you can, either by doing some research or by asking the prospective employer a series of focused questions. Asking the right questions about the company and the project will help you determine whether this is something you'll want to pursue—or if it is something you should run from. Several years ago, attorney Leventhal and a group of associates prepared a handy list of such questions. Though geared for Internet projects, they are applicable, with a little reworking, to any kind of interactive project. They can be found on his website (*www.wiredlaw.com*) under ESP (for Ethical Standards and Practices) in the section called Q1.

EDUCATING YOURSELF

In any case, concerns about contracts and protecting your intellectual property are matters to be dealt with once a career is established. Let's take a few steps back and discuss how one prepares for a career in new media. It usually begins, as you might expect, with the right education. In terms of a formal education, you have a choice of two different paths. Path number one is to get a good foundation in the liberal arts, and then pick up specialized training, if needed, after graduation. Path number two is a more focused route: to enroll in an undergraduate program in computer science or in digital arts. Digital arts programs

NON-DISCLOSURE AGREEMENT

This non-disclosure agreement ("Agreement") is entered into as of _____ ("Effective Date") by and between _____, located at _____ ("Artist"), and _____, located at _____ ("Recipient"). Artist and Recipient are engaged in discussions in contemplation of or in furtherance of a business relationship. In order to induce Artist to disclose its confidential information during such discussions, Recipient agrees to accept such information under the restrictions set forth in this Agreement.

1. Disclosure of Confidential Information. Artist may disclose, either orally or in writing, certain information which Recipient knows or has reason to know is considered confidential by Artist relating to the [NAME] Project ("Artist Confidential Information"). Artist Confidential Information shall include, but not be limited to, creative ideas, story-lines, characters, trade secrets, know-how, inventions, techniques, processes, algorithms, software programs, schematics, software source documents, contracts, customer lists, financial information, sales and marketing plans and business plans.

2. Confidentiality. Recipient agrees to maintain in confidence Artist Confidential Information. Recipient will use Artist Confidential Information solely to evaluate the commercial potential of a business relationship with Artist. Recipient will not disclose the Artist Confidential Information to any person except its employees or Artist's to whom it is necessary to disclose the Artist Confidential Information for such purposes. Recipient agrees that Artist Confidential Information will be disclosed or made available only to those of its employees or Artist's who have agreed in writing to receive it under terms at least as restrictive as those specified in this Agreement. Recipient will take reasonable measures to maintain the confidentiality of Artist Confidential Information, but not less than the measures it uses for its confidential information of similar type. Recipient will immediately give notice to Artist of any unauthorized use or disclosure of the Artist Confidential Information. Recipient agrees to assist Artist in remedying such unauthorized use or disclosure of the Artist Confidential Information. This obligation will not apply to the extent that Recipient can demonstrate that: (a) the Artist Confidential Information at the time of disclosure is part of the public domain; (b) the Artist Confidential Information became part of the public domain, by publication or otherwise, except by breach of the provisions of this Agreement; (c) the Artist Confidential Information can be established by written evidence to have been in the possession of Recipient at the time of disclosure; (d) the Artist Confidential Information is received from a third party without similar restrictions and without breach of this Agreement; or (e) the Artist Confidential Information is required to be disclosed by a government agency to further the objectives of this Agreement, or by a proper court of competent jurisdiction; provided, however, that Recipient will use its best efforts to minimize the disclosure of such information and will consult with and assist Artist in obtaining a protective order prior to such disclosure.

3. Materials. All materials including, without limitation, documents, drawings, models, apparatus, sketches, designs and lists furnished to Recipient by Artist and any tangible materials embodying Artist Confidential Information created by Recipient shall remain the property of Artist. Recipient shall return to Artist or destroy such materials and all copies thereof upon the termination of this Agreement or upon the written request of Artist.

4. No License. This Agreement does not grant Recipient any license to use Artist Confidential Information except as provided in Article 2.

5. Term.

(a) This Agreement shall terminate three (3) years after the Effective Date unless terminated earlier by either party. Artist may extend the term of the Agreement by written notice to Recipient. Either party may terminate this Agreement, with or without cause, by giving notice of termination to the other party. The Agreement shall terminate immediately upon receipt of such notice.

(b) Upon termination of this Agreement, Recipient shall cease to use Artist Confidential Information and shall comply with Paragraph 3 within twenty (20) days of the date of termination. Upon the request of Artist, an officer of Recipient shall certify that Recipient has complied with its obligations in this Section.

(c) Notwithstanding the termination of this Agreement, Recipient's obligations in Paragraph 2 shall survive such termination.

Figure 22.3 A model NDA, a document which guarantees that valuable information will be kept confidential. Document courtesy of Michael Leventhal.

6. Underline: General Provisions.

(a) This Agreement shall be governed by and construed in accordance with the laws of the United States and of the State of California as applied to transactions entered into and to be performed wholly within California between California residents. In the event of any action, suit, or proceeding arising from or based upon this agreement brought by either party hereto against the other, the prevailing party shall be entitled to recover from the other its reasonable attorneys' fees in connection therewith in addition to the costs of such action, suit, or proceeding.

(b) Any notice provided for or permitted under this Agreement will be treated as having been given when (a) delivered personally, (b) sent by confirmed telefacsimile or telecopy, (c) sent by commercial overnight courier with written verification of receipt, or (d) mailed postage prepaid by certified or registered mail, return receipt requested, to the party to be notified, at the address set forth above, or at such other place of which the other party has been notified in accordance with the provisions of this Section. Such notice will be treated as having been received upon the earlier of actual receipt or five (5) days after posting.

(c) Recipient agrees that the breach of the provisions of this Agreement by Recipient will cause Artist irreparable damage for which recovery of money damages would be inadequate. Artist will, therefore, be entitled to obtain timely injunctive relief to protect Artist's rights under this Agreement in addition to any and all remedies available at law.

(d) This Agreement constitutes the entire agreement between the parties relating to this subject matter and supersedes all prior or simultaneous representations, discussions, negotiations, and agreements, whether written or oral. This Agreement may be amended or supplemented only by a writing that is signed by duly authorized representatives of both parties. Recipient may not assign its rights under this Agreement. No term or provision hereof will be considered waived by either party, and no breach excused by either party, unless such waiver or consent is in writing signed on behalf of the party against whom the waiver is asserted. No consent by either party to, or waiver of, a breach by either party, whether express or implied, will constitute a consent to, waiver of, or excuse of any other, different, or subsequent breach by either party. If any part of this Agreement is found invalid or unenforceable, that part will be amended to achieve as nearly as possible the same economic effect as the original provision and the remainder of this Agreement will remain in full force.

(e) This Agreement may be executed in counterparts and all counterparts so executed by all parties hereto and affixed to this Agreement shall constitute a valid and binding agreement, even though the all of the parties have not signed the same counterpart.

IN WITNESS WHEREOF, the parties have executed this Agreement as of the Effective Date.

RECIPIENT ARTIST

_____ _____
Typed Name Typed Name

_____ _____
Title Title

Figure 22.3 Continued.

are becoming increasingly common at institutions of higher learning all over the world, both as undergraduate programs and as master degree programs. The IGDA offers an international listing of such schools on its website, *www.igda.org*, under the section "Student and Newbie Outreach." Specialized programs can give you a good background on theory and invaluable hands-on experience in creating interactive projects; they sometimes offer internship programs and can serve as fairly smooth stepping-stones to a good job.

Not everyone, however, feels that it is good to focus on new media as an undergraduate. Game developer and designer Greg Roach, for example, strongly believes that no matter what position you are angling for in interactive media, you should first have a liberal arts education. He says "a grounding in the classical

humanities is critical. Programmer, 3D artist, designer, whatever... I'd much rather hire a traditional painter who's a Luddite that understands about color theory—and then train her in Maya—than hire a hot-shot 3D modeler whose aesthetic has been shaped exclusively by console games."

If you are already out of college or if going to college is not an option for you, you might consider a certificate program in new media arts. Such programs are offered by many community colleges and by university extensions. Or your might select just a few courses that prepare you in the direction you wish to go in—classes in Flash animation, for example, or Web design. How much technical know-how you need varies from position to position. It is always helpful to have a grasp of basic software programs, but if you want to be a digital storyteller, it is even more important to understand the fundamentals of drama and literature. You would be well advised to take a course that teaches narrative structure, or one in world mythology, and you should definitely take a course in dramatic writing. Psychology is another excellent field of study; the more you understand about human nature, the richer and more authentic your characters will be.

Not all of your education has to take place in a classroom. If you don't already, spend some time playing games, trying out different genres and different platforms. Include MMOGs, wireless games, and iTV games on your "to play" list so you can see how the experiences differ. Even if you aren't interested in working in games, they can teach you a great deal about interactivity and immersiveness. If a particular area of gaming is unfamiliar to you, find someone who plays this kind of game—a relative, a local student, a family friend—and ask them to give you a tour of one or two. Most people are happy to oblige, but you can always make it more attractive by treating your guide to a pizza. Also attend as many movies as you can and watch them critically, asking yourself what makes one character so believable and another so wooden, or why your attention wandered during one movie while you were riveted by another.

Finally, you can get an excellent free education online by visiting websites devoted to various aspects of interactive media. You can also sign up to receive electronic and print trade publications. Each segment of the new media arena has several websites devoted to it and usually several publications. Many have been mentioned in this book, and a diligent online search will turn up others.

INDUSTRY EVENTS

Another excellent way to educate yourself is by attending conferences, trade shows, and other industry events. Most of these gatherings are divided into two quite different parts, a conference and an exposition. By strolling around the expo floor, you get a chance to see demonstrations of the latest hardware and software in the field, often given by some of the creators of these products. And by attending the conference sessions, you will hear talks by industry leaders and learn about the latest developments in the field. Although these trade events can be expensive, many of them offer student discounts and many also have volunteer programs. By working as a volunteer, you can take in as much of the event as you want during your off hours.

Virtually every segment of the interactive arena holds at least one annual event. Although many of these shows take place in the United States, they are

also held in various spots around the globe. Two big non-American conferences are Milia, which is held in Cannes, France, and the Tokyo Game Show in Japan. In the United States, one of the most massive and exciting gatherings is E3 (Electronic Entertainment Expo), which includes all forms of electronic media and is held in the cavernous halls of the Los Angeles Convention Center. In this show, the expo is the star, with elaborate multistory booths to show off the work of major companies, exhibitors in goofy costumes, and blaring music and flashing lights. The conference plays a back seat here. E3 is the place to check out the newest games—a total of 1,300 of them were unveiled at the 2003 show—and you can find exhibitors from almost every part of the world. The other big annual event is the Game Developers Conference (the GDC), an entirely different sort of gathering. Here the emphasis is on the conference, not on the expo, and you can sit in on excellent presentations on every facet of game design and production, including wireless games and MMOGs. The talks at the GDC are immensely informative and stimulating, and many of the topics are of particular interest to digital storytellers.

Another important annual event is SIGGRAPH, which focuses on computer graphics, and is one of the few shows where significant attention is paid to VR. For people interested in iTV, AFI's annual Creative Showcase is an excellent place to see demonstrations of cutting-edge iTV programming and to learn the latest developments in the field. The training field has its special gatherings, too, with the Training and Online Learning Conference and Expo being one major example. The events mentioned here are just a small sampling of trade shows, conferences, and conventions that involve interactive media; new ones are started every year, and a few older ones sometimes fall by the wayside. The best way to find out about the industry events in your particular area of interest is by subscribing to electronic and print publications that specialize in the field.

THE PEOPLE CONNECTION

Industry events, excellent as they are, only take place at infrequent intervals. To stay more closely involved, and to connect with others who work in new media, you would be well advised to join one of the many professional organizations in this field. Networking with others in the field is one of the best ways to find work and stay on top of developments in the industry, as virtually any career counselor will tell you. It is in even more important in a fast moving field like interactive media. Merely joining and attending an occasional meeting, however, brings limited benefits; you'll reap far greater rewards if you join a sig (special interest group) or a committee within the organization and become an active, contributing member. By participating on a deeper level, you are more likely to form valuable connections that can lead to jobs.

Among the many excellent organizations you can choose from are the Academy of Interactive Arts and Sciences (AIAS); the International Game Developers Association (IGDA); the Association of Internet Professionals (AIP); the Internet Society; the Interactive Television Alliance (ITA); and Women in Technology International (WITI). Some of these have online job boards.

A number of guilds and other organizations within the Hollywood system now welcome members who specialize in interactive media, and offer qualified

individuals the full benefits of membership. Among these mainstream organizations are the Writers Guild, noted earlier, the Producers Guild, and the Academy of Television Arts and Sciences, generally known as the TV Academy. These organizations all have active committees or peer groups made up of new media members and put on special events focusing on interactive entertainment.

Unfortunately, many of the organizations mentioned here only hold meetings in certain geographical regions, and if you live outside these regions, it is difficult to become actively involved. However, you might also look into the possibility of forming a local branch, which can be a great way to meet other members in a less congested setting.

Finally, in terms of making valuable connections, at some point you might also want to form your own personal team of professionals. This is particularly worth considering if you are a freelancer or are planning to start your own design or development company. One of the foremost individuals on your team should be an attorney who is knowledgeable about new media and intellectual property. If you are a freelancer, you might also want to be represented by an agent or manager. Unfortunately, only a handful work in new media, although several of the top Hollywood talent agencies have recently formed divisions in this area and are particularly interested in representing the top players in the game business. Another specialist you might want in your camp, particularly if you have your own business, is a publicity person. Although PR services are expensive, it can be a major asset in promoting your business.

SOME POINTERS FOR A CAREER IN NEW MEDIA

Although new media involves cutting-edge technology, some of the best advice anyone can give you for establishing a career in this field boils down to a few tried and true old-fashioned values. For example, a couple of industry pros were asked to list the three keys to success in the games industry (*GIGnews*, March 2002). The answers they gave were hardly high tech; they would have worked as well for a stone-age hatchet maker. One, Stevie Case, said the three keys were drive, dedication, and the desire to learn. The second, John Romero, named passion, hard work, and an optimistic outlook. And they both also stressed the importance of being a finisher—to complete any project you commit yourself to doing. In addition to these eternal qualities of a good work ethic, here are some other helpful ideas:

- Plan for change. This field does not stay still, so you need to continually educate yourself on digital technologies and new forms of digital entertainment.
- Don't restrict your vision only to this field. Indulge your interests in the world beyond. Not only will this be of value to you in your professional work but it will also help keep you balanced.
- Educate yourself on narrative storytelling techniques, especially classic drama and film. All good narrative storytelling relies on certain basic principles.
- Stay tuned to traditional popular culture—to television, film, and music. To a large extent, new media and traditional media intersect and influence each other.

- If you are angling for a first job or a better job, consider building your own showcase. Not only will it give you a way to display your talents, but you will also learn something in the process. For more on showcases, see the next chapter.
- As one of our experts said in the chapter on Smart Toys, sometimes you have to dump all the pieces on the floor and play with them. Playing games and participating in interactive experiences is the single best way to keep your edges sharp.

Creating Your Own Showcase

Is it a good investment of your time to create an original piece of work or a portfolio of samples to show off your talents?

If you do decide to create your own showcase, what should it include, and what is the best way to highlight your strengths?

What sorts of things do not belong in a showcase and can make a negative impression?

SHOWCASING YOUR WORK: IS IT WORTHWHILE?

It is reasonable to wonder, given how much effort it takes to create an original piece of work, if it is ever worth the investment of your time and energy to put together your own showcase. I would answer this question with a resounding yes, based on my own observations of the interactive entertainment industry, and also based on the interviews I've done for this book. A little later in this chapter, we will examine some actual situations in which people have successfully showcased their work. Creating your own showcase can benefit you if one of these scenarios fits your personal situation:

1. You have not yet had any professional experience in interactive media, but are interested in working in the field.
2. You are already working in digital entertainment, but are considering moving into a different area within it or would like to move to a higher level.
3. You are working as an employee in the field, but want to work as a freelancer.
4. You are working as a freelancer, and want to attract new clients.

Having an original piece of work to show, or a portfolio of work, is of particular importance if you have not yet had any experience in the field. How else will you be able to demonstrate to a prospective employer what you are capable of doing? A well thought out calling card of original work illustrates what your special talents are, where your creative leanings lie, and also reveals something about who you are as a person. A showcase of original work also bears a powerful subtext: You are serious enough about working in this field to spend your own time putting a demonstration project together. It carries the message that you are energetic, enterprising, and committed.

Even if you are not looking for your first job in the area, a showcase can be an extremely valuable tool in advancing your professional goals, and it's a strategy used by small companies as well as by individuals. As we saw in Chapter 13, Free Range Graphics undertook *The Meatrix* in part to stimulate new business, a gamble that paid off handsomely for it. Yet the advice to build a promotional calling card must be given with a serious note of caution. If you do undertake such a significant self-assigned task, you need to go about it in a way that will set off your abilities in the most positive light possible and avoid doing things that can undermine your prospects.

CONSIDERATIONS IN CREATING A PROFESSIONAL SHOWCASE

For some people, putting together a showcase is a relatively easy task, because they can use samples of student projects or volunteer work that they did, or even of professional assignments. But if you don't have any such samples, or the samples you have are not well suited to your current goal, you are faced with the daunting job of creating something original from scratch. You will have a number

of things to consider before you actually begin. Among the questions that will almost certainly cross your mind are:

1. Is it better to take a portfolio approach and include several brief samples of your work, or is it more effective to showcase a single more ambitious piece? Each approach has its own pros and cons. With the portfolio approach, you can effectively demonstrate your ability to work in a range of styles and on different types of subject matter. However, the portfolio approach also means that you will have to undertake several different projects and build them out to the point that they are solid enough to serve as good samples. By showcasing a single piece, on the other hand, you can create a richer and more fully developed project than you'd have in a portfolio, where the samples tend to be short and fairly superficial. But having just one piece of work to showcase can be a little risky, because the work you are exhibiting might not be what the prospective employer or client is looking for, and you will have nothing else to illustrate what you are capable of. So where does this leave you? It's best to make the call based on your own individual situation. If you already have a couple of samples you can use, and have some ideas about another one or two you could put together, then you are probably already well down the path toward the portfolio approach. On the other hand, if you feel confident you've got a great concept to showcase, and that it would work well as a demo piece, than that's probably the best way for you to go. There's no right or wrong answer here.

2. What distribution method should you use for your showcase? The three most obvious choices are the Internet, CD-ROMs, and DVDs. Virtually any prospective employer or client should be able to view your work on any one of these platforms, so ease of viewing is not a factor here. Your work itself, and your own leanings, are really your best guides. It makes sense to distribute your showcase on the medium in which you are most interested in working. But if you want to work in an area that falls outside of the three already mentioned avenues of distribution—if you are interested in iTV, say, or in VR—then pick the medium that you feel will display your material to the best advantage. One final consideration for a multiproject portfolio: It is advisable to package your showcase on a single platform rather than having a jumble of different works that cannot easily be viewed together. If you have both Web and CD-ROM samples, you might want to put your Web pages on the CD-ROM with the other examples, or vice versa. As another possibility, you could embed links to your Web pages in your CD-ROM.

3. What kind of subject matter works best for a showcase, and what sort of approach and style should you use? The honest answer is that no one can tell you what to do here. The best choices are the ones that most closely reflect your own personal interests, talents, and expertise. By picking a subject you really care about, you have the best chance of producing something that will be strong and will stand out from the crowd. As you will see from the two very different showcases profiled in this chapter, they closely reflect the interests and styles of their creators. The way you decide to construct your showcase should also reflect

your personal taste and style—within limits, of course. Coarse humor and disparaging portrayals of any particular ethnic group are never appropriate. Also, you do yourself no favors by employing a sloppy, unprofessional looking style.

But what if you have tried your best to think of a topic for your showcase and still come up blank? Then you might consider volunteering your services for a nonprofit institution in your community. Possible choices include your church, synagogue, or mosque; the local chamber of commerce or a community service group; or a school sports team or Brownie troop. Another alternative is to create a promotional piece for a business belonging to a friend or relative. Although on the surface such projects seem to be creatively limiting, you may be inspired to create something quite clever. For instance, you could design an amusing advergaming activity for your brother-in-law's landscaping business, or an interactive adventure tale about Brownies for your niece's Brownie troop. Volunteer projects for nonprofit organizations or for businesses have some solid advantages. They give you hands-on practical experience, and also give you a professional sample to include in your showcase, even if the work was done without monetary compensation.

4. What do you do if you lack all the skills necessary to put together your own showcase? This is a common problem, because few people are equipped with the full range of talents necessary for building an effective sample piece. The problem can be solved in two ways: by teaching yourself what you don't already know, or by teaming up with someone who is strong where you are weak. Teaching yourself a new skill like Flash animation may seem like an intimidating project, but as we will see from the case studies in this chapter, people do manage it. Software is becoming ever easier to use, and books are available to tutor you in animation programs, image manipulation, Web page design, and media authoring. You might also take a community college course to fill in a particular gap.

But if you prefer to team up with a colleague instead, keep in mind you need not even be in the same community. Many collaborations take place in cyberspace, and sometimes occur between people who have never met in person. Perhaps you are good at art, writing, and conceptualizing, while the other person excels at the more technical side of things. If you work together, you can create a project that is more effective than either of you could do alone, and also demonstrates your special abilities. This can be a win-win solution for both parties. Of course, you will want to be sure that each person's contribution is made clear in the credits, and that no one is claiming solo authorship for the entire project.

ODD TODD: A CASE STUDY

While it is important for a personal showcase to look professional, this does not necessarily mean it needs to follow a conservative, play-by-the rules approach. If you take a look at the website *Odd Todd* (*www.oddtodd.com*), you will find an immensely quirky piece of work that breaks almost all the rules and yet has

Figure 23.1 Odd Todd is the fictional hero of the *Odd Todd* website, an endeavor that has turned its creator's life around. Image courtesy of Todd Rosenberg.

become a wildly successful endeavor. This is not to say that everyone should build a project as idiosyncratic as this one is, but it does effectively illustrate the power of being fresh and original, and of having something meaningful to say. Essentially a one-person operation and done on a tiny budget, *Odd Todd* has thrust its creator, Todd Rosenberg, into the spotlight and changed his life.

The site is named for a fictitious character, Odd Todd, and is loosely based on the experiences of the site's creator, who lost his job with a dot com company during the dot com bust. In a series of Flash-animated episodes, we watch Todd as he futilely searches for a new job and gives in to such distractions as fudge-striped cookies, long naps, and fantasies about large-breasted women. The artwork in the cartoons is rough and child-like, and the only speaking character is Todd, who chronicles his hero's struggles in a voice-over narration. (See Figure 23.1.) The voice he uses is distinctive, marked by a puzzled kind of irony and bewilderment at his predicament, and further made unique by his urban drawl and a particular way of stretching out the end vowels in such words as money (mon-aaay) and cookie (cook-aaay). And though the site is extremely funny, it does have a serious side, touching on the painful issues of being unemployed and serving as a kind of a community center in cyberspace for laid off white-collar workers.

Beginning with just a single animated episode, the site has mushroomed into a full array of features. It includes about 18 cartoons, games, and interactive amusements, all relating to Odd Todd and his life and obsessions. It also includes a variety of daily and weekly specials such as a feature called "What's Happening," a diary-like log of Todd's life, to the Tuesday lunch special—recipe concoctions sent in by fans to nourish other laid-off stay-at-homes. It even contains at least one "hidden" feature, a hyperlink called "Kittens" placed way at the bottom of the home page. If you find it and click on it, you will be rewarded by a series of cat photos sent in by fans and given goofy captions by Todd.

Since its launch late in 2001, Odd Todd has been visited by well over one million unique users and has attracted major media attention. Over twenty articles have been written about the site, and it has been featured on at least a dozen TV and radio shows. Loyal fans have contributed close to $30,000 to Odd Todd's online tip jar, one dollar at a time, and they also support the site by buying a great variety of Odd Todd merchandise, from tee shirts to coffee mugs. The site has also spawned a book, *The Odd Todd Handbook: Hard Times, Soft Couch*, which, like the site, was created by Rosenberg.

THE HOWS AND WHYS OF ODD TODD

Why has a site featuring roughly drawn cartoons about an unshaven, unemployed guy in a blue bathrobe become such a hit? How did the creator, Todd Rosenberg, set about making this site and how does he keep it going? And as a showcase, what has it done for his career? The real Todd shed some light on these questions during a phone interview and several follow-up emails.

First of all, let's address one burning question right away. No, the real Todd does not sound like the voice he uses on the website. That is a made-up voice, and many of the situations depicted in the cartoons are invented as well. But the core conceit—that this is a site built by an unemployed dot comer, is totally true. The authenticity of the character's predicament, the real Todd believes, is an important reason why the site has become so immensely popular. People identify with it, Rosenberg explained. "They see it and say to themselves: 'It's so me!' or 'Someone else is doing exactly what I'm doing!'"

Although one need not be unemployed to get a kick out of the site, Rosenberg recognizes that most of his audience is in the same jobless state as the site's hero. He shapes his content with their situation in mind, and he is very respectful of them. He offers his visitors features like a club called "LaidoffLand," where they can commiserate with each other about being jobless, and a service called Oddjobs.org, which hooks up businesses in need of freelancers with the members of Laid-OffLand. Because of the strained finances of Odd Todd's fans, he refuses to turn the site into a big money-making vehicle. And he won't do pop-up ads because he hates them, though he realizes that's a key way to turn a site into a profit center. He does, however, put up a few ads on a *quid pro quo* basis, receiving some merchandise in return. The people who donate items are called "officials," as in "the official bottle opener of *OddTodd.com*," or "the official desk provider of *OddTodd.com*."

THE REAL TODD AND THE FICTIONAL TODD

The real Todd actually did work for a dot com company, *AtomFilms.com*. There he had an uncreative, corporate-style job as director of business development, a position that primarily involved sales. Then in June, 2001, he was laid off, part of a company-wide bloodbath that eliminated 75% of the staff. Thinking he'd only be out of work for a few months, he decided to spend some of it doing something he'd always enjoyed—cartooning—and create something that might possibly help him become employed again. The result was the first episode of Odd Todd. He took the name from a line of greeting cards he'd previously created,

Odd Todd Greetings. The unshaven character in the blue bathrobe, however, was a new creation, invented just for this venture.

Originally, Rosenberg was just planning to do a one-minute rant about the plight of the unemployed, but his idea evolved into the first episode of a series. The debut episode was a humorous take on what it is like to be newly laid off, with too much time and too little money. As the series continued, however, the life of the fictitious Todd and the real Todd began to diverge. While an episode might show Odd Todd sending out résumés and trying to find work, in actuality Rosenberg was no longer doing that. The success of the site, and the creative satisfaction it brought him, caused him to lose interest in returning to the 9 to 5 corporate world. Other, more attractive possibilities were presenting themselves, and he was making just enough money to keep going at what he was doing. The combination of his tip jar, the merchandise he was selling, and the freelance jobs he was getting via the site were keeping him afloat.

A LOW-TECH, LOW-BUDGET APPROACH

Although Rosenberg had worked for an entertainment-oriented dot com company and had learned basic HTML at a prior job, he lacked training in almost every other skill he would need in order to build and maintain his new site. When asked what he'd studied in college (the University of Hartford), he replied: "I never studied in college. I wasn't much of a student." During class, he said, he would fill his notebooks up with cartoons instead of lecture notes. Later, he came to regret never having taken an art class. He said he learned to draw by using *Mad Magazine* as a model. He also had no training in screenwriting—he owned books on the subject, he said, but had never read them—and had never acquired experience in acting, either, because he had stage fright.

One of the first things he needed to learn, in order to bring Odd Todd to life, was Flash animation. He taught himself how with the help of a book called *Flash 5 Cartooning*. His "studio" was his apartment in New York, and he did everything from there. The voice he used for the cartoon's narration was his own, and to record it, he used the microphone that came with his computer. At first he just used his regular speaking voice, but he decided it sounded too plain. Another vocal approach was, he thought, too menacing. Finally, the right sort of Odd Todd voice emerged, capturing the sort of character Rosenberg had in mind, which he described as "a kind of friendly, lazy guy." To lay down the voice track, he recalled that "I talked in this weird voice, and I repeated the same phrase over and over. The neighbors must have thought I was very strange."

Though Rosenberg's cartoons have an unpolished, homemade appearance, he can actually draw much better than the work on his website would suggest. In doing the animation for his first cartoon, he made a quick series of drawings, intending to use them as placeholders. But after he refined them, he discovered he much preferred the look of the rough first set, and discarded the more polished ones. Even now, with multiple episodes behind him, he still makes five or six versions of each cartoon before he has one that he feels is right. Making the website look quickly dashed out and candid is totally in keeping with the fictional Odd Todd character. However, accomplishing the right look actually takes a great deal of work.

In the beginning, however, Rosenberg's abilities in many areas truly were less than polished. His Odd Todd character would look different from picture to picture; he had trouble making him consistent. In addition, he didn't know how to synch the sound and the picture properly, or how to make a button to let users replay an episode or game. He kept going back to his books and to more knowledgeable friends from his old job for help before he mastered what he felt he needed to know, and he still hasn't licked the problem of the long download times that his cartoons and games require. It's one of the few complaints he gets about his site.

By doing practically everything himself and using equipment he already owned, such as the mic that came with his computer, Rosenberg managed to keep his start-up costs low. One of his largest expenses was a graphics tablet and a stylus, which allowed him to draw directly on the screen. All told, during his first year of running the Odd Todd site, he estimates he spent under $1000.

MAINTAINING THE SITE

Now that the site is up and running, it requires regular daily maintenance, which includes dealing with voluminous email. Sunday nights may find him up past 2 a.m., adding new weekly features. He strives to put up new cartoons on a regular basis, though the freelance work he gets sometimes siphons off time he'd like to be spending on a new episode. He has no shortage of ideas for new cartoons, though, imagining his Odd Todd character in a variety of humorous situations that go beyond his jobless situation. He still has not solved the challenge of adding speaking roles of human characters (he's already incorporated some nonhuman ones, which make strange chirps and other sounds). But because Odd Todd's adventures are told via voice-over narration, adding new speaking characters would require some changes in his approach. He continues to add other new features, though, going from a couple of weekly specials to one for every day of the week. He's also discovered that people especially enjoy the games he puts up. For example, when he added the *Cook-ay Slots* game to the site, traffic spiked, jumping from an average of 15,000 unique daily visitors to 25,000 visitors. "People like games more than I thought," he commented.

A CYBERSPACE SUPPORT SYSTEM

Rosenberg has managed to keep his expenses low in part by an informal exchange system. For instance, his site is hosted for free by Peak Webhosting, which saves him a great deal of money. In return, he promotes Peak Webhosting on his site, which has brought them business. He has also received significant volunteer assistance from one of his fans, Stacey Kamen, a website designer. In return, Rosenberg prominently promotes her design skills and her website business on his site. (Kamen and her work will be discussed in more detail later in this chapter.)

Another fan, Geoffrey Noles, also contributes his services to Odd Todd. He assists by programming the games on the site, including the enormously amusing and popular *Cook-ay Slots*, a wacky slot machine game. Noles, too, receives credit on Odd Todd, as well as a link to his site. Rosenberg has never met either of these

two important contributors face to face. They communicate by various electronic means, including, in the case of Noles and Rosenberg, by webcam.

However, Rosenberg is well acquainted with two of his other important helpers—his mother and father. Both are retired and have time to lend a hand. His mother helps by finding items for his "Daily Good News" feature and by overseeing his email, and his father helps by managing the merchandising. Despite their support, however, Rosenberg confessed that his parents are sometimes a little concerned about him, perhaps believing that the troubled tales of Odd Todd were more autobiographical than they really were.

THE PAYOFF

In truth, Rosenberg is anything but dejected. Despite the work involved, and the creative challenges he's had to deal with, Rosenberg has no regrets about the time he's invested in this endeavor. "I've had a lot of fun with the site," he said. His highly original site has brought him rewards he could not have imagined when he first launched it. He has more than met his initial goal of having a creative outlet, one that would hopefully land him some work. The work he's taken on, however, is all freelance; he no longer wishes to work full time in a corporate environment. Ironically, he's actually making a living by being unemployed. The modest income he earns from the site, plus the freelance jobs he takes on, give him enough to meet his needs. Even though he's not making as much as he was before he was laid off, he's enjoying himself more. Rosenberg isn't sure where it will all lead, though he hopes he can continue making a living off his fictional creation. There's even talk of a TV series based on Odd Todd.

ANOTHER APPROACH TO SHOWCASING

For a different approach to producing a digital calling card, let's take a look at how Rosenberg's right-hand helper, Stacey Kamen, has gone about promoting her own work. Kamen, introduced earlier in this chapter, describes herself as a Web and graphic designer with a specialty in business imaging (giving businesses a particular image via websites, brochures, and other materials). She has taken two routes to making her work known: by contributing to the Odd Todd site, and by building a site of her own (*www.StaceyKamen.com*), which is totally different from Rosenberg's.

Interestingly, when she first approached Rosenberg and volunteered her services, she wasn't thinking about how helping him out might boost her own career. She first learned of Rosenberg's website when she was working at a dot com company and it became clear that she was about to lose her job. A friend sent her a link to Odd Todd, and she visited it every day. "It made me laugh, and it took away that alone feeling," she told me. "It had a big draw, apart from the humor. You felt you were in good company."

Still, she said, the site was driving her nuts because the home page was so disorganized and the navigation was so clumsy. She contacted Rosenberg and offered to help, but he wasn't interested, maintaining that the unprofessional

look was part of the Odd Todd mystique. Still, she persisted, and even sent him a plan of what she had in mind. Rosenberg looked at her design, but felt it was too slick looking. Still, she managed to convince him that a better design would be helpful. Finally, the day before Rosenberg was due to make an appearance on CNN, he agreed to let her redesign the home page. She had just one day to do it, but managed to tidy things up and add a smoothly functioning, jaunty new navigation bar on the left-hand side of the screen.

That was the beginning of their successful collaboration. Kamen continues to help him out with special tasks, like adding falling snowflakes to the site for Christmas, and giving it an appropriate seasonal look for other holidays. She also gives him feedback on new things he is trying, calling herself Rosenberg's "number one critiquer." Even now, long after their difference of opinion about his home page, they don't always agree. "We like to lock horns," she said, "but it's really fun." Being in different cities, they communicate via emails, instant messaging, and even pick up the phone once in a while, and a firm friendship has developed between them.

In return for her help, Rosenberg makes a point of promoting Kamen throughout his site as "The Official Web Designer of Odd Todd.com!" and includes several links to her site. As a result, Kamen reports, 90% of the inquires she gets from prospective clients have come to her from the Odd Todd site. She's also getting more of her dream clients—companies and individuals from the arts and entertainment world, including musicians.

Looking back on how she first hooked up with Rosenberg and started working with him, Kamen said: "I guess it was in the back of my mind that it might help my business, but I didn't ask for anything; I really wanted to do it. I was coming out of a corporate situation, always working with the same color palette. I was looking for more creative opportunities. It turned out to be the best business move I ever made."

A DIFFERENT LOOK

Kamen's own website for her freelance design business, which she launched soon after she was laid off from her dot com job, is entirely different from the casual bachelor style of Odd Todd. It is crisp, polished, and elegant, laid out in a highly organized way. (See Figure 23.2.) Its design earned it a Golden Web Award from the International Association of Webmasters and Designers. While the site contains no cartoons or games or other features that would be considered "entertainment," it does contain striking nature photos and an innovative interactive scrolling feature.

"My website says a lot about me," Kamen said. "For instance, I love nature and earth tones, and I'm organized." She says the site also reflects her skills and style at a glance, without making the visitor sift through mountains of text. She wanted her site to show her creative side and eclectic nature. "A site like everyone else's—standard layout, standard buttons, standard navigation—wouldn't be 'me,'" she asserted. "I created my site with the idea of doing something different, not only its visual structure, but in navigation as well." The samples of her work that are included on the site reveal the diversity of her design approaches. "If you are going to be successful in the design business," she said, "you need to be flexible, and be able to shift gears easily. That's what makes it fun for me. For instance, I hate orange personally, but I can use it for a client, and find it works."

Figure 23.2 Kamen's elegant style features a bank of scrolling images (far right) and utilizes a quite different approach from Odd Todd. Image courtesy of Stacey Kamen.

She also feels her site is effective because its approach is visual rather than verbal. The text she does use describes her career path and professional experience, somewhat like a nonfiction story. The style of writing is very personable, and the text works well in conjunction with the graphics.

A feature she is particularly proud of is the scrolling bank of images—all samples of her work—that revolves when the user rolls over the up or down arrows. She said it was the trickiest part of the site to do, even though it might look simple, and took her about five weeks of nonstop work to build. And just as Todd Rosenberg has turned to Kamen for help when he needs it, Kamen turned to a technically savvy colleague, Bryant Tyson, when she was having trouble with her scrolling feature, and he was able to give the pointers she needed to make it function. Kamen refers to Tyson, the owner of a full service Web design company, as a "virtual co-worker." They met playing an online game and have continued to stay in close touch because of mutual professional interests. The assistance Tyson has given her with the scrolling feature and other technical matters goes both ways. Kamen gives Tyson a leg up with design direction, critiques, proofreading, and occasional assistance with graphics. In addition to Tyson, Kamen has a number of other online associates she can call on in the event of a roadblock, some from former jobs and others she has met in cyberspace.

POINTERS FOR MAKING YOUR OWN SHOWCASE

If you are planning to create and build your own professional showcase, the following suggestions are helpful to keep in mind:

1. Define your ultimate objectives and mold your showcase accordingly. The material it contains should demonstrate your abilities in the type

of work you want to do and be appropriate to the general arena where you hope to find employment.

2. Don't confuse the making of a showcase with the making of a vanity piece. This isn't the place to display cute pet pictures or to brag about your snowboarding trophies. It is, however, appropriate to include your professional credits and contact information.

3. Don't imitate others; be an original. Let your showcase reflect what you really care about. This is the first piece of advice offered by Todd Rosenberg, and the results speak for themselves. It is the same advice offered by professionals in every creative field to anyone endeavoring to make something to show off their talents, be it a painting or a movie script or a novel or an interactive game.

4. Be sure your showcase actually works. Try to get a friend to beta test it for you. If the piece is for the Web, look at it on different browsers and on both dial-up and broadband connection speeds. Also look at it on both Macs and PCs.

5. If you are lacking in a particular skill, don't let that be a roadblock. Either teach yourself that skill or team up with more skilled colleagues. If you do team up, however, be sure to credit each person's contribution in the credits of your piece.

6. Humor can be an asset in a showcase, but inappropriate humor can backfire. If you think your piece is comic, run it by other people to see if they agree. Ideally, seek the opinions of people who are about the same age and at the same professional level to whom you are targeting your showcase.

7. If your work includes text, keep it concise and easy to read. Try whenever possible to find a way to do something visually rather than by printed words.

8. Make sure that the interactive elements you include are well integrated into the overall concept and have a legitimate function. The interactivity should demonstrate that you understand how to use interactivity effectively.

9. If you are taking a portfolio approach instead of showcasing a single piece, select pieces that contain different types of subject matter and display different styles and approaches.

10. Get feedback from others, and be open to what they say. Receiving feedback can be uncomfortable, but it is the only way you will find out how others see your work. Don't become so attached to any one feature that you are unable to discard it, even if it meets with a universally negative response. As a story editor once said to me: "Sometimes you have to kill your babies."

The process of creating an effective showcase will take time, but be patient. You will probably experience some frustrations and hit some walls. Such setbacks indicate you are stretching yourself, which is a positive thing. If you persist, you will end up knowing more than you did when you began the project, and are likely to create something of which you can be proud.

Conclusion

We have now reached the end of this exploration of digital storytelling. I hope I've succeeded in conveying to you what a dynamic and exciting field this is, filled with creative possibilities. The pioneering storytellers introduced in these pages have demonstrated how the new digital technologies can be used to construct rich entertainment experiences. They have courageously ventured into unexplored narrative territory and have taken exhilarating leaps of the imagination. In the process, they have provided us with excellent working models to study.

In writing this book, I have been painfully aware that this field is a continually moving target. Breakthroughs occur on a regular basis, and a project can be hot one day only to vanish by tomorrow. During the time I was writing this book, several excellent companies have turned off their lights for good, and some remarkable new projects have been launched too late for me to include here. Nevertheless, the works described in this book are outstanding examples of digital storytelling and I hope they will serve as a stimulus for your own digital stories.

As you go about creating your own work in this field, try to keep in mind that although digital storytelling is a newcomer to a very ancient craft, it is, like its predecessors, a powerful instrument. Not only can it entertain, but it can also be a vehicle for binding communities together, for preparing young people for adulthood, and for helping us understand who we are. I hope that as you join the company of digital storytellers, you will use its power in a positive and creative way, and in doing so, will help advance this evolving craft a few more steps forward.

Consider this book the beginning of a dialogue on digital storytelling. I will be posting updates on the subject on my website, *www.digital-storytelling.net*, and invite you to share your discoveries or questions with me at Carolyn@CarolynMiller.com.

Glossary

3G third generation: See *third generation*.

Advanced TV Enhancement Forum (ATVEF): Set of standards that allows Web-based content to be broadcast on TV.

advergaming: An entertainment that incorporates advertising into a game. Such games appear on the Web and on wireless devices. They are generally short, designed as a quick burst of fun.

AI: See *artificial intelligence*.

algorithm: A logical system that determines the triggering of events. In a game, an algorithm may determine such things as what the player needs to do before gaining access to "X" or what steps must be taken in order to trigger "Y." An algorithm is a little like a recipe, but instead of the ingredients being foods, they are events or actions.

alternate reality game (ARG): An interactive game that blurs real life with fiction. Alternate reality games usually involve multiple media and incorporate types of communications not normally associated with games, such as telephone calls and faxes.

analog: One of two ways of transmitting and storing information, including entertainment content, electronically; the other being digital. Analog information is continuous and unbroken. Film, video, LPs, and audiotape are all analog storage media.

ancillary market: The secondary use of an entertainment property. Typical ancillary markets for movies and TV shows are videos, DVDs, music CDs, and video games. Wireless games are also becoming part of the ancillary market.

animatronic: A replica of a living creature that is computer operated but moves in a life-like way and may also speak.

ARG: See *alternate reality game*.

artificial intelligence (AI): Computer intelligence that simulates human intelligence. A digital character with artificial intelligence seems to understand what the player is doing or saying, and acts appropriately in response.

attract mode: A visual tease on a kiosk screen that loops continuously until a user engages with the kiosk and triggers the program.

ATVEF: See *Advanced TV Enhancement Forum.*

automata: Self-operating mechanical figures that can move, and, in some cases, make life-like sounds. Automata have been made since ancient times and are the forerunners of smart toys.

avatar: A graphic representation of the character controlled by the player. Players often have the opportunity to construct their own avatar from a selection of choices.

backstory: Background story that relates to events that happened or relationships that were established before the current narrative begins and must be revealed at some point in the current work for it to make sense.

bandwidth: The capacity of a communications channel to receive data; usually measured in bits or bytes per second. The higher the bandwidth connection, the better able the user is to receive streaming video and to enjoy a high-quality Internet experience. High bandwidth connections are also called broadband and are available via DSL lines and cable and satellite services. Dial-up modems are only able to support low bandwidth; such connections are quite slow and do not support streaming video well. See also *broadband.*

beta tester: A person who looks for bugs in a software program or game before it is released to the public. This type of job is often a stepping stone to a higher level position in the software industry.

bible: A document that describes all the significant elements in a work that is in development. The term comes from television production and is used in the development of interactive content. The bible includes all the settings or worlds and what happens in them, as well as all the major characters. It may also give the backstories of these characters. Some bibles, called character bibles, only describe the characters.

blog: A Web log. An online diary or journal that is accessible to anyone on the Web, or a site that expresses a personal opinion.

Bluetooth: A protocol that enables high-speed wireless connections to the Internet.

Boolean logic: Logic that uses only two variables, such as 0 and 1, or true and false. A string of such variables can determine a fairly complex sequence of events. Boolean logic can be regarded as a series of conditions that determine when a "gate" is opened—when something previously unavailable becomes available, or something previously undoable becomes doable. Boolean logic is also used to do searches on the Web.

BOOM (Binocular Omni Orientation Monitor): A type of VR device that works like an HMD but is mounted on a rotating arm rather than on one's head. See also *head mounted display.*

bot: Short for robot; an artificial character. On the Internet, bots are programs that can access websites and gather information that is used by search engines.

branching structure: A classic structure in interactive works. It is a little like a pathway over which the user travels. Every so often, the user comes to a fork and will be presented with several different choices. Upon selecting one, the user will then travel a bit further until reaching another fork, with several more choices, and so on.

branding: A way of establishing a distinctive identity for a product or service; an image that makes it stand out from the crowd. By successful branding, the product is distinguished from its competitors and is made to seem alluring in a unique way.

broadband: A transmission medium capable of supporting a wide range of frequencies. Broadband can transmit more data and at a higher speed than narrowband, and can support streaming audio and video. The term is often used to mean high-speed Internet access. See also *bandwidth*.

CAVE (CAVE Automatic Virtual Environment): An extremely immersive type of VR environment in which the user is surrounded by rear view projection screens and the 3D images are seen through stereoscopic glasses.

CD-i (Compact Disc-interactive): A multimedia system developed jointly by Philips and Sony and introduced in 1991. It was the first interactive technology geared for a mass audience. CD-i discs were played on special units designed for the purpose, and connected to a TV set or color monitor.

CD-ROM (Compact Disc-Read Only Memory): A storage medium for digital data—text, audio, video, and animation—which can be read by a personal computer. The CD-ROM was introduced to the public in 1985 and could store a massive amount of digital data compared to the other storage media of the time.

CGI: See *common gateway interface; computer generated image*.

chatterbot: An artificial character, or bot, with whom you can chat.

cinematic: A cut scene. See *cut scene*.

common gateway interface (CGI): A Web term for a set of rules that governs how a Web server communicates with another piece of software.

computer generated image (CGI): An image produced by a computer rather than being hand drawn, often used as shorthand for computer animation.

concatenation: The efficient reuse of words and phrases to maximize space on a chip.

console game: A game played on a game console. See also *game console*.

convergence: A blending together of two or more entities into one seamless whole. In terms of interactive media, it may be used to mean the integration of telecommunications and broadcasting or the integration of the PC and the TV.

critical story path: The linear narrative line through an interactive work. This path contains all the sequences a user must experience, and all the information that must be acquired, for the user to achieve the full story experience and reach a meaningful ending point.

cross media production: The merging of a single entertainment property over multiple platforms or venues.

cut scene: A linear story segment in an interactive work; also called a cinematic. Cut scenes are used to establish the story or to serve as a transition between events; they are also shown at the culmination of a mission or at the end of a game.

cyberspace: A term used to refer to the nonphysical world created by computer communications. It was coined in 1984 by William Gibson in his sci-fi novel, *Neuromancer*.

database narrative: A type of interactive movie whose structure allows for both the selection and the combining of narrative elements from a number of categories drawn from a deep database.

design document: The written blueprint of an interactive work used as a guide during the development process and containing every detail of the project. It is a living document, begun during preproduction but never truly completed until the project itself is finished.

developer: A company that does the development work for a new software product, such as a game or smart toy.

digital: One of two ways of transmitting and storing information, including entertainment content, electronically, the other being analog. Digital information is made up of distinct, separate bits: the zeroes and ones that feed our computers. DVDs, CD-ROMs, CDs, and digital video are all digital storage media. Digital information can be stored easily, accessed quickly, and can be transferred among a great variety of devices. It is digital technology that makes interactive entertainment possible.

dual screen interactivity: A form of iTV in which a television show and a website are synchronized. This form of iTV is available to anyone with a computer, online access, and a TV set; it does not require any special equipment.

dungeon master: The person who, during the playing of an RPG or a real-time simulation, helps shape the action, serves as the game's referee, and manipulates the game's nonplayer characters. Dungeon masters were first introduced in LARPs and are a feature of MMOGs and other interactive experiences, including training simulations.

DVD: An electronics platform that plays digitized programs, particularly movies and compilations of TV shows, on special discs, also called DVDs. The initials DVD once stood for "Digital Video Disc," but now the initials do not stand for any particular words; the initials themselves are the name of the technology.

early adopter: A person who is one of the first to use a new technology or device.

edutainment: An interactive program for children that combines entertainment and education; one of the most successful categories of children's software.

e-learning: Online education and training. College courses, university extension courses, and adult education courses are all offered as e-learning opportunities. Online training may be offered through an organization's Intranet service.

electronic kiosk: A booth or other small structure that offers the user an easy-to-operate computerized experience, often via a touch screen. Although usually used for pragmatic services like banking (ATM machines), kiosks are also used for entertainment and informational purposes.

emoticon: Symbols used in text messages to express emotions.

engine: The computer programming that operates a game or other piece of software in the specific way it does.

first-person point of view: The perspective we have while participating in an interactive work in which we see the action as if we were in the middle of it and viewing it through our own eyes. We see the world around us, but we don't see ourselves, except for perhaps a hand or a foot. It is the "I" experience. See also *third-person point of view*.

first-person shooter (FPS): A shooting game in which the player is given a first-person point of view of the action. The players control and play the protagonist, but they cannot see themselves. They can, however, see the weapon they are holding. See also *first-person point of view*.

flowchart: A visual expression of the through line of an interactive project. Flowcharts illustrate decision points, branches, and other interactive possibilities.

FMV: See *full motion video*.

fourth wall: The invisible boundary that, in the theatre, separates the audience from the characters on the stage, and in any dramatic work divides reality (the audience side) from fiction (the characters' side). Works of digital storytelling often break the fourth wall by bringing the participant into the fictional world or by the fictional world invading the real world.

FPS: See *first-person shooter*.

full motion video (FMV): Live action video seen on a computer.

functionality: How an interactive program works, particularly its interactive elements and its interface.

game console: A device made for playing video games. Some consoles plug into a TV set and use the TV as a monitor; small hand-held consoles are self-contained. Most can support multiplayer games and the majority of the current generation of consoles can connect to the Internet and can play DVDs.

genre: A category of programming that contains certain characteristic elements. Major types of entertainment properties, like movies and video games, are broken into genres to distinguish them from each other.

griefer: A player in a MMOG who enjoys killing off new players and otherwise making life miserable for them.

head mounted display (HMD): A device worn on the head in a virtual reality simulation that enables the user to see the digital images.

high bandwidth: See *bandwidth*.

HMD: See *head mounted display*.

HTML (Hypertext Markup Language): The software language used to create Web pages and hyperlinks.

HTTP (Hypertext Transfer Protocol): Protocol used to transfer files, including text, sound, video, and graphics, on the Web.

hyperlink: A word or image that is linked to another word or image. See also *hypertext*.

hypertext: A technique used in digital works that enables the linking of words or phrases to other related "assets," such as photographs, sounds, video, or other text. The user makes the connection to the linked asset by clicking on the hyperlinked word or phrase, which usually stands out by being underlined or by being in a different color. See also *hyperlink*.

hypertext markup language: See *HTML*.

hypertext transfer protocol: See *HTTP*.

I cinema: An interactive movie. Interactive movies fall into two broad categories. One type is designed for a large theatre screen and is usually intended to be a group experience; the other type is for a small screen and meant to be enjoyed by a solo viewer.

IF: See *interactive fiction*.

if/then variable: A fundamental way of expressing choice and consequence in an interactive work. In an if/then scenario, if the user does A, then B will happen. Or, to put it slightly differently, choosing or doing A will link you to B.

IM or IMing (Instant Message or Instant Messaging): See *instant messaging*.

immersive environment: An artificially created environment or installation that seems real. Immersive environments are similar to VR but are less dependent upon the user wearing heavy-duty hardware. Sometimes the immersive effect is produced via a large curved screen in a specially equipped theatre and the seats may move in sync with the story's action (motion base chairs). To further enhance the immersive experience and trick the senses, designers may call upon artificial smell, tactile stimulation, artificial weather effects, sound effects, virtual characters, and animatronic figures.

infotainment: A presentation that combines information and entertainment.

instant messaging (IM or IMing): A method of exchanging messages with another person while you are both online, much like a conversation. Although IMing began as a text-only medium, some service providers offer graphic and audio options as well.

intellectual property (IP): A unique work of human intelligence—such as a photograph, a script, a song, a piece of animation, even a game engine or the design of a smart toy—that is given legal protection such as a copyright, patent, or trademark. Intellectual properties can be extremely valuable and are closely guarded.

interactive fiction (IF): A work of interactive narrative, usually text based, into which users input their commands via their computer keyboard. Works of IF are available on the Internet and as CD-ROMs and sometimes contain graphics and video. Works of IF resemble text-based adventure games (MUDs), but are engaged

in by a solo user, not multiple players. They also lack a win/lose outcome. See also *MUD*.

interactive voice response (IVR): Communications that take place on the telephone that facilitate the acquisition of information. The user is asked a series of questions by a recorded voice and responds by pressing the telephone's number keys or by speaking. Based on the caller's input, the system retrieves information from a database. IVR systems are commonly used by banks to provide account information to customers. They are also being called into play for games.

interface: The elements of an interactive work that enable the users to communicate with the material, to make choices and navigate through it. Among the many visual devices used in interface design are menus, navigation bars, icons, buttons, and cursors.

Internet 2: A faster, more robust form of the Internet. It is used by government and academic organizations; it is not accessible to the general public.

interactive television (iTV): A form of television that gives the viewer some control over the content or way of interacting with it.

IP: See *intellectual property*.

iTV: See *interactive television*.

IVR: See *interactive voice response*.

kiosk: See *electronic kiosk*.

landline telephones: Telephones that are connected to wires and cables, as opposed to wireless phones.

LARP: See *live action role-playing game*.

laser disc: A storage and playback format, also called a video disc, introduced in the late 1970s and used for watching movies and for educational and training purposes, as well as for arcade games. They have largely been replaced by DVDs, though a small number of devoted fans still use them.

latency: The time it takes for a program to react.

LBE: See *location based entertainment*.

leaderboard: A list of the top scorers in a live game.

level: A structural device in a game or other interactive work; it is a section of the work, akin to a chapter or an act. Each level has its own physical environment, characters, and challenges. Games may also be "leveled" in terms of degree of difficulty, with levels running from easy to difficult. Characters, too, can attain an increase in level in terms of their powers or skills; they are "leveled up."

licensed character: See *licensed property*.

licensed property: A piece of intellectual property, often a movie, a novel, or other work of entertainment, that is covered by a licensing agreement, allowing another entity to use it. By the same token, a licensed character is one whose use is licensed to another. Licensed properties and characters are generally highly recognizable and popular, and their use can add value to a new work. The Harry Potter novels are licensed properties and Lara Croft is a licensed character.

linearity: A state in which events are fixed in a set, unchangeable sequence, and one event follows another in a logical, fixed, and progressive sequence. Films and novels are linear, while interactive works are always nonlinear.

live action role-playing game (LARP): Games that are played by participants in the real world as opposed to role-playing games played on computers or online. The earliest LARPs were war game simulations. Such games were the predecessors of the highly popular Dungeons and Dragons LARPs, which evolved into today's MMORPGs. See also *MMORPGs.*

location based entertainment (LBE): Entertainment that takes place away from the home. Venues can include cultural institutions like museums as well as theme parks. In many cases, LBE experiences involve immersive environments. See also *immersive environment.*

low bandwidth: See *bandwidth.*

massively multiplayer online game (MMOG): An online game that is played simultaneously by tens of thousands of people and is typically set in a sprawling fictional landscape. MMOGs are persistent universes, meaning that the stories continue even after a player has logged off.

massively multiplayer online role-playing game (MMORPG): An online role-playing game played simultaneously by thousands of participants, and one of the most popular forms of MMOGs. MMORPGs contain many of the elements of video game RPGs, in which the player controls one or more avatars and goes on quests. These avatars are defined by a set of attributes, such as species, occupation, skill, and special talents.

matrix: A table-like chart with rows and columns that is used to help assign and track the variables in an interactive project.

metatag: Information used by search engines, important for constructing indexes.

milestone: A project marker that specifies when the different elements of a project must be completed.

MMOG: See *massively multiplayer online game.*

MMORPG: See *massively multiplayer online role-playing game.*

MMS: See *multimedia service.*

MOB (Mobile Object): An object in a game that moves.

MOO (MUD, Object Oriented): A text-based adventure game that is a close cousin to the MUD. See also *MUD.*

MUD: A text-based adventure game in which multiple players assume fictional personas, explore fantasy environments, and interact with each other. MUD stands for Multi-User Dungeon (or Multi-User Domain or Multi-User Dimension). Aside from being text based, MUDs are much like today's MMOGs.

multimedia service (MMS): A feature offered on wireless phones that enables users to send and receive more data than with SMS. It can support a variety of media, including photographs, long text messages, audio, and video, and different media can be combined in the same message. See also *short messaging service.*

natural language interface: A life-like method of communication between a user and an artificial character, in which the artificial character can "understand" the words the user freely types or says, and is able to respond appropriately.

navigation: Method by which users move through an interactive work. Navigational tools include menus, navigation bars, icons, buttons, cursors, rollovers, maps, and directional symbols.

NDA: See *nondisclosure agreement*.

networked gaming environment: The linking of computers together into a network that allows many users to participate in an interactive experience. Such networks may be used for educational and training purposes as well as for gaming.

newbie: A new player or new user.

node: A design term sometimes used to indicate the largest organizational unit of a game (similar to a world) and sometimes used to indicate a point where a user can make a choice.

nondisclosure agreement (NDA): A document used when potentially valuable information is about to be shared with another party. The party that is to receive the information, in signing the NDA, agrees to keep the information confidential.

nonplayer character (NPC): A character controlled by the computer, not by the player.

nonlinearity: Not having a fixed sequence of events; not progressing in a preset, progressive manner. Nonlinearity is a characteristic of interactive works. Though the work may have a central storyline, players or users can weave a varied path through the material, interacting with it in a highly fluid manner.

NPC: See *nonplayer character*.

PC game: A game that is played on a computer.

PDA: See *personal digital assistant*.

PDR: See *personal digital recorder*.

peer to peer learning: An educational environment that facilitates collaborative learning. Online peer to peer learning environments may include such features as instant messaging, message boards, and chat rooms.

persistent universe: A virtual environment that continues to exist and evolve after the user has logged off or gone away; a common feature of MMOGs.

personal digital assistant (PDA): A wireless device that serves as an electronic Rolodex, calendar, and organizer. PDAs can download material from the Internet and from PCs.

personal digital recorder (PDR): Same as a personal video recorder. See *personal video recorder*.

personal video recorder (PVR): A device that lets viewers select and record television programs; the best known device is TiVO. Personal digital video recorders offer viewers more control than VCRs, including features like pausing live TV and the ability to skip commercials.

pixel: Short for PICture ELement. A pixel is a single tiny unit of a digital graphic image. Graphic images are made up of thousands of pixels in rows and columns, and they are so small that they are usually not visible to the naked eye. The smaller the pixels, the higher the quality of the graphic.

platform game: A genre of game that is very fast paced and calls for players to make their characters jump, run, or climb through a challenging terrain, often while dodging falling objects or avoiding pitfalls. Such games require quick reflexes and manual dexterity.

player character: A character controlled by the player.

point of view (POV): The way the user views the interactive material. The two principle views are first person and third person. See *first-person point of view* and *third-person point of view.*

POV: See *point of view; first-person point of view;* and *third-person point of view.*

project creep: A situation in which a project grows much bigger than it was originally understood to be. Also called scope creep.

proprietary: The state of being owned or controlled by an individual or organization. In interactive entertainment, certain software is sometimes called proprietary, meaning that it is the exclusive property of that developer.

protocol: A set of instructions or rules for exchanging information between computer systems or networks.

prototype: A working model of a small part of an overall project.

publisher: A company that funds the development of a game or other software product and packages and markets it. A publisher may also develop projects in-house.

PVR: See *personal video recorder.*

real-time strategy game (RTS): A genre of game that emphasizes the use of strategy and logic. In these games, the players manage resources, military units, or communities. In a real-time strategy game, the play is continuous, as opposed to a turn-based strategy game, where players take turns.

real-time 3D graphic (RT3D): Three-dimensional animation that is rendered in real time instead of being prerendered. In a game environment, the images respond to the players' actions.

repurposing: Taking material from one medium and porting it over to another with little or no change.

ridefilm: An entertainment experience that takes place in a specially equipped theatre. The audience may sit in special seats (motion based chairs) that move in sync with the action taking place on the screen, which may give them the illusion that they are traveling though they are not actually going anywhere.

role-playing game (RPG): A genre of game in which the player controls one or more characters, or avatars, and vicariously goes on adventures. These games evolved from the precomputer version of *Dungeons and Dragons.* See also *avatar.*

RPG: See *role-playing game.*

RT3D: See *real-time 3D graphic.*

RTS: See *real-time strategy game.*

schematic: An easy to understand diagram that illustrates how something works.

short messaging service (SMS): A feature offered on wireless phones that enables users to send and receive short text messages up to 160 characters in length.

simulation: A realistic and dramatic scenario in which users make choices that determine how things turn out. Simulations are featured in many types of interactive environments, including virtual reality and CD-ROM programs, and are used for entertainment and educational and training purposes.

single-screen interactivity: A form of iTV in which interactive programming is furnished via a digital set top box provided by a satellite or cable company.

smart toy: Any type of plaything with a built-in microprocessing chip. They can include educational games and life-like dolls, animals, or fantasy creatures that seem intelligent and interact with the child playing with it. They can also include playsets that tell a story as the child interacts with it.

SMS: See *short messaging service.*

state engine approach: An interactive mechanism that allows for a greater range of responses to stimuli than a simple if/then approach, which allows for only one possible outcome for every choice. See also *if/then variable.*

stereoscope: A device that enables people to see images in 3D. Stereoscopic devices are used in VR installations.

stickiness: The ability to draw people to a particular website and entice them to linger for long periods of time; also the ability to draw visitors back repeatedly.

storyboard: A graphical illustration of the flow of action and other elements of the content of an interactive project, displayed sequentially. A storyboard is somewhat similar to an illustrated flowchart.

streaming: Receiving video or audio in real time, without a delay, as it downloads from the Internet. Video received this way is called streaming video; audio received this way is called streaming audio.

third generation (3G): A stage of development in wireless technology that enables wireless telephones to have high-speed access to the Internet.

third-person point of view: The perspective we have in an interactive work in which we watch our character from a distance, much as we watch the protagonist in a movie. We can see the character in action, and can see their facial expressions, too. Cut scenes show characters from the third-person POV, and when we control an avatar, we are observing it from this POV as well. See also *first-person point of view.*

TiVo: See *personal video recorder.*

treadmill: An internal structural system of a MMOG that keeps the user involved playing it, cycling repeatedly through the same types of beats in order to advance in the game.

url (Uniform Resource Locator): A website address.

verb set: The actions that can be performed in an interactive work. The verb set of a game consists of all the things that players can make their characters do. The most common verbs are walk, run, turn, jump, pick up, and shoot.

video on demand (VOD): A service that gives viewers the ability to select and view videos.

viral marketing: A marketing strategy that encourages people to pass along a piece of information; originally used in Web marketing but now also used for wireless devices.

virtual channel: A designated channel where VOD videos are "parked."

virtual reality (VR): A 3D artificial world generated by computers that seems believably real. Within such a space, one is able to move around and view the virtual structures and objects from any angle. A VR world requires special hardware to be perceived.

VOD: See *video on demand*.

VR: See *virtual reality*.

walled garden: An area of restricted access, generally relating to Internet content.

WAP: See *wireless application protocol*.

webcam: A stationary digital video camera that captures images and broadcasts them on the Web. Webcams often run continually and the footage is broadcast without being edited.

webisodic: A story-based serial on the Web that is told in short installments using stills, text, animation, or video.

Wi-Fi: A protocol that enables a mobile device to have a high-speed connection to the Internet and to connect with other devices, like game consoles and DVRs.

wireless application protocol (WAP): A set of instructions that enables mobile devices to connect with the Internet and perform other functions.

wireless telephony: Communications systems that enable the transmission of sound, text, and images without the use of wires, unlike landline telephony.

Additional Readings

The following books offer additional information on various aspects of classic narrative, digital storytelling, design, and career issues:

- Adams, Ernest, *Break into the Game Industry: How to Get a Job Making Video Games* (Emeryville, CA, McGraw-Hill Osborne Media, 2003). A good guide to careers in the game industry.
- Aristotle, *The Poetics* (New York, Hill & Wang, 1961). The classic treatise on dramatic writing.
- Bonime, Andrew, and Pohlmann, Ken, *Writing for New Media: The Essential Guide to Writing Interactive Media, CD-ROMs and the Web* (Hoboken, NJ, John Wiley & Sons, 1997). Written at the crest of the CD-ROM and Internet wave and thus not inclusive of more recent technologies, this book is addressed specifically to writers.
- Campbell, Joseph, *The Hero with a Thousand Faces* (Princeton, NJ, Princeton University Press, Second Edition, 1968). A classic study of mythology and particularly of the hero's journey, a universal myth that many dramatic works, including digital stories, are modeled on.
- Crawford, Chris, *Chris Crawford on Game Design* (Indianapolis, IN, New Riders, 2003). A somewhat idiosyncratic but lively look at game design by a well-known game guru.
- Curran, Steve, *Convergence Design: Creating the User Experience for Interactive Television, Wireless and Broadband* (Gloucester, MA, Rockport Publishers, 2003). A handsomely illustrated work focusing primarily on design issues for iTV, wireless, and broadband.
- Dodsworth, Clark, editor, *Digital Illusion: Entertaining the Future with High Technology* (Boston, MA, Addison-Wesley, 1997). A collection of articles primarily on theme park development and location based entertainment.
- Dombrower, Eddie, *Dombrower's Art of Interactive Entertainment Design* (McGraw Hill, 1998). Now out of print, this book was written by the game designer who once headed the interactive division of the Jim

Hensen Studio (creators of the Muppets), and focuses primarily on game design.

- Garrand, Timothy Paul, *Writing for Multimedia and the Web* (Focal Press, Burlington, MA, 2000). A good general book about writing for interactive media containing many case studies.
- Herz, J, *Joystick Nation: How Videogames Ate Our Quarters, Won Our Hearts, and Rewired Our Minds* (New York, Little Brown-Warner Books, 1997). Now out of date, a provocative and interesting work on the cultural impact of video games.
- Iuppa, Nicholas V., *Designing Interactive Digital Media* (Burlington, MA, Focal Press, 1998). A very thorough and practical book that primarily addresses design issues.
- Maciuba-Koppel, Darlene, *The Web Writer's Guide: Tips and Tools* (Focal Press, Burlington, MA, 2002). This book focuses entirely on writing for the Web.
- Meadows, Mark Stephen, *Pause and Effect: The Art of Interactive Narrative* (Indianapolis, Indiana, New Riders, 2003). A beautifully illustrated and thoughtful examination of interactive narrative with an emphasis on design.
- Mencher, Marc, *Get in the Game: Careers in the Game Industry* (Indianapolis, IN, New Riders, 2002). A guide to careers in the game industry.
- Murray, Janet *Hamlet on the Holodeck: The Future of Narrative in Cyberspace* (Cambridge, MA, MIT, 1998). A well-regarded and thoughtful study of the potential of digital storytelling.
- Pearce, Celia, *The Interactive Book: A Guide to the Interactive Revolution* (Indianapolis, IN, Macmillan Technical Publishing, 1997). Now out of print, a collection of essays exploring the social, cultural, and psychological impact of interactive media.
- Rollings, Andrew, and Ernest, Adams, *Andrew Rollings and Ernest Adams on Game Design* (Indianapolis, IN, New Riders, 2003). A solid book on game design.
- Tollet, John, and Rohn, David, with Williams, Robin, *Robin Williams DVD Design Workshop* (Berkeley, CA, Peach Pit Press, 2003). A thorough explanation of DVD design.
- Vogler, Chris, *The Writers Journey: Mythic Structure for Writers* (Studio City, CA, Michael Wiese Productions, 1998). An examination of Joseph Campbell's theory of *The Hero with a Thousand Faces*, a mythic structure which is the basis of many games; this book is geared toward writers.
- Wimberly, Darryl, and Samsel, Jon Samsel, *Writing for Interactive Media* (New York, Allworth Press, 1998). One of the first books on writing and designing interactive media, it focuses primarily on CD-ROMs, the Internet and videogames but is still a good introduction to the subject.

Subject Index

435

Project Index